Robert Campin

A monographic study with critical catalogue

Felix Thürlemann

ROBERT CAMPIN

A monographic study with critical catalogue

Prestel
Munich · Berlin · London · New York

For Barbara, Nina and Moritz

TABLE OF CONTENTS

Foreword

Robert Campin was one of the greatest painters of the fifteenth century. Yet, because he did not sign his works, his name was soon forgotten. Even today, Campin, or the Master of Flémalle, as art historians once described this formerly anonymous artist, remains a little-known figure in spite of the enormous significance of his œuvre.

The plan for this study of his life and works emerged after reading Erwin Panofsky's *Early Netherlandish Painting*. This magisterial work succeeds in suggesting the central role that Campin undoubtedly played, along with the brothers Hubert and Jan van Eyck, in the development of early Netherlandish painting, but Panofsky is no more successful than the art historians before him in identifying and clearly distinguishing the group of works produced by Campin and his pupil Rogier van der Weyden, respectively. Traditional art historiography would have us believe that the younger of the two, van der Weyden, began his artistic career with an unparalleled stroke of genius in the form of his *Descent from the Cross* (now in the Prado in Madrid), while maintaining that the eclectic panels of the Werl Altarpiece in the same museum are the work of the older artist, Robert Campin, implying the sudden demise of his creative powers towards the end of his life.

Having already begun to doubt this traditional view of things, a meeting with Jochen Sander of the Städelsches Kunstinstitut in Frankfurt brought some decisive insights. Standing in front of the original works, the so-called Flémalle Panels and the *Thief on the Cross*, our conversation served to consolidate the view that Campin was an outstanding artist whose intellectual vigour was as great as his creative vitality. Then, reading *The Genius of Robert Campin* by Mojmír S. Frinta encouraged me to question, where necessary, conventional assumptions made by art historians about the work of Campin.

A fuller appreciation of Campin's artistic personality meant going beyond the strictly limited stylistic analysis undertaken by Frinta. It was no longer a question of distinguishing between the painterly techniques of different authors, but was also a matter of identifying the intellectual and conceptual approach that lends Campin's œuvre its coherence and exemplary distinctiveness. In short, by taking into account both the 'hand' and the 'mind' behind the œuvre, this study is also intended as a contribution to a critique of method and connoisseurship.

No mere summary of generally accepted findings can suffice in compiling a monographic study of Robert Campin. Many a traditional attribution is contested today and many a hypothesis, long rejected, deserves to be reconsidered. This explains why the list of works presented in this publication differs considerably from that published by Albert Châtelet in his 1996 monograph. I have included here Campin's designs for two major textile works: a considerable proportion of the tapestries in the Cathedral of Tournai depicting the lives of Saints Piatus and Eleutherius and the three richly embroidered copes in the Ecclesiastical Paraments of the Order of the Golden Fleece. The paintings by Campin, whether original or known only as copies, are bracketed, as it were, by these textiles – the tapestries, produced in 1402, being the oldest surviving works by Campin, while the embroideries, created after 1432, are among his last.

The most important new attribution to Campin is the *Descent from the Cross* in the Prado, Madrid. Still widely regarded as an early work by Rogier van der Weyden, this work can be linked, as Mojmír S. Frinta already suggested in 1966, to the so-called Flémalle Panels in the Städel, Frankfurt. The publication, in 1993, of Jochen Sander's painstaking analyses of the Flémalle Panels added further weight to Frinta's hypothesis and, in my view, important evidence that allows us to reconstruct, almost completely, the original scope of the masterpiece that Campin created for the chapel of the Louvain Guild of Crossbowmen.

New light is also shed on copies after lost originals by Campin, among which the fifteen-part series of sibyls and pagan wise men is of particular importance. This series, whose fame is documented by three independently produced early copies of the cycle, played a key role in the development of early Netherlandish portraiture, reflected in the works of Petrus Christus, Hans Memling and Joos van Ghent. Finally, it has been possible to identify three drawings by Campin and add them to the painterly œuvre.

Apart from works by Rogier van der Weyden and Jacques Daret, we have identified four further groups of works presumably by pupils of Campin. These are presented here under the names Master of the Louvain Trinity, Master of the Betrothal of the Virgin, Master of the Hortus conclusus and Master of the Madonna by a Grassy Bench. Each of them has a distinctive artistic style.

Finally, a few words should be said on the illustrations provided as a means of underpinning the arguments presented in the text. Originals by Campin and compositions by him that have survived only in the form of copies are reproduced in colour. Full-page details are all reproduced on a scale of 1:1 to permit direct comparisons. At the same time, it shows that the artist worked, for the most part, in two entirely different scales: the figures are either more or less life-size or reduced to about hand-size. The human figure is the point of reference of Campin's œuvre, to which all objects and landscapes are subordinated as tools and settings.

This publication represents the fruit of several years' work. Inevitably, it has involved the assistance and support of many individuals to whom I am very grateful. My thanks go first of all to Marion Thielebein and Christian Langner, representatives of a group of students at the Freie Universität Berlin, who, in the summer of 1990, gave the author the opportunity of presenting an initial outline of the Mérode Triptych for public discussion. I also wish to thank all the curators and archivists who were willing to discuss with me, either personally or by correspondence, the works and documents in their charge. They are, first and foremost, Maryan W. Ainsworth, Emil Bosshard, Marika Ceunen, Matia Diaz Padron, Susan Foister, Rainald Grosshans, John Hand, Manfred Huiskes, Henri Installé, Géza Jászai, Michael Miller, Henri Patelle and Helmut Trnek. Invaluable support was also given by friends and colleagues, and by the staff of the Universität Konstanz, who provided encouragement and constructive criticism: Hans Belting, Steffen Bogen, Rolf Eichler, Peter Fröhlicher, Catherine and Jacques Geninasca, Anja Grebe, Doris Harrer, Andreas Hauser, Ingo Herklotz, Peter Klein, Christiane Kruse, Ekkehard Kaemmerling, Wolfgang Kemp, James H. Marrow, Anne van Buren, Rolf Winnewisser.

I also wish to point out that this work was made possible in part by the special research division of Literature and Anthropology at the Universität Konstanz, financed by the Deutsche Forschungsgemeinschaft.

The Artist Identified

A Painter in Tournai between 1406 and 1445

All that we know today of Robert Campin's life and work we owe to painstaking art historical research. The more we find out, the clearer it becomes that Campin played a key role in the development of Netherlandish *ars nova*. Yet by 1548 at the latest, barely a century after his death, the name of Robert Campin had already been forgotten.

False leads and misinterpretations

As with so many other painters of that period, information about Robert Campin as an artist and individual had to be gleaned indirectly, working at first, by necessity, on the basis of an invented pseudonym. Art connoisseurs identified a number of stylistically similar works and, believing them to be by the same artist, grouped them together as the œuvre of an anonymous artist they chose to describe as the Master of Mérode on the basis of the triptych now in the Cloisters in New York (Cat. I.12). Later, in recognition of the three panels in the Städel in Frankfurt (Cat. I.18), he was referred to as the Master of Flémalle. In 1909, the Belgian art historian Hulin de Loo identified the Master of Flémalle as Robert Campin of Tournai, teacher of Rogier van der Weyden and Jacques Daret.

In doing so, he aroused a new interest in the many archival documents on Campin that had already been published, most of them during the second half of the nineteenth century.[1] At the time, however, the widespread romantic notion of the artist as genius hindered scholars in their attempts to flesh out Campin's name with the aid of documents, even leading to a number of misunderstandings, some of which still prevail today. Surviving receipts indicate that Robert Campin was involved primarily in work that would be regarded according to modern criteria as 'mere' craftsmanship. Because of this, Emile Renders and other art historians regarded him as no more than an obscure 'decorative painter' who could not possibly have been the teacher of Rogier van der Weyden. The fact that Campin was convicted by a city court in 1429 and 1432 – the first time on grounds of obscuring the course of justice as a witness, and the second time on grounds of adultery – gave some scholars reason to cast his fate in the mould of an activist involved in the political upheavals that shook Tournai at the time. They saw Robert Campin as a kind of early fifteenth century Jacques-Louis David, as a revolutionary and popular hero who had played a leading role in the 1423 uprising of craftsmen against the ruling oligarchy. In this light, they saw the two court convictions as acts of vengeance wreaked by the ruling classes.[2]

The social context

For a painter of the period, the number of surviving documents on Robert Campin is quite remarkable (most of the originals were burnt in 1940 during the bombardment of Tournai). Apart from the two court convictions already mentioned, there are entries in the municipal accounts and in the public records of various church parishes, magistrates' notices, records of lifetime annuities and testaments, totalling more than sixty texts in all. None of the surviving documents relates directly to any surviving work of art.[3] Together, however, they do

enable us to reconstruct the social context in which Campin lived and worked, allowing us to trace his life and broadly outline his artistic career. Finally, a number of witnesses give us an insight into the reputation enjoyed by Campin during his lifetime.

Robert Campin was born in the year 1375, or perhaps three or four years later, probably in Valenciennes or Tournai. His family came from Valenciennes, but at least one member of the family – probably the artist's uncle – had close links with Tournai as early as 1400.[4] Initial works by Campin are recorded in the documents of the city of Tournai for the year 1406. At the time, Campin was thirty years old and presumably already headed his own workshop. Four years later, in 1410, he acquired rights of citizenship in the city of Tournai. The fact that Campin took this step does not necessarily prove that he came from elsewhere, but it does provide evidence of his early reputation as an outstanding painter. The acquisition of citizens' rights was a privilege not generally available to craftsmen in Tournai before 1423. In Campin's case, this may well be related to his function as municipal painter. Although there is no record of such an office in Tournai, works both large and small were regularly commissioned from Campin and the members of his workshop by the municipal authorities, most notably after 1410.

At the time, the town on the Schelde (figs. 1, 2) was a flourishing community with a population of some 30,000, a politically largely independent enclave within the Burgundian territory that was under the direct rule of the French crown. Close business and economic links existed to neighbouring cities of Flanders. A bishopric with a Benedictine Abbey and other important monasteries, including a Franciscan monastery, Tournai was also an important ecclesiastical centre.

Artistic professions were firmly established in Tournai. A guild of painters is documented there as early as 1365. Three years later, the painters joined forces with the goldsmiths under one and the same *bannière*. In the year 1404, they forged a new alliance, joining forces with the sculptors to form a brotherhood of *sculpteurs et imagiers*. This organisation had no political rights, a fact that was not to change until 1423 following the craftsmen's uprising.

The works executed by Campin's workshop for the municipal authorities were seminal in shaping the image of Tournai in the early fifteenth century. The painter and his apprentices adorned the flags and turrets of many public buildings with the coat of arms of the city and the French king – as documented in the case of the *beffroi* (bell tower), the town hall and various city gates. In the year 1414, they painted the *bretèque communale* in gold and oils, the bay window of the *halle des consaux*, as the town hall of Tournai was known (fig. 3). Moreover, they polychromed a number of the sculptures that adorned certain public buildings. They decorated the banners, standards and shields for the city's archers with golden

Fig. 1 Gabriel Bodenehr, Plan of the city of Tournai before the building of the citadel at the Porte de Valenciennes in 1668

Campin's first residence was in the immediate proximity of the Cathedral choir (1). After 1420 he lived in the parish of St.-Pierre (8).

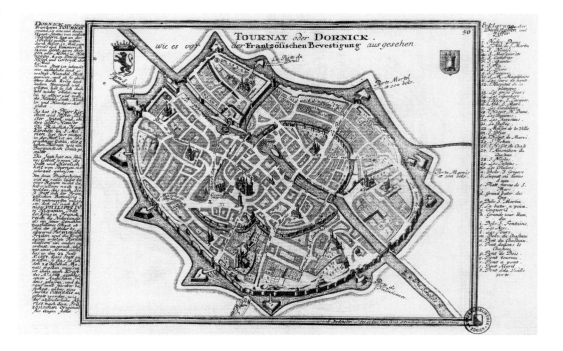

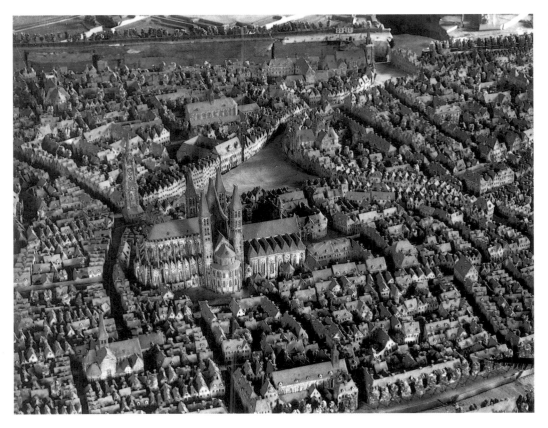

Fig. 2 Model of the city of Tournai (detail), mid-eighteenth century

The town centre is dominated by the huge, five-towered cathedral. On the lower left we can see the church of Saint Pierre, which was demolished in 1821.

fleurs de lis whenever a company was dispatched to support the French king. From 1428 onwards, a large mural created by Campin could be seen in the *halle des consaux* portraying the city's patron saints Piatus and Eleutherius, as well as members of the French royal family. The municipal authorities commissioned Campin to paint a number of smaller objects as well, such as caskets, panels by which an oath could be sworn, and wine ewers. In 1426, he designed the new ceremonial robes for the magistrates, as well as the shrine that they carried through the city in the September procession following the dissolution of the patrician *confrérie des Damoiseaux*.

Another important source of work was the city's churches. Altarpieces by Robert Campin and sculptures polychromed by his workshop graced the places of worship throughout the town. In the Chapel of Saint-Pierre, there was a large sequence of canvases for which Campin supplied the designs. Finally, in the salons and bedchambers of Tournai's wealthy citizens, there were votive pictures created by his hand, and, though no surviving document proves this, very probably the first examples of the new genre of the autonomous portrait.

Early success

Robert Campin must have enjoyed a reputation as one of the leading Netherlandish painters at a very early stage. Around the year 1415, Gheraart van Stoevere, a respected and wealthy painter from Ghent, apprenticed his son Jan to Campin, probably after giving him some initial training himself.

Campin soon achieved a certain wealth. On 6 February 1408, he purchased a house in la Lormerie, the street where he was already living. The entrance to the house was opposite the *grande boucherie*, and the rear of the house was bounded by the cathedral annexe (figs. 1, 2). Twelve years later, in 1420, Campin sold this property and settled in the parish of Saint-Pierre in the Rue Puits-l'eau. Just two years later he purchased a second house in the same district. Also in the year 1422, at the age of forty-seven, he purchased municipal lifetime annuities for himself and his wife, who was about seven years older than him. Yet it was around 1430 that Campin reached the apex of his wealth and artistic success.

By moving into the Rue Puits-l'eau, in the year 1420, the forty five year old artist gained a social status befitting his professional success. The parish of Saint-Pierre was a lively district inhabited by wealthy citizens and craftsmen (fig. 2). In the same year, Campin became a churchwarden of his parish and in 1425 and 1427 respectively, the assembly of

burghers and house owners of the parish elected him as one of their two representatives on the thirty-strong body of *eswardeurs*, one of the institutions governing the fortunes of the city. In the same period, between 1420 and 1427, Campin also acted as treasurer of a convent, as *capitaine* of his district and, finally, even as *commis aux comptes*, one of the city's six auditors and keepers of the seal. Those craftsmen of Saint-Pierre who, like Campin, possessed citizens' rights, clearly regarded him as a trustworthy colleague well versed in financial matters.

Campin was also highly respected by his closest colleagues, the painters and sculptors. In the year 1426, he acted as executor of the estate of the painter Piérart de le Vigne. He maintained particularly close contacts with the families of the sculptors Jacques de Braibant and Jean Daret. In the year 1422, Campin was evidently the driving force behind the removal of the Altar of the Guild of St Luke from the cathedral to the church of his own parish. It may be assumed that he was at the time the *prévôt* or head of the guild and it may also be assumed that he played a leading role in the reorganisation of the painters' guilds following the craftsmen's uprising of 1423.

The revolution of 1423

"On Tuesday, Wednesday and the Thursday thereafter, the 8th, 9th and 10th of June, the people of the city gathered with arms on the market place day and night." Thus reads the official report on the events running up to the revolt of craftsmen and workers against the patrician oligarchy of Tournai in the year 1423.[5] The uprising, which also affected other Netherlandish cities in the fourteenth and fifteenth century, had wider repercussions in Tournai, where the rebels, members of a politically impotent social stratum, regarded themselves as loyal supporters of the French king against the upper classes who sympathised with the Duke of Burgundy.[6]

Older literature repeatedly maintains that Campin was one of the ringleaders in the uprising and that he had been a member of the new upper chamber of the city council following the restitution of the old guild order of 1368 with its thirty-six *bannières*, in his capacity as *sous-doyen* of the guild of goldsmiths and painters. However, as Schabacker noted in 1980, there is no evidence that Campin ever held this political office. Instead, having been a citizen of the town since 1410, he already possessed all the privileges that the rebels were demanding in 1423.

Nevertheless, in one case, at least, Campin did indeed put his loyalty to a rebel colleague before his own personal interests. On 21 March 1429, in the course of the municipal authorities' proceedings against political agitators who were seen as a menace to the common weal, the painter Henri le Kien was brought before the court and sentenced to lifelong banishment on grounds of *paroles sedicieuses et malsonnans* (seditious and offensive talk).[7] That same day, Campin was called as a witness, evidently in connection with this particular case. His refusal to make a statement made him a victim of justice as well, albeit only indirectly. Campin was sentenced to pay a fine and to undertake a pilgrimage of penance to St.-Gilles in Provence on grounds of *oultraiges d'avoir celé vérité* (obscuring the truth). It is almost certain that Campin did not actually undertake the pilgrimage, but that he had the sentence commuted to an additional fine instead, as was common practice at the time.[8] The sentence also entailed a permanent ban on his appointment to any public office in the city.

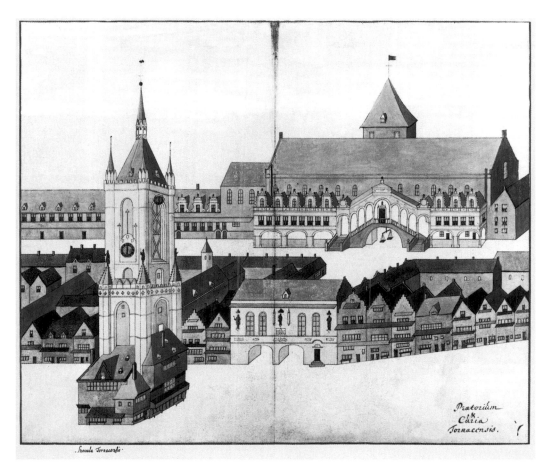

The ban, however, was soon revoked. The conviction does not appear to have had any adverse effect on Campin's career as a painter either, for in the same year and the following year he received further commissions from the municipal authorities.

1432: second court conviction and dissolution of the workshop

Campin's second conviction was a very different matter. On 30 July 1432, the painter was called before a court once again, this time on grounds of repeated adultery. Campin, who was married, without children, to a woman seven years his senior by the name of Elizabeth van Stockem, was accused of having led a dissolute life with one Leurence Polette in Tournai for some time ('pour l'orde et dissolue vie que lui, qui est marié, a maintenue par long temps en la cité avec Leurence Polette'). Although older

Fig. 3 "Praetorium et Curia Tornaciensis" from A. Sanderus, *Flandria illustrata*. Brussels. Bibliothèque Royale Albert Ier, ms. 16823, fol. 15 v° – 16 r°

The drawing shows the political centre of the town with the belfry and the two public or civic buildings that are no longer extant – the Halle des Doyens with its ground level passageways and the huge Halle des Consaux or town hall. The seventeenth century double stairway at the front replaced the original "bretèque communale".

literature tends to link the two there is no reason to suppose that the second court case had anything to do with the first. The new trial against Campin need not necessarily have any political undertones. Instead, the accusation can be seen as part of a broad-based campaign launched by the church during that period to root out the adultery to which it had turned a blind eye for so long.[9]

Robert Campin was sentenced to one year's banishment. At this, the painter clearly decided to close down his workshop before the sentence came into effect. Within the space of only a few days, two of his students, Rogier van der Weyden and a certain Willemet, who had already completed the four year apprenticeship required by the new guild order, were named free masters. A third student, Jacques Daret, followed on 18 October, the name day of Saint Luke. Yet one week later, on 25 October 1432, the sentence of banishment against Campin was repealed after Marguerite de Bourgogne, stadholder of the county of Hennegau, intervened on his behalf with the municipal authorities of Tournai.

The last thirteen years

If Campin continued to run a workshop at all after 1432, then it must have been a much more modest operation. Jacques Daret and Rogier van der Weyden set up their own studios as independent artists. Moreover, after 1432, there is no further record of any students of Campin in the registers of the painters' guild. Tournai's bleak economic situation at the time may well have led to cutbacks in the workshop anyway.[10] Whereas the municipal authorities and the church parishes had regularly commissioned works from Campin before 1432, only four or five such commissions are documented for the last thirteen years of his

life. However, these documents do not indicate the extent to which Campin may have received commissions from other patrons during this period.[11]

Two documents from the archives from the city of Tournai prove that, towards the end of his life, Robert Campin enjoyed an outstanding reputation as an artist in his home town. When the executors of the will of Regnault de Viesrain, who died at the end of 1438, carried out his wish for a portrayal of the Life of Saint Peter to be donated to the Chapel of Saint-Pierre in Tournai, it was Robert Campin who was commissioned to produce it. Campin, however, limited his own contribution to the key creative design, known at the time among Italian art theorists as *inventio*. He based his designs on a description of the Life of St. Peter by a monk of the Franciscan monastery, but left the painterly execution of the large scale canvases to a younger colleague by the name of Henri de Beaumetiel.

Two years before that, in 1436, when construction work on the *halle des consaux* (fig. 3) had necessitated the destruction of part of the wall painting that Campin had created only eight years previously, the municipal authorities undertook conservationist measures. They commissioned one 'Maistre Rogier, le pointre' – very probably Campin's former student Rogier van der Weyden – to create a copy of the section in question showing the Kings of France and Aragon on horseback.[12] The copy was intended to be used as a basis for reconstructing the mural once the building work was finished. This would certainly indicate that at least one work by Campin was regarded even in his own lifetime as an outstanding and irreplaceable treasure of individual artistic creation.

Robert Campin died at the age of almost seventy, in Tournai, probably on 26 April 1445.[13]

The Artistic Personality Outlined

Surviving archival documents have allowed us to grasp Robert Campin as a historic figure and an individual. They tell us when he worked, the circles he moved in, and the patrons for whom he and the members of his workshop carried out their commissions. Yet because these documents cannot be linked directly to any of the works traditionally attributed to Campin, they contribute very little to an interpretation of these works. Even once the Master of Flémalle has been identified as Robert Campin, the works of art themselves still require independent study. In analysing them, we can flesh out what we know of the historic figure by reconstructing his artistic personality.[14]

The very concept of the artistic personality as such has recently been called into question, particularly with regard to studies of late medieval painting. The concept is regarded as inappropriate because the panel paintings of the period were not works by individual artists, but collective efforts involving the collaboration of highly specialised workshop members. While we may assume that Robert Campin, too, headed a well organised workshop, this does not devalue the notion of the artistic personality. It would be short-sighted to seek to determine the authenticity of a work solely by way of identifying the hand of the artist. After all, with craftsmanship and conceptual design constituting dual aspects of artistic creativity, the outstanding artists of the time were perfectly capable of producing artistically satisfying works with a distinct personal style even when this involved the employment of assistants.

Principles of composition

In order to define an artistic personality, we need to locate a group of works executed by that artist himself. Robert Campin can be understood only on the basis of a group of paintings that are the product of both his intellect and his hand. With their aid, we can determine the compositional principles that define Campin's personal style. Once these have been described with adequate precision, it becomes possible to attribute the design and composition of further works to this artist, even if they have not been directly painted by his hand.

A personal painterly style can only be determined on the basis of abstract principles of composition that possess a certain continuity over a lengthy period of creative activity. As such principles are not bound to any figural motifs, they are difficult even for direct students of the artist to imitate. In order to determine an initial group of such compositional principles, we shall compare two works that are almost unanimously accepted as paintings by the hand of Robert Campin himself. They are the small fragment showing *John the Baptist* at the Museum of Cleveland (Cat. I.2; fig. 5) and the *Virgin and Child* (Cat. I.18b; fig. 4) which is one of the Flémalle Panels at the Städel in Frankfurt. Because these two paintings represent Campin's early and late work, respectively, we may assume that the stylistic elements they have in common are to be found throughout the entire œuvre of the artist.

An early work

The fragment held at the Cleveland Museum of Art (fig. 5) is the upper half of the right wing of a small domestic altarpiece created around 1410. The bust of the saint, who is bearing the banner of the cross in his left hand, stands out against a regularly patterned green and gold ground. The artist based this background pattern on a piece of Italian silk fabric. Scattered across a seemingly endless pattern of ornamental foliage, we see dogs running towards the left. The prophet is looking in the same direction, his head slightly inclined, his gaze directed towards the central panel on which the Redeemer was once portrayed. John the Baptist is wearing the hair shirt whose locks echo the locks of the hair on his head. Over the fleece, he is wearing a white mantle knotted on his right shoulder. The shadows of this white mantle are not painted in black, but shaded in a violet hue.

The fairly young face, shown in three quarter profile, has a distinctly melancholy expression that is both alert and at the same time composed and inwardly tranquil. The black-rimmed nimbus of gold – flat like the background but clearly allocated to the figure of the saint – stands behind his head like a metal disk. The banner with the red cross echoing the cross of the saint's staff like a shadow is slit along almost its entire length. The banner peters out into two slender ribbons that spiral away in opposite directions at the ends. The pennant is positioned in such a way that its ends seem to be attached to the back of the saint like the handle of a pitcher. What we see here has to do with a phenomenon of painterly composition described by Otto Pächt as a 'dual valency of the projected form', which he noted as characteristic of southern Netherlandish paintings. It consists in 'adapting the contours to each other', linking forms that are 'connected neither in terms of content nor in terms of space'.[15] No Netherlandish painter pursued this principle as clearly as Robert Campin and it is by no means a coincidence that Pächt should take the central panel of his Mérode Triptych (fig. 41) as a prime example of the phenomenon he describes.

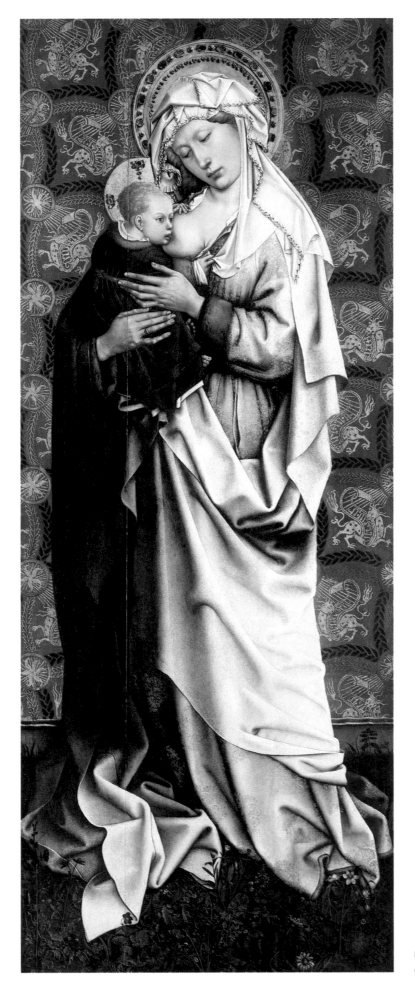

Fig. 4 Robert Campin, *Virgin and Child (Maria lactans)*, c. 1430. Frankfurt, Städelsches Kunstinstitut

Fig. 5 Robert Campin, Saint John the Baptist, c. 1410.
Cleveland Museum of Art

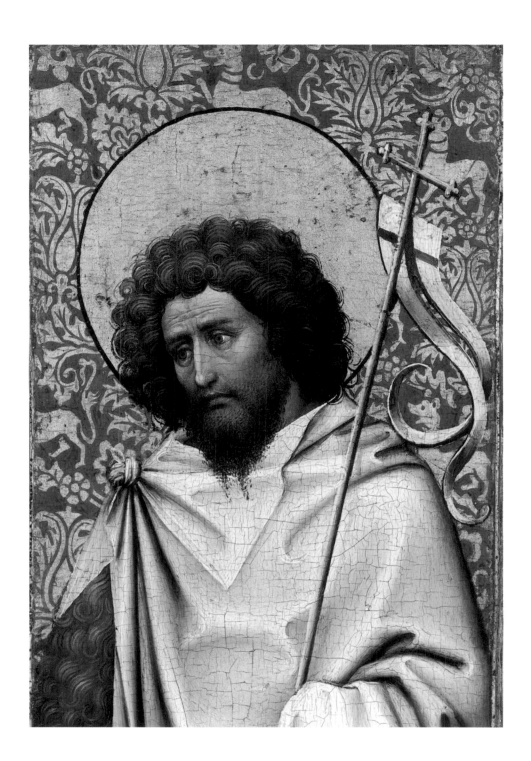

A late work

The *Virgin and Child* is portrayed on one of the three Flémalle Panels (fig. 4). In a very different format – life size rather than postcard size – the Virgin stands before us suckling the Infant. This panel was originally part of a larger ensemble. This mature work shares certain compositional principles that also inform the early *John the Baptist* fragment. In the later work, we find once again the two extremes of simulated spatiality; a flat, ornamental ground – this time a brocade drape – forming a neutral compositional groundswell that corresponds visually, at least in the upper part, to the flat panel on which the picture is painted. Against this background, the sculpturally rounded figures of the *Virgin and Child* seem to have been raised, almost relievo-like, out of the picture. The regularity of the background, void of any compositional centre, contrasts and underpins the rich diversity of the draperies

of the figures portrayed. Yet thanks to the colour composition of the robes, modulated from white to blue, they take on a powerful sculptural presence. Here, Campin has once again adopted the principle of employing a colour to portray the shadows of the white fabric, this time creating the additional effect of constructing a kind of visual column out of the blue shadow of the Virgin's mantle to support the figure of the Infant in his blue robe.

Once again, the nimbi act as mediating interim elements between two extremes of painterly composition: that of the ornamental ground and that of the free-standing group of figures. Flat and parallel to the picture plane, the nimbi form part of the background; as contoured metal bodies set behind the heads, they belong to the foreground figures. Here, the artist has gone further than in the nimbus of John the Baptist, lending the nimbi of the Virgin and Child a certain ambiguity: the decorative background is echoed in the regular pattern of pearls and precious stones, while their aspect of glittering, simulated goldsmithing places them in the world of the figures.

Campin also played with the 'dual valency of the projected form' in his later work: the tip of the Virgin's headdress, bordered with tiny pleating, seems to touch the head of the Infant as though offering a further tender gesture of loving affection.

Finally, there is another detail that shows how the artist repeats the same painterly process and yet reinvents it each time: in the early *John the Baptist* fragment (fig. 5), a triangular section of cloth, under the saint's chin, falls over the folds of the mantle beneath it in such a way that the otherwise harsh folds are concealed from the spectator's gaze and perceived only in soft relief. Similarly, in the lower third of the *Virgin and Child* panel (fig. 4), the fabric of the white mantle is drawn over the moving, draped figure like a second, calming layer.

A comparison of these two panels indicates that, over a period of some fifteen years in the work of Campin, a number of remarkably incisive compositional principles have been remained effective. These provide us with some initial elements by which to determine the artistic personality of the painter. Indeed, these two paintings constitute the yardstick by which we can measure the painterly quality of the remaining works traditionally attributed to Robert Campin.

The Œuvre

BEGINNINGS

Robert Campin's training as a painter is not documented. The attribution to Campin of the designs for a considerable proportion of the tapestries depicting the lives of the city's patron saints Piatus and Eleutherius in the Cathedral of Tournai enables us to reconstruct, at least hypothetically, the context of the workshop in which the twenty-five year old artist was employed. The singular narrative talent evident in those parts of the tapestry designed by the young Campin links this early work to his oldest extant painting, the Seilern Triptych. Campin probably created the triptych more than ten years later for an unknown private patron, once he had founded a workshop of his own in Tournai.

1400: Robert Campin in the Workshop of his Teacher

The question of Robert Campin's artistic background has remained more or less unanswered up to the present day. Because there are no documents relating to his apprenticeship, art historians have had to make do with attempts to link Campin's specific style with earlier works that he may have sought to emulate. Since the early years of the 20th century, three stylistic 'sources', generally in combination, have been proposed for Campin's painting. They are the Franco-Flemish manuscript illuminations, the Burgundian panel painting linked with the names Melchior Broederlam and Henri Bellechose, and fourteenth century Burgundian sculpture, primarily the works of Claus Sluter in the Charterhouse of Champmol near Dijon.

The somewhat tenuous documentation of surviving monuments makes it seem almost impossible to allocate Campin's œuvre to any particular school. Nevertheless an attempt is to be made to do so here. We believe that a long accepted yet inaccurate theory of Campin's origins has so far distracted scholars from an important clue. The key is a work still situated in Tournai today, in the very place for which it was originally created.

Until recently, because of the fact that Campin acquired his citizens' rights in the year 1410 (see Doc. 8), it was widely assumed that he had moved to the city from elsewhere and that he had trained as a painter in some other town.[16] However, as we have already pointed out, this conclusion is not necessarily imperative.[17] We cannot dismiss the possibility that Robert Campin actually trained as a painter in the very town in which he later worked.

A pair of tapestries dated 1402

Flourishing painters' workshops are documented in Tournai as early as the end of the fourteenth century.[18] Yet there is not one single surviving painting that can be said with certainty to have been created in Tournai during Campin's early years. Nevertheless, to this very day, the Cathedral of Tournai houses an artistic monument of unparalleled importance whose relationship to early Netherlandish painting still tends to go largely unnoticed. The work in question is a pair of tapestries depicting scenes from the lives of the city's two patron saints Piatus and Eleutherius. The tapestries were displayed above the choirstalls of the cathedral until the middle of the eighteenth century (figs. 6, 7).[19] An inscription, now lost, but docu-

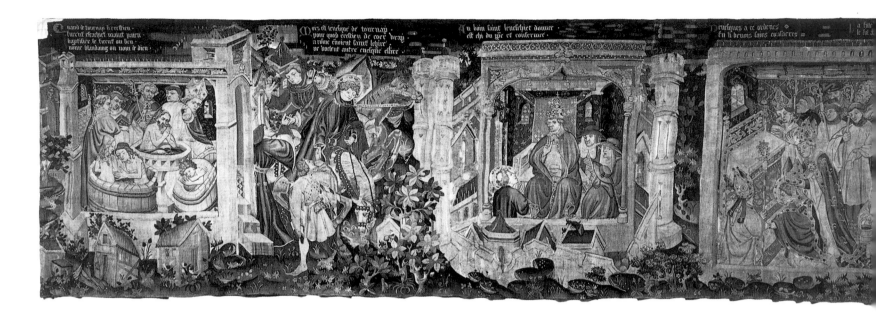

Fig. 6 Eleutherius Tapestry, 1402. Tournai, Cathédrale Notre-Dame

mented in transcription, provides a precise record of their production. Completed in December of the year 1402 by the tapestry weaver Pierre Feré in Arras, they had been commissioned by Toussaint Prier, a canon of the Cathedral of Tournai, who had previously acted as father confessor to the Dukes of Burgundy.[20] The inscription does not mention who actually provided the cartoons for the tapestries. It is perfectly possible that they were designed in a painter's workshop in the city of Tournai. After all, the tapestries contain a number of elements that herald the new aesthetics of Netherlandish realism.[21] What is more, the realistic portrayal of a number of the city's important buildings also supports this possibility.

The work consists of two parts: a sequence of six scenes from the *Life of Saint Piatus* (fig. 7), which originally included three further scenes, and a sequence of eight scenes from the *Life of Saint Eleutherius* (fig. 6). The last parts of this second sequence have also been lost. Each scene bears a brief title in French. The two tapestries were mounted opposite one another, flanking the high altar: one on the gospel side (or north side) and the other on the epistle side (or south side).

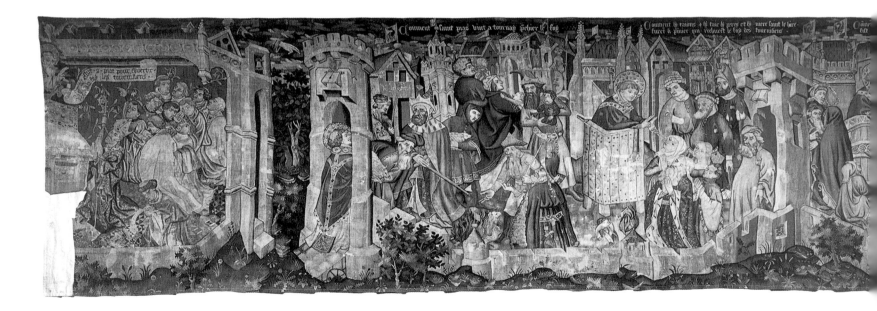

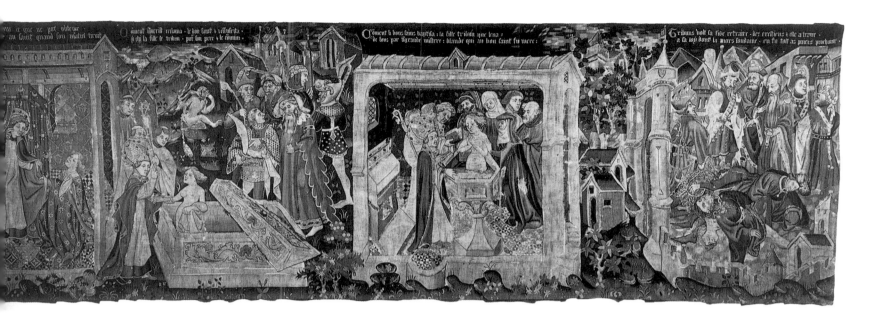

As this is the only surviving figurative rendering of the life and passion of the two patron Saints of Tournai,[22] it may be assumed that these tapestries were created directly on the basis of a text. The text in question must have been more detailed than the descriptions of the lives of these two saints that have been handed down to us in the *Acta Sanctorum* and in Jean Cousin's *Histoire de Tournai*, for the tapestries include a number of additional motifs with no explanatory captions which are either not mentioned in the relevant literature to date or have yet to be interpreted.

The tapestry depicting the *Life of Saint Eleutherius* (fig. 6) is more conventional in its narrative structure and overall design. The six interior scenes are set in box-like chambers that open out towards the spectator. This approach in the portrayal of the internal spaces is commonly found in French manuscript illuminations around 1400.[23] Almost all the scenes are portrayed on a square plane. The two open scenes set between the chambers also share the same dimensions. The sequence depicting the *Life of Saint Piatus* (fig. 7), on the other hand, involves narrative units of varying widths. What is more, events that actually occurred at different times in the city of Tournai are portrayed in parallel.

Fig. 7 Piatus Tapestry, 1402. Tournai, Cathédrale Notre-Dame

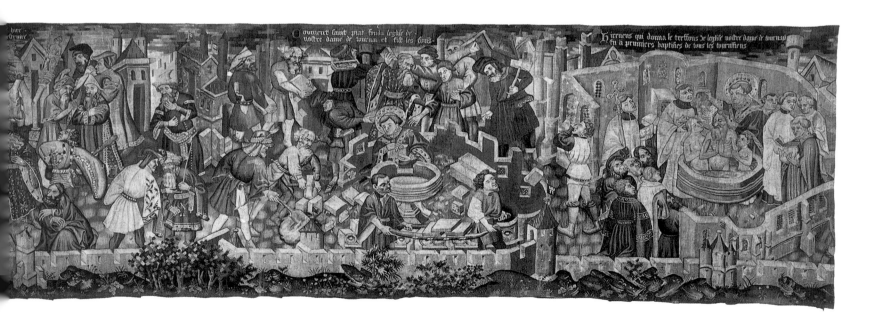

The Life of Saint Piatus

Let us take a closer look at the tapestry depicting the story of Saint Piatus. The first scene [1] (fig. 8) shows his vocation as a missionary. In a church room that is open to the front and the side, the bishop is seen kneeling with eleven others before an altar whose retable is richly ornamented with precious stones. The figure of God the Father appears above the altar. In his left hand he holds a banderole bearing the inscription: "I have chosen Saint Piatus to convert the people of Tournai to the faith." Each of the twelve clerics responds in his own way to the heavenly tidings.

Scenes [2] and [3] (fig. 9) are set in the still pagan city of Tournai. The city is bounded to the left and right by mighty gateways. In the background, high buildings create a horizon line, while in the foreground an extremely low wall – a conventional pictorial device at the time – permits a view of the events taking place on the interior. The buildings in the background are realistic portrayals of actual edifices. Below them, we see the *beffroi* as it looked around 1400, without a clock face (cf. fig. 3).

In keeping with the mode of continuous narrative style, the saint, identified by a jewel-encrusted nimbus, is portrayed twice (fig. 9). On the left he is passing through the city gate and the herald preceding him has already arrived inside the town. There, in the presence of four idolaters, a lamb is being sacrificed. Directly above the fire, a man with another lamb is waiting to make the next sacrifice. In the background, a couple with two children are appealing to the figure of a deity on a column that appears to turn its face away from them so that those seeking help see only the grimacing face of his shield. A fifth pagan priest carrying a little boy in his arms looks down towards the flames that are consuming the lamb alive.

The costumes of the idolaters, most of them shown as old and toothless, are picturesque. All are wearing pointed hats. Some have robes ornamented with borders bearing pseudo-Hebraic letters and a meander or fret. The richly ornamented belts are particularly striking. A dagger is dangling from the belt of the priest with the lambskin-lined robe on the outside right facing the spectator.

The next scene [3] (fig. 9) shows the saint preaching from a simple wooden pulpit. Gesticulating expressively, he is expounding the new faith. Facing the preacher, kneeling and looking towards him attentively we see the family of Iranaeus, one of the city's most influential citizens. This noble, white-haired figure is wearing a red robe of brocade lined with ermine, both here and in two further scenes. Behind the family, on crutches, there are four beggars in tattered clothes, most of them with amputated limbs. It is hardly surprising that Jean Voisin, who rediscovered the tapestries in the nineteenth century, should have chosen this particular scene, with its portrayal of humanity foreshadowing the visions of Brueghel, for reproduction in a colour lithograph.[24]

The narrative structure of scenes [4], [5] and [6] is particularly interesting (figs. 12, 14). The three scenes are bounded by a single city wall. In scene [4] we see Saint Piatus preaching again. This time he is speaking from a round and decoratively ornamented pulpit. At his feet, three men are listening attentively. Behind him there are three figures – one of them a woman with her face covered – who seem to be discussing the saint. Opposite him are Iranaeus and two other men. They are setting about turning the preacher's words into deeds, and have taken up cudgels with which to topple the heathen idol already portrayed in the second scene from its pedestal. In the upper half of the picture we see five followers of

Fig. 8 Anonymous artist – "second hand" (cartoon), Piatus Tapestry, Scene 1: "I have chosen Saint Piatus to convert the citizens of Tournai to the Christian faith."

the old faith, desperately wringing their hands and tugging at their beards as they watch. Two others are standing in the foreground on the right and conspiring to murder the missionary. The younger of the two grasps the dagger of the idolater portrayed in the second scene, who is now pointing to the saint in the following scene as the target of their assassination plot.

The last two scenes, [5] and [6] (fig. 14), are closely linked. The first shows Saint Piatus among craftsmen building the new church. It is an extraordinarily lively portrayal informed by a precise observation of contemporary building. We can see apprentices mixing mortar and others carrying it away in a wooden pail, stonemasons chiselling blocks and others carrying them to the building site where they are to be cemented into the walls with mortar. These scenes unite a great variety of motifs as elements within a complex overall context, rather than showing them individually in the manner of the 'woodcutter' tapestries that were popular around the middle of the fifteenth century.

Above the figure of Saint Piatus, who is adding the finishing touches to the baptismal font, we once again see Iranaeus in his red, ermine trimmed brocade coat. He joins the work, goading on some dilatory craftsmen who are carrying a trowel and hammer in their left hand, respectively. In the foreground, two men are carrying slabs of stone on a wooden stretcher. The man at the front is looking up in alarm at a falling stone which has clearly hit the man on the outside right on the head – could he be the assassin in the service of the idolaters?

In the sixth and last surviving scene of the Piatus story (fig. 14) we see the family of Iranaeus in the still unroofed church, standing naked in the baptismal font and being baptised by the bishop in the presence of a group of Christians.

Three hands

The literature to date has generally assumed that the designs for the two tapestries showing the lives of Saint Piatus and Saint Eleutherius were created by one and the same artist. However, this is not possible. A closer examination of the stylistic characteristics of the individual

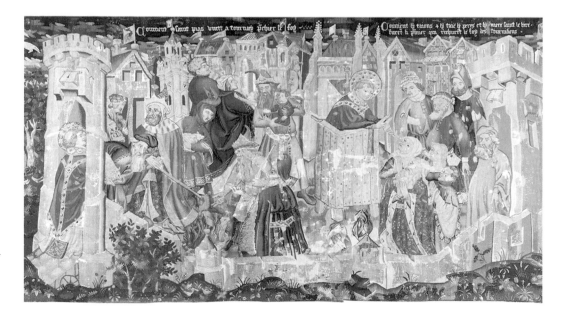

Fig. 9 Robert Campin (cartoon), Piatus Tapestry, Scene 2: "How Saint Piatus came to Tournai to preach to the faithful." – Scene 3: "How the grandfather and grandmother, father and mother of Saint Eleutherius were among the first in Tournai to adopt the faith."

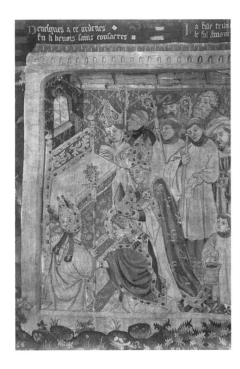

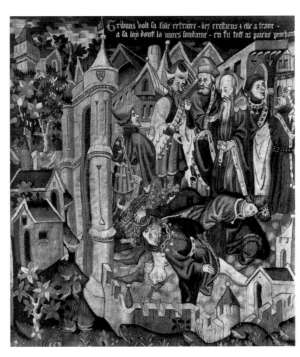

Fig. 10 Anonymous artist – "first hand" (cartoon), Eleutherius Tapestry, Scene 4: the ordination of Eleutherius as bishop

Fig. 11 Anonymous artist – "first hand" (cartoon), Eleutherius Tapestry, Scene 8: Plague in the City of Tournai

The "first hand" gives a much more conservative rendering of the city than the "third hand" (fig. 9).

scenes indicates that it was the work of three different artists. The designs for the entire Eleutherius story (fig. 6) in its current state were produced by one artist. His style is marked by a conservative approach, and in the following we shall refer to him as the 'first hand'. The designs for the *Life of Piatus* (fig. 7) were produced by two other artists, and we shall refer to their contributions in the following as the 'second' and 'third' hands respectively. The second hand designed only one of the surviving scenes – the first scene showing the vocation of Saint Piatus.

A comparison of two related scenes allows us to point out the characteristic differences between the first and the second hand. Let us compare the fourth scene of the Eleutherius tapestry, showing the ordination of Eleutherius as bishop (fig. 10), designed by the first hand, with the scene portraying the vocation of Saint Piatus (fig. 13).

The figures in the Eleutherius scene (fig. 10) are stocky and their heads are often disproportionally large. Hair and physiognomy are limited to a few types. They tend to have small mouths with soft, feminine lips. The noses often end in an oddly bulbous tip. The alignment of the standing figures in two horizontal rows appears rather monotonous. Their robes are draped in long, parallel folds. The robe of the crowned bishop is the only one with a simple lily pattern, whereby the folds barely alter the pattern.

In the corresponding Piatus scene (fig. 13) designed by the second hand, the heads of the figures are strongly individualised. The noses are generally pointed and often have a strongly emphasised flat bridge. The proportional relationship between head and body is more balanced. The alignment of the figures is extraordinarily lively and inventive. The same is true of the drapery. Note, in particular, the remarkably richly structured and undulating folds in the brocade robe of the bishop that impart a sense of swirling movement to the finely patterned garment.

Fig. 12 Robert Campin (cartoon), Piatus Tapestry, Scene 4: "How Irenaeus, grandfather of Saint Eleutherius, had the idols of the people of Tournai destroyed."

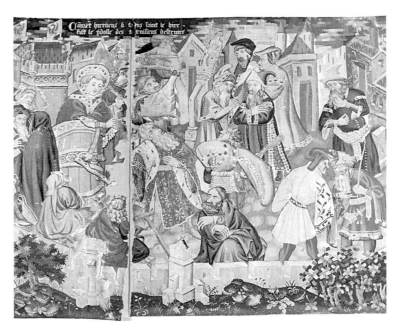

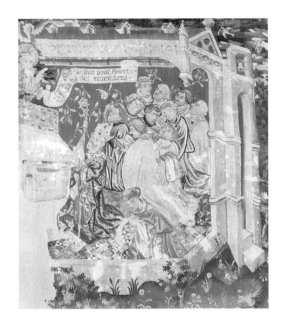

Fig. 13 Anonymous artist – "second hand" (cartoon) Piatus Tapestry, Scene 1: Vocation of Saint Piatus

Fig. 14 Robert Campin (cartoon), Piatus Tapestry, Scene 5: "How Saint Piatus laid the foundation stone for the Church of Our Lady and erected the baptismal font." – Scene 6 (Campin together with the "first hand"): 'Irenaeus, who donated the site for the Church of Our Lady in Tournai, was the first of all the people of Tournai to be baptised."

The two scenes also differ considerably in their spatial structure. In the Eleutherius scene (fig. 10) there is a certain horror vacui; the figures fill the chamber up to the ceiling and from wall to wall. In the corresponding Piatus scene (fig. 13) on the other hand, empty space is actually employed as a compositional element.

Finally, the portrayal of the altars could hardly be more different. The first hand (fig. 10) gives an overview of the altar without affecting the parallels, rather in the manner of today's process of axonometric architectural drawings. This is systematic, as we can see in the portrayal of the altar by the same hand in the baptismal scene of the Life of Eleutherius (fig. 14).

In the first Piatus scene (fig. 13), by the second hand, all the architectural elements are perspectively foreshortened. This is obvious in the portrayal of the altar and in the way the profiles of the right-hand outer wall of the church are tapered towards each other – albeit not entirely consistently.[25]

The third hand, i.e. the painter who is responsible for designing almost all the other scenes in the *Life of Piatus* (figs. 7, 12, 14), represents, even more than the second artist, a remarkably progressive aesthetic approach for the period around 1400. Of the three artists involved, he is the most imaginative. Above all, he proves himself a talented story teller. His distinctly sculptural style counters the linear and ornamental approach to the human figure evident in the work of the second hand. The faces are even more varied and life-like.

The portrayal of the architectural elements, too, is more realistically convincing in the scenes designed by the third hand. Note, for example, how the two city gates that frame the second and third Piatus scenes (fig. 9) are composed to create a focal point of elementary stereometry. Although they feature the same details, crenellations and battlements, one has a circular layout and the other a square one. This contrast between round and angular is reiterated in the pair of pulpits adjacent to the city gates (fig. 7). We can see just how much more conventional the approach of the first hand is in composing the architectural space and filling it with figures if we take a look at the portrayal of the city in the last surviving scene of the Eleutherius tapestry (fig. 11), depicting the plague.

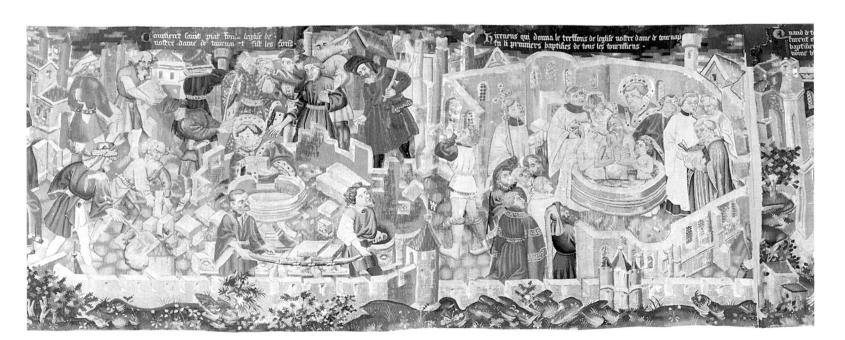

Evidence of the first and stylistically most traditional hand can also be found in some places in the Piatus tapestry, notably in the last surviving scene showing the baptism of the family of Iranaeus (fig. 14). Surprisingly, however, the entire scene was not designed by the same hand. It is only in the central figures of the baptismal group – the family being baptised, the saint and the deacon on the right – that we find the disproportionately large heads and the typically bulbous noses of the first hand. The group of kneeling faithful in the foreground is the work of the third hand.

Members of a single workshop

In spite of the obvious differences between the three hands involved in the design – one traditional and two progressive but still contrasting modes of composition – there are so many stylistic affinities between the individual scenes that the three artists involved must surely have belonged to the same school. Moreover, the precision with which the three of them worked together make it seem highly probable that they all belonged to one and the same workshop. This is also suggested by the fact that the three artists have evidently discussed the choice of costumes and agreed on these in considerable detail, such as the use of bejewelled borders for the vestments of the two saints.

It would seem only logical to consider the first hand, being the most traditional of the three artists, as the leader of the workshop. He would have entrusted two talented and ambitious young co-workers with about half of this major public commission. There is much to suggest that the co-worker who designed most of the scenes in the *Life of Piatus* (fig. 7) was in fact Robert Campin, who would have been about twenty five years old at the time. Even though recognition of the artist's style has been rendered more difficult by the fact that this is a work of textile art which undoubtedly possesses less of the finesse of the painterly design on which it is based and has perhaps distorted it to some degree, we feel that the arguments in favour of an attribution to Campin are strong enough to deserve at least a critical assessment.

One compositional element that is to be found only in the work of the third hand, is the use of Kufic lettering to ornament the borders and the stripes of the robes. An ornamental border of this type can be seen on the mantle of the figure carrying one of the lambs in the second scene (fig. 9). Moreover, the horizontal stripes of the coat of one of the kneeling faithful in the last scene of the Piatus tapestry (fig. 14) is also decorated with pseudo-Hebraic signs. Numerous textile ornaments of this kind are to be found above all in Campin's early paintings, such as *The Nativity* (fig. 25) and the Seilern Triptych (fig. 19).

Another typical feature of the work by the third hand is the distinct interest in the surface texture of individual things. Note, for example, the precision with which the roof tiles

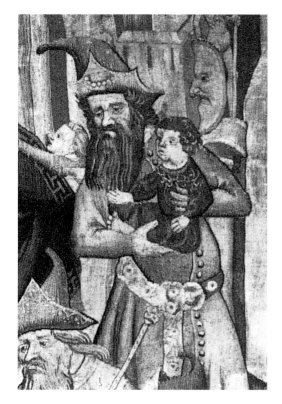

Fig. 15 Robert Campin, *Virgin and Child (Maria lactans)*, c. 1430, (detail). Frankfurt, Städelsches Kunstinstitut

Fig. 16 Robert Campin (cartoon), c. 1400, Heathen priest with child (detail of fig. 9)

Campin's artistic personality is expressed with remarkable consistency in these two works created at an interval of some thirty years.

on the public buildings of Tournai are portrayed in the second Piatus scene (fig. 9). Also note the precision with which the wood grain and the heads of the nails on the pulpit are rendered, suggesting the same kind of painstaking attention to detail that we also find in the Mérode Triptych (fig. 41).[26]

We are also reminded of Campin in the second and the third scene, where the figure of a bearded, toothless old man is used to portray the pagan priests. He seems to anticipate the figure of Joseph in Campin's paintings (cf. figs. 25, 41). In the tapestry and the painterly œuvre alike, the furrowed brow and the vertical lines between the eyebrows are emphasised.

The fourth scene of the Piatus tapestry (fig. 14) shows a clear correlation between movement and robe. The figure of the builder with his right foot outstretched, mixing mortar, his coat tucked into his belt, appears thirty years later, with no major changes, in the portrayal of another figure, equally dedicated to the task in hand: Joseph of Arimathaea in the *Descent from the Cross* in Madrid (fig. 103).

The woman swathed from head to foot in a dark robe in the fourth scene (fig. 12) is a figure that occurs repeatedly in Campin's œuvre like a leitmotiv. Portrayed in rear view or from the side, this robed woman is used for a variety of stylistic devices, invariably with the same impact, appearing as Mary Magdalene on the left wing of a surviving copy of the Bruges Altarpiece showing the *Descent from the Cross* (fig. 117) and as Saint Bridget on the Marian Cope of the Ecclesiastical Paraments of the Order of the Golden Fleece in Vienna (fig. 163).

Finally, the group of figures featuring an adult and child in the Piatus tapestry bears comparison with a similar group in the painterly œuvre of Campin. In the second Piatus scene the idolater with the little boy in his arms, whose toes look like a little row of pearls (fig. 16), bears a striking resemblance to the Flémalle Panel of the *Virgin and Child* in the Städel in Frankfurt (fig. 15). Yet what we have here is something more than a mere repetition of motifs. The two pairs of figures created at an interval of thirty years show the same arresting combination of two contrasting impressions; a sense of the ephemeral and coincidental that results from a direct observation of nature and a sense of definitive finality that results from the compositional working of that which has been observed. Taken together, they indicate that their author must have been the same artist.

Of the three hands that supplied the designs for the tapestry maker Pierre Feré in Arras, the first deserves our particular attention, for it is in this hand that we believe we can see Campin's teacher. In a bid to distinguish clearly between them, we have had to emphasise the differences between the first hand and the third hand. Yet in spite of the conservative traits in certain compositional elements, as mentioned above, the scenes designed by the first hand would appear to have had an important influence on Campin right through to his mature work. Take, for example, the sixth scene from the *Life of Eleutherius*, showing the Raising of Blanda from the Dead (fig. 17), in which certain architectural elements – in this particular case the tilted cover of the sarcophagus – are used as a means of structuring the picture plane or distributing the figures involved into clearly legible groups according to their roles as active participants or passive commentators. Note, for instance, how the pagan commander in his long, scalloped robe, places his right hand reassuringly on the shoulder of the startled executioner with the twist of cloth knotted around his waist, and contemplates the wondrous raising of the dead. A similar pair of figures is used by Campin as commentators within the picture, on the right wing of the *Descent from the Cross* altarpiece that he painted for Bruges (fig. 117).

Fig. 17 Anonymous artist – "first hand" (cartoon). Eleutherius Tapestry, Scene 6: The Raising of Blanda from the Dead

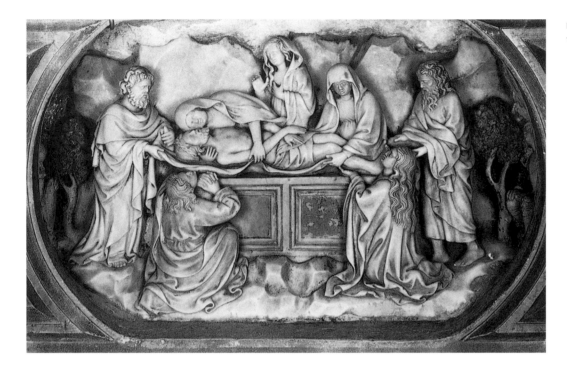

Fig. 18 Burgundian, late 14th century, *The Entombment*.
Venice, San Pantalon, Cappella del Sacramento

The Piatus and Eleutherius tapestries in the Cathedral of Tournai are of enormous importance in our quest to discover the origins of Netherlandish painting. If we are correct in assuming that key parts of the Piatus tapestry were designed by the young Robert Campin, these tapestries allow us to reconstruct the workshop context within which Campin developed his creative talents as a painter. If we are also correct in assuming the generation differences of the three hands involved, we can observe how Campin, at the age of twenty five, was receptive to new artistic ideas, how he vied with a co-worker who was probably about the same age, and how, at the same time, he emancipated himself from his teacher, the creator of the *Life of Eleutherius*, only to surpass him with his remarkable gift of narrative.

A Triptych with the Entombment of Christ

The Seilern Triptych (Cat. I.3, fig. 19) – named after its former owner, Count Antoine Seilern – is widely regarded today as the oldest complete surviving painting by Robert Campin. This small, three part work, just sixty centimetres in height, with the Entombment as its centrepiece, was probably created around 1415. Although it does feature a few traditional compositional elements such as a gold ground and a variable scale of figures, this is an extraordinarily innovative work. With its small format, it foreshadows a number of the key elements of Campin's Passion altarpieces while at the same time fully exploring the possibilities of the genre of private votive image to which it belongs.[27] We may never know the name of the donor portrayed on the left wing. Yet an analysis of the work can reveal the role that it played for him.

The Seilern Triptych still has its original frame. Its unusual form with four semi-circles is unparalleled in surviving panel paintings and must have seemed quite archaic in a period dominated by the gothic style. The reiteration of the arches in the central panel links it closely with the wing panels. However, there are, above all, two elements of

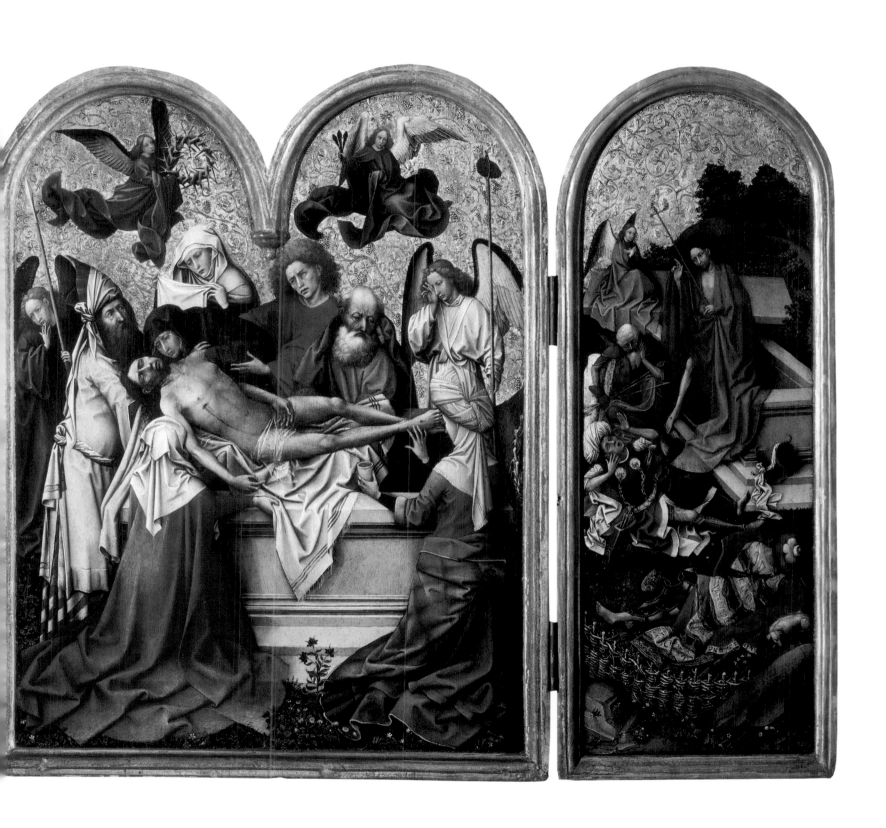

Fig. 19 Robert Campin, Triptych with *The Entombment*, c.1415. London, Courtauld Institute Galleries

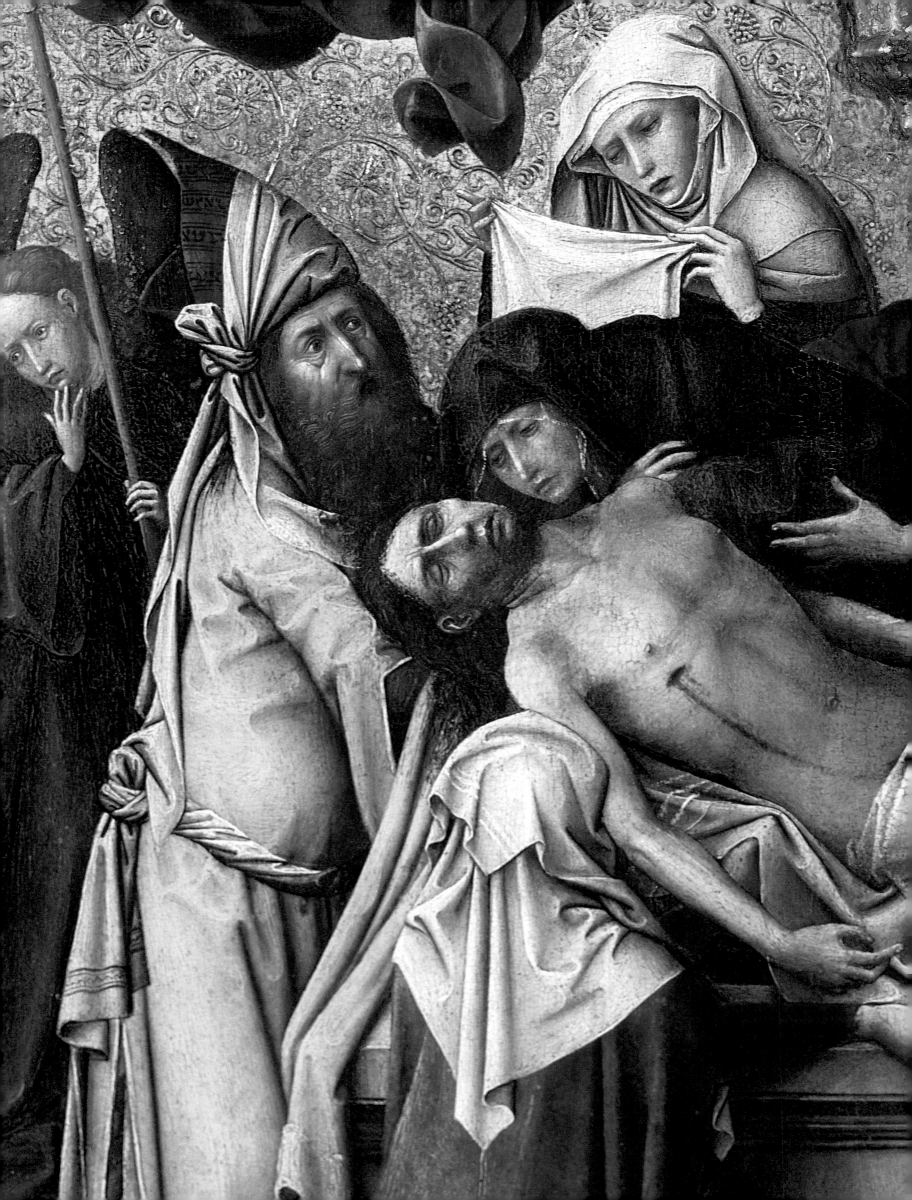

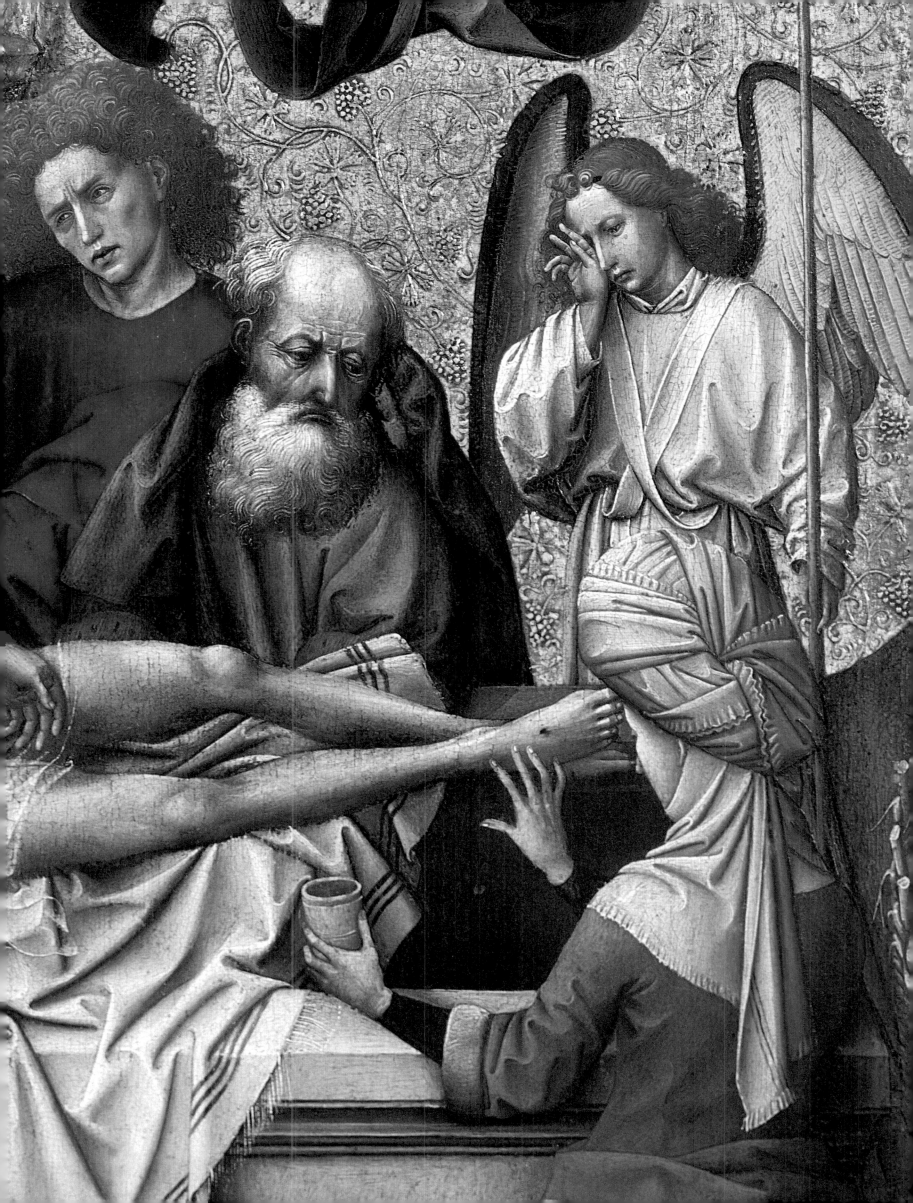

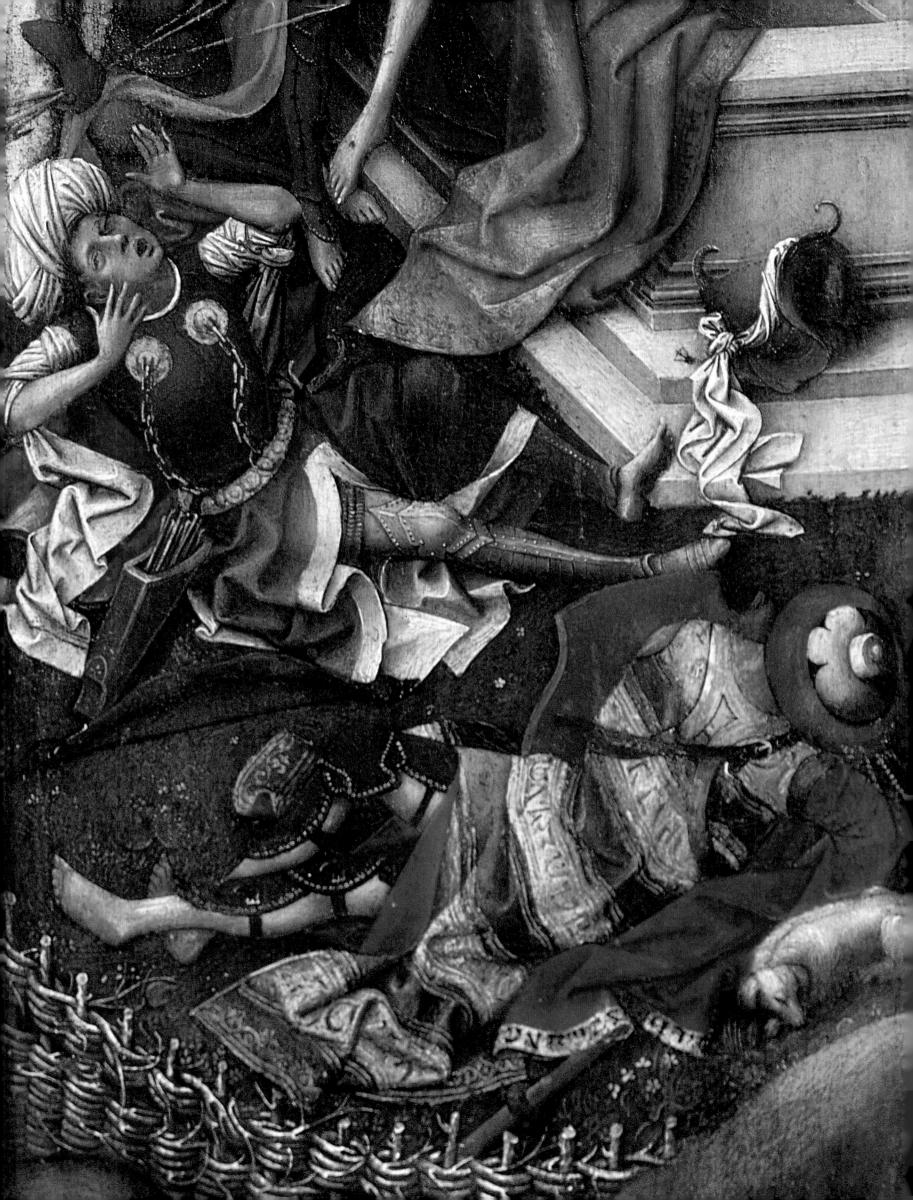

painterly composition that combine these three panels to create the impression of a single unit: their gold ground for the heavens and the uninterrupted lower zone showing the same landscape across all three panels – a device found here for the very first time in the history of the triptych.

The position of the donor

In the background of the left wing we see the Hill of Calvary with the three crosses. These take up the entire upper half of the panel. The body of Christ has already been deposed from the cross. The two thieves – tiny but extraordinarily finely painted nude studies full of movement – are still bound to their crosses by ropes. A narrow path lined with bushes and trees runs down from the highest point of the hilly landscape, past Golgotha, into the foreground. There, it converges through an opening in the woven fence with a flower-strewn meadow bounded by trees. Here kneels the donor and first owner of the triptych, accompanied by his little white dog.[28] He is wearing a fur trimmed black coat. Over his shoulders lies an open red cape, the only coloured highlight on the left wing.

On the left wing of the triptych, which is dominated by the figure of the donor, Christ is present only in word. In his hands, the donor is holding a covered prayer book. A now empty banderole which probably once bore the words *Miserere mei, Domine*, runs in a serpentine line linking the mouth of the praying donor with the lower rungs of the ladder by which the body of Christ was taken from the cross. The upper end of the ladder indicates the caption with the name of the Redeemer to whom his prayer is directed: *I.N.R.I., Iesus Nazarenus Rex Iudaeorum*. The donor's gaze turns towards the Entombment scene on the central panel where the inner image he contemplates in his prayer is realised in the painting.

Narrating the Passion

The tomb around which the followers of Christ are grouped stands on the same grassy enclosure as that on which the donor is kneeling. In this way, the donor is separated from the main scene only by the frame between the central panel and the left wing. On the right wing, the tomb is shown again from a different angle, this time with Christ Risen. This Resurrection scene is completely enclosed by a fence that clearly marks out the area.

In this continuous landscape divided into three by the frames of the individual panels, we can read from left to right three successive moments of the Passion of Christ: the Descent from the Cross, the Entombment and the Resurrection. The central Entombment scene, in which the figures are painted on a larger scale, serves as the time frame; it is the *hic et nunc* by which the spectator can read the story of the Passion. The scenes on either side are painted on a smaller scale and represent the 'before' and 'after' of the story.

Nevertheless, the Calvary scene on the left wing can still be regarded together with the Entombment scene as a kind of 'snapshot'. This is because the episode showing the Descent from the Cross is portrayed allusively by means of the empty cross. The fact that the thieves are still hanging on their crosses indicates that Christ has just died.[29] From the Entombment to the Resurrection, the story takes a leap in time. In contrast to the wing showing the donor, the right wing represents an autonomous narrative unit.

On the central panel, there are vines bearing ripe grapes. This eucharistic symbol points towards the sacrificial death of Christ. The plants in the gold ground of the two wings also undoubtedly refer to the respective scenes portrayed. On the right-hand wing the plants probably represent a flowering gourd vine, recalling the Old Testament story of Jonah (Jonah 4:6), which is traditionally equated with the Resurrection. The plants on the left-hand wing are likely to be redcurrants (in the southern Netherlands they are called Jans-besen, meaning John's Berry), perhaps in reference to the patron depicted here.

Fig. 20-22 Details of fig. 19

The gold ground on each of the three panels shows different plants to be interpreted symbolically. Left: possibly redcurrants; Centre: grape vine; Right: probably flowering gourd vine.

The Entombment

The central panel showing the Entombment is surprisingly powerful in its carefully considered composition. Large areas of bright colour, with vermilion, yellow, blue, green and white, link the figures positioned in rows on the picture plane according to archaic rules of perspective. The same vermilion is used for the robes of the angel hovering on the upper left, for the figure of Saint John and for the figure on the left in the foreground painted in back view, all of whom are aligned in a triangle. A complementary triangle features the blue of the second angel, that of Mary and the figure with its back to us in the right foreground. The sculptural portrayal that emphasises the autonomy of the figures makes the scene appear positively monumental in spite of its small format.

In terms of its figural composition, Campin's painting is closely related to a Burgundian alabaster relief (fig. 18) that was probably installed in the altar of the Church of San Pantalon in Venice as early as the mid fifteenth century.[31] A comparison of the two works, however, reveals differences that are, for the most part, qualitative. Campin's painterly portrayal of the Entombment is an unusually dense composition in which every single gesture contributes to form a cohesive scene, and one that also succeeds in grouping a number of separate episodes – anointment, valediction, mourning – around the central biblical scene. It is well worth observing each figure individually as well as in relation to the others.

The dead Christ is held directly over the tomb into which he is to be placed, with Nicodemus supporting his upper body and Joseph of Arimathaea holding his legs.[32] The body of the Redeemer is presented almost frontally to the spectator. His head has fallen back and his feet are still crossed. The men carrying him are not directly touching his wan body, underpainted in black, but are holding him by a large white cloth edged with three

blue stripes.[33] Nicodemus, a nobleman with a long, brown beard, is clad in a kind of Oriental-Jewish fantasy costume. He is wearing an orange-shadowed yellow coat with long, slit sleeves over a brown and yellow diagonally striped skirt. On his head he is wearing a crimson hat shaped like a mitre, adorned with Kufic letters and with a white cloth knotted around it. One end of the cloth is hanging down his back and the ends of his white belt act as an optical continuation of the cascading fabric. Joseph of Arimathaea, on the other hand, a bald-headed elderly man with a white beard, is wearing the simple costume of the day: a fur-trimmed green coat and a mantle in the same colour.

On the left and right, in front of the tomb, with their backs to the spectator, kneel two of the Marys.[34] On the left, Mary of Salome is helping to place the body in the tomb. She is wearing a white vermilion mantle and a white headdress. On the right kneels Mary Magdalene with a pink-shadowed yellowish turban tied in a complex structure, a blue skirt and a fur-lined mantle of brownish green. In her left hand she is holding the ointment jar and with her right hand she is anointing the injured feet of the Lord under the sympathetic gaze of Joseph. The Mother of the Redeemer leans lovingly forwards towards her son's head. Saint John the Evangelist is standing ready to support the Mother of Christ when her dead son is taken from her. Above her stands Mary the wife of Cleopas, with a white headdress and a white shoulder covering. She is holding the cloth that will be placed over the dead man's face in the tomb, according to Jewish custom.[35] Her headdress is identical to the one worn by Mary of Salome, who is kneeling with her back turned to us in the foreground. Together, the headdresses of the two women create a kind of visual bracket that emphasises the heads of Christ and the Virgin at the emotional climax of their final parting.

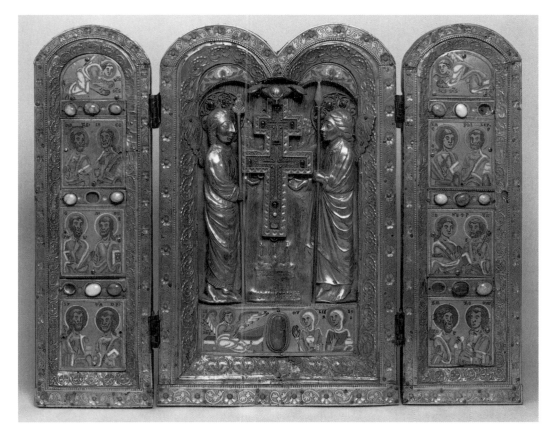

Fig. 23 Reliquary of the True Cross ("Grand Reliquaire"), 1150, Moselle region. Paris, Musée du Petit-Palais

Not only the frame of the triptych indicates that Campin looked to the art of the goldsmith in creating his composition. The two angels with the lance and sponge are also foreshadowed here.

The role of the angels

The seven figures grouped around the dead Christ are accompanied by four angels. Two of them are hovering in the air and two are standing on the ground. Together they present for contemplation four of the *arma Christi* – the crown of thorns, the nails, the vinegar-soaked sponge and the lance.

The two standing angels with the lance and the vinegar-soaked sponge are foreshadowed by relievo figures on three closely related reliquaries in triptych form, from the Mosel region, all dating from the middle of the twelfth century (fig. 23). The unusual form of the frame of the painted triptych is also derived from a similar piece of goldsmithing work.[36] In the reliquaries, the two symmetrically aligned figures flanking the fragments of the cross possess a ceremonial function. The painter adopts this function, and, in doing so, takes it one step further.

In Campin's work (fig. 19), the two standing angels are dressed differently. The angel standing on the left is wearing a purple robe; his wings are also dark, as are those of the angel hovering above him. The robe of the angel standing on the right, on the other hand, is white; his wings are also pale, as are those of the angel above him. This contrast between dark and light reflects the way the triptych is divided into a left-hand side portraying Death and a right-hand side portraying Life.

The angel on the right with the sponge is wearing the white alb of the deacon. The crossed stola indicates his participation in the act of Communion.[37] The reference here is to the Crucifixion of Christ, which Campin, in accordance with Christian doctrine, regards as a sacrifice repeated in the daily celebration of the Eucharist. The sarcophagus parallel to the picture plane with the body of Christ presented to the spectator in a white cloth like a host, corresponds to the altar itself.

The angel standing on the left in the violet robe of mourning has a different function, in spite of his parallel pose. His gaze and gesture of mourning are no longer directed towards the dead Christ, but towards the figure of the man praying on the left wing. In other words, he acts as an affective bridge between the central panel with the Entombment and the space in which the donor is situated. At the same time, the left wing represents the real world of the donor, the place in front of the painted work in which he is kneeling. The fact that the angel wearing the liturgical colour of mourning is cropped by the frame is in keeping with his role as a mediator between the pictorial space and the viewer's space.[38]

Between the body of Christ, the two standing angels and the praying figure of the donor, the artist has created a dense network of lines of view that serve as guidelines for an appropriate reception of the work. The real donor kneeling before the triptych will look into the work, in much the same way as the painted figure of the donor looks beyond the borders of the left-hand panel to contemplate the Entombment scene on the central panel. At the same time, however, the real donor will note how the gaze of the violet-clad angel in mourning is directed with an expression of suffering towards his own portrait on the left wing. In this way he is called upon to become an empathetic participant in the Passion of the Redeemer.[39]

Promise of salvation

In his triptych, Robert Campin links the two traditional functions of the religious image: that of narrative and that of icon. He presents the Passion of Christ in an extraordinarily rich narrative form. At the same time, however, he fixes it within a single, arresting moment, thereby rendering it as a mirror of the constantly repeated mystery of the Eucharist that goes beyond all boundaries of time.[40]

In the transition from Death to Resurrection, the picture presents the donor with the transformation that he himself hopes to achieve through his prayers and good works. The sacrificial death of Christ and his subsequent resurrection represent the promise of the donor's own salvation on the Day of Judgement. This is underlined by the two portrayals of the same little white dog at either end of the triptych. Irrespective of the question as to whether the little dog might have played any role as a reference to the coat of arms or name of the donor,[41] it is associated with him on the left wing in the manner of an attribute. It appears once again on the Resurrection wing, sleeping next to one of the soldiers. Here, it

represents its absent master. The sleeping dog is a key to the meaning of this work. It expresses the hope of the donor that he might be among those who will rise from the sleep of death and be admitted to Paradise. The gaze of Christ Risen and his blessing are directed towards the donor in a way that would seem to anticipate fulfilment of that wish.[42]

FAMILY HISTORIES

Between 1420 and 1430, Campin, whose move to the parish of St. Pierre was an outward sign of his success, created three works featuring scenes from the Childhood of Jesus: The Nativity now in Dijon, a narrative portraying several scenes from the Life of Saint Joseph, which has been handed down to us only in the form of a copy, and the Mérode Triptych. In all these works, he lends Joseph, the "bourgeois" saint an unusually prominent role. In the Mérode Triptych, which, on closer inspection, turns out to be a wedding picture for a Cologne couple, the biblical family story serves to mirror the lives of the donors. Even the names of the couple are woven into the imagery.

The Nativity

In contrast to the Seilern Triptych, Campin's portrayal of *The Nativity* (Cat. I.6, fig. 26) involves only a few elements that might serve to determine the original function of the painting. One example of this is to be found in the opening words of the *Salve Regina*, inscribed in golden letters on the front of the side border of the Virgin's white mantle. This tells us that the work is first and foremost a Marian image. The spectator – if we may deduce the picture's function from the prayer inscribed on it – was meant to appeal to the Virgin Mary in her role as mediator between mortal beings and Christ. Their plea, echoing the first verses of the hymn, was that the Virgin should show them the blessed fruit of her womb (*benedictum fructum ventris tui*) following Jesus' earthly "exile".[43] There is nothing to indicate that this panel was originally part of a larger ensemble – (as in Daret's variation on the scene (fig. 189) – or that it might have had painted wings. The composition is completely self-contained.

The symbolism of the stable

The foreground is dominated by a humble wooden hut set at an angle. Only its thatched roof is more or less intact. A dilapidated building constructed from the beams of some other demolished building, its structure is doubly marked by the passage of time. The corner post on the left in the foreground – an extraordinary piece of painting whose virtuosity reveals Campin's enormous capacity for material realism – bears the notches and dowel holes that tell of its past use and, though pieces of dried bark are still attached to it, it is already riddled with worms.

The dawn of the new era coinciding with the birth of the Saviour unfolds within a scenic framework that indicates a profoundly complex and palimpsestic concept of time. All that is new appears to be made up of elements that are old. Campin's stable is the visual expression of the relationship between the Old and New Testament described by theologists

in terms of the replication and superation of the Old Testament by the New Testament. The artist makes it clear that all that belongs to the new era is subject to earthly decay and will one day have its end. On the thatched roof we can see some ripe ears of corn. They indicate the Hebrew significance of Bethlehem as the House of Bread and allude to the Eucharistic significance of the Nativity.[44]

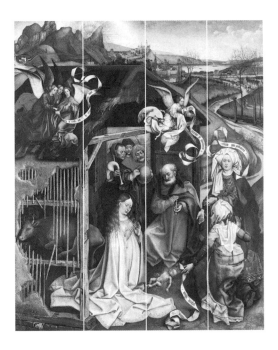

Fig. 24 Underlying structure of the wooden support in fig. 26

None of the faces are divided by the joints between the wooden boards.

Compositional function of the stable

The stable, placed on the diagonal, dominates and structures the entire scene by dividing the picture into four vertical strips which the author treats as spatially separate quarters. It is interesting to note that the four zones correspond fairly precisely to the four pieces of wood on which the picture is painted (fig. 24).[45] In each quarter of the picture we find contrasts between the celestial and the earthly, the sacred and the profane, the faithful and the non-believing, figures and groups of figures placed along the verticals. The stable also structures the composition by revealing and concealing the various groups of figures to different degrees.

The lower part of the left-hand quarter of the picture shows a crumbling wall of wood and clay that coincides with the picture plane. It represents an element of painted visual theory in that the painterly treatment provides a glimpse of some imagined world beyond. Through the hole in the dilapidated wall, in the semi-darkness of the stable, we can make out the two animals traditionally present in such Nativity scenes, the ox and the donkey, their dumb eyes meeting the gaze of the spectator. On one of the stones of the foundation wall at the side, near the front, we can see an abandoned wasps' nest, probably as an indication that the devil has abandoned this sacred place.[46] Above the animals, the three angels of the Annunciation to the Shepherds can be seen hovering against the dark background formed by the roof.

The symmetrically structured front of the stall is placed diagonally in the pictorial space, framing the three main figures in the scene, the members of the Holy Family, like a theatre stage. This dominant central part of the triptychon-like composition is further divided into two partial areas by the specific form of the back wall of the stall. On the right-hand side, the figure of Joseph is framed by a closed wall of planking. Above him hovers an angel robed in white. At his feet lies the naked Infant, depicted realistically as a new-born. To the left of him kneels the Virgin Mary, her long hair worn loose, her hands raised in a gesture of worship before her child. Her white mantle bordered with gold flows out in a bell shape into the area occupied by the animals and that occupied by Joseph. Directly behind her, we can see a stable door in perfect condition. The upper half of the door is open, creating an almost square, window-like aperture, whose wooden frame parallels the frame of the painting. Within this window-like aperture, like a picture within a picture, we see the three shepherds solemnly and attentively contemplating the naked Infant in the manner of Joseph and Mary. These three figures seem to mirror the spectator, setting an example of how onlookers ought to approach the scene.

In the last quarter of the picture, on the extreme right, the two midwives take up their positions. Here, the spectators' gaze, unimpeded by the stable, can linger over a sweeping landscape.

Fig. 25 Master of the Brussels Initials (Zenobi da Firenze), *The Nativity*, early 15th century, London, British Museum, Add. ms. 29433, fol. 56

The midwives

Campin's panel portrays the Nativity in the manner of a new type that had begun to gain ground around the beginning of the fifteenth century. The divine Infant is lying naked on the ground, its mother kneeling in worship before it. There are a few unexpected details, such as the two midwives and the candle Joseph is holding in his hands, that can also be found in earlier portrayals of this scene. Both these motifs occur in a miniature by an Italian artist who worked in the service of the Duc de Berry during the early years of the century (fig. 25).[47] On closer inspection, however, we find that Campin has made far more striking use of these unusual details – the two midwives, Joseph with the candle – than did his predecessor. We have to assume that Campin had reread the text on which they are based, and had interpreted it by his own painterly means.

The episode involving the midwives, to be found in early portrayals of the Nativity, is derived from apocryphal texts, and found widespread acceptance through the dissemination of the *Legenda aurea*. A learned contemporary of Campin, however, the theologist Jean Gerson, rejected this episode as *mendatium et fabula*[48] and it soon disappeared entirely from the visual arts. In Campin's portrayal of the Nativity, the midwives play a remarkably important role emphasised by the extensive use of banderoles and the surprisingly sumptuous robes the two women are wearing. Because of these superb costumes and the strong emphasis on the word, it has been assumed, probably quite rightly, that Campin took some of his inspiration from the mystery plays of the time, which are known to have involved particularly ornate costumes.[49]

Indeed, the scene portrayed by Campin does possess a certain dramatic theatricality through its combined use of gestural and textual elements. The episode involving the midwives plays much the same role in relation to the central event of the Nativity as the apparition of the angels on the upper left, where there is also a banderole. With the words *Gloria in Excelsis deo. Et in in terra [a pax homi] nibus bone vol [untatis]* the angels draw the attention of the shepherds to the birth of the Saviour. In the case of the midwives, too, the gestures and texts are commentaries on the miraculous event. The scene is a reference to the dispute that arose between the two midwives, Salome and Zebel (named Azel here) regarding the virgin birth, which is confirmed by the affliction of the doubter and her subsequent miraculous healing by the Infant Christ. The artist has based this scene on a precise reading of the text and has translated it into a new and profoundly effective visual form.[50]

In the single scene within which all these events take place, Campin gives us no indication as to the order in which we are to read the fragments of dialogue on the banderoles, nor does he indicate the order in which we are to look at the individual elements of the plot. What the painter expresses most forcefully in the gestures and poses of these figures is the antagonism between them, and the contradiction that lies behind their dispute. The two midwives represent the astonishment of the faithful and the doubt of the non-believer.

Salome is portrayed standing and facing the spectator, stating provocatively *[Nullum] credam quin probavero* (I believe it only when I have proved it). Azel is portrayed in rear view, kneeling and wearing an almost identical headdress.[51] The banderole of the believing midwife bears a caption referring to the prophesies of Isaiah (Isaiah 7:14): *Virgo peperit filium* (a virgin … shall bear a son).

The gestures of the midwives underline the story portrayed in terms of its motifs and its impact. The hands of the two women relate exactly to one another with obvious parallels

and inversions. We see the back of the faithful Azel's right hand raised in astonishment at the miracle, in a gesture that corresponds precisely, albeit in inversion (upwards/downwards, inwards/outwards), to the palm of the disbelieving Salome's loosely dangling right hand. The left hand of each midwife, respectively, expresses an almost identical position in parallel. Azel is holding the banderole that announces the miracle and at the same time is pointing to the child to whom it refers. Salome is gesturing towards the hand that has been lamed in punishment, and at the same time in the direction of the divine Infant, who is the object of her disbelief and the source of her salvation. The message of the white robed angel turning towards Salome from the heavens – *Tange puerum et sanaberis* (Touch the boy and be healed) – explicitly refers to the possibility of healing.

Three sources of light

Some other unusual motifs in Campin's *Nativity* can be explained by reference to another text, the *Revelations* of Saint Bridget of Sweden. They are the white robe and mantle worn by the Virgin and her worshipful pose, the position of the naked Infant on the bare ground, and the candle held by Joseph. All these elements, also conveyed in the works of Campin's students Rogier van der Weyden and Jacques Daret, were soon to become almost obligatory features of Netherlandish portrayals of the Birth of Christ.

In Campin's painting, the candle is not isolated, but part of a complex interaction of three different sources of light. Again, it is probable that Campin's portrayal is directly based on the text of the *Revelations*. In the text, the moment of the birth is described in a single sentence: "Mary bore a son, from whom such a splendid and ineffable light radiated that not even the sun could stand comparison; nor could the candle placed [in the cave] by the old man radiate its light against him, for the splendour of the divine glow had completely annihilated the earthly glow of the candle."[52] In accordance with this text, Campin portrays a miraculous light emanating from the Infant in the form of golden rays with which both the artificial light of Joseph's candle and the natural light of the sun, also portrayed in real gold, must vie.

Yet the artist reinterprets Bridget's vision in that he no longer uses the sun as a negative comparison (*sol non esset ei comparabilis*). The rising sun, at the moment portrayed in Campin's painting, represents not only the dawning of a new day and the beginning of a new year, but also the advent of a new age heralded by the birth of Christ. In the tradition of the concept of the *sol novus* the sun is also a metaphor for Christ himself. The candle held by Joseph, its light surpassed by the wonderful radiance of the new-born Infant Christ, also takes on a positive aspect. Joseph holds the candle directly over the head of the new-born Infant lying helpless on the ground and at the same time protects the flame from the draught with his hand. In this way, he shows himself to be the child's provider, and the one who will "protect the still weak life light of the new-born child".[53]

The landscape and its meaning

Art historians have often noted the remarkably progressive approach to landscape in which Campin has set his *Nativity*. However, this new view of the world should not be misconstrued as an independent aesthetic achievement. In Campin's painting, the landscape relates

Fig. 26 Robert Campin, *The Nativity*, c. 1425. Dijon, Musée des Beaux-Arts

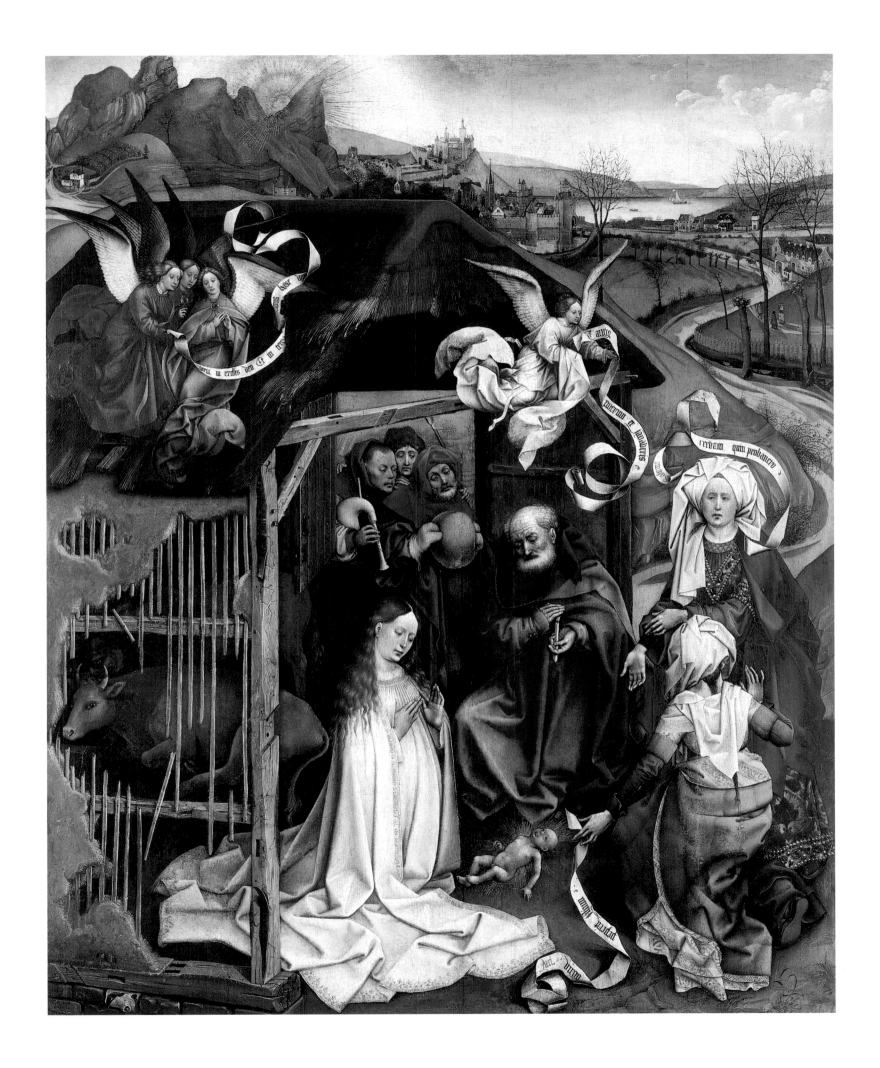

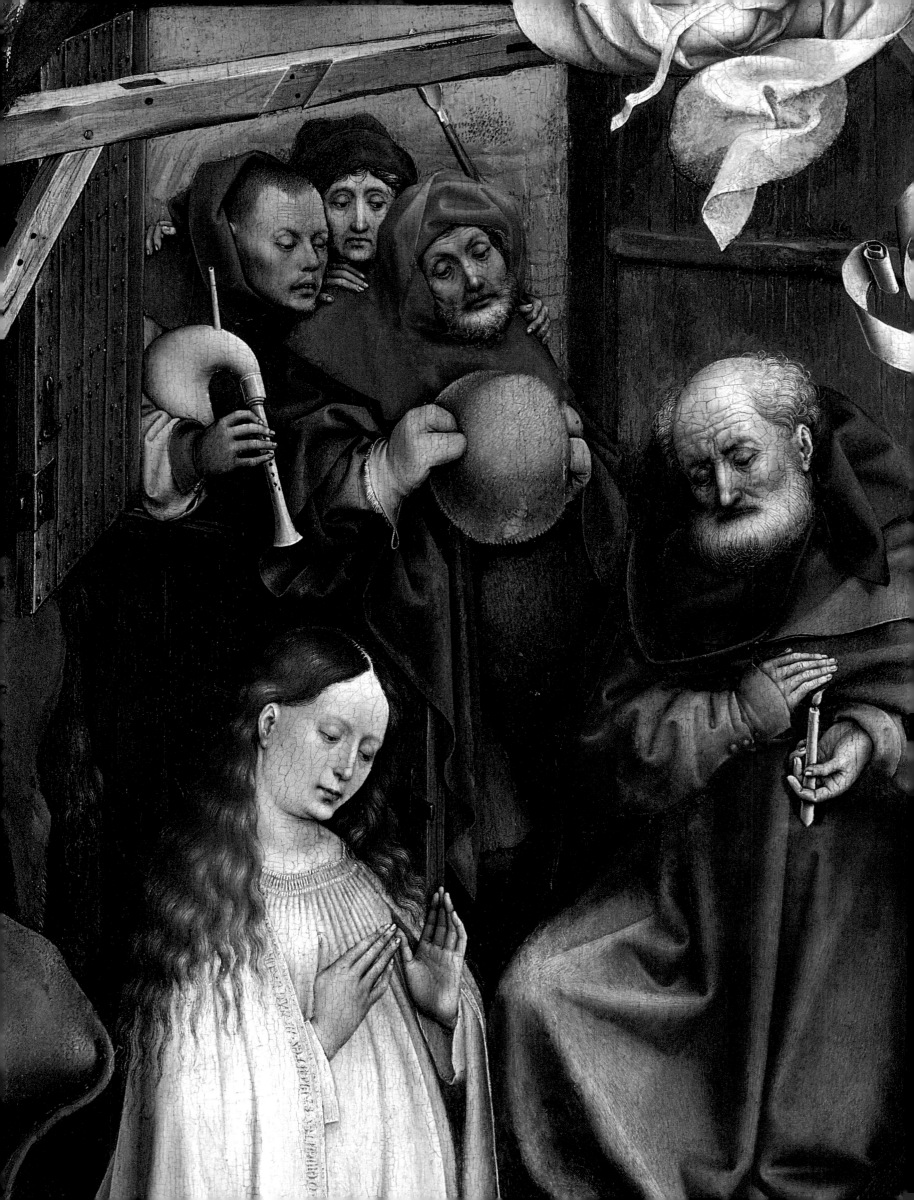

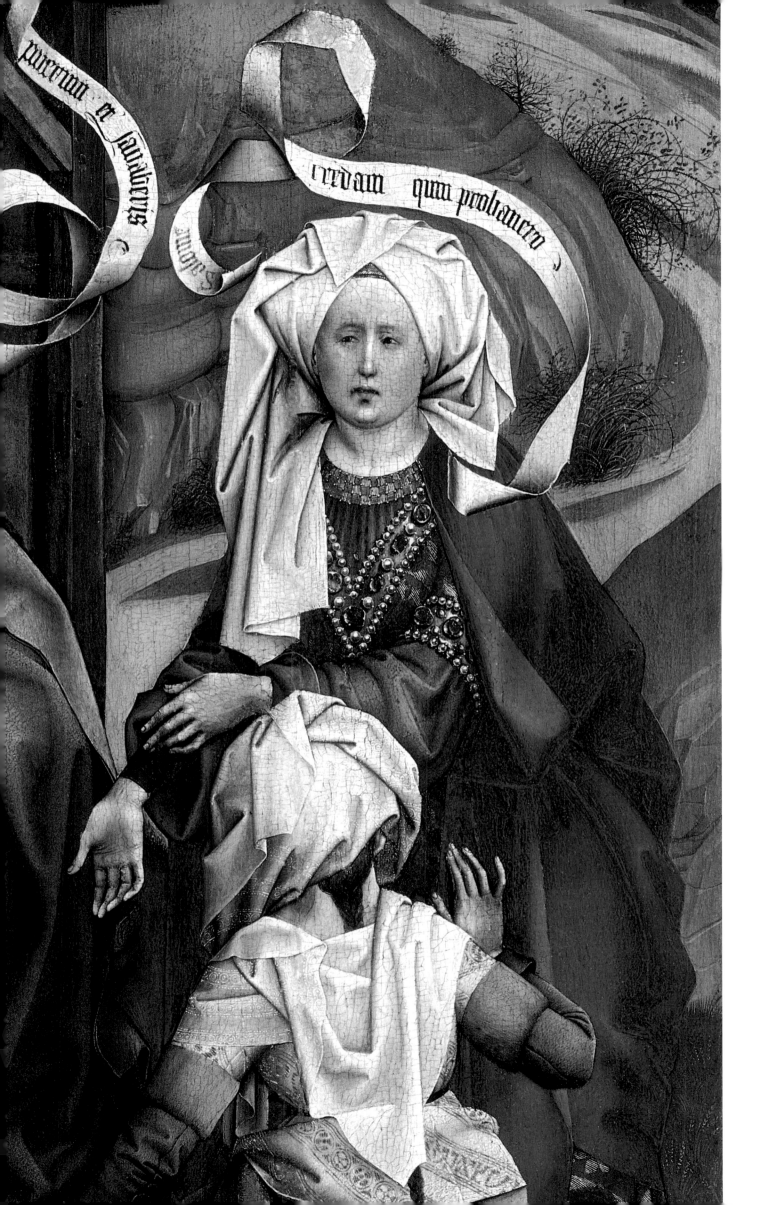

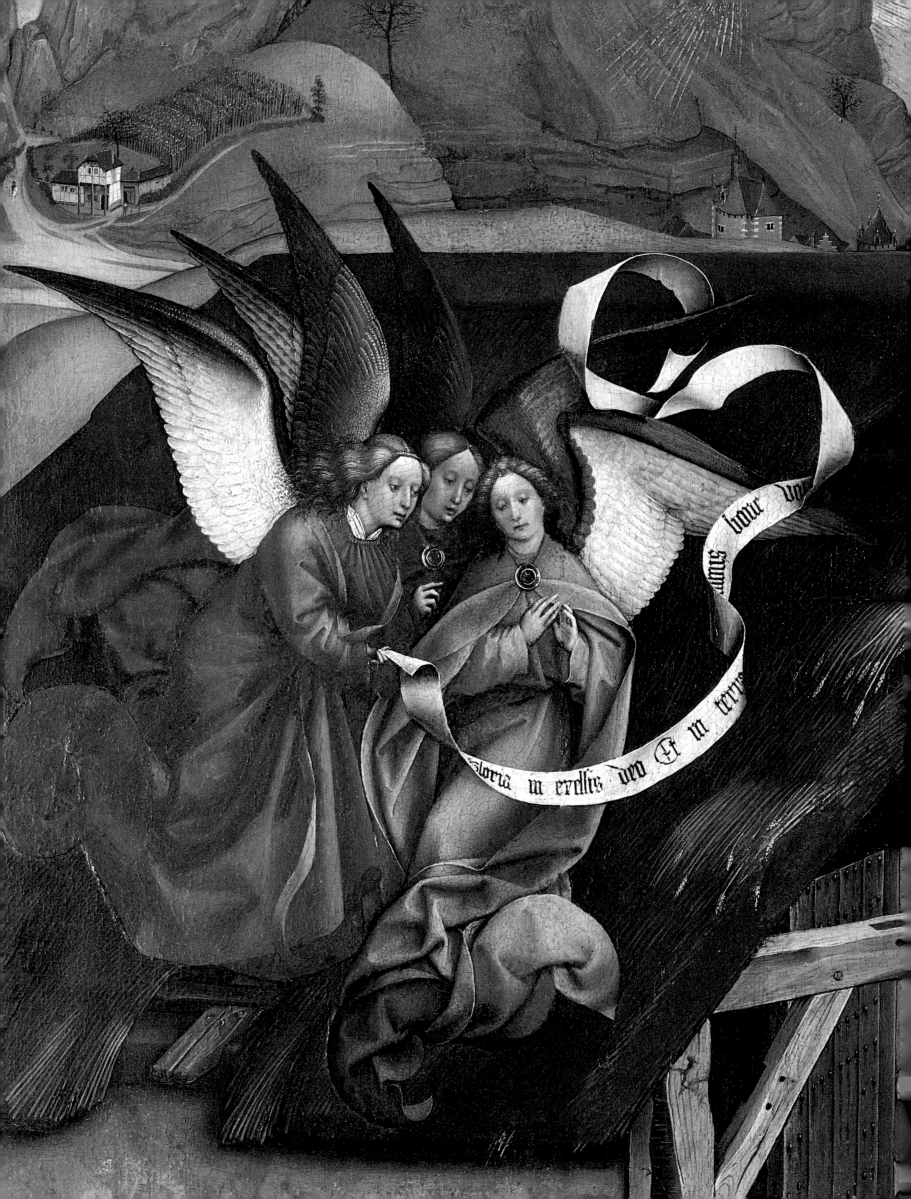

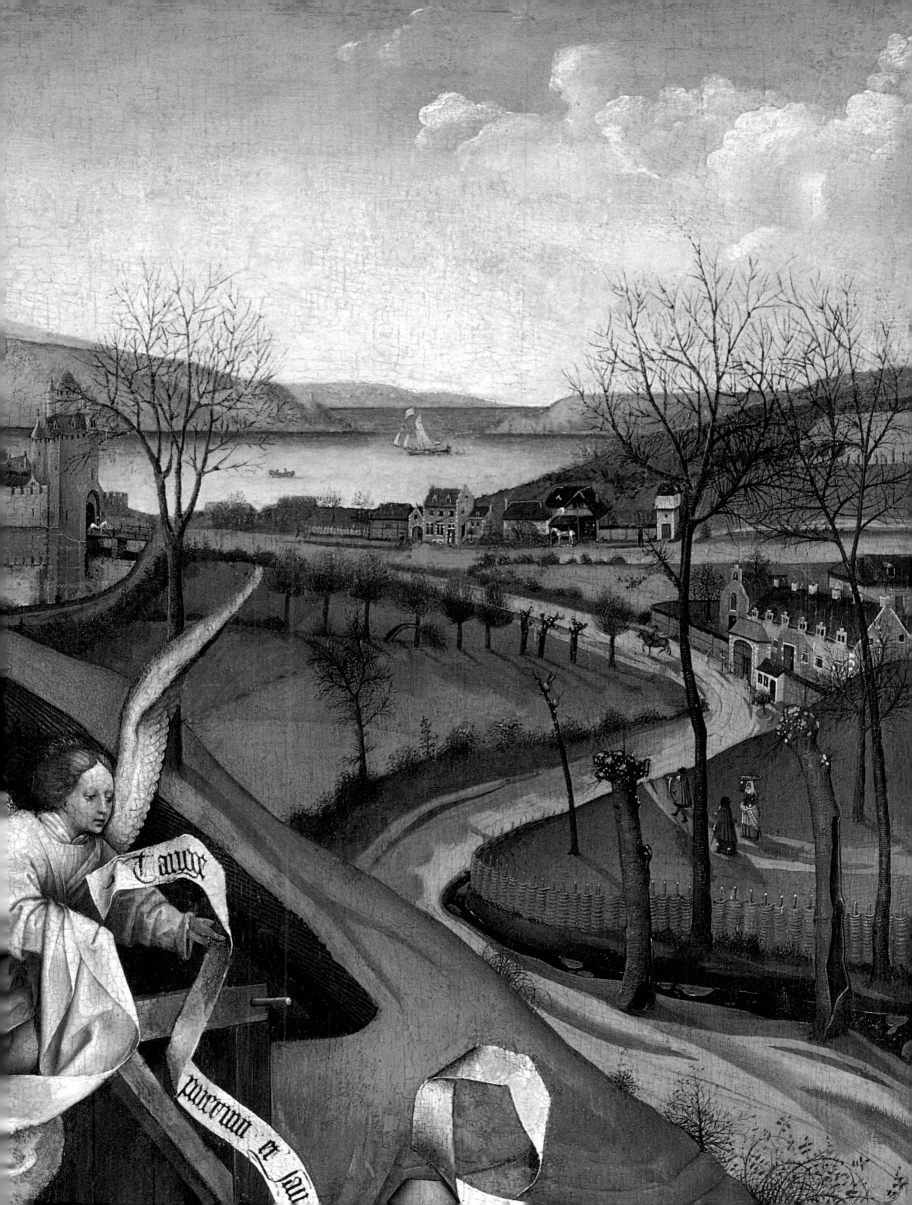

to the *Nativity* scene in three ways – in terms of atmosphere, space and narrative. The rising sun and the long shadows cast by the trees and by individual figures all indicate the dawn of a new day, just as the sparse vegetation and the ice floating in the stream pinpoint the beginning of a new year. Moreover, in Campin's painting, the background is linked with the scenic foreground for the first time with the aid of a winding path. As Otto Pächt has pointed out,[54] this path not only serves to unify the setting of the scene, but also has a narrative function. It places the protagonists in relation to the places depicted in the background. We may take it, for example, that the pregnant Mary, together with Joseph and the two animals, came over the mountain pass that can be seen in the top left-hand corner, that they were turned away from the inns in the town visible in the background, that they finally asked for shelter at the hospice to be seen on the extreme right of the picture and that they finally took the winding path to the humble stall in the foreground where the child was born.[55]

Campin's decision to integrate the biblical scene within an everyday world familiar to the spectator, both in this painting and in others, was to set an precedent that would be followed by Netherlandish painters down the centuries. Bethlehem looks for all the world like a fifteenth century walled town in Flanders. Indeed, so true to life is his portrayal that Campin's Bethlehem has been identified as the town of Huy near Liège. Even if the painter did not actually intend to provide a geographic portrait, his form of portrayal certainly meant, that, to contemporary spectators, the world in which the biblical figures were set must have appeared thoroughly familiar.

Yet the artist did not fully integrate the biblical figures into the world of the spectator. Note, for example, that unlike the protagonists, most of the figures featured in the little everyday scenes in the background are positioned against the presumed direction of movement of the main figures and are taking no notice whatsoever of the biblical miracle. Just below the hospice in the upper right-hand corner we can see three people going to market, two men and a women with a basket of eggs on her head, making their way to the town. The figure who has just left the entrance door of the hospice behind him is also heading in the same direction.

The significance of colour

Campin's realism was not simply the product of an innocent imitation of nature. This is also evident in his carefully considered approach to the use of colour. The colours of the clothes and robes, in particular, are used not only as elements of compositional structure but also as bearers of meaning. Note how the nondescript grey felt hat held by the gloved shepherd occupies precisely the centre of the painting, like a navel. This object, an entity of almost abstract stereometry in its sculptural portrayal, is the hub around which the various groups of figures with their distinctive colourings are aligned in central symmetry. The colours of the three shepherds' hoods – red, blue and brown – are echoed in Joseph's clothes. On the same diagonal, another triad of colours is grouped in pairs at wider intervals: the three angels on the upper left, linked to the shepherd scene, are dressed in blue, red and green robes respectively, while the midwife standing on the lower right is dressed in the same colours. Campin clearly employs red, blue and brown for the shepherds and Joseph as a 'lesser' variation on the well known gothic triad of red, blue and green.[56] The working men, the three shepherds and Joseph are all clad in the 'lesser' triad that features brown instead of

green, while the classic triad is used for the angels and the midwives who comment the miracle for the spectator.

The white of the Virgin and the white of the lone angel are aligned on the opposite diagonal running from lower left to upper right. The same bluish-grey shade of white is also repeated in the headwear of the two midwives, albeit independently of the dominant central symmetrical structure. This special treatment of the colour white in the painting corresponds to its use as a colour symbolic of purity. However, the colour white only symbolises the purity of a figure that is completely dressed in it, as are Mary and the angels. When used only as a part of the clothing, it merely indicates the subject of purity as treated in the midwives' dialogue.

The dispute between the midwives is the central theme of this painting. The banderole of the faithful Azel stands out from the three other banderoles by dint of the fact that the verso is not grey but golden. White and gold are the two celestial colours combined in the mantle of the Virgin Mary and to some extent in the dress of the faithful midwife.

By giving the Infant a 'lowly' off-centre position in an otherwise centrally structured composition, Campin indicates the seemingly unspectacular appearance of the Divine incarnate. He uses more subtle compositional means to indicate the divine nature of the future Redeemer: the banderole of the faithful Azel, emphasised by the use of gold, is positioned so that the word *virgo* adjoins the mantle of the Virgin, while the word *filium* points towards the Infant Jesus. Together with the robes of Joseph and Mary, the banderole creates a border around a enclosed sacred area within which the Infant, in spite of its otherwise marginal position, is elevated to the significative central point of the painting.

Traces of Early Narrative Paintings

Around 1425, in mid-career, Campin created an important narrative painting depicting the *Life of Joseph*. Although the original is no longer extant and this work has come down to us only in copies, its formal and compositional approach is so distinctive that it deserves our attention. Another narrative painting, created by Campin some ten years earlier, has survived in the form of a partial study by the master's own hand.

Two scenes from the legend of Saint Julian of Brioude

Created around 1415, the drawing presents an almost filmic juxtaposition of two successive moments in the life of Saint Julian of Brioude, rendered by the same figures on the same picture plane (Cat. I.4, fig. 28). The drawing, now in the Cabinet des Dessins of the Louvre, is a detailed study for a wall painting. It may be assumed that the composition was planned as part of a major mural work featuring scenes from the life of the saint. Julian of Brioude was worshipped in a number of French provinces, especially in the Auvergne. The church of Ath, near Tournai (fig. 27), was also dedicated to him and even claimed to posses a relic of the saint.[57] It is possible that Campin's drawing was submitted as a design for the interior decoration of the church which was completed in 1415.[58]

In the first scene beneath the left hand arch, we see four soldiers gathered around their captain who is standing behind a rectangular trough. One of the soldiers is leaning forward

to put the saint's head into the water. At the request of the man beside him, the captain orders the soldier standing to the right of the trough to bring the head once it has been washed to the palace, which can be seen on the right. There, beneath the portal, two men are waiting to receive the relic of the saint from the captain and his soldiers. The figures are shown in this second episode wearing the same clothes and weapons, but regrouped.[59]

Campin has succeeded in deftly linking the two scenes. The figure of the soldier with his back to us in the centre of the picture acts as a fulcrum point. He has turned his head to look back at the trough on the left, but has already stepped into the pictorial space on the right. The architectural elements of palace and trough are aligned towards the same central vanishing point so that the double scene takes on a unified appearance. Originally, all the figures were illuminated from the right. In a second phase, Campin reworked the scene with black ink in order to give the figures an independent source of light from the left. It is possible that the section of the wall for which this composition was envisaged may have been flanked by two windows, which would explain the double illumination from left and right. Yet there was probably another reason for reworking the picture. By using independent lighting to separate the two episodes, which are treated in terms of perspective as a single unit, Campin was able to underline the composite character of the portrayal.

The Life of Saint Joseph

In a work created around 1425, Robert Campin portrayed a number of episodes from the *Life of Saint Joseph*, setting them all in a common landscape. A copy of the work has survived in the Church of Hoogstraten, north-east of Antwerp. Though this copy may not meet the standards achieved in fine Netherlandish painting of the period, it does give a faithful rendering of the basic elements of the lost composition (Cat. I.7, fig. 31). It is not known who commissioned the original or where it was displayed. Its broad format suggests that it served as an antependium or retable. Admittedly, the dedication of an altar to Joseph in the period around 1425, when the original composition must have been executed, would certainly seem surprisingly early.[60]

Fig. 27 Hendrik Van Wel, View of Ath (detail), 17th century, Brussels, Bibliothèque Royale Albert Ier, Cabinet des Estampes

Campin probably created the scenes from the Life of Saint Julian of Brioude (fig. 28) as a study for a mural in the Church of Saint Julien von Ath, completed in 1415. The building was almost completely destroyed in 1817 and rebuilt according to new plans.

The painting portrays several episodes from the *Life of Joseph* according to the principle of continuous narrative. Joseph is the only figure to appear in all the scenes, and it may be assumed that Mary's golden nimbus was added by the copyist and did not feature in the original.

Apart from the copy at Hoogstraten, there is also a partial copy of the left-hand third in a painting in the Prado (fig. 36). It is the wing of an altarpiece showing the *Miracle of the Rod* and the *Betrothal of the Virgin*, in which the figures have been considerably altered in comparison to the lost original.[61] For a long time, the panel in Madrid was regarded as an original by Campin. However, it was actually painted by one of his early students and was probably not created until around 1440.

The copy of Campin's composition in Hoogstraten (fig. 31) is the oldest known example of multi-scenic narrative painting in northern Europe. Famous late examples are two works by Memling, the *Passion of Christ* in Turin and the *Seven Joys of Mary* in Munich (fig. 30). The Marian panel dated 1480 is compositionally closely related to the *Life of Joseph* in Hoogstraten. It may therefore be assumed that Campin's original was Memling's most important source, at least with regard to the narrative structure.

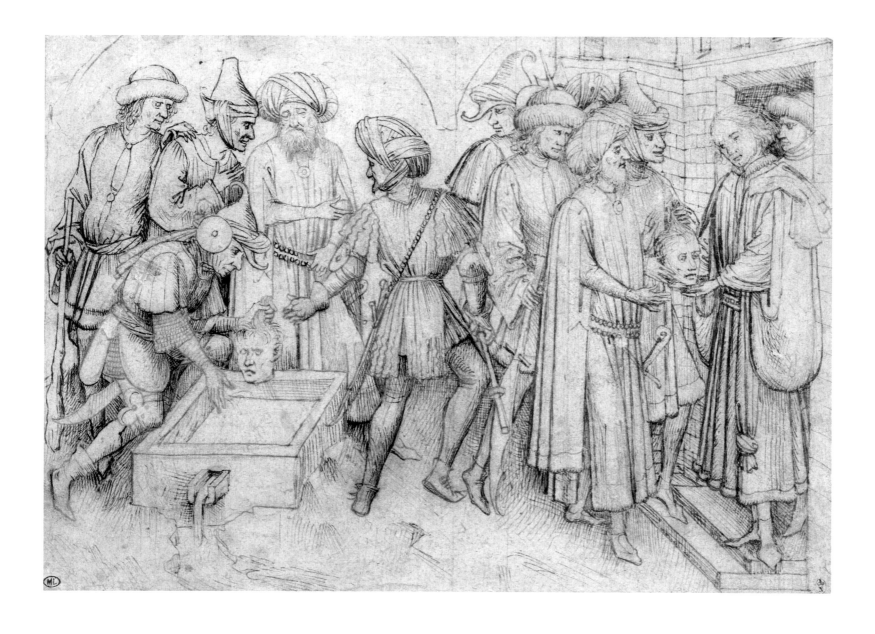

Fig. 28 Robert Campin, two scenes from the Life of
Saint Julian of Brioude, c. 1415. Paris, Musée du Louvre,
Cabinet des Dessins

Campin's composition is structured thematically into seven clearly defined individual scenes (fig. 32). In the foreground, five of the scenes are arranged in three groups according to the places in which they are set – Jerusalem, Bethlehem, Nazareth – with Bethlehem taking the central position. Two further scenes are shown in the background. The three cities in the foreground are each represented by a building that identifies them clearly – temple, birthplace, house of Mary. The buildings can be compared with the so-called *mansiones* in medieval mystery plays, in which several scenes were visible at the same time (fig. 29).[62] The narrative structure of the simultaneous images in late medieval painting is also related to the tradition of the mystery play. In both cases, the flow of narrative is created by having the protagonists move from place to place. However, whereas the actors in the mystery plays really did move on to the next set or *mansion*, the figures in a painting have to be portrayed repeatedly to enable the spectator to reconstruct a sense of movement and change of location in the course of contemplating the painting.[63]

The individual scenes are to be read from left to right. A path running through all the scenes links the various episodes with one another. Apart from the actual sequence in which the scenes are portrayed, the overall compositional scheme is also important for an understanding of the panel. The scenes are aligned in pairs according to a principal of mirror symmetry, with the exception of the central Nativity scene, which has no counterpart. This symmetrical structure serves to render visible the logical framework on which the narrative is based.

The story begins on the left with the Miracle of the Rod [Scene 1] (fig. 34). The high priest is distributing the rods. Joseph is standing at the front, with his back to the spectator, wearing a brown robe, as in all the other scenes, and over it he has cast a red mantle lined with white. He has pulled a dark red hat so far down over his head that not even his eyes can be seen. The man chosen by God is already holding the flowering staff in his hand and is being detained by the others, for they have noticed the miracle. The scene takes place in a round pillared building that represents the Temple at Jerusalem. Around the temple we can see the walls of a new church in the gothic style.

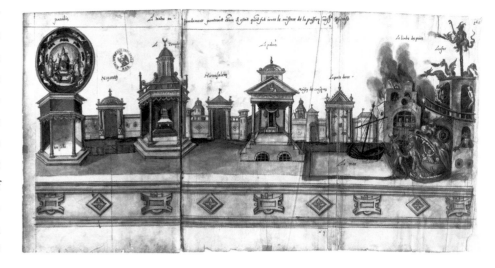

Fig. 29 Hubert Cailleau, mansion stage used for the performance of mystery plays at Valenciennes, 1547. Paris, Bibliothèque Nationale

The pictorial structure of the *Life of Saint Joseph* (fig. 31) corresponds to the structure of simultaneous settings in the medieval mansion stages.

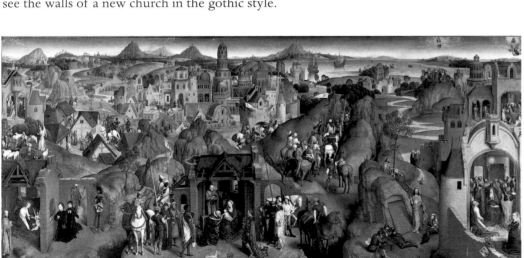

Fig. 30 Hans Memling, *The Seven Joys of Mary*, 1480. Munich, Alte Pinakothek

Campin's *Life of Saint Joseph* (cf. fig. 31) was probably the main basis for this work.

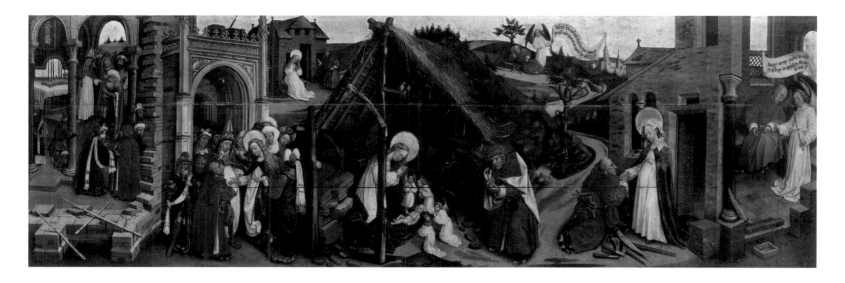

Fig. 31 Robert Campin (copy after), *The Life of Saint Joseph.* Hoogstraten, St. Katarinakerk

One portal has been completed already, and the next episode, the Betrothal of the Virgin to Joseph [Scene 2], takes place there in the presence of the high priest and several witnesses.

The next scene, Joseph's Doubt [Scene 3] (fig. 37) is portrayed in the background to the left. In front of her house in Nazareth we see Mary, dressed in virginal white, her hair worn loose. She is clearly pregnant, and this is noticed by her husband.

Having turned away from Mary, Joseph appears again in the first Dream Vision [Scene 4] (fig. 38) in the background on the right. He is lying asleep under a tree by the side of the road, the tools of his carpenter's trade spread on the ground. The angel's message to Joseph is also displayed on a banderole for the spectator: *Joseph fili david noli timere accipere mariam conjugem tuam quod [enim] in ea natum est de spiritu sancto est.* (Matthew, 1:20: Joseph, thou son of David, fear not to take unto thee Mary thy wife: for that which is conceived in her is of the Holy Ghost.) This depiction of Joseph's first Dream Vision is set as a corrective counterpart to the scene showing Joseph's Doubt [3] (fig. 37) which is symmetrically aligned as its pendant.

A long, winding path – similar to the one in the Dijon *Nativity* (fig. 26) – leads into the foreground with the scene showing Joseph's Repentance [Scene 5] (fig. 41): Joseph has followed the heavenly command to return to Mary and has gone down on his knees before her in remorse to beg forgiveness for doubting her loyalty. Mary forgives Joseph and tells him to

Fig. 32 Series of scenes from the Life of Saint Joseph by Robert Campin (cf. fig. 31)

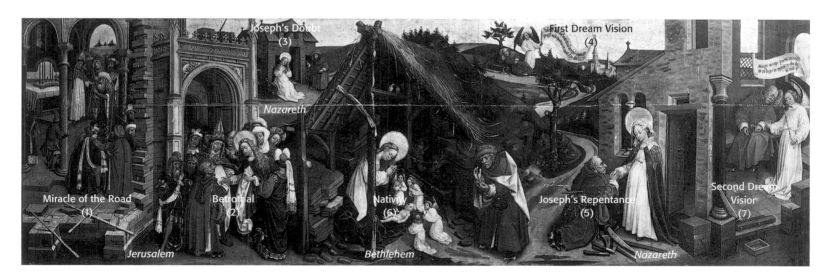

stand up again. Once again, the tools of the carpenter's trade – a saw, two axes and a com-
pass – are lying on the ground beside him. The three drills and a chisel tucked into his belt
on his back where Mary cannot see them seem rather odd. Compared with the parallel
motif in the panel of the Mérode Triptych (fig. 42) that shows Joseph drilling holes, the
concealment of the tools may be regarded here as an allusion to the suppression of his
sexuality.[64]

Chronologically, the Nativity [Scene 6] in the central foreground (fig. 39) comes next.
This marks a break with the otherwise uninterrupted flow of narration from left to right. Its
position in the central foreground underlines its importance as the focal scene around which
the rest of the story revolves. In Campin's composition, the *Life of Joseph* is portrayed in rela-
tion to his role in the birth of the Saviour. Indeed, this is the main theme of the work. By
centring the picture on the Nativity scene the panel becomes a votive image imbedded
within a narrative sequence of ancillary episodes.

One iconographically interesting feature is the fact that the place of birth is presented
here as a combination of cave and stable. As in the Dijon *Nativity* (fig. 26), there are ripe ears
of corn to be seen on the roof. The naked Infant is placed precisely on the central axis of the
panel, worshipped by Mary and four white-robed angels. Note that the angel kneeling at the
front in rear view has no wings. This figure may perhaps be intended to represent the priest
within the picture.

Again, as in the Dijon *Nativity*, Joseph is holding a burning candle and protecting the
flame with his hand. Although the compositional alignment places Joseph within a triangle
together with Mary, he is clearly detached from the group of worshippers. The cooing doves

Fig. 33 The Temple of Solomon and the Church of Christ,
typological pair of images from the Viennese Bible *moral-
isée*, c. 1220. Vienna, Österreichische Nationalbibliothek,
Cod. 2554, fol. 50v (detail)

Already in this miniature the difference between the Old
and New Testament is rendered metaphorically by the
contrast in architectural styles.

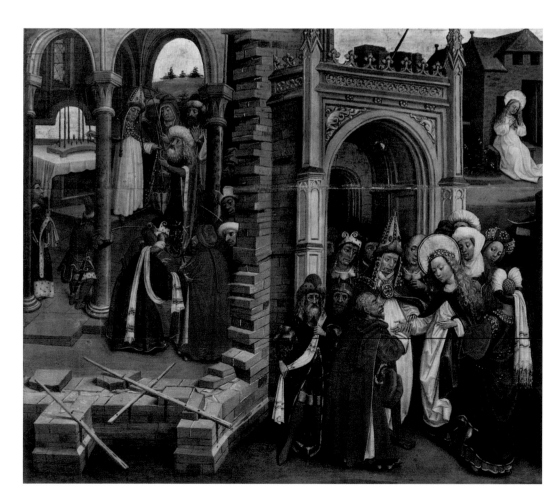

Fig. 34 *The Miracle of the Rod* (1) and *The Betrothal of
the Virgin* (2), details of fig. 31

Fig. 35 Brussels, south portal of the Church of Notre-Dame des Sablons (before restoration)

The Master of the Betrothal of the Virgin has included a portrait of this portal in his copy (fig. 36).

in the roof beams above the mother and child refer to the relationship of love – though not between Mary and Joseph, but between the mother and her new-born child.[65]

Another remarkable motif is the dead tree on the side of the road beside the stable (fig. 31). A single green twig is growing from it. This motif plays an important role in the cycle of mosaics portraying the Life of the Virgin in the Church of Kariye Camii in Istanbul, created after 1303 (fig. 40). There, a similar tree can be seen twice – both times beside the figure of the pregnant Mary – in the double scene of Joseph's Doubt and Joseph's Regret. The fact that this is a symbol of the child expected by the Virgin is evident in the Nativity scene, where the motif is located directly below the group of mother and child, and is observed by Joseph in sorrowful pose.[66] Campin's reiteration of this ancient eastern pictorial motif in the same thematic context and his portrayal of the Nativity in a cave-like location – a most unusual motif in the west – would suggest that he took some inspiration for his *Life of Joseph* from a cycle of pictures of Byzantine origin.

The closing scene is the second Dream Vision [Scene 7] (fig. 41) at the front on the right in which the angel commands Joseph to flee to Egypt: *Surge [et] accipe puerum et matrem eius et fuge in egiptam et esto ibi [usque] dum dicam tibi* (Matthew 2:13: Arise, and take the young child and his mother, and flee into Egypt, and be thou there until I bring thee word). Note that banderoles are used only in the two dream scenes. On both occasions, the heavenly messages addressed to Joseph are taken from the opening chapters of the Gospel according to Matthew. This is further evidence of the fact that the role of the earthly father in the Birth of Christ, debated in the Gospels, is in fact the key theme of the *Saint Joseph* panel.

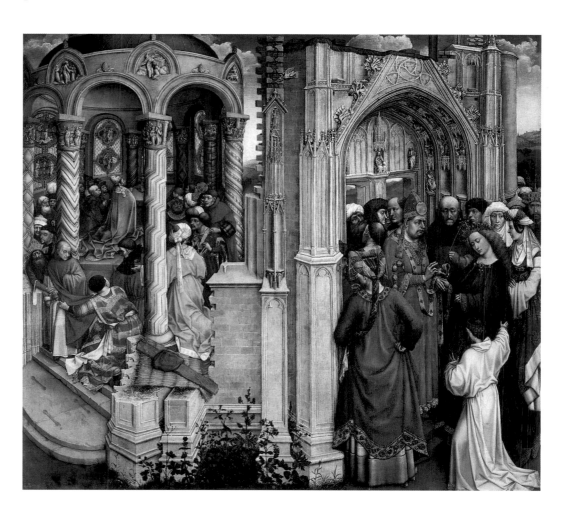

Fig. 36 Master of The Betrothal of the Virgin (free copy after Robert Campin), *The Miracle of the Rod* and *Betrothal of the Virgin*, c. 1450. Madrid, Prado

The story Campin tells in his composition leaves the future open at the right of the picture. Nevertheless, this does not allow us to assume that the Hoogstraten copy is merely a fragment of a larger ensemble.[67] With the flight to Egypt – the last event in which Joseph is actually mentioned in the Gospels – he has fulfilled his most important tasks as Christ's earthly father. The self-contained compositional structure

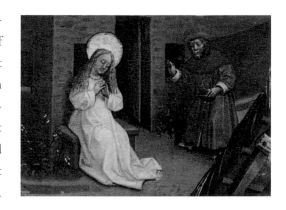

Fig. 37 *Doubting Joseph* (3), detail of fig. 31

Fig. 38 *First Dream Vision* (4), detail of fig. 31

also indicates that the seven scenes represent the work in its entirety. The architectural framework in which scenes [5] and [7] are set (fig. 41) is similar to that of the first two scenes (fig. 31). The content is also comparable. In terms of both composition and content, the scene showing Joseph's Repentance [5] is the pendant to the Betrothal [2] scene: here, following Joseph's Doubt, the bonds of marriage are renewed. The sceptre held by the angel in the closing scene [7] echoes the blossoming staff in the first scene [1]: just as the Miracle of the Rod shows Joseph being divinely chosen as the husband of Mary, the second Dream Vision shows him being allocated the task of protecting the child.

In his treatment of the Madrid copy, Erwin Panofsky has shown how Campin illustrated the transition from the Old Testament to the New Testament in the first two scenes by portraying two different architectural styles. The round temple shown in the Madrid panel (fig. 36) is a Romanesque building embellished with ancient and eastern elements. It

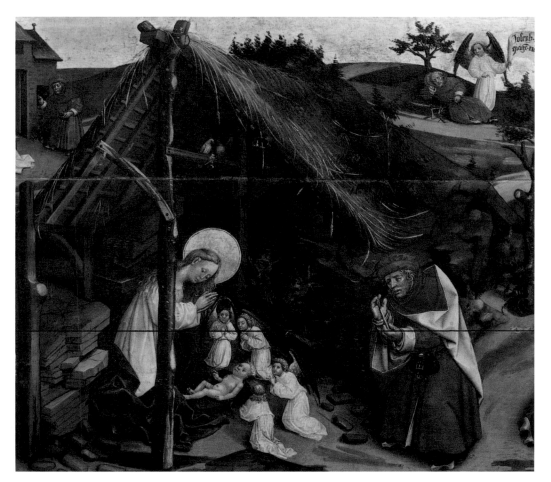

Fig. 39 *The Nativity* (6), detail of fig. 31

Fig. 40 *Doubting Joseph*, mosaic (detail), after 1303. Istanbul, Kariye Camii

The barren tree with a single green twig beside the Virgin Mary is a reference to the Coming of Christ.

must have corresponded closely to Campin's original, as indicated by its similarity to the temple building in Jacques Daret's *Presentation of Christ in the Temple* (Cat. III.A.1d). Decorated with relievo scenes from the Old Testament, it represents the age of the Old Covenant. The building shown in contemporary gothic style, of which only one portal has been completed, indicates the age of the New Covenant heralded by the Betrothal of the Virgin.[68] The building in the new style – which will replace or embrace the ancient Jewish Temple once it is completed – stands at the same time for Ecclesia.[69] Campin's approach is not entirely new. In the *Bible moralisée* created around 1220, now in the National Library in Vienna, the same contrast between these two architectural styles is used to distinguish the *Ecclesia* founded by Christ from the *Templum Salomonis* (fig. 33).[70] What is thoroughly original, however, is Campin's idea of building the gothic church around the Temple of Solomon as a means of indicating that the Old Testament will be superseded by the New Testament.

The temple building with the new church building on the left corresponds to a similarly complex architectural entity on the right-hand side of the panel, namely the house of Mary and Joseph in Nazareth, which is also undergoing conversion (fig. 41). The richer architectural forms of the house's new façade – it is shown in its original form in the background to the left (fig. 31) – mirror the gothic portal of the new temple. On the far right, only the foundations for the new side wall have been built, affording a glimpse into the interior of the building in much the same way as the composit structure on the left-hand side of the picture.

The renovation of the house of Christ's parents in Nazareth can also be read symbolically. Just as the Temple of Jerusalem in its different stages of construction points to chang-

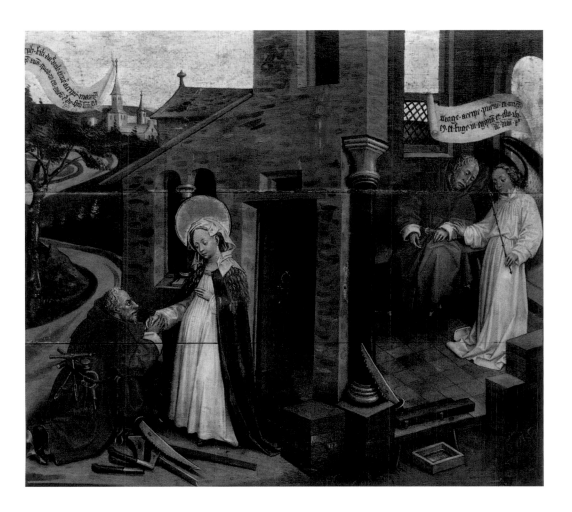

Fig. 41 *Joseph's Repentance* (5) and *The Second Dream Vision* (7), detail of fig. 31

ing eras of history, the changes to the house in Nazareth may indicate the earthly life of Christ as the Son of Man. The very obviously placed pillar with a saw leaning against it is rather enigmatic. It may possibly be intended as an indication of the coming Passion of Christ.

A Triptych of the Annunciation

The Mérode Triptych, now in the collection of the Cloisters in New York (Cat. I.12; fig. 42), is known by the name of its last private owner. It is a work of modest size, just 43 cm in height, and is a typical example of the kind of private votive painting used as a domestic altarpiece. Long and painstaking research has recently revealed that it was originally commissioned by one Peter Engelbrecht and his wife Margarethe Schrinmechers, whose names are worked into the altarpiece in the symbolic and metaphorical manner of a rebus. In the following, we trace the story of how these patrons were identified and, in doing so, we trace the meaning of the triptych itself.[71]

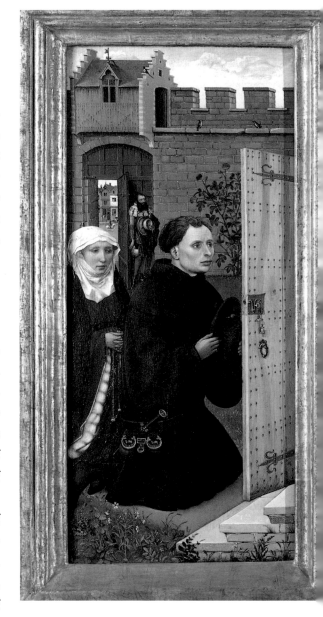

Some initial theories of origin

Many attempts were made at an early stage to identify the couple portrayed on the left-hand wing of the triptych by means of the coats of arms that can be seen as stained glass motifs in the background windows of the central panel (fig. 43). In 1898, Hugo von Tschudi attributed the man's coat of arms to the Inghelbrechts or Ymbrechts family and that of the woman to the Calcum family also known as Lohausen. According to Tschudi, the two coats of arms were indicative of Flanders and the Lower Rhine regions.[72] Although the identification of the male coat of arms has not been questioned since, the identity of the woman's coat of arms proved less certain.[73]

In 1907, Georges Hulin de Loo succeeded in establishing a link between the family of the man portrayed on the left wing of the triptych and the city of Mecheln. He was able to prove that this unusual coat of arms featuring a chain over a chevron was also borne by a certain Elizabeth Inghelbrechts who had married a patrician from Mecheln in 1457. From this, the author deduced that some well-aimed research in the archives of the city of Mecheln would one day enable us to identify the patrons.[74]

Then, in 1925, Adolphe Hoquet published a document dated 1434 from the municipal archives of Tournai in which one Rombaut Inghelbrechts, also a resident of Mecheln, was recorded as the recipient of a municipal Wine of Honour.[75] Another document recorded that Rombaut, born in 1394, had acquired lifetime annuities of that city for himself and his young wife Lizebette van den Ende. Yet these could not be the couple portrayed on left wing of the triptych, as Lizebette did not bear the coat of arms attributed to the woman in the picture. Nevertheless, the document appeared to be of some importance. After all, it linked Mecheln, which Hulin believed to be the home of the couple, with Tournai, the home of the artist Robert Campin.

Another seventy years were to pass before the patrons who commissioned Campin's *Annunciation* triptych could be identified. In the meantime, Meyer Schapiro was to publish his brilliant essay on the subject of the mousetraps in the Joseph panel, and many another

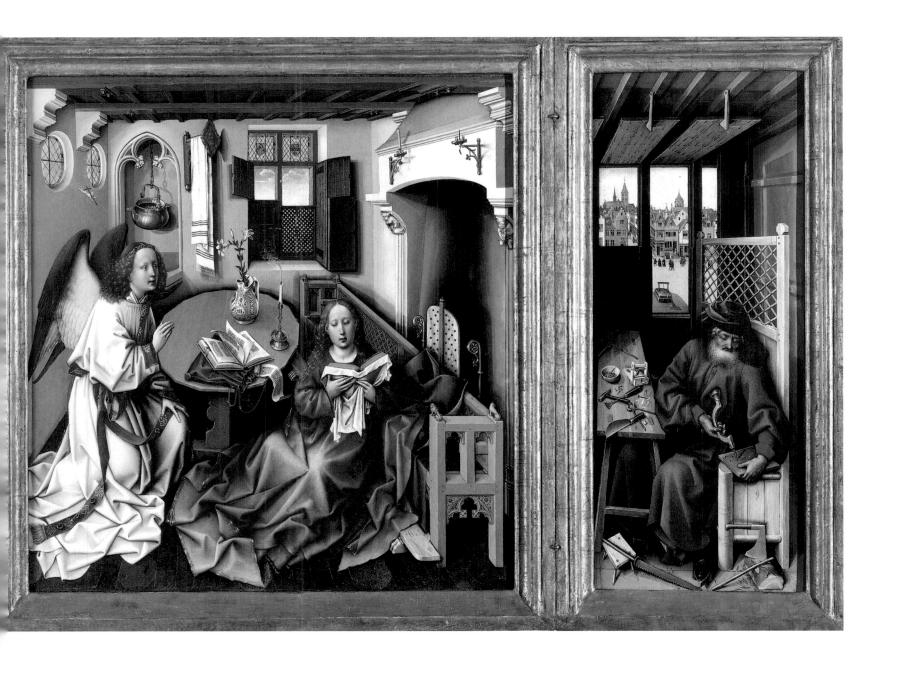

Fig. 42 Robert Campin, 1425–30. Mérode Altarpiece. New York, Metropolitan Museum of Art, Cloisters Collection

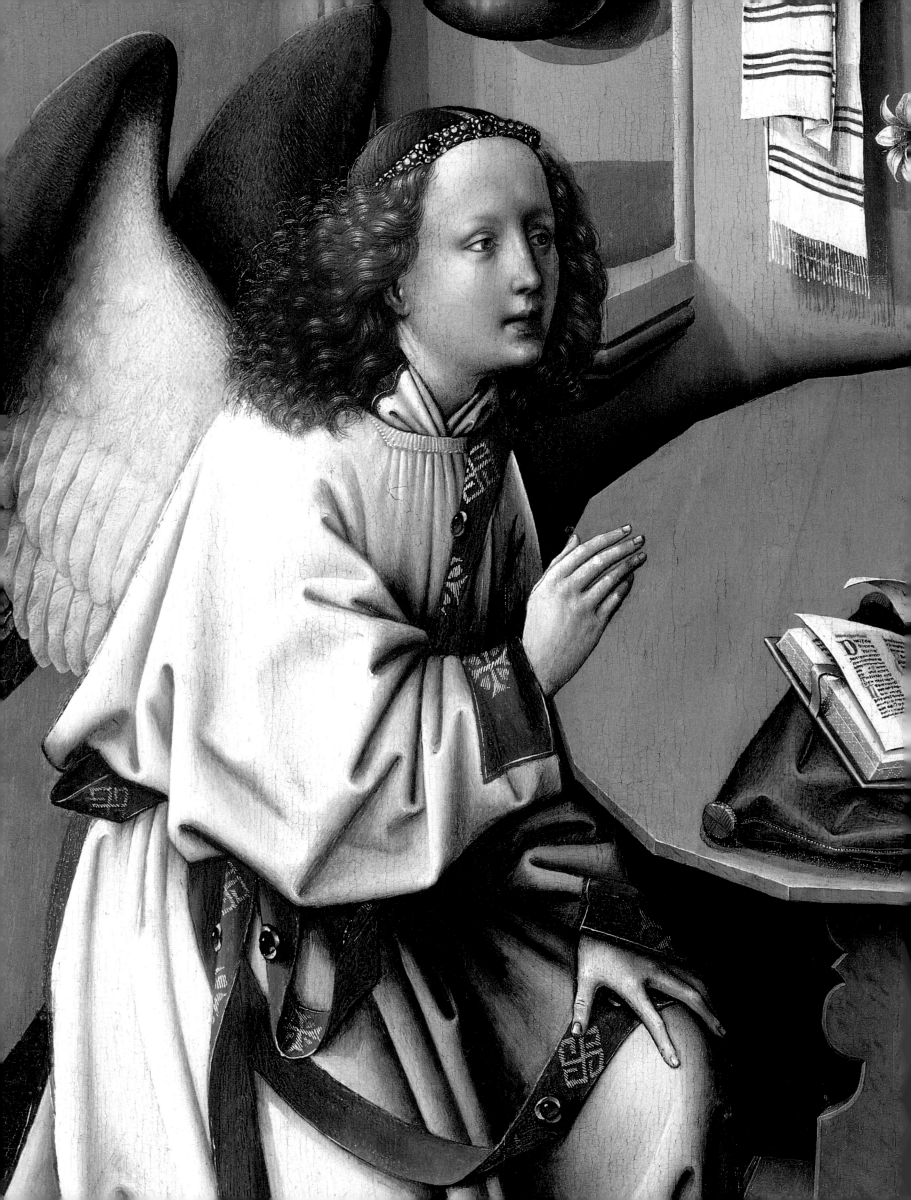

Fig. 43 Detail of fig. 42 (central panel)

The coats of arms belonging to the respective families of the couple on the left-hand wing are worked into the back window of the central panel: on the heraldic right the device of the man named Inghelbrechts, on the heraldic left that of the woman.

scholar was to take delight in unravelling its iconographical meaning. Without these studies, the document discovered by Hulin in 1907 might never have helped to unlock the mystery as he predicted it would. The puzzle had many pieces: a thorough art historical analysis of the specific portrayal of the Annunciation in this triptych was required, along with a detailed study of the relevant heraldry and archival documents. What is more, stylistic and techno-logical analysis of the panels in their present state revealed that the painting had been reworked at a later date.

A painting reworked

X-rays made after the New York Museum had acquired the work indicate that the left hand panel did not always look exactly as it does now (figs. 44, 46). The man in black with the black hat in his hand was originally portrayed alone. The woman in the fur-lined red robe with a black cape at the edge of the picture and the flamboyantly dressed, bearded man by the gate were both added later to areas of the painting that had already been completed.[76] The bearded man by the gate was a herald or messenger of the city of Mecheln.[77] On his chest he bears the official sign of his trade: the messenger's box with the city's coat of arms. The large bag, the pointed shoes and the wide-rimmed straw hat are all typical of his profession.

And there is something else: the windows of the central panel, as the X-rays also show, originally had a gold ground. An *Annunciation* panel in the Musées royaux at Brussels, which we will discuss later, shows how the back windows of the central panel must have looked originally (fig. 54). The Brussels panel is a variation on the Mérode Triptych, painted by a student of Campin in the workshop of the master.

It may be assumed that the window apertures were repainted to show a realistic cloudy sky at the same time that the woman and city messenger were added to the left-hand wing. It certainly cannot have been a case of Robert Campin having second thoughts in the course of the painterly process. After all, overpainting the golden heavens in the central panel (fig. 42) meant that an important colour difference between the central panel and the right hand panel became incomprehensible. In keeping with the original gold background, the scene of the Annunciation is suffused with a bright, warm light that falls on the tips of the divine messenger's wings like yellow dust. This magnificent heavenly light contrasts with the dull everyday light of the right-hand panel that steeps the beamed ceiling, walls and furniture in a cold, violet grey tone. The reason for the different lighting is clear: Joseph, sitting in his workshop, has not noticed the divine presence in the house of his betrothed.

Some unusual features of the donor panel

There is another curious detail. The left hand panel – even in its original form showing the man alone – cannot have been painted by the same artist as the other two panels of the trip-tych. The voluminous, strongly coloured figures in the central panel with the Annunciation scene and the Joseph panel are entirely in keeping with the style of Robert Campin. Set in perspectivally structured rooms, these figures vie with individualistically detailed and clearly distinguished objects that cast double and even treble shadows as they are illumi-nated by several sources of light at the same time.

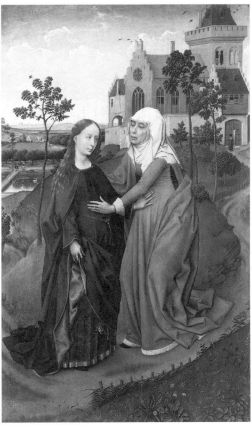

Fig. 45 Rogier van der Weyden, *The Visitation*, c. 1435.
Leipzig, Museum der bildenden Künste

Fig. 44 Detail of fig. 42 (left wing)

The painterly style evident in the left-hand panel (fig. 44) is very different indeed. The figures and the objects are flatter and less distinct from one another. The treatment of space is more atmospheric and the use of perspective seems less artificial to the modern eye. Only the door that is standing ajar and the three steps leading up to it, linking the scene with the central panel, are strongly foreshortened.[78] The portrayal of objects is sometimes rather clumsy and even sketchy, such as the bricks of the wall in the background which seem far too big in comparison, for example, with the sandstone blocks of the steps.[79] Certain painterly details indicate that the left hand panel was created by Campin's most talented student, Rogier van der Weyden. This panel is closely related to an early work by Rogier – *The Visitation* in the Leipzig Museum (fig. 45). Not only the gatehouse, but also the grass and flowers, are similar in both paintings.

Dendrochronological analysis has shown that the wooden panels of the left and right wings were both felled at the same time. They were probably also painted at the same time. If so, then Robert Campin must have entrusted a member of his workshop – whom we assume to be Rogier van der Weyden – with the execution of the donor panel.[80] We can state with even greater certainty that it was indeed Rogier van der Weyden who added the figures of the woman and the city messenger of Mecheln to the left hand panel at a later date and that he was also very probably the person who painted over the windows on the central panel at the same time. The figure of the city messenger by the gate, with his slender and elegantly curved silhouette, corresponds to Rogier's mature style. The figure of the messenger has little in common with Campin's stocky, sculptural

Fig. 46 X-radiograph of the left wing (cf. fig. 44)

The woman and the bearded man at the gate have been added later over completed areas of the picture.

figures in the central panel and the right-hand panel of the Mérode Triptych. There must have been a considerable time lapse between the original completion of the altarpiece, generally accepted as some time between 1425 and 1428 on stylistic grounds, and the point at which it was subsequently reworked. From these observations, it seems reasonable to deduce that the altarpiece was in fact repainted to include the newly-wed wife of the patron and to add her coat of arms to the back window of the room in which the Virgin Mary is seated.

So much for the stylistic and painterly findings. However, before any attempt can be made to ascertain the names of the patrons and their social situation by consulting archival documents, we must first take a look at the painting itself. Any examination of the documents first requires a close study of the way in which the biblical story of the Annunciation is presented in the Mérode Triptych.

A theology of mousetraps

In 1945, the American art historian Meyer Schapiro published a now famous essay on the symbolism of mousetraps in the Mérode Triptych. He had set about finding an explanation for the singular fact that the scene on the right-hand wing of this triptych, juxtaposed with the Annunciation, shows Joseph at work in his carpenter's shop. According to Schapiro, Joseph's presence in the triptych can be explained primarily by the fact that, around 1400, the figure of Christ's earthly father had begun to take on a new importance as the representative of prevailing 'domestic and bourgeois' values. Yet the true key to the role of the right hand panel within the tripytch as a whole could be found, according to Schapiro, in the two mousetraps – one of them, a more old fashioned block-type model, on the windowsill, and another more modern type on Joseph's workbench (fig. 42).[81] Meyer Shapiro saw in them the visual expression of a metaphor used by Saint Augustine to describe the redemption of man by Christ's sacrifice: Christ as *muscipula diaboli* or 'mousetrap for the devil', whose incarnation and crucifixion had baited and deceived the devil while concealing his true divine nature. According to Schapiro, the mousetraps featured in Campin's painting also refer to this theological concept.[82]

This interpretation, however, is not entirely satisfactory. Though Campin's mousetraps are undoubtedly intended as visual metaphors, the reference is not to Christ, but to Joseph. Mary's betrothed is portrayed as the person who has fashioned them. The mousetrap he has placed on the windowsill of his workshop is both a symbol of his profession and a sample of his work intended to solicit custom. By displaying this mousetrap, he seeks to attract and "catch" the customers passing by his workshop. In this way, Campin's mousetraps do not symbolise Christ's deceptive disguise of divinity in becoming human, but a different form of deception by Joseph. Campin must have reinterpreted Saint Augustine's metaphor in his painting by replacing this reference to Christ with a reference to Christ's earthly father, Joseph.[83]

A particularly thorny problem for medieval theologians lay in explaining why the Virgin Mary should have been betrothed or married to Joseph in the first place if he played no role in the conception of the Son of God anyway. One of the most important arguments was that Mary and Joseph had to appear to the outside world as a normal married couple for only in this way could the devil be deceived as to the true nature of Christ, whose birth from a virgin mother had been predicted by the prophet Isaiah.[84] It is in this role, as the pseudo-husband of the Virgin Mary, as we will explain in greater detail below, that Joseph is portrayed in Campin's triptych. And it is to this particular role played by Joseph that Campin's new use of the old mousetrap metaphor applies.

Inghelbrechts – 'the angel brought it'

The Mérode Triptych would appear to be the first Netherlandish triptych featuring the Annunciation scene as its central panel.[85] Moreover, a number of compositional elements have been used to create an unusually close link between the couple on the left hand panel and the main biblical scene. For this reason, some scholars have surmised that the choice of the Annunciation as a central theme may even be a reference to the man's family name. Ymbrechts or Inghelbrechts is derived from *"der Engel brachte"*, meaning "the angel brought [it]".[86]

The manner in which Robert Campin presents the Annunciation indicates that this reference to this patron's name is indeed significant. In contrast to conventional portrayals in which banderoles are used to illustrate the communication between the angel and the Virgin, two books play a key role in Campin's work (fig. 42). The Virgin is immersed in a book bound in a white cloth and has apparently not noticed the arrival of the angel. On the table, between the angel and the Virgin, there is a second book, almost in the centre of the picture. Its pages are gilt-edged and patterned, as opposed to the plain edges of the book Mary is reading. The pages are being leafed over as though by a gust of wind. This second book is lying on a green bag with a red cord. The right-hand cover presses down on a parchment scroll bearing an inscription, which is hanging over the edge of the table towards Mary.

The bag indicates that the book on the table is the one that *the angel brought* to the Virgin. It represents the good tidings in the material form of the Gospel. The book wrapped in a cloth, on the other hand, is Mary's own book, the Old Testament, in which, as was widely accepted at the time, she has just been reading Isaiah's prophecy of birth of the Redeemer (Isaiah, 7:14): "Behold, a virgin shall conceive, and bear a son, and shall call his name Immanuel". The scroll held by the New Testament is reminiscent of a banderole, indicating verbal communication. We may assume – even if we cannot decipher the letters on the scroll – that it quotes the words of the angel to the Virgin, the *Ave Maria*, which is part of the Gospel the angel brought.

The dwelling house of the Lord

The room portrayed in the central panel is a self-contained space, allowing the spectator a glimpse as though the front wall has been removed, rather like a doll's house. The Virgin's room is treated as a house of God and thus becomes a metaphor for the Virgin herself as the bearer of Christ.[87] In the upper left hand corner, we see the Infant Jesus entering the room through a closed window on seven golden rays, underlining the metaphorical equation of the room with Mary herself. At the same time, the painting thus renders a popular metaphor of the immaculate conception, described by Saint Bernard as follows: "just as the brilliance of the sun penetrates the glass of a window without breaking it, permeating its hard matter with supernatural finesse, neither injuring nor fragmenting it on entering or leaving, so too did the Word of God, the brilliance of the Father, enter the Virgin's home and come forth again leaving it intact."[88]

The interpretation of the room as a metaphor of the Virgin also allows the artist to portray the prerequisites for the immaculate conception of Christ. All the furnishings and objects in the room serve to illustrate the virtues and spiritual character of the Virgin, which have made her fit to become the mother of God incarnate.

The *keerlys* – the long bench or settle on the right in front of the fireplace, with its adjustable backrest or *keerlys* that can be mounted on either side – is significant for the fact that it is not actually used by Mary.[89] Instead, she is sitting in front of it on a cushion on the ground. This unusual pose illustrates the first of her two main virtues. *humility*, as portrayed in Italian art. The other key virtue of the Virgin, her *purity*, is illustrated by the traditional symbol of the lilies. These are not held by the angel, as in conventional portrayals, but placed in a jug as part of the decor. Other indicators of her purity are the waterbasin with

two spouts and the cloth hanging beside it on the moveable red stand ornamented with a bearded head.[90] These objects are not, as art historians since Panofsky have assumed, 'disguised symbols' that can be deciphered only with the aid of biblical exegeses and obscure theological treatises.[91] Instead, their significance in the context of the scene shown here is derived first and foremost from their possible functional use for the person living in this room and only secondarily from the possibility of their references to a generally widespread religious knowledge.[92]

Joseph as husband and provider

In the fittings and furnishings of her home Mary's purity is expressed for the most part indirectly with many references to her sexual chastity. The relationship between man and woman is alluded to on two occasions. The mantelpiece supports take the form of a male and a female figure (fig. 42). Above each of these figures is a hinged candlestick, whereby only the candlestick above the figure of the woman bears a candle. This asymmetry is clearly intended to cancel out the complementary relationship of man and woman represented by the figures.

The same would appear to apply to the carved figures of animals, lion and dog, on the armrests of the bench. Here, Campin is alluding to the traditional symbolism of these two animals. The tombs of married couples frequently feature a lion (originally a sign of strength) at the man's feet and a dog (originally a sign of loyalty) at the feet of the woman (fig. 47). Whereas these animals tend to face each other on such tombstones, Campin has placed the 'male' lion and the 'female' dog with their backs to each other, once again negating the sexual relationship.[93]

Nor is it a coincidence that all these figures are shown near the fireplace. Fire is an ancient symbol of sexual desire. This is why, in Mary's home, fire is present only in negated form: the fire in the fireplace has gone out and the back of the adjustable bench has been placed in its summer position, turned away from the fire. Finally, as a further clear indication of her rejection of this element, a large screen has been placed between Mary and the fireplace.

The piece of wood that Joseph is working on has given art historians much food for thought over the years. They have tried to identify the object and interpret it according to the theory of disguised symbolism. The proposals – eight or more to date – range from a lid for a fish bait box to a strainer for a small winepress.[94] It is not certain that even Campin's contemporaries would have been able to identify this unfinished and rather unspecific object unequivocally.[95] Yet they would undoubtedly have noted that the holes Joseph is drilling in the wood have exactly the same pattern of alignment as the holes on the fire-screen in the central panel. This would identify Joseph as the person who produced the fire-screen, which serves, symbolically speaking, to shelter Mary from the flames of physical desire.[96] This interpretation of the fire-screen corresponds to Joseph's known role as the Virgin's accomplice and pseudo-husband.

For the people of the fifteenth century, Joseph's activity – drilling holes – would have been more significant than the object itself. This is indicated by the popularity of this motif among painters in the following generations. They repeatedly show Joseph drilling holes in a board in all manner of scenes, from the *Adoration of the Magi* to a portrayal of *Saint Luke*

Fig. 47 Tomb of Johann von Holtzhausen (died 1393) and his wife Gudela (died 1371). Frankfurt am Main, Cathedral

At the feet of the man lies a lion, at the feet of the woman a dog.

Painting the Madonna (fig. 88).[97] In all these scenes, Joseph is portrayed with Mary, and often with the Infant as well, but is invariably separated clearly from them. This indicates that the gesture of drilling holes refers to Joseph's role as a pseudo-husband and that it is to be regarded in a sexual sense as a kind of substitute activity.

The theological significance of the scene shown in the right hand panel is also indicated by the tools at Joseph's feet. They are placed closest to the spectator in a very carefully calculated arrangement. On the left, supported by a little stool, there is a saw, and on the right – in mirror symmetry – an axe and a rod. These, too, are propped up by a piece of wood so that Joseph can reach them more easily. With these three objects, Robert Campin evokes an Old Testament text that must have been familiar to any regular church-goer at the time. In chapter 10 of the Book of Isaiah, the prophet turns to the godless king of Assyria, calling upon him to remember that he is a creature of God and not to rise up against his Lord (Isaiah 10:15): "Shall the axe boast itself against him that heweth therewith? Or shall the saw magnify itself against him that shaketh it? As if the rod should shake itself against them that lift it up, or as if the staff should lift up itself, as if it were not wood."[98]

There is no doubt that Campin, in portraying these specifically mentioned tools, intended them as a reference to man's obligation of obedience towards his Creator. The tools point once again to Joseph's role as a pseudo-husband, a role he was willing to play as an instrument of God so that Christ could become incarnate, borne by a virgin.

A tale of marriage and succession

The moment of the Annunciation in which the angel tells Mary that she is to be the Mother of the Redeemer, is, according to church dogma, also the moment of conception. This notion, widely accepted in the Middle Ages, was the basis for a form of Annunciation that was particularly popular in northern European art in the fifteenth century, and one that was also employed by Campin. It features the tiny, naked figure of Christ, sent by God, flying towards the lap or the ear of the Virgin (fig. 48). As an indication of his mission of redemption Christ often has a little cross on his shoulders.[99]

The Annunciation is also generally interpreted in Bible commentaries as the Betrothal of the Virgin. In the tradition of the Song of Solomon, Christ himself is also occasionally regarded as the groom. However, theologians generally attribute this role to the Holy Ghost. The fact that the Annunciation scene in the Mérode Triptych is also intended as a portrayal of this particular interpretation – the Betrothal of the Virgin with the Holy Ghost, the fruit

of which will be Christ – is indicated by one element in which Campin deviates from the norm. Conventionally, in Annunciation scenes featuring a tiny figure of the Infant Christ, this figure is almost invariably preceded by the dove symbolising the Holy Ghost. In the Mérode Triptych, the dove may be missing, but not the Holy Ghost (fig. 42). Indeed, it plays an active participatory role. In Campin's painting, the Holy Spirit is portrayed as the *flatus Domini* (the breath of the Lord) that has just extinguished the candle on the table, from which a wisp of smoke is rising.[100] The extinction of the candle can also be linked with a custom commonly practised in the Netherlands at that time, in which a contract became valid when the candle lit at the beginning of negotiations was extinguished.[101] This custom is probably also alluded to in the burnt-down candle that can be seen in Jan van Eyck's *Arnolfini* double portrait, which Panofsky interpreted as a marriage ceremony.

The smoking candle shown by Campin has more than just this symbolic narrative meaning. It also pinpoints the scene as a historic turning point and radical transition from one state to another in a manner rarely achieved in painting. What it shows is the replacement of the era of the Old Covenant with the age of the New Covenant.

The patrons

With the aid of the documents in the city archives of Mecheln, Antwerp and Cologne, scholars have recently succeeded in drawing up a complete family tree for the Ymbrechts/Inghelbrechts family in the fifteenth century, outlining the social standing and professional situation of their leading members (fig. 49).[102] In the Mecheln documents, it is interesting to note that only one branch of the family uses the name Inghelbrechts.[103] The specific manner in which Robert Campin has portrayed the Annunciation scene as an *angel having brought* (Engel brachte) the Gospel, suggested that further research should concentrate on this particular branch of the family, especially the brothers Heinrich, Rembolt (or Rombaut) and Peter. All three were merchants.[104]

The documents in the archives of the city of Tournai, as we have already mentioned, record Rembolt's birth in the year 1396. The above mentioned two brothers were also probably born before 1400. Any of them might well have been the man who commissioned the Mérode Triptych. Peter Inghelbrecht is the brother whose name occurs most frequently in the archives of Mecheln. The documents include a detailed will and testament of 1476, the year of his death, in which, although there is no mention of the triptych, we do find the name of Peter's first wife, Margarete Scrynmakers, and the information that she came from

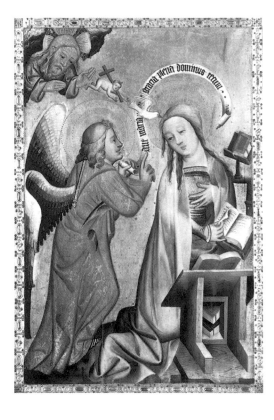

Fig. 48 Master Bertram von Minden, *Annunciation* from the Grabow Altar, c. 1379. Hamburg, Kunsthalle

The figure of the Christ Child with the cross is preceded, as usual, by the dove of the Holy Spirit.

Fig. 49 Family tree of Peter Engelbrecht (according to Installé 1992)

70

Cologne.[105] These two details, together with the observations outlined here on the reworking and iconography of the painting, allow us to reconstruct the early history of the Mérode Triptych. Scrynmakers or Schrinmechers, as the name is recorded in Cologne, is also a canting name meaning 'cabinetmaker'. The discovery of this family name is doubly significant: it explains why the right-hand panel shows Joseph and why he is not presented as a carpenter as he usually is on the basis of the biblical texts, but as a *cabinetmaker*, a craftsman producing finer pieces such as mousetraps and fire-screens. At the same time, it confirms the assumption that the choice of the Annunciation scene for the central panel of the triptych has some relation to the family name of the man.[106]

Further research has shown that Peter Inghelbrecht, too, originally came from Cologne, where he was known as Enghelbrecht. The Enghelbrechts, like the Schrinmechers, were Cologne patricians. The Schrinmechers, in particular, were wealthy and Gretchen (Grietgin), as Peter Englebrecht's wife is referred to in the Cologne documents, brought considerable property with her when she married. The documents indicate that the marriage was solemnised some time between 1425 and early 1428. This tallies precisely with the hitherto accepted dating of the work on stylistic grounds. Dendrochronological dating and the age of the patron also indicate that the triptych was painted around or after 1428.

In his work, the artist reflects on the connection between the two biblical scenes that refer to the names of the patrons. Just as marriage regulates the relationship between a man from the Engelbrecht family and a woman from the Schrinmecher family, the triptych also addresses the relationship between the cabinetmaker Joseph and the Virgin Mary, to whom an angel brings good tidings. It should be noted, however, that although the surname of the woman may point towards Joseph as a craftsman, the reference is indirect. After all, in the fifteenth century, as a rule, the female members of a family took the genitive form of the surname (created by adding an '*s*'). This meant that Gretchen Schrinmechers was not to be identified directly with Joseph (the cabinetmaker = 'Schrinmecher'), but with Mary; for the Virgin, as Joseph's wife, could also very well have taken the name Schrinmecher*s* meaning 'of the cabinetmaker'.

It may be assumed that the triptych was originally intended as a private devotional picture through which the newly weds could address their desire for children to the Virgin Mary. Her immaculate conception had made her the figure to whom such prayers for offspring were directed. In this case, it is quite possible that it was not Peter Engelbrecht himself who actually commissioned the painting but his brother Rombaut or Rembolt, who had close links with Tournai. He may have commissioned the triptych from Robert Campin as a wedding present for his brother in Cologne.

Even if Peter Engelbrecht's first wife Margarethe Schrinmechers was not portrayed beside her husband on the left-hand panel, she was nevertheless present in the triptych through the panel depicting Joseph – at least for those capable of interpreting it. It is also possible that her coat of arms was included next to her husband's in the back window in the central panel over the gold background.[107] But who is the woman we can see today on the left hand panel (fig. 44)? When and why was she added to the picture together with the messenger of the city of Mecheln? Peter Engelbrecht's complex and chequered life can provide the answer.

The life of Peter Engelbrecht

Peter Engelbrecht, son of the Cologne alderman Tielmann Engelbrecht, lived an unusually long and eventful life. He lived to the ripe old age of about eighty, was married three times, and fathered at least thirteen children, nine of them legitimate and four illegitimate. (See family tree, fig. 49). His first wife, Gretchen Schrinmechers, is documented as residing in Cologne in the late autumn of 1456.[108] However, the archives lead us to suppose that, since 1449 at the latest, her husband had been living with one Heylwich Bille of Breda, who was later to become his second wife. Given that the four illegitimate children mentioned in his will of 1476 were living in Cologne at the time, they were probably also born before 1450.

Before the death of Peter Engelbrecht's first wife, a significant event cast its shadow on the family. In 1450, the monk Martin van Zweensberghen was murdered in Cologne, for reasons that can no longer be reconstructed, by two nephews of Peter Engelbrecht, the sons of his sister Margaretha. Subsequently, the murderers, their mother and Peter Engelbrecht were arrested together with the latter's business partner Tierry Helsekamp. Helsekamp was executed and Peter Engelbrecht himself was freed only after the Burgundian Duke Philip the Good and the Bishop Prince of Liège had personally intervened on his behalf. When Peter Engelbrecht's appeal to the imperial court was rejected, he gave up his rights of citizenship of the city of Cologne and moved in 1453 to Mecheln where his brother Rembolt had been trading since 1435.[109]

The young woman whose portrait was added later to the left hand panel together with the messenger of the city of Mecheln is almost certainly Heylwich Bille, the woman mentioned above, whom Peter Engelbrecht must have married shortly after 1456. The new coat of arms (fig. 43) inserted on the central panel over a realistic sky is probably hers.[110]

There is one detail that strongly indicates that the triptych, even after it had been reworked, was still intended to fulfil its original function as a votive painting seeking the blessing of children. The rosebud on the brim of the man's black hat expresses more than just the wearer's esteem for the Virgin Mary.[111] It is also a reference to a child, either wished for or expected, just as the still-closed bud among the three lilies on the central panel (fig. 42) refers to the third divine person, Christ, whose earthly life has just begun.[112]

The bearded messenger of the city of Mecheln – again undoubtedly a portrait – is not easy to identify. Yet whoever had this figure added to the picture was well aware of the original meaning of the triptych. The figure of the city messenger reiterates in earthly form the role of the angel as divine messenger in the Annunciation. With the addition of this figure, the two biblical scenes together and the patrons' wing each feature a couple and a messenger.[113]

There is, however, also a certain loss of meaning involved in the reworking of the triptych: the Joseph scene no longer bears any relationship to the name of the second wife and therefore no longer has any more justification than the conventional one of its biblical significance.

Peter Engelbrecht married a third time when he was about seventy and fathered two more children. By this time the wish for children was clearly no longer central, for he did not have the left hand panel reworked yet again to reflect his new situation. For him, and for his heirs, the triptych had become a memento and soon a work of art cherished above all for its outstanding aesthetic qualities.

Fig. 50 Mecheln, Onze-Lieve-Vrouw-over-de-Dijle. One of six corbels in the burial chapel of Peter Engelbrecht (cf. fig. 51)

The escutcheons and the banderoles of the angels are now void.

Fig. 51 Mecheln, Onze-Lieve-Vrouw-over-de-Dijle. Exterior

The annexe, completed before 1472, housed the burial chapel of Peter Engelbrecht.

A fortnight before his death, on 29 May 1476, at the age of about eighty, Peter Engelbrecht dictated a detailed will and testament in which Lutter Engelbrecht, his youngest son from his marriage with Gretchen Schrinmechers, is particularly singled out. This son was given the task of establishing an unusually generous church endowment for the salvation of his father's soul. Peter Engelbrecht had had a burial chapel built as an annexe to Mecheln's most important Marian church, Onze-Lieve-Vrouw-over-de-Dijle, and it was already completed by 1472 (fig. 51). The chapel dedicated to the Virgin and Saint Peter, the patron saint of the donor, still exists, albeit without its original interior fittings (fig. 50). Every day a specifically ordained chaplain was to read a mass for the soul of Peter Engelbrecht accompanied by nine, but no fewer than six, singers in harmony. Their salaries and the maintenance of the chapel were to be paid for *in perpetuum* out of the revenues from a farming estate near Mecheln. Another unusual and almost demonstratively generous condition was that, on the day of his funeral, three thousand loaves of white bread should be distributed to the needy of the twenty thousand strong city of Mecheln. At the end of his life, as he stated in his will, the merchant was impecunious. It would seem that, apart from a thousand guilders left to his third wife, he had already distributed his entire wealth to the members of his family or to charitable causes. Would it be going too far to deduce from this that, in his old age, he was taking great pains to make good a life that had not always been lived in accordance with the commandments and mores of his religion?

A tale continued by a student

Campin's *Annunciation* altarpiece for Peter Engelbrecht and Gretchen Schrinmechers has had an enormous impact on the history of painting. Its influence, however, has been mainly indirect, via a closely related *Annunciation* (Cat. III.C.1, fig. 54) now housed in the Musées royaux in Brussels. The Brussels painting was intended as a single panel right from the start. Instead of the open door which, in the Mérode Triptych, forms a link with the left hand panel, the Brussels painting shows an aperture through which the spectator can glimpse into a semi-darkened antechamber. Nor does the Brussels *Annunciation* make any reference to private donors. Instead of coats of arms, the two windows in the background bear portrayals of the four great prophets.

A comparison of the two main figures on the central panel of the Mérode Triptych and those of the Brussels *Annunciation* shows that the angels in both are very similar indeed. The portrayals of the Virgin, by

contrast, differ considerably. In the Brussels version, the monotony of the parallel folds and the lack of corporeality results in an artistically much weaker figure. Only in the Mérode Triptych do the angel and Mary possess the same high degree of compositional fluency and – together with Joseph on the right hand panel – evidence of the same authorship. This finding can only be explained by the fact that, in the Brussels *Annunciation*, a less talented painter chose to create the figure of Mary anew, rather than copying it from the Mérode Triptych. The Brussels *Annunciation* is the later of the two works.

There are some significant differences between the two paintings with regard to the objects portrayed. The jug of lilies, and the table on which it is standing, are shown from a slightly different angle, shifted somewhat to the left in the Brussels version. As the bird ornamenting the belly of the jug can now be seen in full, this suggests that the artist did not work solely from the Mérode Triptych. The same Florentine majolica pitcher must have been available as a model to both the painter of the Brussels panel and Campin. In other words, the Brussels version must have been created in the workshop of Robert Campin by a talented student in response to the work of his brilliant master. These two works were not only created in the same workshop, but were actually painted at the same time.

The slightly different angle at which the student portrays the Annunciation is intended to signalise a slight time lapse between the two scenes. The same principle is used by artists in cycles depicting scenes from the childhood of Christ, for example by presenting the Ado-

Fig. 52 Robert Campin, central panel of the Mérode Altarpiece (detail of fig. 42)

ration of the Magi in the same stable as the Nativity scene, but from a different angle (cf. Cat. III.A.1).[114] The Brussels panel is a student's response to his master's artistic discourse. Accordingly, the work does not portray the angel addressing the Virgin, but Mary's response to the angel.

Whereas, in the Mérode Triptych, Mary has not yet noticed the arrival of the angel and the book he has placed on the table – she is still reading her own Old Testament in its cloth cover – the two books have been swapped in the painting by the student: Mary is now reading the new book brought by the angel, and the bag in which it was wrapped is lying at her feet. She has placed the Old Testament back on the table. Her hand is placed at her breast – we now realise why the student had to rework the figure of Mary – indicating that she has received the message of the angel. Finally, the woodcut of Saint Christopher attached to the mantelpiece with sealing wax (fig. 53) shows that the miracle of the incarnation, and with that the advent of a new era, has already taken place: Mary has become the *christophora*, the Bearer of Christ.[115]

The existence of the Brussels *Annunciation* is a most fortunate coincidence for the study of early Netherlandish painting. The systematic manner in which a member of Campin's workshop responds to his master's painting makes this version an invaluable instrument in critically examining the interpretation of the Mérode Triptych. After all, who would have understood the visual syntax of Robert Campin better than his own pupils? The

Fig. 53 *Saint Christopher*, coloured woodcut (unique), early 15th century. Berlin, Staatliche Museen, Kupferstichkabinett

A similar woodcut is affixed with sealing wax to the mantelpiece in the Brussels *Annunciation* (fig. 54). The anachronistic scene of Saint Christopher carrying the Christ Child is a punning reference to Mary after the Immaculate Conception.

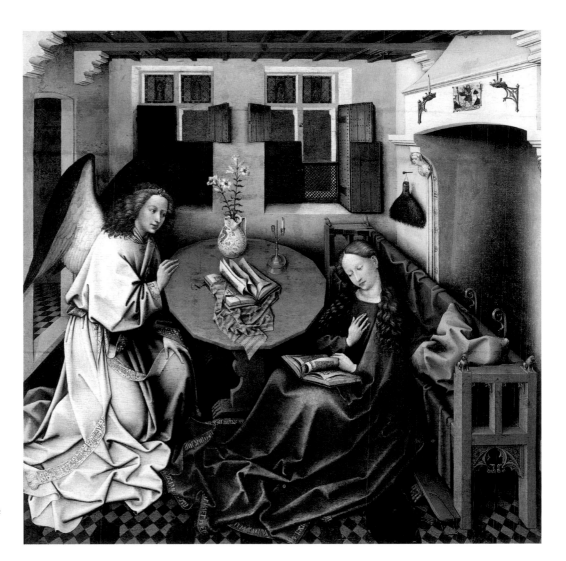

Fig. 54 Master of the Hortus conclusus, *The Annunciation*, 1425–30. Brussels, Musées Royaux des Beaux-Arts

The student presents the Annunciation a moment later, after the Immaculate Conception has occurred. The angle of view, shifted slightly to the left, also indicates the time lapse.

fact that the books have changed places in the two paintings confirms that they are indeed meant to represent the Old and New Testaments. A number of further minor changes made by the artist of the Brussels *Annunciation* also support the theory of a narrative and contextual interpretation of the symbols, such as we have applied above in respect of the Mérode Triptych. For example, the ensemble of water basin and towel has been omitted by the student and another metaphor of purity has been added in the form of a broom hanging by the fireplace. If the fire-screen is missing from the Brussels version, then this can be explained by the fact that it has no significance without the Joseph panel.

A comparison of the Brussels *Annunciation* and the Mérode Triptych permits a remarkably precise insight into the teaching methods that prevailed in Campin's workshop in the form of an artistic dialogue between master and apprentices. In other words, artistic training under Campin was not only a matter of technical instruction, but also an intellectual exercise.

Fig. 55 Jan van Eyck, *Portrait of a Man*, known as *"Timotheos"*, 1432. London, National Gallery

In Jan van Eyck's portraits the sitters face the source of light.

In both the Seilern Triptych and the Mérode Triptych, Campin portrays the donors in the traditional position, kneeling in prayer, on the left-hand panel. Yet he has them communicate directly with the sacred figures, without the conventional intercession of their respective patron saints. In terms of art historical development, the autonomous portrait and the diptych of the married couple follow on from here, with Campin contributing significantly to the emergence of both. Finally, in his study for an altarpiece with the Bearing of the Body to the Sepulchre, *Campin integrates the bourgeois individual into the religious image according to a new formula. Here, the donor is portrayed in the guise of Nicodemus, and can thus participate directly in the divine action. The role portrait may be regarded as the painterly equivalent of the inner participation in biblical events demanded by the religious tracts of the day. For the artist himself, the role portrait provides an opportunity of undertaking a complex character analysis of the individual in question.*

Fig. 56 Robert Campin (copy by a student), *Portrait of a Stout Man*. Madrid, Thyssen-Bornemisza Collection

Forms of Portraiture

Compared with the eight portraits signed by Jan van Eyck or generally ascribed to him, Robert Campin's contribution to early northern European portraiture may seem modest at first glance. Only two comparable works have survived in the original or in the form of copies dating from the same period. But Jan van Eyck's portraits, with one possible exception, were all painted later than Campin's.[116] If we include those portraits that do not conform entirely to the narrow definition established in the nineteenth century, however, Campin's contribution is all the more significant.

Portrait of a Stout Man

If the dating of the original to around 1420 is indeed correct, then the *Portrait of a Stout Man* (Cat. I.5/C; fig. 56) is the oldest known autonomous portrait in early Netherlandish painting of which we have any precise knowledge. None of the proposals offered so far to identify the sitter – Niccolò Strozzi or Robert de Masmimes – is entirely convincing. One indication of the portrait's original function is the fact that it has survived in two versions of more or less equal quality. Both these copies must have been made at a very early stage, either in Campin's own workshop or in the studio of one of his students. We may surmise that the copies were executed for family members, perhaps as mementoes of their father, as is documented in the case of other early Netherlandish portraits.[117]

The Madrid version of the panel has survived in its original red-and-black marbled frame, which surrounds the head unusually closely in this portrait set starkly against a white ground. The apparent physical presence of the figure is heightened by having him turn

away from the source of light so that the cheek, which is the most unstructured part of the face, is lit the strongest. This technique, common to the works of Campin as opposed to those of Jan van Eyck (cf. fig. 55), was regarded by Panofsky as archaic. Yet Campin's formula of portraiture corresponds to the basic tendencies of his aesthetic approach. Moreover, since it continued to be employed by subsequent generations as an alternative to the Eyckian approach of having the sitter look towards the light, it cannot be regarded as outmoded.

Campin further underlines the sense of physical presence by equating the contours and inner forms of the head with elementary geometrical lines and stereometric volumes. In spite of this tendency to stylise, the portrait allowed the artist to undertake a character analysis of the sitter. The complex facial expression of the *Stout Man*, which seems to combine the kind magnanimity of a gentle giant with a sense of profound and long-suffering melancholy, is still capable of touching us today, even at the end of a five hundred years tradition of portrait painting.

The lifelike effect of the portrait, the illusion of being confronted with one of our own kind, is every bit as strong when we look at Campin's painting as it is when we contemplate a portrait by Jan van Eyck, however different they may be. Each wrinkle, each scar, each hair of the chin has been rendered. These are the details that make this a convincing portrayal of a real and unique individual, though we do not know him. In this early portrait by Campin, the art of portraiture has already reached the stage that Jacob Burckhardt and others saw as evidencing the regaining of the category of the individual. As such it is an important document of a genuinely modern world view.

Fig. 57 Robert Campin (copy after), *Barthélemy Alatruye*. Arras, Bibliothèque municipale, Ms 266, f° 282

This drawing and the one now lost, based on the *Portrait of a Woman*, are not based on the same version of the ditpych as the painted copies (figs. 58-59).

Two diptychs

The diptych of the married couple is a form of portraiture that is, perhaps, almost as old as the individual portrait painted on a wooden panel. In it, both individuals, man and woman, are also presented on individual framed panels. However, their portraits are compositionally harmonised with one another. Moreover, the two portraits were generally hinged together.[118]

The oldest known diptych of a married couple can be attributed to Robert Campin (Cat. I.8/C; figs. 58-59). It has survived only in the form of a late sixteenth century copy. The dating 'A° 1425' on the two frames may well have been adopted from the original. Stylistically, at any rate, it may be regarded as reliable. The painted inner frame, bearing what is probably the man's motto *Bien Faire Vaint* (good deeds vanquish), may correspond to the sculpted frame of the original.

The man and the woman, both shown in three-quarter profile, are facing each other. The man occupies the traditional position on the heraldic right (*dexter*), the woman the heraldic left (*sinister*). Both have their hands placed just above the lower edge of the picture, giving the impression that they are resting on the frame. This formula, which treats the picture frame like a window frame, is also employed in the oldest portraits attributable to Jan van Eyck.[119]

Both heads are illuminated from the right, so that the eyes of the man are turned towards the source of light, in contrast to Campin's usual approach in portraiture. It is striking that the bust of the man, like the *Portrait of a Stout Man*, is set against a light background, while the woman is shown against a dark ground. This difference underlines the individuality of the sitters. On the other hand, the man's black chaperon is echoed in the dark ground

Figs. 58-59 Robert Campin (copies after), Portraits of
Barthélemy Alatruye and his wife Marie de Pacy, late
16th century copies after a 1425 original. Tournai,
Musée des Beaux-Arts

of the female portrait, while the woman's white headdress is reiterated in the pale ground of
the male portrait, creating an optical rapport that links the two individuals as a complemen-
tary pair.

The slightly irritating difference in size of the hands may be due to the fact that the
two panels were copied by different artists. The copy of the male portrait is of higher qual-
ity and corresponds precisely to the sculptural and obsessively detailed style of Campin. It is
therefore hardly surprising that Hugo von Tschudi should have regarded it as an original by
the Master of Flémalle himself.

The man, wearing lavish jewellery, a chain, two jewelled rings, a fur-lined mantle and a
chaperon, has unmistakably distinctive facial traits, with a strong jaw-line, thin lips, a rather
long and slightly indented bridge of the nose and strikingly pronounced rings under his
small, alert eyes. The face of the woman, smoothed still further by the copy, seems to pos-
sess less character.

The couple in question are not the individuals named on the frame, but Barthélemy
Alatruye and his wife Marie de Pacy. They were identified with the aid of the collection of
drawings and copies of portraits known as the *Recueil d'Arras* (fig. 57) which included drawn
copies of another, different version of the diptych. Today, only the drawing of the male por-
trait survives.

Barthélemy Alatruye, whose forebears came from the region around Tournai, served
as a high-ranking financial functionary in the *chambre des comptes* at Lille and was a close con-

fidant of the Burgundian ducal house. A document dated 1416/1417 records that at one point the Conte de Charolais, later Philip the Good, Duke of Burgundy, stayed at his home for some time, as did the Conte de Saint Pol, nephew of Philip the Good and later Duke of Brabant.[120] Alatruye belonged to that circle of associates and courtiers around the Duke of Burgundy for whom Jan van Eyck would later act regularly as portraitist.

A second diptych of a married couple has survived in the original. It was probably created slightly later, around 1430 (figs. 60-61) and is traditionally ascribed to the Master of Flémalle. The two heads are facing each other in three quarter profile, this time both set against a dark ground and illuminated by different sources of light. It is striking that the man and the woman are not painted according to the same portrait formula. The hands of the man are not shown, and those of the woman are cropped by the frame. The head of the man is portrayed on a slightly larger scale than that of the woman. Moreover, there are stylistic differences between the two panels, especially in the treatment of the skin.

The woman's face, framed by her white headgear, is stylised according to elementary geometric forms, as is the face of the stout man. The face of the man, however, is more detailed, making the surface seem mutable, as though submerged in flickering light. His eyes seem strangely undetermined and dull compared to the smoothly rounded eyes of the woman. Finally, X-radiography of both panels has revealed clear differences in the employment of oil painting techniques.[121] The two parts of the diptych cannot have been painted by the same artist.[122]

On the other hand, the two panels have precisely the same dimensions; the painted surfaces, too, are of identical size, and the backs of both panels are painted in the same brownish tone.[123] The panels were prepared at the same time and almost certainly painted at the same time. The conclusion to be drawn is obvious: Campin shared the portrait commission with another artist, probably one of his master students.[124]

The findings of technological studies of the female portrait can give us an insight into the working methods of Campin as a portraitist. X-radiography has shown that the physiognomic effect of the face, the contented and slightly mischievous look on the face of the young woman, has been deliberately heightened by the artist using calculated techniques. In the underlying layers of paint, the protruding horn-like sections of the headdress were set lower, on a level with the ears. In the final version, Campin has drawn them higher so that they reiterate the silhouette and line of the eyelids on a larger scale. In other words, Campin made changes to the costume to heighten the mood reflected in the face.[125]

Portraiture and characterisation

The images of patrons and donors in altarpieces and votive pictures gave the artist a further opportunity of painting portraits of living individuals. The figure of the unknown patron on the left hand panel of the Seilern Tripytch (fig. 62) is the oldest surviving portrait by the hand of Robert Campin. The head of the young man is turned just slightly out of profile. His gaze is directed towards the Entombment scene on the central panel. In spite of the characteristic form of the nose, the face is not particularly distinctive. In particular, the ear is painted very schematically. In comparison to the heads of the men in the central panel (cf. fig. 63), the portrait of the patron is remarkably insipid and lacking in expression. Erwin Panofsky assumed that the head of the patron was in fact a later overpainting. Recent tech-

Fig. 60 Student of Robert Campin (Rogier van der Weyden?), *Portrait of a Man*. London, National Gallery

Fig. 61 Robert Campin, *Portrait of a Woman*. London, National Gallery

The portraits of this unknown couple, though different in style and painterly technique, were created around the same time as mutual pendants. Campin probably entrusted the portrait of the man to one of his students.

nological studies, however, have shown that this is not the case. The Seilern Tripytch has survived in its original state. This leaves us with something of a paradox: the character heads in the Entombment scene of the Seilern Triptych (fig. 19) possess a stronger affinity with portraiture than the portrait properly speaking – the head of the patron. In this early work, Campin's imaginary faces seem more individualistic and expressive than his portraits. Each of the four male faces – Christ, Saint John, Joseph of Arimathaea and Nicodemus – is clearly distinguished from each of the others in terms of physiognomy, age, and hairstyle.

The head of Joseph of Arimathaea, with his high, domed bald head and his bushy white beard, is particularly lifelike (fig. 63). The strongly profiled aquiline nose and deeply furrowed brow make the figure seem almost sculptural. Indeed, there is a closer rapport between the imaginary depiction of Joseph of Arimathaea and the *Portrait of a Stout Man* (fig. 56) than there is between the latter and the portrait of the patron in the Seilern Triptych.

This observation allows us to draw certain conclusions regarding Campin's artistic development in the field of portraiture and perhaps even with regard to the beginnings of portraiture in the modern era as such. Faced repeatedly with the task of depicting the same biblical characters, Robert Campin, like other creative painters, developed a repertoire of typical faces based on particularly striking individuals, with traits corresponding in some degree to the deeds described in the biblical texts. In this way, these artists developed a

capacity for a painterly analysis of human characteristics that gave them an increasingly keen analytic eye and painterly versatility. The same skills could then be applied to portraiture in the narrower sense.

However, the ideal portrait was an important factor in Campin's development as an artist, not only at the beginning of his career. Towards the end of his life, the series of ideal portraits of pagan wise men and sibyls (fig. 129 ss), which we shall discuss later, provided an opportunity of exploring new portrait ideas within the freer context of imaginary depiction. Painters of the following generation, including Petrus Christus and Hans Memling, soon adapted these formulae for the portrayal of their contemporaries.

Fig. 62 Robert Campin, Seilern Triptych. Detail of fig. 19: Head of the donor

Fig. 63 Robert Campin, Seilern Triptych. Detail of fig. 19: Head of Joseph of Arimathea

The imaginary portrait of the biblical figure seems much more realistic than the portrait of the donor (fig. 62)

The role portrait

In an essay published in 1931, Max Jakob Friedländer adopted Emile Renders' theory that the Master of Flémalle was in fact Rogier van der Weyden. He illustrated this point with two pictures: the head of Nicodemus in the Madrid *Descent from the Cross* and the Berlin *Portrait of a Stout Man* (fig. 64). Friedländer intended to use this comparison, adopted from Renders, with no further commentary in his text, as a means of pointing out the problems involved in attributing two works of such great painterly similarity to two different artists.

The comparison in question is between two portraits by Campin created at intervals of about ten years. The earlier of the two works is a small individual portrait for private use, while the later one is a role portrait in an altarpiece (fig. 103). The role portrait, which can already be found in classical sculpture and in medieval painting, depicts an iconographically traditional figure in such a way that it can at the same time function as a portrait of another individual by dint of its individualised facial features. In the case of Nicodemus in the Madrid *Descent from the Cross*, the clothing, the fur-trimmed gold brocade mantle and the headwear all indicate that the biblical figure is embodied by a contemporary of the artist.

Thanks to the role portrait, the patron or donor, hitherto depicted on a separate panel, could be involved actively in the biblical events – not only in the mode of a "vision", but in a way that overcomes spatial and temporal distance. It is no mere coincidence that the role portrait is such a regular feature of fifteenth century art, especially in portrayals of the Passion of Christ. Many late medieval tracts recommended that the faithful practice a form of meditation aimed at achieving a kind of inner participation in biblical events. Bearing this in mind, the role portrait may be regarded as precisely the kind of spiritual identification called for by the church and as evidence that the figure in question had achieved this aim. At the same time, the contemporary individual acting in the privileged role of a biblical figure can also serve as a mediating figure, giving other believers easier access to the biblical events portrayed.[126]

The role portrait, if not disregarded entirely, has tended to be dismissed in studies of the history of modern portraiture as an allegedly "impure" form.[127] Yet it deserves greater attention, for it is a complex form based on the individual portrait and may be regarded as taking the art of portraiture a step further. Whereas the individual portrait aims to present the individual as a pure character unaffected by emotions, the figure in the role portrait can be defined, over and above his or her physiognomic traits, as a being capable of passion. The role portrait can give the artist an opportunity of capturing the emotions evoked by participation in the events depicted.

Ideally, the momentary emotions triggered by the narrative context should not be an additional effect but an expression of the character of the individual portrayed. Robert Campin certainly achieved this ideal in his portrait of the donor in the guise of Nicodemus in the panel of the *Descent from the Cross* (fig. 103). The face streaming with tears expresses profound suffering nobly borne. The individual seems to control his emotions through will and strength of character. This self control may also be regarded as indicative of the individual's self-awareness. This would correspond precisely to his role in the scene depicted: the Passion of Christ is not only a call for the donor to empathise, but also to reflect on his own death.

In Campin's painting, the accomplished analysis of character and emotion represent the art of portraiture at its very finest. The head of Nicodemus in the Madrid *Descent from the Cross* may be regarded as one of the most significant contributions to the painterly portrayal of the individual in the fifteenth century.

An Altarpiece with the Bearing of the Body of Christ to the Sepulchre

The drawing in the Louvre showing the *Bearing of the Body of Christ to the Sepulchre*, set within a frame decorated with gothic tracery (Cat. I.10, fig. 65), is one of the most precious drawings to have survived from the early days of Netherlandish painting. In contrast to widespread opinion, it is not a replica of a lost composition by Rogier van der Weyden, but an original design by his teacher Campin. It is a definitive sketch for the compositional structure of a panel that survives today only in copies.

We can tell that this is an original because the pen and ink lines deviate creatively at a number of points from the rough charcoal sketch. For example, some of the heads were originally higher and the tips of the angels' wings carrying the body of Christ next to Joseph of Arimathaea were initially both turned towards the right. In the pen and ink version, they are turned away from each other in mirror symmetry.

In its overall approach, the drawing is thoroughly painterly. The rapidly sketched hatching over the folds and drapes in the

Fig. 64 Max J. Friedländer, "Flémalle-Meister-Dämmerung", Pantheon 1931

In order to show that the head of Nicodemus in the Madrid *Descent from the Cross* (fig. 103) must be by the same artist as the *Portrait of a Stout Man* (cf. fig. 56), the author juxtaposes them.

shadow zones gives each figure its place within a flat pictorial space. Note the hatching that shadows the floor in the centre of the drawing (fig. 67): short, parallel, curved strokes super-imposed like blades of grass. This is precisely the same type of distinctive shading that has been revealed by infrared reflectograms in the underdrawings of the Salting Madonna and the Mérode Triptych (fig. 66). It has not been ascertained in underdrawings of works ascribed to Rogier van der Weyden.[128]

The scene

The Paris drawing depicts an event from the Passion of Christ: the *Bearing of the Body of Christ to the Sepulchre*. For an artist interested in the narrative possibilities of the image, this scene is doubly attractive; marking the moment of transition between the Descent from the Cross and the Entombment, it also points back to the Passion of Christ and forwards to the Resur-rection. At the same time, it allows the artist to explore the complementary aspects of *actio* and *passio* – active deed and passive suffering. Joseph of Arimathaea and Nicodemus, carrying the body with the help of an angel, lead the composition forwards in one direction, while at the same time signalling the painful withdrawal of the Mother of the Redeemer and the fig-ures accompanying her, in an act of final separation from their most dearly beloved. The suf-fering of two of the women is so strong that it creates a *reactio*, or countermovement, within the composition. The Virgin has fallen to her knees and seeks to hold back her son with both arms, while Saint John the Evangelist stands behind her, ready to lend her support. At the opposite side – in mirror symmetry to the Virgin – Mary Magdalene sets a counterpoint with her gaze fixed on the injured feet of Christ that she had washed with her tears and dried with her hair when he was still alive. She, too, has a figure assisting her at the edge of the picture, bearing the ointment jar that is her attribute as the repentant sinner.

The remaining figures, too, are symmetrically arranged around the central axis. The angel on the right corresponds to one of the Marys whose deep pain is reflected in her swooning gesture. Joseph of Arimathaea finds his counterpart in a bearded helper whose hammer and pincers refer to the recent Descent from the Cross. The angels hovering in the upper corners are carrying the *arma Christi* – the crown of thorns and three nails – that represent the sacrificial death of Christ. Campin paints these angels in similar form and comparable composi-tional role in his Entombment scene in the Seilern Triptych (fig. 19).

The symmetrical correlation between the figures on either side of the central axis are primarily compositional equivalents between comparable entities. The figures and their counterparts undertake different and sometimes contrary actions. In terms of content, the apparent equilibrium of the

Fig. 65 Robert Campin, The *Bearing of the Body of Christ to the Sepulchre*, c. 1425. Paris, Musée du Louvre, Cabinet des Dessins

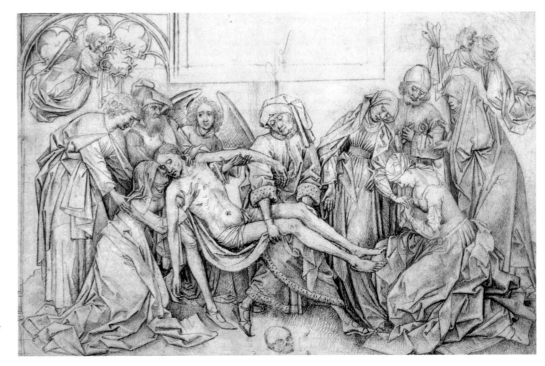

composition is that of a stalemate charged with tension resulting from the insolubly contradictory intentions of the active participants. Campin's composition depicts a moment of indecision described by Ludolph von Sachsen in his *Vita Jesu Christi* as a 'pious dispute' in the *Bearing of the Body of Christ to the Sepulchre*. The dispute is between those seeking to carry the body of Christ away and the Virgin Mary and her retinue who are doing all they can to keep the dead man with them.[129]

Fig. 66 Robert Campin, Mérode Altarpiece, 1425–30, underdrawing (detail of the right wing). According to Asperen de Boer et al.

Fig. 67 Detail of fig. 65

The floor area of the drawing with *The Bearing of the Body of Christ to the Sepulchre* reveals the same characteristic hatching as the underdrawing of individual paintings by Robert Campin. (cf. fig. 66).

Design for an altarpiece

The presence of the large figure of an angel helping the two men mentioned in the Gospel according to Saint John to carry Christ's body to its grave comes as something of a surprise. Suzanne Sulzberger has provided a persuasive explanation for his inclusion in this scene. The reference is to the angel called upon by the faithful at mass after consecration to carry the sacrificial offering to the heavenly altar.[130] The angel of the Eucharist is an indication that Campin's drawing was in fact a design for an altarpiece. The spatial composition correlates closely to that of the Madrid *Descent from the Cross* (fig. 103) – a room of little spatial depth set within a framework of tracery – and strongly suggests that this panel, too, was designed as a painting simulating a polychromed sculptural group in a shrine. The fact that the best painterly copy of Campin's lost panel (fig. 68) has a gold background indicates that the simulated shrine was also gilded in the original painting.

In Campin's design for a retable, Mary Magdalene has an unusually prominent place on the same level as the Virgin Mary and as her mirror image. Her arms raised in supplication reiterate the gesture of the Virgin Mary seeking to retain her son. It may be assumed that this particularly strong emphasis on the figure of Mary Magdalene, which has no basis in Scripture, had to do with the dedication of the altar for which the painting was intended.

Fig. 68 Master of Frankfurt (workshop), copy after the central panel of the altarpiece of *The Bearing of the Body of Christ to the Sepulchre* by Robert Campin, c. 1500. Los Angeles, Paul Getty Museum

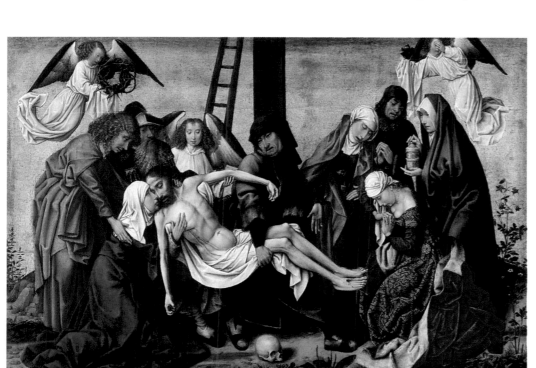

The format of the planned panel with its central recess is also unusual. Fredricksen assumed that it was designed in this way in order to accommodate a window or some other architectural impediment at the site of the altar.[131] It would certainly seem plausible that the altarpiece was intended for a small church room, such as a choir or side chapel, with a low window above the altar, and that the painter had taken this fact into consideration in selecting the format.

Robert Campin's altarpiece with the *Bearing of the Body of Christ to the Sepulchre* was undoubtedly intended to have wing panels. There are two surviving triptychs from the workshop of the Master of Frankfurt which each possess a central panel with a fairly precise copy of the *Bearing of the Body of Christ to the Sepulchre*, at least as far as the actual figures are concerned. The first is a large-scale version that can still be seen on the high altar of the church of Watervliet, while the second is a smaller triptych intended for private worship (fig. 70).[132] Our illustration shows the smaller version, which, though of lesser quality, is the better preserved of the two. As both triptychs show the same scenes with no major differences on the inside and outside of the panels, respectively, it may be assumed that the wings were also designed after Campin's lost altarpiece. The iconographic programme of the two triptychs is perfectly coherent and is closely related to the Seilern Triptych (fig. 19). When opened, the left-hand panel shows the Bearing of the Cross and the right-hand panel shows the Resurrection. Christ is thus depicted in three scenes of the Passion, corresponding to the chronological order of events when read from left to right. The sarcophagus on the right-hand wing defines the destination of the procession on the central panel. When closed, the two wings combine to show a single scene: Christ before Pilate (fig. 70). In this way, the closed altarpiece portrays the moment that introduces the Passion of Christ depicted in the three striking scenes on the inside of the opened altarpiece.[133]

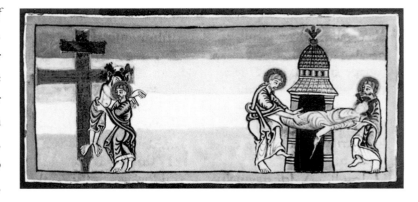

Fig. 69 Descent from the Cross and *The Bearing of the Body of Christ to the Sepulchre*, manuscript illumination, c. 975. Göttingen, Niedersächsische Staats- und Universitätsbibliothek, MR 2° Cod. Ms. theol. 231 Cim, 64r°

The impact of classical antiquity

The Bearing of the Body of Christ to the Sepulchre is a typically eastern Byzantine motif. In the west, the only known examples are to be found in early manuscript illumination. The last of these were created around the year 1000 A.D., more than four hundred years before Robert Campin adopted it anew (cf. fig. 69).[134] It is unlikely that Campin, in composing his work, would have been influenced by Byzantine or early western precursors. In traditional iconography, the body of Christ is already wrapped in winding cloths in this scene and is being carried, head first, by Joseph and Nicodemus.

Campin must have developed his own pictorial version on the basis of texts. Apart from the relevant passages in the gospels and apocryphal texts, his main sources were probably the corresponding scenes from the Passiontide plays and the descriptions of the Bearing of the Body to the Sepulchre that are to be found in the meditative texts on the life of Christ which were so popular during his lifetime, including the *Vita Jesu Christi* by Ludolph von Sachsen, mentioned above.

There was, however, one work of art that was of key importance for Campin's fresh approach to this scene. Art historians have long noted a remarkable proximity between Raphael's *Deposizio Borghese* painted in 1507 (fig. 71) and the drawing of the *Bearing of the Body to the Sepulchre* in Paris. W. Houben has taken this to indicate that Raphael must have had some form of access to the Netherlandish copy in Italy.[135] However, there is no evidence to support this and it is highly unlikely anyway. A far more plausible explanation is that both artists, Robert Campin and, at a later date, Raphael, based their portrayals of this biblical event on one of the many surviving sarcophagus reliefs depicting the *Death of Meleager*.

Fig. 70 Master of Frankfurt (workshop), copy after
The Bearing of the Body to the Sepulchre altarpiece by
Robert Campin, workday and holiday sides, c. 1515.
Lawrence Spencer Museum of Art (Helen F. Spencer
Acquisition Fund), University of Kansas

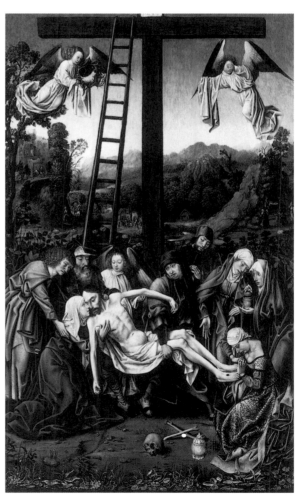

It was again Susanne Sulzberger who first posited the possibility of Campin's knowledge of such a work, illustrating her theory with a sarcophagus housed at the Villa Doria Pamphili (fig. 72).[136] This art historian's theory, which has so far met with little acknowledgement, is better supported by comparison with another antique monument: a fragment of a late Antonine sarcophagus created in Rome and 'restored' – that is to say freely embellished – in the sixteenth century (fig. 73).[137] In its original, fragmentary form, this portrayal of the *Death of Meleager* bears striking similarities with Campin's drawing (fig. 74); the figure on the right holds the body by the thighs, and in both cases the cloth hanging from the body traces a similar curve. Above all, however, the complex position of Campin's dead Christ corresponds precisely to that of the ancient hero: note the angle at which the upper body is tipped towards the viewer, the horizontal position of the left arm, the dangling right arm and, finally – a particularly striking feature – the way the face is turned backwards. As no other surviving portrayal of the scene depicting the *Death of Meleager* bears anything like as many elements in common with the Paris drawing, it would appear that Campin

was familiar with this particular fragment or at least with a closely related work that has since been lost.[138] The clear references to the ancient relief give us sufficient grounds to assume that Robert Campin had visited the Holy City at least twenty five years earlier than his student Rogier van der Weyden and that while he was there he closely studied at least one work of classical antiquity, very probably recording it in a precise drawing.[139]

More significant still than the well founded assumption that this Netherlandish painter travelled to Italy is the fact that Robert Campin should have adopted this pagan scene of mourning at all. In what can only be described as an act of pure Renaissance thinking, he took the theme in its entirety and transposed it to the portrayal of the *Bearing of the Body of Christ to the Sepulchre* some fifty years before Andrea Mantegna and eighty years before Raphael.[140]

Fig. 71 Raphael, *The Bearing of the Body of Christ to the Sepulchre*, 1507. Rome, Galleria Borghese

Fig. 72 *Meleager Sarcophagus* (detail). Rome, Villa Doria Pamphili

Given that he studied the classical work closely, as we may assume he did, it is surprising that Campin should have diverged from it somewhat in his rendering of the nude male body. The body of Christ in the Paris drawing, with its slender limbs, is still very much in the mould of medieval stylistic ideals. We believe that this form of portrayal is the result of a conscious decision by the artist rather than any lack of understanding of the antique work. After all, when Campin later created his Good Thief for the triptych of the *Descent from the Cross* in Bruges (fig. 117), he evidently turned once again to the drawings he had brought back with him from Italy. The only plausible explanation for this particular male nude, unique as it is in the artistic context of northern Europe, is that it is based on a close study of the physical ideal of classical antiquity.[141]

In the role of Nicodemus

In Campin's painting of the *Bearing of the Body to the Sepulchre* (fig. 65), there are only two figures with no counterpart or pendant – a fact that emphasises their importance in the eyes of the spectator. They are the dead Redeemer positioned asymmetrically within the picture space, to which all the remaining figures relate in their actions or expressions of suffering, and the figure of Nicodemus, placed on the central axis. He, too, is integrated within the story as the bearer of the body of Christ; yet his exclusive position in the centre of the composition sets him apart from all the other actors in the scene. Only the fact that he has been placed below the recession in the frame prevents him from taking on a position of too much importance in comparison to the biblical figures.

The costume, too, lends a certain ambivalence to the figure of Nicodemus, for his ermine-trimmed mantle and sendal-bound chaperon identify him at the same time as a member of the Burgundian upper classes of the early fifteenth century. The biblical figure of Nicodemus is in fact a portrait of the donor of the projected painting. By integrating his portrait into the narrative of this sacred scene, he is allowed to participate in the Passion of Christ along with the hallowed figures and biblical characters.[142]

In spite of his broad step, the figure of the donor embodied in Nicodemus is the fulcrum point on which the entire composition rests. The diagonals of his legs are reiterated in the inner contour lines of the adjacent figures, the woman on the left and the angel on his right, and together form a saltire or Saint Andrew's Cross. The centre of this cross is formed by the hands of the donor. His head is inclined backwards, parallel to the head of Christ. The eyes, however, are cast downwards towards the ground. The gaze of the donor falls first upon the wound on Christ's left and then on the skull of Adam, a *memento mori* as symmetrical correspondence and counterpart to his own figure. The reflection on the death of Christ is intended to evoke contemplation of his own death.

By way of preparation, Campin has sketched the central vertical as a notched structural line. This primary structural line in the composition has been mimetically reiterated in a second step as a line of vision in relation to the donor. It is as though the central vertical, running exactly between the eyes of the donor and leading to the skull that is his counterpart, actually penetrates the left hand of Christ on its way.

Fig. 73 Fragment of a sarcophagus with the *Death of Meleager*. Roman, c. AD 180. New York, Metropolitan Museum of Art (Rogers Fund) (without later additions)

Fig. 74 Detail of fig. 65

The alignment of figures in Campin's *The Bearing of the Body of Christ to the Sepulchre* corresponds largely to that of The *Death of Meleager* on the ancient sarcophagus. (Cf. fig. 73).

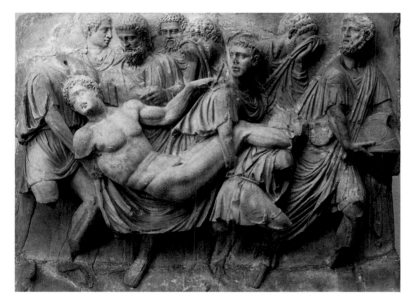

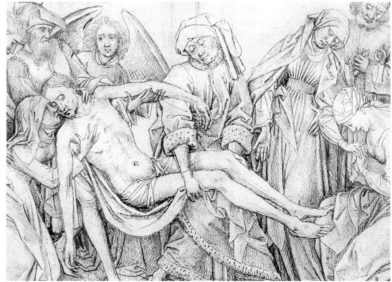

Fig. 75 Robert Campin (copy after), *Barthélemy Alatruye*, dated 1425. Tournai, Musée des Beaux-Arts

Fig. 76 Robert Campin, head of the donor in a study for *The Bearing of the Body to the Sepulchre* altarpiece. Detail of fig. 65

Proposed identification of the donor

As the Paris drawing of the *Bearing of the Body to the Sepulchre* is to be regarded as a late compositional design, it may be assumed that the individualised head of Nicodemus is in fact a portrait sketch of the patron – an abbreviation of the portrait study which Campin surely created with a view to realising the painting. The drawing (fig. 76) shows Nicodemus as a man of about fifty with an expressive face, thin lips, a strong chin and pronounced rings under his eyes. These specific individual traits can all be found in the copy of the portrait of Barthélemy Alatruye (fig. 75). In their overall effect, the two heads – one painted and one drawn – are also similar, in spite of the difference in pose and angle. The clothing is also similar. Is it possible that the donor of the altarpiece designed by Campin in the Paris drawing was Barthélemy Alatruye?

Two singular aspects of the drawing may be taken as possible indications of the original intended location of the altarpiece: the unusual format of the central panel which suggests that it was meant to be placed beneath a low window in a small church room, and the

Fig. 77 Ferdinand-Ignace Malatou, Recueil des anciens tombeaux, épitaphes et sépultures des églises des Pays-Bas [...]. Douai, Bibliothèque municipale, ms. 966, p. 359 (detail)

The parents of Barthélemy Alatruye (cf. fig. 75), Ogier Alatruye (†1425) and Marie Escarpelle (†1424), were buried in the Church of Sainte-Marie-Madeleine near Lille.

unusually prominent position of Mary Magdalene in the composition that might be related to the dedication of the altar. This combination – Barthélemy Alatruye and an altar dedicated to Mary Magdalene in a small church – did in fact exist. In his description of the *Recueil d'Arras*, Louis Quarré-Reybourbon reports that Barthélemy Alatruye's tomb was located in the church of La Madeleine in Lille.[143] Though this statement is not actually correct, it does put us on the right track. Barthélemy himself was not buried in the little parish church that was destroyed in 1708, but his parents, Ogier Alatruye and Marie Escarpelle as well as one of his nephews, Ruffin Alatruye, together with his wife Jeanne de Dons, were buried there. Their epitaphs, together with the dates of their deaths, have been handed down to us in an eighteenth century manuscript in the

Fig. 78 Floor plan of the old Church of Sainte-Marie-Madeleine near Lille. Lille, Archives départementales du Nord

Fig. 79 View of the old Church of Sainte-Marie-Madeleine near Lille. Lille, Archives départementales du Nord

municipal library of Douai (fig. 77).[144] Barthélemy's father, who probably came from the area around Tournai, was a respected citizen of the city of Lille and acted as a magistrate on several occasions. He died on 26 November 1425. Bathélemy's mother Marie Escarpelle had died one and a half years earlier on 8 February 1424. The copies of portraits of their son and their daughter-in-law Marie de Pacy, the originals of which are ascribed to Campin on strong grounds, are dated 1425 (figs. 58-59). This means that Barthélemy, a resident of Lille, had personally been in contact with the painter Robert Campin from the neighbouring town of Tournai around the time that his parents died. Moreover, Campin's design for an altarpiece with the *Bearing of the Body of Christ to the Sepulchre* can also be dated to around 1425 on stylistic grounds.

It is perfectly possible that this respected and wealthy man wished to have additional mass said for his parents in the church where they were buried and that this prompted him to present the church with a new altarpiece. The appearance of the old parish church of La Madeleine near Lille is recorded in one precise floor plan (fig. 78) and one rather less precise view (fig. 79). The entrance of the church was situated beneath the tower on the west side. There was only one altar in the choir, whose flat end wall was probably illuminated by a single window.[145] The tombs of the Alatruye family were located "in a chapel to the left of the choir".

In the Gospel according to Saint John (19:38-42) we can read how Christ's disciple Nicodemus, together with Joseph of Arimathaea, ensured a worthy burial for the Redeemer. His role corresponds precisely to the role that Barthélemy Alatruye may well have taken on in respect of his late parents.[146] Campin's design for the altarpiece with the *Bearing of the Body of Christ to the Sepulchre* is the earliest example of a role portrait of Nicodemus. This was to become remarkably widespread even in Italy right up to the time of Titian, Michelangelo and Tintoretto, probably through the influence of Rogier van der Weyden's painting of the *Entombment* in Florence (fig. 196).[147] If the altarpiece by Robert Campin was in fact commissioned for the church of La Madeleine in Lille on the occasion described above, it would certainly have given the artist reason enough to present the figure of Nicodemus, arranging the burial of Christ, as a role portrait of the donor for the first time.

THE THEOLOGY OF THE SETTING

Between 1425 and 1430, two works were created in which the simulated room is systematically used to convey a specific meaning. One of these is the so-called Salting Madonna or Virgin and Child before a Fire-Screen, *in which the figures are placed within a contemporary setting that makes them more accessible to the believing spectator. In this painting, the fittings and furnishings have also been carefully calculated to illustrate the theological significance of the Incarnation and to portray the central tenets of faith relating to the Passion of Christ as the Son of Man. The other is the Saint Luke Triptych, probably created around 1430 for the altar of the painters' guild of Tournai, which has survived in the form of a replica in a remote rural church in eastern Germany. In this second work, closely related to the Salting Madonna in terms of content, Campin reflects on the function of religious painting as an instrument of mediation between the divine figures and humankind.*

The Virgin and Child before a Fire-Screen

The National Gallery in London possesses the only surviving independent panel of the *Virgin and Child* by Robert Campin (Cat. I.13, fig. 86). It is generally referred to by the name of the last private owner as the Salting Madonna, or as the *Virgin and Child before a Fire-Screen.*[148] In this painting, Campin plays on the dual structure of the image as a two-dimensional plane and a simulated space, placing the round fire-screen behind the head of the Virgin in such a way that it acts as a material substitute for a nimbus.[149] This substitution of the conventional, abstract sign of divinity by an everyday object has long been regarded as a typical example of Campin's interest in achieving the most 'realistic' possible portrayal of the divine.[150]

An everyday scene

The interior is not portrayed as an archaic cell-like room as it is in the Mérode Tripytch (fig. 42), but as a detail or section of a room that can be imagined as continuing further on all sides. It would seem to present the spectator with a familiar scene from everyday life. In a richly furnished room with a tiled floor, we see a young woman, her long hair worn loose, about to nurse her naked infant. She is sitting in front of a settle adorned with lion figures, either on a cushion or a low footstool, which is completely hidden by her fur-lined white mantle with the ornamental border. She is gazing down attentively at her child, who in turn is looking alertly at the spectator.[151] Her left arm is leaning on an opulently carved cupboard. The entire lower half of the picture is dominated by the flowing folds of her robe, whereas the upper body of the woman and child both take up the right-hand side of the picture. This compositional alignment draws the spectator's gaze to the book that is lying open on the settle, on a red and green cushion. At the left-hand side of the picture there is a three-legged stool in front of the window through which we can see a bustling townscape. The sides of the fireplace seem to frame the mother and child. This seemingly casual scene from everyday life is in fact stringently composed.

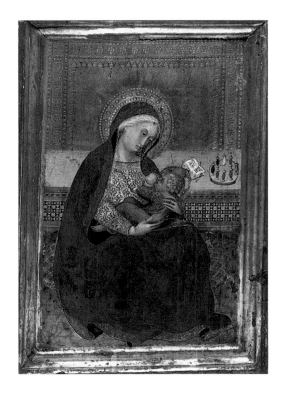

Fig. 80 Benedetto di Bindo, *Madonna humilitatis* (left wing
of a diptych, c. 1430). Philadelphia Museum of Art
(The John G. Johnson Collection)

A domestic setting is evoked by a few elements such as
the settle with the book and spool of yarn. As in Campin
(fig. 86) the Virgin is seated on the ground, nursing the
Infant.

Madonna humilitatis

The foremost feature of the London panel is the humility of the Virgin, as expressed by her
crouching position on the floor. In this respect, the panel is in the tradition of the *Madonna
humilitatis* or Madonna of Humility that was probably introduced by the Sienese artist
Simone Martine in the early fourteenth century (cf. fig. 80).[152] Campin adopts the symbolic
stance of humility, vindicating it further by showing the settle – as he does in the Mérode
Triptych as well – to indicate that the Virgin has deliberately chosen not to sit on it. In the
earliest Italian paintings of this type, the *Madonna dell'umilità* is invariably a *Madonna del
latte*. Campin's Virgin, too, is nursing her child. This is a further indication that Campin, a
Netherlandish painter, did indeed refer in his work to the Italian painting of the previous
century.[153]

Not only the references to a traditional pictorial scheme tell the spectator that this is a
portrayal of the Virgin and Child. The unusually sumptuous, regal robe and the chalice that
can now be seen on the cupboard at the right also indicate a religious context. Admittedly,
the chalice, and indeed the entire right-hand section of the painting for the full width of the
cupboard, is the work of a nineteenth century restorer. This fact, together with certain
painterly inconsistencies in the area where the Madonna's mantle meets the cupboard, have
caused some doubt to be cast on the authenticity of the objects portrayed at the right.
Although there is a copy, now lost, of the Salting Madonna (fig. 81), it cannot be accepted as
firm evidence of the composition's original appearance, for it was probably created after the
work had already been restored in the nineteenth century. Nevertheless, we may assume
that the restorer was able to base his addition on a badly damaged but still legible fragment
of the original. Indeed, so unusual is the chalice with its quatrefoil-shaped rim that this can
more than likely be taken as an indication that the restoration is in fact correct.[154] Moreover,
the tripartite compositional scheme of the work can be placed within a firmly established
pictorial tradition.

Erwin Panofsky regards the portrayal of the chalice, which he interprets as a 'symbol
of the future Passion of Christ', as a relapse into an older and more conventional form of
'open' symbolism that the painter had otherwise put behind him when he adopted the
newer form of 'disguised' symbolism. The new spirit of Campin's symbolism, according to
Panofsky, is reflected not only in the fire-screen but also in the wooden bench behind the
Virgin, which he describes as 'a bourgeois version of the Throne of Solomon' because of
the ornamental figures of two lions adorning the armrest at the side. The symbols Panofsky
mentions – the chalice referring to the Passion of Christ, the fire-screen as halo, the bench as
a 'disguised' portrayal of the Throne of Solomon – do not suffice to provide a coherent
interpretation of the work as a whole. As so often happens when interpretations are based
on the concept of disguised symbolism, the work is taken as an motley amassment of sym-
bols with scant regard for the overall compositional arrangement. Such an approach is
rather like trying to decipher a foreign text word by word with the aid of a dictionary, with
no knowledge of the syntax or grammatical structure.

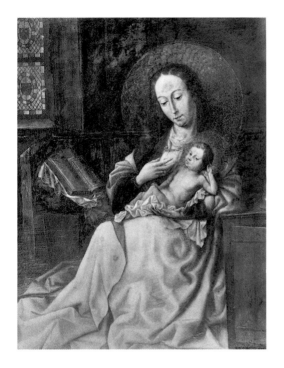

Interpreting the composition

The compositional structure, however, is central to an understanding of the work, as is invariably the case with Campin. For example, the book that Panofsky describes as a bible, giving no further explanation, cannot simply be regarded as an object in its own right. It is placed in mirror symmetry to the Infant Jesus and is a counterpart to the Infant both formally and in terms of content. This is underlined by an additional detail: the chemisette that serves as a cover for the book is made of the same white fabric – delicate and finely draped in tiny folds – as the cloth on which the Virgin has placed the Infant. The analogy goes still further, for the book is supported by the bench and the cushion just as the Infant is cradled by the Virgin. The fact that this formal analogy between the bench and the Virgin is also intended to be regarded as a correspondence in terms of content, is indicated by the traditional interpretation of the Throne of Solomon as a symbol of the Virgin Mary, who is the New Testament's *sedes sapientiae* or 'seat of wisdom'. The book in question is the Old Testament, and the correspondence between the book and the child illustrates the words of the Gospel according to Saint John (1:14): "And the Word was made flesh".[155]

Another equation can be found between the Infant Jesus and the liturgical chalice, which evokes the central words of the Mass: *Hic est enim calix sanguinis mei ...* (this is the chalice of my blood). In other words, the trinity of Book, Infant and Chalice symbolises, in that order, the Old Testament prophecy of the Coming of Christ, the Nativity and the daily sacrifice of the Mass. Reading from left to right, we thus find three eras of the story of salvation presented in chronological order by way of two equations.

Fig. 81 Robert Campin (after), Copy of *Virgin and Child before a Fire-Screen*. Formerly in the possession of Mme Reboux, Roubaix
This copy, now lost, dates probably from the 19th century and is based on the Salting Madonna (fig. 86) in its restored form.

Majestas domini

In his painting of the Virgin and Child, Campin has combined the typology of the *Madonna humilitatis* with a second traditional portrayal – that of the *Majestas Domini* in a specific form known and documented since the thirteenth century in numerous illustrations, missals and books of hours (cf. fig. 83).[156] The *Majestas Domini* is a portrayal of the adult Christ enthroned, holding in his hand the *Evangelium* that bears his message. On a pedestal to his left are the Tablets of the Law symbolising the Old Testament, while the liturgical chalice of the Eucharist is placed to his right. Campin has changed this arrangement slightly, realigning the objects that symbolise the Eucharist and the Old Testament so that they correspond to the spectator's direction of reading, and has replaced the figure of Christ enthroned by the figure of the Madonna of Humility.

The tripartite compositional scheme of the *Majestas Domini* also forms the basis for an early altarpiece by Rogier van der Weyden, of which only fragments survive, though it is documented in a drawing (fig. 82). In this work, the dawn of a new era is expressed by Christ's turning away from the book of the Old Testament, proffered by the standing figure of John the Baptist, and turning to write in the book of the Gospels held by the kneeling figure of Saint John the Evangelist.

In the Salting Madonna, Campin has employed a highly sophisticated compositional arrangement of the spatial environment to

Fig. 82 Rogier van der Weyden (after), partial copy of an altarpiece. Stockholm, Nationalmuseum

The two books between which the Christ Child chooses are references to the Old and New Testaments, respectively, in the same manner as the book and the chalice in the Salting Madonna.

illustrate the different values attached to the two equations. The Old Testament borne by the Throne of Solomon is set slightly further back than the figure of the Infant borne by Mary, the *sedes sapientiae*. The chalice borne by the cupboard, on the other hand, is placed on the same level as the child. The distinction is clear, implying, as it does, an enrichment (corresponding to the typological conceptual pair of Annunciation and Fulfilment) in the transition from the Word of the Old Testament to the Word of Christ, while the spatial equation between the child and the chalice illustrates the doctrine of the real presence of Christ in the Eucharist. The distinction is also echoed in the linguistic difference between the two sentences quoted: *Verbum caro factum est* (present perfect) as opposed to *hic est enim calix sanguinis mei* (present).

Because the chalice and the Infant are closer to the spectator than the Old Testament, the era in which the spectator lives appears as the culmination of the story of God's deeds and Christ's life and suffering portrayed in the painting, and derives its significance from this.

Fig. 83 Jean le Noir, Majestas Domini, c. 1380. Paris, Bibliothèque Nationale, ms. lat. 18014 (Petites Heures du Duc de Berry), fol. 53

In this miniature, the figure of Christ Blessing with the Book (Logos) is flanked by the Tablets of the Law and the Chalice of the Eucharist in reference to the Old and New Testaments respectively.

A votive image

The *Virgin and Child before a Fire-Screen* was intended as a private devotional image for a new form of prayer that had emerged in the late Middle Ages and was characterised by a dialogue between the believer and the divine figure portrayed. As in the Flémalle Panel and in the *Madonna in Half-Length* by Campin, which has survived in the form of an unusually precise early woodcut replica (fig. 84), the Virgin is portrayed as *Maria lactans*, as the mother nursing her infant. This particular portrayal of the Virgin was a popular subject of devotional images because it so clearly underlined her universal human aspect, an aspect that positively predestined this figure for a role as mediator between Christian believers and their God.

It is interesting to note that the Virgin in the Salting Madonna has directed her naked breast towards the spectator, as though to indicate that the sustenance she offers is intended as much for the spectator as for the divine Infant. The painting appears to hint at a form of communication with the Virgin Mary achieved by Saint Bernard of Clairvaux in his *Lactatio* vision when, in response to his prayer to Mary to "show that you are a mother", he received a ray of milk from her breast (fig. 85).

Fig. 84 Robert Campin (after), *Virgin and Child*, woodcut, second half of 15th century, copy after an original of 1425/30. Brunswick, Herzog Anton Ulrich Museum

Fig. 86 (right) Robert Campin, *The Virgin and Child before a Fire-Screen* (Salting Madonna), 1425/30. London, National Gallery

Fig. 85 Master of Zwolle, *The Lactatio Miracle of Saint Bernhard*, 1490. Amsterdam, Rijksmuseum, Rijksprentenkabinet

The view from the window

As a counterpoint to the orientation towards the spectator, the Salting Madonna features a view out of the window into the secular world of the background. The window, towards which most of the orthogonal lines are directed, frames a contemporary townscape seen from an elevated vantage point. In this way, the Virgin Mary's home town of Nazareth is placed in the midst of the spectator's own world, while at the same time remaining at a distance from it. It was Mary's humility that enabled her to become the Mother of the Redeemer, ultimately elevating her above all others. In the miniature study framed by the window we see workmen clambering up a long ladder to repair a roof (fig. 86, det.) in what would appear to be a rather tongue-in-cheek comment on the endeavours of mere mortals to place themselves on a level with the Virgin Mary.

The image of the town seen from the window is also a kind of miniature reiteration of the panel as a whole. At the centre, we can see a gothic church built of white stone with a blue roof. The colours and contours echo the Virgin Mary clad in white and blue garments. Here, in her function as mediator between God and humankind, Mary is equated with *Ecclesia*. It is, to all intents and purposes, the same theological concept visualised by Jan van Eyck in his Berlin *Madonna in a Church*.[157]

The view from the window would appear to tell us the following: by having Mary conceive and bear Christ, God has made his domicile among mankind. It is precisely this concept that is specifically mentioned in the second half of the sentence in the Gospel according to Saint John (John 1:14), the first half of which Campin illustrated in his equation between the Book and the Infant: "and the Word was made flesh, and dwelt among us". It would, however, be inappropriate to regard Campin's *Virgin and Child before a Fire-Screen* as a unique and idiosyncratic pictorial interpretation of this biblical quote. The very fact that Robert Campin rendered one of the central tenets of the Christian faith with such enormous consistency and clarity helped Netherlandish painting in the earliest stages of its development to find a pictorial concept that was to shape artistic practice in the north of Europe for

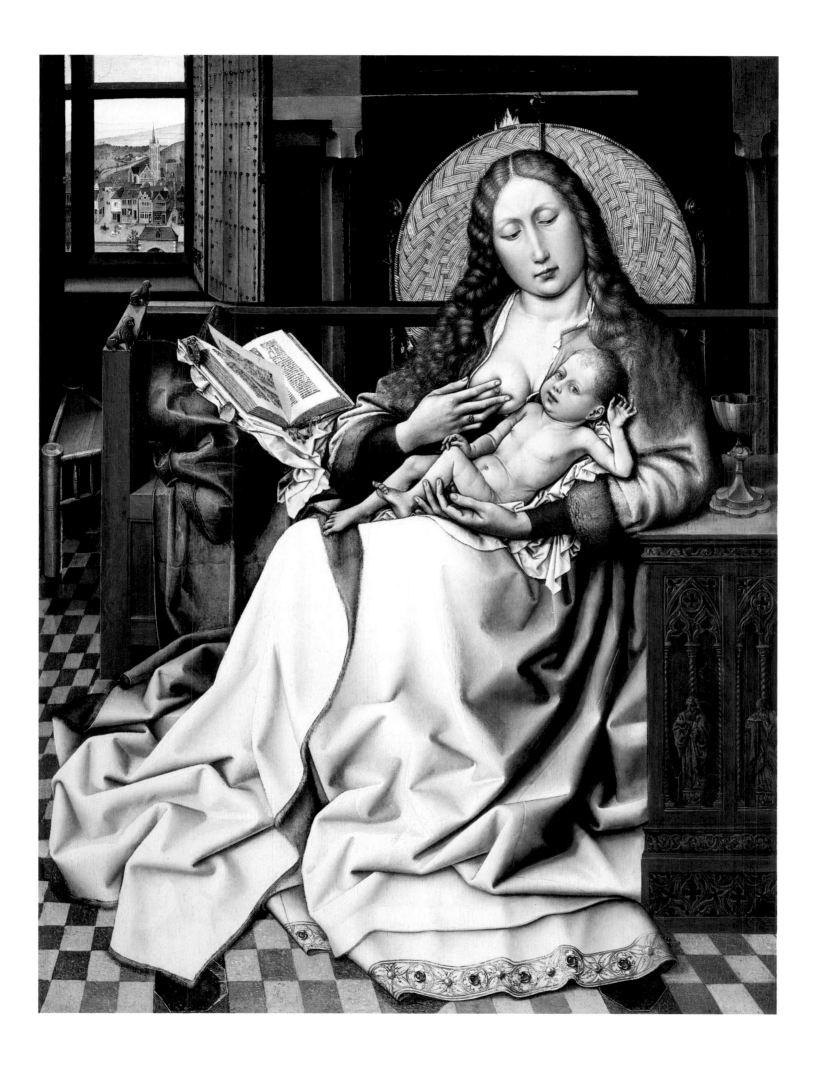

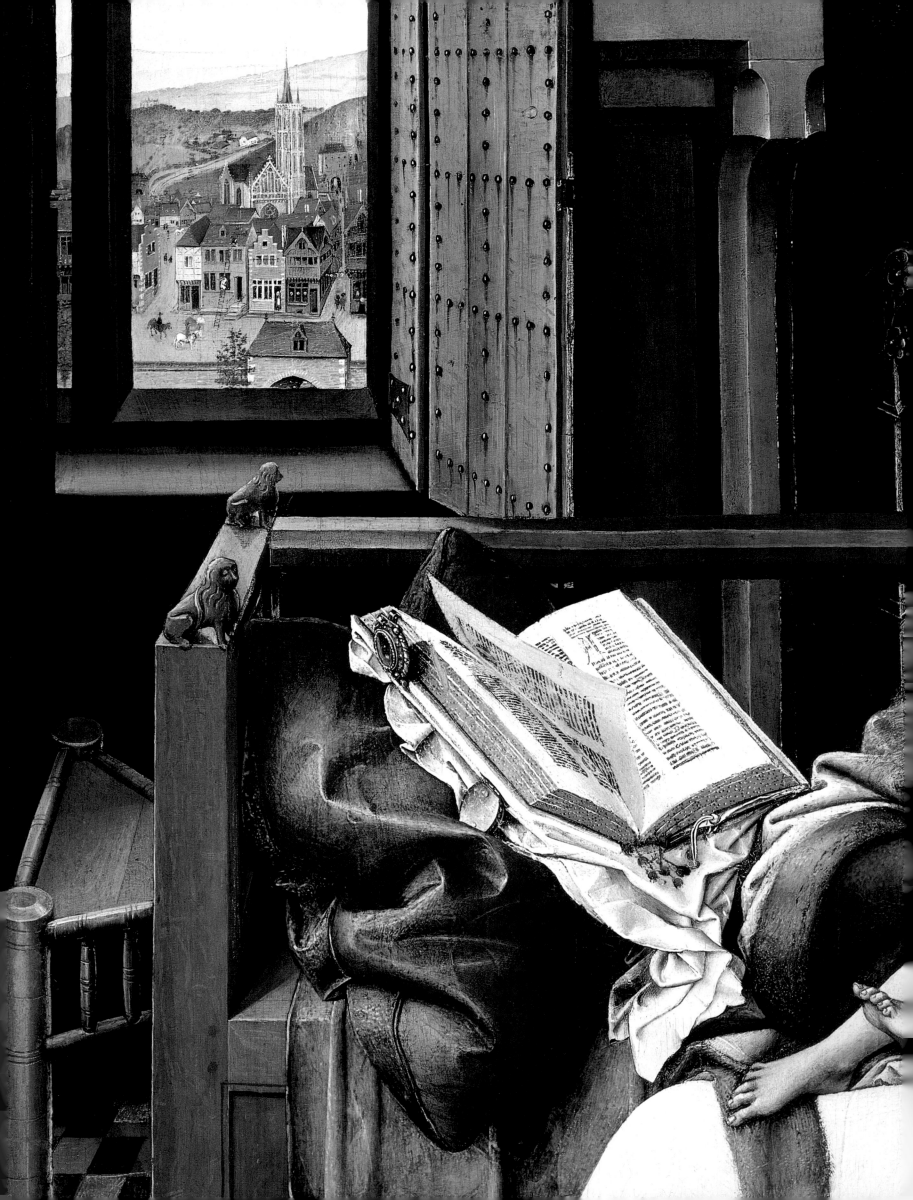

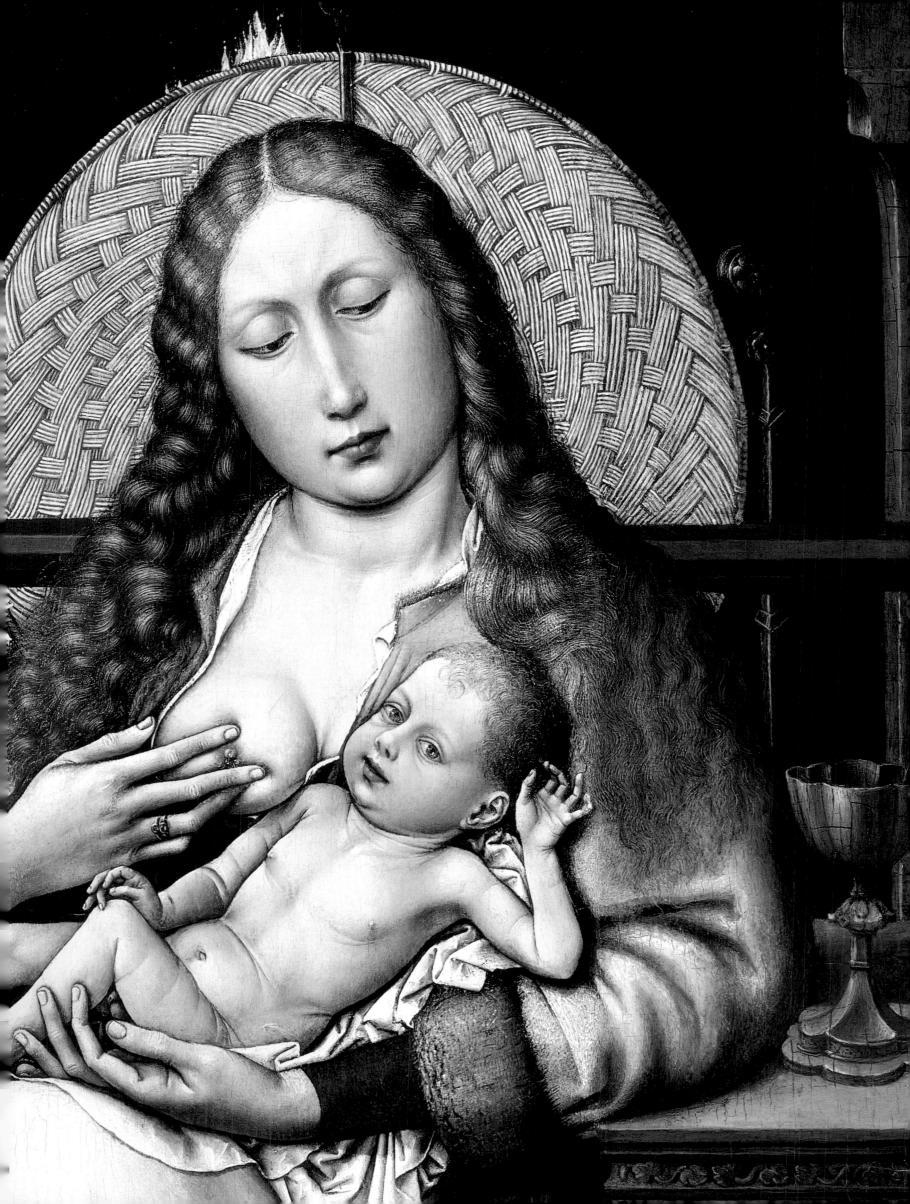

generations to come. In retrospect, the Salting Madonna is an aesthetic manifesto. It is not only an early example of new realistic pictorial practice, but at the same time provides the theological foundation for that practice.

The Saint Luke Altarpiece

The numerous renderings of Saint Luke painting or drawing the Virgin Mary executed in the Netherlands in the course of the fifteenth and sixteenth centuries by leading artists for the altars of their guilds can be classified according to two basic types.[158] Either Saint Luke is seated at an easel facing the mother and child, or he is kneeling before them to capture their features in a preliminary sketch.

The second type featuring the saint kneeling and drawing is represented by Rogier van der Weyden's oil on wood painting of *Saint Luke Drawing the Virgin* (fig. 87). It was very probably Rogier van der Weyden himself who invented this particular type. The oldest Netherlandish version of the earlier type of portrayal, in which the saint is seated at an easel, has not survived. Many scholars have taken a panel dating from the end of the fifteenth century and signed by the Brussels-based artist Colijn de Coter (fig. 88) to be the most faithful rendering of the lost prototype, which they attributed to Robert Campin.[159]

Certainly, a number of elements in Colijn de Coter's rendering of Saint Luke are indeed reminiscent of Campin, most notably the figure of Joseph in the centre ground framed by the doorway, engaged in an activity we have already seen in the Mérode Triptych (fig. 42) – he is drilling holes. Yet this reference alone cannot be taken as firm evidence that Colijn de Coter's painting is a faithful copy of a composition by Campin. On the contrary, it is unlikely that a painter renowned for his extraordinary powers of invention would have quoted himself in this way. Surely Colijn de Coter's painting of Saint Luke is to be regarded instead as an adaptation of Rogier van der Weyden's composition rendered in a deliberately archaic style. Both the format of the picture and the clothing of the main figures in de Coter's painting correspond precisely to Rogier van der Weyden's Saint Luke.[160] Coter achieved a somewhat archaic effect by presenting the painter seated at his easel and by replacing a number of key elements of the original with motifs that are typically Campinesque. To name but a few examples: Rogier's palatial architecture has been replaced by a bourgeois interior, his throne-like brocade curtain by a mantelpiece, and the couple viewed from the rear in the central ground by the figure of Joseph drilling holes.

Two copies from the workshop of Derick Baegert

In a remote rural church in eastern Germany, in the village of Stolzenhain in Brandenburg, a triptych has survived that would appear to have a far stronger claim to being a copy of the frequently postulated painting of Saint Luke by Robert Campin (Cat. I.15/C; fig. 92). The fact that this work was based on a Netherlandish original is evident from the way in which the tripartite structure of the frame appears to be superimposed like a facade over the continuous scene portrayed – an approach that is most unusual in German art. In particular, the complex treatment of the spatial environment and the distinct realism, clearly evident even in a copy, suggest the hand of Campin himself. Finally, there is one firm piece of evidence

that this triptych must indeed be a more or less faithful replica – the surviving fragment of a Netherlandish oakwood sculpture showing Saint Luke at his easel in a form closely related to the painting (fig. 90). Indeed, the style of the drapery must be even closer to Campin's original than in the painted copy.

The *Saint Luke* triptych was created around 1480 in the workshop of Derick Baegert, an artist working in Wesel on the Lower Rhine. He also signed a single panel painting (fig. 89) that corresponds precisely to the central panel of the triptych in format and portrayal, with only a few minor discrepancies. The central panel of the triptych, in accordance with the first type of portrayal, shows Saint Luke seated at his easel. The symbolic ox that is his attribute lies at his feet to the right. Opposite the painter saint, the Virgin Mary clad in a red mantle crouches on the floor in a pose of humility, holding the naked Infant on her lap on a white cloth. The figures of Virgin and Child are repeated to the right of centre, this time against a dark ground, in the finished portrait by Saint Luke.

Until now, the figure of the young man with curly brown hair on the left-hand panel (fig. 92) was something of an enigma.[161] He is seated at his desk, writing on a parchment scroll in the ancient manner. Just as Saint Luke is accompanied by the traditional attribute of the ox, this figure is accompanied by a small dog. His clothing – a red drape over a green robe – also links him with the artist saint of the central panel. The bronze pedestal of the column with the lions of Solomon beside him, however, is a reference to the Old Testament. The key to the young scribe's identity is to be found in the background scene, in which we

Fig. 87 Rogier van der Weyden, *Saint Luke Drawing the Virgin*, 1440–45. Boston, Museum of Fine Arts

Fig. 88 Colijn de Coter, *Saint Luke Painting the Virgin*, c. 1490. Vieure, parish church

see him embarking on a boat journey accompanied by an angel. The young man from the Old Testament can surely be none other than Tobias, however surprising the presence of this particular figure in a composition of the early fifteenth century may seem. In the foreground, he is presumably writing the apocryphal Book of Tobit that relates how he cured his father's blindness.

On the right-hand panel, we see Joseph at a chopping block. He has raised an axe to cut a branch and is being assisted by the boy Jesus dressed in a blue robe. The detailed portrayal of the chopping block indicates an unusually keen perception of everyday things. Each painstaking detail – the bark still clinging to the tree trunk, the way the wood has split without tearing the bark, the wood shavings that have fallen from the branch he is cutting – indicates that the author of the Mérode Triptych (fig. 42) must have provided the basis for this work.

The complexity of the spatial environment

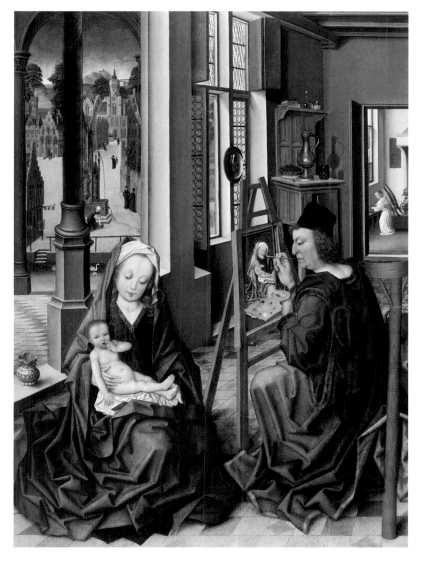

Fig. 89 Derick Baegert, *Saint Luke Painting the Virgin*, c. 1470. Münster, Westfälisches Landesmuseum (on loan from the Westfälischer Kunstverein)

Though the Stolzenhain Triptych is remarkably rich in its complex interweaving of very different spatial registers, this is not an exercise in structural complexity for its own sake,[162] but is precisely calculated to convey a specific meaning. It is unparalleled in Western painting.

Together, the three panels of the triptych form a perspectivally uniform scene, though not a geometrically precisely constructed one. In other words, they show a single room with many exterior and interior views and apertures, with the angle of viewing strongly slanted to the right of the central axis. The orthogonal lines of the room converge in the right hand panel in an area just below the horizon formed by the distant landscape near the outermost gateway arch.

This room, seen from a side angle, and encompassing all the main figures – Joseph and the boy Jesus, Saint Luke the painter, the Virgin and Child, the Prophet – is remarkably composite in character. The left-hand half of the triptych features pillared architecture of a majestic and sacred character, while the right half shows a bourgeois secular interior. In spite of the contrasting architectural forms, the overall spatial impression is harmonious. This seeming uniformity is achieved by a carefully calculated use of stylistic means. The boundary of the room viewed from the right changes gradually as it runs its course from right to left: it begins as the wall of a bourgeois living room with a lozenge-glazed mullioned window, wooden shutters at the top, and oiel-de-bœuf panes below. Then the wall opens up, leading the spectator's gaze into a pillared arcade. There are no windows, and the parapet wall tapers down until it disappears entirely on the left hand panel, becoming a mere trace upon the ground.

The bourgeois half of the triptych, on the right, appears self-contained, because the angle of portrayal has been chosen so that the beamed ceiling fits precisely between the upper right-hand

corner of the triptych and the middle of the central panel. Together, the right-hand panel and the right half of the central panel create a doll's house view in much the same way as the central panel of the Mérode Triptych (fig. 42). The relative self-containment of the right-hand, bourgeois half of the triptych, contrasts with the openness of the majestically magnificent left half. Because the beamed ceiling stretches only as far as the middle of the central panel, at the point where the sacred or regal area begins, the simulated space seems to encroach upon the viewer's space. The picture does not actually reveal the architectural superstructure of the pillars on the left, but this is indicated by the treble arches of the arcade that runs through the centre ground of the left-hand half of the triptych. This same treble arcade lends the open left-hand side of the picture the necessary coherence and provides an optical counterpoint to the bourgeois half.

While the architecture of the sacred or majestic area is structured on the basis of the bourgeois secular architecture, it also transcends it by carrying the structure forward into infinity beyond the borders of the picture at the side and the front, following the structural lines of perspective. This handling of space – going beyond the bounds of the picture plane itself – is unparalleled in northern European painting in the early modern period. Not even in the works of Jan van Eyck, famous for their bold spatial experiments, do we find anything comparable.

The two pillars bearing the left-hand wall in the sacred area stand on different pedestals, each of which has one distinctive part highlighted in gold or brass. It would seem only logical to associate the pillared architecture of the left-hand half with a portrayal of *Ecclesia*, the Church, in the theological sense. Because the left-hand column makes reference to Solomon through the two (of four?) lions on its pedestal, while the right-hand column is situated close to Mary and the child Jesus, we may equate these two different columns with

Fig. 90 Northern Netherlandish(?), *Saint Luke*, oak sculpture, c. 1515. Amsterdam, Rijksmuseum

The position and clothing correspond precisely to the figure of Saint Luke in the paintings from Baegert's workshop (figs. 89 and 92). The drapery style, however, is closer to that of Campin.

Fig. 92 Derick Baegert and workshop, Triptych of Saint Luke, c. 1470. Stolzenhain, Brandenburg, Evangelische Pfarrkirche

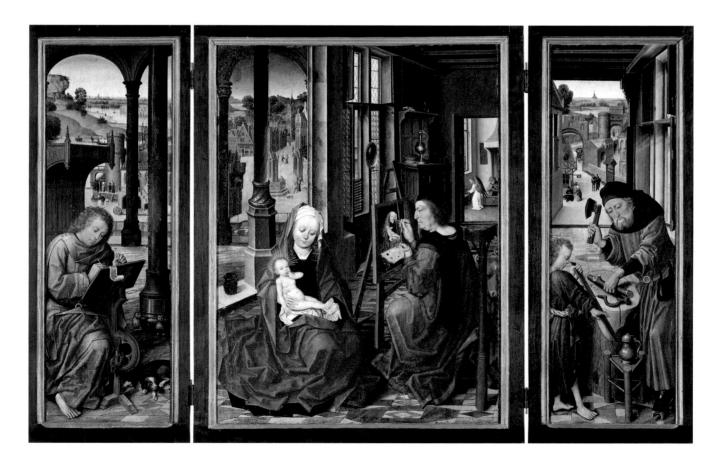

Fig. 91 Master of Frankfurt, *Self Portrait of the Artist with his Wife*, 1496. Antwerpen, Koninklijk museum voor schone kunsten

The ensemble of pewter jug, knopped glass and cherries can also be found in Baegert's triptych of *Saint Luke* (fig. 92), the fly and the vase in his Saint Luke panel (fig. 89).

the Old and New Testaments as the dual pillars of the Church. The hierarchical difference between the eras of the Old Testament and the New Testament is indicated by the fact that the metal plinth of the left hand column is right at the base, while the corresponding feature of the right-hand column is raised on a stylobate.

Looking outwards

Apart from the dual structure of this work according to a sacred, majestic area and a bourgeois, secular area, there is another more subtle subdivision. Each of the four figures and pairs of figures in the foreground is allocated a different view towards the background of the picture. Behind Joseph and the boy Jesus, the back wall of the workshop is completely open, providing direct access to the street along the city ramparts and leading out through the city gate to the right. Behind the figure of Saint Luke the painter, an open door provides a glimpse into a back room where an angel is busy grinding pigments and where Saint Joseph has taken a seat to read by the fire. Behind the Virgin and Child, the archway reveals a view of a city square with a fountain and a church tower. Behind Tobias, we can see the other end of the city ramparts, near the port which opens onto an wide river. These landscape views present three typical aspects of a contemporary city, which, taken together, provide a panoramic survey of the life world left behind by the faithful when they kneel in prayer before the triptych.

The relationship between the main figures and the everyday world takes a different form in each half of the triptych. Whereas the secular right hand area is directly linked with the world of everyday reality through the open back wall of Joseph's workshop, the sacred area on the left is separated from it by an empty antechamber and by the waterway running behind the pillared terrace. By a countermovement, the sacred realm of the left half of the picture is more strongly oriented towards the actual space of the spectator, which is to be identified with the interior of the church.

Two against three

In analysing the spatial structure, we have so far examined only the order of the world portrayed. Yet this world interacts in a complex contrapuntal way with the structure of the triptych itself. The frame of the triptych is placed in front of a coherently simulated space that is subdivided into two distinct and very different areas. The interaction of dual and treble rhythms is of great importance in interpreting this work. The framework of the triptych emphasises the hierarchical predominance of the central panel as a place where the two contrasting areas, the sacred and the secular, meet and interact. The wing panels on either side each represent an unadulterated version of their respective realms of meaning.

The theme of mediation in the central panel is the main theme of the triptych. In the encounter between Saint Luke the painter and the Virgin and Child, the earthly and the divine meet. In Campin's Saint Luke Altarpiece, represented by the Stolzenhain copy, the process of painting – underpinned by the dynamic flight of perspective towards the right – is interpreted as a dynamic act of transition in which the divine world enters the secular world. It is first and foremost the eye of the painter, rather than the hand, that plays the decisive role as an instrument of transformation: the finished painting showing the *Madonna*

humilitatis in full length on Saint Luke's easel appears as a precise, scaled-down portrayal of the 'real' Madonna before him, even though the picture is set at an angle. The eye of the painter is the point at which the lines of the picture converge, bringing together the pairs of correspondences in the reality portrayed and the painting portrayed. As Géza Jászai has noted, the instrument of mimesis by which the original and the image refer systematically to one another thus provides the spectator with proof of the authenticity of the devotional image, thereby becoming "a *demonstratio sacra* of the creation of the true image (of Christ and of Mary)".[163]

The triptych form with its hierarchically and thematically contrasting areas invites us to consider the relationship between the figures on the three panels. For example, there is a translaterally symmetrical correspondence between the figure of Saint Luke seated at his easel with his head thrust forward attentively, and that of Joseph the carpenter standing bent over his work. Both have adopted a very similar position of arms and hands in their work. Both are allocated to the same secular area of the painting and both, carpenter and painter alike, belong to the world of craftsmen. Like Luke, Joseph is not alone at his work. He too has Christ as his opposite number, albeit now as his young helper handing him the yardstick by which to measure the rough piece of wood he is working at. In this scene, which is also portrayed in a wooden sculpture of the Holy Family from the third quarter of the fifteenth century (fig. 93), the boy Jesus appears to embody the complex role of the Son of Man willingly apprenticed to his earthly father and the *deus faber* putting worldly things into proportion.

At the same time, Saint Luke the painter is linked with the Old Testament scribe on the left hand panel. The two are seated at almost the same distance from the Madonna, in mirror symmetry, facing each other. Both are working – one with pen and knife, the other with brush, palette and maulstick – at a rectangular wooden panel placed horizontally or vertically, respectively, in front of them. Like Luke, Tobias was also entrusted with the task of mediating divinity to mankind. Yet unlike the painter Saint Luke, the Old Testament scribe does not need a physical opposite as his 'model'. Seated within the sacred space, he is listening to the voice of God and writing directly what he has heard. The painter, on the other hand, lives in a secular world and is surrounded by scenes of daily life. Nevertheless, he is by no means inferior to the promulgator of the divine Word. For only he is able to translate the divine into a visible presence for the world of humankind. The devotional image itself is very much a part of the secular world, though its origins and points of reference lie in the realms of the divine.

A definition of painting

This definition of the function of the religious image, which may be regarded as the central statement of the triptych, goes hand in hand with a commentary on the essence of painting formulated by painterly means: directly behind and above the easel bearing the framed panel as a product of the painter, Campin has portrayed a convex mirror hanging on a half-open window (fig. 92). The window and the mirror, if we regard them as metaphors of the picture below them, provide a double, complementary definition of the art of painting: the painted image is like an open window on the world, and yet, at the same time, like a mirror, it can imitate the world within the close confines of a framed space.

Fig. 93 Netherlandish, *The Holy Family*, oak sculpture, second half of the 15th century. Utrecht, Rijksmuseum Het Catharjinekonvent

Fig. 94 Tournai, Church of Saint Pierre (destroyed). Elevation and section after Bozière. (Cf. fig. 2)

In 1420, the painters' guild of Tournai moved its altar to the parish church of the artist Robert Campin. The church was demolished in 1821.

The two rows of objects displayed on the sideboard above the painter's head probably point to the two professions of the Evangelist. The filled glass carafe between a casket and books on the upper shelf probably refers to the art of the physician, while the elegantly long-stemmed wine pitcher between a green glass decorated with knops and a basket of cherries on the lower shelf would seem to point towards painting. In the single Münster panel signed by Baegert, the artist has added a trompe-l'œil fly alongside the cherries. The Master of Frankfurt, who was active in Antwerp, also painted a self portrait with his wife (fig. 91) in which the fly appears together with the cherries and the same wine pitcher under the sign of Saint Luke.[164] These parallels in a Netherlandish work would indicate that the original from which Baegert made his copy, that is to say the triptych painted by Campin, also included a fly as a demonstration of painterly supremacy.[165]

Symbolic meaning

Just as the objects in the living room of the Holy Family behind the painter and his easel serve to comment on the essence of painting as such, so too are the objects and architectural features behind the Virgin akin to a symbolic commentary on her role as the Virgin Mother of the Redeemer (fig. 97). The church with its soaring tower underlines the significance of the columns as already discussed above. On the square in front of the church there is a Gothic fountain adorned with strange figures. Above the corner columns of the lower part, there are gilded male figures in armour who appear to be urinating and directing rays of water into the fountain in this manner. A fountain from the thirteenth century with just such a feature has survived in Lacaune in the south of France (fig. 95). Moreover, an *Annunciation* by the Master of Sainte Gudule (fig. 96), active in Brussels, indicates that such fountain figures must have existed in northern Europe long before the *Manneken-Pis*. In this work by the Master of Sainte Gudule, Joseph casts a stern glance at the fountain with the urinating figures as he leaves the pregnant Mary, indicating that this motif was regarded by contemporaries as a symbol of fertility. The white swan swimming on the waterway in Campin's composition next to the head of the Virgin Mary may be regarded as an allusion to Mary's virginal purity and, with that, as a necessary annotation to this notion of fertility.

The swan appears on the right-hand panel (fig. 92) a second time, this time in an entirely secular function. There, it can be found on the sign of a tavern below which a maid is serving a jug of wine to a man dressed in black. Like the swan, the jug also appears a second time, this time in the foreground of the same panel. The example of

the two wine jugs shows that it is not the individual objects themselves that possess a symbolic significance. Instead, they achieve their significance only through their inclusion within a specific context. The wine jug in the foreground has been removed from its everyday pragmatic context and is presented to the spectator as an object of reflection. The fact that the jug is set on a three legged stool and the fact that the boy Jesus is pointing towards it with the yardstick would indicate that it is to be understood here as a reference to the Eucharist.

If we summarise the significative elements of the triptych and the three panels as read from left to right, we find that they represent three eras of the story of salvation. The left-hand wing with Tobias seated beside the pillar of Solomon indicates the era of the Old Testament in which God was accessible to the faithful only through the Word, while the central panel shows the Son of God incarnate seated on the lap of his mother and both of them being captured for posterity in a painting by their contemporary, Saint Luke, while the right-hand wing contains a symbolic reference to the Eucharist in which Christ is present for the faithful contemporary spectator. It is the same complex iconographic concept on which Campin's *Virgin and Child before a Fire-Screen* is also based.

Tracing the location of the original

It seems likely that the lost triptych of Saint Luke by Robert Campin, which we believe to have been the original on which Baegert's workshop copy was based, was created for the altar of the Guild of Saint Luke in Tournai, of which Campin was undoubtedly the most prominent member for many years. Initially, the guild of painters and goldsmiths had its chapel in the cathedral, but the altar was later transferred in 1422 to the parish church of Saint Pierre, which Campin had been attending since 1420, and it may be assumed that Campin himself had urged this move.[166]

The church of Saint Pierre (figs. 2, 94) was a small, three-aisled building with a transept, erected in the twelfth century on older foundations and demolished in 1821 in the course of urban redevelopment. The columned architecture that features in the left half of the triptych would correspond to this church. In a Romanesque church, the spatial structure portrayed in the painting would be continued beyond the frame by the actual round arches of the architecture in which it was set. In this way, the church interior would appear as a continuation of the painted *Ecclesia* supported by the pillars of the Old and New Testament, in which the painter chose to set the Virgin Mary and the Old Testament scribe. Finally, the strongly angled viewpoint of this painting, with the focus shifted to the right, suggests that Campin's Saint Luke Triptych was originally intended for an altar situated in a left hand side chapel parallel to the high altar, where it would be seen at a sharp angle from the central aisle.

Of course, these reflections on the original site of Robert Campin's lost original are somewhat speculative, for we cannot dismiss the possibility that the painter may have created the triptych – as later artists are known to have done – for another guild.[167] Nor is the view of the town in the background of the picture an entirely reliable indication of its original location. After all, we do not know whether it was intended as a portrait of a real town, and even if it was, to what extent Baegert and the members of his workshop may have changed this particular part of the original.[168]

A high point in Campin's artistic career is marked by the creation, around 1430, of two altarpieces depicting scenes from the Passion of Christ. In one of these, a Descent from the Cross *for the chapel of the guild of crossbowmen of Louvain, Campin further develops the compositional approach he had already used some five years previously for his altarpiece with the* Bearing of the Body to the Sepulchre. *We propose the thesis that the three Flémalle panels in the Städel in Frankfurt originally belonged to the* Descent from the Cross *that is now in the Prado in Madrid. A photographic reconstruction of the ensemble gives us an idea of how one of Campin's masterworks originally looked. The second altarpiece, a* Descent from the Cross *created for a church in Bruges, no longer survives, but for a fragment of the right wing, featuring the* Good Thief, *now in the Städel in Frankfurt. This unusual nude portrayal is further evidence of Campin's close study of the sculpture of classical antiquity.*

The Altarpiece of the Louvain Guild of Crossbowmen

The Madrid *Descent from the Cross* (Cat. I.17; fig. 103), one of those epoch-making works that is included in virtually every universal history of art, is almost invariably regarded as a well documented and even unequivocally 'authenticated' work by Rogier van der Weyden.[169] A survey of early documents reveals that this *Descent from the Cross* has been regularly mentioned since the mid-sixteenth century and that it was indeed attributed to a painter by the name of Rogier as early as 1565. But what is the significance of these documents in terms of a modern critique of sources?

'M. Rogerii Belgae inuentum' – the inventor invented

The earliest mention of the *Descent from the Cross* is to be found in a printed report of a journey to the Netherlands undertaken by the treasurer Vicente Alvárez in the company of the future king Philip II of Spain in 1548. In the course of their journey, the princely cortège visited the Palace of Binche which was then the residence of Queen Mary of Hungary, the Spanish stadholder. In the description of the palace rooms, the chapel is mentioned as containing an altarpiece showing the Descent from the Cross. The author describes the altarpiece as "the best piece in the entire palace and even, I believe, in the entire world. For I have seen many good pictures in these parts, but none that was painted could rival it in naturalness and piety. This opinion was shared by all who saw it. The altarpiece, I am told, was painted more that 150 years ago and was originally in Louvain. Queen Mary had it brought from there and donated in its stead an almost equally good copy painted precisely after the original by the hand of a good painter, though not quite so good."[170]

The fact that the work he describes is the very painting now in Madrid is evident from a further remark by Molanus, which will be discussed later, confirming the origins of the altarpiece. Let us bear in mind for a moment that Alvárez' anonymous source was remarkably well informed, being able not only to specify the original location, but also to give a fairly precise dating of the work. However, there is no mention of the artist who created it. It is unlikely that Vicente Alvárez would have failed to mention the name of the artist who

previously, probably for the Church of Sainte-Marie-Madeleine in Lille (fig. 100). In the Altarpiece of the Louvain Guild of Crossbowmen, the figure of Nicodemus is also the portrait of a real person (fig. 102). The donor must have been a respected member of the guild of crossbowmen.[181] It was probably this donor who requested that the work be in a similar vein to Campin's altarpiece with the *Bearing of the Body to the Sepulchre*.

The two main differences compared to the earlier version may be regarded as adaptations related to the intended location of the altarpiece. The chapel in Louvain was spacious enough to accommodate the conventional form of altarpiece with an elevation in the middle of its central panel. The new dedication meant that the Virgin Mary had to be given a particular emphasis alongside the figure of Christ, while Mary Magdalene was to play a lesser role. Without the elevations at the side featuring the two hovering angels, the ten figures from the earlier version remained – the eight mentioned in the bible, and two helpers. Campin placed the cross in the elevated central zone. The inclusion of the cross meant that not only the Bearing of the Body, but also the final stage of the Deposition could be portrayed. For this reason, the conventional description of this painting as a 'Descent from the Cross', which we will continue to use here for reasons of convenience, is not entirely accurate.

The group of two figures bearing the body of Christ is moved further to the right than in the earlier version, so that Christ now occupies the central area which is further emphasised by the elevation. The young helper on the ladder replaces the figure of the large angel in the earlier version. Over his red and green *mi-parti* he is wearing a sumptuous white mantle, which additionally confers upon him the role of a deacon within the sacred scene. Mary Magdalene is now shown standing, but with the same arm position. This makes her a counterpart to the figure of Saint John, who has retained his position and stance in the picture. The other two women have been moved to the left.

The most important change involves the figure of the Virgin Mary. She is now emphasised by her position parallel to the body of Christ. The figure of the Mother of Christ sinking to the ground, supported by Saint John the Evangelist and one of the women, involuntarily echoes the figure of the dead Christ.

Compared to the central panel of the altarpiece with the *Bearing of the Body to the Sepulchre*, the overall appearance of the Louvain painting is even more impressive, yet at the same time, because of its less obvious symmetries, more natural. The unusual density of the compositional structure makes this one of the most important examples of narrative painting in northern Europe.

Simulated sculpture – tableau vivant

Campin has adopted one element in particular from the earlier altarpiece: the Passion scene is rendered as a sculptural group set in

Fig. 99 Louvain, street plan (detail)

The church of the guild of crossbowmen, Onze-Lieve-Vrouwe-van-Ginderbuiten (Nr. 18), was situated outside the old city walls.

Fig. 100 Robert Campin, *The Bearing of the Body to the Sepulchre*, c. 1425. Paris, Musée du Louvre, Cabinet des Dessins

The Altarpiece of the Louvain Guild of Crossbowmen (figs. 102, 103) proves a further development of this composition.

Fig. 101 Louvain, Onze-Lieve-Vrouwe-van-Ginderbuiten. Brussels, Bibliothèque royale Albert Ier, ms. II 2123, fol. 209r

The gothic church was demolished in 1798. For the high altar of this church Campin created a retable around 1430, the central panel of which is now in the Prado (fig. 102s).

Fig. 102 Robert Campin, *The Descent from the Cross*, c. 1430. Madrid, Prado

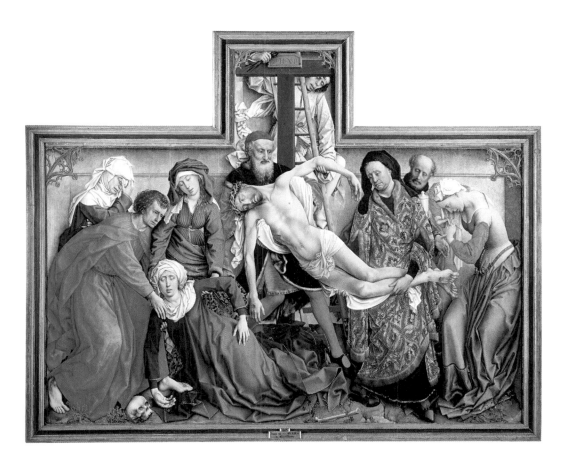

a shrine. The significance of this indirect form of portrayal can be examined more easily in the second version, which has survived in the original.

At first glance, Campin's painting (figs. 102, 103) would appear to be an economical but effective substitute for the most lavish form of retable of the time – a group of figures created by a sculptor and polychromed by a painter. The very fact that a painter should execute the part normally reserved for the sculptor must have seemed like a provocation in a late medieval guild system governed by strict regulations and voluntary courtesy. Even if it did not mean that a sculptor had been deprived of work, it suddenly made him seem dispensable.

The aesthetic implications of Campin's act are more important still. His trompe l'œil rendering of the human body in what appears to be three dimensions was one of the great achievements of Netherlandish ars nova in the early fifteenth century. Campin was able to display this new painterly strength in the two simulated shrine retables. This indirect form of portayal is an example of painted art theory, proof *avant la lettre* for the phenomenon of the *paragone*, the competition between the arts, that was to become a favourite theme of Italian art theory.

This indirect form of mimesis also has its advantages with regard to the specific task in hand, for it permits the painter to form a narrative scene without the deficits normally associated with artistic mimesis. He is not obliged to imitate life through the immobile and inanimate medium of the painting. The thing he claims to portray is already art and as such is removed from life. This justifies the immobility of the painterly approach.

Yet there is more to it still. When a polychromed group of sculptures is imitated by the medium of fine painting, something unexpected happens. Paradoxically, the simulated figures of wood or stone appear more life-like than polychromed sculptures, in spite of the enclosing shrine. Indeed, they appear like a group of real people suddenly frozen in midmovement. The portrayal possesses precisely the qualities that has always made the *tableau vivant* (a picture posed by live models) so popular throughout the centuries, not least of all in the fifteenth-century Netherlands.[182] The moment captured appears to sublate the narration as a trace of the past and an indication of the future.

It is interesting to note that, in the second altarpiece, the artist has presented unstable 'transitional' movements. The

swooning Virgin is still falling, the robe of Saint John still fluttering as he rushes to her aid. Nicodemus, following the direction of movement of Saint Peter's gesturing hand, turns slightly to avoid colliding with the figure of the mourning Mary Magdalene and steps on the hem of her robe as he does so, pulling the fabric downwards. The 'instability' of this composition, so often criticised in older literature, was entirely intentional: Campin's sculpture, executed with a painterly approach, seems like a group of biblical figures frozen in action.

Suffering and piety

The tearstained face of Nicodemus marks a solitary apex in the early history of European portraiture. Yet the portrait of an individual cast in the role of some other figure (recognised as early as 1928 by August Schmarsow) has been more or less neglected in the shadow of the autonomous portrait.[183] The face of the donor is touched by profound emotion. The expression of deep mourning is informed by the extraordinarily complex structure of perception in this picture. The donor's gaze follows a downward diagonal line that culminates in a counter-image of himself in the form of the skull of Adam, whose empty eye sockets stare back eerily as a *memento mori*. Yet the skull is only the last object in the line that runs downwards from the donor's eyes. In the Altarpiece of the Louvain Guild of Crossbowmen, Campin adopts the approach of multiple perception first documented in the altarpiece with the *Bearing of the Body to the Sepulchre* (fig. 100) and develops it further. In this portrayal of the *Descent from the Cross*, the donor's gaze falls upon not one but both of Christ's pierced hands, as well as on the hands of the Virgin.

The major diagonal is the main compositional line in terms of both structure and content. Along this line, the body of the Virgin appears to mirror the body of the dead Christ, thereby elucidating the notion of the *compassio Mariae* as the perfect echo of the *passio Christi*, in keeping with the prevailing theology of the day.[184] Moreover, by employing the compositional line underlying the *compassio* motif as the line of sight of the donor, any spectator can adopt the position of the donor and empathetically experience the passion scene with respect to personal salvation.

The piercing gaze

The unusual portrayal has its origins in the text of the bible. In the Gospel according to St John, the description of the Passion of Christ culminates with a reference to two passages in the Old Testament (Exodus 12:46 and Zechariah 12:10) which are interpreted as fulfilled by the Crucifixion. "For these things were done, that the scripture should be fulfilled. A bone of him shall not be broken. / And again another scripture saith, They shall look on him whom they pierced." (John 19:36, 37) This is followed by the information that Joseph of Arimathaea approached Pilate for permission to remove the body of Jesus from the cross and that he and Nicodemus placed the body in a sepulchre.

In the Vulgate, the second Old Testament quotation is so literally translated from the Greek that its form is, strictly speaking, grammatically incorrect: *videbunt in quem transfixerunt*. In this light, Campin's portrayal of the Crucifixion appears to capture the gaze of Nicodemus, which not only concentrates on the body of Christ, but actually goes *through* the wounds on Christ's hands, as though in a bid to translate the passage from Zechariah

Fig. 103 Robert Campin, *The Descent from the Cross*, c. 1430. Madrid, Prado

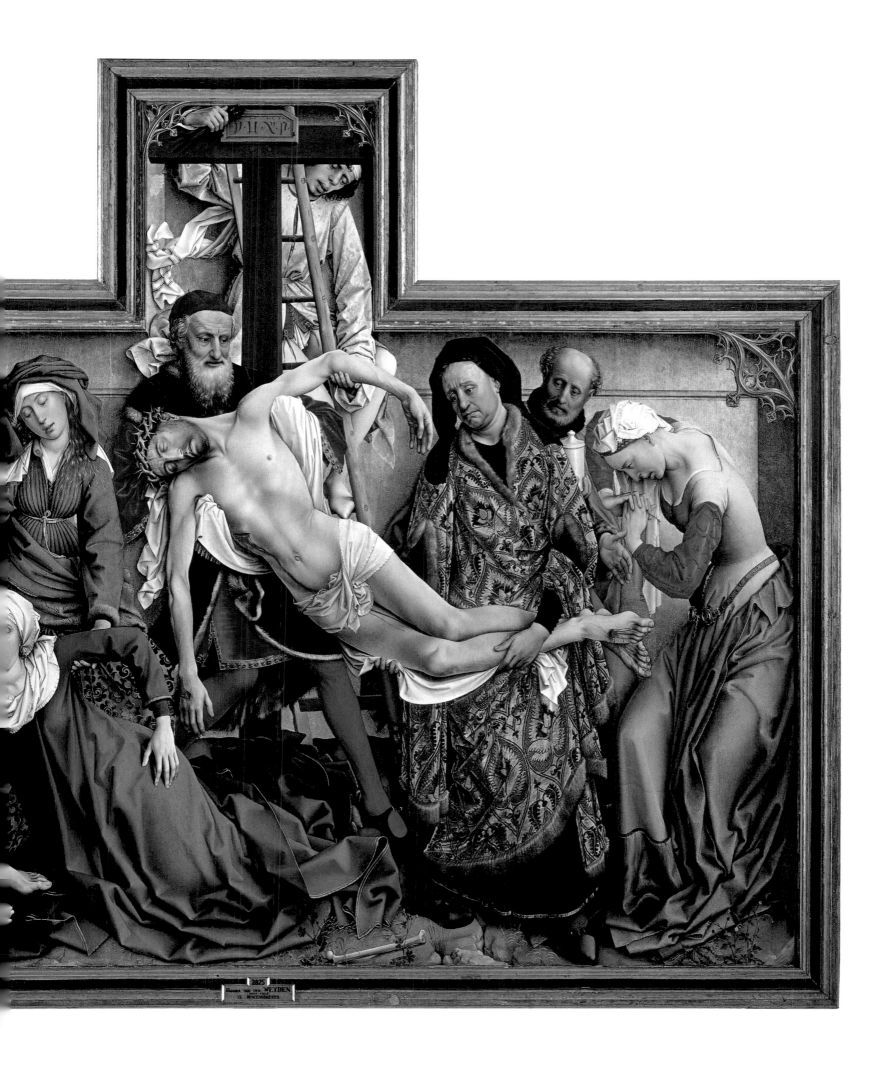

quite literally into visual terms. The convergence of the 'line of sight' and the 'line of piercing' corresponds to the double function of the relative pronoun *quem*, which refers simultaneously to both verbs in the sentence *videbunt in* and *transfixerunt*. The specific compositional approach of the Louvain altarpeice lends it two superimposed time forms: the New Testament scene of the *Descent from the Cross* is portrayed at the same time as the fulfilment of the Old Testament prophecy of Zechariah: *Videbunt in quem transfixerunt*, meaning: "They shall look on him whom they pierced".[185]

Fig. 104 Detail of fig. 103

The small tracery ornaments on the corners of the elevated part were probably added after the wing panels were removed.

A fragment

The panel with the *Descent from the Cross* is a fragment. Like all large altarpieces at the time, it had to have movable wing panels. Two forms are possible for the Madrid *Descent from the Cross*. Either the altarpiece took the form of a triptych with two large, almost square, wings with two narrow, vertical sections, or it was a polyptych with four large vertical rectangular wings and two small wings affixed to the elevated central part. This second form, frequently found in fifteenth century works (fig. 107), is probably the form originally taken by the Altarpiece of the Louvain Guild of Crossbowmen. It is striking that all the early copies (cf. figs. 98, 112) show a complete cross.[186] It may therefore be assumed that the ends of the horizontal beam of the cross with the holes for the nails were portrayed on the insides of the small wing panels.

It was not until after 1500 that variations on this *Descent from the Cross* began to feature a cross with a truncated horizontal beam (fig. 105).[187] Even the two texts written around 1550, describing Campin's *Descent from the Cross* in the collection of Mary of Hungary, make no mention of any wing panels.[188] The wings must have been removed while the altarpiece was still in its original location in the chapel of the Louvain Crossbowmen. It is probable that the less carefully painted little tracery ornaments on the corners of the elevated part (fig. 104) were added at the time to give a finishing touch to the now isolated central panel.[189]

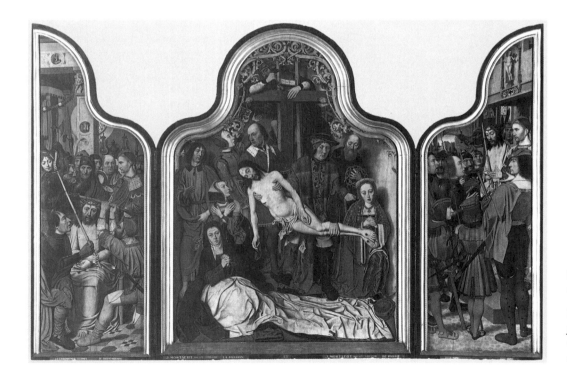

Fig. 105 Jan Mostaert, *Descent from the Cross* altarpiece, c. 1510. Brussels, Musées Royaux des Beaux-Arts

In contrast to all earlier works based on Campin's *Descent from the Cross* panel (fig. 103), Mostaert portrays the cross with truncated transverse beams. This artist clearly knew Campin's altarpiece only without its wing panels.

After its transfer to Spain, wings were added once more to the *Descent from the Cross* panel. This time, the additions took the form of two large panels which must each have had a narrow section at the side that was slightly higher than the central panel. The three surviving documents in which the newly created wings are described are not easy to interpret. At first glance, the most recent of the texts seems perfectly clear. In his *Historia de la orden de San Jerónimo*, published in 1602, José de Sigüenza mentions the 'prophets painted in grisaille' on the wings of the *Descent from the Cross* panel, then housed in the sacristy of the Escorial, as the earliest known work by the court painter Juan Fernandez de Navarrete, known as Mudo (1526–1579). He also notes that these figures of prophets cannot be seen because the wing panels are constantly open.[190] In an inventory drawn up in 1574 listing the works of art transferred by Philip II to the Escorial, these two panels are also ascribed to Mudo. The contents are summarised as follows: "On the inside the four Evangelists with their sayings together with a Resurrection."[191] Apart from these two laconic descriptions, there is another recently discovered document which was submitted to Philip II for approval of Mudo's iconographical programme for the new wing panels.[192] According to this document, texts were envisaged for the inner sides. When closed, the wings were to show many figures: an angel at the empty grave of Christ on the left, the three Marys on the right and, between them, painted in grisaille and placed in niches, the twelve apostles. It is not known with certainty whether Mudo actually executed this unusual composition. Nevertheless, the description in the inventory of 1574 *(por la parte de dentro los quatro Euangelistas con los dichos de cada vno)* would appear to tally with the proposed programme if we assume that, on the inside of the wings, in addition to the texts, there were portrayals of figures of the four evangelists associated with them, and that the phrase *con la Resurreción* actually refers to the exterior. Sigüenza's statement about the exterior bears little weight, since it is not necessarily based on personal observation. The 'prophets in grisaille' could be an erroneous reference to the group of apostles.[193]

The three Flémalle Panels

In 1966, in his book *The Genius of Robert Campin*, Mojmír S. Frinta, having recognised Campin as the author of the Madrid *Descent from the Cross*, presented an astonishing hypothesis – that the so-called Flémalle Panels in the Städel in Frankfurt (Cat. I.18) were originally the wing panels of the Altarpiece of the Louvain Guild of Crossbowmen. By associating the Madrid painting so closely with the Frankfurt panels, Frinta put a radical new slant on the view already offered by Friedländer and other scholars to the effect that these works had all been painted by the same hand. Art historians took little note of Frinta's theory, possibly because it was not accompanied by an optical reconstruction of the retable.[194]

Further studies of the painting technique used in the three Flémalle Panels would appear to support Frinta's hypothesis.[195] Given their common provenance,[196] their almost identical dimensions and their closely related painterly style, it may be taken as ascertained that the three panels originally belonged to the same ensemble. An analysis of the panels themselves has disproved earlier assumptions that the *Trinity of the Broken Body* (Cat. I.18a) and *Saint Veronica* (Cat. I.18c) were the exterior and interior of the same panel.[197] We must therefore accept that, in the case of all three Flémalle Panels, the painting on the other side has been destroyed by planing or reworking. Finally, the panel of the *Virgin and Child* (Cat.

There is, however, a problem arising from the fact that the depiction of the Holy Trinity on the left hand wing of the Edelheer Altarpiece (fig. 112) does not correspond to the depiction on the surviving Flémalle Panel (fig. 110). This would seem to cast serious doubt on the theory that the Flémalle Panels were based on the Altarpiece of the Louvain Guild of Crossbowmen. In the Edelheer Altarpiece, the legs of Christ are directed towards the right rather than the left, and Christ is pointing to the wound in his side with his right hand instead of his left hand. God the Father is supporting the body of His dead son only with the right hand, while holding Christ's loincloth with his left hand. The pose of God the Father raises questions. It looks as though the painter of the Edelheer Altarpiece has altered an existing depiction of the Holy Trinity and, in doing so, has rendered the entire group in a statically impossible pose.

We believe that we can trace the reasons for this amendment. It was not the depiction of the Holy Trinity on the Flémalle Panel that served the Master of the Edelheer Altarpiece as a direct model, but the central panel of a triptych originally located in the same church of Saint Peter in an adjacent private chapel of the van Baussele family (Cat. III.F.1; fig. 111). This composition was probably created around 1435 by a pupil of Campin, referred to in the following as the Master of the Louvain Trinity. Although the composition is of little artistic merit – it is a collage of motifs taken from works created by Campin at various periods – it soon became famous and copies of it spread throughout Europe. It may have been the wish of the patron that the painter of the Edelheer triptych depict the Trinity as in the painting in the church of Saint Peter rather than in the manner of the panel of the *Descent from the Cross* altarpiece. In doing so, the artist sought to cater for the vertical format by portraying God the Father in a standing position, as in the Altarpiece of the Louvain Guild of Crossbowmen, rather than seated, as in the painting by a student of Campin. We believe it was this compromise that led to the statically problematic portrayal.

We have reconstructed the outside of the Altarpiece of the Louvain Guild of Crossbowmen (fig. 114) on the basis of the assumption that the painter of the Edelheer Altarpiece adopted the group of the Virgin and Saint John unaltered from the Altarpiece of the Louvain Guild of Crossbowmen. The reconstruction with the two simulated sculptural groups

Fig. 108 Sienese diptych, *Virgin Enthroned* and *Crucifixion*, c. 1325. New Haven, Yale University Gallery

The child with its cruciform nimbus turns its gaze towards the crucifixion scene.

Fig. 109 Reconstruction of the interior of the Altar of the Louvain Guild of Crossbowmen

The Flémalle Panels (Frankfurt, Städel) were originally wing panels flanking the *Descent from the Cross* (Madrid, Prado)

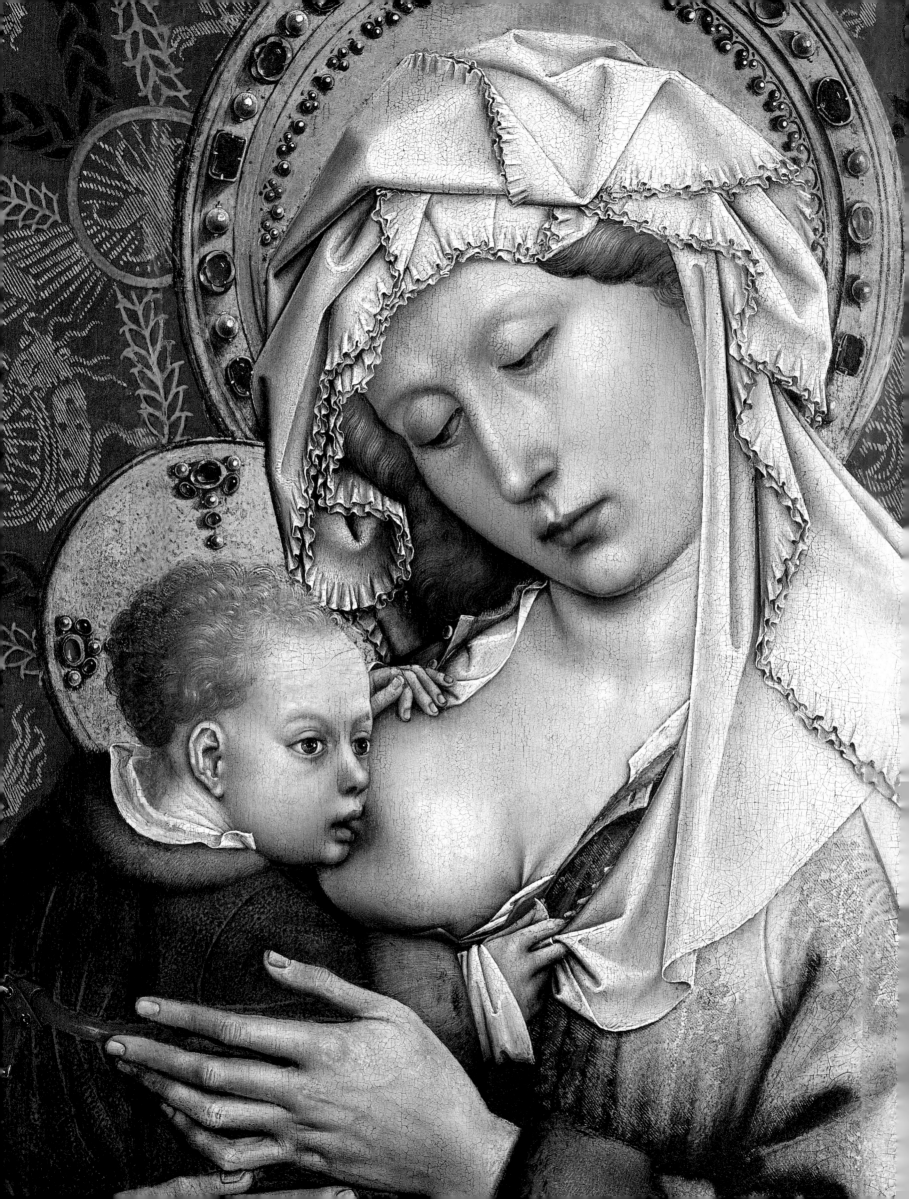

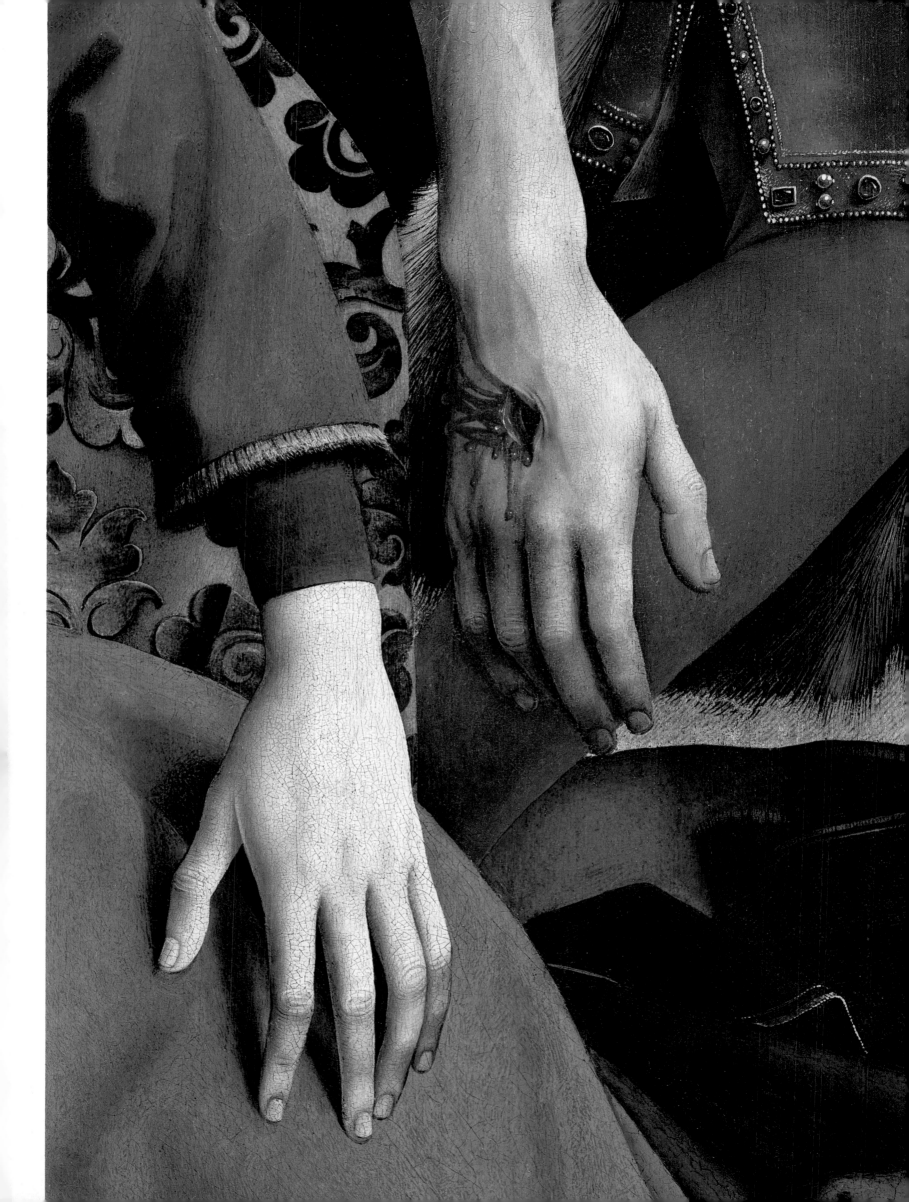

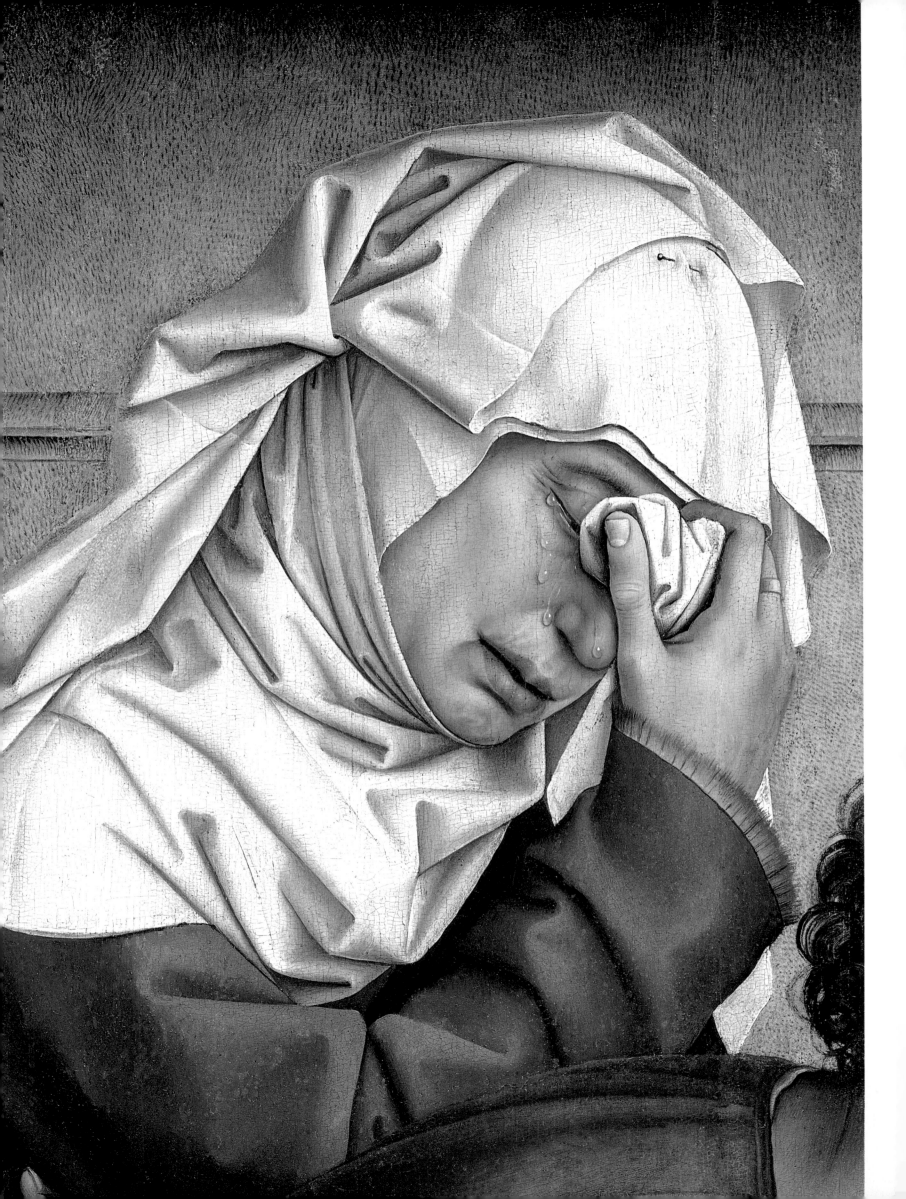

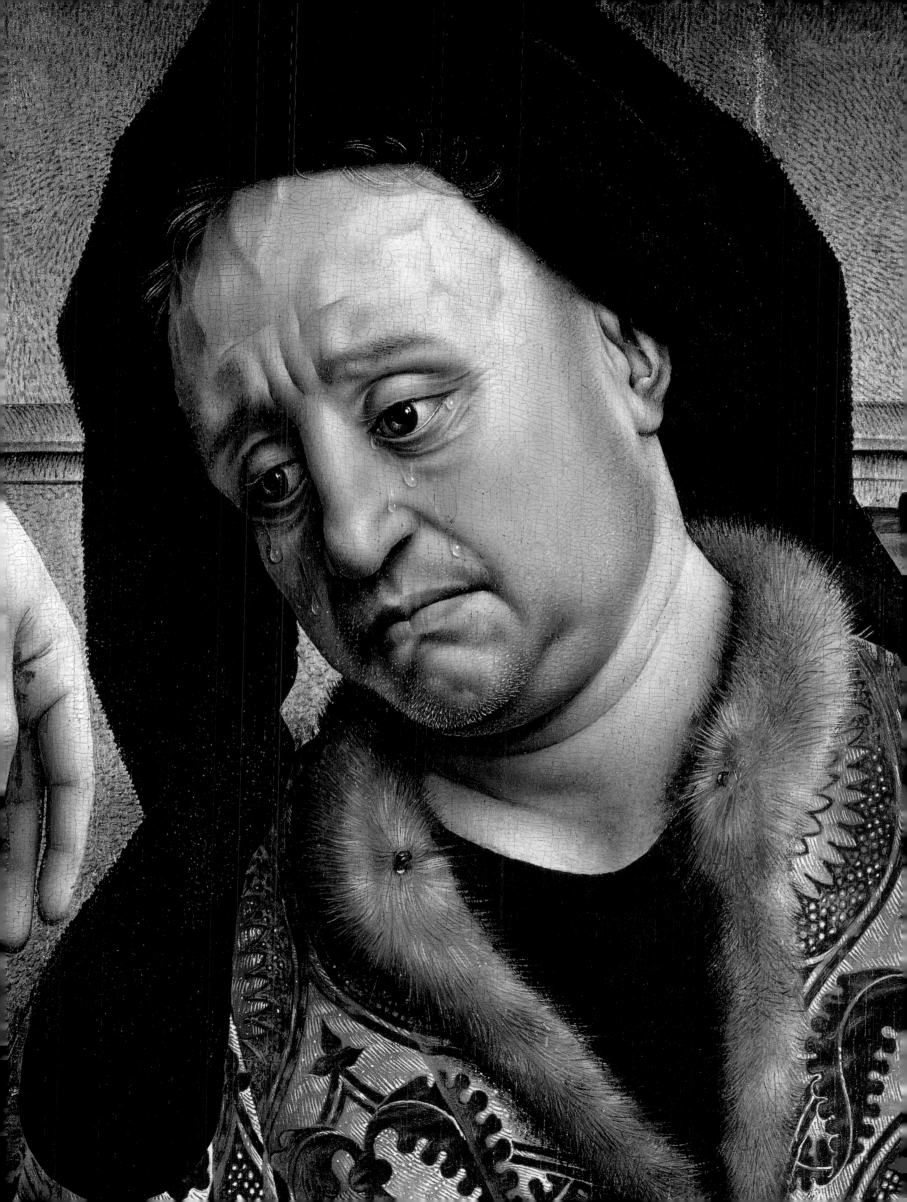

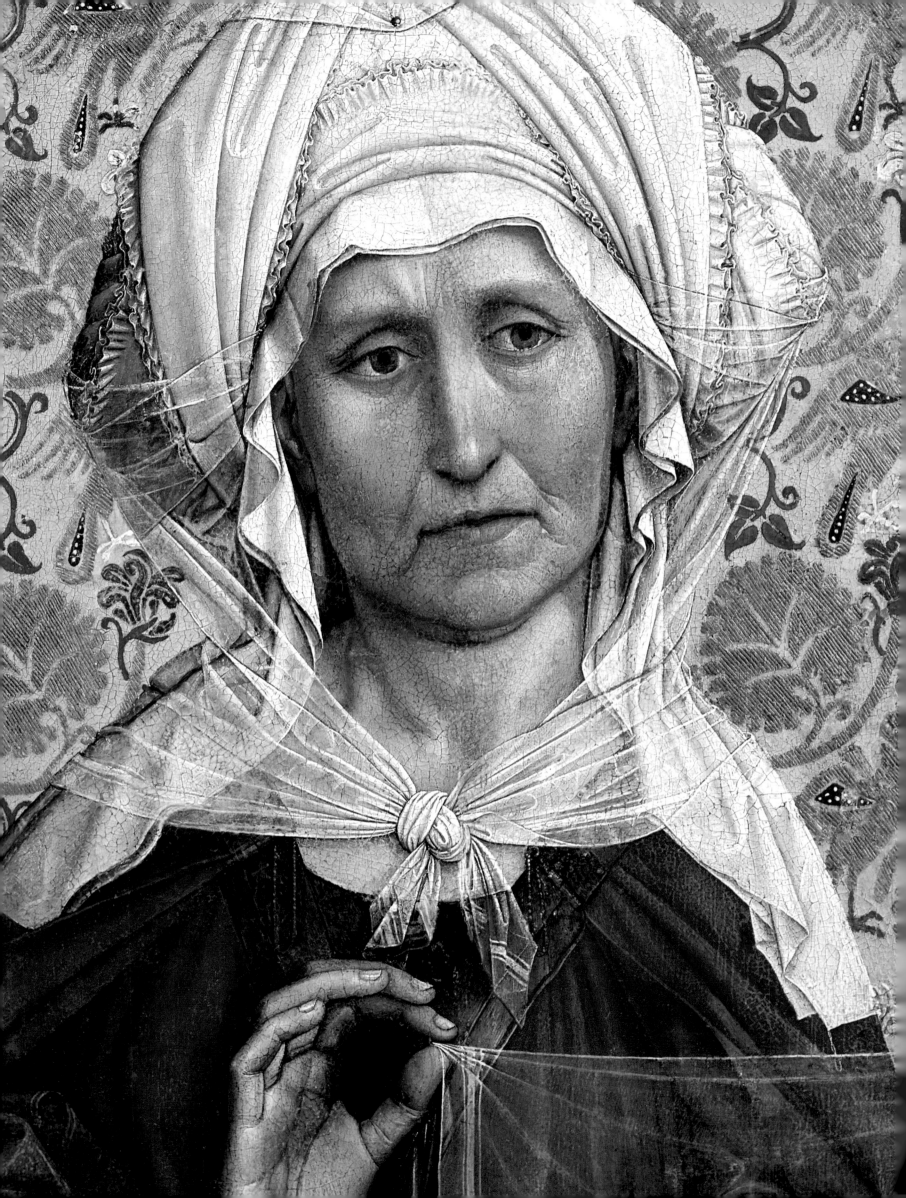

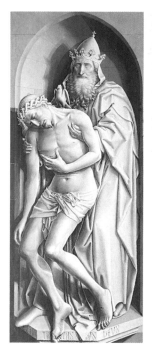

the Virgin and Saint John in the form in which it is copied in the Edelheer Triptych, and the original of the *Trinity of the Broken Body* – is compositionally convincing in its mirror symmetry (fig. 114). This would mean that the wings of the workday side of the Altarpiece of the Louvain Guild of Crossbowmen already addressed the concept of compassion that is the focus of the *Descent from the Cross* on the holiday or feast-day side.

It may be assumed that the painter of the Edelheer Altarpiece also adopted the two angels which he portrays at the feet of the *Trinity* (fig. 112) from the model he was copying.[207] They probably graced the outsides of the two small wings mounted on the elevated part of the Altarpiece, in the form of simulated stone figures. The Edelheer Triptych, on the other hand, provides no indication as to the content of the four almost square areas that flanked the two vertical groups of figures.[208]

Fig. 110 Robert Campin, *The Trinity of the Broken Body*, c. 1430. Frankfurt, Städelsches Kunstinstitut

Fig. 111 Master of the Louvain Trinity, *The Trinity of the Broken Body*, c. 1435. Louvain, Stedelijk Museum

A chequered history

As we have already mentioned, there are a number of indications that the wings of the Altarpiece of the Louvain Guild of Crossbowmen were removed from the central panel around 1500, at a time when the altarpiece was still located in the chapel of Onze-Lieve-Vrouwe-van-Ginderbuiten. This may be the reason why the wings and the central panel do not share the same history and provenance.

As for the Flémalle Panels, at least two of them were later used in a context other than the one for which they were intended. The reverse of the Virgin and Child panel, originally divided by a transverse strip of wood in the middle, was later smoothed over and painted with a grisaille portrayal of the Virgin Mary, her heart pierced by a sword (fig. 115). The figure is placed in a niche whose form and perspective are such that they could be reunited with the grisaille of the Trinity of the Broken Body as a new pendant. The

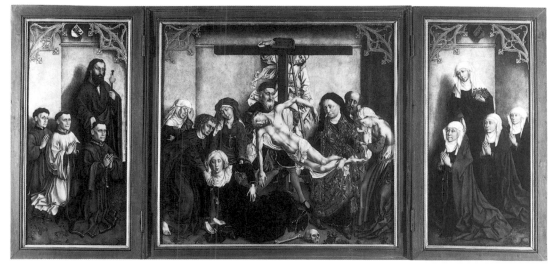

Fig. 112 Anonymous Master, Edelheer Triptych (exterior and interior), dated 1443. Louvain, Saint Peter

The central panel of the triptych is the oldest surviving copy of Campin's *Descent from the Cross* panel. The outsides of the wings bear grisaille portrayals of *The Trinity of the Broken Body* and *Saint John with The Virgin*.

Mater dolorosa was probably created around 1600 by the Louvain artist Josse van der Baren after an engraving by Anton II Wierix (fig. 113).[209] If we assume that the original grisaille pendant to the *Trinity of the Broken Body*, which probably portrayed the Virgin in the arms of Saint John, still existed around 1600, a change in religious views must have been the reason for the new portrayal of the Virgin Mary in grisaille.

In the last decade of the fifteenth century, Joseph van Coudenberghe, secretary to Philip the Handsome founded a brotherhood dedicated to the cult of the *Mater dolorosa*.[210] This new cult of the Virgin Mary as Our Lady of Sorrows spread quickly throughout the Netherlands and neighbouring regions and with it a new form of portraying her. From then on, the *Mater dolorosa* was portrayed with her heart pierced by one sword, as in some earlier archetypes, or by seven swords.

As early as 1494 the chapel of the Louvain Guild of Crossbowmen became one of the very first places in the Netherlands to introduce the cult of the *Mater dolorosa*.[211] The fact that Our Lady of Sorrows was worshipped there is documented in a woodcut dated 1552 depicting at its centre a pietà in which the Virgin is shown with seven swords piercing her breast (fig. 116). The sculpture shown in the woodcut probably replaced the earlier Marian picture that had been placed in the newly built chapel of the Guild of Crossbowmen in 1365.[212] The same religious renewal that led to the replacement of the pietà was probably also responsible for the creation of the new Marian portrayal in grisaille on the reverse of the *Virgin and Child* panel.

Fig. 113 Anton II Wierix, *Our Lady of Sorrows (Mater dolorosa)*, copperplate engraving. Brussels, Bibliothèque royale Albert Ier, Cabinet des Estampes

The Mater dolorosa (fig. 115) created as a new addition to the *Trinity of the Broken Body* is based on this late 16th century engraving.

Fig. 114 Reconstruction of the exterior of the Altarpiece of the Louvain Guild of Crossbowmen

Fig. 115 Reconstruction of a diptych

After the removal from the *Descent from the Cross* panel a *Mater dolorosa* in grisaille was added to the back of the *Maria lactans* panel and combined with the *Trinity of the Broken Body* to form a diptych.

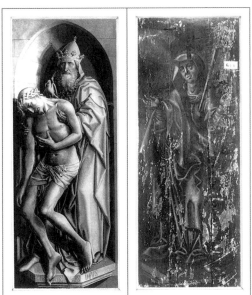

Fig. 117 Robert Campin (copy after), triptych showing the *Descent from the Cross*, holiday side, between 1448 and 1465. Liverpool, Board of Trustees of the National Museums and Galleries on Merseyside (Walker Art Gallery)

The Good Thief on the Cross

There is another major altarpiece of the Passion of Christ that can be reconstructed on the basis of a surviving original fragment and several copies. Campin also created this work around 1430, probably for a church in Bruges. The fragment shows an almost life-size Thief on the Cross (Cat. I.16; fig. 119) set against a gold ground with a regular brocade pattern. Two men are standing to the right below the cross. Both these figures, which the surviving fragment shows only to the waist, are portrayed as attentive observers so that they seem like representatives of the spectators in the picture.

Fictitious chronicle of an execution

This panel is a precise visual chronicle of a scene of martyrdom in which the observer is spared no detail, from the brutally injured limbs – shinbones broken by an axe and dislocated – to the instruments by which this punishment was meted out. We see the rough-hewn wood of the cross, the complex knotting of the rope and the loincloth tied at the side. On closer inspection, this loincloth proves to be a shirt of fine fabric adorned with embroidered seams – the very garment stripped from the thief prior to his crucifixion.[213]

following pages
Fig. 118 Robert Campin (workshop), *St. John the Baptist* (fragment), verso of fig. 119
Fig. 119 Robert Campin, The Good Thief (fragment), c. 1430. Frankfurt, Städelsches Kunstinstitut

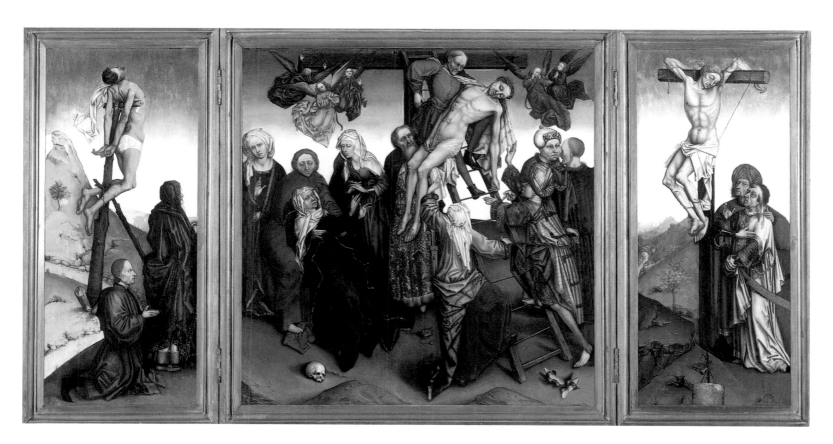

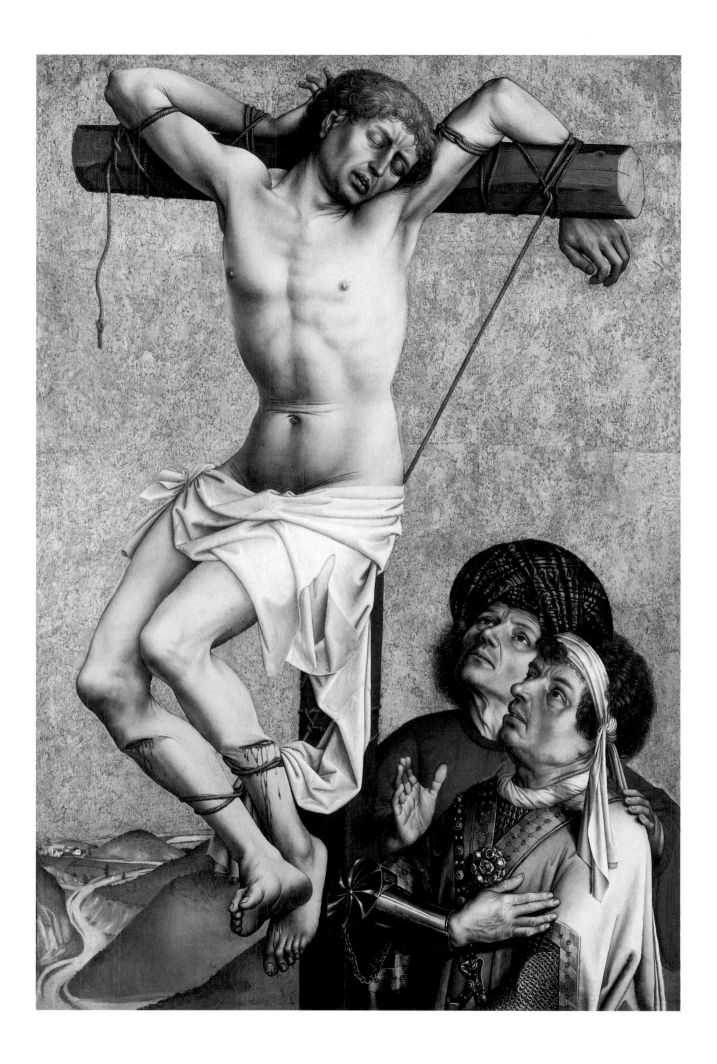

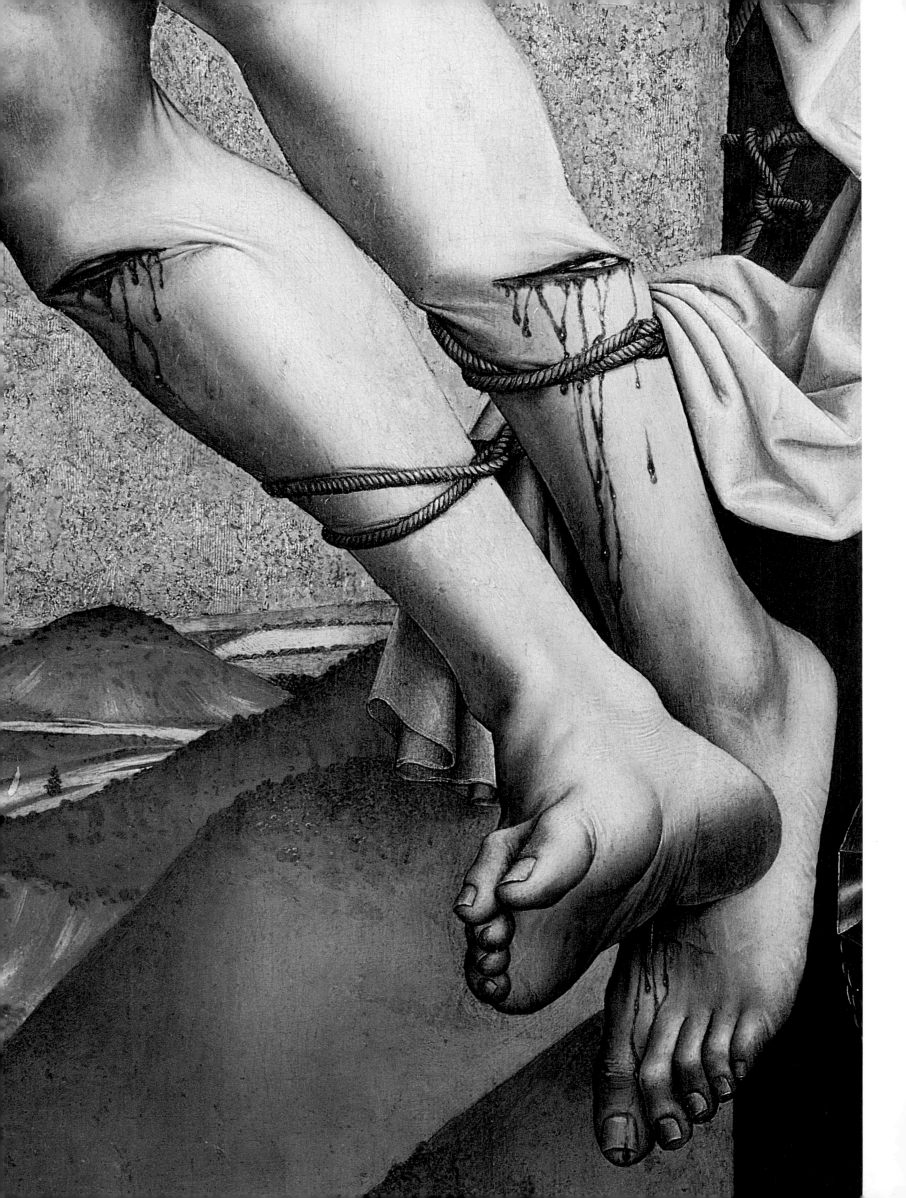

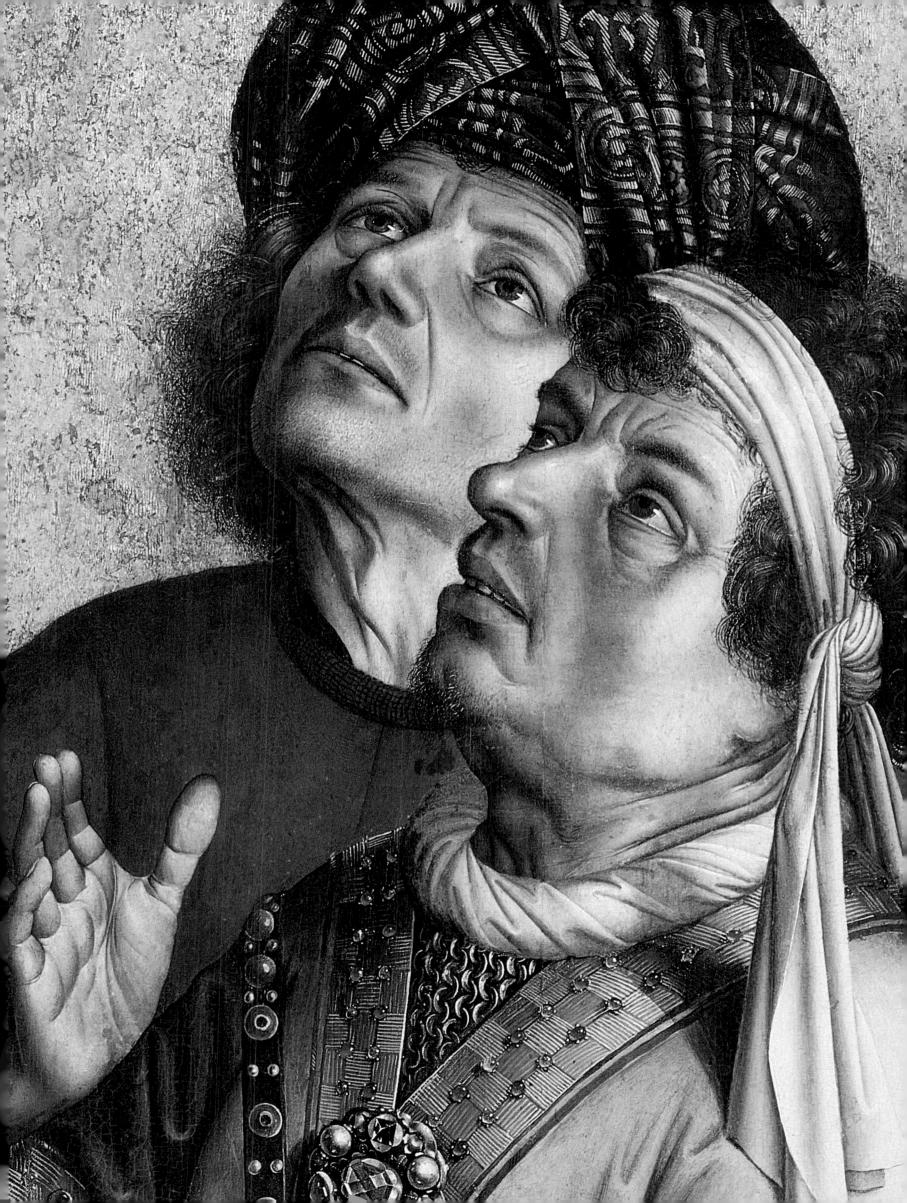

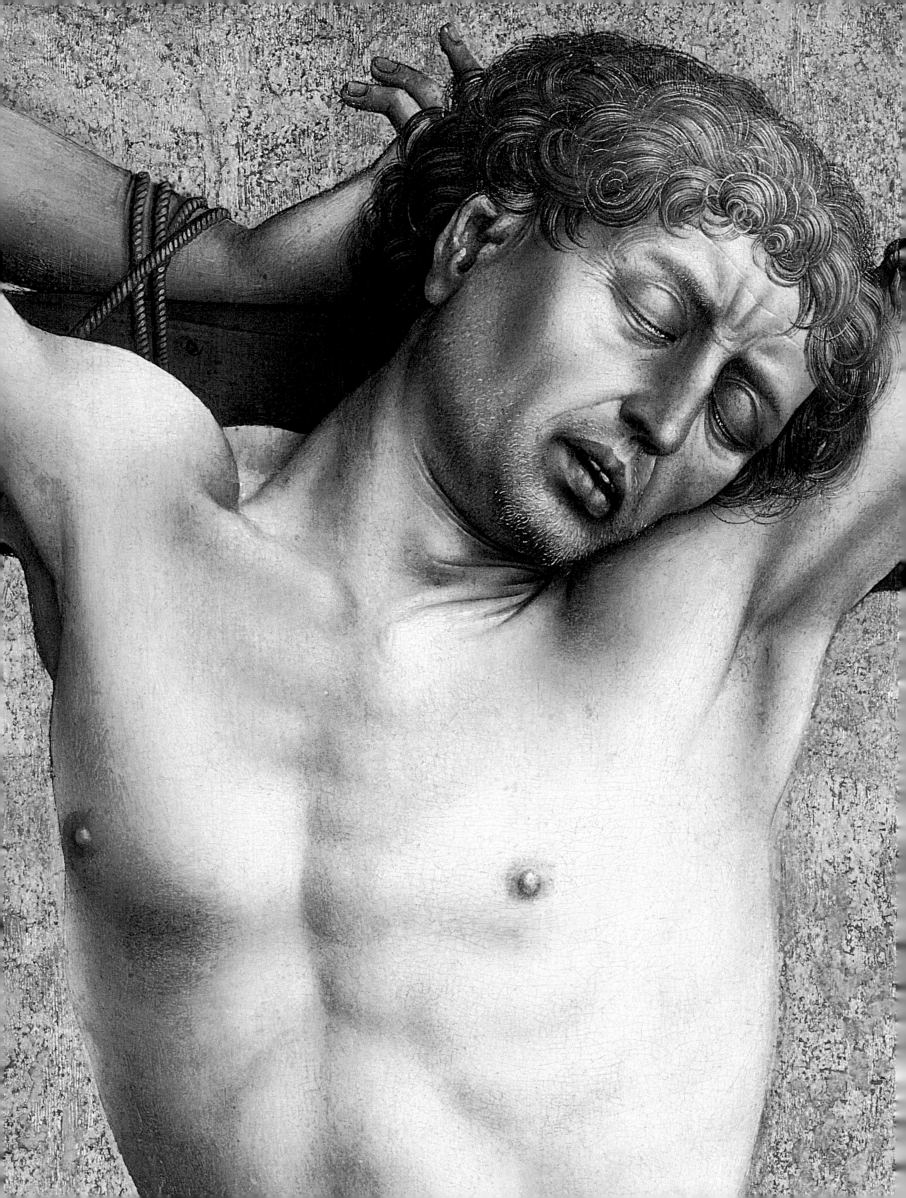

The figure of the thief possesses extraordinary painterly qualities. His athletic body is almost sculptural. Yet in its planar projection, the figure is a complex interaction of parallels and counterpoints. The head leaning to the right corresponds to the legs turned to the left; the lines of motion in profile of the left side of the body contrast with the calm verticality of the right. The contrast of the contour lines is echoed by the contrast between the loosely dangling of the rope on the left and the tautly stretched rope on the right that also reiterates diagrammatically the angle of the head.

The figure of the thief is also marked by an inherent contrast: the broken limbs and traces of blood bear witness to great suffering, while the youthful face, framed by curly hair, has the peaceful look of one quietly asleep, in spite of the furrowed brow. This fact alone contradicts the frequent assumption that this is a portrayal of the Bad Thief.

Fragment of a triptych

The lost composition has survived indirectly in the form of a small-scale copy in Liverpool (fig. 117). According to this copy, the fragment now in Frankfurt forms the upper half of the right wing of a triptych that must have been a good four metres wide when opened. The left-hand panel shows the other thief, while the central panel shows the Descent from the Cross, rather than the conventional Crucifixion.

The scene of the Descent from the Cross differs compositionally from the Madrid *Descent from the Cross*, which Campin created as a further development of his altarpiece with the *Bearing of the Body to the Sepulchre* based on a work of classical antiquity. In the altarpiece painted for Bruges, the artist has looked to an existing archetype. The clearest example of such an archetype is a miniature in the Brussels Book of Hours of the Duc de Berry painted before 1402 in the workshop of Jacquemart de Hesdin (fig. 120).[214] Here, too, the Descent from the Cross is flanked by the crosses of the thieves, while the two onlookers in the Frankfurt fragment are represented by two men at the right hand edge of the picture.[215]

In Campin's composition, the thieves are portrayed on the wings of the altarpiece, and are thus separated from the main scene. The central panel with the Descent from the Cross, directly above the altar itself, is thereby designated as a sacred image. The hill, Mount Golgatha, sloping steeply towards the middle of the triptych, links the three panels.

Apart from the figures of eleven people in the central panel, there are five angels. They hover on either side of the transverse beam of the cross into which the nails have been returned after the deposition of Christ's body. With their expressive gestures, the mourning angels comment the scene of passion with deep emotion, in the manner of a conventional device to be found in Italian painting since Giotto. The various red tones of their robes, reiterated in the earthly figures, set strong compositional accents in the central panel.

The cross divides the picture plane of the central panel – in the original it was vertical – into two halves. The right half shows the actual Descent from the Cross. Joseph of Arimathaea and Nicodemus are removing the body of Christ from the cross, touching it indirectly by holding only cloth and robe. A man and a woman, climbing the first rungs of the ladder leaning against the cross on the right, are coming to their aid. Both have removed their shoes. The woman shown in rear view – surely Mary Magdelene – is placed directly below the figure of Christ and provides an approach to the image as a potent figure of

identification for the viewer. On the right-hand edge of the picture, two men, who can be identified as Pharisees, are engaged in a dispute.[216]

On the left-hand side of the picture, Saint John, in a brilliant red robe, flanked by two women, is supporting the Virgin who is swooning in counter-movement to the body of Christ. Her swooning is rendered tangible by specific painterly means: the two women standing are wearing the same white head dresses as the Virgin. In this way, the lower position occupied by the Virgin appears as the result of a falling movement. The woman on the left, cropped by the picture frame, gazes with pity towards the figure of the donor portrayed kneeling on the left hand wing. This marginal figure has the same mediating role as the angel bearing the lance in Campin's earliest rendering of the Passion, the Seilern Triptych (fig. 19). Beside the donor, also in profile, an elderly woman is standing, her face almost completely covered by the hood of her garment. The ointment jar in her hands alludes to the anointing of the body of Christ.

194.

Fig. 120 Jacquemart de Hesdin (workshop), *Descent from the Cross*, before 1402. Brussels, Bibliothèque royale Albert Ier, Ms. 11060 (Brussels Book of Hours of the Duc de Berry), p. 194

This miniature foreshadows certain essential elements of Campin's composition (fig. 117).

Dismas or Gesinas?

The question of whether the Frankfurt fragment (fig. 119) is a portrayal of Dismas, the Good Thief, or Gesinas, the Bad Thief, has been much debated by art historians. Pictorial tradition would dictate that this is the Bad Thief, Gesinas, who is invariably portrayed to the left of Christ by artists before Campin.[217]

On closer inspection, however, there is every reason to believe that Campin has broken with convention in his Bruges altarpiece. In doing so, he had to muster all the compositional means at his disposal (fig. 117): the cross of the Bad Thief on the left-hand panel is placed at an angle in a stony landscape; the thief himself is shown in rear view, on a rough-hewn cross, head cast back and eyes bound as a sign of his moral blindness. By contrast, the cross of the repentant Good Thief stands in a verdant and gently rolling landscape and the appearance and position of the figure clearly emulate that of the Redeemer. Above all, however, it is the pose, legs bent and head gently tilted to the right, that echoes the figure of Christ.

There can be no doubt about it. The fragment in Frankfurt (fig. 119) shows Dismas, the Good Thief. Campin was the first artist to break with a thousand-year-old iconographic convention in swapping the positions of the two thieves. What prompted him to do so is

Fig. 121 Robert Campin (copy after), *The Bad Thief*. Cambridge (MA), Fogg Art Museum (Alpheus Hyatt and Grace Nichols Strong Fund)

Fig. 122 Robert Campin (copy after), *The Descent from the Cross*. Cambridge (UK), Fitzwilliam Museum

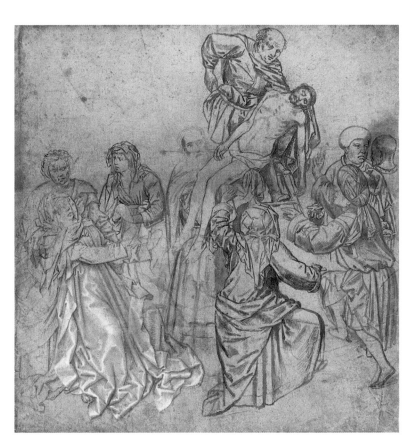

rather more difficult to ascertain. Careful consideration of the two figures who can be seen looking on in the Frankfurt fragment can help us to find an answer to this question. The figure in the chain mail shirt is surely the Roman centurion. His gaze is directed towards Christ on the central panel, and, with a gesture of deeply felt faith – his right hand on his heart – he expresses the thought that most previous artists had presented with the aid of a banderole: *Vere iste erat filius Dei* ('this was truly the Son of God'). The second man, whose turban identifies him as an Eastern Jew, has placed his left hand on the centurion's shoulders, while his raised right hand expresses astonishment. The Jew's gaze – a subtle point that the painter of the Liverpool copy (fig. 117) has overlooked – is directed towards the Good Thief and not, like that of the centurion, to Christ.

Promise of salvation

The gestures and facial expressions of both men have a narrative function or, more precisely, an argumentative function: they refer the portrayal of the Good Thief to that of the dead Son of God. They explain why the body of the Good Thief mirrors the body of Christ and interpret it as an expression of his salvation in accordance with Christ's promise in the Gospel according to Saint Luke (Luke 23:43): "Verily I say unto thee, To day shalt thou be with me in paradise."

In contrast to the traditional portrayal of the two thieves on either side of the picture as a reference to the timeless hierarchical division between Good and Evil, Campin has created a narrative relationship between the wings and the central panel. Campin presents the death of Christ in the form of a narrative addressed first and foremost to the spectator and intended to be perceived from the spectator's position. The individual observer can thus identify with the figure of the repentant thief as a promise of his own salvation.

In the *Artes moriendi* (fig. 123) the figure of the thief is presented to the dying along with Saul, persecutor of Christians, the sinner Mary Magdalene and the denying disciple Peter as an important figure of identification and as an individual saved in spite of his sins. Against this background, it is understandable why Robert Campin should have sought such a radically new treatment of the repentant thief in comparison to the traditional portrayals and why he should have given this figure much greater emphasis than normal in his triptych of the Passion of Christ.

Campin corrected

Not just art historians, but even the artists in the generations to follow Campin, had difficulties with his new pictorial concept. Though the artists, unlike the art historians, tended to interpret Campin's formula correctly, this did not mean that they were prepared to adopt it. (The small copy in Liverpool would appear to be the only work in which the thieves have been adopted in the same positions and with the same significance.)[218] Later artists were fascinated by

Campin's life-like figures of the thieves. However, as they did not wish to adopt the new, spectator-oriented pictorial formula, they set about correcting his composition in a variety of ways.

Let us consider some works that illustrate this ability to grasp the meaning of the work while at the same time refusing to follow it. The Master of the Diptych of Jeanne de France (fig. 124) places Campin's figure of the Good Thief to the right of Christ, in accordance with conventional pictorial tradition, and invents a new Bad Thief, with a swarthy skin tone, whom he presents, as Campin does, in rear view. A different approach is taken by a Bruges Master in a *Crucifixion* (fig. 125) painted around 1480. He uses Campin's figure of the Bad Thief twice – once in the traditional position to the left of Christ, and a second time adapted to represent the Good Thief, portrayed in frontal view and looking down with head inclined towards the figure of Christ.[219]

These examples indicate that other artists did indeed recognise the thief in the Frankfurt fragment as the Good Thief, whom Campin had situated in the 'wrong place'. While emulating Campin stylistically, they applied a variety of means to correct his original in order to retain a traditional and conventional form of portrayal. The simplest means of 'correcting' the original – merely by swapping the two figures in mirror symmetry – was, remarkably, a solution chosen by none of them.

Fig. 123 Scenes from an *Ars moriendi*, c. 1430. London, Wellcome Institute Library, Ms. 49, fol. 29v (detail)

The angel shows to the dying the redeemed and repentant sinners of the New Testament.

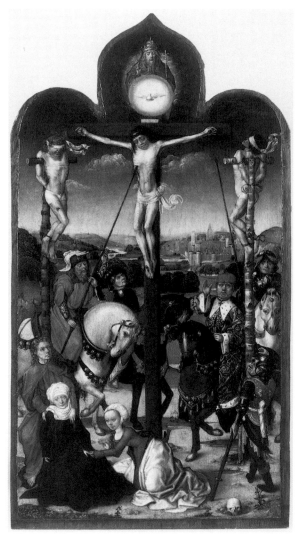

On 30 July 1432, Campin was found guilty by a Tournai court of continued adultery. In the period following the passing of this sentence – Campin appears to have disbanded his workshop shortly afterwards – he created two extraordinary works. One is a series of fifteen pagan wise men and sibyls, probably for the cathedral at Münster in Westphalia. The other is his design for three lavishly embroidered liturgical copes commissioned by Philip the Good. These copes were probably produced between 1433 and 1442 in the workshop of Thierry du Chastel, an embroiderer who originally came from Paris. The vestments, worn at the prayer services of the Order of the Golden Fleece, may be regarded as an artistic response to the Ghent Altarpiece by the van Eyck brothers, completed in 1432.

A Series of Pagan Wise Men and Sibyls

Until the Second World War, portrayals of six sibyls (figs. 126, 127) graced the rood screens that separate the high choir from the ambulatory in the cathedral at Münster in Westphalia. They were created by the painter Melchior Steinhoff in 1602 and 1604, shortly before his death. Steinhoff's early baroque sibyls were the last renewal of a fifteenth century cycle in keeping with prevailing iconographic standards and aesthetic tastes. The original cycle, which can be reconstructed with the aid of early copies, comprised portraits of five pagan wise men, each flanked by two sibyls, forming fifteen panels in all (Cat. I.22/C; fig. 129ss).

Reconstructing the original series

The lost original series was associated with the Master of Flémalle from a very early stage. Certain stylistic characteristics clearly evident in early copies, together with the originality of the overall artistic concept, confirm this attribution. We can obtain the best idea of how Campin's lost portraits must have looked by studying eight painted copies by Ludger tom Ring the Elder, an artist active in Münster (fig. 130ss). These are the surviving remnants of a series of copies made by that artist following the iconoclasm of the Anabaptists in 1534 in which the earlier panels were damaged. By 1572, Hermann tom Ring had produced his own freely interpreted secondary copies after the copies by his father, adding attributes to the portraits of the wise men and sibyls (fig. 128). These were mounted in new stone frames in the place where the earliest cycle of images had hung: on the walls separating the ambulatory from the high choir. The copies by the younger Hermann tom Ring are no longer a reliable indicator of the lost originals. However, as the series is complete but for one single panel, it does allow us to ascertain the original alignment of images created by Campin and copied by Ludger tom Ring the Elder.[220]

In the fifteenth century, even before Ludger tom Ring the Elder created his painted copies, two cycles of graphic reproductions – one anonymous woodcut series (fig. 129ss) and one series of copper engravings (fig. 135ss) attributed to the Master of the Banderoles – were created entirely independently of each other. There was also a copy of one portrait panel in the form of a drawing by an artist in the circle of Hans Pleydenwurff (fig. 139ss). Individual prints from each of the two print cycles have survived as precious and unique examples. Together with the panels created by Ludger tom Ring the Elder, they bear impres-

Fig. 124 Rogier van der Weyden (school of), *Crucifixion* (right wing of the diptych of Jeanne de France), 1452. Chantilly, Musée Condé

The artist has placed Campin's Good Thief in the conventional position to the right of Christ and has invented a new Bad Thief, showing him from behind as Campin also does.

Fig. 125 Bruges Master, *Crucifixion*, c. 1480. Philadelphia Museum of Art, Johnson Collection

Campin's Bad Thief takes up the conventional position on Christ's left. The same figure, portrayed frontally, becomes the Good Thief.

sive witness to the fame of Campin's œuvre. A comparison of all the surviving copies, illustrated on the following pages, shows that the panels attributed to Ludger tom Ring the Elder were not freely invented by that artist, but were more or less reliable copies of paintings dating from the first half of the fifteenth century.[221]

The sole drawn copy of the Tiburtine sibyl from the circle of Hans Pleydenwurff of Nuremberg (fig. 139) provides the clearest evidence that the lost design for the Münster cycle must be ascribed to Robert Campin. The striking facial traits of the sibyl with her eyes half closed – a strangely pained and distorted expression recalling her alleged prophecy of Christ's death on the cross – are almost identical, even in the copy, with the traits of the Virgin in the Louvain *Descent from the Cross* (fig. 103); an elongated nose with a slight hump in the middle, protruding S-shaped eyelids and a strongly modelled chin. Rogier van der Weyden must have been profoundly impressed by this figure by his teacher, with her fantastic, wheel-like headwear. Some twenty years later, he was to use it as the model for his Mary Magdalene in the Braque Triptych (fig. 153), albeit with facial traits altered to suit his typically wiry type.[222]

The fifteen original portrait panels were individually framed, but grouped in threes. Each of these groups, one male portrait flanked by two female portraits, was also treated as a unit within a single pictorial space. In four cases, the pictorial space is defined by the walls of an interior, and once by a similarly designed garden wall.[223] In this way, Campin was transposing to the portrait genre a formula he had already used to good effect in the Seilern Triptych (fig. 19) with its continuous landscape and in the Saint Luke Triptych (fig. 92) with its interior spanning all three panels.

The alignment of sibyls and pagan wise men within a single pictorial programme is most unusual.[224] Conventionally, the sibyls, if they do not appear alone, are presented as counterparts to Old Testament prophets. In their specific selection of five pagan wise men, the Münster pictures are unique.[225] Although the names of the ten sibyls have been firmly established since Lactantius – Europaea and Agrippina having been added towards the end of the fifteenth century to make up the preferred number of twelve – there is no corresponding firmly established number of pagan wise men. The selection at Münster seems to be based on the principle of geographical representation, as proposed by Vöge. Accordingly, Milesius stands for Greece, Balaam for Asia, Virgil for Rome, Albumasar for Arabia, and Hermes for Egypt. Together, these five wise men represent the entire pagan world.

It is difficult to discern the reasons behind the choice of the respective sibyls to accompany each specific wise man. Neither their prophecies nor their origins would seem to offer a satisfactory explanation. Only the Cumaean and the Tiburtine sibyls flanking Virgil in the central group (III) bear any obvious relationship to the wise man they accompany: Virgil himself refers to the prophecy of the Cumaean sibyl, the *carmen cumaeum*, and the Tiburtine sibyl who prophesied to the Emperor Augustus the birth of the Redeemer belongs in the life sphere of the Roman writer.

Fig. 126 Münster (Westphalia), Cathedral of Saint Paul, ambulatory (after Savels 1904)

This turn-of-the-century photograph shows three of the six sibyl paintings by Melchior Steinhoff dated to 1602 and 1604. They were created as latest replacements for the fifteen-part fifteenth century series of pagan wise men and sibyls. The stone frames were probably created before 1572/73 for the third series of pictures completed by Hermann tom Ring (cf. fig. 128ss). The original panels were probably smaller, as were the copies painted by Ludger tom Ring the Elder (cf. fig. 129ss).

Among the fifteen portraits by Campin, the portrayal of Virgil (fig. 141) is given preferential treatment, not only by its central position. His is the only frontal portrayal, while the spectacles held on the bridge of the nose with thumb and forefinger emphasise the symmetry of the composition along the central verticals. On the parapet, again in mirror symmetry, lies an open book. It is undoubtedly the Book of Eclogues containing the famous passage from the fourth Eclogue which Christian interpreters regarded as a prophecy of the Coming of Christ: *Ultima cumei iam venit carminis etas./Magnus ab eterno sanctorum nascitur ordo.* This is the text presented in simulated relief lettering on the front of the painted stone parapet.[226] Virgil is also set apart from all the other figures by means of a specific spatial *mis en scène*. An additional cell has been added for him within the space allocated to the third group of three. On the right hand wall of this cell, we can see a small still life inside an open cupboard containing three further books as an indication of the other writings of Virgil and, set upon a casket, a little basket of apples.[227]

The portraits are arranged in five equal groups of three corresponding to the architectural structure of the ambulatory, with its floor plan of five sides of a decagon in which they were displayed (fig. 127). Only the central wall is emphasised specially by its position on the longitudinal axis of the east facing church. It was on this axis that the symmetrically composed figure of Virgil in a cell was placed.

The basic structure of the series – five groups of three with the emphasis on the centre – indicates that Campin created it specifically for an ambulatory, which frequently has a five sided layout. The iconographical programme itself is also geared to the architectural situation. The outer side of the ambulatory, fringing the threshold to the most sacred part of the church, where Christ is manifested in the sacrifice of the daily Mass, is a suitable place to portray figures who lived before the Christian era and who nevertheless prophesied the coming of the Messiah in their writings and sayings.[228]

Surprising as it may seem, there are grounds for assuming that the series of portraits copied by Ludger tom Ring the Elder after the iconoclasm was in fact an original work created by Robert Campin specifically for the cathedral in faraway Münster. The first and last group of three in the series are both set within a simulated space which differs clearly from the three others in one respect: whereas the portrait groups II, III, and IV are presented in closed windowless spaces, the two outer groups (I and V) have walls pierced by window and door apertures that open up the picture towards the background. This difference in the treatment of space reflects the irregularity in the original alignment of the five walls of the screen that separated the high choir from the ambulatory in Münster. According to an eighteenth century plan (fig. 127), the two outer walls of the screen were originally set back towards the choir, which meant that there was a niche some two metres deep between the pillars. The additional opening up of the simulated space into the background of the pictures in the two outer portrait groups appears to correspond to the recession of the architectural niches in which they were displayed.[229]

Fig. 127 Münster (Westphalia), Cathedral of Saint Paul, floor plan of the choir after an 18th century plan

The fifteen images of pagan wise men and sibyls hung in groups of three (I-V) on the outside of the screens that separated the high choir from the ambulatory.

Fig. 128 Hermann tom Ring (after Ludger tom Ring the Elder), sibyls and wise men, c. 1570. Münster, Domkammer (on loan from the Bayerische Staatgemäldesammlungen, Munich)

As the copies are numbered, it is possible to reconstruct the original alignment of the fifteen portraits in groups of threes on the ambulatory side of the choir screen (cf. fig. 127).

Group I

Sibylla Libyca – Milesius – Sibylla Delphica
(cf. figs. 129-132)

Group II

Sibylla Eritraea – Balaam – [Sibylla Frigia]
(cf. figs. 133-137)

Group III

Sibylla Tiburtina – Vergil – Sibylla Cumaea
(cf. figs. 138-142)

Group IV

Sibylla Samia – Albumasar – Sibylla Hellespontica
(cf. fig. 143 s)

Group V

Sibylla Persica – Hermes – Sibylla Chimica
(cf. figs. 145-148)

Three figures in one room

The outer group of portraits (group I) on the south side in which the Libyan and Delphic sibyls flank Milesius [230] is the only one to survive completely in the copies by Ludger tom Ring the Elder (figs. 130-132). It gives us a precise indication of how Campin used compositional techniques to group his ideal portraits into hierarchically structured groups of three. The three panels together simulate a glimpse into an interior space. The viewpoint has been chosen so that the side walls on the outer panels run symmetrically towards a central vanishing point. The back wall parallel to the picture plane goes beyond the frame of the central panels and extends into the side panels, strengthening the impression that they are closely linked to the central panel.

Wide open windows on the left hand panel and an open door and window in the central panel give a sweeping view of a rolling landscape with trees. On the left-hand panel there is a separate area bounded by a brick wall, and in the central panel there is a geometrically landscaped garden. The panel showing Sibylla Delphica on the right-hand side, by contrast, features closed walls and a fireplace.

In this group, the two sibyls are not dressed in oriental costume, but in northern European garb with white hoods. Only the negroid facial traits lend the figure of Delphica a hint of the exotic. The pagan wise man Milesius, on the other hand, is one of the most imaginatively composed figures in the entire series. Over his garment of burgundy red highlighted in white, he wears a strangely shaped hood trimmed with black and white striped fur. Its neckline falls in a goitre-like double fold below his chin. Milesius is looking grimly to the right, towards the figure of Virgil. His long beard is parted in two and braided.[231] He is leafing through a book lying in front of him on the parapet.[232]

Apart from the background settings, Campin employs a pictorial formula based on works of classical antiquity in these three panels, by presenting the figure behind a stone parapet. Jan van Eyck used this same device in 1432 in his so-called *Timotheos* (fig. 55).[233] In the work of Campin, the figures have placed their hands on the stone parapet just as the figures of Barthélemy Alatruye and his wife Marie de Pacy seem to have placed their hands on the picture frame in the diptych of 1425 (figs. 58-59).

Like Jan van Eyck in his *Timotheos*, Campin also uses the stone parapet to convey a text. On the upper surface, the names of the figures have been 'carved in stone', foreshortened towards the centre; while the front of the parapet bears trompe l'œil relief carvings of sayings by the prophets. Both these textual elements, the names and the sayings, were visible in similar form in Campin's lost original.[234]

Just how the other four groups of portraits originally looked is less easy to ascertain. Only one portrait from each group (and in one case two portraits) has survived in the form of copies by Ludger tom Ring the Elder. However, a synopsis of all the surviving fragments of different replica cycles indicates that all the portraits were arranged in groups of three according to the same spatial scheme. What differed was the specific detailing of these mirror symmetrical rooms; two are stone buildings with a beamed ceiling (groups II and III: figs. 133-142), one a courtyard bounded by a high brick wall (group IV: fig. 143 s) and two are bourgeois living rooms with glazed windows (groups I and V: figs. 129-132, 145-148).

Campin displayed extraordinarily inventive creative powers in developing a wide variety of facial types, costumes and gestures in order to lend each of the ideal portraits its distinctive singularity. This is evident in the remaining figures of sibyls that survive in the copies by

tom Ring the Elder. Frigia appears as an elderly, grey-haired woman in a fantastically exotic costume with a helmet-like headdress adorned by a long white cloth (fig. 137). Her body is facing the spectator, but her head, and her eloquently gesturing hand are turned energetically towards the figure of Balaam in the central panel, emphasising her harsh profile.

The Cumaean sibyl in the central group of portraits is dressed less extravagantly (fig. 142). She is wearing a cloth knotted to form a turban over a red cap ornamented with a medallion. Her slightly bowed, youthful head has soft traits. Her entire pose is one of calm and concentration.

The next figure, the Samian sibyl, is surely one of the most appealing figures in the entire cycle (fig. 144). Her costume, its ornamentation and colour, appear exotic. Over a gold-coloured dress with golden trimmings, she is wearing a pink-lined robe of olive green, and her pink cap with golden tassels has a white cloth knotted about it. With a delicate gesture of her hand, Sibylla Samia presents an empty banderole to the spectator. It evokes the way in which the figure of Veronica in the Flémalle Panel in Frankfurt presents the transparent sudarium bearing the face of Christ (fig. 174).

In keeping with the Flemish interior, the Sibylla Chimica in the last group is also wearing contemporary northern European dress (fig. 148). Over a red garment with a finely pleated white collar, she is wearing a pale green bell-shaped coat with a regular pattern of radiating folds that wider out with the flare of the garment. The geometrically simple cut of the coat corresponds to the stiff spherical cap that forms a double arch at the top. A typical Campinesque feature is the way the head is turned towards the spectator so that the face seems to be framed by only one of the two symmetrical halves of the headdress. In much the same way, only one half of the hood frames the face of Milesius in the first group (fig. 131).

Even the arrangement of the hands demonstrates Campin's stereometric thinking in terms of the picture plane. The hands of the figure of Chimica are portrayed in symmetry, like those of Hermes beside her (figs. 145, 148). It is this compositional drive, so typical of

Fig. 129 Netherlandish (copy after Robert Campin), *Sibylla (Libyca)*. Coloured woodcut (unique), c. 1470. Basel, Öffentliche Kunstsammlung, Kupferst.chkabinett

The woodcut is a mirror image of the painting on which it is based.

Figs. 130-132 Ludger tom Ring the Elder (copies after Robert Campin), Sibylla Libyca, Milesius, Sibylla Delphica, c. 1538. Münster, Westfälisches Landesmuseum (Sibylla Libyca, Milesius); Paris, Musée du Louvre (Sibylla Delphica)

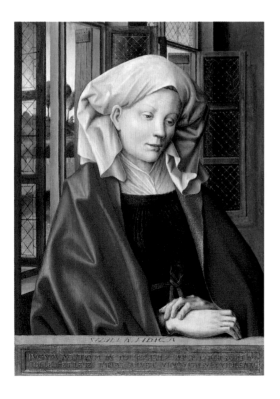

Figs. 133-134 Netherlandish (copies after Robert Campin), *Sibylla (Frigia)*, *pagan wise man (Balaam)*. Coloured woodcuts (unique), c. 1470. Basel, Öffentliche Kunstsammlung, Kupferstichkabinett

The woodcuts are mirror images of the paintings on which they are based.

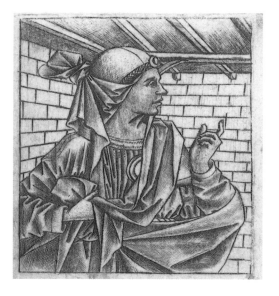

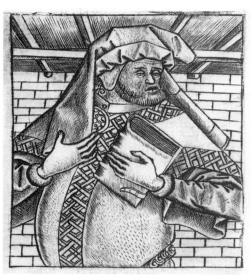

Figs. 135-136 Master of the Banderoles (copies after Robert Campin), *Sibylla (Frigia)*, *pagan wise man (Balaam)*. Copperplate engravings (unique), before 1461. Munich, Graphische Sammlung (on loan from the University of Munich), (pagan wise man); Brunswick, Herzog Anton Ulrich Museum, Kupferstichkabinett (Sibyl)

The engravings are mirror images of the paintings on which they are based.

Fig. 137 Ludger tom Ring the Elder (Copy after Robert Campin, c. 1538), Sibylla Frigia. Münster, Westfälisches Landesmuseum

The panels showing Sibylla Eritraea and the prophet Balaam are lost.

Sibylla Eritraea

Balaam

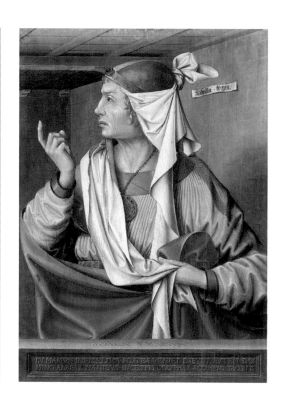

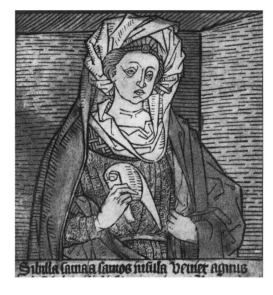

Fig. 139 Circle of Hans Pleydenwurff (copy after Robert Campin), *Sibylla (Tiburtina)*
Pen and wash, c. 1460/70. New York, The Ian Woodner Family Collection

The pain-filled gaze of the sibyl is explained by the caption referring to the death of Christ.

Fig. 140 Master of the Banderoles (copy after Robert Campin), *pagan wise man (Virgil)*, before 1461. Munich, Graphische Sammlung (on loan from the University of Munich)

The copperplate engraving is a mirror image of the painting on which it is based.

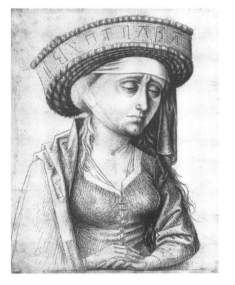

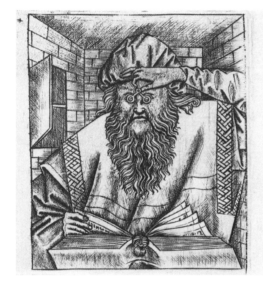

Fig. 138 Netherlandish (copy after Robert Campin), *Sibylla (Cumaea)*. Coloured woodcut (unique), c. 1470. Basel, Öffentliche Kunstsammlung, Kupferstichkabinett

In contrast to the original painting, this image is labelled *Sibylla Samia*. The beginning of the sibyl's caption also corresponds to that of fig. 144.

Figs. 141-142 Ludger tom Ring the Elder (copies after Robert Campin), *Virgil*, *Sibylla Cumaea*, c. 1538. Münster, Westfälisches Landesmuseum

The panel showing *Sibylla Tiburtina* is lost.

Sibylla Tiburtina

Fig. 143 Netherlandish (copy after Robert Campin), *pagan wise man* (*Albumasar*). Coloured woodcut (unique), c. 1470. Basel, Öffentliche Kunstsammlung, Kupferstichkabinett

Robert Campin, that indicates more strongly than any reiteration of motifs, that Campin was indeed the author of the original cycle of portraits of pagan wise men and sibyls.

An exploration of portraiture

In the above, we have discussed these five groups of portraits more or less in the order in which they were painted. The south-facing outer group (I), must have been painted first. The Libyan sibyl (fig. 130) represents a thoroughly conventional form of portraiture. It is a half-length portrait with upper body and head turned to three quarter profile. The hands are visible, but immobile. In Campin's œuvre, the London *Portrait of a Woman* (fig. 61) and the diptych of *Barthélemy Alatruye and Marie de Pacy* (figs. 58-59) correspond to this scheme. The Delphic sibyl (fig. 132) is portrayed according to a similar formula, though her frontal position is not represented in any other portraits by the school of Campin.

In creating these fifteen portraits of pagan wise men and sibyls, Campin had considerable scope for creative licence. There were no hard and fast rules regarding the portrayal of these pagan figures – neither in terms of iconography, nor in terms of pictorial formula. In the course of his work, Campin moved further and further away from the conventional scheme of the bourgeois portrait. The solutions he developed in doing so were to have an impact on the very genre that he had taken as his basis for these figures, and came to be adopted by artists of the following generation for portraits of their contemporaries.

Fig. 144 Ludger tom Ring the Elder (copy after Robert Campin), *Sibylla Samia*, c. 1538. Münster, Westfälisches Landesmuseum

The panels showing *Albumasar* and *Sibylla Hellespontica* are lost.

Albumasar

Sibylla Hellespontica

149

Fig. 145 Netherlandish (copy after Robert Campin), *pagan wise man* (*Hermes*). Coloured woodcut (unique exemplar), c. 1470. Basel, Öffentliche Kunstsammlung, Kupferstichkabinett

The woodcut is a mirror image of the painting on which it is based.

Figs. 146-147 Master of the Banderoles (copies after Robert Campin), *Sibyls* (*Chimica* and *Persica*), before 1461. Brunswick, Herzog Anton Ulrich Museum, Kupferstich-kabinett

The paper on which the copperplate engraving of *Sibylla Chimica* has been mounted is dated 1461. In contrast to the painting on which it is based, the figure is identified here as *Sibylla Persica*.

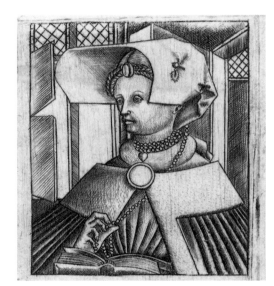

Fig. 148 Ludger tom Ring the Elder (copy after Robert Campin), *Sibylla Chimica*, c. 1538. Münster, Westfälisches Landesmuseum

The panels portraying *Sibylla Persica* und *Hermes* are lost.

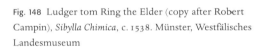

Sibylla Persica

Hermes

In groups II to V of the pagan wise men and sibyls an increasing proportion of the body is shown, until, in the case of the Phrygian and Samian sibyls (figs. 137, 144), what we see is to all intents and purposes a half-length portrayal. At the same time, the hands are no longer passive. They now hold parts of the costume or banderoles, and the pose of the figure is no longer static, but seems to be captured in movement. Above all, however, the figures seem more alive, gesturing expressively with their hands or pointing towards figures and objects.

A number of examples can be found to illustrate how these new solutions, with which Campin was experimenting here for the first time, were adopted in fifteenth century portraiture as a whole. The new potential tapped by Campin in his later period was to remain more or less valid until the advent of photography.

When Petrus Christus, in his 1446 portrait of *Edward Grymeston* (fig. 152), shows the sitter beneath a beamed ceiling in a corner of a room, he is transposing Campin's invention for the two sibyls of the second group into the medium of the autonomous portrait.[235] What Panofsky celebrates as a pioneering development is in fact the adaptation of a pictorial scheme created by Campin for his ideal portraits.[236]

In the triptych he painted after 1452 for the widow of Jean Braque (fig. 153), Rogier van der Weyden not only adopts Campin's figure of the Tiburtine sibyl as the model for his Mary Magdalene, but also emulates his former teacher's concept of uniting all three portrait panels by means of a single background. Moreover, he composes the work in such a way that the figures can be shown to move their hands freely, as in some of Campin's groups of three. The figure of the Delphic sibyl created by Jörg Syrlin the Elder for the choir stalls in the cathedral of Ulm around 1470 (fig. 150) is not based, as was previously assumed, on Rogier's Magdalene (fig. 153). Instead, as has been proven in the case of other figures carved by Syrlin, the model was undoubtedly a lost print from the series of early woodcut copies after Campin's Tiburtine sibyl, whose appearance has been recorded in the drawing from the circle around Pleydenwurff (fig. 139).[237]

Fig. 149 Master of the Banderoles, *Holy Kinship*, copperplate engraving (unique exemplar), c. 1470. Dresden, Staatliche Kunstsammlungen, Kupferstichkabinett

In this portrayal, teeming with figures, the eastern Netherlandish artist has re-used some of his earlier copies of sibyls and prophets based on paintings by Campin.

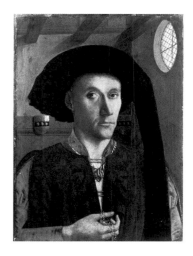

Figs. 150-151 Jörg Syrlin the Elder, *Sibylla Delphica*, *Sibylla Eritraea*, 1469–1474. Ulm, Münster, choirstalls

Syrlin has based some of his sibyls on the woodcut series after Robert Campin. For example, his *Eritraea* (right) is

based on Campin's Cumaea (fig. 142). His *Sibylla Delphica* (left) reiterates the *Sibylla Tiburtina* (cf. fig. 139) of Campin's cycle. The same is true of the figure of Mary Magdalene in Rogier van der Weyden's Braque triptych (fig. 153).

Fig. 152 Petrus Christus, *Portrait of Edward Grymeston*, 1446. London, National Gallery

The oldest portrait panel showing the figure in a room betrays a knowledge of Campin's cycle of ancient prophets and sibyls.

In a triptych painted in 1487 for Benedetto Portinari (fig. 154), Hans Memling leans unusually heavily on Campin's portrait groups, transposing Campin's treatment of space into the genre of devotional image combined with a portrait. Memling's figures of the donor, his patron saint and the Virgin and Child, are presented in a single, frontally portrayed interior, with sweeping views to an idyllic landscape in the background. Even the stone parapet with the perspectival lettering on the upper surface is a feature Memling has adopted from Campin's work. As the parapet is not included in the two printed replicas published before that date, it must be assumed that Memling had personally seen Campin's originals in the cathedral of Münster, whose fame had been spread by the printed copies.[238]

It is less surprising to find that Campin's work was also a major influence on Joos van Ghent's iconographically closely related work in 1476 for the *studiolo* of Duke Federico da Montefeltro in Urbino, for which he was commissioned to create a major sequence of portrait pairs of pagan and Christian scholars (figs. 155-156).[239] A comparison of Campin's work with the cycle of portraits designed by Joos van Ghent, and executed to some degree by assistants, gives an insight into a fascinating artistic dialogue.

Fig. 153 Rogier van der Weyden, Braque Triptych, after 1452. Paris, Musée du Louvre

Regarding the figure of Mary Magdalene on the right wing see fig. 139.

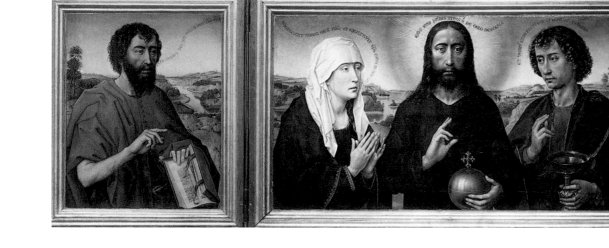

Fig. 154 Hans Memling, Triptych of Benedetto Portinari, 1487. Berlin, Staatliche Museen, Gemäldegalerie (central panel); Florence, Uffizi (wings)

The foreshortened inscriptions on the stone parapet indicate that Memling had seen Campin's cycle in the original.

Like Campin, Joos van Ghent has given each figure a face that, though not a portrait in the narrower sense, is distinctive and individual enough to appear convincingly life-like. It is what Max Jakob Friedländer described as "portrait invention rather than portrait observation". The painter also follows Robert Campin in his decision to place each group of figures in a single space and to separate them from each other by the secondary device of foreground framing elements. The disputation between a representative of the pagan world and the Christian world, central to the concept of the Urbino cycle, was foreshadowed in the Münster cycle in the sense that Campin, unfettered by iconographic necessity, frequently showed two of the three figures in the group engaged in conversation with one another. The fact that Joos van Ghent had studied this specific element in the work of his predecessor particularly closely is evident in the figure of Boethius (fig. 156). Not only is he attired in a manner similar to Campin's Hermes (fig. 145), but his hands are forming the same argumentative gesture, the *computus digitorum*. In one important respect, Joos van Ghent has

Figs. 155-156 Joos van Ghent, *Ptolemy and Boece*, c. 1476. Paris, Musée du Louvre (Ptolemy); Urbino, Galleria Nazionale delle Marche (Boece)

In creating the setting for his ideal portraits of Christian and pagan scholars for the studiolo of the Duke of Urbino, Joos van Ghent followed Campin's cycle. Even individual figures, most obviously that of Boece, are variations on figures created by Campin (cf. fig. 145).

gone further than Campin. He has related the simulated rooms perspectively to the specta-
tor and has shown the figures seated, as though in loggias, seen from below.[240] Campin's
series of portraits showing the prophets and sibyls appears to have found a final echo around
1530 in the work of Abraham Benson.[241]

Figs. 157-158 Anonymous French(?) Master, c. 1420(?)
and Robert Campin, after 1432/33 (cartoons), altar frontal
and dossal from the Ecclesiastical Paraments of the Order
of the Golden Fleece. Vienna, Kunsthistorisches Museum,
Weltliche Schatzkammer

The central image of the dossal designed by Campin
(fig. 162) was probably created to replace an earlier por-
trayal.

The Ecclesiastical Paraments of the Order of the Golden Fleece

The three copes and the central image of the altar dossal of the Ecclesiastical Paraments of the Order of the Golden Fleece (Cat I.23; figs. 157s, 163-165) represent Robert Campin's most important work, on the grounds of the sheer number of figures alone. Also known as the Vienna Vestments or Burgundian Vestments, these paraments have not been studied in depth by art historians in recent times.[242] Even publications on Campin's work as a whole ignore these embroideries in spite of the fact that Julius von Schlosser linked them to Robert Campin as early as 1912.

Paintings in textile

There are two reasons for this neglect of such an outstandingly important work. One is that the romantic notion of the artist as genius still tends to prevail, with the result that only those works involving the hand of the artist himself in their actual production tend to be accepted as 'original' and thus as aesthetically significant creations. The other reason it that art history is still a history of the three great genres of painting, sculpture and architecture. Embroidery is regarded as an 'applied art' or a 'decorative art' and, as such, tends to be studied only in terms of craftsmanship and stylistic development.

In Campin's day, however, silk embroidery was the most precious form of depiction. The Paraments of the Order of the Golden Fleece, 'the absolute apex of western embroidery'[243] are largely worked in an exceptionally time consuming and costly technique, the so-called Burgundian technique of superimposing silk embroidery over a background of gold threads, also known as *or nué*. This form of pictorial embroidery is comparable with the subtle shading involved in the glazing technique of oil painting, perfected around the same time by such pioneers of early Netherlandish painting as Robert Campin and the van Eyck brothers. Both these techniques of painting and embroidery are based on the concept of an optical mix achieved by superimposing different layers of colour. In the portrayal of draperies – it is here especially that the Burgundian technique of *or nué* is applied – coloured silk threads are embroidered in varying densities over a background of gold threads. The underlying gold threads radiate a warm and mutable brilliance throughout the entire portrayal. Flesh tones, by contrast, tend to be executed solely in coloured silk, in a technique known as needle-painting, while architectural frameworks are created for the most part by means of relief embroidery using gold thread. Even if the artist who designed the figures did not actually produce the final work himself, he could nevertheless precisely calculate the possible effects of Burgundian embroidery and the other techniques on the basis of their similarity to the painterly techniques with which he was familiar.

Fig. 159 Robert Campin (cartoon), Cope of Mary (cf. fig. 163), c. 1435

The copes were worn by officiating priests with their backs turned to the congregation.

Origins and history

The Paraments of the Order of the Golden Fleece consist of two altar hangings (figs. 157-158), three copes (figs. 163-165), one chasuble and two dalmatics (figs. 169-171). Together, they constitute a complete set of liturgical paraments, also known as a *chapelle*. Only the smaller items, stoles and maniples, are missing today. The paraments are first listed in detail in 1477 in the inventory of the Order of the Golden Fleece drawn up after the death of Charles the Bold. Although the paraments do not bear any of the known emblems of the Order of the Golden Fleece, the priests' robes at least were intended right from the start for the ecclesiastical ceremonies of this order founded in 1429 by Philip the Good, Duke of Burgundy. In accordance with their function, the figural embroideries of the vestments are all applied on a velvet background of crimson, the official colour of the order.

The designs for the vestments were drawn up by four different artists belonging to three different eras. With the exception of the central image of the altar dossal, which was designed by Campin, altar hangings still represent the late gothic style (figs. 157-158). The designs for all the figures of the three copes (figs. 163-165), the most significant contribution to the ensemble, can be ascribed to Robert Campin himself. It is surely Campin, too, who is also responsible for the honeycomb framework system that perspectively interprets the bell shape of the copes. The designs for the remaining three vestments, the chasuble and the dalmatics (figs. 169-171), are by two later artists. Some of them reflect figures invented by Campin, but in a harder style reminiscent of Rogier van der Weyden.

Julius von Schlosser identified the two altar hangings of the Vienna Vestments with an entry dated 1432/33 in the treasury books of Philip the Good. Thierry du Chastel, an embroiderer from Paris, was *varlet et brodeur* to the court of Philip the Good and had produced a number of embroideries for him since 1424. The document in question records that Duke Philip purchased from him two already completed and particularly sumptuous altar hangings together with smaller liturgical items: *deux tables d'autel très richement estoffées avec les IIII garnemens, stole, fanons, aubes, amits et tout ce que y appartient.* We may assume that the so-called *tables d'autel* or altar hangings mentioned, are indeed those now in Vienna (figs. 157-158) and that they formed the basis for the *chapelle* intended for the order that had been founded three or four years previously. By 1442, the three copes had been completed and were handed to the treasurer of the order.

Robert Campin's design for the central image of the altar dossal, featuring the *Trinity of the Broken Body* (figs. 157, 162), must have replaced an already existing portrayal in late gothic style. It is known that the endowments in connection with the foundation of the order were for the ducal chapel of the Charterhouse of Champmol, dedicated to the Trinity. There is a simple explanation for the fact that Robert Campin designed only the central image, assuming that the already completed altar dossal mentioned along with the antependium in the record of payment of 1432/3 had a central image closely related to the dedication of the altar for which it was originally intended.[244]

The embroidered group of the *Trinity of the Broken Body* on the altar dossal (fig. 162) bears a close affinity to the grisaille on the Flémalle Panel (fig. 161). The embroidery presents God the Father seated on a throne of porphyry with gothic ornamentation. He is holding the body of Christ in such a way that his left hand symmetrically reflects the pierced right hand of the Son. This compositional motif is reminiscent of the counterpoint between the hands of Christ and those of the Virgin Mary in the Madrid *Descent from the Cross* (fig.

103). God the Father is dressed in a red garment and red mantle. A long blue cloth flows from his shoulders spiralling twice around the body of Christ.

The similarity of form and content with the Flémalle Panel in this new and equally original figural composition are so striking that they can be no doubt as to Campin's authorship. (Note, for example, the way in which, in both works, the thumb and index finger of the hand with which Christ shows the wound in his side press into the naked skin.) The fact that such comparisons are possible at all would also indicate that the embroidery – for which Thierry du Chastel was probably responsible – corresponds to the painter's design in the minutest detail.[245]

Fig. 160 Hubert and Jan van Eyck, holiday side of the Ghent Altarpiece, before 1426/1432. Ghent, St. Bavo

A counterpiece to the Ghent Altar

The figures of the *Deësis* on the hoods of each of the three copes (figs. 166-168) are variations of the corresponding figures on the holiday side of the Ghent Altarpiece (fig. 160) probably created by Hubert van Eyck. The most striking similarities are between the two figures of Saint John, especially in terms of pose and facial type. The powerfully formed right hand, raised in blessing, in Campin's portrayal corresponds precisely to the model. Campin's figure of the Virgin is no longer reading but shown in the classical pose of intercession. The three differently composed thrones under baldachins are Campin's own invention. The throne of the Virgin has been composed as a small architectural structure that seems to foreshadow the semi-classical round temple that Jan Gossaert was to paint almost a hundred years later for his portrayal of *Danae* in Munich. The open drapes wound around the pillars recall the blue cloth that winds around the body of Christ in the central image of the altar dossal.

Fig. 161 Robert Campin, *The Trinity of the Broken Body.*
Frankfurt, Städelsches Kunstinstitut

Fig. 162 (right) Robert Campin (cartoon), *The Trinity of the Broken Body* (detail of fig. 157)

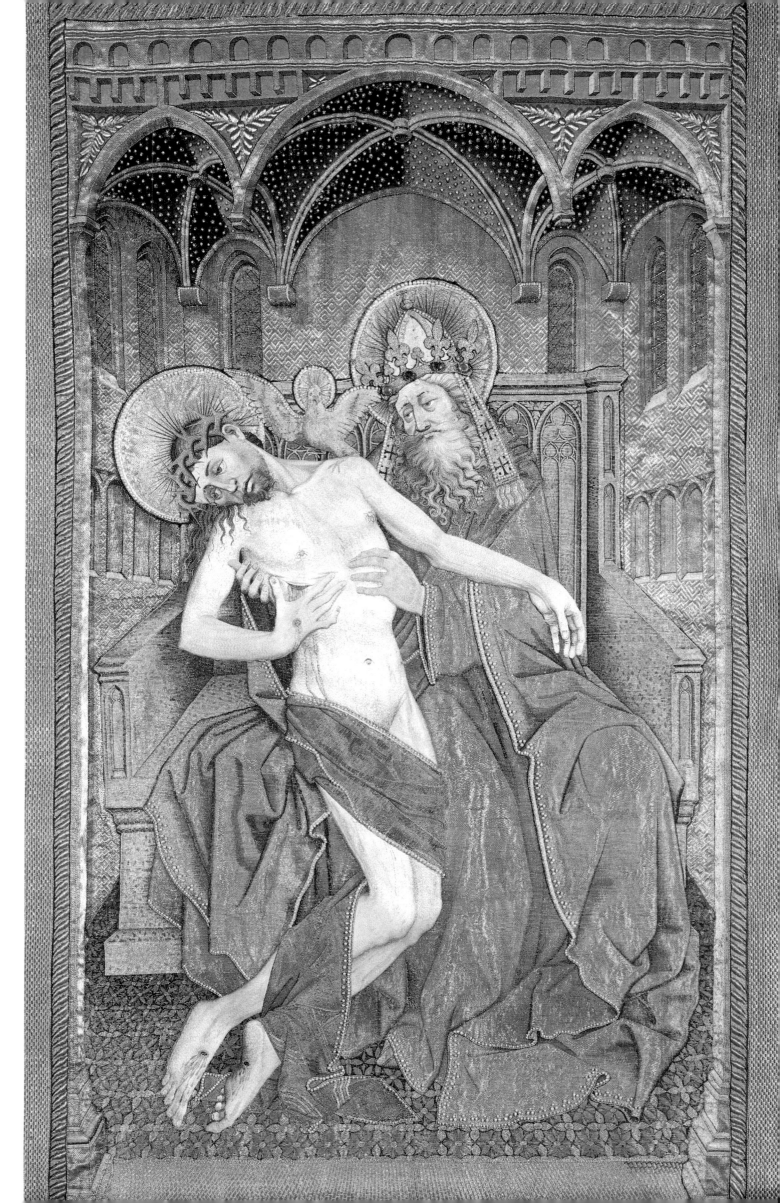

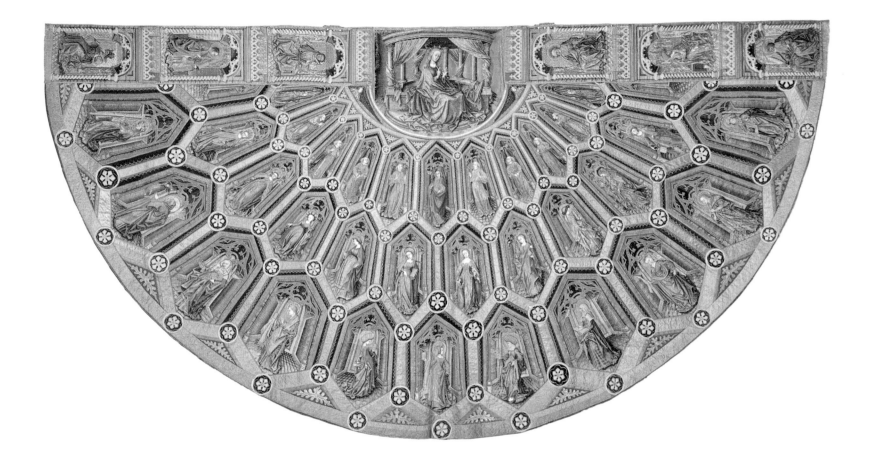

Figs. 166-168 Robert Campin (cartoon), hoods of the three copes, c. 1435 (details of figs. 163-165)

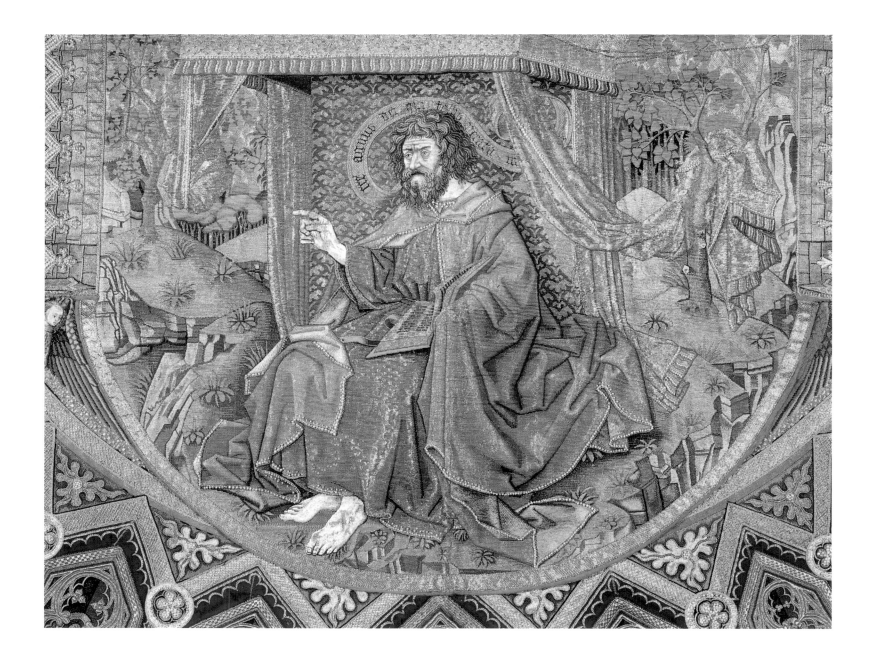

The three copes (figs. 163-165) are all structured according to the same scheme. The semi-circle formed by the cope when it is spread out flat has been divided up into an elongated honeycomb pattern radiating from the hood. Where the panels of cloth meet, there are pearl studded rosettes. The hexagons in three horizontal rows all contain the same tracery-ornamented niches. In the niches of the upper row there are always ten angels or cherubs and in the two lower rows there are twenty one (ten plus eleven) figures of saints.

As Herbert von Einem noted, the three copes reiterate the same iconographic programme as the *Adoration of the Trinity* on the holiday or feast-day side of the Ghent Altarpiece completed in 1432 (fig. 160). The *Deësis* group portrayed on the hoods is accompanied by choirs of angels and saints, distributed between the three copes according to traditional hierarchical categories: virgins, women and widows on the Cope of Mary, martyrs, princes, bishops and learned men on the Cope of Christ, patriarchs and prophets, monks and hermits on the Cope of Saint John. The Cope of Mary features the archangel Gabriel, angel of the Annunciation, surrounded by adoring angels, in the first row, while the Cope of Christ features the highest ranking archangel Michael among cherubim, and the Cope of Saint John features the archangel Raphael, also flanked by angels. On the orphrey of each cope there are three apostles to the right, and three prophets to the left, in sumptuously ornamented rectangular niches (figs. 163-165).[246]

It may be assumed that Philip the Good had these vestments produced as a courtly rival to the altarpiece donated by a Ghent citizen. The difference in technique is significant. In place of oil painting, in which material value played a secondary role, the Duke of Burgundy commissioned a work in the most sumptuous and costly form of figural expression – embroidery worked in gold, silver and silk and studded with pearls and precious stones.

Unlike the Ghent Altarpiece, none of the three copes features the Lamb of God which is traditionally the central figure of an Adoration of the Trinity. It may be assumed that this has been replaced by the figure of the dead Christ in the central image of the altar dossal (fig. 162). In this way, all three copes would refer to the central motif of the portrayal of Christ above the altar itself.

One hundred and fourteen figures

Each one of the one hundred and fourteen figures features the powerfully modulated folds so characteristic of the drapery style in Campin's mature work. Even where one of the figures can be found repeated in another work by Campin, the robe is not identical. Take, for

Figs. 169-171 Workshop of Rogier van der Weyden and anonymous artists (cartoons), the two dalmatics and the chasuble from the Ecclesiastical Paraments of the Order of the Golden Fleece, after 1442. Vienna, Kunsthistorisches Museum, Weltliche Schatzkammer

The cartoons for these three robes were created after the cartoons for the copes from which they have adopted a number of figures.

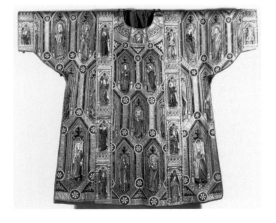
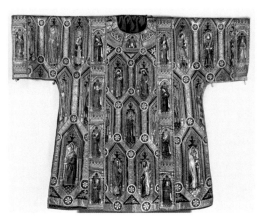
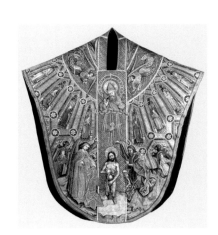

Fig. 172 Robert Campin (cartoon), *Saint Gudula*, c. 1435
(detail of fig. 163)

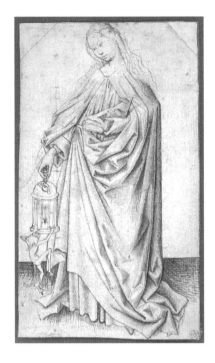

Fig. 173 Robert Campin, *Saint Gudula*, c. 1430. Rotterdam,
Museum Boymans-Van Beuningen

Fig. 174 Robert Campin, *Saint Veronica displaying the
Sudarium*, c. 1430. Frankfurt, Städelsches Kunstinstitut

Fig. 175 Robert Campin (cartoon), *Saint Veronica displaying
the Sudarium* (detail of fig. 163)

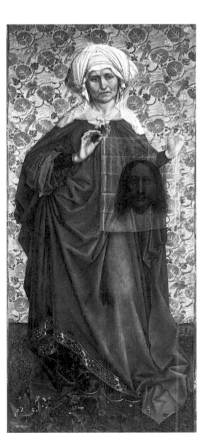

example, the figure of Saint Gudula. On the
Cope of Mary (fig. 172) and in the drawing
in Rotterdam (fig. 173), she has the same
facial type and exactly the same position of
the right hand – in both works she is holding
a lantern with her crooked index finger. In
the drawing, the long, vertical folds empha-
sise the block-like and statuary character of
the figure, while the figure in the textile
work adopts an elegantly mobile pose
whose fluid lines set a striking contrast to
the geometric framework. The same is true
of the figure of Veronica, which Campin
also portrayed twice. On the Cope of Mary
(fig. 175) and in the Flémalle Panel (fig.
174), she has similar turban-style headwear;
in both cases she is presenting the *sudarium*
with a similar hand position. However,
whereas the saint in the altarpiece appears
upright and immobile, the figure in the
embroidery seems to echo something of
the gothic serpentine.

A textile choreography

Campin tended to place figures of saints in
similar clothing in the same row of niches,
distinguishing them from one another by
means of different body poses. For example,
the lower row of the Cope of Saint John (fig.
165) features ten monks dressed in long
habits, each carrying a stick, and, with one
exception, all carrying a rosary with thick
beads in their hands. Some are shown in pro-
file, some frontally, some in rear view with a
slight sideways turn of the head. Often, two
adjacent figures look towards each other
over the boundaries of their niches. Some-
times, a rapid change of direction is sug-
gested by a strong turn along the body axis.
The spectator perceives such an alignment of
similarly clothed figures 'cinematographi-
cally', as it were. Together, they appear like a
single figure moving and adopting different
poses within a space in which it is presented.

On the lower row of the Cope of Mary (fig. 164) there is a group of three saints, similarly attired and in similar pose, aligned in mirror symmetry along the central axis. Surprisingly, this group of three does not represent an iconographic unit. The attribute of an ointment jar identifies two of these women as Marys. The third, with a crown in her hand, is Saint Elizabeth of Hungary. The figure of the third Mary, also carrying an ointment jar in her hand, is set apart from the group of three and turned away from them. The ambivalence of her position forges a link with the following figures of saints. Such subtle shifts between groups, defined on the one hand by content and on the other hand by form, allow Campin to link long rows of isolated framed figures of saints in persuasively composed sequences.

Featuring no fewer than one hundred and fourteen figures, these three copes overshadow Robert Campin's entire painterly œuvre in terms of numbers alone. Yet aesthetically, too, they may be regarded as Campin's most mature work. They deserve to be regarded on equal terms with the painterly miracle of the Ghent Altarpiece. Although the copes were created later than the altarpiece by the van Eyck brothers, and although they are based in part on them, this is no mere imitation. Campin's choreography of sixty-three saints, thirty-three angels, nine prophets and nine apostles, is an original creative achievement in its own right. Campin cannot have had any real precursor for the design apart from the Ghent Altarpiece. It is a work so lavish, so exquisite and so inaccessible, that – with the exception of the *Trinity of the Broken Body* on the altar dossal – it has remained an isolated example of its art.

CAMPIN'S PLACE IN THE HISTORY OF ART

Campin and the van Eyck Brothers

Hans Belting has described the *Ghent Altarpiece* (fig. 160) as a 'compendium of painting', a work representing all the major themes that informed the aesthetic discourse of the early fifteenth century. Accordingly, the polyptych also bears numerous traces of an artistic dialogue between the three pioneers of early Netherlandish painting, Robert Campin and the brothers Hubert and Jan van Eyck.

When Robert Campin designed the three liturgical copes for Philip the Good, Duke of Burgundy, the Ghent Altarpiece was the point of reference for his artistic work. Yet the inspiration was mutual, the influence reciprocal. Standing before the finished altarpiece some time after 1432, and contemplating the workday side, Campin would have noted that the central theme of the Annunciation (fig. 176) cited two motifs he had developed himself.

Lavabo niche and window view

Technical studies have shown that the figures in the *Annunciation* scene of the Ghent Altarpiece were originally intended to be portrayed within an abstract space beneath semicircular arches reiterating the tracery of the niches in the lower zone, and that the decision to set the figures in a realistic interior with a beamed ceiling and aperture was made during the course of the work.[247] Certain stylistic features of the room indicate that it was Jan van Eyck who was responsible for this change. The two figures, on the other hand, possess the same heavy style of drapery as the apostles and prophets in the *Adoration of the Lamb* (fig. 160), indicating that these, or at least the designs for them, are the work of Hubert van Eyck.

Fig. 176 Hubert and Jan van Eyck, *Annunciation* from the outside of the Ghent Altarpiece. Ghent, St. Bavo

The two middle panels with lavabo niche and double window are a mirror-image variation on the back wall of the Virgin's room in the Mérode Altarpiece (fig. 42).

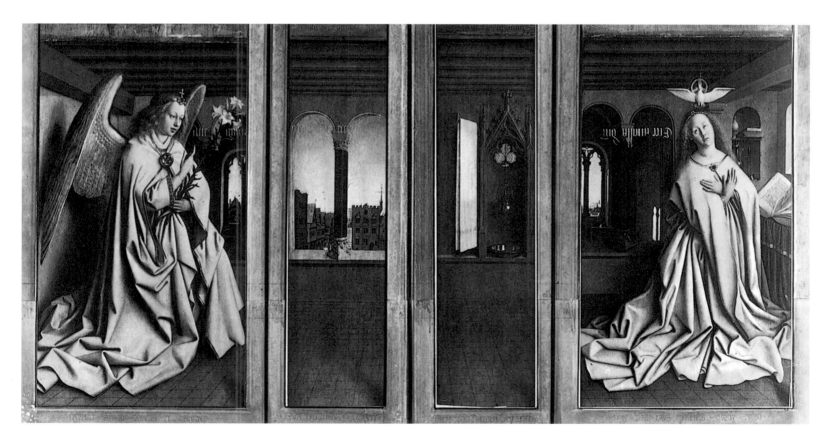

It has long been widely acknowledged that the ensemble of lavabo niche and towel is very similar to that in the Mérode Tripytch (fig. 42). Even the stripes on the towel are similar. Karl von Tolnai has pointed out that a view from the window also appears on the Saint Joseph panel of Campin's tripytch.[248] There are other parallels, too. In both works, the two motifs – the view from the window and the lavabo niche with the towel – belong together. The section of the back wall that can be seen on the narrow inner panels of the Ghent *Annunciation* corresponds, albeit in reverse, to the back wall in Campin's *Annunciation* scene. By dividing the window and the lavabo ensemble between two panels, Jan van Eyck has created two contrasting spatial situations: on the side of the angel the chamber is open wide to the world, while on the side of the Virgin it is closed, and the still life serves to visualise the virtue of Mary's virginity.

It has been firmly ascertained that Jan van Eyck was inspired by Campin rather than vice versa. Infrared photographs show that, in Jan van Eyck's underdrawings, the lips of the basin were set diagonally, as in the Mérode Triptych, and that the calmer symmetrical alignment was achieved only in the course of the painterly process.[249]

Studio visits in Tournai

Being a privately commissioned work, the Mérode Triptych was delivered to the home of the Engelbrecht-Schrinmechers in Cologne soon after its completion. This means that Jan van Eyck must have had the opportunity of studying the painting while it was still in

Fig. 177 Hubert and Jan van Eyck, grisailles und donor figures from the outside of the Ghent Altarpiece. Ghent, St. Bavo

Fig. 178 Jan van Eyck, Dresden Altarpiece, closed, 1437. Dresden, Staatliche Kunstsammlungen

The grisaille figures, in contrast to those in the Ghent Altarpiece (fig. 177) are quite unsculptural.

Fig. 179 Robert Campin. *The Trinity of the Broken Body.* Städelsches Kunstinstitut, Frankfurt am Main

Campin's studio, if he did not merely base his work on a design by Campin or a workshop copy. As it happens, there is documentary evidence that Jan van Eyck did in fact visit Tournai on two occasions at precisely the time when Campin must have been working on the Mérode Triptych. The first visit was on 18 October 1427, the name day of Saint Luke, and the second visit was on 23 March of the following year.[250]

Campin's recently completed work, though modest in proportion, must have made a profound impression on this court painter to Philip the Good. Following an unsettled period of extensive travel in the service of his patron, Jan van Eyck set about completing the altarpiece that Hubert van Eyck had left unfinished and, in doing so, introduced many new elements that he had discovered in Campin's studio. He adopted Campin's central idea of setting the Annunciation in a bourgeois living room with a background view of the earthly world, thereby rendering more tangible the event of Christ coming to dwell among men in the spectator's own world. The idea of using the furnishings in Mary's living room to describe her virtues is also taken from Campin, albeit rather tentatively and with a slightly different slant. The symbolic interpretation of scenically integrated everyday objects, probably developed by Campin, and used extensively in the Mérode Triptych, is applied by Jan van Eyck in a more symbolic form that is not so closely woven into the narrative of the picture.

In his portrayal of the Annunciation, Campin employs a metaphor of the Virgin birth already documented in texts – the capacity of light to penetrate glass without breaking it. Whereas Campin illustrates this by way of a round window in the wall on the left, Jan van Eyck chooses to place a glass vase on the parapet behind the Virgin (fig. 176). This motif of glass penetrated by light in the isolated form of a vase or other vessel was to become a versatile and subsequently frequently copied symbol of virginity as such.[251] Presented on a separate panel, the ensemble of water basin and towel appears more symbolically charged in the work of van Eyck than it does in Campin.

Significance and perspective

The back window in the central panel of the Mérode Triptych (fig. 42) originally opened onto a golden sky. According to Tolnai, Jan van Eyck adopted the view of the world from the Joseph panel in the same work and transferred it to the *Annunciation* scene. However, van Eyck's view from the window onto a contemporary townscape differs in one important respect from the Mérode Triptych. It is shown from an elevated vantage point.

If we regard the workday side of the Ghent Altarpiece as a view into a three-storey building with its facade removed, we might be tempted to explain this angle by the fact that the *Annunciation* scene is set on the first floor. Yet this downward view from an elevated vantage point also has a symbolic aspect. It presents the Virgin Mary as a sublime figure on a level far above those standing before the painting, who have come from the world portrayed in the background. This is precisely the concept underlying the view from the window in the Salting Madonna (fig. 86). It may be assumed that Jan van Eyck was also familiar with this portrayal of the Virgin or a comparable work by Campin. In his Rolin Madonna produced only a few years after completion of the Ghent Altarpiece, Jan van Eyck repeated the same motif of the window view from an elevated position, this time with an unequivocally symbolic significance.[252]

Campin between Hubert and Jan van Eyck

The simulated unpolychromed stone sculptures on the outside of the Madrid panel showing the *Betrothal of the Virgin* (Cat. III.D.1a) were long regarded as the oldest surviving grisaille works in Netherlandish painting, for the work had been erroneously attributed to Campin and incorrectly dated. Occasionally, Campin was even hailed as the first painter to decorate the workday sides of altarpieces with imaginary sculpture.

Given that so few fifteenth century works of northern European art have survived, there seems little point in drawing up such lists of priorities. It is nevertheless possible to comment on the position of individual works within the overall development of grisaille painting by making some comparisons. Let us do so by way of example of some works by Campin, Hubert and Jan van Eyck.

The heavy and voluminous draperies have led most scholars to regard the simulated stone sculptures of Saint John the Evangelist and John the Baptist on the workday side of the Ghent Altarpiece as elements at least designed or underdrawn by Hubert van Eyck before his death in 1426 (fig. 177). If we compare these figures with the *Trinity of the Broken Body* on one of the Flémalle Panels (fig. 179), they appear to be more elementary, but also more coherent. They are consistently designed to simulate statuary plausibly, with their thick hemlines and solidly massed locks of hair. In the work of Campin, the draperies are similarly sculptural, yet the beard of God the Father has such fine locks that it could not possibly have been hewn in stone. The same applies, in particular, to the fragile dove of the Holy Spirit. Whereas Hubert's figures are clearly intended as examples of double mimesis, as sculpture simulated in paint, certain details of Campin's group of figures make them appear as painting without colour, as grisaille in the narrower sense.

The two figures of John the Evangelist and John the Baptist attributed to Hubert van Eyck foreshadow Campin's group of figures in one further respect. If we compare the *Trinity of the Broken Body* (fig. 179) with the other two Flémalle Panels (fig. 109), we find that they are treated in an entirely different way as regards the asthetic boundary of the picture plane. The simulated sculpture, to be regarded as the work of a mortal from the world of the spectator, uses all the means of trompe-l'œil technique available to the artist so that the figures seem to reach into the spectator's own space, stepping out from the wall formed by the picture plane. The figures on the holiday side, by contrast, the *Virgin and Child* and *Saint Veronica*, remain contained within the pictorial space, because they belong to a heavenly sphere separate from the spectator.

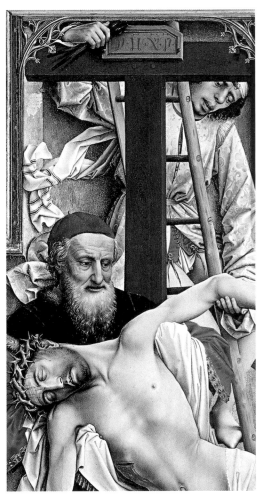

Fig. 180 Robert Campin (copy after), *The Bad Thief* (detail of fig. 117)

Fig. 181 Robert Campin, the helpers in the Madrid *Descent from the Cross* (Detail of fig. 103)

Both figures are wearing a white browband, whose ends flutter freely and cross in the air.

Fig. 182 Antonio Pollaiuolo, *Naked Dancer*, Detail of a fresco, c. 1470. Villa della Gallina, Arcetri near Florence

The figure with the browband (cf. figs. 180 and 181) is probably based on a work of classical antiquity.

The same difference in the treatment of simulated living figures and simulated sculptures can also be determined in the Ghent Altarpiece, albeit in a single and barely noticeable detail (fig. 177). The front edge of the pedestal on which the figure of John attributed to Hubert van Eyck is standing corresponds to the edge of the picture plane. Each saint has placed one foot on the pedestal in such a way that the tip of the foot appears to jut slightly into the spectator's space.[253]

Jan van Eyck's grisailles – two pairs of wing panels, each combining to portray an Annunciation scene – belong to a separate group in that they are small scale works intended for individual owners. The outside of the small Dresden Altarpiece (fig. 178) dated to 1437 shows the figures entirely enclosed in a deep, box-like niche. The draperies are remarkably painterly[254] and the laws of sculpture are demonstratively sublated in the painting, as indicated by the hovering dove. In this respect, Jan goes further than Hubert and even Robert Campin. In a work of his last years, the *Annunciation* diptych in the Thyssen-Bornemisza collection, Jan van Eyck ultimately adopts Hubert's heavy drapery style and simulates the transgression of the aesthetic border just as effectively as Campin does in his Flémalle Panel.

A comparison of Campin's work with that of the van Eyck brothers reveals, surprisingly, a closer artistic relationship between Robert Campin and Hubert van Eyck than between the two supposed brothers.[255] What is more, the surviving works, if our attributions are correct, indicate that Campin had studied closely only those parts of the Ghent Altarpiece known with some certainty to be the work of Hubert van Eyck, that is to say, the grisailles on the workday side and the *Deësis* on the holiday side.[256] On the other hand, Jan's undoubted contribution to the workday side – the room of the Annunciation scene – is clearly the result of Jan's close study of Robert Campin's work. In other words, Campin looked to Hubert, and Jan looked to Campin. In terms of artistic generations, then, the order in which we must name the pioneers of early Netherlandish painting is as follows: Hubert van Eyck, Robert Campin, Jan van Eyck.

Italy

A study of the drawing in the Louvre (fig. 65) has surprisingly revealed that Campin must have undertaken a journey to Italy prior to 1425. The *Meleager Sarcophagus* (fig. 73) on which he based his portrayal of the *Bearing of the Body of Christ to the Sepulchre* long before Italian Renaissance painters adopted it, is a work that Campin could have only have studied at first hand in Italy. His portrayal of the Good Thief (fig. 119) is probably based on the same work of classical antiquity. At any rate, the figure of the thief would be virtually inconceivable without a prior knowledge of the athletic physical ideal of classical sculpture.

Another motif to be found in two altarpieces created by Campin around 1430 are also based on an ancient work: a band tied to a man's head, its fluttering ends of equal length crossing in the air behind him (figs. 180, 181). Pollaiuolo later used this same ancient pathos formula, independently of Campin, in the figure of one of his naked dancers in the frescos for the Villa Gallina near Florence (fig. 182).[257]

Sienese and Florentine Painting

Apart from these references to works of classical antiquity, Campin's works also clearly reflect aspects of earlier Italian painting, especially that of Siena and Florence. Unlike the *Meleager Sarcophagus*, however, Campin need not have studied these models in Italy, as Italian panel paintings arrived in northern Europe fairly early, where they were studied by northern European painters and used as models for their own works.[258]

The asymmetrical composition of the Mérode Triptych (fig. 42) is foreshadowed by the Sienese altar painting of the trecento some eighty years earlier. An altarpiece created in 1342 by Pietro Lorenzetti (fig. 184) is strongly related to Campin's triptych. It portrays the Birth of the Virgin on three panels and was flanked by two figures of saints at its original location on an altar in the cathedral of Siena.[259] It is surely no coincidence that this particular altarpiece should be echoed in Rogier van der Weyden's Columba Altarpiece, perhaps through the intermediary influence of Campin.[260]

Unlike Jan van Eyck, who does not appear to have used this formula, Campin clearly has a preference for the iconographic type of the Madonna of Humility, which also originated in Siena.[261] The figure of the Virgin and Child crouching on the ground in the triptych of *Saint Luke* (fig. 92) bears striking similarities with a surviving painting signed by Domenico di Bartolo (fig. 183). We may assume that Campin was familiar with a closely related Italian *Madonna* panel.[262]

Fig. 183 Domenico di Bartolo, *Madonna of Humility*, 1433. Siena, Pinacoteca Nazionale

For his Saint Luke Triptych (cf. figs. 89, 92) Campin looked to a related Italian work.

Amor and Psyche in Tournai

Campin clearly encountered Italian painting in another even more remarkable way. Although Campin's *Life of Joseph* (fig. 185) is a multi-scenic narrative that does have some precursors in northern European painting, it is highly unusual in its use of a horizontal format and strictly axial symmetry. Both these elements are typical of the Florentine *cassone* panels of the quattrocento. Campin would appear to have designed his portrayal of the *Life of Joseph* on the basis of such a work.

The Berlin Museums collection includes the surviving front panels of a pair of wedding caskets, which, taken together, relate the story of Amor and Psyche after Apuleius and Boccaccio (figs. 186, 187). They were created by the Master of the Argonaut Panels around 1470, probably in connection with the marriage of Lorenzo de' Medici and Clarice Orsini in 1469. The Master of the Argonaut Panels did not invent the composition himself. The first of the two images can be found in two other *cassone* pictures produced at a later date but featuring older architectural forms. This would suggest the existence of a lost prototype.[263]

The *Life of Joseph* is closely related to the first of the two panels by the Argonaut Master in terms of compositional structure, as the following common features indicate: the horizon is located about four fifths up, a meandering path links a foreground scene on the left with a scene in the centre ground, the centre of the panel is occu-

Fig. 185 Robert Campin (copy after), Life of Saint Joseph. Hoogstraten, St. Katarinakerk

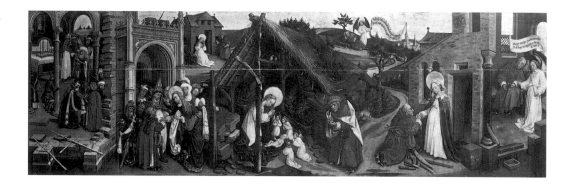

pied by a symmetrical structure such as a rocky outcrop or a hovel. At the left and right edges respectively, there are two buildings, their fronts parallel to the picture plane and open to the spectator, with side walls containing a door aperture facing along the perspectival lines of flight that lead into the centre of the picture.

As if all of this were not enough, both the Netherlandish and the Italian composition contain a secondary scene in front of a building in the left-hand centre ground and another secondary scene featuring a figure asleep under a tree in the right-hand centre ground. The obvious conclusion to be drawn from this is that Campin not only knew a work of the same compositional structure as the Berlin *cassone* panel, but must also have been familiar with a portrayal of the tale of Amor and Psyche that foreshadowed the work by the Argonaut Master.

A glance at the second panel by the Florentine master (fig. 187) confirms this. Here, we find Psyche kneeling before the mother of the gods, Juno, in front of her palace to beg forgiveness for her indiscretion. In Campin's work, Joseph is kneeling before the pregnant Mother of Christ in front of their house to beg forgiveness for his doubts.[264]

Fig. 184 Pietro Lorenzetti, *The Birth of the Virgin*, 1342. Siena, Museo dell'Opera del Duomo

Campin's asymmetrical triptych structure can be found in earlier works of the Sienese school.

Campin has considerably altered the buildings on the left and right edges in comparison to the picture on which he has presumably based this work. Campin clearly felt that the technique used in the Italian composition of opening up the walls to provide a view into the interior of the building was outmoded. It almost seems as though he developed his sophisti-

Fig. 186 Argonaut Master, c. 1470. First part of the story of *Amor and Psyche* (cf. fig. 187). Berlin, Staatliche Museen, Gemäldegalerie

Fig. 187 Argonaut Master, c. 1470. Second part of the story of *Amor and Psyche* (cf. fig. 186). Berlin, Staatliche Museen, Gemäldegalerie

The motif of Psyche begging forgiveness from the goddess Juno before her palace was adopted by Campin for the scene of Joseph's Repentance.

cated solution with the church under construction to the left and the dwelling house to the right as a means of countering the archaic spatial handling of the earlier work.

Even the meaning of the myth seems to have played a role for Campin. Although there is a radical change of genre in the transition from the two Italian wedding pictures to the Netherlandish altarpiece, the basic narrative structure remains the same. The pagan tale of love between a god and a mortal is transformed into the biblical tale of an equally impossible marriage between the mortal Joseph and the blessed Mary, Mother of Christ. Campin must have had the portrayals on the two Florentine *cassoni* explained to him in detail by the artist or owner, either in Florence or in Tournai.[265]

Six Students

Campin's outstanding role in the development of early Netherlandish painting, and indeed in the development of northern European painting as a whole, went unrecognised for a long time due to a number of unsolved questions of authorship. Today, there can no longer be any doubt that Campin's work had a far stronger impact, both and direct and indirect, on subsequent generations of painters than the œuvre of Jan van Eyck. In Netherlandish painting, the fifteenth century was not so much the age of van Eyck as the age of Campin.[266]

Apart from contemporary awareness of his work – Campin's works were highly regarded during the artist's own lifetime throughout the southern Netherlands among the bourgeoisie and aristocracy alike – a number of different forms of indirect reception also contributed to the dissemination of Campin's artistic concepts. First of all, this took the form of works by his own students, then the works of other artists eager to emulate him from an early stage, not only within the Netherlands, but also to an almost equal degree in nearby north-west Germany. Finally, there were many copies and paraphrases after compositions by Campin created predominantly around fifteen hundred in the course of the revival of the style of the first generation painters.

Campin appears to have headed his own workshop by 1406 at the latest. Here, he successfully trained a number of students, some of whom went on to enjoy considerable success themselves as master painters, most notably Rogier van der Weyden and Jacques Daret. Apart from these two artists officially registered as students of Robert Campin between 1427 and 1432, the register of the painters' guild of Tournai also documents two others: Haquin de Blandin, who began his apprenticeship in 1426 and probably never completed it, and a certain Willemet, also documented for the period 1427 to 1432, for whom no surname is noted in the register. The fact that Campin had four advanced students under his tuition at the same time prior to 1432 would certainly indicate an active workshop.

As the register of the painters' guild has not survived in full, with entries referring to students available only for the years following 1426/7, nothing is known about any earlier students of Campin, with one notable exception. According to a surviving document from a different source, Hannekin (Jan) van Stoevere, son of the respected and wealthy Ghent based painter Gheerart van Stoevere, studied under Campin from around 1415 to 1419, before completing an additional goldsmithing apprenticeship.

As the register of the painters' guild of Tournai mentions no further students of Campin for the period after 1432, the year in which Campin was sentenced by a court for the

second time, we may assume that Campin took on no more apprentices in the last thirteen years of his life.

Apart from the works associated with the names of Rogier van der Weyden and Jacques Daret, stylistic studies allow us to ascertain four further groups of works that must surely have been created by students who trained under Campin himself. Each of these four groups of works is informed by a distinctive and clearly definable artistic personality. As we do not know the names of the artists who painted them, they are named here by their major works: the Master of the Hortus conclusus, the Master of the Madonna by the Grassy Bank, the Master of the Betrothal of the Virgin and the Master of the Louvain Trinity. Two of these anonymous artists may well be the early student Jan van Stoevere or the enigmatic Willem, who was a member of Campin's workshop until 1432.

Without further evidence, it is not possible to ascertain whether a panel that we attribute to one of these six students of Campin was actually created during the period spent in Campin's workshop or whether it was produced once the artist in question had become a master painter with a studio of his own. There are, however, two exceptions. One is a variation on the Mérode *Annunciation* in the Musée des Beaux-Arts in Brussels (Cat. III.C1; fig. 54) for which there are a number of indications that it must have been painted in Campin's workshop. The other is the pair of altarpiece panels in Madrid showing the *Betrothal of the Virgin* and the *Annunciation* (figs. 207, 208) which reveal the involvement of at least two different artists, indicating that they were produced by a student of Campin who had already left his teacher's workshop and employed assistants of his own.

Jacques Daret

Of all Campin's students, the life of Jacques Daret is the most fully documented.[267] Daret was born in Tournai, probably in 1401. Both his grandfather and his father were sculptors in wood. By 1416, at the latest, young Jacques, who had lost his mother at an early age, was apprenticed to Robert Campin. After 1418, Daret's guardian no longer had to make any payments to Campin, indicating that the youth, who was by then about seventeen years old, had begun to make a useful contribution to the work of the studio. It was not until 1427, however, following the reorganisation of the guilds and corporations, that Daret and three other advanced assistants were officially registered as students of Campin. In the year 1423, holy orders were conferred upon him by the Bishop of Cambrai. On the name day of Saint Luke in the year 1432, he was declared a free master and, on that same evening, was elected by the members of the Guild of Saint Luke as their *prévot* – probably as successor to his own teacher, who had been sentenced on charges of adultery.[268]

After the dissolution of his master's workshop, Daret founded a workshop of his own in Tournai. His half-brother Daniel was apprenticed to him on 8 January 1433. In 1436, he took on another student, this time only for miniature paintings. One of Jacques Daret's most important commissions was received from Jean du Clerq, Abbot of the Benedictine Abbey of Saint Vaast in Arras. The four panels showing scenes from the *Life of the Virgin*, created by Daret for the Abbot in 1434/5 (Cat. III.A.1) are the only surviving works in the entire Campin group that can be ascribed with certainty to a single artist on grounds of extant documents. These documents enabled Hulin de Loo to identify the figure of Robert Campin as an artist in 1902.

Daret also produced a number of works, now lost, for the Abbey of Saint Vaast in Arras, including a cartoon in tempera, in 1449, for a tapestry depicting the *Resurrection of Christ*. Daret lived in Arras between 1446 and 1458, later returning to Tournai. He was in charge of a team of artists commissioned to create two festive decors for the Court of Burgundy – for the *Voeu du faisan* in 1454 and for the marriage of Charles the Bold in Bruges in 1468. Daret probably received these two commissions not so much on the strength of his reputation as an easel painter, but because of his ability to execute major decorative commissions within a short time. Daret's name does not appear in documents after 1468.

Among the students of Campin, the work of Jacques Daret is the most distinctive. His painterly style remained extraordinarily consistent for a full quarter of a century, with its painstaking yet remarkably soft draughtsmanship. His faces are strikingly monotonous; the same long, crooked noses, large ears and thick lower lips can be found in almost all of his figures, be they biblical characters or individual portraits (figs. 188-191). The gaze is strangely glassy. If we compare Daret's *Nativity* (fig. 189) with the *Nativity* painted by his teacher Campin (fig. 26), on which it is based, we note an obvious tendency to simplify and even diminish the artistic syntax. Nevertheless, Jacques Daret had a distinct sense of subtle color-

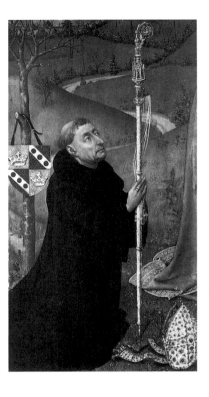

Fig. 188 Jacques Daret, *The Visitation*, 1434/35, detail. Berlin, Staatliche Museen, Gemäldegalerie

Donor Jean du Clerq, Abbot of the Benedictine Abbey of St. Vaast in Arras

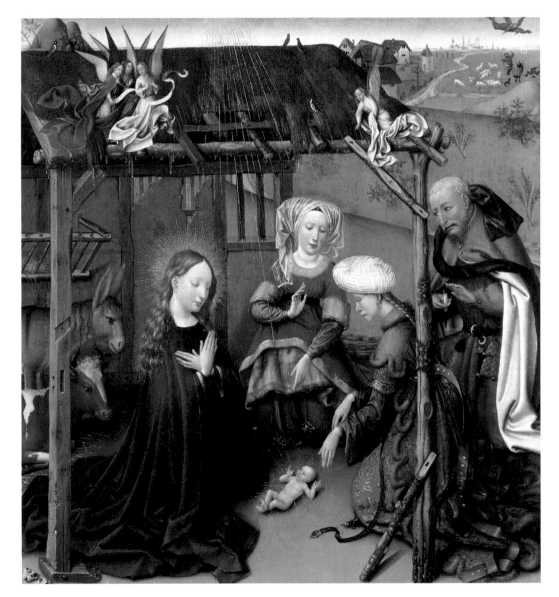

Fig. 189 Jacques Daret, *The Nativity*, 1434/35. Madrid, Thyssen-Bornemisza Collection

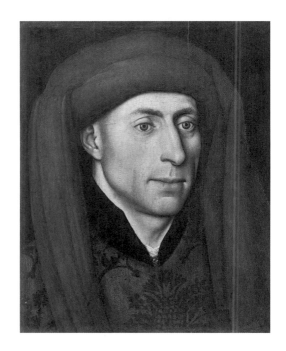

Fig. 190 Jacques Daret, *Portrait of a Man*. Berlin, Staatliche Museen, Gemäldegalerie

ity. In this particular respect, the handling of colour in his *Nativity* surpasses the extremely calculated handling of colour in Campin's work.

Daret seems to have been particularly in demand as a designer of tapestries. The series of tapestries dated 1460 for the Cathedral of Beauvais with scenes from the *Life of Saint Peter*, the designs for which Fabienne Joubert has convincingly attributed to Daret, have a remarkably archaic and formulaic expression that relies strongly on decorative effects (cf. fig. 191). The same style can be found in a number of other tapestries woven in Tournai around 1460.[269] Daret's work as a *cartonnier* would appear to be primarily responsible for the fact that the medieval tapestry style with its high horizons and non-perspective buildings survived so long in Tournai.[270]

Rogier van der Weyden

Campin's most brilliant and most famous student was another native of Tournai, Rogier van der Weyden (fig. 192). The few surviving documents relating to his early years pose a number of interpretative problems.[271] Rogier, the son of a cutler, was born in 1399 or 1400. According to the register of the painters' guild, he was already a married man and the father of a son when he studied under Campin between 1427 and 1432, along with Jacques Daret, who was about the same age. The remarkably late official start of his apprenticeship can be explained by the fact that the guilds and corporations of the city of Tournai had been reorganised shortly before. It does not allow us to deduce that Rogier had already completed an apprenticeship under another artist. Nor can there be any doubt that the Rogier de le Pasture mentioned in the documents of Tournai is identical with the later municipal painter of Brussels, where he bears the Flemish form of the name, van der Weyden. Several documents from his Brussels period record that van der Weyden came from Tournai.

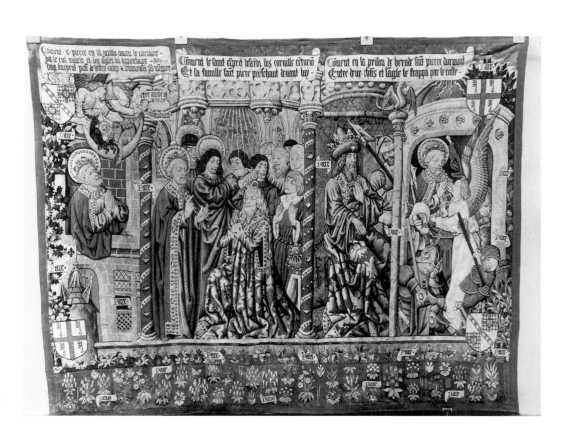

Fig. 191 Jacques Daret (cartoon), tapestry with scenes from the Life of Saint Peter, 1460. Beauvais, Cathedral

The fact that Rogier is not mentioned in a document dated 18 March 1426 concerning the sale of his father's house, has been interpreted in a number of ways. Either Rogier no longer had any share in the property,[272] or he was represented by someone else *in absentia*.[273] Just how long Rogier was away from Tournai in this case must remain a moot question.

Fig. 192 "maistre rogiel, peintre de grand renom", drawing after a portrait of Rogier van der Weyden. Arras Bibliothèque municipale, Ms 266

There has been considerable debate about the documents recording that one 'Maestre Rogier de le Pasture' received a gift of wine from the city of Tournai on 17 November 1426.[274] The gift may have been made to mark Rogier's marriage around the same time to Elisabeth Goffaert from Brussels. As Wymans 1969 has indicated, the word *maistre* was a commonly used title of honour, though the rules regarding its use were strict – before completion of his apprenticeship it cannot have been used to indicate that he was a free master painter. The author mentions five different uses of the word, two of which may have applied to Rogier. One definition was that he had completed studies at a university prior to becoming a apprentice painter. Another, more probable, explanation is that Rogier, like Jacques Daret, had taken holy orders, which need not have precluded later marriage. It is interesting to note that only Jacques Daret and Rogier van der Weyden already bear the title of *maistre* in the entries of the Guild Register documenting the appointments of master artists.

Recently discovered documents record that Rogier was paid independently for some minor works as early as 1427/8 while he was still officially a member of Campin's workshop. By the year 1434, at the latest, Rogier had his own workshop in Tournai.[275]

Rogier is documented as living in Brussels in April 1435. In a document dated 2 May 1436, he bears the title of municipal painter, and it is in this function that he painted the pictures of Justice for the Town Hall that were to seal his fame among his contemporaries. As the successful municipal painter of Brussels, Rogier continued to maintain many personal and professional contacts in his home town of Tournai. A number of commissions from people in Tournai are documented, including the Altarpiece of the Sacraments for Bishop Jean Chevrot and the triptych painted for the widow of Jean Braque (fig. 153). Rogier van der Weyden died on 18 June 1464, and the painters' guild of Tournai celebrated a funeral mass for him before the Altarpiece of Saint Luke in the church of Saint-Pierre.[276]

Even before 1445, Rogier had achieved international fame and was receiving commissions for works from patrons in Spain and Italy. In addition to the four famous panels of Justice in Brussels, destroyed in 1695, it was above all the works he created for the court at Ferrara that were so highly accolated in early documents. Ironically, this meant that Rogier's name was handed down through the centuries while the name of his teacher Robert Campin, to whom he owed more than his basic craftsmanship alone, was soon forgotten.

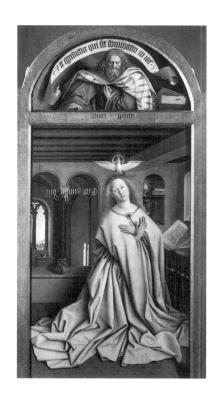

Fig. 193 Jan van Eyck, *The Prophet Micah* and *The Virgin Annunciate*, detail of the workday side of the Ghent Altarpiece, 1432. Ghent, St. Bavo

It is quite possible that Rogier van der Weyden, even inadvertently, had himself contributed to Campin's *damnatio memoriae*. A survey of the early surviving works that can be attributed with some certainty to Rogier – all created after he left Campin's workshop in 1432 – indicates that many of these works refer explicitly to individual works by Jan van Eyck, some of which can be precisely dated. In his small *Madonna* panel in Vienna (fig. 194), for instance, Rogier includes motifs from the Ghent Altarpiece (fig. 193), completed in 1432, while his Paris *Annunciation* (fig. 195) and the donor wing of the Werl Altarpiece (fig. 275) feature motifs adopted from van Eyck's *Arnolfini Marriage* of 1434. Finally, the handling of space in his *Saint Luke* (fig. 87) echoes that of the Rolin Madonna of about 1435.[277]

These visual references suggest that, in the period after 1432, Rogier knew Jan van Eyck personally. The *Arnolfini Marriage*, at any rate, was not a publicly accessible painting. Even so, there is nothing to support the previously widespread theory that Rogier had studied for a time under Jan van Eyck. In his *Saint Luke drawing the Virgin* (fig. 87), for example, Rogier adopts the general composition of Jan van Eyck's *Virgin and Child with Chancellor Rolin*, but the details of his landscape view are entirely in keeping with the formula used in Campin's workshop. These obvious references to the works of van Eyck led early art historians to accept the long-standing legend invented by Bartolomaeus Facius during Rogier van der Weyden's own lifetime, repeated by Giovanni Santi and finally published by Giorgio Vasari, that he had been a student of Jan van Eyck.[278]

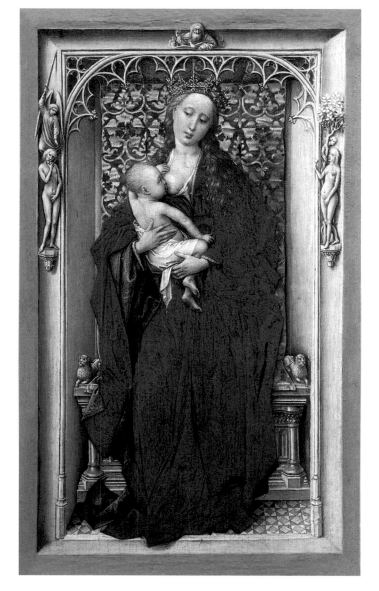

Fig. 194 Rogier van der Weyden, *Madonna*. Vienna, Kunsthistorisches Museum

The figure of God the Father on the upper edge of the picture is based on the figure of the prophet in the Ghent Altarpiece (fig. 193).

The very fact that Rogier's works are so closely related to those by Campin both in terms of painterly technique and in a number of formal details, makes it extremely difficult to distinguish between his works and those of his teacher. Nevertheless, the works of both painters – as clearly evidenced in the Mérode Altarpiece (fig. 42) where they converge – have their own distinctive touch. Above all conceptually, Rogier's works have their own unmistakable charac-

teristics. Yet previous scholars were unable to determine these features because of the traditional erroneous attribution of the Madrid *Descent from the Cross* and the Werl Panels.

Even in one of his earliest independent works, the Vienna *Madonna* (fig. 194), we can find a number of characteristic artistic concepts that epitomise Rogier van der Weyden's œuvre. His treatment of the aesthetic border differs clearly from that of Campin. Although the brocade curtain in this work echoes the Flémalle Panel of the *Virgin and Child* while the tracery in the upper corners recall the Madrid *Descent from the Cross* (fig. 109) Rogier does not treat the relationship between the picture plane and the spectator's space in the same way as Campin. Rogier no longer uses the tracery merely to mark the aesthetic boundary and delineate the space in which the sacred figures are placed. Instead, Rogier develops the painted framework of tracery with its grisaille figures into an independent pictorial register that creates a fluid transition between the secular and sacred realms. The garment of the Virgin juts into the interim zone, yet it is only the grisaille figures – and in this respect Rogier does follow Campin – who are allowed to step into the world of the spectator. These compositional principles, tangible for the first time in this early work, can also be found in the Miraflores Altarpiece painted before 1445 (fig. 256) and the Saint John Altarpiece produced after mid-century.

There are, however, some areas in which Rogier adopts the pictorial concepts developed by Campin. For example, he also uses the triptych formula as a means of structuring a narrative process. Three early works bear witness to this: the Annunciation Triptych, now in Turin and Paris, the Bladelin Altarpiece and the Abegg Triptych. The scenic handling of the transition between the central panel and the two wings in the Annunciation Triptych (fig. 195) is very similar to the approach used in the Mérode Triptych (fig. 42).[279]

Fig. 195 Rogier van der Weyden, Annunciation Triptych. Paris, Louvre (central part) and Turin, Galleria Sabauda (wings)

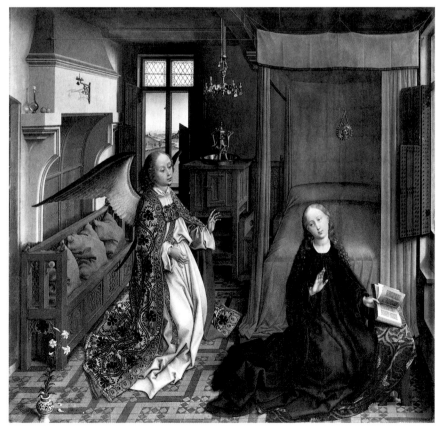
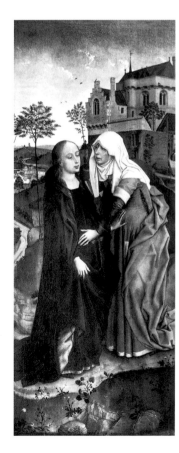

Often enough, though, Rogier van der Weyden acts like a second-generation painter simply adopting his teacher's solutions to specific problems like given formulae. This is particularly clear in his use of the symbolism of objects developed by Campin and anchored contextually and narratively in the respective work. In the work of Rogier, as in the work of Jan van Eyck, symbolically laden objects tend to become mere props and signs that can be combined arbitrarily whatever the context. For example, the same pewter jug and basin – once with a towel and once without – can be employed as a reference to the purity of the Virgin (*Annunciation*, Louvre; fig. 195) or to Saint Barbara (Werl Panel, Madrid; fig. 258).

What is more, Rogier van der Weyden takes up some of Campin's emotionally charged gestures and applies them in different contexts as freely disposable quotations that speak for themselves – very much in the manner of the formulaic imagery of pathos in classical antiquity that was the subject of Aby Warburg's inquiry. A figure frequently imitated, even by Rogier's students and emulators, is that of Saint John rushing to support the swooning Virgin. Rogier uses this figure for the first time in the central scene of the Miraflores Altarpiece, even though Mary is portrayed seated with her Son on her lap and is in no need of support. The same applies to the *Lamentation* in the Uffizi (fig. 196). The billowing robe of

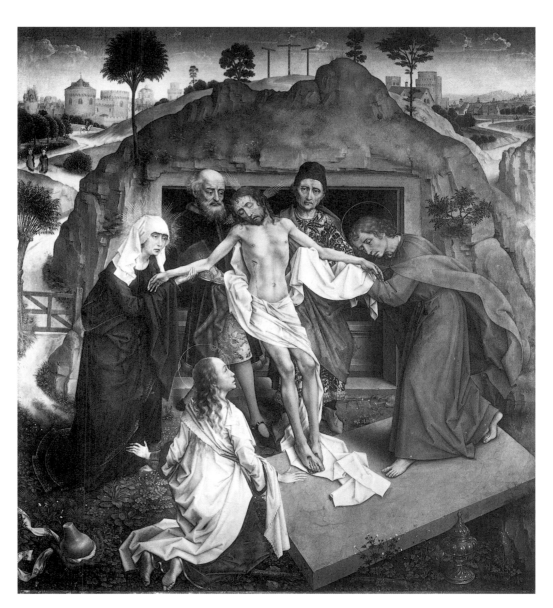

Fig. 196 Rogier van der Weyden, *The Entombment*. Florence, Uffizi

The fluttering movement of John's coat is not causally linked with the narrative, as in Campin (fig. 103).

Saint John, which in Campin's Madrid *Descent from the Cross* (fig. 103) indicates the rapid movement of the figure rushing to help, has no narrative foundation whatsoever in Rogier's new context in which Saint John is kissing the hand of Christ, nor does the striding movement of Joseph of Arimathaea, also adopted from the Madrid *Descent from the Cross*.

Master of the Hortus conclusus (Willem van Tongeren?)

The National Gallery in Washington possesses a large altarpiece showing the *Virgin and Four Saints in a Garden Enclosed* (Cat. III.C.2; fig. 198). We have taken this painting to designate the artist who is known to have been a student of Campin. Only one further work can be ascribed to him with certainty: the variation on the Mérode *Annunciation* which he created in Campin's workshop parallel to the triptych of the master between 1425 and 1428 (fig. 197). By this time, the student was already advanced in his training and had developed a style of his own. This stylistic independence is particularly evident if we compare his work with the Mérode *Annunciation* which served as his model. Note the wiry bodies and the finely elegant facial traits of the figures as well as the graceful execution of the objects. Moreover, this artist has a distinct drapery style featuring long, slender folds and correspondingly expansive troughs, especially tangible in the figure of the Virgin, which is a creation of this artist. He also differs considerably from Campin in his new and much more atmospheric portrayal of the room.

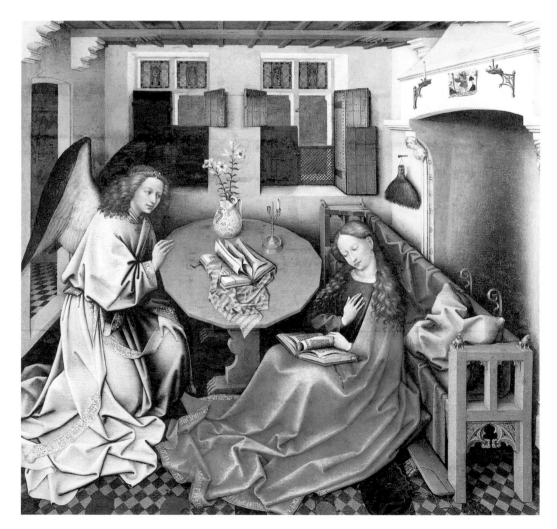

Fig. 197 Master of the Hortus conclusus, *Annunciation*. Brussels, Musées Royaux des Beaux-Arts

The same characteristics can be found in the altarpiece at the National Gallery, which is certainly later. The figure of Saint Catherine is closely related, both in pose and drapery, to the figure of the Virgin in the Brussels *Annunciation*, and in both cases there is a gloomy antechamber to the left. Even the chequered board flooring is identical.

In this work, there is an additional element that also strongly indicates that this artist came from Campin's workshop: two flowers at the feet of the Virgin have been painted from the same life studies or copies after them as the corresponding flowers on the Flémalle Panel of the *Virgin and Child* (fig. 4). Finally, the bust of *Saint Barbara* in the Washington panel is a quotation of one of the Marys in the *Descent from the Cross* altarpiece created by Campin around 1430 for a church in Bruges (fig. 117). The Christ Child is probably also based on a work by Campin.

As the Washington panel also came from a church in Bruges, it may be assumed that this student of Campin was active in Bruges as an independent master artist. It is possible that the Master of the Hortus Conclusus is in fact the student of Campin referred to as Willemet and appointed a free master in 1432 along with Jacques Daret and Rogier van der Weyden. In the first half of the fifteenth century there was only one painter in Bruges with the Christian name of Willem. He was Willem van Tongeren, who is regularly mentioned in

Fig. 198 Master of the Hortus conclusus, *The Virgin and Four Saints in a Garden Enclosed*. Washington, National Gallery of Art

The drapery of Saint Catherine is closely related to that of the figure of the Virgin in the *Annunciation* panel (fig. 197). Even the two dimly lit antechambers at the left hand edge of the pictures are similar.

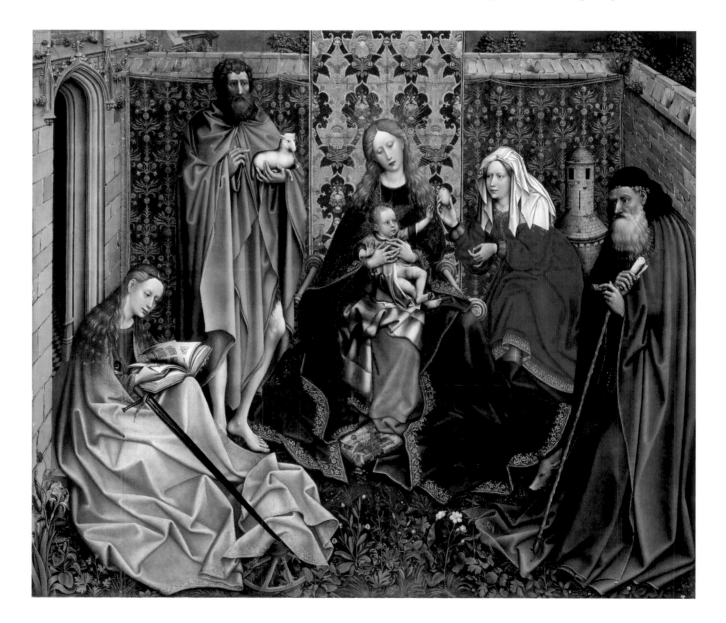

municipal documents from 1433/4 until his death in 1456.[280] The fact that only the Christian name appears in the register of the Guild of Saint Luke in Tournai may be because Willem used the name of his birthplace rather than a family name.

In 1435, Willem van Tongeren was found worthy of polychroming and gilding one of the eight statues of *Counts and Countesses of Flanders* for the new Town Hall in Bruges, along with Jan van Eyck and one further painter. In 1441 he was dean of the Bruges Guild of Saint Luke.

Master of the Madonna before a Grassy Bench (Jan van Stoevere?)

In the Berlin Gemäldegalerie, there is a small panel of the *Virgin and Child* (Cat. III.E.1; fig. 200) – probably originally the left wing of a diptych – that displays a strange dichotomy. The paint is applied thickly in a careful technique characteristic of the Campin workshop, yet the composition, the design of the drapery folds and a number of individual details are strikingly clumsy. The elegant oval face with the distinctive chin and characteristic broad hand with the peculiarly slender wrist can also be found in similar style in the *Madonna in an Apse* (Cat. III.E.2/C, fig. 199), one of the most frequently copied and interpreted pictorial creations of all early Netherlandish painting.

A further characteristic feature of the Master of the Madonna before a Grassy Bench is his penchant for particularly filigree items of jewellery, such as crowns, belts, pendants and other goldsmithing works. (Cf. in particular Cat. III.E.3/C, III.E.C/4 and Cat. III.E.6/C; figs. 202, 237). For the most part, this artist uses a radiating nimbus to designate a divine or holy figure, and, in contrast to the work of Campin's other students, portrays the hair of the Virgin worn loose and falling in parallel lines, covering her ears.

In later compositions that can be attributed with some certainty to the same master, the drapery folds and physiognomies closely approximate the work of Robert Campin, though there is clearly a preference for slightly curved, parallel lengths of fabric. The face of the Virgin is unnaturally elongated initially, and replaced later by a rounder type. The hands and the head appear much softer and more fleshy than in Campin's work.

The *Adoration of the Magi* (Cat. III.E.3/C), precisely documented in Berlin in two independent copies, one painted (fig. 237) and one drawn, is particularly close to Campin's work. Although the lost original is frequently attributed to Campin himself, the softness of the facial traits and the drapery folds are alien to Campin.

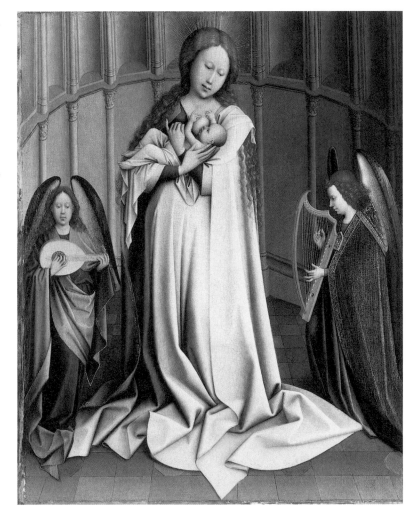

Fig. 199 Master of the Madonna before a Grassy Bench (copy after), *Virgin and Child in an Apse*. New York, Metropolitan Museum of Art

The most important work by this former Campin student was a Justice depiction showing *The Revenge of Tomyris* (Cat. III.E.6/C; fig. 202), created for the Ghent city authorities as a pendant to a portrayal of *Jael slaying Sisera* which we believe can be ascribed to Hubert van Eyck. As it may be assumed that the artist who created *The Revenge of Tomyris* was also based in Ghent, it would seem quite possible to identify the master of the Madonna before a Grassy Bench as Jan van Stoevere, son of the respected Ghent painter Gheraart van Stoevere, and a member of Campin's workshop in the period around 1415 to 1419.[281]

The composition with *The Revenge of Tomyris* which we attribute to this master plays an important role in the history of Netherlandish depictions of Justice. For this reason, it deserves to be examined more closely. The best impression of the lost original can be gained from a canvas in the Berlin Gemäldegalerie (fig. 202). It is likely that this copy was produced in the early sixteenth century by an unknown Ghent artist as a replacement for the original panel painting. Its large format of 176 cm by 176 cm probably corresponded to the dimensions of the original.

The composition portrays an episode of ancient history first recorded by Herodotus, in which Tomyris, Queen of the Massagetes, takes her revenge on the Persian King Cyrus, who had persecuted her in cruel wars, by submerging the severed head of the tyrant in a skin of human blood. It is precisely this moment of vengeance that the artist portrays. His work is not based directly on Herodotus, but on medieval texts, primarily on the *Speculum humanae salvationis*, a typological treatise widely known in the fifteenth century and translated into several languages.[282] In this text, in contrast to earlier versions, the vessel in question is described as an urn rather than a skin. Moreover, King Cyrus is already the prisoner of Tomyris when he is decapitated. The passage in the text on which the painting is based reads: "Finally Queen Tomyris captured and decapitated him. She cast his head into an urn filled with human blood and said: 'now quench your thirst with human blood, for which you thirsted, and of which you could never have enough in your lifetime'."[283]

In the *Speculum humanae salvationis* (fig. 203), Queen Tomyris conquering her enemy is one of three prefigurations of the Virgin Mary, who, through her empathy with the Passion of Christ, triumphs over the Devil. The two other typological scenes are *Jael slaying Sisera* and *Judith killing Holofernes*.

The *Speculum* manuscripts were illustrated. However, even if the artist who created this painting was familiar with the illustration of the Tomyris scene, he did not adopt the traditional formula. Although he, too, places the triumphant queen grasping her enemy's head on the central vertical, she herself is no longer holding the sword. The artist has added further figures not mentioned in the text – two men on the left and two women on the right. On either side there is one active servant figure and one figure observing the scene.

The figural composition emphasises the two diagonals of the square format: one diagonal is drawn by the sword which the execu-

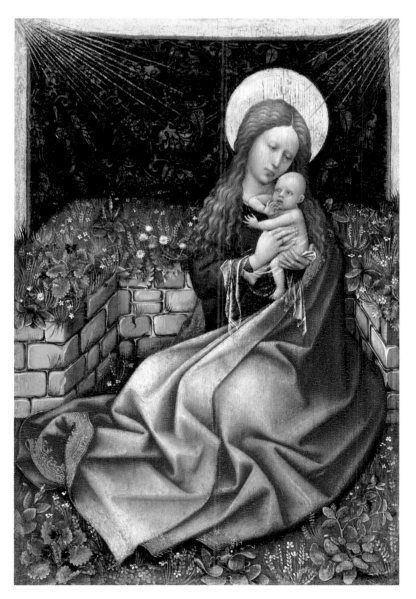

Fig. 200 Master of the Madonna before a Grassy Bench, *Madonna before a Grassy Bench*. Berlin, Staatliche Museen, Gemäldegalerie

tioner is replacing in its sheath following the deed. The other diagonal runs from the body of Cyrus at the lower left and the poodle licking the blood flowing from the corpse, to the bust of the lady-in-waiting with the lapdog at the upper right. The lapdog is looking towards the spectator, as is the little monkey on the opposite side of the picture behind the executioner. The severed head of Cyrus is aligned on the diagonal linking the two dogs.

The specific role played by these two dogs in the painting makes it probable that the advisor who summarised the story of Tomyris for the artist was familiar with other sources apart from the *Speculum humanae salvationis*. Herodotus, for example, reports that Cyrus was abandoned in a forest as an infant, where he was nursed by a dog. The same version is reiterated by Petrus Comestor, with the foundling being given the name *Sparticus*, derived from the Persian word for dog (*spartos*).[284]

The robes of the protagonists are ornamented with a number of inscriptions. Two different alphabets are used. The Queen of the Massagetes and her followers have Greek letters, while Kufic letters grace the robe of the conquered Persian king. Kufic letters also adorn the neck of the pitcher into which his head is dipped.[285] On the sword of the executioner we can also read the Latin word *IYCTIXIa* (Justice) written in Greek letters. The setting is a sumptuous colonnaded hall in the palace of Tomyris. The floor is covered in a complex geometric pattern of coloured stones. The windows in ancient Roman style are ornamented with glass paintings of warriors. The pillars themselves are adorned with figure capitals depicting scenes of war, probably outlining the bloody campaigns of the Massagetes against the Persians in the run-up to the episode portrayed.[286]

The pattern of the floor runs towards a point slightly beyond the picture plane on the left. It may therefore be assumed that the *Revenge of Tomyris* was intended as a pendant to another painting on its left. It is probable that the painting in question, like the *Speculum humanae salvationis* (fig. 203) showed Jael driving the tent-peg through Sisera's temple. In Brunswick, there is a Netherlandish drawing of this very scene (Cat. II.5; fig. 201), of unusually high quality, which can be dated to around the same time as the lost painting by the Campin student.[287] Not only does the Brunswick drawing bear some remarkable similarities to the Tomyris scene, but the two portrayals are also compositionally compatible. Jael, in mirror symmetry to the servant of Tomyris, has kilted up her skirts in the same way and is wearing the same thick-soled shoes. The male victims in the two scenes are also shown in mirror symmetry. Both warriors are wearing similar armour with disc-like

Fig. 201 Hubert van Eyck, *Jael slaying Sisara*, c. 1425. Brunswick, Herzog Anton Ulrich Museum

The composition recorded in this work probably served, on a different scale, as a pendant to the painting by the Master of the Madonna before a Grassy Bench (fig. 202).

arm shields beneath their cloaks. The Jewish heroine is wearing the same turban as the Queen of the Massagetes. Moreover, both women have the same highly unusual hairstyle with the end of a braid tucked over the right ear.[288]

Clearly, these compositions are intended as a complementary pair, even though the size of the figures in the drawing do not correspond proportionally to those in the painting. Contrary to widespread opinion, the scene showing *Jael slaying Sisera* (fig. 201) cannot be the work of Robert Campin. The characteristic soft curves of the limbs in the drawing are alien to Campin's style. The grim face of Sisera and his unkempt hair is far more similar to the figures of apostles, hermits and pilgrims in the Ghent Altarpiece ascribed to Hubert van Eyck (fig. 160). The heavy robes of Jael, which form close, horizontal loops on the floor, can also be found in the figure of Mary in the *Annunciation* scene of the Ghent Altarpiece (fig. 176) and in the figure of the kneeling apostles on the panel with the *Adoration of the Lamb*. We therefore assume that the Brunswick drawing is an original presentation drawing for a composition by Hubert van Eyck or a replica by his own hand.[289]

The composition which we attribute to the Master of the Madonna before a Grassy Bench (fig. 202) plays an important role in the history of the Justice genre as an interim link in the transition from religious to secular iconography. It is situated between traditional portrayals of the Last Judgement and the scenes based on antique and medieval texts painted by artists of the two subsequent generations, Rogier van der Weyden, Dieric Bouts and Gerard David, for the courts in Brussels, Louvain and Bruges. Because it is recorded in the *Speculum*

Fig. 202 Master of the Madonna before a Grassy Bench (copy after), *The Revenge of Tomyris*. Berlin, Staatliche Museen, Gemäldegalerie (not on exhibition)

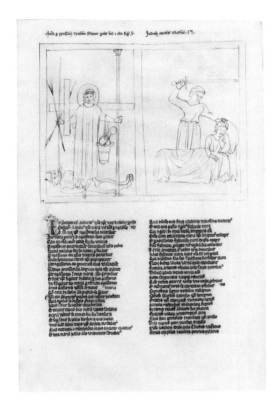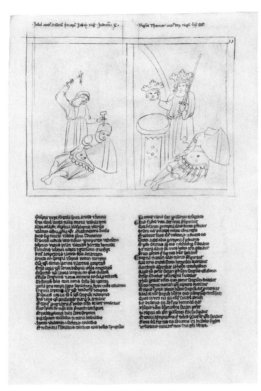

Fig. 203 Double page from a manuscript of the *Speculum humanae salvationis*. Munich, Bayerische Staatsbibliothek, Cod. lat. 146/I, 32v und 33r

In the well-known typological tractatus, the Virgin Mary, having triumphed over the Devil through her suffering at the Passion of Christ, is accompanied by three prefigurations: Judith and Holofernes and – recto – Cyrus and Tomyris (right), and Jael and Sisara (left).

humanae salvationis, where the figure of Tomyris serves as a prefiguration for a Marian scene, the story of the Revenge of Tomyris may still be regarded as a religious scene. However, it may also be interpreted as a purely secular example of a punishment befitting the transgressions of the perpetrator. Two details indicate that the religious significance of this scene still played a role for the artist: the pendant of Tomyris' jewellery includes a cross, and the letter on the central vertical directly under the queen's right hand also takes the form of a cross.

The typological interpretation of the Revenge of Tomyris against her enemy was also familiar to the painter Pieter Pieters, who was commissioned by the municipal authorities of Bruges in 1610 to produce a copy of the Tomyris painting for the city court (fig. 206). Only because he saw in Tomyris a prefiguration of Mary could the copyist alter the face of his model (fig. 204) in such way that it took on the traits of the Virgin from the *Deësis* of the Ghent Altarpiece (fig. 205). In order to ensure that this 'correction' would be recognised by the spectator, he gave the neckline and sleeves of the pagan queen's dress the same ornamental border as that of the Virgin, and gave her a veil which he also tied with a tasselled cord.

The compositions discussed above, designed as a pair, probably for the magistrates' court of the city of Ghent, are of enormous value as documents of a unique artistic confrontation. Here we find the style of figural painting typical of Hubert van Eyck and, through the medium of a student, the figural painting style typical of Robert Campin, juxtaposed in a public artistic competition.

Master of the Betrothal of the Virgin

Another direct student of Campin is represented by a single surviving work. It is the *Betrothal of the Virgin* in the Prado (Cat. III.D.1 a; fig. 207), based on a cycle of scenes from the *Life of Saint Joseph* by Campin, which is now lost, but survives in the form of an early copy in Hoogstraten (fig. 31). The Master of the Betrothal of the Virgin must have belonged to Campin's workshop around 1415/20, and does not appear to respond to his teacher's later work. The striped robe of the priest in the foreground of the scene in which Joseph is chosen has pseudo-Hebraic inscriptions strongly reminiscent of the clothing of one of the soldiers on the right hand wing of the Seilern Triptych (fig. 19), while the costume of the

Fig. 204 Master of the Madonna before a Grassy Bench (copy after), detail of fig. 202

Fig. 205 Hubert van Eyck. *The Virgin* of the Ghent Altarpiece (Detail). Ghent, Cathedral St. Bavo

Fig. 206 Pieter Pieters (Copy after fig. 202), *The Revenge of Tomyris*, 1610. Bruges, Court of Justice

The copyist has replaced the facial traits of Tomyris (fig. 204) with those of the Virgin Mary from the Ghent Altarpiece (fig. 205). He has also adopted the latter's ornamental borders and the clasp of her mantle.

woman in rear view in the *Betrothal* scene has an ornamental border closely related to that of the kneeling midwife in Campin's *Nativity* (fig. 26).

In this work by the Master of the Betrothal of the Virgin, Campin's pain appears in a variation that takes the form of an additive love of small detail verging on *horror vacui*. At least one of many heads without bodies has been added by the artist only during the actual painterly execution of the *Betrothal* scene.[290] He has a characteristic tendency to portray figures with a slightly open mouth so that the upper row of teeth can be seen.

This artist excels in finely sculpted architectural portrayals, some of them showing real buildings. The student who painted the *Annunciation* panel (fig. 208) has attempted to emulate his teacher in this respect. As the architectural originals by the master can be found in Brussels, it may be assumed that he had his studio in that city. The small *Madonna* panel in the Thyssen-Bornemisza collection (Cat. III.D.2; fig. 209) with a very similar and equally skilfully executed architectural frame as that of the *Betrothal* scene must have been created in the circle of this master, if not by himself. Contrary to the traditional attribution, this work bears little relationship stylistically to the Vienna *Madonna* by Rogier van der Weyden (fig. 194) created after 1432, in spite of the thematic correspondence.

Fig. 209 Master of The Betrothal of the Virgin, *Madonna Enthroned* (Northbrook Madonna). Madrid, Thyssen-Bornemisza Collection

The work shows the same precise treatment of architectural details as the panels of the Marian Altarpiece (figs. 207, 208).

Master of the Louvain Trinity (Pseudo-Vrancke van der Stockt)

Campin's most successful student apart from Rogier van der Weyden and Jacques Daret was the Master of the Louvain Trinity, who was probably a few years older than his two colleagues. He was an early student of Campin from the period around 1415, and may have headed his own workshop by about 1420. The figure of this artist is of particular art historical interest, because twenty study drawings, by him have survived – far more than by any other painter of that period. In 1938 Paul Wescher attributed the drawings without ade-

Fig. 207 Master of The Betrothal of the Virgin, *The Miracle of the Rod* and *The Betrothal of the Virgin*. Madrid, Prado

Fig. 208 Master of The Betrothal of the Virgin (Workshop), *Annunciation*. Madrid, Prado

Fig. 210 Master of the Louvain Trinity, *The Trinity of the Broken Body* and *Virgin with Child*. St Petersburg, Hermitage

Fig. 211 Master of the Louvain Trinity, *The Trinity of the Broken Body with Angels*. Louvain, Stedelijk Museum

The painting formed the central panel of a triptych. The angel at the left hand edge of the painting created a link with the donor on the left wing, as in the work by Campin (fig. 19).

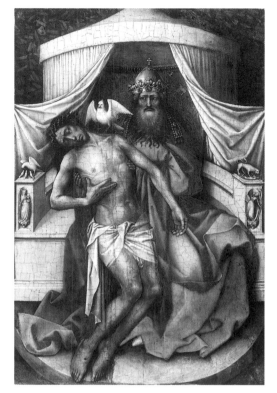

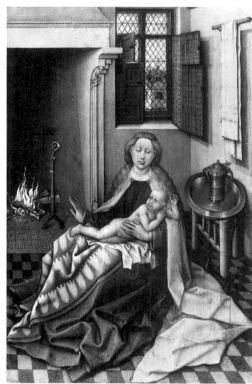

quate foundation, to Vrancke van der Stockt, Rogier van der Weyden's successor as the municipal painter in Brussels.²⁹¹ However, most of these drawings must have been created before mid-century, given the costumes, certain stylistic details and a number of datable water marks.²⁹²

In an early painting, the *Trinity of the Broken Body* (Cat. III.F.1; fig. 211) created around 1435, after which this anonymous master has been named, his personal style is clearly evident. It is characterised by a penchant for juxtaposing simple, starkly contrasting colours, such as red-blue, yellow-violet and red-yellow-green. Scenes are frequently illuminated without a clearly defined source of light, but there is a distinct sense of detailed and highly effective handling of light and shadow. His drapery style is also distinctive, being characterised, especially in his early work, by a fan-like bundling of elongated folds with an emphasis on the troughs which, in his later work, occasionally form concave patterns. This artist has a tendency to adopt motifs and entire groups of figures from his teacher Campin, aligning them in new compositions, though with occasionally startling weaknesses in spatial portrayal. Because of the strong leaning towards the work of his teacher, some paintings by the Master of the Louvain Trinity have, until now, been incorrectly ascribed to Campin.

The *Trinity of the Broken Body* in the Louvain city museum (fig. 211) was originally the centrepiece of a triptych that the painter had created for the funerary chapel of the van Baussele family in the

Fig. 212 Master of the Louvain Trinity, *Church Father* (*Saint Ambrosius*). Paris, Musée du Louvre, Cabinet des Dessins

Fig. 213 Anonymous, *Church Father*, Misericordia from a choirstall, oak sculpture. Formerly Berlin, Oppenheim Collection

The drawings in the Louvre with the four Latin Church Fathers were created by the artist as designs for Misericordia.

church of Saint Peter in Louvain. This composition can be described as a *pasticcio*. It features one of Campin's latest inventions together with figures of angels, one of which is taken from one of Campin's earliest surviving works: the actual group of the Trinity is taken from the central image created by Campin for the altar dossal of the Ecclesiastical Paraments of the Order of the Golden Fleece (fig. 162). The figure of Christ has been altered only slightly. In the student's painting Christ's eyes are no longer open, and the left hand has been turned so that the spectator can also see the wound there. In contrast to Campin's work, the figure of Christ is wearing a loincloth which God the Father, now seated upright and facing the spectator, is covering with His left hand.[293]

In spite of these differences, the dependence on Campin's *Trinity of the Broken Body* in the Vienna Vestments can be regarded as certain. In the Louvain panel, God the Father is wearing the crown of lilies that was probably intended as a reference to the ducal client in the embroidered original, while the feet of the dove of the Holy Spirit, which are all that remains of this figure in the Louvain painting, correspond precisely to those in the Vienna Vestments.

Fig. 214 Master of the Louvain Trinity, *Church Father* (*Gregory the Great*). Paris, Musée du Louvre, Cabinet des Dessins

The angel on the upper left is taken from the Seilern Triptych (fig. 19). In addition to the lance he is now bearing the three nails and has adopted the gesture of mourning of the angel with the sponge in Campin's work. However, the angel fulfils the same function: slightly overlapped by the frame, he creates the affective link with the left wing showing – as a copy documents – the kneeling donor.

For all its compositional weaknesses, this work enjoyed considerable success among fellow artists. The Louvain *Trinity* is one of the most frequently copied and freely varied paintings from the early period of Netherlandish painting.

Campin's student later repeated the group of the *Trinity of the Broken Body* in even closer emulation of Campin's work in a small diptych now in the Hermitage, where it is set against a portrayal of the Virgin and Child in a bourgeois interior (fig. 210). There is a certain link with the *Madonna in Sole with Saint Peter and Saint Augustine* in Aix-en-Provence (fig.

215). The facial type of the Virgin is the same and the sides of the throne – this time in bronze rather than in stone – also feature variations on the figures of *Ecclesia* and *Synagogue* already represented in the diptych.

The figures of Saint Augustine and Saint Peter correspond in their seated pose and in their clothing to the figure of Gregory the Great in one of the drawings formerly attributed to Vrancke van der Stockt (fig. 214). It is one in a series of four designs for wooden sculptures of Church Fathers that graced choir stalls as misericordia. One of these sculptures is documented in a photograph (figs. 212, 213).[294]

One of the early drawings by the master of the Louvain Trinity is a study of a Madonna with Child reading on her lap, from about 1430 (fig. 218).[295] It is the same motif

Fig. 215 Master of the Louvain Trinity, *Madonna in Glory (Maria in sole), Saint Peter and Saint Augustine with donors.* Aix-en-Provence, Musée Granet

The two figures of saints in the painting are closely related in terms of pose, expression and drapery, to the figure of Saint Gregory (fig. 214).

 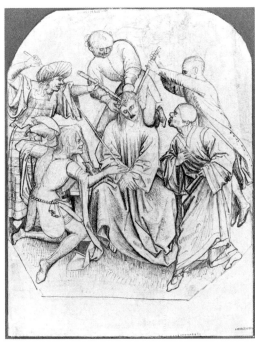

Fig. 216 Master of the Louvain Trinity, *The Flagellation of Christ*. Rotterdam, Museum Boymans-Van Beuningen

Fig. 217 Master of the Louvain Trinity, *The Crowning of Christ*. Rotterdam, Museum Boymans-Van Beuningen

Two designs for a cycle of scenes from the Passion of Christ, which, given the large number of surviving copies, must have enjoyed considerable fame.

that is used by Rogier van der Weyden in his later Durán Madonna in a similar niche.[296] The artist returned to this design once again in his 1432 canvas with the highly unusual theme of the Holy Family for the Convent of the Order of Saint Clare in Le Puy (fig. 219).

Studies for two cycles of painting, one of them showing scenes from the Life of the Virgin, one with scenes from the Passion of Christ, were possibly created before 1430 (figs. 216, 217).[297] These cycles must have been famous, the scene showing the Flagellation of Christ being the most frequently copied and adapted.[298]

The most famous drawing by the Master of the Louvain Trinity shows the *Virgin and Child in an Interior*, flanked by male and female members of the donor family; the man accompanied by Saint James, the woman by Saint Catherine (fig. 221). This composition, created around 1440, like the *Madonna in Sole* and the diptych in Saint Petersburg, shows the holy figures alongside members of the family in a bourgeois interior, but sets the Madonna apart by portraying her beneath a baldachin. The way in which the interior communicates with the outside world by way of door apertures at the sides and window apertures at the back, foreshadows Memling's composition of the Donne Triptych.

This drawing, too, is an original by the Master of the Louvain Trinity and not, as previously generally believed, a copy after a work by Campin. The unusually painstaking execution of the drawing with its effective washes appears to be unparalleled in the early fifteenth century. The distinctly painterly character of the drawing can probably be explained by the fact that it had no function in the actual production of the work, but was intended as a sample for the patron.

Lorne Campbell has noted that the wife of the donor is dressed in the same costume and portrayed in the same pose as the *Portrait of a Woman* in Dumbarton Oaks inscribed with the words SIBYLLA AGRIPA and ALOISIA SABAUDA (Cat. II.7; fig. 220).[299] In contrast to conventional opinion, the panel cannot be an original from the time of Campin. The pendant and the ornamentation of the headwear belong stylistically to the sixteenth century. In our opinion it is in fact, as the inscription states, a portrait of the mother of François I, Louise de Savoie, in the guise of a Roman sibyl. It may be assumed that the

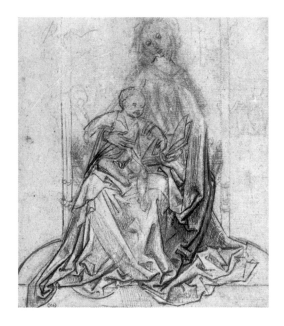

Fig. 218 Master of the Louvain Trinity, *Madonna with the Christ Child Reading*. Paris, Musée du Louvre, Cabinet des Dessins

author of the portrait, in order to mark the time lapse between the sitter and the role she represents, looked to the donor figure in the almost hundred year old painting by the master of the Louvain Trinity, of which the drawing in the Louvre still conveys a precise representation.

Impact

It was not only Campin's own students who helped to disseminate his artistic concepts. Major compositions by Campin were copied and emulated by artists outside his own workshop from an early stage. Private clients would commission local artists to make copies of altarpieces that were publicly accessible in churches. The oldest example of such a copy is the Edelheer Altarpiece (fig. 112) dated 1443, whose central panel reiterates the *Descent from the Cross* of the Louvain Guild of Crossbowmen (fig. 103). The copy of the *Life of Saint Joseph* in Hoogstraten (fig. 31) was probably made at around the same time, while the small copy of the Bruges *Descent from the Cross*, now in Liverpool (fig. 117), was created slightly later. In all these cases, artists unfamiliar with Campin's style endeavoured with varying

Fig. 219 Master of the Louvain Trinity, *The Holy Family*. Le Puy-en-Velay, Cathedral

In the altarpiece created for the Order of Saint Clare at Le Puy the artist has looked to an older study (fig. 218).

degrees of success to emulate the famous original as closely as possible.

Of more interest and importance, however, are the individual artists who took it upon themselves to study Campin's work closely. The list of those known to have been influenced by Campin is long indeed. It includes such illustrious names as the Master of the Aix Annunciation (Barthélemy van Eyck) and Konrad Witz. Three of the earliest examples of a serious artistic reflection on Campin's painting are presented here by way of example. They bear witness to the international impact of Robert Campin's art as early as 1450.

Fig. 220 Anonymous, *Portrait of Louise de Savoye as the Agrippine Sibyl*, c. 1525. Washington, Dumbarton Oaks Research Library and Collection

The painter of the role portrait looked to the figure of the donor in a votive image by the Master of the Louvain Trinity (cf. fig. 221), in order to mark the historic distance between the figure portrayed and her role.

The Master of the Iserlohn Life of the Virgin

Robert Campin's painting was known beyond the Netherlands, in the north-west of Germany, Westphalia and the Lower Rhine, from a very early stage.[300] There are obvious indications of a close study of this southern Netherlandish Master from around 1440. It is interesting to note that, towards the end of the fifteenth century, Derick Baegert, active in Wesel, chose to create a triptych of *Saint Luke* (fig. 92) and a *Saint Luke* panel (fig. 89), with typically

Fig. 221 Master of the Louvain Trinity, *Madonna with two saints and the donor's family*. Paris, Musée du Louvre, Cabinet des Dessins

This painstakingly executed work in unusual technique probably served to present the donors with a preview of the family's votive image.

Fig. 222 Master of the Banderoles, *The Annunciation*, c. 1460, copperplate engraving (unique). Dresden, Staatliche Kunstsammlungen, Kupferstichkabinett

This engraving is based on an Annunciation composition that was also employed by the Master of the Iserlohn Life of the Virgin.

programmatic references to the art of painting, after an original by Campin rather than to his own design.

A generation earlier, around 1450, a series of paintings was created that refers to various works by Campin. These show eight scenes from the Life of the Virgin and a portrayal of the Coronation of the Virgin created by an anonymous Westphalian artist for the exteriors of the wing panels of the high altar retable in the Marienkirche (Church of Our Lady) of Iserlohn to be added to an existing Flemish carved altarpiece created around 1400 showing scenes from the Passion of Christ (cf. figs. 223-224).[301]

This Westphalian painter, who has yet to gain the recognition he deserves,[302] was a distinctive artist in his own right, in spite of his strong leanings towards the work of Campin. Indeed, his works betray a genuine understanding of the works of the Netherlandish master he so clearly admired. This German artist vies with Robert Campin by adopting all his major innovations, his varied landscapes without a gold ground, his complex interiors with their unexpected angles related to the position of the observer, and his precise portrayal of simple everyday objects. At the same time, the Master of the Iserlohn Life of the Virgin retains his own distinctive aspects, such as rocky faces integrated into the landscape, their grimaces commenting on the atmosphere of the biblical scene in question. For example, in the round arched gateway of the first

Figs. 223-224 Master of the Iserlohn Life of the Virgin, *The Annunciation* and *The Nativity*, c. 1450. Iserlohn, Oberste Stadtkirche (formerly Marienkirche)

The two panels indicate that this Westphalian artist studied Robert Campin's works very closely.

scene (fig. 223), a wooded hillside takes on a profile that reflects the dignified facial expression of Gabriel. In the central ground of the following *Nativity* scene (fig. 224), a large and joyfully smiling face appears to jut out of the rock above the figure of the Virgin.

The first two scenes of the Life of the Virgin – *Annunciation* and *Nativity* – appear to be particularly strongly influenced by the art of Campin. This impression arises even though no direct precursor is known in the work of Campin for either of these compositions. The *Annunciation* is situated in an antechamber separated from the living room by a double arcade. Like all the interiors portrayed in the Iserlohn Altarpiece, the house of the Virgin has a kind of stage-like framework below and to the side, but not on the upper edge, thereby linking the sacred world portrayed with the secular world of the observer.

Although the figures of the *Annunciation* scene are closely related to those of the Mérode Altarpiece (fig. 42) in their pose and their relationship to the setting, we must

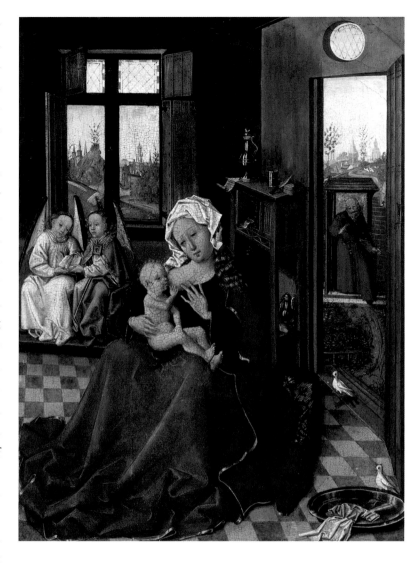

Fig. 225 Master of the Iserlohn Life of the Virgin, *Virgin and Child in an Interior*, c. 1440. Münster, Westfälisches Landesmuseum

This panel may be a copy after a work by the Master of the Louvain Trinity.

assume that they refer to another, lost painting by Campin. This is because the figural composition portrayed by the Master of the Islerlohn Life of the Virgin can also be found in a copperplate engraving by the Master of the Banderoles (fig. 222), albeit with a slightly different drapery style and in mirror image. Two unusual details show that both these works are based on the same source: the backward leaning cross affixed to a diadem on the brow of the angel, and the book on the lap of the Virgin. Yet the painting in Iserlohn is closer to Campin's original than the copperplate engraving, as the ornamental border of the angel's mantle and its sharply tapering end indicate.[303] The furnishing of the room that can be seen behind the figure of the Virgin is also based on Campin. The window at the back, its half open shutters, the fireplace with the little earthenware jug, the cabinet set at an angle to the perspectival lines with its rich still life, the door at the side opening onto another room, are all reminiscent of the Netherlandish master.[304]

The *Nativity* scene also contains a number of elements typical of Campin, such as the blend of cave and stable as the setting for the Birth of Christ, the alignment of the figures described in the *Revelations* of Bridget of Sweden, and the midwives mentioned in the apocryphal texts. Moreover, as the beams of the stable show, there is a precision in the painterly portrayal of everyday objects that can be found only in the work of Campin.[305]

Two further works can be attributed to the Master of the Iserlohn Life of the Virgin, a *Virgin and Child in an Interior* (fig. 225) and, somewhat controversially, the famous *Liebes-*

Fig. 226 Jan van Eyck (copy after), *Woman at her Toilet*. Detail from: Willem van Haecht, The Art Collection of Cornelius van der Geest. Antwerp, Rubenshuis

Fig. 227 Master of Iserlohn Life of the Virgin (attributed to), *"Liebeszauber"*, c. 1450. Leipzig, Museum der bildenden Künste

The portrayal of the interior is more strongly reminiscent of Campin than of Jan van Eyck.

zauber in the Leipzig Museum (fig. 227). Both these works are strongly Netherlandish. The portrayal of the Virgin nursing her child in an interior is very probably a copy. The original on which it is based may have been a Madonna by the Master of the Louvain Trinity, closely related to the small panel in London (Cat. III.F.6b).[306]

The *Liebeszauber* (fig. 227) which we, like Stange, also ascribe to the Master of the Iserlohn Life of the Virgin, suggests a particularly close study of early Netherlandish painting.[307] This unusual composition has repeatedly been associated with Jan van Eyck, who is documented in an old description and in copies (fig. 226) as having produced nudes.[308] Yet the Leipzig panel with its doll's-house interior opening out to the back is less reminiscent of Jan van Eyck than it is of Campin and his treatment of space, for instance in the Mérode Triptych.

The Master of Catherine of Cleves

Around 1440, a Book of Hours was created for the Duchess Catherine of Cleves, lavish and original in its illustration. Split into two parts in the nineteenth century., it has since been reunited and is now housed in the Pierpont Morgan Library. The miniaturist, probably active in Utrecht, whose work can be found in a number of further illuminated manuscripts. is one of the leading northern Netherlandish painters of the period around 1450.[309] The Master of Catherine of Cleves, as the artist is known, must have been an admirer of Robert Campin's work. He has copied a number of Campin's compositions in drawings. These were then coloured, either by the artist himself, or by one of his assistants, with no major changes in the figural alignments. The compositional models include Campin's lost *Crucifixion* panel (Cat. I.14/C; fig. 241) and the central panel of the Bruges *Descent from the Cross* (now also lost). The latter has survived in the form of miniatures from the workshop of the Master of Catherine of Cleves, in two different versions.[310]

For the most part, however, references to the southern Netherlandish master's work are rather more subtle. Take, for example, a miniature portraying the Holy Family in the Book of Hours of Catherine

of Cleves (fig. 228).[311] The rendering of the Virgin nursing her infant, seated on the ground in a white garment before a chair, appears to be based on Campin's Salting Madonna (fig. 86). The distinctly dignified portrayal of the Virgin is countered by a burlesque portrayal of Joseph, seated clumsily on a chair roughly fashioned from a barrel, and eating soup. The objects behind Joseph indicate kitchen work and there are cracks on his side of the chimney breast. The depiction of everyday life is used by the Master of Catherine of Cleves to characterise the role of the figures in the picture.[312]

The portrayal of the Annunciation to the Virgin in a later Book of Hours created around 1450 for Catherine of Lochhorst (fig. 230) also shows how accomplished this illuminator was in adapting a variety of styles.[313] The figure of the Virgin corresponds remarkably closely to that of the Mérode Triptych (fig. 42). Only the head and the gaze of the Virgin are now turned towards the angel, and the garments Campin rendered in the same colour, red on red, are now shown in different colours: over a robe of white brocade ornamented with the initials *m* and *a*, lies a blue mantle, and the angel is also wearing a richly decorated cope.[314]

The illuminator has integrated the figures into a new architecture whose courtly and sacred character is radically different to that of the Mérode Triptych. The Annunciation scene in the Book of Hours of Catherine of Lochhorst is set in an antechamber of the temple portrayed in the background in the form of a gothic choir. For his version of this biblical scene, the miniaturist has created a new pictorial space corresponding stylistically to the world of his aristocratic patron. The Annunciation adopted by him and the two portrayals of the Holy Family show that, for the Master of Catherine of Cleves, the realism developed by Campin to portray the details of bourgeois life had become one possible form of painterly expression among others.

Fig. 228 Master of Catherine of Cleves. *The Holy Family*, c. 1440. The Book of Hours of Catherine of Cleves. New York, The Pierpont Morgan Library, Ms. 917, p. 151

The illuminator uses Campin's realistic pictorial language to distinguish between Mary and Joseph.

Itinerant Northern European Artists in Italy

In the Dominican friary of Santa Maria di Castello in Genoa, there is a fresco of the *Annunciation* bearing the signature of "Justus d'Allamagna" and the date 1451 (fig. 231). This artist has been identified as Jos Ammann, a citizen of Ravensburg, from Rottweil near Lake Constance. In a number of documents of the city of Genoa dated the same year as the fresco, Jos Ammann is mentioned as a wealthy merchant. One year later, he appears in a Ravensburg document as purchasing the house of his father. His occupation is now expressly specified as *mauler* (painter).[315] Jos Ammann's domicile was the seat of the *grosse Ravensburger Handelsgesellschaft* – The Great Ravensburg Trading Company – that had branches throughout Europe, in Vienna, Antwerp and Bruges, Geneva, Lyon, Genoa, Milan, Valencia and Saragossa. It may be assumed that Jos Ammann travelled to these places and that, in doing so, he was able to combine his activities as painter with his trading as a merchant.

Fig. 229 Master of Catherine of Cleves. *Saint Catherine*, c. 1440. The Book of Hours of Catherine of Cleves. New York, The Pierpont Morgan Library, Ms. 917, p. 296 (detail)

The figure of the saint is a mirror image copy after an altar wing by the Master of The Betrothal of the Virgin, possibly based on a work by Campin (cf. fig. 234).

Fig. 230 Master of Catherine of Cleves. *Annunciation*, c. 1450. Book of Hours of Catherine of Lochhorst. Münster, Westfälisches Landesmuseum, fol. 16v

The figures, especially that of the Virgin, are composed after Campin's Mérode Altarpiece (fig. 42), though the scene has been transposed to a courtly, secular setting.

The *Annunciation* fresco in Genoa (fig. 231) is part of a larger decorative work. Jos Ammann also created the ceiling paintings showing the busts of sibyls and prophets amid foliage in five groin vaults. The mural of the *Annunciation* is somewhat eclectic. The facial type of the Virgin is Italian, as is the black and white framing of the door opening onto the Virgin's bedroom. The overall impression, however, is determined by Netherlandish elements, especially his decision to set the *Annunciation* scene in a richly furnished bourgeois

Fig. 231 Jos Ammann von Ravensburg, *The Annunciation* (fresco), 1451. Genoa, S. Maria di Castello

In this fresco, this itinerant northern European artist employs the very latest achievements of the Netherlandish painters, especially Robert Campin.

Fig. 232-233 Anonymous, *The Annunciation* and *The Visitation*. Modena, Galleria Estense

The two panels are from a Marian altarpiece, probably created in northern Italy. In particular, the *Annunciation* has many references to works of the Campin school.

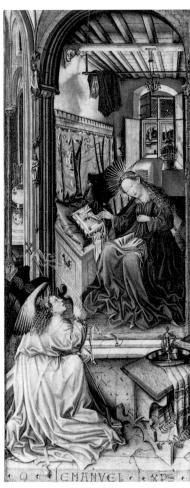

living room. The hands of the Virgin, folded across her chest, appear to be based on the *Annunciation* scene of the Ghent Altarpiece (fig. 176), while the treble arcade through which we see a landscape in the background is reminiscent of Jan van Eycks's Rolin Madonna. Yet it is primarily the heavy-set angel and the many objects of everyday use, casting their strong shadows, that point towards Campin's painting as Jos Ammann's true point of reference.[316]

Friedrich Winkler has attributed a significant group of works in every leading genre and medium – from frescos to panel paintings, book illuminations and graphic works – to the author of the *Annunciation* fresco in Genoa. Yet Jos Ammann's authorship has not been firmly authenticated for any of these works.[317] The eleven miniatures in a codex with the Tractatus of the Twenty-Four Elders, previously in Venice before being divided up in the nineteenth century, and the panels of one or two altarpieces now in Modena, Venice and Liège (figs. 232-233 and 235-236), are probably by another artist trained in northern Europe.[318] The first two locations of the panels indicate that

Fig. 234 Robert Campin (copy after), *Saint Catherine* (drawing). Amsterdam, Rijksmuseum

Fig. 235-236 Anonymous, *Saint Catherine* and *Saint Barbara*. Venice, Museo Correr

The figure of Saint Barbara is based on the grisaille copied in fig. 234.

they, like the miniatures, were probably produced in northern Italy. Whether or not the seven panels, all of which possess the same format, originally belonged to one and the same altarpiece, is not known with certainty.[319]

Of all the scenes portraying the Virgin, the *Annunciation* on the interior of a left-hand altarpiece wing in the Galleria Estense is of particular interest (fig. 232). This vertical format painting appears as a complex structure of three rooms. On the upper right, the round-arched aperture of a wall on the right-hand edge of the painting affords a view into a room in which the Virgin is seated on the floor in a pose similar to that portrayed by the Master of the Iserlohn Life of the Virgin (fig. 223). She has an open book on her lap. With her right hand she is gesturing towards a closed book that is lying on a cushion on a chest in front of her. It may be assumed that this book – like the book on the table in the Mérode Triptych (fig. 42) – contains the good tidings brought to the Virgin by Gabriel, who is kneeling in an antechamber below Mary. To the right of the archangel we see the appurtenances of washing on a bench, designating the entire pictorial space as a place of purity and cleanliness. To the left above the angel part of another arched aperture affords a view into the interior of the temple.

A number of elements in this panel and in other panels by the anonymous master recall works from the school of Campin. Apart from works by Campin himself, these are paintings by the Master of the Louvain Trinity, the Master of the Betrothal of the Virgin and the young Rogier van der Weyden.[320] Whether it was the painter of the *Annunciation* panel who created a synthesis of individual Campinesque elements or whether they had already been united in an earlier composition that is now lost, is difficult to say. The figure of Saint Barbara represented on the wing of a triptych in Venice (fig. 236) is related to the grisaille portrayal of Saint Catherine that belonged to the Marian Altarpiece by the Master of the Betrothal of the Virgin and which has survived in the form of a precise drawing (fig. 234).

The life of the itinerant artist Jos Ammann, like that of his anonymous colleagues trained in the north, is an interesting case, for it shows that it was not just

the import of art works that brought the new Netherlandish painting to southern Europe. In fact, the painters themselves travelled there. The *Annunciation* fresco in Genoa by the painter and merchant Jos Ammann of Ravensburg is of particular importance in this respect, for it presented to Italian artists the very latest achievements of Netherlandish painters, most notably those of the school of Campin, on a grand scale.

Looking Back on Campin

Painting in the Netherlands, more than anywhere else, was at one time governed by rigid conservatism, clinging to conventional motifs and traditional stylistic and painterly processes. The work of Robert Campin, along with that of the van Eyck brothers, was seminal in generating the emergence of a distinctively Netherlandish style of painting. Yet only Campin can be regarded as the founder of his own school. The compositional schemes and pictorial concepts he developed were taken up by his students, most notably by Rogier van der Weyden, and passed on, in turn, to their own students in an unbroken line of tradition. In this respect, their influence spanned generations as the most important stylistic forces in Netherlandish painting.

Fig. 237 Master of the Madonna before a Grassy Bench (copy after), *Adoration of the Magi*. Berlin, Staatliche Museen, Gemäldesammlung

Towards the end of the fifteenth century, the artistic movement that had been initiated with such force two generations before was plunged into crisis. This took the form, for example, of a distinct return to its own origins.[321] Around 1500, an extraordinary number of copies were produced in which the works of the van Eyck brothers, Robert Campin, his students, and Hugo van der Goes, were imitated as precisely as possible in all their specific stylistic characteristics. In many cases, the respective painterly style was so painstakingly emulated that art historians could barely distinguish between copy and original, and some copies probably still remain unrecognised as such.[322]

Historicism

The faithful replicas that accounted for such a large proportion of the region's artistic production over a period of several decades represent a form of historicism that can give us an indirect yet art historically interesting insight into the works created by the movement's founding fathers. It was during this period that they came to be appreciated as works of art in their own right and as precious and unique expressions of individual creativity. During the revivalist movement around 1500, works in the style of Robert Campin were copied with particularly frequency. Nor was a distinction

Fig. 238 Jacob van Oostsanen (after the Master of the Madonna before a Grassy Bench), *Adoration of the Magi*, c. 1520. Verona, Museo Civico

In this painting the Campinesque figural composition is precisely copied, while the landscape is adapted to contemporary style.

always made between the works of the master himself and those of his students. In particular, paintings created as devotional images for private patrons enjoyed enormous popularity. Let me cite an example: towards the end of the fifteenth century, entirely independently of one another, a replica drawing and a painted copy were made of an *Adoration of the Magi* (fig. 237, Cat.III.E.3/C) in which the stylistic characteristics of the original by a student of

Campin are imitated so painstakingly that it is even possible to date the lost original with some probability to around 1425.³²³ Moreover, the figures of this same composition were copied with equal attention to detail, and in the same format, in a painting from the workshop of Jacob van Oostsanen, who was active in Antwerp between 1507 and 1533 (fig. 238). The archaic aspect of the figural composition has been emphasised here by setting the figures against the backdrop of a newly invented landscape in the prevailing Antwerp style of the day.³²⁴

The pursuit of the perfect copy, however, is only one of several possible expressions of a re-evaluation of the works of the pioneering generation. Even within free painterly production, references to the works of the older generation played a new role, both quantitatively and qualitatively, around 1500, taking on an emphatically archaic tone. Once again, the works by Campin and some of the students who were stylistically closest to him, played an especially important role. They made it possible to regain what Erwin Panofsky describes, in reference to Rogier van der Weyden, as "that sense of measurable space and ponderable solidity which Roger himself had sacrificed at the altar of transcendentalism."³²⁵

Campin's compositions were copied not only by painters, but also remarkably often by sculptors in wood (fig. 239). Campin's special technique of placing the figures as clearly distinct bodies within a simulated space lent itself to this procedure. In this respect, even though he himself probably worked only in two dimensions, Campin appears as one of the most important inventors of sculptural groups in the fifteenth century.³²⁶

Among the painters of the period around 1500, the Master of Frankfurt, who was active in Antwerp, developed a particular affinity to Robert Campin. Apart from the paintings by Campin, he looked only to the early works of Hugo van der Goes with their relatively ponderous figural style. In the workshop of this Antwerp-based master, a number of copies were produced of Campin's altarpiece of the *Bearing of the Body to the Sepulchre*, in various sizes and versions (figs. 68, 70).³²⁷ The Master of Frankfurt not only adopted entire compositions from the work of Campin, but also integrated individual motifs into his own compositions. The left hand wing of the Frankfurt Altarpiece of the *Holy Kinship* (1492) featuring the *Birth of the Virgin* (fig. 240), makes twofold reference to Campin. The maid with her back to the spectator at the foreground, providing a highly effective lead-in to the vertical composition, corresponds in mirror image, and with a slightly altered head position, to the faithful midwife of Campin's *Nativity* in Dijon (fig. 26).³²⁸ The position of her hands has been retained as in the original, yet instead of presenting the banderole, she is taking a swaddling cloth from a basket and is about to hand it to another servant. The Master of Frankfurt thus transposes Campin's midwife into a traditional sphere, thereby consolidating her function as a figure with whom the spectator can identify.

Fig. 239 *The Bearing of the Body to the Sepulchre*, sculptural copy after *The Bearing of the Body to the Sepulchre* altarpiece by Robert Campin, late 15th century. Detroit, Institute of Arts (Gift of Mrs. Edsel B. Ford)

Campin's altarpiece (cf. fig. 65) is cited in numerous wooden sculptures.

The scene in the centre ground in which another maid is holding the newborn Mary on her lap while warming one hand at the fire, is an adaptation of a motif that can be found in several versions and was probably also invented by Campin (fig. 208).[329]

The Fiction of the Perfect Picture

One of the most interesting pieces of evidence documenting a revivalist approach to the painting of the pioneering era can be found in an early work by Gerard David. It is the *Crucifixion* in the Thyssen-Bornemisza collection, painted around 1485 (fig. 243). What is unusual in this panel is the fact that it is probably only the self portrait at the right hand edge of the picture that can be regarded as a genuine invention by the painter. David's painting is a collage of a very special kind. It is made up of elements of three paintings by older masters. The stylistic characteristics of the works partially cited, are precisely emulated.

The group of soldiers on the right below the cross, and probably the crucifix itself, are

taken from a work by Robert Campin. The group corresponds fairly accurately to a miniature in the Book of Hours of Catherine of Cleves (fig. 241). In this copy, the lost composition by Campin has been complemented by two figures of thieves, taken from another work by the Master of Tournai.[330] In Gerard David's painting, the stripes and the voluminous folds of the yellow robe worn by the figure facing into the picture indicate that he had copied the original more precisely than the miniaturist.

In view of this, it is all the more surprising to note that Gerard David's group of the four Marys and Saint John the Evangelist diverges considerably from the group portrayed in the miniature. In the Book of Hours of Catherine of Cleves, Saint John, supporting the swooning Virgin, looks up towards the figure of Christ, and the head of the Virgin leans to the left, taking up a position parallel to her son. In his rendering of these figures, as the stylistic characteristics betray, Gerard David is no longer citing Campin's original but the work of another painter who must have been based in the northern Netherlands. His drapery style is lighter and the figures, though they cover a similar area to that of Campin's group of soldiers, appear more graceful. Yet the northern Netherlandish painter also uses very different techniques in order to simulate spatial depth. The respective positions of the figures are determined primarily by their overlapping silhouettes. The style of the group of women is reminiscent of the work of Geertgen tot Sint Jans, who may have been Gerard David's teacher.

The city of Jerusalem in the background is taken from the work of a third painter – one of the two van Eyck

Fig. 240 Master of Frankfurt, *The Birth of the Virgin*, left wing (holiday side) of the Kinship Altarpiece, 1492. Frankfurt, Historisches Museum

brothers. The Eyckian original is a depiction of the *Bearing of the Cross* (fig. 242), documented in two mutually complementary copies.[331] Here, again, the portrayal of the city by Gerard David is a persuasive emulation of the van Eyck style.

All in all, David's collage is like a tribute to three leading lights of the first and second generations of Netherlandish painting. Yet at the same time it passes critical judgement on each one of them. By uniting the three fragments, David places himself in the position of a judge of his predecessors, whose specific achievements he salutes. One of the van Eyck brothers appears as the painter most accomplished in the portrayal of landscape and the detailed representation of faraway cities. Campin is juxtaposed with him as a particularly able figure painter. In this, however, he is equated with a northern Netherlandish painter whose style appears in many ways contrary to his own. It is surely no coincidence that Gerard David should quote Robert Campin's weighty style in none other than the group of soldiers, while he cites a northern Netherlandish painter (possibly Geertgen tot Sint Jans) in the fluid and graceful figures that make up the group of women. David interprets the stylistic differences between these two painters physiognomically, putting them to use in his own work in accordance with their respective expressive value.

The process of assessment, selection and combination involved in such a collage recalls a famous anecdote from classical writings on art. The Greek painter Zeuxis, faced with the task of creating a portrait of the beautiful Helen, was said to have called upon five virgins from Croton as models for individual body parts. Gerard David took a similar approach, though it is not the beauty of nature that is the subject of his collage procedure, but the Netherlandish painting of the pioneering era. If there is an art theoretical credo to be gleaned from Gerard David's painting, then it is that it is the task of the artist to adopt those elements of the older masters that best serve the respective subject matter. In combining the specific achievements of individual precursors in their own works, the artists of around 1500 seemed to believe that they were taking art to new heights.[332]

The loose juxtaposition of the examples of painterly perfection cited by Gerard David do not, however, lend his painting of the *Crucifixion* a higher ideal aspect. In its collage-like approach, the work of this young painter, from which he looks out on himself with a critical eye, formulates the central aim of his future work. His aim, in short, was to blend the individual perfec-

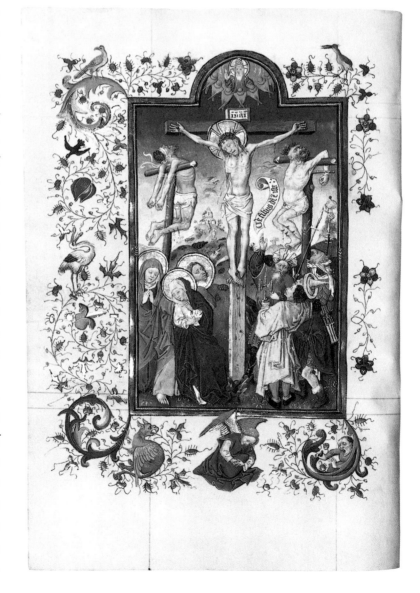

Fig. 241 Workshop of the Master of Catherine of Cleves (copy after Robert Campin), *The Crucifixion*. The Book of Hours of Catherine of Cleves. New York, Pierpont Morgan Library, Guennol Collection Ms. 945, f° 64v

This miniature represents the most complete record of the figural composition of Campin's lost original. The figures of the Good Thief and the Bad Thief were not part of the original composition.

Fig. 242 Hubert oder Jan van Eyck (copy after), *The Bearing of the Cross* (detail). Budapest, Szépmüvészeti Múzeum

tions of his predecessors in a personal painterly synthesis.[333]

David's early *Crucifixion* makes one thing quite clear: at the end of the fifteenth century, Robert Campin ranked alongside Hubert or Jan van Eyck as an outstanding artist of the founding generation. This corresponds fully with the conclusion that we have reached on grounds of a critical analysis of Campin's œuvre.

Fig. 243 Gerard David, *The Crucifixion*, c. 1485. Madrid, Thyssen-Bornemisza Collection

The painting is an "ideal" composition based on various works. The group of men under the cross is from a painting by Robert Campin (cf. fig. 241), while the landscape cites a composition by van Eyck (cf. fig. 242).

Summary

It is not easy to summarise Campin's œuvre. Each new commission prompted him to seek innovative and unexpected solutions. And yet, behind the diversity of his surviving works, we can discern a distinctive artistic personality.

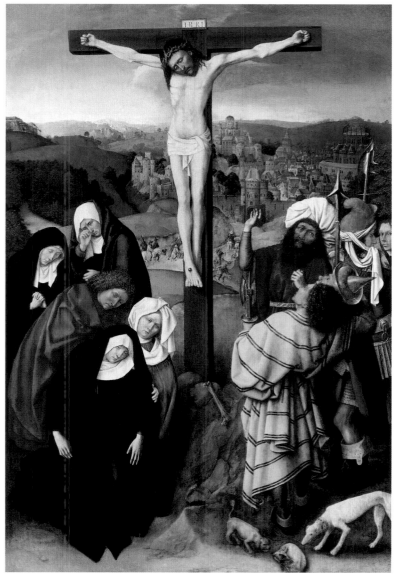

Robert Campin was a particularly imaginative narrator and a figure painter of extraordinary compositional prowess. This is evident in his small devotional works for private worship as well as in his great altarpieces of the Passion of Christ. His figures, even when they express a state of turbulent emotion, still exude an air of statuary calm. Thus, the double mimesis, the portrayal of sculptural work through the medium of painting, as demonstrated by Campin on the exterior and interior of the Altarpiece of the Louvain Guild of Crossbowmen, is very much in keeping with his artistic character. In terms of the sculptural aspect of his painting, in particular, the one artist with whom he may have had most in common was his short-lived Florentine contemporary Masaccio.

Of the artists active in northern Europe in the fifteenth century, Robert Campin is the only one who can be described as a Renaissance artist in the narrower sense. The very fact that Campin, long before Mantegna, Raffael and Signorelli, actually took his inspiration for an

iconographically new portrayal of the *Bearing of the Body of Christ to the Sepulchre* from a Roman sarcophagus showing the *Death of Meleager*, is proof enough of his profound understanding of the art of classical antiquity.

Campin's particular interest in the specific appearance of individual things, his "painterly nominalism", went hand in hand with an equally strong sense of quasi-abstract composition reduced to elementary forms. This led to some remarkably striking results, especially in the field of portraiture.

Another typical feature of Campin's work is his particular understanding of the 'projective behaviour' of the things he portrays, for the interaction of simulated three dimensional order with the real, planar order of the painting. On many occasions, as in the firescreen of the Salting Madonna or the stable of the Dijon *Nativity*, this double legibility of the pictorial structure serves the constitution of meaning.

The clearest expression of Campin's creative originality, however, lies in the symbolic language he created. It takes tangible form for the first time in the Mérode Triptych, in which it embraces every aspect of the composition. His ability to combine the accoutrements of everyday life – household goods, tools, architectural forms – in such a way that they convincingly simulate a familiar world while at the same time telling of divine secrets, is genuinely creative. What Erwin Panofsky described as 'disguised symbolism' is a form of conveying meaning that owes nothing to any theological advisor. Though the artist may have been familiar with the ideas of those who propagated the *devotio moderna*, it was not their writings that produced the Mérode Triptych.

None of Robert Campin's students – not even the most famous of them all, Rogier van der Weyden – was truly able to take on his master's heritage. The late altarpieces that Campin created for churches in Louvain and Bruges were masterpieces beyond the artistic reach of his students and many other artists. Most of them merely plundered his works, adopting individual figures or slavishly replicating entire works. Even the realistic symbolism developed by Campin was regularly adopted, though mostly reduced to an ensemble of easily legible signs. Voluntarily or not, all the Netherlandish painters of the fifteenth and early sixteenth centuries were in some way students or emulators of Campin. Yet the Master of Tournai had no true successor.

Endnotes

1 This chapter summarises the surviving documents pertaining to the life and work of Robert Campin, which are published and commentated in the appendix.

2 Although Peter H. Schabacker was able to disprove this notion of Campin as seditiary artist in a study published in 1980 it was still presented emphatically by Albert Châtelet at the International Art Historians' Congress in Strasbourg in 1989 on the subject of "L'art et les révolutions". See Châtelet 1990. Châtelet, pp. 24-29, is more circumspect.

3 The connections that Paul Rolland made with two surviving works (Rolland 1932b and 1942, 1946), prove incorrect on closer inspection. Cf. Cat. II.1 and II.2.

4 This may be regarded as proven on grounds of the documents first published by Châtelet, pp. 358-60. The surviving documents do not indicate where Robert Campin trained as a painter.

5 *Le mardi, merquedy et jeudi ensuivant viije, ixe, et xe jour dudit mois fu le peuple de ledite ville en armes assemblé sur le marchié, jour et nuyt.* According to Vandenbroeck 1863, p. 42.

6 See Houtart 1908.

7 De la Grange/Cloquet 1888, p. 119.

8 Although Alexandre Pinchart had already pointed out in 1882 that most such sentences were commuted to fines, individual art historians have sought to explain certain aspects of the dissemination of Netherlandish *ars nova* in France by maintaining that Campin did indeed undertake a pilgrimage to St.-Gilles. According to an itinerary drawn up by Troescher 1967, for example, this pilgrim artist equipped with brush and palette must have broken his journey for some time in Dijon, capital of the Duchy of Burgundy, where he probably painted the Nativity that is now housed in the city's museum (Cat. I.6). Then he would have gone on to Annecy or Chambéry, calling at the court of Duke Amadeus VIII of Savoy, where he painted a portrait of the Duke's daughter Mary of Savoy (see Cat. II.7). At the court of Savoy he would have met Konrad Witz and the artist who was later to create the Annunciation altarpiece in Aix, and introduce them to the latest achievements in Netherlandish painting. Finally, on reaching his destination, St.-Gilles, he would have painted the work that is now housed in the Musée Granet in Aix-en-Provence: Maria in Sole (Cat. III.F.4).

Such a pilgrimage would have been highly improbable. Wymans 1969 was able to show that the artist who is supposed to have walked from Tournai to Provence and back – a distance of more than two thousand kilometres – and to have painted a number of works on the way, could not have had more than five months in which to do so. Wymans' essay was barely noted by art historians. Even Sterling 1969/71, p. 5, regards such a journey by Campin to Provence and Savoy as a *sérieuse probabilité*.

9 See Henne/Wauters (1845, vol. 1, p. 227s) with particular reference to the situation in Brussels.

10 It is interesting to note that Rogier van der Weyden, who initially worked as an independent master artist in Tournai, accepted the post of municipal painter in Brussels in 1435 and that Jacques Daret undertook major works for the Abbot of St. Vaast in Arras after 1433.

11 There is a work attributable to Campin that can be dated with certainty to the period after 1432: the cartoons for the three copes in the Paraments of the Order of the Golden Fleece (Cat. I.23) commissioned by Philip the Good.

12 The fact that Rogier was commissioned to make the copy – and thus it may be assumed the subsequent restoration of the mural – does not necessarily indicate, in our opinion, that it was Rogier, rather than his teacher Campin, who actually created the fresco, as surmised by Châtelet, p. 372.

13 On grounds of a document recently discovered by Châtelet in the archives of the city of Valenciennes, the year of the artist's death, previously thought to be 1444, should probably be corrected by one year. See Châtelet, p. 361.

14 On a distinction between the historic and the artistic personality, see Berenson 1901, p. VIII.

15 Pächt 1977, p. 22.

16 Châtelet, p. 345, still makes this assumption, even though the newly discovered documents he presents do not support this.

17 See Schabacker 1980, p. 8.

18 See the collection of documents of De la Grange/Cloquet 1887/1888.

19 For example, Panofsky, whose express aim it is to examine the origins of Netherlandish painting, does not even mention the tapestries.

20 The text is reproduced verbatim in catalogue entry Cat. F.I.1.

21 Cf. Verlet in Verlet 1977, p. 41: *L'auteur des cartons est inconnu mais son art se distingue par des apports réalistes, dans les paysages et les accessoires surtout, qui laissent transparaître des influences plus flamandes que françaises.* Joubert 1993, p. 42, suggests the possibility that the client approached a workshop in Arras because the tapestry industry in Tournai was not yet fully developed.

22 Cf. Stucky-Schürer 1972, p. 69, and Huvelle 1983/84.

23 See, for example, the Grandes Heures of the Duc de Berry completed in 1409.

24 Voisin 1863.

25 The first hand is also familiar with the technique of perspective, but uses it only for selected objects, such as the sarcophagus in the sixth scene of the Eleutherius tapestry showing The Raising of Blanda from the Dead (fig. 17).

26 The details described indicate that the *tapissier* Pierre Feré had a feeling for the special qualities of

Campin's designs and that he was also capable of rendering them faithfully in a textile medium.

27 Although the theme of the Eucharist, as Lane 1975 stresses, does indeed play an important role in the Seilern Triptych, it is too small to have served as a retable. The central panels of the triptychs, which served as retables, are the same width as the altar table. The many illustrations in Steinmetz 1995 show the different mounting of small-format triptychs intended as domestic votive images and larger works placed above altars.

28 Botvinick 1992 has interpreted the donor's journey unconvincingly as an indication of a spiritual pilgrimage.

29 Jacopo Bellini takes a similar approach in a double page of his Paris sketchbook in which he complements the Mourning scene on fol. 53 with a portrayal of Golgotha on fol. 52 verso. (See Degenhardt/Schmidt 1984, p. 66s). Unlike Campin, however, Bellini shows all three crosses empty.

30 See Villers/Bruce-Gardner 1996, p. 29.

31 None of the comparative examples illustrated by Lane 1975, ill. 3-8, and Châtelet, p. 56s, corresponds as closely to Campin's composition as the alabaster relief in Venice, dated to around the end of the fourteenth century.

32 On the identification of the two figures carrying the body, see Stechow 1964.

33 The three blue stripes and the fringes of the winding sheet, reiterated in the hand towel in the later Mérode Triptych (fig. 42) alludes to the Jewish prayer shawl, the tallit.

34 The following identification of the female figures was proposed by Gelder 1967.

35 This interpretation is to be found in Gelder 1967, p. 14. (Cf. Lane 1975, p. 27, n. 39). The female figure is occasionally identified as Saint Veronica, a thesis that Gelder quite rightly rejects. The female figure with the cloth also appears in two sculptures of the Pietà, which may be based on a lost altarpiece by Campin. See Cat. Bruxelles 1979, No. 40 and No. 41.

36 The similarity was already noted by Frinta, p. 30, n. 2, and was studied in detail by Lane 1975. All three reliquaries are illustrated in Lane and, more recently, in Monroe 1992. According to Lane, Robert Campin may well have been familiar with the reliquary that is still kept in the Church of the Holy Rood in Liège. This particular version includes the background grape motif. On the other hand, the frame of Campin's triptych corresponds more closely to the *Grand reliquaire* in the Petit Palais (see fig. 23). It is therefore possible that the artist based his triptych on another work that is now lost.

37 Cf. Lane 1984, p. 43, and Blum 1969, p. 9, for a more detailed explanation of the Eucharistic significance of the portrayal.

38 Frinta, p. 31, did not understand this fully, which is why he regarded the angel as a subsequent addition by a student. On the function of the figures cropped by the frame, see Thürlemann 1989, p. 23 s.

39 In front of the sarcophagus, below the figure of the dead Christ, there is a flower which, according to Fisher 1996, p. 118, may be a stylised iris (*Iris germanica*). The donor is flanked by two of the same flowers. Fisher believes that the flower may have had a personal or heraldic significance in respect of the donor. At any rate, they certainly serve to emphasise the relationship between the figure of the donor and the figure of the dead Christ in the triptych.

40 Blum 1969, p. 9, arrives at a similar conclusion: "The artist dramatizes a religious subject in such a way that both its physical roots within Christian history and its sacred meaning as codified by Christian liturgy are equally apparent. The transitory historical moment and the permanent ideograph are captured simultaneously."

41 Gelder 1967, p. 4s, suggested that the dog might be a reference to the donor's name, as in the case of the Antwerp triptych painted for Abbot Chrétien de Hondt (Friedländer vol. 4, No. 37). The name Le Quien (Le Chien) is also documented in Tournai. Henri Le Quien was the name of the artist protected by Campin's refusal to make a statement before the court. Cf. doc. 52.

42 Châtelet, p. 58, draws a similar conclusion.

43 Comblen-Sonkes 1986, p. 189s, saw the prayer as evidence of a specific liturgical function for the painting. Yet Kieser 1968, p. 168, had already pointed out that the *Salve Regina* is also the prayer with which clerics still conclude their breviary each evening.

44 Cf. Nilgen 1967, p. 316, n. 45.

45 This is surely no coincidence. In other works, too, the artist avoids painting a single face on two boards. Irrespective of whether the boards themselves dictated the compositional structure of four groups of figures in Campin's Nativity or whether the artist had the panel prepared in this way to correspond to his four-part compositional scheme, he excluded the possibility that the faces could be damaged by the joints in the wood. Suckale 1995, p. 71, n. 4, noted a similar approach in the central panel of Rogier van der Weyden's Saint John Altarpiece.

46 The interpretation proposed by Minott 1985 – the wasp's nest as the domicile of the devil – omits to take into account the narrative aspect of the motif. Jacques Daret's version of this scene (Cat. III.A.1b) in which the wasp's nest in the same position is even more damaged, indicates that it is meant to be seen as an abandoned wasp's nest. Kemperdick, p. 57, sees a flintstone instead of a wasp's nest.

47 The similarity between this miniature and Campin's Nativity has been pointed out by Otto Pächt 1956, p. 115. Pächt identifies the painter of the Brüssels Initials (cf. Meiss 1974, vol. 1, p. 377) as Zenobi da Firenze.

48 Kieser 1968, p. 164, n. 21.

49 There are numerous examples of the scene featuring the midwives in surviving Nativity plays. See Kieser 1968, p. 156, n. 6.

50 In the *Legenda aurea* the scene with the midwives is described as follows in indirect speech (Jacobus a

THE ŒUVRE
Beginnings / A Triptych with the Entombment of Christ
pages 28 ss

THE ŒUVRE
Family Histories / The Nativity
pages 37 ss

Voragine 1890, p. 42): *Joseph licet Deum de virgine nasciturum non dubitaret, morem tamen gerens patriae obstetrices vocavit, quarum una vocabatur Zebel et altera Salome. Zebel igitur considerans et inquirens et ipsam inveniens exclamavit virginem peperisse. Salome autem dum non crederet, sed hoc probare similiter vellet, continuo aruit manus ejus. jussu tamen angeli sibi apparenti puerum tetigit et continuo sanitatem accepit.*

51 The curtsey-like position on one knee (Kieser 1968, p. 162) adopted by the figures of Joseph and the faithful midwife is probably intended to be read as a dynamic movement of the act of kneeling.

52 *Peperit Maria filium, a quo tanta lux ineffabilis et splendor exibat quod sol non esset ei comparabilis, neque candela illa quam posuerat senex quoquo modo lumen redebat, quia splendor ille divinus splendorem materialem candelae totaliter adnihilaverat.* (Cited according to Kieser 1968, p. 162, n. 17).

53 Kieser 1968, p. 162.

54 Pächt 1978, p. 10 s.

55 Kieser 1968, p. 160, draws a similar conclusion.

56 On the gothic colour system, see Frodl-Kraft 1977 / 78.

57 See Réau 1958/59, vol. 3.2, p. 771 s.

58 The church dedicated to Saint Julian at Ath was built between 1395 and 1415. This gothic edifice was almost completely destroyed when struck by lightning in 1817 (see Herman 1980). The only indications of its original appearance are to be found in drawings and in a model of the town produced shortly after 1743 under Louis XV (Grodecki 1965, planches III and V). In the south transept of the late gothic Sint-Genovevakerk at Zepperen in Brabant there is a picture plane divided into two sections, in the manner of the drawing, which was decorated with frescoes in 1509. See Buyle/Bergmans 1994, pp. 176-179.

59 In subsequently reworking the drawing, Campin erroneously replaced the sword of the warrior on the far left with a club.

60 On the history of the cult of Saint Joseph see Seitz 1908.

61 See Cat. III.D.1a.

62 On the term *mansio* see Cohen 1956, p. 66.

63 Campin's pictorial structure differs from the simultaneous scenes of the medieval mansion stages in the sense that the same place – the house of Mary and Joseph at Nazareth – is portrayed twice on the picture plane.

64 See p. 88 s.

65 Cf. the Adoration of the Infant by Lorenzo Lotto in der National Gallery in Washington, in which the same motif is used in a similar function. For another interpretation see Colalucci 1990, p. 79 and p. 86, n. 29.

66 In the scene in which Joseph is told to flee to Egypt (Underwood 1966, plate 11) the trunk of the tree alludes to the content of Joseph's dream: the Infant borne by the Virgin.

67 This opinion is expressed by Coo 1991, p. 82.

68 The church portal was the place where marriages were performed in medieval times. (See Veit 1936, p. 142 s.) The portal shown in the Madrid copy (fig. 36) is a faithful rendering of the south portal of the Church of Notre-Dame des Sablons in Brussels, showing it in its unfinished state as it remained until the early twentieth century (fig. 35). It may be assumed that this portal was a 'marriage portal'.

69 The compositional structure of the panel indicates that the church built in the new gothic style is a reference to Ecclesia, the Christian church. The buildings in the background are linked with the corner buildings in the foreground by an X-shaped structure. Just as the dwelling house of Mary and Joseph in scene 3 is reiterated in the double scene 5/7, the new church building of the double scene 1/2 corresponds to the village church in the background to the right.

70 See Haussherr 1968, p. 102.

71 This chapter is an abridged and amended version of a study of the Mérode Altarpiece published by the author in 1997. The identification of the donor couple is the result of close cooperation with the municipal archivist of the City of Mecheln, Henri Installé. The present author's criticism of Albert Châtelet's proposed identification of the donor, published in 1990, prompted Henri Installé to undertake further archival research into the Inghelbrechts family. His findings were published in 1992.

72 Tschudi's statements are based on Rietstap 1884.

73 See Cat. I.12, *coats of arms*.

74 Hulin in Heins 1907, p. 218.

75 Hocquet 1925.

76 See Rousseau 1957, p. 126, and Suhr 1957, p. 144.

77 It was Nickel 1965/66 who succeeded in identifying the profession of this figure, confirming that the triptych is linked with the city of Mecheln.

78 Kemperdick, p. 88 and n. 1, p. 181, maintains that we are looking at the outside of the door, which would mean that it is fully opened. This is incorrect. The Paris preliminary sketch for a family devotional image (Cat. III.F.5; fig. 221) also shows that the brackets are on the inside and the struts affixed by nails on the outside.

79 Both Heckscher 1968, p. 45 s, and Frinta, p. 13-29, noted the stylistic idiosyncracy of the left wing. The different style of underdrawing (cf. Asperen de Boer et al., p. 114) lends credence to their observations.

80 One possible reason for this may have been that the donor was not available to sit for a portrait. In such a situation, Campin may well have dispatched his master student to paint the portrait of this sitter who lived outside Tournai, and also have entrusted him with the task of painting the entire left-hand wing. In this respect, we amend the view expressed in Thürlemann 1997a, which assumed that the present left-hand panel replaced an older one.

81 The block-type mousetrap is not recognised as such by Châtelet, p. 292. However, folkloristic studies allow it to be identified with certainty. See Berg 1966 and Installé 1992, ill. 19.

82 Schapiro was clearly unaware of the footnote that Huizinga added to the last edition edited by him. (See Huizinga 1969, p. 515, n. 1). In the main body of the text, p. 439, Huizinga regards the mousetraps as genre elements, but in the footnote he does refer to a passage in Petrus Lombardus and points out the possibility that the mousetraps may have a symbolic meaning.

83 In the Holy Family depiction by Pere Terencs of 1485/95 and in a copperplate engraving by the Master Na.Dat of 1515/20 (ill. 3 and 7 in Berchtold 1992) the mousetraps are also attributed to Saint Joseph rather than to Christ.

84 See also the relevant passage in Saint Jerome's exegetical commentary on the Gospel according to Saint Matthew (Saint Jérôme 1977, p. 78): *Martyr Ignatius etiam quartam addidit causam cur a sponsa conceptus sit: ut partus, inquiens, eius celaretur diabolo, dum eum putat non de uirgine sed de uxore generatum.*

85 According to Tolnay 1959, p. 68.

86 See also Coo 1981, p. 131. In his 1984 essay, Coo retracted his initial interpretation and made a new proposal (featuring a link to the Netherlandish word *winket*), which is not convincing.

87 The concept of the Virgin Mary as 'the dwelling place of the Trinity' was widespread in the late Middle Ages. See Kern 1971, pp. 128-138.

88 This passage is cited verbatim in Meiss 1945, p. 176. The seven rays indicate the seven gifts of the Holy Spirit. According to Bernardinus de Busti (*1513) these were 'inscribed' upon the Mother of Christ at the Annunciation. See Schreiner 1990, p. 359.

89 For a detailed commentary on this item of furniture, see Coo 1981.

90 Hütt 1989 has persuasively argued against the liturgical interpretation of the basin proposed by Lane 1984.

91 The traditional interpretation of early Netherlandish painting according to the concept of 'disguised symbolism' developed by Panofsky, esp. pp. 131-148, has recently come under critical fire. See, for instance, Carrier 1986/87.

92 For further details, see Thürlemann 1990.

93 A reference to funerary monuments is already to be found in Heckscher 1968, p. 54, albeit with a different interpretation. Châtelet, p. 99, like most earlier authors, sees only lions.

94 For a summary, see Thürlemann 1990, p. 395, n. 19. The additional interpretation, provided by Kerstin Brenner (cited in Reuterswärd 1998, p. 49) is that it is a 'louse-board'.

95 Installé 1992, commentary on ill. 14, identifies the board as the cover of a footwarmer, which brings us back to the earliest interpretation of the object by Panofsky, p. 164.

96 Arasse 1976, p. 49, interprets the fire in the same way, though he interprets the fire-screen differently. For Hahn 1986, p. 61, "the firescreen may be a demonstration and model of Joseph's chastity."

97 Two examples are illustrated and discussed in Arasse 1993, p. 159ss. Others include: Master of the Legend of Saint Barbara, Adoration of the Magi (Friedländer vol. 4, Add. 152), and Veit Stoss, Holy Family (fig. 12 in Thürlemann 1997a).

98 Although Minott 1969, p. 267, was the first to make the link with this passage in the Bible, he interprets the tools, in contradiction to the compositional structure of the work, as "diabolical" instruments, with references to more or less obscure exegetical commentaries.

99 For details of this form of portrayal, see Robb 1936, p. 523 ss.

100 Blum 1969, p. 9, recognised the Holy Spirit extinguishing the candle, but her interpretation was not taken up by subsequent art historians, until Châtelet, p. 99, offered the same interpretation, which he attributed to a verbal remark by William Voelkle. See also Jacobus a Voragine [translated here from the German edition of 1890, p. 42 – transl. note]: "… for she did not conceive from human seed, but a mystic breath [*ex mistico spiramine*]: the Holy Spirit took the purest and most immaculate blood of the Virgin and created from it the body of Christ."

101 See Bedaux 1986, p. 10, n. 14.

102 For the following, see Installé 1992.

103 Installé 1992, caption of ill. 5, states that both forms of the name (Imbrechts/Ymbrechts and Inghelbrechts) were used indifferently. This is incorrect. The statement by Installé 1992, p. 116, n. 9, is correct. The persons recorded in Family Tree I, p. 75, bear solely the name form Imbrechts/Ymbrechts in the documents.

104 See Family Trees II and III in Installé 1992, p. 76s. Cologne documents mention two further brothers, Johan and Simon. They cannot be the patrons, as the triptych has a definite link to the town of Mecheln, as confirmed by the presence of the messenger on the left-hand panel.

105 The entry reads: *Margarete … Scrynmakers, de Colonia, de priori thoro.* See Installé 1992, p. 60, line 32.

106 The rebus-like process of portraying objects that literally illustrate elements of proper names seems to have been common practice in the fifteenth century Netherlands. Consider the case of the *scupstoel* capital in the new Brussels Town Hall built in 1444–50 (Cat. III.G.4) and the commentary by Haverkamp-Begemann in Cat. New York 1999, p. 109 (with reference to further examples). This phenomenon has yet to be studied systematically.

107 See Cat. C.12, *Condition*.

108 According to a letter from Manfred Huiskes of the municipal archives of the City of Cologne (letter dated 25 November 1993). The information in Installé 1992, Family Trees II and III, should be amended in this respect.

109 Long before Rembolt, members of the Cologne branch of the Engelbrecht family had come to Mecheln with the Knights of the Teutonic Order. See Installé 1992, p. 79s. Their descendants were named Ymbrechts in the fifteenth century. This explains why the new arrivals from Cologne – and

only they – are mostly referred to in the documents by the different-sounding name 'Inghelbrechts'.

110 The coat of arms of the Bille family of Breda has not yet been authenticated. Installé 1992, p. 147, n. 172, surmises that the rings (*bellen* in Flemish) may be a punning reference to the name Bille.

111 See Freeman 1957, p. 136.

112 Snyder 1985, p. 120, already linked the three lilies with the Trinity. The expression *lilium trinitatis* is documented in the thirteenth century in the writings of Gertrud von Helfta. See Gössmann 1957, p. 214.

113 Installé 1992, p. 139, n. 128, and p. 148, n. 173[ter], considers that the messenger has been portrayed on the donor wing because he brought the message of the Duke of Burgundy and the Bishop Prince of Liège to Cologne in 1450, leading to the release of Peter Engelbrecht. Installé presents some interesting arguments in favour of identifying this figure as Wallerand Van Loeffene, who is mentioned as a messenger in the documents of the City of Mechelen. Apparently, Wallerand Van Loeffene had close contacts with the Engelbrecht family. He is even mentioned as early as 1435 together with Peter Engelbrecht's brother Rembold in documents of the City of Tournai and was called upon by the City of Mechelen in 1454 to negotiate in a similar murder case.

114 The same procedure is documented in the Book of Hours of the Maréchal de Boucicaut, Musée Jacquemart-André, Paris, fol. 73 v and 83 v. The two miniatures are illustrated side by side in Panofsky, plate 31.

115 See Beaujean 2001, pp. 19-21.

THE ŒUVRE
The Imaging of the Bourgeois Individual /
Forms of Portraiture
pages 77 ss

116 Only the Portrait of a Man in Bucharest (Friedländer vol. 1, plate 46) is likely to have been painted before 1432 and to be earlier than Campin's Portrait of a Woman in London (Cat. I.9). All the other portraits by Jan van Eyck are dated later or are stylistically later than 1432.
It is doubtful that the number of surviving portraits by Jan van Eyck and Robert Campin reliably reflects their actual proportional production. In contrast to the portraits by Campin, those by Jan van Eyck were signed regularly, at least after 1432. It may be assumed that they were therefore coveted by collectors at an early stage and that this would have protected them better from destruction.

117 Cf. the catalogue entry on the diptych Cat. I.8/C. A similar incident can be found in the case of Anselm Adornes. Before embarking on a pilgrimage to Jerusalem in 1470, he bequeathed to his three children copies of a portrayal of Saint Francis receiving the Stigmata by Jan van Eyck, with portraits of himself and his wife on the wing panels. (See Rohlmann 1994, p. 105 ss.)

THE ŒUVRE
The Imaging of the Bourgeois Individual /
An Altarpiece with the Bearing of the Body
to the Sepulchre
pages 84 ss

118 The diptych of the Roi René and his second wife Jeanne de Laval, painted around 1476 and now housed in the Louvre, may well be the oldest surviving example of a marital diptych still in its original hinged frame with the original velvet lining. See Dülberg 1990, Cat.-No. 174 and ill. 112-114.

119 See the Portrait of a Man in Bucharest (Friedländer vol. 1, plate 46) and the courtship portrait of Isabella of Portugal painted by Jan van Eyck in 1428, which has survived in the form of a replica drawing, using the same formula, albeit in a particularly lavish form. See Pächt 1989, p. 110 s with ill. 62.

120 The document is transcribed in Dehaisnes 1881, p. 77.

121 The less confident painterly technique in the male portrait may well be the reason why it is in considerably poorer condition than the female portrait.

122 Although Frinta 1966, p. 59 s, makes this unequivocally clear, later authors, including Davies. Cat. Campin/London 1, Campbell 1990, pp. 90-94, Châtelet, Cat.-No. 13 & 14, and Kemperdick, p. 119, worked on the assumption that both were by the same artist.

123 Probably this was originally intended to imitate the effect of flamed marble. See Davies 1953, plate CXX, and Dülberg 1990, Cat. 134 and 135.

124 We consider it possible that the male portrait is one of the oldest existing autonomous works by the hand of Rogier van der Weyden. See Cat. III.G.2.

125 The x-radiography is illustrated in Frinta as ill. 37. This and other changes are described precisely by Frinta p. 57, n. 1, albeit without reference to the physiognomy. It is interesting to note that the x-radiography of the male portrait (ill. 65 in Frinta) does not indicate any changes in form in the course of the painterly process.

126 In the prayer guide *Zardino de Oration* of 1454, for example, the pious believer is advised, when meditating on the suffering of Christ, to imagine the individual episodes occurring in familiar settings, and to imagine the figures involved as contemporaries. The passage referred to here is cited in Baxandall 1974, p. 46.

127 The study by Campbell 1990, for example, does not provide a systematic treatment of the "role portrait": Pope-Hennessy 1966, on the other hand, dedicates an entire chapter (Chapter IV) to the subject. More recently, Polleross 1988, addresses this subject, using the term *sakrales Identifikationsporträt* (sacred identification portrait). We do not feel that it is justifiable to restrict the concept of the 'role portrait' to that of an 'actor portrait' as is so often the case.

128 See Asperen de Boer et al.

129 Ludolphus de Saxonia 1878, vol. II, p. 144: *Illi volebant eum tradere sepulturae, et ipsa volebat eum retinere, et sic erat haec pia lis et miseranda contentia inter eos.*

130 The passage in the Canon of the Mass reads: *Supplices te rogamus, omnipotens Deus: jube haec perferri per manus sancti Angeli tui in sublime altare tuum.*

131 Fredricksen 1981, p. 134: "There may have been a

window or some other architectural impingement above it."

132 See Friedländer vol. 7, Add. 202 (Altarpiece in Watervliet). The small-scale version (Lawrence, Spencer Museum of Art, University of Kansas) is not mentioned by Friedländer.

133 The exteriors with the hand-washing scenes are based on Campin, in contrast to the views expressed by Veronée-Verhaegen (1966, p. 43). The weapons on the left and the high backrest of the throne on the right, as shown in the smaller copy, were undoubtedly intended to fill out the elevated corner areas of the original format. Moreover, there is another, probably older, freely interpreted copy of this scene by the Master of Saint Gudule, which is also divided in the middle. (See Friedländer vol. 4, Supp. 122). However, it is unclear whether the scene in Campin's work was a grisaille or whether it was a coloured portrayal, as in the work by the Master of Saint Gudule.

134 See Schiller 1968, pp. 181-185.

135 Houben 1949.

136 Sulzberger 1950/51, p. 259, and ill. on p. 261.

137 See McCann 1978, Cat.-No. 8 (additions ascribed to the Paduan artist Andrea Bregno). According to Weinberger 1945 the restorer was the Florentine artist Valerio Cioli, commissioned by Cardinal Ippolito II d'Este.

138 See Koch 1975 for a full visual documentation of all extant Meleager Sarcophagi.

139 It is unlikely that Campin would have been using drawings by a third party.

140 It is not known whether Campin would have been able to interpret the mythological scene correctly. However, even if he could not, the nudity of the main figure would have indicated to him that the story portrayed took place in pagan antiquity.

141 Note the half-open mouth of the dead thief in Campin's portrayal and its similarity to the half-open mouth of the dying Meleager on the New York fragment, Merback 1999, p. 114, was also reminded of classical antiquity when he described the figure of the thief as "a kind of disjointed, judicial analogue to the drunken sleeping Satyr of Hellenistic art".

142 The figure of Nicodemus was determined for the first time as a role portrait of the donor by Thürlemann 1993b, p. 38 – at the time without any proposals as to his identity. On Nicodemus as a role portrait see Stechow 1964, Pope-Hennessy 1966, pp. 289-300, and Polleross 1988, pp. 227-232.

143 Quarré-Reybourbon 1900, p. 41, with reference to M. H. Fremaux.

144 See Leuridan 1903, p. 264s. According to Denis du Péage 1908, p. 900, Barthélemy Alatruye died at The Hague before 1450. It may be assumed that he is also buried there.

145 On the history of the Church of Sainte-Marie-Madeleine in Lille see Robinet 1977. Following the erection of new city defences by Vauban towards the end of the seventeenth century the priest and his church were cut off from most of the congre-

gation, who now lived inside the city walls. In 1705 it was therefore decided to demolish the old church and build a new one inside the walls.

146 It is not impossible that the hypothesis proposed here may yet be confirmed or at least supported by documents still to be found. The fifteenth century archives of the parish of Sainte-Marie-Madeleine have not survived. Nevertheless, as Henri Patelle informed the author in a letter dated 27 March 1994, documents pertaining to La Madeleine have repeatedly been found in the archives of the City of Lille which were not designated as such in the inventory.

147 On the various interpretations of the figure of Nicodemus in Rogier's Entombment as a role portrait (selfportrait or donor) see Rohlmann 1994, p. 133, n. 121.

148 Frinta, p. 43 s, surmises that the panel was originally the right-hand panel of a diptych. This seems to us to be unfounded. In the diptychs from the circle around Campin, the vanishing point of the flooring is between the two panels.

149 A similar woven fire-screen can be seen in the January illustration of the Très Riches Heures of the Duc de Berry (ill. 88 in Panofsky). There, it serves to emphasise the figure of the Duke and set him apart from all the other figures.

150 Tolnay, p. 15s; Panofsky, p. 163.

151 X-radiography shows that the Infant originally looked the other way, gazing up at the Virgin. See ill. 11 in Campbell et al. 1994, p. 27.

152 See Meiss 1936.

153 This leaning towards the Sienese school is questioned by Reynolds 1996 on flimsy grounds.

154 See Cat. F.13, Commentary.

155 Pitts 1986, p. 90, also saw a reference to John 1:14 in the link between the swaddling and the book cover.

156 See François Avril in Avril et al. 1989, pp. 268-271 (Commentary on our fig. 83).

157 Mazurczakowa 1985, p. 18, also noted the use of colour to link the Madonna with the church building.

158 For a survey of extant portrayals of Saint Luke painting the Virgin, see Klein 1933 and Kraut 1986. The present chapter summarises the findings already published in Thürlemann 1992.

159 Grete Ring was the first to link Colijn de Coters work hypothetically with the Master of Flémalle (Ring 1913, p. 105, n. 1): "Perhaps an even earlier version [of Rogier van der Weyden's theme] was painted by the Master of Flémalle. The lost original would then have been handed down to us in a freely interpreted copy by Colijn de Coter in Vieure." Panofsky, p. 175, went on to publicise this twofold assumption as a double certainty: "... a 'St. Luke Painting the Virgin' reflected in a picture by that great parasite of the past, Colin de Coter." In Kraut 1986, p. 27 ss, de Coter's work is then discussed under the heading "The Master of Flémalle".

THE ŒUVRE
The Theology of the Setting /
The Virgin and Child before a Fire-Screen
pages 92 ss

THE ŒUVRE
The Theology of the Setting /
The Saint Luke Altarpiece
pages 101 ss

THE ŒUVRE
Two Altarpieces with the Descent from the Cross /
The Altarpiece of the Louvain Guild of Crossbowmen
pages 109ss

160 Both panels measure 135 x 108 cm.

161 Hans Spaemann's identification of the figure as Saint Dominic (Spaemann 1925, p. 25) is based on an incorrect description of the colours of the saint's garments. The identification as Saint John the Evangelist (proposed by Pieper 1937, p. 235, as a hypothesis) may also be discounted, as the attribute of an eagle, rather than a dog, would have accompanied him. The hypothetical proposal put forward by Thürlemann 1992 that this might be the prophet Daniel does not tie in with the boat scene in the background.

162 See Sprung 1937, p. 35.

163 Jászai 1986, unpaginated leaflet.

164 The panel originally had two wings. (See Cat. Antwerpen 1985, No. 5096, p. 105s.) The triptych, which bears the coat of arms of the Antwerp guild of painters, may be regarded as a secular and artist-related variation on Campin's Saint Luke triptych.

165 On the motif of the *musca depicta* see Pigler 1964, Chastel 1984 and Kühnel 1989. It is possible that the motif, first recorded in the portrait of a Carthusian monk by Petrus Christus (Friedländer, vol. 1, plate 74), was introduced into Netherlandish painting by Campin in his Saint Luke triptych. A still-life closely related to the one featured above the head of Saint Luke in Baegert's copy can also be found – also on a sideboard – in the miniature of the Birth of John the Baptist in the Turin Book of Hours (fol. 93v). Again, it features a dish filled with red fruits (cherries?), an almost identically formed brass pitcher shown at the same angle, and a knopped glass with another glass added. (For a good colour reproduction, see Pächt 1989, plate 16). The composition is further related to the central panel of the Saint Luke triptych in that it also shows a open door on the far right of the picture, affording a view into a back room in which a seated male figure (Zacharias) can be seen reading by a window and sitting before a fireplace. In our opinion, this miniature, conventionally ascribed to Hubert or Jan van Eyck, is a later, mid-fifteenth century copy after a work by Hubert or Jan van Eyck, as indeed are most of the works attributed by Hulin de Loo to 'Hand G'. The well-founded arguments for a late dating of the miniatures by 'Hand G', presented by Lyna 1955, have been all but ignored by later historians.

166 Cf. Doc. 26.

167 Cf. Thürlemann 1992, n. 77.

168 There are several striking similarities between the background in the replica of the central panel in Münster signed by Derick Baegert (fig. 89) and the background in Rogier van der Weyden's Saint Luke (fig. 87). Both works feature a building with brass plates hung on display opposite a massive stone building with a facade of arcades on several storeys. The similarity is probably because both works refer, where these elements are concerned, to Campin's triptych.
The tavern sign of a swan on the right-hand panel (fig. 92) may be a reference to a street in Tournai – the rue des cygnes, which is the southern extension of the rue St. Jacques. However, an iconographic comparison in support of such a thesis is rather difficult, given that the urban landscape was considerably changed in the years 1513–1519 by the construction of the château at the end of this street and the stronghold quadrant in the south-west of the town. For information on this, see Marie-Suzanne Gilleman in Thomas/Nazet 1995, pp. 217-228.

169 The statement in Folie 1963, p. 208, makes a subtle distinction: *Un seul tableau de Roger van der Weyden est unanimement considéré comme authentifié par un document, bien que la source d'archives invoquée soit tardive.* See also Davies 1937, p. 243, no. 2: "his [Molanus'] statement may be held merely to prove that the original of the Deposition [i.e. the Escorial picture] was known as Rogier (...)"

170 Calvete de Estrella 1548/1876, p. 83, also mentions the Descent from the Cross in his contemporary description of a journey: *Au bout de cette salle s'ouvre une chapelle où l'on entre par un portique de jaspe & à l'interieur de laquelle on admire un retable figurant la descente de croix, qui est un chef-d'œuvre de peinture.*

171 See Davies, Cat. Rogier/Madrid 1.

172 See Folie 1963, p. 208.

173 See Zülch 1938, p. 379.

174 See Marijnissen 1985, p. 311.

175 Quoted by Folie 1963, p. 209.

176 *Ibid.* De Vos 1999, p. 38s, is of a different opinion, and considers the author, in keeping with a 140 year tradition, to be Rogier van der Weyden, as deduced from De Vos' six-step 'genealogy': Rogier van der Weyden, Dieric Bouts, Aelbrecht Bouts, Michiel Coxcie, Cornelis Cort, Hieronymus Cock.

177 See Cat. I.17, *Dating*.

178 Panofsky, p. 251.

179 This fact was pointed out by Birkmeyer 1962, p. 330.

180 See van Even 1895, pp. 437-440.

181 The connection with the guild is alluded to by the small crossbows that seem to hang from the large tracery ornamentation. On the hypothesis that the donor may have borne the Christian name of Peter, see Cat. I.17 *Commentary*. According to a letter from Marika Ceunen of the Louvain municipal archives, the epitaphs on the tombs in the now demolished church of Onze-Lieve-Vrouwe-van-Ginderbuiten are not documented, which means that the name of the donor of the altarpiece cannot be traced in this way.

182 Several written and visual documents prove that in the fifteenth century there was a close correlation between the tableaux vivants performed primarily at royal processions, and the painting of the day. The tableaux vivants were presented in box-like spaces very similar to that in which the Descent from the Cross is portrayed. See Jooss 1999, pp. 34-37; esp. 36 with reference to ill. 6.

183 Cf. p. 108s.

184 The analysis of the painting by Simson 1953 is devoted entirely to the concept of *compassio*.

185 In a fifteenth century French translation of the bible in the dialect of Picardy (Zentralbibliothek Zürich, Codex C 175, fol. 150r) the passage is similarly worded to the Vulgate version, and reads as follows: *il verront au quil ont tresperchut.*

186 This is the case in the following copies: Edelheer Altarpiece, 1443 (fig. 112), Engraving by the Master of the Banderoles, second half of the fifteenth century (Friedländer vol. 2, No. 3k), copy by Joos van Cleve, c. 1518 (ill. 21 in Thürlemann 1993b), engraving by Cornelis Cort, 1565 (fig. 98). The notion of a 'symbolic cross' with a truncated horizontal beam does not tally with the detailed realism of this artist. The two blood-smeared nails held by the helpers on the ladder were previously driven into the wood.

187 Apart from the central panel of the altarpice by Jan Mostaert (fig. 105) produced around 1510, there is also a Descent from the Cross by the Master of the Bartholomew Altarpiece in the Louvre, created around the same time.

188 Cf. p. 109s.

189 The right hand with which the helper is holding the two nails on the cross seems to get caught in the tracery. In Thürlemann 1993b, p. 44, n. 799, the lililes on the minor tracery are interpreted as a reference to the new owner of the painting, Mary of Hungary. De Vos 1999, p. 40, no. 12, considers the elevated tracery as original and regards this as an indication of Tournai as the place of production.

190 Sigüenza 1602/1909, vol. 2, p. 548: *Lo primero que sabemos hizo aqui fueron unos Profetas de blanco y negro en unas puertas de un tablero, de la quinta angustia, que esta agora en medio de la pared de la sacristia encima de los cajones, que por estar de continuo abierta no se gozan.*

191 The full text reads (according to Folie 1963, p. 208): *Una tabla grande en que está pintado el Descendimiento de la cruz, con Nuestra Señora y otras ocho figuras, que tiene dos puertas, pintado en ellas por la parte de dentro los quatro Euangelistas con los dichos de cada uno con la Resurreción, de mano de Maestre Rogier, que solía ser de la Reyna María, pintadas por de fuera las puertas de mano de Juan Fernández Mudo, de negro y blanco, que tiene de alto la tabla de en medio, por lo que toca a la cruz que en ella está pintada, siete pies y de ancho diez pies escasos.*

192 The document is cited (without precise reference) by Steppe 1985, p. 271.

193 De Vos 1999, p. 32, notes that the design submitted to Philip II was 'obviously rejected'. However, this is not entirely evidence, since it is not true that the inventory of 1574 portrays the "four evangelists with banderoles on the left and the resurrection on the right". Verougstraete-Marq 1981, p. 127, had assumed that the wings attached to the Descent from the Cross in the Escorial were later works created in the Netherlands with no exterior painting.

194 The few authors to take note of this hypothesis dismissed it. See for example the reviews by Grange

1969 and Blum 1970. Sander 1993, p. 106, mentions the hypothesis without passing judgment on it. In our initial attempt to reconstruct the Altarpiece of the Louvain Guild of Crossbowmen (Thürlemann 1993b), we did not take Frinta's hypothesis into account.

195 See Sander 1993, pp. 88-98.

196 Sander 1993, p. 93, comes to the conclusion that 'nothing but contradictions' can be gleaned from the information on the original location of the panels issued by the Städel on their acquisition.

197 Sander 1993, p. 114.

198 Söding 1995, p. 119, is also of the opinion that these are the wings of a retable. On the reconstruction of the original ensemble by Châtelet and Kemperdick see Cat. C.I.18, *Commentary.*

199 See the *Commentary* on Cat. I.16. In the Bruges Descent from the Cross both the niches must have been composed to accommodate a side view.

200 The affinity is even greater than Frinta, p. 101, assumed. According to new measurements taken by Dr. M. Diaz Padron (Museo del Prado) and Dr. R. Eichler (University of Constance) in October 1996, the height of the painted area in the Madrid Descent from the Cross is 148.5 cm at the sides. The mean height of the painted surface in the Flémalle Panels is 148.27 cm.

201 The panel of the Virgin and Child, which has survived uncropped, has dowel holes at regular intervals on the edge, indicating that it was framed by dowelled-on mouldings according the technique known as *cadre appliqué* (see Verougstraete-Marcq/Schoute 1989, p. 50). The unpainted margin, which is 5 cm wide, corresponds to the actual frame width in this form of framing. The Madrid Descent from the Cross panel was also framed in the same manner. By adding the same frame width of 5 cm to either side of the 258.5 cm painted surface of the panel we arrive at an overall framed width of 268.5 cm. Thus, four wings with an average painted width of 57.65 cm would, if framed, add up to an overall width of 270.6 cm. Here, too, the discrepancy is negligible.

202 Cf. Kemperdick, p. 19. The same author, p. 171, n. 83, incorrectly states that the figures in the Descent from the Cross are "slightly larger than those in the Frankfurt panels".

203 Apart from the shrine retable in Geel (fig. 107) see the retable from Brussels workshops, now in Warsaw, with the same polyptych form of four large and two small wings. (See Friedländer, vol. 4, plate 101.)

204 In the description of the isolated Virgin and Child panel, Sander 1993, p. 90, describes the gaze of the Infant Christ "as though suddenly distracted from the process of suckling".

205 Several examples are illustrated in Kermer 1967. In these diptychs, the Infant frequently has a cruciform nimbus, as in Campin.

206 As regards the Holy Day sides, it might be said that the lost first wing on the right was very probably dedicated to the theme of Christ Risen. The sepul-

THE ŒUVRE
Two Altarpieces with the Descent from the Cross /
The Good Thief on the Cross
pages 131 ss

chre of Christ would have been the natural goal of the group of men on the Madrid panel carrying the Body of Christ out of the picture towards the right. A comparison with the earlier altar of the Bearing of the Body to the Sepulchre (fig. 65) whose appearance can be reconstructed on the basis of copies (cf. fig. 70) also underpins this assumption. This would mean that, on the three interior panels (Maria lactans – Bearing of the Cross – [Resurrection]), the figure of Christ was portrayed three times in persona and once, on the far right panel, as an effigy on the sudarium displayed by Saint Veronica, as the *vera icon* alluding to the Passion of Christ. If we are to assume an axial symmetry in the compositional alignment of the panels of the polyptych when opened, then the far left wing would have to feature a saint with an image or effigy of the Infant Jesus. Saint Luke at his easel would be the logical choice. A vertical format portrayal of Saint Luke painting, which must originally have had a corresponding Madonna panel as its pendant, has survived in a panel ascribed to a follower of Quentin Massys. (See ill. 29 in Thürlemann 1992). The portrayal of Saint Luke on the exterior of the right wing of the Saint Luke Altarpiece of the Hamburg Corporation of Painters, dated to 1499 and now housed in the Sankt Jacobikirche there bears strikingly Campinesque traits. The panel, begun by Hinrik Bornemann, was probably completed after his death by Wim Dedeke. (See Klée Gobert/Wiek 1968, pp. 202-205, ill. 271). We consider it possible that this panel – with left and right reversed – reflects something of Campin's lost work. This is also suggested by the fact that the panel painted by Saint Luke corresponds to a Madonna that has survived in numerous versions by artists in the circle around Rogier van der Weyden. (Cf. Friedländer vol. 2, Cat.-No. 40Ab).

207 See Verougstraete-Marcq 1981, p. 127. Studies of the painterly technique permit the assumption that the copyist did not originally envisage the two angels in this position. It may therefore be taken as certain that they were placed elsewhere in the original.

208 Given that a coherent overall scale must surely have been applied for the figures on the outside, the figural painting of the four small compartments (picture area 72.5 x 58 cm) would have featured half-figures. These were most likely to have been portrayals of 'four prophets' or 'four evangelists'.

209 See Kemperdick, p. 21 s. The authorship of Josse van der Baren for the new Madonna is a further persuasive indication that the Flémalle Panels, like the Descent from the Cross, also originated in Louvain.

210 See Schuler 1992 and Gerdts 1954.

211 According to Steyaert 1981, p. 22.

212 The church was known from the early seventeenth century, at the latest, as the Church of Our Lady of Sorrows, indicating that it was a centre of the new Marian cult. See Opmeer, *Opus chronographicum*, Antwerpen 1611, vol. 1, p. 406, where the origin of the Descent from the Cross is given as '*Lovanii ab aedibus sacelli dolorum beatae Mariae Virginis*'. (Cited in Simson 1953, p. 15, n. 44). The original Madonna donated to the chapel in 1365 is a life-size Pietà group now in the Louvain municipal museum (Steyaert 1981, ill. 1). The author's assumption that the 1552 woodcut (fig. 116) is a freely interpreted portrayal of the fourteenth century sculpture can hardly be correct. Van Even 1895, p. 437, also incorrectly describes the old Marian image as a portrayal of the *Mater dolorosa*.

213 For details, see Merback 1999, pp. 113-121. The author shows that the painter persuasively reconstructed the Roman *crurifragium* on the basis of the biblical text and elements of personal observation, as noted by Herrlinger 1951/53 (p. 120): "In Campin the real infiltrates the rhetorical to the extent that the wounds are not only shocking but shockingly *familiar*."

214 Brussels, Bibliothèque Royale Albert Ier, ms. 11060-1, p. 194; see Meiss 1974, vol. 2, ill. 495. Kemperdick, p. 30 and 39, also points out a Franco-Flemish ivory medallion dating from around 1400 (ill. 50).

215 There are further correspondences. In both portrayals a man is climbing up a ladder that is leaning against the cross on the right; in both, the Virgin Mary reaches out her hands towards her son and is supported by Saint John.

216 The copyist has simplified here. In the drawing in the Fitzwilliam Museum in Cambridge (fig. 122) both the hands of the man with the cap can be seen. This means that this was not an indicative gesture but the *computus digitorum* as an an expression of argumentation. Châtelet, p. 31, surmises that Campin may have rendered the figure of the man with the cap as a self-portrait.

217 Panofsky, p. 167, like other art historians before him, interpreted the figure in Frankfurt as the Bad Thied on the basis of iconographic convention. This interpretation has been contradicted with good reason by Held 1955, p. 213 s, and others. A summary of the debate can be found in Sander 1993, p. 142.

218 In the Passion painting by the so-called 'Bruges Master of 1500' (Friedländer vol. 9.2, No. 184) Campin's Thief figures are left in their original positions, but have probably been interpreted according to the conventional alignment, as Christ on the Cross has inclined his head towards the Thief on his right with the blindfold.

219 The same solution can be found in the engraving by the Master of the Banderoles (Friedländer vol. 2, No. 3k), in which the original Descent from the Cross group is replaced by the group of figures from the Altarpiece of the Louvain Guild of Crossbowmen. In order to exclude any possible doubt as to the identity of the two Thieves, the engraver has included their names on banderoles. For the

crucifixion group of a southern Netherlandish tap-
estry of 1480–1490 the solution employed by the
Bruges Master of 1480 (fig. 125) is also adopted.
However, here, the Good Thief has been placed to
the right of Christ, without a blindfold and with
a head position analogous to that of Christ. (See
Cavallo 1993, No. 15.)

220 The actual order of the sybils is known, as they
are numbered, starting on the north side, in the
cycle by Hermann tom Ring. The position of the
pagan wise men can be deduced from the space
alloted in each group of three. Clark 1978, p. 81,
n. 53, recognised that Albumasar, rather than Bal-
aam, as previously believed, belonged to the group
with Sybilla Samia and Sybilla Hellespontica. On
the other hand, the rearrangement within the
sequence of sybils, which Clark 1978, p. 52, pro-
poses for the original sequence, is unnecessary.

221 The relationship between the three series of copies
can be determined by means of comparing the
variations on the Phrygian Sybil (figs. 133, 135, 137),
which has survived in all three cycles. It shows that
the three series are independent of each other
and, at the same time, that they can all be regarded
as more or less faithful copies. The copperplate
engraving by the Master of the Banderoles cannot
have been created after the woodcut copy, as only
the copperplate engraving features the ornamental
band on the shoulder, also found in Ludger tom
Ring's painting. On the other hand, as regards the
draperies, the painted copy by Ludger tom Ring
is closer in many details than the copperplate
engraving. The fact that Ludger tom Ring's painted
copy cannot be based on the copperplate engrav-
ing is evident from the fact that, in his version, the
sybil is facing the other way (the engraving being
a mirror image) and is gesticulating more persua-
sively than in the two graphic copies. Clark 1978,
pp. 32-35, arrives at the same conclusion on other
grounds with regard to the relationship between
the series of copies.
The comparison of the three separate copies indi-
cates that Ludger tom Ring the Elder made slight
amendments to some aspects of the prototype. For
instance, a breastplate is reinterpreted as an item
of jewellery, or the index finger of the right hand
is altered slightly. As regards the physiognomic
expression, the woodcut copy, in spite of the
rougher technique, seems much closer to the origi-
nal than the copperplate series. The changes are
undoubtedly due more to the modest talent of the
Master of the Banderoles than to any desire to
innovate.

222 The New York drawing (fig. 139) cannot possibly
be a free copy after Rogier's Mary Magdalene
(fig. 153) as assumed by Gropp 1999, p. 161. It is
highly improbable that a German artist active
around 1460/70 would have corrected the facial
traits of Rogier's Magdalene in accordance with
the facial traits of Rogier's teacher Robert Campin.
Rainer Schoch in Cat. Nürnberg 1983, p. 168, cor-
rectly identified the drawing as a sibyl and classified
it as a "copy after a lost painting by Rogier or his
close circle".
Evidence of the relationship between the drawing
and the Münster series of sibyls is provided by
the parapet on which the figure places her hands,
and by the fact that Jörg Syrlin the Elder created
three-dimensional figures, including this sibyl,
based on the Münster series, for the choirstalls of
Ulm Cathedral (compare figs. 139 and 150). The
fact that the figure copied in the New York drawing
is a pendant to the Cumaean sibyl of the central
group of three, that is to say the Tiburtine sibyl,
is indicated by the figure's orientation towards the
right and her immobile hands. It is difficult to
imagine that the sibyl copied in the drawing is
intended as a pendant to the Frigian sibyl in the
second group or, inversely, to the Samian sibyl in
the fourth group – figures with gesticulating or
raised hands – unless the copyist simplified the
original position of the hands after the model of
the Lybian sibyl in the first group (fig. 130). This
is indeed a possibility, since the rendering of the
shortened lower arms in the copy is somewhat
clumsy compared to the otherwise high quality of
the drawing.

223 H. Kerssenbroch's description of the church before
1573, prior to the iconoclasm, emphasises the
particular alignment of the images of sybils: *Per
circuitum chori Sibyllarum vaticinia cum earum ima-
ginibus admiranda arte per certa intervalla a se invi-
cem fuere disposita.* (Cited by Geisberg 1937,
p. 344.)

224 The mid-thirteenth century frescoes of four sybils
and four pagan wise men in the Cathedral of Lim-
burg is the only surviving example in northern
Europe of such a cycle before Campin. Cf. also two
miniatures produced around 1022/23 in a manu-
script of Montecassino, in which ten sybils and ten
pagan wise men adorn the beginnings of two dif-
ferent chapters. See Vöge 1950, pp. 20-22. On the
iconography of sybils, see Clerq 1979 and Clerq
1980. (On the sequence in Münster, see Clerq
1979, pp. 59-61, though this contains a number
of errors.)

225 It should be noted that in Münster on the outside
of the ambulatory before the seventh-century addi-
tion of the choir chapel there were stone sculptures
of Old Testament prophets. See Clark 1978, p. 13,
and n. 46, p. 80s. The closest correspondence to the
Münster programme is to be found in a series of
quotations that survive in a copy in a Vienna manu-
script. In this cycle, the original of which has been
dated by Vöge 1950, pp. 169-171, to the fourteenth
century and interpreted as a pictorial programme,
six sybils are correlated with six philosophers.
Three of the wise men there, Balaam, Virgil and
Albumasar, also appear in Münster.

226 In the Middle Ages, the second hexameter was
altered to bring it into line more closely with the
alleged Christian content. Revised critical editions
today render Ecl. 4.4s as: *Ultima cumaei venit iam*

THE ŒUVRE
The Late Work / A Series of Pagan Wise Men and Sibyls
pages 141 ss

carminis aetas. / Magnus ab integro saeclorum nascitur ordo. (The last era of the Cumaean prophecy has come. / The great order of the ages begins anew.)

227 Ludger tom Ring the Elder changed the space of the central portrait group in his copy. It may be assumed that in the original, as in the woodcut, the corner of a room could be seen behind the Cumaean Sybil. Virgil's cell had its vanishing point on the central vertical and had two visible walls.

228 Cf. Vöge 1950, p. 23. Albumasar, a ninth-century Arab philosopher included in Campin's series, did not live in pre-Christian times, but geographically outside Christendom. Indeed, the term 'pagan wise man' generally used to describe these male figures (following Cat. München 1972) does not apply, strictly speaking, to Albumasar.

229 Today additional walls have been added in the outer sections, so that the differences are no longer noticeable. When the cathedral was rebuilt after wartime bombing, the stone frames were not reconstructed in the manner recorded in turn of the century photographs (fig. 126).

230 The figure of Milesius can be traced to the Greek god Apollo, worshiped in Milet, and misconstrued in the Middle Ages. See Vöge 1950, p. 26. Lactantius mentions an orcale of Apollo as a prophecy of Christ in the *Institutiones divinae* I.7.1 (Lactance 1986, p. 84) directly after the chapter on the sybils.

231 Clark 1978, p. 68, has found no other example of a braided beard in northern European painting. But this unusual motif can be found elsewhere in the work of Campin: one of the prophets on the orphrey of the Cope of John in the Vienna Vestments has a treble-braided beard.

232 Wherever Campin's figures are accompanied by writing, a clear distinction is made. The ancient prophets have books, while the sybils have banderoles to indicate the spoken word.

THE ŒUVRE
The Late Work / The Ecclesiastical Paraments of the
Order of the Golden Fleece
pages 155 ss

233 On its origins in classical antiquity, see Panofsky, p. 196.

234 Memling used foreshortened writing on the upper edge of the parapet in his triptych for Benedetto Portinari (fig. 154) in exactly the same way. On the other hand, the lettering and framing of the two lines of text on the front in Ludger tom Ring's version is somewhat modernised. Geisberg 1937, p. 344, has pointed out that the framing corresponds to the simulated frame of Dürer's portrait engravings after 1523.

235 Cf. the portrait drawing of a Man with a Falcon, now regarded as an original by Petrus Christus. (Friedländer vol. 1, Plate 66; Cat. New York 1995, No. 24).

236 Panofsky, p. 310. The idea of opening up the room by portraying a view of the outdoor world through a window, which, according to Panofsky, p. 316, is an innovation introduced by Dirc Bouts based on Petrus Christus' corner-of-a-chamber depictions (cf. Portrait of a young Man, dated 1462, London, National Gallery; Friedländer vol. 3, No. 12) can also be traced back to Campin's series of paintings. The room in Bouts' portrait appears as a simplifi-

cation of the Libyan Sibyl rendering (cf. fig 130). As Bouts has the crossed hands of the sitter rest on the frame, we may assume that he did not refer directly to Campin's composition, but to the copperplate engraving reproduced in the series by the Master of the Banderoles, published before 1461. By contrast, in Bouts' slightly later Madonna in London (Friedländer vol. 3, No. 14) which Panofsky, p. 317, regards as the first half-length Madonna to be "placed in a definite interior", the Infant is seated on a stone parapet. The lozenge-glazed window is bordered with coloured rectangles and is cropped at the same height as the panel of Sybilla Chimica in the copy by Ludger tom Ring the Elder (fig. 148).

237 Vöge 1950, p. 139, assumes that Jörg Syrlin based his Delphic Sibyl with the disc-shaped hat on Rogier's Mary Magdalene. Syrlin's reference to a lost sheet of the woodcut cycle after Campin is a more likely explanation.

238 In his diptych painted in the same year, 1487, for Maarten van Nieuwenhove Memling adopts the interior with windows from the first group of portraits. Here, too, the parapet has been adopted, albeit without an inscription. It is an element that the painter was to abandon later in favour of the more conventional solution with the hands placed directly on the picture frame.

239 As far as we are aware, only Clark 1978, p. 58, has so far noted Joos van Ghent's dependence on Campin's series.

240 Admittedly, the effect is evident only in the figures of the lower row.

241 See Friedländer vol. 11, No. 270, 271, plate 173 A, and Marlier 1957, Cat.-No. 87.

242 Pächt 1989, p. 33, aptly described it as "a work whose significance is in inverse proportion to its fame".

243 Schuette/Müller-Christensen 1963, p. 43.

244 Campin's designs must have been created between 1432 and 1442. The date of execution is probably nearer the earlier date, as the complex embroidery would have taken years. Such a commission, for which the artist needed no workshop assistants, would fit well into the period after 1432, when Campin probably dissolved his workshop following his second court case. (Cf. Doc. 56). It is not impossible that Jan van Eyck, court painter to Philip the Good, may have arranged for the commission to be given to this colleague in Tournai whose work he admired.

245 The extraordinary precision of the rendering suggests that Campin supplied cartoons on a scale of 1:1.

246 In all, nine apostles and nine prophets are portrayed. This number is surprising. It may be assumed that Campin intended the remaining prophets and apostles to be portrayed on a further liturgical garment – probably the chasuble. The chasuble later produced (fig. 171) does not bear any of the missing figures.

247 See Coremans 1953, pl. LXII, 1.

248 Tolnai 1932, p. 324.

249 Asperen de Boer 1979, ill. 9b. Kemperdick, p. 91, employes a complex argumentation to show that the Mérode Annunciation may be based on the Ghent Altarpiece.

250 Houtart 1914, p. 108. Although documents mention only *Johannes peintre* it may be assumed that the reference is to Jan van Eyck. Dhanens 1980, p. 48, surmises that Jan van Eyck was on his way back from Spain at his first visit and that he was one of the delegation in search of a bride for Duke Philip the Good, that was received by the authorities of Tournai on 20 October.

251 It is in this general sense that it appears in the Saint Barbara panel of the Werl Triptych. (Cat. III.B.4a).

252 See Roosen-Runge 1972, who links the spatial setting with the fragments from the matins of the Little Office of Our Lady embroidered on the Cope of Mary.

253 It is surprising to note that the two donor figures remain enclosed within the pictorial space. This suggests that these may possibly be intended as anticipated, *post mortem* portrayals. On the holiday side of the same altarpiece the figures of Adam and Eve, representing the Fall of Man, are painted in life-like colours, but are treated aesthetically in the manner of the grisailles. (They are shown from a lower viewpoint and cross the border to the viewer's space.) The hallowed figures, on the other hand, remain within the pictorial space.

254 The robe of the sculptural Virgin on the exterior appears as a variation on the robe of Saint Catherine on the interior.

255 As far as we can see, no attempt has ever been made to determine whether the traditional designation of Jan as the 'brother' (*frater*) of Hubert as inscribed on the Ghent Altarpiece is accurate, or whether the word is used as it often is in Latin to describe a less direct relationship, such as nephew or cousin. Kemperdick, p. 155, points out that Jan van Eyck was by no means a contemporary of Campin, but was about the same age as his pupil Rogier van der Weyden. Hubert van Eyck, on the other hand, must have belonged to Campin's generation and may even have been older than him.

256 Campin may well have got to know it as early as 1426, after the death of Hubert van Eyck. To date we have found only one work by Campin in which he may have looked to a work by Jan van Eyck: the inscribed stone parapets in the cycle of pagan wise men and sibyls (fig. 130ss) may be based on Jan van Eyck's so-called 'Timotheus' portrait (fig. 55). The Werl panels (Cat.III.B.4), presented in earlier literature as firm evidence that Campin, in his later years, looked to the work of Jan van Eyck, are by Rogier van der Weyden.

257 Pollaiuolos ecstatically moving male figure is based on a classical work, see Fritz Saxl 1922, p. 222.

258 The most spectacular example is surely the Sienese panel, around 1340, with its unusual rendering of the Fallen Angels which came from Bourges to the Louvre. Variations can be found by Paul de Limbourg in the Très Riches Heures of the Duc de Berry (fol. 64v) and independently by Hubert (or Jan?) van Eyck before 1416(?) in the New York diptych, possibly also for the Duc de Berry. See Belting/Eichberger 1983, pp. 61-75 and ill. 20-23. (The 1416 inventory of the duke, though not the 1413 inventory, lists an entry that may refer to the Eyckian diptych. See Belting/Eichberger 1983, p. 21.)

259 Campin undoubtedly also studied the famous Marian frescoes that adorned the facade of the Ospedale di S. Maria della Scala opposite the Cathedral until 1720. In his portrayal of the Birth of the Virgin – ascribed in the relevant literature to Ambrogio or, more credibly, to Pietro Lorenzetti – it is probable that a fireplace was set in the wall separating the birth chamber from the anteroom where the child's father is waiting, as in the Mérode triptych. Moreover, both rooms were open right through to the background. The best idea of the lost fresco can be found in the altarpiece by the Master of the Osservanza in the Museo d'Arte Sacro in Asciano. On the lost frescoes, see Maginnis 1988 and – on the Birth of the Virgin and its portrayal by a Strasbourg master around 1420 – Lorentz 1994, who assumes without sufficient reason that the fireplace was missing in the fresco with the Birth of the Virgin.

260 The interior of the temple on the right hand wing of the Columba Altarpiece is based on the left-hand wing of the altarpiece by Pietro Lorenzetti. This reference has been proven by Schulz 1971, p. 69.

261 See Meiss 1936.

262 The panel by Domenico di Bartolo, dated 1433, could hardly have been a direct model for Campin. As Vasari reports, this Sienese painter trained in Florence. The panel shown bears a striking affinity to the sculptural style of Masaccio. The finger-sucking motif, too, can be found in two Madonnas by Masaccio.

263 A first version, from the workshop of Jacopo del Sellaio, is housed in the Fitzwilliam Museum in Cambridge. (See Cat. Cambridge 1967, No. M. 75, ill.) A second, closely related version from the same workshop is in the Museum of Fine Arts in Boston (Cat. Boston 1994, No. 50). On the Berlin panels, see Schubring 1912, Bode 1912/17 and Grohn 1957 (dated 1448). Fahy 1989, Nützmann 1997 and Nützmann 2000 (dated 1475 and 1468/69 respectively), Nützmann 1997, p. 227, points out 'Late Gothic traits' in the panels of the Master of the Argonauts. This could reflect the use of the considerably older model.

264 There are further analogies in content and form between the first scenes of the first panel and the first scene in Campin's work – both are courtship scenes – and between the last scene of the second panel and the second scene in Campin (Betrothal).

CAMPIN'S PLACE IN THE HISTORY OF ART
Campin and the van Eyck Brothers
pages 173 ss

CAMPIN'S PLACE IN THE HISTORY OF ART
Italy
pages 177 ss

265 The ancient myth of Cupid and Psyche was known in northern Europe in the fifteenth century, but there was no tradition of it being portrayed in art there. An old French translation of Boccaccio's *De genealogia deorum*, one of the sources for the cassone versions, has survived and was published in Paris in 1531. See Boccaccio 1531/1976. The story of Amor and Psyche is related by Boccaccio in chapter 22 of Book V after Apuleius.

CAMPIN'S PLACE IN THE HISTORY OF ART
Six Students
pages 180ss

266 Friedländer 1924, p. 163 (Friedländer vol. 1, p. 92) noted: *Jedenfalls führt die Suche nach Tafelbildern Eyckschen Stils, also nach Werken, die Schülern oder unmittelbaren Nachfolgern Jan van Eycks zugeschrieben werden können, zu äußerst spärlichen Ergebnissen.* (At any rate the search for panel paintings in the style of van Eyck, i.e. for works that can be attributed to pupils or direct followers has borne little fruit.)

267 See Houtart 1907, Houtart 1914, Lestocquoy 1937 and Chatelet, pp. 362-366.

268 The title *prévôt* probably referred to a religious office and not, as formerly assumed, to the position of Dean of the Guild. Cf. Schabacker 1982, p. 26.

269 Kurth 1918 still provides the fullest treatment of the Tournai tapestries.

270 Daret's tapestry designs are a step back to the stylistic stage achieved before in the Piatus and Eleutherius tapestries of 1402.

271 On the information available about his time spent in Tournai, see Châtelet 1974 and Schabacker 1982, which also provides a critique of earlier literature.

272 See Houtart 1914, p. 101.

273 According to Châtelet 1974, p. 37s.

274 On this discussion, see Feder 1966, Schabacker 1982, Châtelet, p. 372, and Kemperdick, p. 153s.

275 Cf. Dumoulin/Pycke 1993, p. 309.

276 See Renders 1931, p. 172, n. 22.

277 The idea of portraying the attribute of Saint Barbara, a tower, in the process of construction on the Werl panel may be based on Jan van Eyck's small Saint Barbara panel of 1437 (Friedländer vol. 1, plate 26).

278 For a conspectus of early literature mentioning Rogier, see Löhneysen 1956, Sulzberger 1961 and Dhanens/Dijstra 1999. In Dhanens/Dijkstra 1999, p. 99s, Elisabeth Dhanens posits that Rogier van der Weyden was a student of Hubert van Eyck until 1426, though this theory is not supported by documents or stylistic findings.

279 See Thürlemann 1997a, p. 68s.

280 The register of the Bruges guild of painters is printed in Vanden Haute 1913. On Willem van Tongeren in general, see Weale 1908, p. 21. In the list of Bruges painters in the first half of the fifteenth century given by Duverger 1955, p. 107ss., erroneously only Willem's son Anthonis, who was also a painter, is mentioned. See also the documents illustrated by Duverger 1955, p. 109ss, in which Willem van Tongeren is mentioned several times after 1433/34.

281 On the possible date of the start of the apprenticeship, see van der Haeghen 1913, p 128, and Houtart 1914, p. 90.

282 Hulin 1901 regarded the *Speculum humanae salvationis* as the sole source for the painting. This cannot be correct, as discussed later.

283 Cap. 30: *Et caput in urnam plenam sanguine humano projiciens ait: / Satia te nunc sanguine humano, quem in tantum sitisti, / Quod in vita tua illo nunquam satiari potuisti!* Quoted by Lutz/Pedrizet 1907/1909, p. 63.

284 Petrus Comestor 1855, col. 1471 (cap. XVI: De Cyro). For a summary of other sources see Braun 1954.

285 The leaf motif of the pitcher is portrayed unaltered in three further works, all by pupils of Campin. They are Rogier van der Weyden's Paris Annunciation (fig. 195), the Madrid Annunciation from the workshop of the Master of the Betrothal of the Virgin (fig. 208) and the Holy Family in Le Puy by the Master of the Louvain Trinity (fig. 219). This shows that the painting in Berlin is a very careful and detailed copy.

286 The identification of two reliefs with Old Testament scenes proposed by Tschudi, p. 104, (The Expulsion from the Garden of Eden and the Cluster of Grapes carried from the Land of Canaan) cannot be correct.

287 In our opinion there is much to suggest that this drawing is an original. See Cat. II.5.

288 The same motif is to be found in the Betrothal of the Virgin (fig. 209) in the head in profile to the right of the Virgin.

289 Noted by Dhanens 1987, p. 37. For Kemperdick, p. 118, who attributed both the Jael and the Tomyris compositions to the same author, it is not impossible that both designs for a *taeffele* (panel) of unknown content commissioned from Hubert van Eyck by the magistrates of the city of Ghent in 1424/25 may have had some link with the commission for the justice depictions. This is only possible, however, if Hubert, as we assumed, painted only one of the two.

290 See Frinta, p. 64

291 Sonkes 1973 has re-examined the inventory of drawings already expanded by Winkler 1965 after Wescher 1938 and has rejected the attribution to Vrancke van der Stockt. Sonkes places the artist in Brussels at the end of the fifteenth century, a generation later than Vrancke van der Stockt. Because of this late dating, the author has to regard most of the drawings, many of them featuring costumes from the first half of the century, as copies. The fact that these are originals is evident in that the penwork often deviates creatively from the preliminary charcoal sketch. To the sheets that Sonkes ascribes to the artist, one must add a design for a Virgin and Child with two Saints and the Family of the Donor (Paris, Musée du Louvre, Cabinet des Estampes, Inv.-No. 20669; here Cat. III.F.5); by contrast, the drawing with two scenes from the Life of Saint Julian of Brioude (No. 20. in Sonkes 1973) is a design by Campin (Cat. I.4). On ascrib-

ing the drawings to the pupil of Campin who created the Louvain Trinity, see Thürlemann 1993 b, p. 41 s.

292 Almost all the drawings by the Master of the Louvain Trinity are in pen and ink over a rough charcoal sketch. This is the same technique that Campin used for his Paris Bearing of the Body to the Sepulchre. It is interesting to note that most of the sheets are coloured with red watercolour. The same colouring is also evident in Campin's drawing with two scenes from the Life of Saint Julian of Brioude (Cat. I.4). Both the preference for pen and ink and the colouring of the paper is unusual for the early Netherlands, where silverpoint drawing was the norm for drafts. Some of the pink-coloured sheets still bear traces of highlighting applied with a brush (this is the case in the design for an angel bearing coat of arms in the Cleveland Museum; Sonkes 1973, Cat.-No. 12.) All pen and ink drawings on pink-coloured paper listed by Sonkes 1969 in her Corpus volume are attributed by the author to the school of Campin. It may be assumed that Campin passed on to his pupils the technique of mezzotint, practised by Italian artists at that time.

293 Probably the Master of the Louvain Trinity did not base his panel on Campin's original, but after a preliminary sketch, as he omits the traces of blood emanating from the wounds that is such a typical feature in Campin's work.

294 The four designs with the Church Fathers were probably created somewhat earlier than the painting in Aix. The style of underdrawing in the Louvain Trinity (see Asperen de Boer et al., No. W9) accords with the style of drawing in the Pseudo-Vrancke van der Stockt group. Note, in particular, the hatching technique using vertical and sometimes slightly wavy parallel lines. They are accompanied in the drawings by a few long, criss-cross areas of hatching. The folds are rendered in long, straight lines to which small, sometimes angular hooks are added. As Asperen de Boer et al. have noted, the technique of underdrawing in the Louvain Trinity is closer to that of Rogier than to that of Campin.

295 The drawing is on a sheet with a rare watermark that can also be found on a document dated 1431. It is Drachen II.835 (Piccard 1980).

296 The Durán Madonna (Friedländer vol. 2, No. Supp. 132) was probably created around the time of the Miraflores Altarpiece, about 1445.

297 The following designs have survived from the series of Passion scenes: Flagellation, Christ Crowned with Thorns and the Bearing of the Cross (Sonkes 1973, Cat.-Nos. 4, 5, 6), and from the Life of the Virgin: Jesus among the Pharisees, Christ Appearing to His Mother, the Descent of the Holy Spirit (Sonkes 1973, Cat.-Nos. 3, 8, 9). Although the Bearing of the Cross is rendered in a different technique – it is a very fine brush drawing – it is probably still part of the Passion series, on grounds of format.

298 Two copies of the Flagellation based on the lost Passion cycle by the Master of the Louvain Trinity are illustrated in Sonkes 1973, ill. 3 and 4. A scene from the Life of the Virgin, Jesus among the Pharisees (Sonkes 1973, Cat.-No. 3), is copied in a painting by the Master of the Legend of Saint Barbara (Friedländer, vol. 4, No. 62).

299 Campbell 1973, Cat.-No. XI, pp. 231-39.

300 See Petri 1956 and Jakoby 1987.

301 The church is now known as the Oberste Stadtkirche (Upper Town Church). The paintings on the exterior of the wing panels were later removed from the carved altarpiece and are now displayed separately above the choirstalls. The two small wings with the Coronation of the Virgin, which covered the elevated part, entered a private collection and are now in the Westfälisches Landesmuseum in Münster (Cat. Münster 1986, pp. 205-208).

302 On the Master of the Iserlohn Life of the Virgin see Cat. Münster 1952, Stange 1954, Nr. 107-118, and Cat. Münster 1986, pp. 204-211. For colour reproductions of all the panels of the Iserlohn Altarpiece see Kirchhoff 1976.

303 Jakoby 1987, ill. 16s, reproduces an Annunciation spread over two panels, created around 1555/60 by the Cologne Master of the Glorification of the Virgin, that shows the Angel of the Annunciation in the same pose and garments as the painting by the Master of the Iserlohn Life of the Virgin, but which is probably not based directly on it.

304 The Annunciation from the workshop of Rogier van der Weyden in the Antwerp Museum (Friedländer vol. 2, No. 10) supports the assumption that the Master of the Iserlohn Life of the Virgin also adopted the treatment and structure of the spatial setting from the model on which he based it. The Virgin is kneeling at a prie-dieu, just as she is in the Louvre Annunciation by Rogier, but the side wall visible on the right also has two window axes separated by a beam structure. Moreover, the Annunciation setting in the Antwerp painting features two steps whose stone blocks are held together by metal brackets. The Annunciation by the Master of Liesborn in the London National Gallery (Cat. Münster 1952, Nr. 120) is more closely related still. It probably gives the best idea of the lost Netherlandish original to which the Master of the Iserlohn Life of the Virgin also referred.

305 The remaining panels also refer in many respects to Campin. In the Massacre of the Innocents the mother in the foreground on the left is very similar in both clothing and pose to the figure of Mary Magdalene in Campin's Passion panels. The mother in the centre ground with the turban of striped fabric is probably also based on Campin. In the scene showing the Flight into Egypt the Virgin Mary is wearing a headdress that is typically Campinesque, and the Infant can be found in the same pose in a Half-Length Madonna that probably

CAMPIN'S PLACE IN THE HISTORY OF ART
Impact
pages 201 ss

also goes back to Campin. In the Presentation in the Temple the artist has combined the headdress and mantle of two sybils from the Münster cycle (Cat. I.22/C) for the third figure from the rear. (Compare fig. 147 with Stange 1954, ill. 17.) What is remarkable here is also the portrayal of the temple setting. The open door that gives an urban view is juxtaposed with a tracery-filled window at the end of a side aisle, which can also be found in Konrad Witz' Strasbourg panels of Saints Catherine and Mary Magdalene. Here, too, it seems logical to assume a common source in a work by Robert Campin. On the relationship of the Iserlohn Panels to the work of Robert Campin see also Euw 1965, pp. 108-110.

306 See Cat. Münster 1986, p. 209.

307 See Stange 1954, p. 13s and ill. 12.

308 See Panofsky, p. 3, and Friedländer vol. 1, plate 62 (here fig. 226).

309 For a summary of the works by the Master of Catherine of Cleves see Brinkmann 1996.

310 See the following miniatures: Book of Hours of Catherine of Cleves, Plummer 1966, No. 28, and Book of Hours of Catherine of Lochhorst, fol. 106v (Pieper 1966a, ill. 12).

311 On the Book of Hours of Catherine of Cleves see Plummer 1966, Gorissen 1973 and Calkins 1979.

312 The miniature in question is preceded directly by another portrayal of the Holy Family (Ms. 917, p. 149; Plummer 1966, No. 92). It shows Mary and Joseph at work and indicates a similar division along the central vertical.

313 On the Book of Hours of Catherine of Lochhorst see Pieper 1966a.

314 In the Madrid Annunciation (fig. 208) the angel is wearing a mantle and the Annunciation is set in a church. Yet this panel cannot have served as a model for the Master of Catherine of Cleves, as the position of the left hand of the Virgin corresponds to that in Campin's work. A direct link in the other direction can also be excluded. We believe that the Master of Catherine of Cleves and the painter in the workshop of the Master of the Madrid Betrothal both had at their disposal closely related drawings as models.

315 For the details of the life of Jos Ammann discussed here see Winkler 1959.

316 Previous literature has not pointed out the clear link with the Annunciation panel in the 1457 Marienfeld Altarpiece by Johann Koerbecke (see Jakoby 1987, ill. 4, and Cat. Münster 1986, pp. 155-176). In the work by the Westphalian master, too, the scene is fronted by a grisaille rendering of gothic architecture with two figures of prophets, structuring the Annunciation scene into three parts with their two pillars placed on the aesthetic border. The figure of God the Father surrounded by angels in the apex of both works is also similar. As it is most improbable that Koerbecke was familiar with the Annunciation fresco in Genoa, we must assume that Jos Ammann and Johann Koerbecke must have referred to the same model.

317 The critique of Winkler's reconstruction of Jos Ammann's work is summarised by Günter Meissner and Eberhard Kasten in Meissner 1992, p. 235s.

318 A poorly preserved wall painting over a tomb dated 1445 in the Cathedral of Constance would appear to be by the author of the Genoese fresco. Those works collated before Winkler under the pseudonym of the "Master of the Munich Marian Panels" as well as the Holy Trinity in Saint Petersburg and the three portraits do not appear to me to be by Jos Amman. A totally different style to that of the Miniatures of the Twenty Four Elders ascribed by Winkler to the Ravensburg Master can be found on the title page of the Liège Bible (London, British Museum, Add. ms. 15254). In our opinion this could be an early work by the Master of Catherine of Cleves.

319 All seven panels are illustrated in Winkler 1959, ill. 32-40. In our opinion, the panel with the Rest on the Flight into Egypt, shown by Winkler 1948, ill. 4, does not belong to them. Collobi Ragghianti 1990, p 18, assumes that the exteriors of the two panels in Venice do not belong to the same altarpiece as the two panels in Modena. This view is supported by the fact the the nimbi of the hallowed figures in Venice and Modena are of different design. In contrast to the opinion voiced by Collobi Ragghianti, the four figures of saints in Venice and Modena are, however, by the same artist.

320 The book on a cushion can be found in Campin's Salting Madonna (Cat. I.13). The details of the interior in which the Virgin is set is most closely related to the London Madonna panel (Cat. III.F.6b). The wall with the rounded arch and the lettering that seems to be chiselled into a step corresponding to the aesthetic border recall the donor panel of the Werl Altarpiece (fig. 257).

321 This phenomenon has already been described many times using a variety of terminology. See Dijkstra 1990 for a conspectus of earlier literature. A comprehensive treatment of the movement from an aesthetic point of view remains to be undertaken. Panofsky, pp. 350-356, still provides the best description of the historicism that prevailed around 1500.

322 The most famous example is the Miraflores Altarpiece by Rogier van der Weyden. Before Rainald Grosshans published the infrared photographs of the Berlin version in 1981, all leading scholars regarded the copy now divided between Granada and New York as the original.

323 For the drawn copy see Sonkes 1969, Cat. C3.

324 Friedländer, vol. 2, No. 76, lists three further painted copies. But two of them – the one from the René de la Faille collection and the one in the Fitzwilliam Museum in Cambridge, are identical. (See Cat. Cambridge 1960, No. M19, p. 32s.)

325 Panofsky, p. 351: "... that sense of measurable space and ponderable solidity which Roger himself had sacrified at the altar of transcendentalism."

CAMPIN'S PLACE IN THE HISTORY OF ART
Looking Back on Campin
pages 210ss

231

326 A considerable number of the figure groups cre-
ated after Campin are discussed in Didier 1981, but
the author tends to date them too early. Occasion-
ally this author posits three-dimensional copies as
models for Campin.

327 See Friedländer vol. 7, No. 123, 124 (Monforte
Altarpiece), Add. 202 (Altarpiece with the Bearing
of the Body to the Sepulchre) and here figs. 68, 70.
See also Michel 1934.

328 This figure is not adapted directly from Campin's
painting. A free, mirror-image copy after Campin's
Nativity in a glass painting at the Museo Civico,
Turin (last quarter of the fifteenth century) shows
the believing midwife with the same altered turn
of the head. See Comblen-Sonkes 1986, plate
CLXXVI b.

329 Apart from the Madonna panel in the St. Peters-
burg diptych by the Master of the Louvain Trinity
(fig. 210) see the scene of Joseph's Return in the
series of tapestries donated in 1474 by Jean Rolin,
Bishop of Autun, to the Church of Notre-Dame in
Beaune and Jan de Beer's Birth of the Virgin, cre-
ated around 1520, in the Thyssen-Bornemisza col-
lection. See Eisler 1989, Cat.-No. 27. The motif
is probably derived from a lost painting by Campin
of the Birth of the Virgin.

330 Only the Thief on Christ's right is a precise quota-
tion from the Bruges Descent from the Cross trip-
tych. The miniature is an example of how Campin's
figures are sometimes adopted while re-establishing
the conventional positioning of the Thieves. The
Thief on the right corresponds to the Bad Thief in
the original, but the copyist interprets the figure as
the Good Thief by turning him towards the figure
of Christ. Campin's figure of the Good Thief is
also left in its original position, but rendered as a
more ugly figure and characterised as the Bad
Thief by turning away from Christ.

331 Friedländer, vol. 1, plate 65 A. The version in the
Metropolitan Museum, New York, is illustrated in
Kemperdick, ill. 126.

332 The painters in the generation of Gerard David
faced problems comparable to those of early seven-
teenth century artists confronted with the alter-
native of following Michelangelo or Titian, choos-
ing between *disegno* and *colore*. Some of them,
like Nicolas Poussin, attempted a synthesis, as
Oskar Bätschmann 1979 has shown, in order to
achieve the *exemplum fictum* of the perfect picture
(p. 37).

333 David's approach to this is evident if we compare
the Thyssen Crucifixion with the Berlin version
produced some thirty years later, around 1515,
(Friedländer vol. 6.2, No. 185), in which individual
details still recall the three models cited in his early
work, but are woven into the picture as a whole
in such a way that they can barely be identified as
such.

Appendix

Catalogue Raisonné

INTRODUCTION: A CRITIQUE OF CONNOISSEURSHIP

Any study of a major artist's œuvre today must take its place in a long line of past research. In the highly complicated case of Campin, that line has taken many unexpected turns over the years, gathering on the way a wealth of fascinating material for a methodology of the empirical analysis that aims to classify works of art by period and author. Our own studies and findings, collated in the following catalogue raisonné, demanded a critical survey of past research.

Preconceived ideas

Research in the field of the Flémallesque group of works is currently in crisis. The development of new possibilities of technical analysis, especially infrared reflectography, initially raised hopes of solving once and for all the age-old problem of attributing works in the circle around the Master of Flémalle. Yet the widespread use of technical procedures brought no such relief. On the contrary. When it comes to attributing surviving works to Campin himself, to his direct pupils and to mere emulators, opinion is more divided today than it ever was.

In retrospect, the reason for this seems simple enough. Even the data gathered by means of new technology still have to be interpreted. And, with that, many preconceived ideas still hold sway. This is particularly evident in the analysis of paintings in the Flémallesque œuvre by means of infrared reflectography – a method that reveals, at least in part, the preliminary sketch or "underdrawing" executed by the artist on a panel primed with chalk before taking up his paints.

In 1992, a research team headed by J.R.J. van Asperen de Boer published a major study of the underdrawings of the two groups of works traditionally ascribed to the Master of Flémalle (Robert Campin) and Rogier van der Weyden. The authors based their work on the widespread assumption that the attribution of the Madrid *Descent from the Cross* to Rogier van der Weyden is firmly authenticated by documents. Because of this, they endeavoured to distinguish as clearly as possible between the style of underdrawing they found in this work and that which they perceived in the Flémalle Panels ascribed to Robert Campin. A more clearly legible montage of infrared reflectograms of the Flémalle Panel of the *Virgin and Child* (fig. 245) subsequently published by Stephan Kemperdick has since shown that this work traditionally ascribed to the Master of Flémalle bears exactly the same typical saw-tooth hatching that can also be found in the *Descent from the Cross* allegedly painted by Rogier van der Weyden (fig. 244). In other words, the long-standing and still largely unchallenged preconceived idea that the works in Madrid and Frankfurt are with certainty by different authors had blinded the researchers in their work.

Rogier van der Weyden the Younger (Johann David Passavant)

The first person to attempt an identification of the artist we now identify with Robert Campin of Tournai, was Johann David Passavant. In an essay published in 1858, he attributed the three Flémalle Panels and the *Thief on the Cross*, all in the Städel in Frankfurt, along with a number of paintings in other collections, to a single artist. Passavant had trained as a

Fig. 244 IRR montage of a detail of the Madrid *Descent from the Cross* (the robe of Mary Magdalene, cf. fig. 103). Photography: J.R.J. van Asperen de Boer

Fig. 245 IRR montage of a detail of the Flémalle Panel of the *Virgin and Child* (folds of drapery on the lower edge; cf. fig. 4). Photography: S. Kemperdick / J. Sander

The two details of the underdrawing share the same individual characteristics: shadows created by means of sawtooth hatching made with a broad brush.

painter himself and possessed an extraordinary talent for recognising artistic styles. Yet he made the error of giving the artist he discovered the wrong name.

The so called Vasari of the North, Carel van Mander, who published his art historiography for the first time in 1603 to 1604, two generations after his admired Italian precursor, based his text on the pioneering years of Netherlandish painting for the most part on the information provided by Vasari. Vasari, in turn, had based his information on the writings of the Netherlandish historian Lampsonius. It was from Vasari, who had no connections with the Netherlands, that Mander adopted the legend of Jan van Eyck being the "inventor of oil painting" and the "teacher" of Rogier. Mander's assertion that there were two different artists called Rogier van der Weyden can also be traced back to Vasari. In the second edition of his *Lives of the Artists*, Vasari had added a chapter headed *Di diversi artefici fiamminghi* in which he mentioned a certain Ruggieri Vander-Weyde di Bruselles, while a chapter taken from the first edition of *Lives of the Artists* continued to speak erroneously of a certain Ruggieri di Bruggia, pupil of Jan de Bruges. What is more, because the year of his death was wrongly given as 1529, citing an engraving by J. Hieronymus Wiericx, van Mander assumed

that there must be a second, younger painter of this name, to whom he attributed the then still extant depictions of Justice in Brussels City Hall.[1]

This doubling of the artist Rogier van der Weyden, which Wauters already pointed out as an error in 1846, without attracting much attention, provided the basis for Johann David Passavant's essay. The title of his study, published in the *Zeitschrift für christliche Archäologie und Kunst,* refers to Rogier van der Weyden in the plural: *Die Maler Roger van der Weyden.* In it he attributes to "Rogier the Elder" a group of eighteen works, most of which are still regarded today as originals by Rogier van der Weyden, and ascribes to "Rogier the Younger" a second, slightly less coherent group of sixteen works. In this second group, Passavant describes a number of works which today are widely accepted as cornerstones of the œuvre of the Master of Flémalle, alias Robert Campin. They are the three panels in the Städel reputed to have originated in the Abbey of Flémalle, the *Thief on the Cross* in the same collection, the *Portrait of a Woman* in London and, astonishingly, as the keystone in Passavant's reconstruction of the œuvre, the *Descent from the Cross* in Madrid.

Even if Passavant's theory regarding the generation gap between the two artists was to prove incorrect, his view that the Madrid *Descent from the Cross* should be treated separately from the group of works that includes the Medici Madonna, the Bladelin Altarpiece and the Columba Altarpiece, and the fact that he linked the Madrid *Descent from the Cross* with the works in the Städel on the basis of a precise study of the originals, is quite remarkable. Passavant foreshadowed the verdict of one of the greatest scholars of Nederlandish Paintings, Max J. Friedländer, who refused in his later years to attribute the work in the Prado and the panels in the Städel to two different painters.

As archival research progressed, the theory that there had ever been two different Rogier van de Weydens finally lost all credibility, and Passavant's distinction between two separate groups of works by two different artists of the same name came to be regarded as outdated. With that, his remarkable study fell into oblivion and had no influence on later art history.

Passavant, in his study, was the first to apply the comparative method that was to play such an important role in all scholarly literature on the Master of Flémalle and Rogier van der Weyden. In his drawing reproduced in an engraving entitled *Two Madonnas by the two Rogier van der Weydens* (fig. 247), he takes the *Maria lactans* motif from two works in the collection of paintings in his charge, and juxtaposes them in the same format: on the left, the *Virgin and Child* of the Medici Madonna by "Rogier van der Weyden the Elder" (fig. 246), and on the right, without the brocade background, the *Virgin and Child* of the Flémalle Panel, attributed by Passavant to "Rogier van der Weyden the Younger" (fig. 248).

These two portrayals of the same theme were intended, according to Passavant "to provide an insight into a difference between the distinctive styles of both masters".[2] The author summarises the stylistic differences as follows: "His [Rogier the Elder's] drawing is ... not without a certain leanness. The expression and movement of his figures touch us by their profundity rather than by their energy. Usually in his paintings a certain mildness and attractive colority predominates. The execution is invariably painstaking, yet magisterial ...". As a rule, the paintings attributed by Passavant to "Rogier van der Weyden the Younger", i.e. Robert Campin, are "Of very different effect ... Draughtsmanship, colour handling and emotive quality are mostly very energetic: textile folds are more sweeping and more painterly. The facial expressions invariably possess clarity and truth, and in this respect he ranks firmly with the most outstanding masters of the early sixteenth century."[3]

The Master of Flémalle (Bode – Hymans – von Tschudi)

Some thirty years later, in 1887, Wilhelm von Bode, Director General of the Berliner Museen, without reference to Passavant's essay and unaware of their attribution to any artist's name, drew up a list of works by a painter of whom he maintained that he had gone entirely unnoticed. Bode postulated the same generational sequence as Passavant, describing the painter as "one of the most noteworthy followers of Jan van Eyck and Rogier van der Weyden".[4] Bode attributed to this master, whose work he dated to the mid-fifteenth century, five works: the Mérode Triptych, the Salting Madonna, the two London portraits – the only ones to correspond with Passavant's list – and the panel with *The Death of the Virgin*, in London (Cat. II.4), which has since proved to be a pasticcio of around 1500.

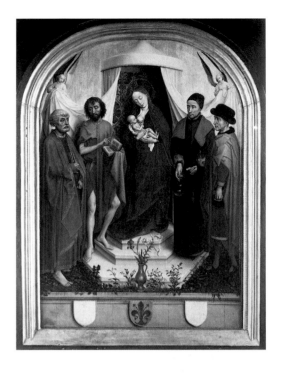

The terms *vigueur* and *vigoureux* in Bode's essay, published in French,[5] echo the terms "energy" and "energetic" used by Passavant to describe the style of his "Rogier the Younger". Bode saw this master as a "distinct realist" with a keen sense of chiaroscuro.[6] Rather surprisingly, his group does not include the *Thief on the Cross* or the Flémalle Panels in the Städel collection. Understandably, however, it does not list the *Descent from the Cross* in Madrid, for only one year before, in 1886, Carl Justi had published a Spanish document dating from 1574 in which the *Descent from the Cross* was attributed to one "Maestre Rogier".

In 1893, in an essay on the Prado collections, Henri Hymans added a further nine works to Bode's list, diluting its strength at the same time. Today, the paintings added by Hymans are either attributed to other artists (*The Betrothal of the Virgin*, *The Annunciation*, and the *Triumph of Ecclesia* in the Prado, *The Manna Miracle* in Douai, *The Marys in Mourning* from the Cook collection and the fragment with Mary Magdalene in London) or they are disputed (the Werl Panels in the Prado).

Fig. 246 Rogier van der Weyden, The Medici Madonna. Frankfurt, Städelsches Kunstinstitut

Finally, in 1898, Hugo von Tschudi published a lengthy essay entitled *Der Meister von Flémalle*, with attributions which Max J. Friedlander accepted almost without exception in the second volume of *Altniederländische Malerei* in 1924. This standard reference work on early Netherlandish painting has influenced our view of this painter's work to the present day. Tschudi more or less adopted Bode's list as extended by Hymans, adding still more works to it, and taking into account copies after lost works by the master. Most importantly, Tschudi also accepted the four Frankfurt panels from Passavant's list as mature works by the master and added them to Bode's list. On the other hand, he omits the *Descent from the Cross*, in Madrid, whose attribution to Rogier van der Weyden was by then thought to have been fully authenticated.

Tschudi considered the Frankfurt panels to be artistically the most important

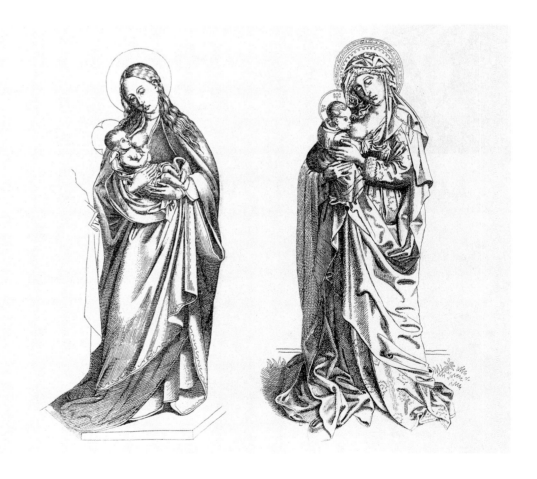

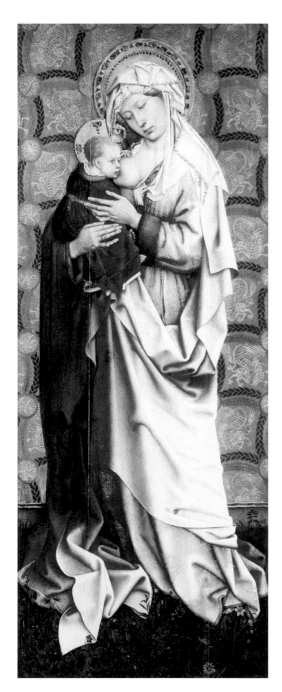

Fig. 248 Robert Campin, *Virgin and Child (Maria lactans)*. Frankfurt, Städelsches Kunstinstitut

Fig. 247 *Zwei Madonnen der beiden Roger van der Weyden*, (Two Madonnas by the two Roger van der Weydens). Illustration of J. D. Passavant's essay on "the two Roger van der Weydens" published under the title *Die beiden Roger van der Weyden* in the periodical *Zeitschrift für christliche Archäologie und Kunst*, 1858

Passavant juxtaposes these images as a comparative study in his attempt to distinguish between the personal style of the Master of the Flémalle Panels and the Madrid *Descent from the Cross*, painted in his opinion by one "Roger van der Weyden the Younger" as opposed to the work of an artist he describes as "Roger van der Weyden the Elder".

works in the group. Because of this, he chose to refer to the anonymous painter as the Master of Flémalle, rather than by the previously accepted name of the Mérode Master. In doing so, he also meant to refer to what he believed was the artist's original place of work. However, this choice of name was later to prove unfortunate, as the Cistercian Abbey of Flémalle near Liège, from which three of the panels in the Städel allegedly originated, according to the seller, had never actually existed.[7]

Early attempts at identifying the Master of Flémalle

From the early nineteenth century onwards, two groups devoted their energies to researching and studying our artistic heritage: connoisseurs and archivists. Their methods could hardly have differed more. The connoisseurs looked to the rules of stylistic history and sought to order European works by period, location and characteristic "signature" so precisely that specific groups of works could be attributed to specific artists, albeit for the most part anonymous. In the archives and libraries, a different, complementary approach was pursued. In a number of Netherlandish cities, local historians began uncovering the history of the artistic "schools" of their region. Whereas connoisseurs were generally confronted with works but no names, historians almost invariably had to do with names but no works.[8]

As the work of the connoisseurs and historians progressed, both parties began to realise the need to consolidate their respective data, and apply the historically documented names of artists rather than anonymous references to works of art. In doing so, they hoped to be able to locate the individual artists within a specific geographical and social setting and flesh them out with biographical data.

The earliest proposed identification of the Master of Flémalle called previous connoisseurship into question again. In 1898/99, Eduard Firmenich-Richartz published an essay in the *Zeitschrift für bildende Kunst*, as a direct response to Hugo von Tschudis's recent study, under the provocative title *Roger van der Weyden, der Meister von Flémalle*. In it, Firmenich-Richartz posited the theory that the figure known as the Master of Flémalle did not correspond to any authentic individual, and that the group of works dealt with under this name in Tschudis's essay was in fact the early work of Rogier van der Weyden.

In the opinion of Firmenich-Richartz, the "so-called Master of Flémalle ... was in fact none other than our Rogier, only at the very apex of his artistic skill". He also maintained that any assumption "that an emulator might have excelled him" was tantamount to "bitter defamation of the great master".[9] Instead, the author preferred to regard the paintings attributed to an anonymous artist known as the Master of Flémalle as the early work of Rogier van der Weyden and, with that, to accept that there had been "a detrimental change"[10] in his talent and a "gradual decline in his means of expression and characters".[11]

This theory, which was later reiterated by Salomon Reinach, disseminated with missionary zeal by Emile Renders and finally adopted even by Max J. Friedländer, can no longer be maintained. It does, however, contain a grain of truth in that the works of the Master of Flémalle were not created by a follower of Rogier van der Weyden, as the connoisseurs of the time assumed, but by a predecessor.

Most art historians, however, accepted the new artist figure presented by von Bode, Hymans and Tschudi, and several attempts were made to establish a connection with the name of a documented artist. In 1900, a curious theory was proposed by Otto Seeck in an essay on the van Eyck brothers, in which he claimed that the Master of Flémalle, because of

the feminine traits that the author believed he could see in the works, was in fact a woman, and he identified her as the legendary sister of Jan and Hubert, Marguerite van Eyck, who is also believed to have practised the craft of painting.[12]

In Ghent, a degree of local pride lies behind Louis Maeterlinck's theory that the Master of Flémalle was in fact a painter by the name of Nabur Martins who cropped up frequently in city documents. Maeterlinck's claim is without serious foundation, being based primarily on a motif that occurs both in a mural in Ghent that is merely attributed to this painter, on the one hand, and in the *Nativity* in Dijon, on the other.

In 1973, Friedrich Gorrissen identified the Master of Flémalle as Hubert van Eyck. Though there are indeed certain elements in common between Hubert's style – in so far as it is represented in the figures of the Deësis group and the apostles in the *Adoration of the Lamb* in the Ghent Altarpiece – and the Flémallesque mode of expression, we do not feel that these offer sufficient grounds to assume that both groups of works were painted by the same hand.

Elizabeth Dhanens, in her study published in 1984, under the title *"Tussen de van Eycks en Hugo van der Goes"* also sees a close relationship, particularly between the panels in Frankfurt Städel and individual panels of the Ghent Altarpiece. She maintains that the Flémalle Panels and the *Thief on the Cross* could only be the works of a painter from the school of Ghent, because of the specific emotional expression of the figures (the terms she uses are *bewogenheid* and *sensibiliteit*). She suggests that the artist in question might be a certain "Meester Hughe" mentioned by Dürer and Vaernewyck whom she does not consider to be identical with Hugo van de Goes. On the other hand, the individual analogies that the author notes between the paintings in the Städel and the panels of the Ghent Altarpiece that she attributes to Hubert van Eyck cannot offset the many more numerous stylistic similarities between the Flémalle Panels and certain works by Rogier van der Weyden. Dhanen's indication that the Master of Flémalle must have studied closely the panels of the Ghent Altarpiece presumably created by Hubert van Eyck and that he imitated individual aspects of them does, however, merit attention.

Robert Campin, The Master of Flémalle (Georges Hulin de Loo)

The identification of the Master of Flémalle that has become widely accepted, and the one that is also the basis of our monographic study, was originally made by Georges Hulin de Loo, who was Professor of Logic and Art History at the University of Ghent. Unlike the authors mentioned above, Hulin, who also convincingly identified some other previously anonymous early Nederlandish artists, had undertaken his own detailed methodical reflections and had published them in his critical catalogue to accompany the exhibition of 1902 in Bruges. It is worth reiterating them briefly here.[13]

Although he realised that there could well be a large margin of error involved in identifying anomymous artists, Hulin felt that it was a risk worth taking. According to Hulin, even if it was not possible to attribute a single work with absolute certainty to a specific artist, it was still possible that there might be so many different clues and indicators pointing towards a single hypothesis that the attribution could at least be taken as highly probable. In this connection, Hulin speaks of what he calls "moral certainty". A prerequisite for the successful identification of an artist was, in any case, according to Hulin, a stylistically logical reconstruction of the respective artistic œuvre.

Hulin's own research in identifying the Master of Flémalle, which he published in four texts dated between 1901 and 1911, follows such an unexpected course with such convincing results that it is the best proof of the value of his methodical reflections.

As early as 1901, in an essay on the painting of *The Revenge of Tomyris*, which Hugo von Tschudi had designated as a copy after a lost original by the Master of Flémalle, Hulin stated his "firm conviction" (*conviction très-arrêtée*) that the anonymous master belonged to the school of Tournai.[14] At the same time, he considered it at least highly likely that this artist was one Jacques Daret, who had studied along with Rogier van der Weyden in the workshop of Robert Campin. Daret, who enjoyed an unusually high reputation in his own lifetime, was very soon forgotten after his death, like so many other artists of that era, only to be rediscovered in the nineteenth century, albeit merely as a documented name at first.

In his critical catalogue for the Bruges exhibition of Flemish Primitives, in 1902, Hulin repeated this proposal. In doing so, he did not omit to point out once more that it was merely hypothetical. The author's main arguments are briefly summarised in the following:[15] A survey of painterly production during the second third of the fifteenth century suggests that, apart from Jan van Eyck and Rogier van der Weyden, there is no artist who approaches the importance of the Master of Flémalle. Among the artists whose names have survived in the archives, however, Jacques Daret would appear to have been the most highly regarded by his contemporaries. Daret turns up on two occasions in which the Princes of Burgundy called together all the painters of the land to carry out festive decorations – for the *Vœu du Faisan* in Lille in 1453 and for the marriage of Charles the Bold to Margaret of York in 1468. In both cases, Daret was the artist paid the highest fee or the artist in charge of the overall project.

Surviving documents indicate that Jacques Daret worked in Tournai, Arras, Lille and Bruges. Works by the Master of Flémalle can also be connected with Bruges and Tournai. Hulin noted that these works were closely related stylistically to the works of Rogier van der Weyden, who was trained in Tournai, but still possessing their own thoroughly distinctive character. If Rogier's art could be described as dramatic and sculptural, he surmised, then the work of the Master of Flémalle could be described as narrative. From this, Hulin deduced that the predominantly narrative trait led to a form of realism that is, in some respects, more archaic than that of Rogier van der Weyden or Jan van Eyck. The Master of Flémalle introduced stylistic elements into panel painting that were already familiar to manuscript illuminators and *cartonniers*, or designers of tapestries. Jacques Daret had worked in both these fields.

In his 1902 text, Hulin expressed the hope that the artistic traces Daret had surely left during his documented working years in Arras (1441 to 1448), would one day provide proof of his hypothesis. He believed he had found an indirect indication of Daret's sojourn in Arras in a painting that bears a close stylistic affinity with the works of the Master of Flémalle, though painted by another hand: *The Visitation* in the Berlin Museum (fig. 250), whose donor he was able to identify by the coat of arms as the Jean du Clerq, Benedictine Abbot of St. Vaast in Arras from 1428 to 1462. This panel was originally part of a larger Marian altarpiece of which two further panels were known at the time. Hulin supposed that the altarpiece had been painted by one of Daret's better students after Daret left Arras in 1458. It was the figure of this teacher, Jacques Daret, that he believed was the Master of Flémalle. So much for Hulin's argumentation in his 1902 essay.

Finally, surviving documents pertaining to the altarpiece in question revealed the solution, albeit an unexpected one. They allowed Hulin to identify the altarpiece as a work by Jacques Daret himself. At the same time, it transpired that it had been created in 1434–35, considerably earlier than he had previously assumed. The identification of the artist and the dating of the Marian altarpiece of Arras, presented by the author in the *Burlington Magazine* in 1909, are based on an ingenious link between three already previously published documents. In the *Journal de la Paix d'Arras* the historian Antoine de la Taverne reports that on 11 and 12 July, 1435, Jean du Clercq, Abbot of the Benedictine Abbey there, had presented a recently completed altarpiece, which he had commissioned for the Chapel of Our Lady in the Abbey Church, to the delegation of the Council of Basel and the Papal delegation respectively. The guests had greatly admired the paintings. In a commentated edition of the *Journal*, issued by Jean Collard in 1651 in Paris, the same altarpiece, still in its original location, is described. It consisted of a shrine containing statuettes of the twelve apostles and the figures of the Coronation of the Virgin. The shrine had doors with figures painted on the outside. The upper register depicted the Annunciation and the lower register represented the following four scenes: Visitation, Nativity, Adoration of the Magi, Circumcision. Collard also provided a precise description of the first scene in which, beside the two biblical figures, "the aforementioned Abbot Jean du Clercq is presented kneeling in lifelike portrayal. He is dressed in the regular habit of his order with the episcopal staff in his hand and the mitra at his knees".[16]

This description is an unequivocal reference to the panel in Berlin and leaves us in no doubt as to the fact that the two other panels known at the time depicting the *Adoration of the Magi* (in the same museum) and the *Presentation of Jesus at the Temple*, erroneously identified by Collard as a Circumcision scene (then in a private collection in Berlin) had all originally formed part of the altarpiece which, according to the *Journal de la Paix d'Arras*, must have already been completed in July 1435. One further document, the private treasury books of the Abbott du Clercq, published in 1889, finally revealed the actual name of the artist. It was Jacques Daret.

There is, however, no indication in the title of the essay *An authentic work by Jacques Daret, painted in 1434* that this discovery also held the possible key to identifying the Master of Flémalle. If the altarpiece panels painted by Jacques Daret for the Abbott of St. Vaast in Arras were works by a student of the Master of Flémalle – as Hulin had identified them stylistically even before the author's name was discovered – then the Master of Flémalle himself could be none other than Robert Campin of Tournai, who, according to surviving documents, had provided Jacques Daret (born shortly after 1400) with his entire painterly training between 1418, at the latest, and 1432. This meant that, in contradiction of previous assumptions, the Master of Flémalle was not a successor of Rogier van der Weyden, nor even a contemporary, but his teacher. This discovery corrected all earlier theories on the historical standing of the Master of Flémalle.

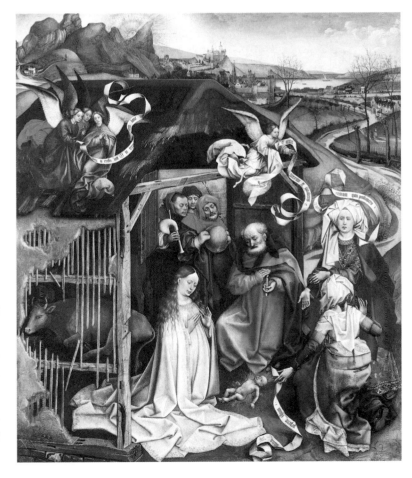

Fig. 249 Master of Flémalle (Robert Campin), *The Nativity*. Dijon, Musée des Beaux-Arts

Hulin's hypothesis was then confirmed by chance when the scholar discovered the missing fourth scene, *The Nativity* (fig. 251), on the London Art market. The painting, which the author published in 1911, again in the *Burlington Magazine*, is of particular importance because it is obviously based on the Dijon *Nativity* (fig. 249), an undisputed work by the Master of Flémalle. In creating his panel, Daret must at the very least have had access to a precise drawing of the Dijon painting as his model.[17] Certain individual details are taken directly from the Dijon work, especially the technically more demanding elements such as the fluttering robes of the four floating angels. He reiterates the white clad angel on the right in mirror image to fit in with the altered position of the midwives. Less obvious perhaps, but undeniable for all that, is his borrowing of another motif: the two belts of Daret's doubting midwife are derived in their linearity from the banderole which the believing midwife is holding in the work by the Master of Flémalle, while in Daret's panel the knot of the broader red belt also imitates the rolled-up end of the banderole in the earlier work.

It should be borne in mind that Hulin's proposed identification of the Master of Flémalle as Robert Campin is based on an indirect and classical analysis of clues and evidence. As Hulin himself had pointed out, what is needed for this is the collation of a coherent group of works based on stylistic analysis and the possibility of attributing them to a single artist. Yet, even today, not all art historians accept that the Master of Flémalle was a single artist. Either the existence of such a figure is dismissed out of hand or, as we have seen again recently, the works have been attributed to several different artists.[18] Yet even those who assume that the Master of Flémalle did in fact exist do not always agree as to whether a work was created by the master himself, whether it is to be regarded as a product of his workshop or even as the work of his students. Spectacular as the findings of Georges Hulin de Loo may have been, the questions surrounding the Master of Flémalle have remained the subject of art historical dispute.

Rogier van der Weyden, the "Master of Flémalle" (Emile Renders)

In the period after 1928, the Belgian art dealer and collector Emile Renders revived the theory, frequently posited in the past, that the group of works attributed to the Master of Flémalle was in fact the early work of Rogier van der Weyden.[19] Renders' enthusiasm for this

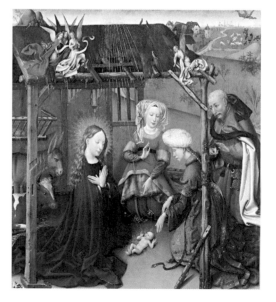

Fig. 250 Jacques Daret, *The Visitation*, 1434/35. Berlin, Staatliche Museen, Gemäldegalerie

Fig. 251 Jacques Daret, *The Nativity*, 1434/35. Madrid, Thyssen-Bornemisza Collection

The identification of this and two further panels as part of the altarpiece painted by Daret for the Abbot of St. Vaast in Arras allowed Georges Hulin de Loo, indirectly, to identify the Master of Flémalle (cf. fig. 249) as Daret's teacher, Robert Campin of Tournai.

theory, which he presented in a number of essays, culminating in a lavishly illustrated book in 1931 (fig. 252–253), was strongly motivated by cultural politics. One of the author's main aims would appear to have been to disprove the view put forward by Houtart and Destrée that any significant school of painting had existed in Tournai. The rather convoluted dedication that prefaces his book reveals the motivation behind it: "I dedicate this study, written in good faith, to the Lord Mayor, the Magistrates and the Archivist of the City of Brussels where once that student of Jan van Eyck, Rogier van der Weyden, born in Tournai, transplanted and trained on Flemish Burgundian soil, exercised his art under the high protection of the city fathers and under the auspices of the great duke of the western world."[20]

Though Renders' essay can hardly be regarded as a great intellectual achievement, it does deserve some attention for two reasons. First of all, because of its systematic comparison of detail and, secondly, because of the enormous impact it had on subsequent research into the work of Rogier van der Weyden and the Master of Flémalle.

The illustrations combine, in pairs and larger groups, related motifs and details from works attributed either to Rogier van der Weyden or to the Master of Flémalle (fig. 253). Renders draws comparisons – where necessary in mirror image and analogous format – between hands, heads, feet, bodies and landscape details from both groups of works, to show that these could not possibly have been executed by two different artists. At first glance, the process is reminiscent of the approach recommended by Giovanni Morelli for a scholarly basis of connoisseurship. Yet the similarity to Morelli's method is merely superficial. Morelli invariably applies the comparison in two directions – differentially and synthetically – in order to distinguish on the one hand between individual artistic signatures and in order to attribute a group of works to a single artist on the other hand. Renders, however, uses the comparison solely in a synthetic sense. The key question of how the work of his "great Rogier" differs from that of other artists, is not even posed by the author.

This made it easy for Edouard Michel to continue the equation of the Master of Flémalle with Rogier van der Weyden ad absurdum by introducing the works of a student of Rogier van der Weyden into the series of comparisons. He "proved" that by applying Renders' method consistently, Rogier van der Weyden, who was born in 1400, had not only produced the work of the Master of Flémalle in his early years but in his mature years had even gone on to create the work traditionally attributed to Hans Memling (died 1494).[21]

Renders did not merely use comparative illustrations to underpin his theory. He also pointed out the difficulties involved in relating all the archival documents mentioning "Rogier" or "Rogelet de le Pasture" to the same real person. Above all, he pointed out a contradiction between two documents that still continues to baffle scholars. Whereas a document of the City of Tournai dated 17 November 1426 mentions Rogier with the title of "maistre", the Register of the Guild of Luke in Tournai records that Rogier did not begin his apprenticeship with Robert Campin until the following year, on 5 March 1427, and that he completed it as a master painter five years later, on 1st August 1432.[22]

Renders assumed that the names mentioned in these two texts actually referred to two different people, both painters born in Tournai, of whom one – Rogier de le Pasture, referred to as master in 1426 – had been a student of Jan van Eyck in Lille and was identical with the famous later municipal painter of Brussels, whereas the other – mentioned in the Register of the Guild in 1427 and 1432 – had been apprenticed to the "decorative painter" Robert

Fig. 252-253 Title page and panel with comparative illustrations by Emile Renders, *La solution du problème Van der Weyden – Flémalle – Campin*, Brussels 1931

In his book Renders juxtaposes details of works, attributed either to Rogier van der Weyden or to the Master of Flémalle/Robert Campin, in order to prove that they are in fact the work of the same artist.

Campin in Tournai, and had sunk into oblivion later as an insignificant figure who left no further traces in the archives.

If Renders' theory of a "great Rogier" who created all the works attributed to the Master of Flémalle in his early years seems improbable, his distinction between two natives of Tournai, both of them painters, sharing the same surname and forename, and of much the same age, is beyond belief. Especially if we consider the close stylistic relationship between some works by Rogier and the altarpieces of Jacques Daret, in Arras, documented as a pupil of Campin.[23]

Surprisingly, though, Renders and his theory found a follower in none other than Max Jakob Friedländer, one of the leading connoisseurs of early Netherlandish painting. Yet it was certainly not his "generous tolerance", as purported by Erwin Panofsky,[24] that made the late Friedländer receptive to the Belgian scholar's theory. As a matter of fact, Renders' notion appealed to him because it conveniently dispensed with a problem that Friedländer found in the widely accepted distinction between the two groups of works attributed to the Master of Flémalle and Rogier van der Weyden. For the more closely Friedländer studied these works, the more inconceivable it became to him that the Flémalle Panels and the Madrid *Descent from the Cross* could have been created by two different masters. As Friedländer believed that the authorship of the *Descent from the Cross* in Madrid had been irrefutably authenticated on the basis of historical documents, Renders' theory offered him a way out of the dilemma – though it meant completely sacrificing the figure of the Master of Flémalle.[25]

Emile Renders' theory, once so eagerly debated, can now be regarded as discredited. That applies both to Renders' denial that Rogier van der Weyden had ever worked in Robert Campin's studio and his proposal (already put forward by Firmenich-Richartz) that the works attributed to the Master of Flémalle should be regarded as early works by Rogier. The works attributed as a group to the Master of Flémalle cannot possibly have been painted by Rogier in his youth – a fact that has become even clearer since the recent discovery of two early Flémallesque paintings (Cat. I.2, I.3). However, Friedländer's refusal to attribute the Flémalle Panels and the Madrid *Descent from the Cross* to two different painters is still to be taken seriously today.

Two hands, two pitchers: on the authorship of the Werl Altarpiece

Conventional attributions have required us to believe that Rogier van der Weyden's career began with an outstanding stroke of brilliant youthful genius that was never to be repeated, while his teacher, Robert Campin, went into decadent decline in his last six years. During this period, we are further expected to believe that an artist previously famed for his unparalleled powers of innovation had begun slavishly imitating not only his considerably younger colleague, Jan van Eyck, but also his own "brilliant pupil" Rogier van der Weyden, and adopting their motifs. The two wing panels of the Werl Altarpiece (fig. 257–258), the only work in the group attributed to the Master of Flémalle and/or Rogier van der Weyden that can actually be dated by its inscription, is presented as evidence of this alleged breakdown in Campin's development.

In the case of the Werl Altarpiece, the attribution to Robert Campin is based on the fairly recent opinion of Henri Hymans, a connoisseur of modest talent. Hugo von Tschudi adopted the thesis in his essay that was to have a far-reaching influence on subsequent research. Among those who actually believed in the existence of the Master of Flémalle, it was Martin Davies who was the first to voice his doubts as to Campin's authorship of the two panels, for they reminded him strongly of Rogier in many respects. Even Beenken had already wondered whether the landscapes might have been painted by Rogier.[26]

In his essay on the work on the Master of Flémalle, Hugo von Tschudi pointed out a striking similarity between the position of the right hand of John the Baptist in the donor's panel of the Werl Altarpiece (fig. 257), and that of the right hand of the Christ Resurrected in the right-hand panel of the Miraflores Altarpiece (fig. 256).[27] Such a strong similarity, as he rightly noted, could not be mere coincidence. In his opinion, the "action" of the hand of Christ in the Miraflores Altarpiece by Rogier van der Weyden was "perfectly appropriate" (*durchaus zweckmäßig*), while the panel of the Werl Altarpiece attributed by him to the Master of Flémalle seemed "strangely unfree and not quite fluent". From this, Tschudi deduced that, in the painting dated 1438, the Master

Fig. 254 Detail of fig. 257: Hand of John the Baptist from the Werl Altarpiece, underdrawing. According to Asperen de Boer et al.

Fig. 255 Detail of fig. 256: Hand of Christ from the Miraflores Altarpiece, underdrawing. According to Asperen de Boer et al.

Both hands are underdrawn with extended fingers. The complicated pose with bent fingers would then seem to have been executed according to the same study drawing. The fact that the same procedure has been used in both works can be taken as further evidence that both are by the same artist.

of Flémalle must have copied the motif from the work by Rogier van der Weyden whom Tschudi still regarded as a precursor of the Master of Flémalle. Indirectly, Tschudi also deduced a surprisingly early *terminus ante quem* for the Miraflores Altarpiece, which was to prove particularly problematic for later research into the work of Rogier on stylistic grounds.

In 1981, Rainald Grosshans published the underdrawings of the Berlin version of the Miraflores Altarpiece, which proved that this version is in fact the original, and not, as was previously widely believed, the version divided between Granada and New York. The under-

drawing of the hand of Christ Resurrected in the Berlin version (fig. 255) is outstretched and does not feature the bent fingers of the final painted version. From this, Grosshans deduced that Rogier had "invented" the position of the hand with the bent fingers in the course of the painting process. This, however, would confirm Tschudi's assumption that the Miraflores Altarpiece had been created *before* the Werl panels, which are dated 1438.

The conclusions drawn by Grosshans from the underdrawings of the Berlin work alone proved premature. The infrared reflectograms of the work in Madrid, which have been published since (fig. 254), show that the hand of John the Baptist in the Werl Altarpiece is also underdrawn with outstretched fingers. From this discovery we can draw two conclusions. First, that the Werl Altarpiece, just as Davies suspected, is a work by Rogier van der Weyden and not by Robert Campin. The same painter has taken the same approach in both works, by schematically outlining the hands with outstretched fingers in the underdrawing and then executing them differently in his painting based on the same preliminary sketch. Secondly, that the Miraflores Altarpiece is no longer to be regarded as a work predating the 1438 Werl Altarpiece. If the position of the hand of John the Baptist in the donor's wing of the Werl Altarpiece appears less clearly defined than that of the hand of Christ in the Miraflores Altarpiece, this may be explained by the fact that it was painted earlier.

Fig. 256 Rogier van der Weyden, *Christ Appearing to His Mother*, right-hand panel of the Miraflores Altarpiece. Berlin, Staatliche Museen, Gemäldegalerie

Fig. 257-258 Rogier van der Weyden (attributed to him here), two wings of the Werl Altarpiece, 1438. Madrid, Prado

According to Hugo von Tschudi, who attributes both wings to the Master of Flémalle, the artist adopted the hand gesture of John the Baptist from that of the figure of Christ in the Miraflores Altarpiece (fig. 256).

Fig. 259 Plate 56 in Emile Renders, *La solution du problème Van der Weyden – Flémalle – Campin*, Brussels 1931

With this comparison of details the author seeks to prove that the two works traditionally ascribed to Rogier van der Weyden and the Master of Flémalle are in fact by the same artist (left: Detail of the Paris *Annunciation*, cf. fig. 195; right: Detail of of the right wing of the Werl Altarpiece, cf. fig. 258).

The fact that the Werl panels can now be excluded from the group of works attributed to the Master of Flémalle and ascribed instead to the early Rogier van der Weyden, has meant that yet another point of art historical contention has been resolved. In this particular case, however, it is not a hand, but a pitcher that plays a key role.

Among the pictorial details compiled by Emile Renders in a bid to prove that the works attributed to the Master of Flémalle are to be regarded as early works of Rogier van der Weyden, there is one particularly interesting pair (fig. 259). A detail from the Paris *Annunciation* with the head of the angel and the pewter jug on the cabinet is juxtaposed with a detail from the *Saint Barbara* panel of the Werl Altarpiece showing the head of the saint and an identical pewter pitcher with a double spout, this time painted from a different angle.

For Erwin Panofsky, who believed in the existence of the Master of Flémalle alias Robert Campin, and who attributed the Werl panels to him as works of his later phase, these two details proved precisely the opposite of what Renders had intended to show. In terms of artistic interpretation, according to Panofsky, the differences between the two pitchers – "whether or not reflecting the same model" – are greater than their common features.[28] And even though Panofsky, railing against Render's obsession with comparison, quotes the warning issued by Friedrich Lippman to his students – "for God's sake children, if you want to prove something, don't illustrate it" – he too portrays almost the same details (fig. 260). There is, however, one important difference. Whereas Renders places the details in such a way that the two figures – the angel from Rogier's *Annunciation* and the figure of Saint Barbara attributed to the Master of Flémalle – seem to be conferring with one another, Panofsky has mounted them the other way around. In this way, the angel, turning away from the saint, seems to be indicating that he really wants to have nothing to do with her.

We believe that in this case, it was not the great Panofsky, but Emile Renders who was right. The Werl panel with the figure of Saint Barbara and the Paris *Annunciation* are both by the hand of the same artist, Rogier van der Weyden. The differences that Panofsky points out in the artistic rendering of the pitchers undoubtedly exist; yet they have nothing to do with the difference between any supposedly "additive" personal style of Rogier and a "divisive" or "synoptic" personal style of Campin. By way of example of these two works, we can

Fig. 261 Rogier van der Weyden, Central panel of the so-called Bladelin Altarpiece. Berlin, Staatliche Museen, Gemäldegalerie

Fig. 262 Rogier van der Weyden, Central panel of the Columba Altarpiece. Munich, Alte Pinakothek

The difference in the portrayal of the stable in both works from different periods of the same artist's œuvre corresponds to the difference in the portrayal of the two pitchers (cf. fig. 260).

Fig. 260 Plate 98 in Erwin Panofsky, *Early Netherlandish Painting*, Cambridge 1953

Panofsky presents the same details as Renders, but juxtaposes them the other way around (fig. 259), in order to show that the works are by two different artists.

trace a distinct development over the space of only a few years, which is characteristic of Rogier's artistic career as such. Just as his early portrayal of the pitcher differs from the later rendering, so too does Rogier's early figural composition for the central panel of the Bladelin Altarpiece created around 1440 (fig. 261) differ from one of his late figure compositions in the central panel of the Columba Altarpiece produced around 1460 (fig. 262). In place of the soft and ample portrayal tending towards asymmetry and diagonal positioning, the later work presents a harsher and more streamlined formal syntax that emphasizes the symmetry and the compositional alignment with the picture plane.

A critical conspectus of past research in this field might be summed up by saying that in the first room of the Prado's collection of early Netherlandish paintings, two nameplates

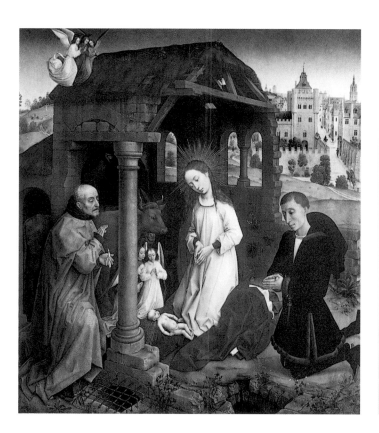

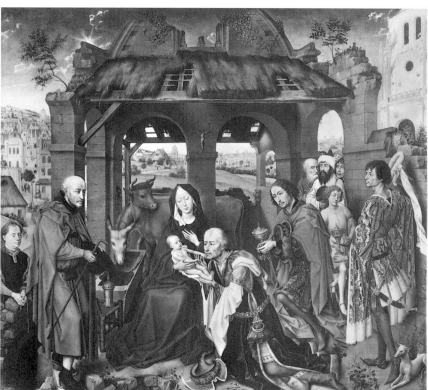

ought to be reversed. It is not the *Descent from the Cross* in Madrid that is an early work by Rogier van der Weyden, but the Werl Altarpiece; and it is not the Werl Altarpiece that is a late work by Robert Campin, but the Madrid *Descent from the Cross*. By amending the conventional canon of attributions in this way, the artistic career and creative development of both painters becomes clear and logical. Just as Max J. Friedländer surmised, it was indeed the same painter who created the panels in the Städel and the *Descent from the Cross*. They are the most important surviving works of his late period. In other words, there is no decadent late phase in the œuvre of Campin.

On the other hand, the panels of the Werl Altarpiece, which feature a convex mirror that is clearly a reference to van Eyck, can quite easily be placed among the early works by Rogier van der Weyden. As the Vienna *Madonna* has already shown, after leaving Campin's workshop in 1432, Rogier van der Weyden became entranced for a few years by the work of his teacher's greatest rival, Jan van Eyck.

Endnotes

1 See Löhneysen 1956 and Folie 1963 as well as the particularly detailed treatment in Dhanens/Dijkstra 1999, pp. 77-88.

2 Passavant 1858, p. 5, n. *)

3 Ibid., p. 4 s.

4 Bode 1887, p. 218: "… dans la manière d'un artiste que nul encore n'a remarqué, bien qu'il soit un des plus anciens, des plus personnels et des plus remarquables successeurs de Jean van Eyck et de Rogier van der Weyden."

5 Ibid., pp. 218, 219.

6 Ibid., p. 218: "… un art du clair-obscur qu'on ne retrouverait chez aucun autre peintre des Pays-Bas au XVe siècle."

7 See Sander 1993, p. 98.

8 On this contradictory characterisation of the work of archivists and art historians, see Hulin 1902, p. XIIIss.

9 Firmenich-Richartz 1898/99, p. 136.

10 Ibid., p. 136.

11 Ibid., p. 140.

12 Seeck 1899/1900, p. 85 s, n. 1. The author's justification for his proposal is still of some interest today as a collection of then prevailing stereotypes of feminity: "Man beachte zunächst die grosse Liebe, mit der vor Allem das Stoffliche der Gewänder und ihr Faltenwurf studiert ist; ferner die Neigung für das Stilleben, namentlich für die Darstellung von Blumen; dann den gänzlichen Mangel an mathematischem Verständnis, der sich in der ungewöhnlich schlechten Perspektive ausspricht; die recht flache Charakteristik der männlichen Köpfe, ob sie Bildnissen oder Idealgestalten angehören; endlich die höchst geschmackvolle, aber etwas kraftlose Farbengebung und die launische Ungleichmässigkeit, die in dem sehr verschiedenen Werte seiner [the Master of Flémalle's] Leistungen zum Ausdruck kommt." (Note the great love with which the materials of the robes and the drapery is studied, moreover the penchant towards still life, particularly the portrayal of flowers; also the total lack of mathematical understanding reflected in the remarkably poor perspective; the quite shallow characterisation of the male heads, be they portraits or ideal figures; finally the extremely tasteful but rather insipid colouring and the moody irregularity expressed in the very diverse values of his [the Master of Flémalle's] achievements.)

13 Hulin 1902, pp. XIII-XVIII.

14 Hulin 1901, p. 228.

15 Hulin 1902, pp. XXXVIII-XLVII.

16 Collart 1651, p. 201: "ledit Abbé Iean du Clerc est peint au naturel à genoux reuestu de son habit Regulier ayant sa Crosse en main & sa Mitre à ses genoux."

17 Kemperdick, p. 58, is of the opinion that Daret looked to Campin's original not only for his Nativity panel, but also exploited it fully (gewissermaßen vollständig ausgeschlachtet) for the other panels of his Marian altarpiece.

18 According to Campbell 1974 and Kemperdick. The debate on the theories of both these authors is discussed in the catalogue raisonné as we are of the opinion that they are based largely on erroneous attributions. Campbell 1974 dismisses any attribution even of part of the Mérode Altarpiece to Campin on grounds of stylistic weakness that he has noted in the left-hand panel, while Kemperdick, p. 164, announces difficulty in attributing the essentially Flémallesque works to Campin because he incorrectly determines the relationship between the Brussels Annunciation (III.C.1) and the central panel of the Mérode Altarpiece (I.12).

19 This theory was already presented by Firmenich-Richartz 1898/99 and by Jamot 1928.

20 "JE / DÉDIE / CETTE ÉTUDE / FAITE DE BONNE FOI / À MESSIEURS LES BOURGMESTRE ÉCHEVINS ET ARCHIVISTE / DE LA VILLE DE BRUXELLES / OÙ JADIS / LE DISCIPLE DE JEAN VAN EYCK / ROGIER VAN DER WEYDEN NATIF DE TOURNAI / TRANSPLANTÉ ET FORMÉ / EN TERRE FLAMANDE-BOURGUIGNONNE / EXERÇA SON ART / SOUS LA HAUTE PROTECTION / DU MAGISTRAT / DE LA CITÉ / ET DANS LE RAYONNEMENT / DU GRAND / DUC D'OCCIDENT"

21 Michel 1931.

22 Houtart 1914, p. 106, already showed that the term maistre in the document of 1426 must have been a title of honour that had nothing to do with the qualification as master artist granted by the guild of painters in 1432. See p. 184.

23 Friedrich Winkler's summary of Renders' argumentation clearly reveals its weaknesses (Winkler 1941, p. 148): "Daret war nicht nur Nachfolger oder Nachahmer der frühen, in Brügge oder sonstwo außerhalb Tournai (nach Renders) entstandenen Bilder des berühmten Brüsseler Stadtmalers Rogier van der Weyden aus Tournai, sondern er war fast gleichzeitig Mitschüler eines Namensvetters desselben, der auch aus Tournai stammte und ungefähr gleichaltrig war. Der große Rogier van der Weyden oder de la Pasture ist um 1399/1400, Daret um 1403, der Mitschüler Rogier de la Pasture bei Campin schwerlich viel später geboren. Hier wird das Ungereimte zum Unsinn." (Daret was not only the successor or emulator of the pictures produced in Bruges or elsewhere outside Tournai [according to Renders] by the famous Brussels municipal painter Rogier van der Weyden from Tournai, but was at virtually simultaneously a co-student of an artist of the same name who was also from Tournai and who was about the same age. The great Rogier van der Weyden or de la Pasture was born about 1399/1400, Daret around 1403, and the co-student Rogier de la Pasture apprenticed to Campin could hardly have been born much later. Here, the non-sequitor becomes nonsensical.)

24 Panofsky in Friedländer, vol. 1, p. 12.

25 Unlike Châtelet, p. 10, we do not see in Friedländer 1950 any indication that the author had abandoned Renders' theory towards the end of his life. Like Friedländer, Paul Jamot 1928, p. 278, had already argued in an essay that was to receive little attention from later scholars: "If one regards the Descent from the Cross in the Escorial [now in the Prado] as a work typical of Rogier and one that ideally sums up his particular qualities, one notes that of all the paintings now attributed to the Master of Flémalle, it is the most beautiful and characteristic of these that bear the greatest similarities to Rogier's masterpiece [namely, the Descent from the Cross]." ("Wenn man (…) die Kreuzabnahme des Escorial als das typische Werk Rogiers betrachtet, das seine besonderen Qualitäten am besten resümiert, stellt man fest, daß von den Gemälden, die heute dem Meister von Flémalle zugeschrieben werden, gerade die schönsten und charakteristischen die sind, die sich dem Meisterwerk Rogiers am meisten annähern.") On the other hand, unlike Friedländer, Jamot notes the impossibility of postulating an artistic career that begins with the Madrid Descent from the Cross and later goes on to produce the polyptych in Beaune, unless one is willing to assume that the artist was struck by some "intellectual catastrophe".

26 See Cat. III.B.4.

27 Tschudi, p. 21 s.

28 Panofsky, p. 256.

Preliminary Remarks

The Condition *of the work in question is discussed only in cases where changes have been made in the course of the painting process, where there has been later reworking or damage, and in cases where such intervention has altered the meaning of the work.*

Wherever such information is available, the findings of dendrochronological analyses of the respective panels are treated under the heading Dating *as "terminus post quem", for this information does not constitute an absolutely reliable means of determining the precise age of the painting itself. (For a more detailed explanation, see Thürlemann 1993a, p. 730s). For example, the fact that the wooden panel on which the* Thief on the Cross *(I.16) is painted comes from a tree that was felled at a later date than the Flémalle panels (I.18) does not necessarily permit us to deduce that the altarpiece was also painted later.*

The statement "1392/circa 1398 + min. 2 + x" is to be read as follows: 1392 (earliest possible felling date) approximately 1398 (probable felling date – mean value for Baltic oak) + min. 2 (plus minimum storage period for seasoning) + x (plus margin of error as a result of the possible loss of outer annuary rings in the course of working the panel and/or exceeding the minimum seasoning period of 2 years). It should be borne in mind that only the first date, specifying the earliest possible felling date, is absolutely reliable. For further information on the dendrochronological study of panel paintings in general, see Klein 1996.

The Literature *listed does not represent an exhaustive bibliography. It is limited to treatments of the individual works in the classical surveys of Campin's œuvre and to the theses propounded in the major monographic studies. Standard works, especially those which include a critical analysis of older literature are marked thus °.*

I. ROBERT CAMPIN

This list covers the surviving paintings by the hand of Campin himself and copies (marked *C*) probably created after no longer extant originals by Campin. Members of his workshop may also have been involved in producing the originals, especially in the case of large altarpieces. (Cf. Commentary on I.16). The list also includes textile works for which Campin created the cartoons (I.1 and I.23).

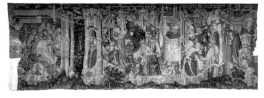
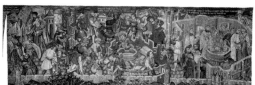

I.1 Six scenes in two tapestries depicting the legends of Saint Piatus and Saint Eleutherius (cartoons) → Fig. 7 and det. (8-9, 12, 14, 16)

Tapestry, originally in two parts (P: Piatus Legend, E: Eleutherius Legend); of which two fragments of each part survive today: (P1) 180-190 x 564 cm; (P2) 180-190 x 551 cm; (E1) 180-190 x 562 cm; (E2) 180-190 x 562 cm
Tournai, Cathédrale Notre-Dame, Sacristie du Saint-Esprit

Inscriptions: The two tapestries depicting scenes from the lives of the two patron saints of Tournai, Piatus and Eleutherius, originally included a no longer extant verse inscription naming the donor (Toussaint Prier, canon of the Cathedral of Tournai), the tapestry weaver (Pierre Feré from Arras) and the date of completion of the work (December 1402): *Ces draps furent faicts et achevés / En Arras par Pierrot Feré. / L'An mil quatre cens et deux / En décembre, mois gracieux. / Veuillez à Dieu tous saincts prier / Pour l'âme de Toussaincts Prier.* (See Stucky-Schürer 1972, p. 66, cited after Cousin 1916). The six surviving scenes from what was originally a series of nine scenes depicting the Legend of Saint Piatus bear the following inscriptions on the upper edge: [1] (on the scroll held by God) *J'ay esslut s. piat pour co[n]vertir a la foy les tournisiens.* [2] *Coment saint pias vint a tournay pr[ê]chier le foy.* [3] *Coment ly taions et ly taie ly peres et ly mere saint le hire / fure[n]t le p[re]mier qui rechure[n]t le foy des tournisiens.* [4] *Co[m]me[n]t hireneus ly taions saint le hire / fist le ydolle des tournisiens destruire.* [5] *Coument saint piat fonda leglise de / nostre dame de tournay et fist les fons.* [6] *Hireneus qui donna le treffons de leglise nostre dame de tournay / fu li prumiers baptisiers de tous les tournisiens.* (For details of the inscriptions on the three no longer extant scenes of the Legend of Saint Piatus see Stucky-Schürer 1972, p. 68, n. 245 [after Cousin 1916, p. 115]. The inscriptions on the scenes from the Legend of Saint Eleutherius are transcribed by Soil de Moriamé 1883, p. 28s, and Stucky-Schürer 1972, p. 68s, n. 245.)

Condition: The tapestries are poorly preserved. The colours of the display side are faded. Some lacunae were filled in during restoration work in 1767, 1876 and 1938. Parts P1 and E1 have been cropped on the left and part P2 has been cropped on the right. (According to Cat. Detroit 1960; Stucky-Schürer 1972, p. 66, n. 234; Dumoulin/Pycke 1982).

Attribution: See pp. 19-28. The surviving fragments of the two tapestries depicting the Legends of Saint Piatus and Saint Eleutherius were analysed in stylistic terms for the first time by Thürlemann 1997c. Before that, it had generally been assumed, either implicitly or explicitly, that one single artist had been responsible for all the cartoons. That artist, it was further

assumed, was based in Arras, where the tapestries were produced. Only this second assumption was occasionally challenged, for example by Voisin 1863, p. 231, Warichez 1934, p. 331, and Châtelet, p. 47s, who thought the designer of the cartoons to be based in Tournai, and by Verlet 1977, p. 41, who quite rightly noted that the realistic elements suggested a Netherlandish rather than a French origin. The stylistic relationship that Stucky-Schürer 1972, p. 72s, believed to exist between the tapestries in Tournai and the miniatures in the pontifical book created around 1400–1405 for Sens is merely general and cannot serve to localise the designs for the tapestries. (For a critique of this thesis, see Lestocquoy 1978, p. 47, and Joubert in Cat. Paris 1981).

The tapestries can be traced to three designers, who differ distinctly in their personal style and to some degree in the overall historical style of their work. The first and stylistically most archaic of the three created all the surviving scenes of the Eleutherius sequence. The second artist designed the first scene of the Piatus sequence. All the other surviving scenes in the Piatus sequence, with the exception of the sixth scene, in which the first artist also intervened, were designed by a third person. That third person was identified for the first time as Robert Campin by Thürlemann 1997c.

Dating: Circa 1400 (cartoons). The tapestries were completed in December 1492 according to a no longer extant, but reliably documented inscription. (See *Inscriptions*).

Commentary: See pp. 19-28. The two tapestries were donated by the canon Toussaint Prier († 1427) for the choir of the Cathedral of Tournai. They were hung facing each other above the choir stalls only eleven times a year on high holidays on the Gospel-side and Epistle-side until 1566. From then on until 1742 they were permanently installed there before being finally removed because they were considered stylistically outmoded and *"plus propres à faire rire qu'à exciter la dévotion"* (Waucquier cited in Dumoulin/Pycke 1982). Towards the end of the nineteenth century the remaining fragments were rediscovered by local historians. (See Dumoulin/Pycke 1982). Because they can be reliably dated, the surviving tapestries have hitherto been regarded primarily as key documents in the history of tapestry weaving in Arras. (For information on the tapestry weaver Pierre Feré who signed the work, see Guesnon 1910.)

Provenance: The surviving fragments of the two tapestries are still housed in the Cathedral of Tournai. Today, however, they no longer hang in the place above the choir stalls for which they were created..

Literature· S: Cousin 1619; Voisin 1863; °Soil de Moriamé 1883; Guesnon 1910; °Crick-Kuntziger 1930; Warichez 1934, pp. 49, 328-331; Warichez 1935, pp. 23-30, Cat. Nos. 38-52; Hulst 1959; Cat. Detroit 1960, No. 148; Cat. Wien 1962, No. 515; Stucky-Schürer 1972, pp. 66-73; Verlet 1977; Lestocquoy 1978, pp. 45-47; Cat. Paris 1981, No. 336; °Dumoulin/Pycke 1982; °Thürlemann 1997c.

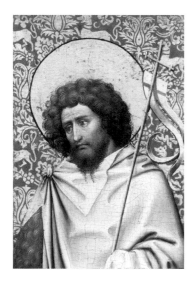

I.2 Saint John the Baptist → Fig. 5

Wood (oak); 17.2 x 12.2 cm
The Cleveland Museum of Art (Gift of the John Huntington and Polytechnic Trust); Inv. No. 66.238

Condition: The upper and side edges are original. At the lower edge, the small panel, which is otherwise in good condition, has been radically cropped. On the back there are traces of plaster priming with writing scratched into it (*ALBER DEVIR[?]* probably intended to be read "Albrecht Dürer").

Attribution: The detailed attribution by Pieper 1966b had already been expressed verbally by Friedrich Winkler. The doubts Davies expresses regarding Campin's authorship (which he describes as "uncertain") are unfounded. An unpublished infrared reflectogramm by the museum has revealed the double hooked lines so typical of Campin in some of the troughs of the drapery. (Cf. Asperen de Boer et al., ills. 32, 46, 60).

Dating: Circa 1415. Terminus post quem (dendrochronology according to Klein 1996): 1375/circa 1381 + min. 2 + x. Existing publications correctly emphasise the close stylistic affinity with the Seilern triptych, with Pieper 1966b and the authors of the Cat. Cleveland 1974 that the panel showing John the Baptist was created slightly earlier. Kemperdick considers both to have been made around the same time.

Commentary: See pp. 15-18. The fragment is probably the upper half of what was once an approximately 40 cm high painting depicting the full figure of John the Baptist. The direction of the saint's gaze indicates that this was the inner side of the right wing of a triptych whose central panel portrayed Christ. (Cf. the reconstruction of the entire panel in Cat. Cleveland 1974; the critique by Châtelet.)

Provenance: Ducs de Clermont-Tonnerre; Nettencourt-Vanbecourt family, Château Choiseul; Le Molt, Bourbonne-les-Bains; Christie's, London, June 26, 1964, No. 44 ["Master of the School of Cologne"]; Thomas P. Grange, London; 1966 purchased for the Cleveland Museum of Art (according to Cat. Cleveland 1974).

Literature: M: Friedländer vol. 2, No. Add. 149; Davies, Campin/Cleveland; Châtelet, Cat. 2; Kemperdick, p. 73 s.
S: °Pieper 1966b; °Cat. Cleveland 1974, pp. 146-149.

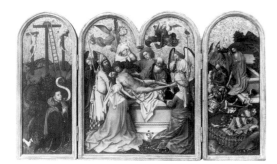

I.3 Triptych with the Entombment of Christ (Seilern Triptych) → Fig. 19 and det.

Wood (oak); 60 x 48,9 cm (central panel without frame), 60 x 22.5 (wing without frame)
London, Courtauld Institute Galleries (The Princes Gate Collection, Cat. no. 1)

Inscriptions: The words on the donor's banderole have been worn away. They were probably, as noted by Gelder 1967, p. 4, the opening words of the Psalm *Miserere mei Deus* or *Miserere mei domine* (Ps. 50/51).

Condition: Apart from the loss of the inscription on the banderole, the triptych is unusually well preserved. The gilded frame is original and, with the exception of the lower edge of the central panel, which has been renewed, is worked from the same piece of wood as the panels themselves. In contrast to the hasty conclusion drawn by Panofsky, p. 160, the figure of the donor has not been "repainted". Whether the "remains of gesso bearing a design in grey paint" on the outsides of the wings mentioned by the restorer S. Rees-Jones (cited in Gelder 1967, p. 17) are indeed the remains of a figure painted in grisaille is doubtful.

Attribution: Sold at Christie's in London on 14 August 1942 as a work by Adriaen Isenbrandt. First written and detailed attribution to Campin by Bauch. This attribution, which, according to Gelder 1967, p. 2, had already been expressed verbally by G. Ring, L. Burchard, E. Schilling and O. Pächt, is now generally accepted. Winkler, having initially regarded the work as a mid-century Spanish copy (cited in Bauch 1944, p. 34, n.1), later adopted the attribution to the Master of Flémalle. Frinta, p. 32, originally assumed a second artist had collaborated on the work, but later revised his opinion (Gelder in Cat. London 1971, p. 15).
The painting diverges considerably from the underdrawing in places, especially on the right-hand panel. (See Asperen de Boer et al., ills. 60-64.) Contrary to the view expressed by these authors, p. 87, the underdrawing is typically Campinesque. Ill. 60, for example, shows the typical multiple hooked-line drawing in the troughs of the drapery that is so characteristic of the hand of Campin. (Cf. also ills. 32, 46, 58, 102 for I.18b, I.13, I.6, I.12, and an unpublished infrared reflectogram by the museum for I.2). In Kemperdick's view this is not the same artist that painted the Frankfurt panels.

Dating: Circa 1415. This work, together with the fragment of John the Baptist (I.2) is generally regarded as the oldest surviving painting by Campin. The dating generally varies between 1410 and 1420 (Baldass 1952, p. 15 s). The following more precise dates have been proposed: 1415–1420 (Panofsky, p. 160), 1410–1415 (Gelder 1967, p. 2), "first years of the second decade of the fifteenth century" (Frinta, p. 29). By contrast, earlier dating is suggested "prior to 1410" by Stange 1966 and Châtelet (circa 1406–1410). Kemperdick dates the work considerably later, around the mid-1420s.

Copies: The figure of the angel bearing a lance at the left-hand edge of the central panel appears once more in the same position and in the same function as a link with the left-hand panel in the Louvain *Trinity* (III.F.1), in which the angel also bears the three nails of the cross.

Commentary: See pp. 28-37.

Provenance: The nineteenth century ink inscription on the back of the central panel ("Mancinelli No. 32/", "DeFalco-"[?] and "Colonna") indicate an Italian source, while the first two inscriptions indicate Naples. Purchased at auction on 14 August 1942 by Count Seil-

ern at Christie's in London from the property of Colonel R. F. W. Hill of Barn's Close, Bickleigh, Devon, whose parents probably purchased the work in Naples around 1880.

Literature: M: Friedländer, vol. 2, No. Add. 147; Panofsky, 160 et passim; Frinta, pp. 29-32; Davies, Campin/London, Seilern; Asperen de Boer et al., F8; Châtelet, Cat. 3; Kemperdick, pp. 67-73.
S: Bauch 1944; Beenken 1951, p. 20s et passim; Baldass 1952, p. 15s et passim; Roethel 1954; Cat. London 1955, No. 1; Stechow 1964; Stange 1966, p. 24; °Gelder 1967; Blum 1969; °Cat. London 1971, pp. 15-17; Lane 1975; Campbell 1973, Cat. no. 1; Botvinick 1992.

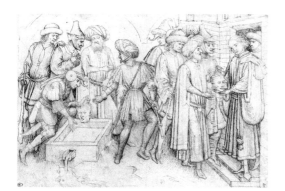

I.4 Two Scenes from the Legend of Saint Julian of Brioude → Fig. 28

Black ink over brown ink (pen) over charcoal sketch on reddish paper; 190 x 272 mm
Paris, Musée du Louvre, Cabinet des dessins; Inv. No. 20.655

Attribution: The drawing was attributed by Wescher 1938 to the student and successor of Rogier van der Weyden in Brussels, Vrancke van der Stockt (prior to 1424–1495). Lugt in Cat. Paris 1968 and Sonkes 1973 accept this attribution. However, the drawing is of considerably higher quality than the remaining drawings in the group whose actual author may be regarded as the Master of the Louvain Trinity, a student of Campin (Thürlemann 1993b). In the drawing in question some of the heads possess the same fine draughtsmanship and physiognomic clarity as those in Campin's design for the *Entombment* altarpiece (I.10). Moreover, the lines in the shading of the floor are typical of the hand of Campin. De Vos also ascribes this drawing and the design for the Entombment altarpiece to the author of the Madrid *Descent from the Cross*, but identifies the artist in accordance with tradition as Rogier van der Weyden.

Dating: 1415–20. Grounds: the costumes of the warriors are very similar to those of Nicodemus and the guard in the Seilern Triptych (I.3). The gestures of the hands are also similar. The slightly more voluminous treatment of the figures and draperies suggests a slightly later date for the drawing.

Commentary: See p. 49s. Wescher 1938 and Lugt in Cat. Paris 1968 took the double arch as an indication that this was in fact a design for a wall decoration, a thesis wrongly refuted by Sonkes 1973. Saint Julian of Brioude was revered particularly in the Auvergne, but less frequently in the remaining French provinces and abroad (Lespinasse 1934). Lugt surmises that the design may have been intended for Saint-Julien-du-Sault in Burgundy. However, the most important church in Ath, not far from Tournai, was also dedicated to Saint Julian. It was built between 1395 and 1415, but no longer exists in its original form. It is not unlikely that Campin's drawing was intended as a design for a wall painting in the newly-built church in Ath. This church was almost completely destroyed in 1817. See Herman 1980.

Provenance: The provenance of this drawing is the same as that of Campin's design for the *Entombment* (I.10).

Literature: S: Lespinasse 1934; Wescher 1938, p. 4; Cat. Paris 1968, No. 27; °Sonkes 1973, Cat. No. 20; Herman 1980; °Thürlemann 1993b, p. 40s; °De Vos 1999, Cat. No. B20.

I.5/C Portrait of a Stout Man (Copy) → Fig. 56

Wood (oak) ; 28.5 x 17.7 cm

Berlin, Staatliche Museen, Gemäldegalerie

Attribution: Until 1957 scholars were aware of only the Berlin version. It was initially attributed to the Master of Flémalle by Friedländer 1902 and subsequently by virtually all other scholars. Burroughs 1938 expressed the opinion, on grounds of an X-radiograph published by him, that the painterly style of the Berlin panel corresponded more closely to that of Rogier van der Weyden. This led Tolnay and Panofsky to regard the Berlin panel as a copy. The discovery of the version now in Madrid (fig. [1]) complicated the situation. Whereas Winkler 1957, p. 40, regarded the Berlin panel and the recently discovered Madrid version as works of equal quality and assumed that both had been produced simultaneously in the workshop of the Master of Flémalle, Davies considered the possibility that both might be copies after a lost original by Campin. Kemperdick, too, regarded them as contemporary replicas. Frinta, Eisler 1989 and Châtelet regard the Madrid version as an original by Campin. However, dendrochronological analysis shows that the early dating of the original assumed by these authors is not possible (see *Dating*). De Vos regards the Madrid version as an original by Campin, created towards the end of his life, and the Berlin version as a copy, possibly by Rogier van der Weyden. The fact that the frame of the Madrid version, unlike that of the Berlin version, is worked from the same piece of wood as the panel itself contradicts the theory of simultaneous production.

[1]

Dating: Original: Circa 1420. Terminus post quem of the Madrid version (dendrochronology according to Klein 1996): 1427/circa 1433 + min. 2 + x. (The Berlin version could not be dated dendrochronologically.) The original portrait was dated around 1430 on grounds of a questionable identification of the figure with the person of Robert de Masmines (See *Commentary*). Campbell 1973 proposes a date somewhere in the early 1430s because he considers the figure in the portrait to be identical with that of the donor depicted in the role of Nicodemus in the Madrid *Descent from the Cross* (I.17). Eisler dates it around 1425(?). However, stylistic considerations suggest an even earlier date of production for the original.

Further Copy: The Madrid version (fig. [1]), whose dimensions (29.5 x 18 cm without frame, 35.4 x 23.7 with frame) are almost precisely the same as those of the Berlin version, is in a much poorer state of preservation. (Many areas have been restored, especially around the mouth, the nose and the left eye. Loss of pigment makes the hair seem flat and unstructured today. A vertical crack running from the top of the panel to the chin of the man has been repaired by wooden plugs on the back of the panel.)

Commentary: See p. 77 s. A number of proposals have been put forward to identify the figure in this portrait. Formerly regarded as a self-portrait by Jan van Eyck, the name Niccolò Strozzi was also proposed after the work was purchased by the Berlin Museum because of a certain similarity with a portrait bust by Mino da Fiesole in the same museum. In 1932 Hulin de Loo identified the figure, on grounds of similarities with a drawing in the Recueil d'Arras, as Robert de Masmines, who fell at the battle of Bouvines in 1430. This identification, which gained widespread acceptance at first, has since been refuted by Campbell 1973 and Künstler 1974 with good reason, in our opinion. (See Campbell's critique of the attempt to date the panel on grounds of the absence of insignia of the Order of the Golden Fleece). Châtelet, who also regards the portrait drawing of Robert de Masmines in the Recueil d'Arras as a copy after an original by Campin, argues again in favour of identifying the figure as Robert de Masmines. The identification of the sitter by Campbell 1973 as the donor in the guise of Nicodemus in the Madrid *Descent from the Cross* (I.17) is not entirely convincing. The similarities between the two heads, noted at an early stage, are as much stylistic as physiognomic, and do not provide sufficient grounds for equating the two figures. (Although the noses are indeed similar, the lower lip, chin area and above all the eyes differ clearly.)

Provenance: Conte van der Straten Ponthoz, Château de Ponthoz, Ocquier near Huy (Belgium); 1958 on the London art market (T. P. Grange, 6 St. James Street); purchased for the Thyssen Collection in 1960.

Literature: M: Winkler, p. 9 s; Friedländer, vol. 2, No. 61; Panofsky, p. 175 (n. 8), 257; Frinta, pp. 54-56; Davies, Campin/Berlin 2; Châtelet, Cat. 12; Kemperdick, pp. 119-221.
S: Friedländer 1902; Hulin in Cat. Anvers 1930/1932, vol. 1, p. 31; Burroughs 1938, p. 226; Winkler 1957; °Campbell 1973, Cat. no. II; Künstler 1974; °Eisler 1989; Campbell 1996; °De Vos 1999, Cat. No. A1.

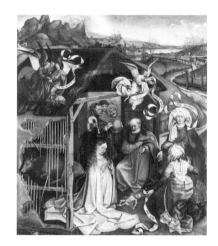

I.6 The Nativity → Fig. 26 and det.

Wood (oak); 84.1 x 69.9 cm
Dijon, Musée des Beaux-Arts; Inv. No. 150

Inscriptions: On the right-hand vertical hem of the Virgin's mantle, beginning at the lower right, in golden capitals that are no longer clearly legible, is the beginning of the "Salve Regina": *SALVE REGIN[A MATER MISERICOR]DIE V[I]TA DVLCEDO ET SPES NOSTRA SALVE AD TE CL[AMAMV]S EXVLES FILII EVE AD TE SVSPIRAMUS GEMENTES ET FLENTES IN HAC LACR[IMARVM VALLE].* (After Comblem-Sonkes 1986, p. 176).
On the banderole of the three angels of the Annunciation to the Shepherds: *Gloria in exelsis · deo Et in terr[a pax homi]nibus bone vol[untatis].*
On the three banderoles of the figures in the Midwives scene, beginning with the kneeling midwife on the lower right: *Azel.* (name in red letters) *Virgo peperit filium.* The standing midwife: *Salome.* (name in red letters) *[Nullum] credo quin probavero.* The angel in white: *Tange puerum et sanaberis.*

Condition: The original painted area shows a number of interventions made in the course of four restorations since 1831, though the faces and hands of the main figures have barely been affected. The landscape in the upper left-hand corner and the area of water on the upper right, where the ship with modern tackle has been painted into an open space, is in particularly poor condition (Sonkes in Cat. Bruxelles 1964, p. 80). The four angels are also in poor condition. The hands of the angel in blue and the mouth of the angel in red have been added to. The figure of the Infant Christ has been heavily restored The first word, *Nullum*, on the banderole of Salome, is no longer legible. (After Comblen-Sonkes 1986, p. 160).

Attribution: After it was purchased by the museum in 1828 the panel was initially attributed to Memling. Tschudi recognised it in 1898 as a work typical of the Master of Flémalle. This attribution is widely accepted in recent scholarship. (Comblen-Sonkes 1986, pp. 177-182, outlines the debate surrounding the question of attribution). Gavelle 1904, p. 9, followed by Nagelmackers 1967, having failed to recognise the sailing ship in the upper right-hand corner as the work of a restorer, sought to date the panel to the seventeenth or even nineteenth century.

Frinta saw in some parts the intervention of a less talented hand, though this was refuted by Comblen-Sonkes 1986, p. 181, on grounds of a thorough study of the painterly technique. Kemperdick ranks the panel among the core group of works by the Master of Flémalle, but does not exclude the possibility that the assistant involved in painting the *Saint Veronica* in Frankfurt may also have made an important contribution to this painting.

On the basis of infrared photography, Sonkes 1971/72 recognised the same style of underdrawing as that to be found in works traditionally ascribed to Rogier van der Weyden. Van Asperen de Boer et al., on the other hand, regard the style of the underdrawing as typical of the Master of Flémalle.

Dating: 1420–1425. A *terminus ante quem* of 1435 has been established with certainty. 1435 was the year in which Jacques Daret completed his Marian altarpiece for the church of Saint Vaast in Arras featuring a Nativity (III.A.1b) that is a simplified version of the same scene by his teacher Robert Campin. Recent publications differ widely in their proposed dating on the basis of stylistic considerations. The range spans the decade between c. 1420 (Tolnay) and 1432 (Kemperdick). Some authors, among them Friedländer and Panofsky, believe that it pre-dates the Mérode Triptych, while others (including Winkler, Verlant 1924 and Kerber 1931/32) believe it to be a later work. However, firm evidence that might help to date the two works in respect of one another is lacking. Tröscher 1967, p. 122, dates the *Nativity* panel to the year 1428, but this is purely speculative and is based on the assumption that it was painted in Dijon on Campin's return journey from his supposed pilgrimage to St. Gilles. (See Commentary on Doc. 52).

Copies: No precise replica of the entire composition has survived. For a list of partial copies and free variations based on this painting see Comblen-Sonkes 1986, p. 186s. It should be noted that the glass painting in the Museo Civico in Turin (p. CLXXVI, Comblen-Sonkes 1986) and the altarpiece of the *Holy Family* by the Master of Frankfurt (Fig. 204) belong together. In both of them the figure of the believing midwife is inverted, with a different head position and different headwear.

Commentary: See pp. 37-49. The theory posited by Van Camp 1951 that the town dominated by a castle in the background of the painting portrays the town of Huy near Liège has been discussed in many publications. Although Génicot 1960 put forward a well argued critique, Nagelmackers 1967, Joris 1976 and Lejeune in Cat. Liège 1968 defended Van Camp's thesis and even sought to consolidate it. Lejeune in Cat. Liège 1968 and Joris 1976 also established a link between the painting and the "Croisier" monks from whose monastery the artist allegedly painted the view of the city.

Kieser 1968 provided a thorough iconographical study of the work. Further details can be found in Vines 1978 and Minott 1985.

Provenance: Purchased for the museum in 1828 from one Arnaud Père of Dijon. The earlier history of this painting is unknown. Allegations that it originated in the Charterhouse of Champmol and suggestions of a possible link with the Dukes of Burgundy (see for example Troescher 1967 and Comblen-Sonkes) are without foundation, as are the links established by Châtelet with the de Thoisy family.

Literature: M: Tschudi, pp. 90-92; Winkler, pp. 31-34; Friedländer, vol. 2, No. 53; Panofsky, p. 126s, 158s et passim; Frinta, pp. 33-38; Davies, Campin/Dijon; Asperen de Boer et al., F7; Châtelet, Cat. 10; Kemperdick, pp. 56-59.
S: Gavelle 1904; Verlant 1924, p. 43; Kerber 1931/32; Van Camp 1951; Génicot 1960; Cat. Bruxelles 1964; Nagelmackers 1967; Troescher 1967; °Kieser 1968; Cat. Liège 1968; Joris 1976; Sonkes 1971/72; Vines 1978; Minott 1985; °Comblen-Sonkes 1986.

I.7/C Life of Saint Joseph (Copy) → Fig. 31 and det. (34, 37-39, 41)

Wood (oak); 64 x 203 cm
Hoogstraten (Belgium), St. Katarinakerk

Inscriptions: The banderole of the angel in the first Dream Vision scene (Scene 4): *Joseph fili david noli timere accipere mariam conjugem tuam quod in ea natum est de spiritu sancto est. [...].* (after Matthew 1:20); the banderole of the angel in the second Dream Vision scene (Scene 7): *Surge accipe puerum et matrem eius et fuge in egiptam* [sic] *et esto ibi dum dicam tibi.* (after Matthew 2:13).

Condition: Generally good. A few areas have been repaired. Two horizontal joints. Loss of pigment along the upper joint.

Attribution: Hulin 1902 regarded the panel in Hoogstraten as a copy after a lost work by the Master of Flémalle or the Master of Arras (Jacques Daret). According to Winkler the panel is based on the *Betrothal of the Virgin* in Madrid (III.D.1a; fig. [1]), which he, like Tschudi before him, ascribes to the Master of Flémalle. Friedländer, who did not wish to regard the work as a copy, attributed it to a painter from the circle around Jacques Daret, who was familiar with the style of manuscript illumination. Sterling 1972 proposes attributing the surviving panel to Daniel Daret. Panofsky surmises that all the scenes in the Hoogstraten panel

were originally part of an altarpiece including the panel with the *Miracle of the Rod* and the *Betrothal of the Virgin* (III.D.1a), both of which he attributes to Campin. A similar stance is taken by de Coo 1991, in whose opinion the original, which he also ascribes to Campin, must have included further scenes not reiterated in Hoogstraten.

Given that the Madrid panel of the *Betrothal of the Virgin* (III.D.1a) cannot be an original by Campin, the relationship between the *Life of Saint Joseph* and this panel has to be reappraised. (See *Further Copies*). In our view, the panel in Hoogstraten is a rather rough but on the whole faithful copy after a lost work by Campin.

Dating: Lost original circa 1425. There appears to be no firm evidence that would allow us to establish a relative chronology for the three compositions in which Joseph is a prominent figure – the Mérode Triptych (I.12), the *Nativity* (I.6) and the *Life of Saint Joseph*. Stylistic considerations suggest that all three were produced within the space of a few years.

The panel in Hoogstraten is dated to the early sixteenth century by Hulin 1902 and to the late fifteenth century by Panofsky and Châtelet. Friedländer places it in the generation of the students of Robert Campin, which seems plausible in view of the somewhat archaic traits of the panel. Sterling 1972 dates it to the early 1440s, and Urbach 1974 to circa 1440.

Further Copies: The scene with the *Betrothal of the Virgin and Joseph* in the Hoogstraten panel can also be found in a number of other works, often with considerable changes to the figural composition. The Master of the Betrothal of the Virgin probably based his painting (III.D.1a; fig. [1]) not only on the design for the Hoogstraten panel, but also on a composition by Campin showing only the *Betrothal* scene (See III.D.1a, *Commentary*.) It was also the idea of this master to replace the straight-linteled church portal beneath which the Betrothal takes place with a rendering of the south portal of the church of Notre-Dame des Sablons in Brussels (Fig. 35). The architectural features in a Saint Laurence panel by Hans Bornemann, dated 1447, in the Nikolaikirche in Lübeck (Ill. 2 in Kemperdick 1995) resemble those in the first scene of the Hoogstraten panel so closely that it must be assumed to be a faithful rendering of Campin's original, in spite of its obvious lack of finesse.

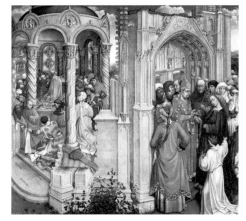

[1]

Commentary: See pp. 50-58. It is doubtful whether the original had a gold background. The similarity of the landscape with that in the Nativity (I.6) would suggest it did not.

Provenance: Unknown. Hulin 1902, p. 95, surmises that the Lalaing family, who played an important role at the court of Philip the Good and who ruled Hoogstraten, had the copy produced after the original in their possession for the church of Hoogstraten. The assumption posited in local historiography that the panel was created for the "Sint Jozefsgilde" in Hoogstraten is refuted by de Coo on sound grounds. There is no evidence, either, to support Châtelet's claim that it came from the Convent of the Order of Saint Clare founded in Hoogstraten in 1484.

Literature: M: Winkler, p. 15; Friedländer, vol. 2, No. 82; Panofsky, p. 161; Davies, and Campin/Madrid 1; Châtelet, Cat. 11a.
S: Hulin 1902, p. 95 s; Cat. Berlin 1930, No. 8080; Sterling 1972, p. 19; Urbach 1974, p. 235 s; °Ceulaer 1988, No. 225, p. 168 s; °De Coo 1991, pp. 82-87; Kemperdick 1995, p. 609.

I.8/C Portraits of Barthélemy Alatruye and his Wife Marie de Pacy (Copies) → Figs. 58-59, 75
I.8a/C Portrait of Barthélemy Alatruye
I.8b/C Portrait of Marie de Pacy

Wood (oak); 44.0 x 31.5 and 44.5 x 31.5 cm (painted area). Panel and frame are worked from the same piece of wood
Tournai, Musée des Beaux-Arts (on loan from the Musées Royaux des Beaux-Arts de Belgique, Brussels; Inv. No. 406, 407)

Inscriptions: Both panels bear the device *Bien Faire Vaint* repeated four times respectively on the painted inner frame, while the slanting off-set of the frames bear the respective inscriptions: *A° 1425 / Les armes de iehan barrat* (I.8a/C), *A° 1425 / Les armes de iehenne cambri* (I.8b/C).

Condition: The portraits are painted over two heraldic shields which, as already noted by Fétis, do not relate to the names of the sitters portrayed, but to the family names of the individuals named on the offset of the frames. These coats of arms shine through the paint of the portraits and are easily recognisable under raking light.

Attribution: Though Tschudi attributed the two portraits to the Master of Flémalle, he did so *"nicht ohne Zögern und Zagen"* (not without hesitation and doubt). He was working on the incorrect assumption that the original coats of arms of Jean Barrat and Jeanne de Cambry were to be dated 1425 and regarded the portraits as originals painted in the fourth decade of the fifteenth century. Gavelle 1904, following Fétis 1863/89, identified the sitters by the coat of arms in the upper left-hand corner as Barthélemy Alatruye (died 1446), and his wife Jeanne de Pacy (died 1452), but at the same time was able to prove that the date 1425 could not refer to the Barrat/Cambry couple. Jean Barrat, who, like Alatruye, was *maître de la chambre des comptes de Lille*, did not marry Jeanne de Cambry until 1529 and he died in 1576. At best, therefore, the portraits are copies after the Master of Flémalle dating from the sixteenth century, or else he was *"un peintre archaïsant, ou mieux un faiseur de pastiches"*. Renders/Lyna 1931, clearly unfamiliar with the essay by Gavelle 1904, repeated the same findings and took them as the basis for a further claim that this work by the alleged Master of Flémalle had indeed been created by the young Rogier van der Weyden. More recent research attributes the originals of both portraits, with varying degrees of conviction, to the Master of Flémalle, that is to say, Robert Campin (See Winkler, Panofsky, Ninane 1964. Frinta and Campbell 1973). Hulin 1902 attributed only the original of the male portrait to Campin, claiming that the original of the female portrait had probably been created at a later date by a different artist. Campbell 1973 also ponders this possibility. Davies, who makes no claims regarding the identity of the artist or artists who painted the originals questions whether the two paintings were ever intended as a pair in the first place.

Dating: Lost originals: 1425(?), Copies: after 1562.
Frédéric Lyna, who succeeded in reconstructing the provenance of the lost originals (Renders/Lyna 1931), proved that there was no link between the Alatruye and Barrat families until after 1562. The date 1425 which was undoubtedly added later above the family names

of the sixteenth century bearers of the coats of arms need not necessarily have been freely invented by the copyist (or indeed a later restorer), but could conceivably have been inscribed somewhere on the lost originals, as surmised by Hulin 1902, Ninane 1964 and Campbell 1973. The costumes of the sitters, including the woman (Hulin 1902 states otherwise), do not exclude the possibility of such an early date for the originals. Kemperdick favours dating the originals in the 40s. For hypothetical reflections on the identity of the copyist, see Gavelle 1931, p. 384.

Further Copies: In the Recueil d'Arras, created around 1567, there were originally further copies after portrait panels of Barthélemy Alatruye and Marie de Pacy. All that now survives, however, is a drawing after the male portrait (fol. 282), which is very similar to the painted copy in Tournai (Fig. 57). The painting and the drawing cannot have been based on the same original, however. According to a later, but reliable inscription, the originals after which the copies in the Recueil d'Arras were produced were still to be found as late as 1725 in the church of Berclau near Béthune. They had been presented to the church by the Benedictine monk Philippe Alatruye (1417–1486), a son of the couple portrayed, together with several other portraits of members of his family. However, as the originals from which the copies in Tournai were painted were handed down through one Hughues, another son of Barthélemy Alatruye and Marie de Pacy, and were still in the family at the end of the sixteenth century, it would seem that at least two different versions of the portraits of the Alatruye-Pacy couple must already have existed during the lifetime of their children.
Campbell 1973, p. 177, mentions yet another painted copy of poor quality (possible a forgery) of the portrait of the woman, formerly in the von Benda Collection, Vienna.

Commentary: See pp. 78-80. The two sitters are portrayed in the conventional manner, in three-quarter profile, facing each other in mirror symmetry. The woman is situated on the heraldic left. Both heads – in contrast to the pair of portraits in London (I.9 and III.G.2) – are illuminated by a single source of light coming from the upper right. Nevertheless there is a certain unsatisfactory unevenness in the pair: the head and hands of the woman are much smaller than those of the man. Moreover, the backgrounds differ, the background of the female portrait being black and that of the male portrait golden. This use of gold is extremely unusual except in the case of portraits of rulers. The two copies were undoubtedly produced by two different artists. Not only the painterly style, but also the handwriting of the device is of poorer quality in the female portrait. The difference in size between the hands and the heads may also stem from the fact that two painters shared the task of copying. Nevertheless, the possibility cannot be dismissed, as both Hulin 1902 and Campbell 1973 pondered, that the original of the female portrait was created by a different artist as a later pendant to the male portrait. If this was indeed the case, then the originals themselves could also have featured such size differences.

Provenance: Anciens fonds of the Brussels Museum (according to Fétis 1863/1889).

Literature: M: Tschudi, p. 101 s; Friedländer, vol. 2, No. 69; Panofsky p. 175; Frinta, p. 118; Davies, Campin/Brussels 1; Châtelet, Cat. C11-C12; Kemperdick, p. 119s.

S: Fétis in Cat. Bruxelles 1863/1889, No. 53/54; Wauters in Cat. Bruxelles 1900, No. 531/532; Gavelle 1904; Hulin 1902, p. XLI; Gavelle 1931; Renders/Lyna 1931; Hulin 1939; Winkler 1950; Ninane 1964; °Campbell 1973, Cat. No. V, pp. 176-183; Hinz 1974, p. 142s; Campbell 1977, p. 303; Campbell 1990, pp. 211-213; °Cat. Bruxelles 1996, No. 5.

I.9 / Portrait of a Woman → Fig. 61 and det. (frontispiece)

Wood (oak); 40.7 x 28.1 cm
London, National Gallery, Inv. No. 653.2

Condition: Very good. The portrait of the woman is in much better condition than the male portrait of the same size (III.G.2) which has always been its pendant. This fact may be due to the different painterly techniques used in both panels, according to Frinta.

Attribution: The female portrait and the male portrait, together with the Frankfurt panels and the Madrid *Descent from the Cross* were already attributed by Passavant 1858 to "Rogier van der Weyden the Younger". The pair of portraits also appears together with the Mérode Tiptych (I.12) in Bode's list of works (Bode 1887). The attribution of the two portraits to the Master of Flémalle, that is to say Robert Campin, was first questioned by Voll 1923. Kemperdick sees a close affinity between the two heads and the Madrid *Descent from the Cross* (I.17). Frinta was the first to attribute the two portraits to different artists. Whereas he does not hesitate to accept the attribution of the female portrait to Campin, he refutes this attribution for the male portrait with detailed arguments regarding style and painterly technique. (See Cat. III.G.2). However, as the supports of both portraits are from the same tree (Campbell 1998, p. 72) and have exactly the same dimensions and priming it may be assumed that the two portraits were created as a pair at the same time by two different artists.

Dating: Circa 1430. Terminus post quem (dendrochronology according to Klein in Campbell 1998, p. 72): 1419/c.1425 + min. 2 + x. Friedländer dates the two portraits between 1425 and 1429 an, while Tolnay dates them just before the Werl Altarpiece of 1438. According to Hulin 1939 they were created around 1425, at about the same time as the original of the Alatruy-de Pacy pair of portraits (I.8/C). Frinta regards the female portrait as a work of the artist's mature period, created around the same time as the *Thief on the Cross* or slightly later. Campbell 1973, Campbell 1998 and Kemperdick argue in favour of a later date for both portraits, possibly in the 1430s or around or after 1435.

Commentary: See p. 80s.

Provenance: First mentioned in 1832 by Sulpiz Boisserée together with the male portrait (III.G.2) as part of the collection of Dr. Friederich Campe. According to Passavant 1858, p. 129, it was purchased from its former owner in the Netherlands. Acquired by Niewenhuys in 1849 at the auction of the Campe collection. Then part of the collection of Edmond Beaucousin, Paris, which was acquired in 1860 by the National Gallery. (According to Davies 1953.)

Literature: M: Tschudi, pp. 31-34; Winkler, p. 10; Friedländer, vol. 2, No. 55; Tolnay, No. 13; Panofsky, p. 172; Frinta, p. 57 s; Davies, Campin/London 1; Châtelet, Cat. 14; Kemperdick, pp. 119-122.

S: Passavant 1858, p. 128 s; Bode 1887, p. 218 s; Voll 1923, p. 97; Hulin 1939; Davies 1953, No. 33; Campbell 1973, Cat. no. III, pp. 370-372; Campbell 1974, p. 642 s; Campbell 1996, pp. 123-127, °Campbell 1998, pp. 72-79.

I.10 The Bearing of the Body of Christ to the Sepulchre → Figs. 65, 100 and det. (75)

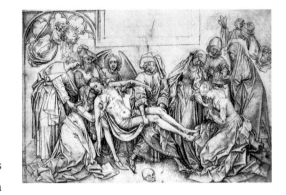

Pen over charcoal sketch on white paper; 24.0 x 35.7 cm.
Paris, Musée du Louvre, Cabinet des dessins; Inv. No. 20.666

Inscription: On the central vertical, top, in pencil, by a later hand: *Roge[rus]*(?).

Attribution: Most scholars link this composition with Rogier van der Weyden because of its affinities with the Madrid *Descent from the Cross* (I.17). The drawing is regarded either as a copy after a lost painting (altarpiece or mural) by Rogier (according to Winkler 1913/14, Friedländer, p. 79), or it is regarded as a design by Rogier for a sculptural work (according to Rolland 1932 a, Panofsky and Verhaegen 1962). According to Destrée 1919 the drawing is a design for a sculpture based on a painting by Rogier. Only Conway 1921 casts doubt on Rogier's authorship. Wescher 1938 believes the drawing belongs to a group of drawings that he attributes to Rogier's student Vrancke van der Stockt (prior to 1424–1495). Sonkes 1969 points out correctly that this drawing is of considerably higher quality than the others in the group of drawings collated by Wescher. As shown by Thürlemann 1993 b this drawing in the Louvre is in fact an original draft design. Moreover, it was not executed by Rogier van der Weyden, but by his teacher Robert Campin. (For a summary of the argumentation see p. 83 s). Kemperdick regards the drawing as a copy dating from the second half of the fifteenth century, based on a painting he dates to the late 30s or early 40s by a painter in the circle around Rogier van der Weyden who may also have created the Berlin *Crucifixion* (II.3). Kemperdick's argumentation, however, is unconvincing, as it is based to some degree on incorrect assumptions and because it does not take into account all the surviving copies of the painting. For example, the lower right does not show a piece of Mary Magdalene's overgarment, but the end of her fur-lined mantle with the fur trim protruding slightly. The large clasp on the mantle worn by Saint John can be found not only in copies from the school of the Master of Frankfurt, but also in works created independently, such as the sculpture group in Detroit (Fig. 239) and the panel by Thoman Burgkmair (see *Copies*). De Vos also emphatically determines this drawing as an original draft design, adding further arguments over and above those presented by Thürlemann 1993 b. De Vos also ascribes the drawing to the author of the Madrid *Descent from the Cross* (I.17) but follows tradition in identifying this artist as Rogier van der Weyden. It is difficult to appreciate how the author can attribute the design for a St Eligius triptych (de Vos, Cat. No. B19) with its stiffly rendered draperies to the same painter.

Dating: Circa 1425. Most authors date this composition in connection with the Madrid *Descent from the Cross* (I.17), to which it is closely related. Some regard it as a precursor (Kerber 1931/32, Maquet-Tombu 1949, Sonkes 1969), and others as a later version (Ed. de Bruyn in Cat. Anvers 1930/32, Schöne 1938, Wescher 1938, Houben 1949, Sulzberger 1950/51, Panofsky, Kemperdick). The composition also bears distinct similarities with the central panel of the early Seilern Triptych (I.3), in which the two raised semi-circular areas also provide the setting for hovering angels bearing the crown of thorns and the three nails. The Paris drawing can easily be placed between the Seilern Triptych and the Madrid *Descent from the Cross*, though its dating is closer to the latter. Winkler 1913/14 and Sonkes 1969 point out that the costume of the woman next to Nicodemus dates from the period around 1420–1430 and rarely occurs after that time. De Vos, p. 35, also supposes that the Louvre drawing is earlier than the *Descent from the Cross*.

Copies: The two female figures on the outer right are to be found in a drawing in the Staatliche Museen Berlin (Sonkes 1969, Cat. no. C24). In contrast to Sonkes' view, this is not a copy after the painting, but a partial copy of the drawing in the Louvre (cf. Thürlemann 1993b, p. 44, n. 86). The original painting by Campin, for which the Paris drawing is a late draft, was as famous as the Madrid *Descent from the Cross* and was copied and emulated in numerous paintings and sculptures. The most complete list of copies is provided by Fredricksen 1981. To this list may be added a late fifteenth century panel by Thoman Burgkmair from the Dominican friary of St. Katharina in Augsburg (Cat. Augsburg 1978).

Commentary: See pp. 83-91, where the drawing is determined as a study for an altarpiece. A hypothetical identification of the donor and the original site of the altarpiece are also discussed here.

A drawing of the *Bearing of the Cross* is erroneously regarded by Winkler 1913/14 and subsequently by Panofsky and Sonkes 1969 (Cat. no. C17) as a copy of the left-hand wing. Although the drawing has the appropriate format, the *Bearing of the Body to the Sepulchre* is framed differently (with an additional concave moulding or scotia). Moreover, the illusionistic interaction between the beams of the cross and the frame itself, belongs to the period of Memling. (Cf. the exterior of the left wing of the Bruges triptych presented by Adriaen Reins around 1480; See Friedländer vol. 6, No. 5). Two triptychs from the workshop of the Master of Frankfurt, whose central panels correlate closely with the drawing of the *Bearing of the Body*, provide a fairly precise idea of the painting of the wing of the altarpiece by Campin. (See Fig. 70.)

Provenance: The drawing is from the Saint-Morys collection seized after the French Revolution. It belongs to a group of 634 drawings by masters of northern European schools which Saint-Morys had purchased (Arquié-Bruley 1987).

Literature: M: Winkler, p. 84s, 99; Friedländer, vol. 2, No. 94a; Panofsky, p. 266 (n. 3), p. 327 (n. 5); Kemperdick, pp. 52-55.
S: Winkler 1913/14; Destrée 1919; Conway 1921; Kerber 1931/32; Rolland 1932a, p. 75; Cat. Anvers 1930/32, t. 2, pp. 16s, 40; Schöne 1938, p. 63; Wescher 1938; Maquet-Tombu 1949; Houben 1949; Sulzberger 1950/51; Verhaegen 1962; Cat. Paris 1968, No. 16; °Sonkes 1969,

Cat. no. C23; Cat. Augsburg 1978, No. 5298, p. 50s; °Fredricksen 1981; Arquié-Bruley 1987; °Thürlemann 1993b, p. 30-33; °De Vos 1999, Cat. No. B22.

I.11/C Madonna in Half-Length (Copy) → Fig. 84

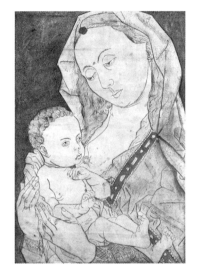

Woodcut; 37.9 x 25.3 cm
Brunswick, Herzog Anton Ulrich-Museum (formerly: Wolfenbüttel, Herzog August-Bibliothek); further exemplar: Breslau, Diocesan Library (according to Schreiber)

Attribution: Schreiber 1927 regarded the woodcut as a copy after a painting. Hind 1935, who ranked it as "the most remarkable of Netherlandish woodcuts of this period [second half of the fifteenth century], and one of the most beautiful cuts of the XV century" saw in it the direct influence of Rogier van der Weyden in compositional terms, but also noted a close affinity with the Salting Madonna (I.13). Winkler 1958 convincingly attributed the lost original to Robert Campin and showed that it must have been faithfully rendered, down to the finest details in the woodcut, albeit in mirror imaging. Campin's authorship of the original is indicated, for example, in the slender and elegantly curved half-closed eyes under distinctly protruding eyelids, exactly like those in the Salting Madonna (I.13). The same is true of the fine folds of skin on the neck of the Madonna and the line of the chin that traces the curve of a recumbent crescent moon.

Dating: Lost Original: 1425/30. *Woodcut copy:* second half of the fifteenth century

Further Copies: All three painted copies mentioned by Winkler 1958, p. 41, of which he illustrated two, are now lost. (According to a letter from Dr. B. Göres of the Kunstgewerbemuseum, Berlin, the glass painting shown by Winkler as ill. 5 must also be regarded as a war loss.) According to Winkler 1958 the painted copies were created independently of the mirror-image woodcut. Winkler, p. 41s, also mentions two woodcuts and a dotted print (*Schrotschnitt*) which he believes are merely second and third grade copies.

Commentary: The woodcut copy shows that it was Campin and not Rogier van der Weyden who introduced the type of the half-figure Madonna to Netherlandish painting. One of the oldest portrayals of a half-figure Madonna by Rogier (III.B.8) is based in a number of fundamental aspects on Campin's composition: the pose of the figures (note the Infant's toes) and essential elements of the clothing (headband, ornamental border, brocade sleeves). What is new in Rogier's work is the gesture of one the Virgin's hands and, with that, the position of the Infant on a cushion. This early Madonna by Rogier, after Campin, was probably the basis for Rogier's portrayal of the Madonna in the Saint Luke altarpiece (III.B.9) and not vice versa. (Friedländer, p. 23, and Davies, Rogier van der Weyden/Chicago, present a different view.)

Literature: S: Schreiber 1927, No. 1039b; Hind 1935, vol. 1, p. 152; °Winkler 1958.

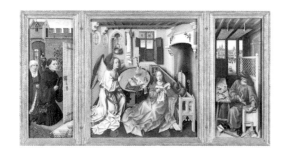

I.12 Triptych of the Annunciation (Mérode Triptych) → Fig. 42 and det. (43-44, 46, 52)

Wood (oak); 64.1 x 63.2 cm (central panel), 64.5 x 27.3 cm (wings)
New York, The Metropolitan Museum of Art, The Cloisters Collection. Inv. No. 56.70

Coats of arms: In the back window of the central panel two escutcheons can be seen which undoubtedly refer to the couple portrayed on the left-hand panel. The coat of arms of the man, featuring a chain (*d'or au chevron de sable chargé sur sa pointe d'une chaîne de quatre chaînons d'argent, ployée dans le sens du chevron*), was identified by Tschudi as the coat of arms of the Inghelbrechts or Ymbrechts family in Mecheln. However, there is no evidence that this branch of the family, long established in Mecheln, using the Ymbrechts variation of the name, ever actually used this coat of arms. This casts some doubt on Châtelet's identification of the man as Jan Ymbrechts. The coat of arms featuring the chain has since been firmly ascertained only for three direct descendents of the Cologne alderman Tielmann Engelbrecht (see family tree, Fig. 49): for two of his sons, Peter and Heinrich, and for one of his grandsons, Peter's son Johan. Heinrich added to his seal an acorn on the upper right, while Peter added a sphere (or a bell). (See Thürlemann 1997a, p. 83, n. 47, and ill. 29 in Installé 1992.) The third son, Rombaut, bore a different coat of arms (ill. 28 in Installé). Given her age, Elisabeth Inghelbrechts, whose daughter Barbe Neeffs married the patrician Simon Huens in Mecheln in 1457, and who also bore this coat of arms, may well have been a sister of Peter Engelbrecht. (Cf. Hulin in Heins 1907, p. 218, and Installé 1992, p. 148, n. 173, and ill. 6). However, Elisabeth Inghelbrecht's origins have not yet been determined with certainty.

The coat of arms of the woman (*d'or à la fasce de gueule accompagnant trois annelets du même*) is not very specific. (Renesse 1892–1903 identified 19 families who bore this coat of arms, three of them using the same colours as those in the triptych.) Tschudi's attribution to the Calcum/Lohausen family was quite rightly called into question by Hulin (see Heins 1907, p. 217): *"Il serait très imprudent de donner d'après cela à cette dame le nom von Calcum ou tout autre."* Nor does the seal of Gilbert van Bergh, illustrated in Châtelet 1990 and Châtelet, p. 294, permit an unequivocal conclusion regarding the surname of the woman portrayed in the triptych, nor, indeed, of her husband, as a member of the Inghelbrechts or Ymbrechts family. As Kemperdick, p. 85, notes, the seal also shows one point in the centre of the rings which is not included in the painted coat of arms. Installé 1992 surmises that this is the coat of arms of Peter Engelbrecht's second wife, Heylwich Bille, whom he married after 1456. The coats of arms now visible are later overpaintings. (See *Condition*.)

Condition: On the whole good. Some important areas of the head of the donor have been restored (mouth, nose and left eye). The figure of the woman and the messenger at the gate are later additions painted over a finished layer of painting. The coat of arms and the cloudy sky were added over the original gold-coloured background (silver foil glazed with yellow). The round windows originally had a gold ground as well. In the area of the coats of arms some of the paint has flaked. (According to Suhr 1957). According to a verbal statement by Maryan W. Ainsworth of the Conservation Department of the Metropolitan Museum, traces of paint have been found under the present coats of arms indicating that two coats of arms were included in the original gold-grounded windows.

Attribution: Since Bode 1887, this triptych has ranked as a key work by the artist to whom many art historians referred as the Master of Mérode until Tschudi designated him as the Master of Flémalle. Heckscher 1968, p. 45 s, and Frinta noted that the left-hand panel is stylistically distinct from the other two panels. Frinta was the first to see a correlation with the works of Rogier van der Weyden. Campbell 1974 considers the entire triptych to be the work of a single artist, and has attributed it, on grounds of certain stylistic idiosyncracies he has noted, especially on the left-hand panel, to a Master of Mérode, as distinct from Robert Campin or the Master of Flémalle. Studies based on infrared reflectography (see van Asperen de Boer et al.) have nevertheless confirmed Campin's authorship of the central panel and the right-hand panel and have at the same time strengthened the assumption that the left-hand panel was the work of a different artist. Kemperdick, p. 98, points out that the dark beams of the half-timbered houses on the left and right panels are painted using different techniques. Châtelet attributes the entire triptych to Robert Campin. Kemperdick posits that each panel was painted by a different artist, though he does note that the underdrawings of the central panel and the right wing are related. The panel showing *Joseph* is attributed to the author of the *Nativity* in Dijon (I.6). Kemperdick does not exclude the possibility that the panel showing the donor may have been painted by Rogier van der Weyden, but considers it impossible, on grounds of costume, for the figure of the woman to have been added later than 1450. In our opinion, however, the figure of the messenger, which was added at the same time, clearly reflects the mature style of Rogier. Ainsworth in Ainsworth/Christiansen 1998, p. 95, also argues in favour of ascribing the left-hand wing to Rogier van der Weyden. We believe that Rogier van der Weyden initially painted the left-hand panel with the figure of the donor alone, adding the figures of the woman and the messenger at a later date. In doing so, he probably overpainted the gold edgings of all the windows in the central panel with a realistic sky and added the two coats of arms that can now be seen.

Kemperdick uses a number of complex arguments in an attempt to show that the central panel is secondary to the Brussels *Annunciation* (III.C.1) and that it has nothing to do with the remaining works of the Flémalle group. The fragility of Kemperdick's argumentation in this case is evident in the fact that he does not mention the multiple cast shadows found only in the New York version and constituting a distinct correlation with the two grisailles in the Städel in Frankfurt (I.16, I.18a). On the other hand, the affinity between the Mérode *Annunciation* and the Seilern Triptych is evident. Compare, for example, the portrayal of the wings of Gabriel with those of the mourning angel on the right in the *Entombment* or the cover of the book that the Virgin Annunciate is reading with the headdress of the red figure viewed from the rear in the central panel of the Seilern Triptych.

The assumption expressed by Thürlemann 1997a that the now extant left-hand panel is a replacement for an older panel is unlikely, as dendrochronological studies have shown the same felling date for both panels. Moreover, one of the boards in each of the wings probably came from the same tree.

Dating: 1425–30. Terminus post quem (dendrochronology according to Klein 1996): 1382/ circa 1388 + min. 2 + x for the central panel, 1409/circa 1415 + min. 2 + x for the two wings. Earliest dating 1425–1428, if the donor couple are identified as Peter Engelbrecht and Margarethe Schrinmechers (for the date of their marriage, see p. 71). The triptych is almost unanimously dated to between 1425 and 1428 on stylistic grounds. (For further details of the

dating see Asperen de Boer et al., p. 105). Châtelet dates the triptych on the basis of his identification of the donor to some time between 1419 and 1422, while Kemperdick dates it slightly later than the Brussels *Annunciation* (III.C.1). Given the stylistic affinities with the Leipzig *Visitation* by Rogier van der Weyden the left-hand wing may be regarded as one of the earliest surviving works by Rogier. The figures added later (the wife of the donor and the messenger of the city of Mecheln) correspond to the mature style of Rogier in the period around 1455/60. The thesis proposed by Châtelet, p. 292, Kemperdick, p. 85, and Ainsworth in Ainsworth/Christiansen 1998, that the central panel might have been painted before the wings, cannot possibly be correct, as the door aperture on the left-hand edge of the painting, already included in the underdrawing, implies the existence of a left wing.

Copies: Copies of the central panel exist in the form of a drawing in Erlangen (Friedländer vol. 2, No. 54c; Sonkes 1969, Cat. no. B5) and two paintings of the same size as the original in Cassel and Genoa. (Friedländer vol. 2, No. 54a, Add. 155). The Cassel copy is dated by Bergen-Pantens 1967 as having been produced before 1511, on grounds of the escutcheons differing from those in the original. Terminus post quem (dendrochronology according to Klein 1996): 1498/circa 1504 + min. 2 + x. The copy in Genoa, according to Denis 1953, bears the inscription "Rogier van der W...", but this cannot be taken as proof of authorship of the original, as Denis assumes. The figures of the Virgin and, with altered robes, that of the angel, were adopted around 1450 by the Master of Catherine of Cleves in a miniature of the Book of Hours of Katharina von Lochhorst (Fig. 230) and in the Madrid *Annunciation* from the workshop of a student of Campin (III.D.1b). For details of the altered copy of the central panel, created by another student of Campin in the workshop of the master, see III.C.1.

Commentary: See pp. 58-76.

Provenance: Purchased c. 1820 by the Prince d'Arenberg in Bruges and later, through the marriage of his daughter Nicolette, passed into the hands of the Mérode family. Purchased in 1957 for the Cloisters collection.

Literature: M: Tschudi, pp. 9-12; Winkler, pp. 27-31; Friedländer, vol. 2, No. 54; Tolnay, No. 4; Panofsky, pp. 129, 142s, 164-167 *et passim*; Frinta, pp. 13-28; Davies, Campin/New York; van Asperen de Boer et al., F11; Châtelet, Cat. 6; Kemperdick, pp. 77-99.
S: Bode 1887; Renesse 1892–1903; Hulin bei Heins 1907, p. 217; °Schapiro 1945; Denis 1955; Freeman 1957; Rousseau 1957; Suhr 1957; Tolnay 1959; Nickel 1965/66; Bergen-Pantens 1967; °Heckscher 1968; Sonkes 1969, Cat. no. B5; Minott 1969; Gottlieb 1970; Campbell 1974; Arasse 1976; Coo 1981; Hahn 1986; Châtelet 1990; °Installé 1992; °Thürlemann 1997a; °Ainsworth/Christiansen 1998, pp. 89-96.

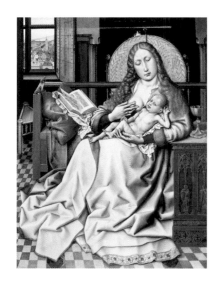

I.13 The Virgin and Child before a Fire-Screen (Salting Madonna) → Fig. 86 and det.

Wood (oak); 63.4 x 48.5 cm
London, National Gallery, Inv. No. 2609

Condition: The panel is on the whole in good condition, but has two modern additions. The painting was restored before 1875, probably in Italy. In the course of this restoration, a 3 cm wide strip was added at the top and a 9.5 cm wide strip was added at the right-hand side. With the exception of the right-hand edge, the edges of the original panel are uncropped, for dowel holes from the original frame system have been ascertained (Campbell 1998, p. 93). The addition at the right-hand edge corresponds to the width of the cabinet on which the Virgin's left arm is resting. Bomford in Campbell et al. 1994 assumes that the restorer removed part of the extreme right-hand edge of the panel following fire damage and repainted it after the damaged original. The addition on the upper edge is clearly not correct, as the horizontal edge of the mantelpiece is missing. Moreover, as Kemperdick, p. 62, notes, the transom of the window is too low.

Attribution: Since Bode 1887 this work has generally been attributed to the Master of Flémalle. Campbell (in Campbell et al. 1994, p. 21s) attributes the work to an emulator of Campin, to whom he also attributed the Mérode Triptych. However, the underdrawing features the multiple hooked lines in the troughs of the drapery that are undisputedly characteristic of Campin. (See Thürlemann 1993a, p. 722). Kemperdick, who does not wish to accept the similarity of the underdrawing, attributes this panel to an artist closely connected with the Master of Flémalle. He further maintains that the same artist was the author of the *Thief on the Cross* (I.16) as well as of the panel of *Christ and the Virgin* (III.C.3).

Dating: 1425/30. Terminus post quem (dendrochronology according to Klein 1996): 1396/circa 1402 + min. 2 + x. Most connoisseurs date this composition before 1430. Winkler believes it was created at the same time as the Mérode Triptych. Frinta, p. 45, surmises that this panel was begun before the Mérode Triptych and completed after it. Campbell (in Campbell et al. 1994, p. 22) dates it around 1440; Kemperdick dates it after the Flémalle Panels (I.18), to around 1438.

Copy: Destrée 1926 published a no longer tracable copy, slightly smaller and of no great artistic merit, from the collection of Madame Reboux in Roubaix (Fig. 81). Kemperdick presented persuasive arguments to show that, in contrast to Destrée's theory, it was not produced at the end of the fifteenth century, but was based on the already restored and extended London panel. In this case, he argues, it would have no value as a means of reconstructing the work's original appearance. However, iconographical considerations would indicate that the London panel, apart from the addition at the top, correponds closely to the original in spite of the fact that the transition between the mantle of the Virgin and the cabinet cannot be correct. This opinion is also voiced by Pitts 1986, p. 92. There is no reason to assume that the reconstruction proposed by Kemperdick, ill. 80, is any more correct. Nor is there any reason to suppose that a restorer should have taken the liberty of inventing the far more complex solution featuring the cabinet and the chalice.

Commentary: See pp. 92-101.

Provenance: Purchased in 1875 by Léon Somzée in Venice. 1903 in the possession of the firm of Agnew, London. Purchased in 1904 by George Salting. Part of the George Salting Bequest

to the National Gallery in 1910. This work was formerly in the possession of Enrico di Borbone, Conte di Bardi (1851–1905), brother of the last Duke of Parma. An inscription on the back in the handwriting of the eighteenth or nineteenth century indicates a link with the Balbiano family from Chieri who had intermarried with the Villa di Villastone family. Members of the Villa family, who were involved in banking in the Netherlands in the fifteenth century, commissioned a number of paintings there by artists including Rogier van der Weyden. (According to Campbell in Campbell et al. 1994, p. 21; on the first owner, see also Campbell 1998, p. 98).

Literature: M: Tschudi, p. 89s; Winkler, p. 31; Friedländer, vol. 2, No. 58; Tolnay, No. 5; Panofsky, p. 163s et passim; Frinta, pp. 39-45; Davies, Campin/London 2; Asperen de Boer et al., F5; Châtelet, Cat. 7; Kemperdick, pp. 59-66.
S: Bode 1887; Destrée 1926; °Davies 1953; Budde 1986; Thürlemann 1993a; °Campbell et al. 1994; °Thürlemann 1997b; °Campbell 1998.

I.14/C Crucifixion (Copy) → Fig. 241

Opaque paint on parchment; 12.5 x 7.4 cm (size of miniature)
New York, Pierpont Morgan Library; Ms. G 917, fol. 77v

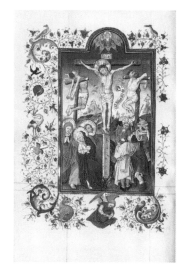

Attribution: Original: Wit 1937 was the first to propose that the Crucifixion scene in the miniature was based on an original by the Master of Flémalle. Panofsky accepted this attribution. The miniaturist added two thieves to the Crucifixion scene, whereby the thief on Christ's left is clearly taken from the Bruges Triptych (cf. I.16). *Copy:* Workshop of the Master of Catherine of Cleves.

Dating: Original: 1425/1430. In particular, the figure of the soldier with his back turned to the spectator suggests that the original was a mature work. *Copy:* circa 1440. (See Plummer 1966 and Pieper 1966a).

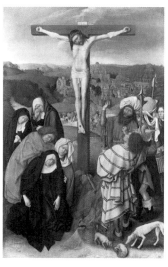

Further Copy: Campin's composition was also the basis for a panel painting by the young Gerard David. (Fig. [1]; cf. van Miegroet 1989 and Eisler 1989.) However, David added to the edge of the picture a portrayal of the city of Jerusalem after Hubert or Jan van Eyck and replaced the group of women and Saint John by a new group adopted from a northern Netherlandish original (by Geertgen tot Sint Jans?). (Cf. pp. 213-215.) It may be assumed that the male group on the left of the crucifix is a faithful rendering of Campin's original, down to the colouring. However, the copyist has added a figure at the right-hand edge which is probably a self-portrait. On the other hand, it may be assumed that the two dogs flanking the skull of Adam, which are not in the miniature copy, were part of Campin's composition. (On their significance and meaning, see Marrow 1979, pp. 36-40). David later adopted one of the two dogs, together with the skull, in his triptych with *Christ Nailed to the Cross* (Friedländer vol. 6, No. 162).

[1]

Commentary: The gaze of the soldier on the right goes beyond the frame, indicating that the original composition formed the central panel of a triptych. According to Eisler 1989 the panel by Gerard David (fig. [1]) was originally rounded at the top. As the miniature copy is also topped by a semicircle it may be assumed that the original did indeed have a rounded upper edge.

Provenance: Prince Arenberg, Guennol Collection, Pierpont Morgan

Literature: M: Panofsky, p. 176s; Davies, Campin/Lugano.
S: Wit 1937; Plummer 1966, No. 26; Pieper 1966a, p. 97s; Gorissen 1973, passim; Marrow 1979; °van Miegroet 1989, Cat. no. 63; °Eisler 1989, No. 14.

I.15/C Saint Luke Triptych (Copy) → Fig. 92

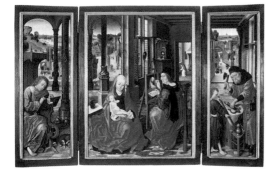

Wood (oak); 116 x 86 cm (central panel), 115 x 39 cm each (wings)
Stolzenhain, Elbe-Elster Kreis, Brandenburg. Evangelische Pfarrkirche

Condition: Repairs to a number of areas, though these do not affect the flesh tones, except in the case of the Virgin's face. The wings are better preserved than the central panel. (Cf. *Attribution*). The frames are original, but were varnished black at some unknown date (after 1937).

Attribution: The triptych in Stolzenhain may be regarded as an essentially faithful copy after a work by Robert Campin. The first to suggest a Netherlandish original as the basis for the partial copy in Münster (fig. [1]; cf. *Further Copies*) was Heise 1918, p. 46, on grounds that "a Netherlandish original" (*ein niederländisches Vorbild*) "determines almost every detail of the homely effect of the picture" (*fast alle Einzelheiten der anheimelnden Bildwirkung bestimmt*). According to Pilz 1970 there is no other example of a triptych with "genre-style scenes on the side panels" in Germany. A number of typical details, such as the still life above the head of Saint Luke and the fountain with the urinating figures behind the Virgin, also to be found in works by the Master of Frankfurt and the Master of Saint Gudula, indicate that the original was Netherlandish. (Cf. Thürlemann 1992, pp. 543-546.) Apart from a number of specific details, Robert Campin's authorship of the original is suggested above all by the distinct material realism and complex yet coherent construction of the simulated space which are tangible even in the copy.

Copy: The wings are of the same painterly quality as the individual scenes on the central panel in the Westfälisches Landesmuseum, signed by Derick Baegert (fig. [1]). The central panel on the other hand is the work of a lesser artist, probably a member of Baegert's workshop.

Dating: Lost Original: circa 1430. The spatial concept is more progressive than that of the Mérode Triptych. On the other hand, at least in the copy, the frames do not cast a shadow on the pictorial space structured by them, as they do in the *Annunciation* scene of the Ghent Altarpiece completed in 1432 and, later, in the wing panel of *Saint Barbara* on the Werl Altarpiece dated 1438 (III.B.4).

Copy: circa 1480. The triptych copy is later than the partial copy of the central panel in Münster (fig. [1]).

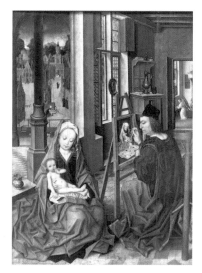

[1]

Further Copies: The Westfälisches Landesmuseum in Münster has a copy of the central panel (fig. [1]) of only slightly smaller formal, signed by Derick Baegert on the pitcher behind the Virgin with the letters BAEG. In contrast to earlier scholarly opinion (including Pieper in Cat. Münster 1986) this is not a fragment of a triptych, but a panel intended as a partial copy based on the central scene of the triptych by Robert Campin. This is evident from the fact that this work, unlike the central panel of the copy in Stolzenhain, does not include the area of water that creates the link with the left-hand panel. The Münster panel is to be dated around 1470 on stylistic grounds. The late dating proposed by Sprung 1937 is based on the erroneous assumption that the painting is an original composition by Derick Baegert. As the Münster panel (fig. [1]) features a pentimento in the robe of the Virgin, while the central panel of the Stolzenhain triptych adopts the later correction, it must be assumed that the workshop member responsible for the central panel of the Stolzenhain triptych worked on the basis of the Münster panel and that Baegert based the wings of the triptych on the drawing after the original triptych. (For a detailed study of the relationship between the two painted versions and their affinity with the lost Netherlandish original, see Thürlemann 1992, p. 563.)

In the Rijksmuseum in Amsterdam there is a fragment of an oak sculpture, with some traces of paint, portraying *Saint Luke seated at an easel, painting* (fig. 90). The sculpture, formerly thought to be Lower Rhenish, is now regarded as northern Netherlandish and dated around 1515. The pose of the saint and the clothing correspond largely to those in the two copies from the Baegert workshop. As the drapery of the sculpture is much closer stylistically to the works of Campin around 1430 than to that of the painted copies, it must have been created independently of them. Moreover, the oak sculpture proves that the triptych from the workshop of Derick Baegert is indeed a copy.

Commentary: See pp. 101-108.

Provenance: It is not known how the triptych arrived at its present location.

Literature: M: Châtelet, Cat. I.16b, c.
S: Heise 1918, p. 46; Spaemann 1925; Sprung 1937, p. 35 s; Cat. Münster 1937, Nos. 34, 42-44; Pieper 1937; Stange 1954, p. 60; Pilz 1970, p. 214; Cat. Amsterdam 1973, No. 89; °Cat. Münster 1986, No. 163; °Jászai 1986; °Thürlemann 1992.

[1]

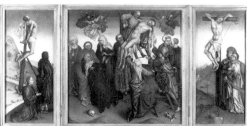

I.16 The Good Thief on the Cross → Figs. 118-119 and det.
(Exterior: John the Baptist)

Wood (oak); 133.7 x 92.2 cm
Frankfurt am Main, Städelsches Kunstinstitut; Inv. No. 886

Condition: The panel, whose lower edge is truncated, is the upper half of the wing of a triptych. *Inside:* the actual figures are in satisfactory condition, but the background of the painting with its gilt brocade pattern has deteriorated considerably in the wake of two successive restorations. On the upper left-hand corner the tip of the robe of an angel featured in the central panel and trailing onto the right wing has been gilded over at a later date. (See X-radiography analysis in Sander 1993, ill. 86). *Outside:* traces of a black coating distributed over the entire surface. Before applying the vertical wooden strut intended to secure a join in the wood the painting was stripped down to the wood on both sides of the join. Further major areas of damage have not been repaired.

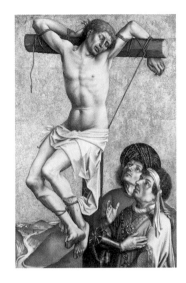

Attribution: Since Passavant 1843 and Tschudi the *Thief on the Cross* has been attributed almost unanimously to the author of the Flémalle Panels (I.18), and has hung beside them in the Städel collection since 1849. With the exception of Davies and Kemperdick there is invariably an implicit or explicit assumption that the work was executed single-handedly by the master himself. However, the panel clearly indicates the involvement of a workshop assistant. While the naked figure of the Thief must be attributed, in our view, to the hand of the master, the heads of the two men below the cross of the Thief possess a remarkably mobile modulation that is not in keeping with the stringently sculptural style employed by Campin in his portrayal of heads. It is not entirely improbable that these figures may have been painted by Rogier van der Weyden, who was later to adopt the faces of these two men in the same position in two of his triptychs (III.B.15, III.B.17). Davies surmises that the rather roughly painted landscape is the work of an apprentice. Kemperdick ascribes the entire work to an assistant to whom he also attributes the panel of *Christ and the Virgin* in Philadelphia (III.C.3). Sander 1993 regards the grisaille on the exterior as the work of the master himself. With their complex play of light and shadow the portrayal has all the characteristics of Campin's painting, yet the artistic quality suggests that it was executed and perhaps even devised by a member of his workshop. The areas of underdrawing visible in the grisaille contain some rather tentative hatching that does not support attribution to Campin. (Cf. ill. 82 in Sander 1993 and ill. 40 in van Asperen de Boer et al.). Here, too, there seems to be some similarity with the style of underdrawing practised by Rogier van der Weyden. (The correlation with the underdrawing in the Frankfurt *Holy Trinity* noted by van Asperen de Boer et al., p. 71, is not evident.) Elisabeth Dhanens (Dhanens 1984 and Dhanens 1998) ascribes the panel to a Ghent artis.

Dating: Circa 1430. Terminus post quem (dendrochronology according to Klein 1996): 1414/circa 1420 + min. 2 + x. In the freely interpreted reiterations of the central panel and one of the two Thief figures of the original triptych as found in two miniatures in the Book of Hours of Catherine of Cleves (cf. Fig. 241) Hulin 1902 saw grounds for a terminus ante quem of 1430. (Today the Book of Hours is dated later, to around 1440. See Plummer 1966.) Kemperdick, p. 36, notes a terminus ante quem of 1437 on the basis of a miniature in an Ulm manuscript of the Nibelungenlied. Hulin's dating of the triptych to before 1430 has been accepted by most scholars. Almost all of them date the lost original to *before* the Madrid Descent from the Cross (I.17). Panofsky dates this latter painting around 1435 and regards it as a "painted critique" (p. 168) by Rogier van der Weyden of the lost central panel (fig. 117) which is documented in copies. Kemperdick dates the triptych to the first half of the 1430s.

Châtelet dates it after the Flémalle Panels, but as early as 1415–20. This early dating is refuted by dendrochronological findings.

In our opinion the two portrayals of the Descent from the Cross are two different versions of the biblical scene by one and the same painter, to wit, Robert Campin. The painterly style of the nude in the fragment in the Städel is closely related to those in the Madrid *Descent from the Cross* (I.18). We do not consider it possible to determine the relative chronology of these two works with certainty.

Copies: The composition of which the Städel fragment formed a part has been handed down to us in a number of more or less true copies and replicas, whose sheer number bears witness to the fame of the original. The most important work in terms of reconstructing the original appearance of the triptych is a small but complete copy of little artistic merit now in Liverpool. (Fig. [1]; cf. Cat. Liverpool 1963/66 and 1977). It is generally assumed that this copy was commissioned by a citizen of Bruges, one Jan de Coninck, some time between 1448 and 1465 for the Hospital St. Julian. (See Geldhof 1975 and Martens 1996 for more precise information as compared to Sander 1993). Kemperdick, p. 31, refutes the identification of this triptych with the "small picture of Saint Julian" mentioned in the sources. He regards it as a work by the Master of the Legend of Saint Ursula and dates it to around the end of the fifteenth century. Dhanens dates the triptych to 1466/67. The outer sides in grisaille showing Saint Julian and John the Baptist have been simplified in comparison to the original and altered to suit the new situation for which the work was commissioned. On the other hand, the inside is a broadly faithful rendering of the original composition, in spite of the clumsy execution. The gold ground has been replaced by a realistic blue sky and on the left-hand panel, at least the head of the donor must have been painted anew by the copyist. As the donor's costume can be dated to the first half of the fifteenth century, Kemperdick assumes that the original also featured a kneeling donor figure. This figure may well have corresponded to a kneeling female figure on the right-hand panel. A comparison of the fragment in Frankfurt with the copy shows that the copyist, whatever his shortcomings in terms of draughtsmanship, took great pains to imitate the colours precisely, right down to the varying skin tones. Another partial copy of the central panel (fig. 122; cf. Sonkes 1969, Cat. no. C21) in which the finely executed garment of the swooning Virgin corresponds precisely to Campin's mature style in rendering draperies, can give us a better impression of the stylistic qualities of the original. A comparison of the right-hand panel with the fragment in Frankfurt shows that the painter of the Liverpool copy broadened the composition somewhat in comparison to the original. In the original, the central panel must have had a vertical format and corresponded more or less to the proportions of, for example, the copy in the Turin-Milan Book of Hours (ill. 41 in Kemperdick). Kemperdick's assumption that the wings did not cover the central panel and that they were firmly affixed to it, is not necessarily correct. The *Passion of Christ* by the Bruges Master, painted around 1500 for the Church of Saint Saviour in Bruges (Cat. Bruges 1969, No. 26), in which individual figures have been adopted from the *Descent from the Cross* triptych may be regarded as a further indication that the lost original was located in a church in Bruges. In a copperplate engraving reproduction of the Madrid *Descent from the Cross* the Master of the Banderoles adds two figures of thieves both based on the thief on the left-hand wing of the Bruges *Descent from the Cross* triptych. This has

occasionally been taken as an indication that the two altarpieces must have been painted by the same artist, identified as Rogier van der Weyden. On further copies see Sander 1993, p. 138s, and Kemperdick, pp. 30-33.

Commentary: See pp. 131-140. This discusses the identification of the figure on the fragment as the Good Thief, Dismas. The grisaille exterior is unusual in one noteworthy respect. Although it is the right-hand panel of two, the niche is perspectively constructed for a spectator stance to the right of the panel rather than the left, in the middle between the two wings, as one might expect. This indicates that the altarpiece, which measured no less than four metres when opened, was not intended for the high altar but for a secondary altar that could be seen at a side angle from the central axis of the church. Kemperdick's assumption (p. 34s), that the grisaille was intended to be seen from the rear of the altar can be excluded on grounds of the pointing gesture made by the figure of Saint John. Dhanens 1984 linked the lost triptych with a major altarpiece in the Church of Saint James in Bruges documented either as a Crucifixion or as a Descent from the Cross and attributed to Hugo van der Goes. Friedländer, vol. 4, p. 13, surmises (though Dhanens 1984 does not mention this), that it may have been the triptych on which the Liverpool copy is based. Given that the name of Robert Campin was so quickly forgotten, the attribution of such a work to Hugo van der Goes would have been quite understandable. The altarpiece was originally located in the Chapel of Saint James in the southern transept of the church but was transferred during the refurbishment of the church in 1472/74 and on several later occasions. (Cf. also Rotsaert 1975 and Martens 1992). According to a seventeenth century document, the altarpiece was donated by Jacob Biese, a citizen of Bruges. According to Kemperdick, p. 37s, this donor may have been the same Jacob Biese the Elder who died before 1450 and who had acquired burial rights in Saint James in 1440, having already made donations to the church at an earlier date.

Provenance: Given the large number of copies produced in Bruges, it may be assumed that the altarpiece to which the fragment belonged had been created for a church in that city (possibly Saint James). Documented in 1811 in Aschaffenburg (possibly in the collection of the librarian Bernhard Hundeshagen or that of Carl Theodor von Dalbert), and acquired in 1840 for the Städel from Johann Baptist von Pfeilschifter in Mannheim. (According to Sander 1993 and Kemperdick.) Châtelet's thesis that the altarpiece was donated in 1415/16 for the Franciscan Church of Valenciennes is unfounded.

Literature: M: Tschudi, pp. 17-20; Winkler, pp. 18s, 41-43; Friedländer, vol. 2, No. 59; Tolnay, No. 3; Panofsky, pp. 167s, 256, 302; Frinta, pp. 50-53; Davies, Campin/Frankfurt 1; Asperen de Boer et al., F4; Châtelet, Cat. 5; Kemperdick, pp. 29-42.
S: Passavant 1843, p. 261s; Hulin 1902, p. XL, p. 6, No. 22, p. 31, No. 120; Cat. Liverpool 1963/66, pp. 39-42; Plummer 1966, p. 8, 20s; Cat. Bruges 1969; Sonkes 1969, Cat. no. C20, C21; Geldhof 1975, p. 75s; Rotsaert 1975; Cat. Liverpool 1977, p. 37s; Dhanens 1984, pp. 5-30; Martens 1992, p. 262s; °Sander 1993, pp. 129-153; Martens 1996, p. 80s; Dhanens 1998, pp. 31-33.

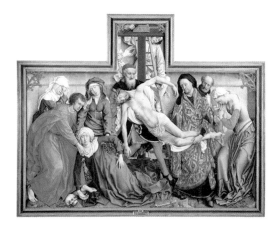

I.17 The Descent from the Cross → Figs. 102-104, 109 and det. (pp. 123-127, figs. 104, 244)

Wood (oak); 148.5 and 201 (elevated part) x 258.5 cm
Madrid, Museo del Prado, Inv. No. 2.825

Inscription: IHESUSMARIA in gothic capitals on the belt of the Virgin

Condition: Generally good. Some loss of paint through abrasion in places.

Attribution: See pp. 109-111, 235-237. The conclusion drawn by Asperen de Boer et al., p. 143, on the basis of the underdrawings is not supported by the material the authors present ("The underdrawing in this painting must be considered to be the absolute bench-mark for Rogier's earlier style. It is ... incompatible with the underdrawing in the Frankfurt *Virgin and Child*"). On the contrary, the fluid brushstrokes of the rapidly sketched underdrawing of the *Maria lactans* and that of the *Descent from the Cross* could well have been by the same hand. The IRR montage of the Flémalle Panels with the *Maria lactans* by Stephan Kemperdick and Jochen Sander (fig. 245) which is more legible than that in Asperen de Boer et al., ill. 2, shows exactly the same characteristic zigzag lines that can be found in the underdrawing of the garment of Saint John in the Madrid *Descent from the Cross* (fig. 244). Moreover, nowhere in the underdrawings of works by Rogier do we find draughtsmanship of such virtuosity and freedom as in the heads of Joseph of Arimathea and Saint John (Asperen de Boer et al., ills. 7, 138).

Frinta assumes that two painters, whom he identifies as Robert Campin and Rogier van der Weyden, shared the work on these panels. Belting/Kruse 1994, on the other hand, posit a vertical division of labour between teacher and student in the sense that Campin designed the panels and Rogier executed them single-handedly according to his teacher's instructions. The extraordinary similarity between the head of Nicodemus and the *Portrait of a Stout Man* (I.5/C), which has so rightly been noted on many occasions, would exclude this possibility. Kemperdick attributes the work in its entirety – design and execution alike – to Rogier van der Weyden, even though he repeatedly notes remarkable stylistic similarities between the *Descent from the Cross* and the Flémalle Panels. De Vos also attributes the *Descent from the Cross* quite emphatically, as an "absolute masterpiece", to the young Rogier van der Weyden. However, his seemingly authoritative arguments reveal themselves to be mere rhetoric couched in prejudice when, for example, on p. 31 – illustrated, of all things, by the anatomically and stylistically identical heads of the Virgin from the Flémalle *Maria lactans* and the *Descent from the Cross* – he asserts that the "typology of the figures" is "completely different in facial composition, handling of hair and rendering of folds". In our opinion both the design and, for the most part, the execution, of the *Descent from the Cross* are the work of Robert Campin. Only in the painterly realisation of individual figures do assistants appear to have been involved. Even if the theory of a division of work between two artists, as proposed by Frinta, is not entirely convincing, some of the heads do indeed appear to have been painted by Rogier van der Weyden. (Thürlemann 1993b argues otherwise). This seems most probable in the case of the head of the woman in green above the figure of the Virgin. A similarly fine-lined and at the same time rather harsh approach can be found quite regularly in the faces within the early œuvre of Rogier van der Weyden, in which the same head posi-

tion is reiterated. (See for example *Saint Veronica* in III.B.5, *Mary Magdalene* in III.B.6 and the *Virgin Mary* in III.B.10.)

Dating: Circa 1430. Terminus post quem (dendrochronology according to Klein, quoted by Kemperdick, p. 46): 1410/circa 1416 + min. 2 + x. The 1435 dating proposed by Panofsky and subsequently adopted by the majority of authors accommodates the traditional attribution of this work to Rogier van der Weyden. Kemperdick, who sees an affinity between the *Descent from the Cross* and the Miraflores Altarpiece, dates it to the mid or late 1430s. The inclusion of the *Descent from the Cross* in the early œuvre of Rogier van der Weyden marks an attempt to explain the striking stylistic proximity to the works of Robert Campin. At the same time, it tends to leave the artistic virtuosity of the work unexplained. Campin undoubtedly painted the Madrid *Descent from the Cross* after the *Bearing of the Body to the Sepulchre*, the composition study for which (I.10) we date to around 1425, and probably before he disbanded his workshop in 1432. Stylistically, the *Descent from the Cross* is very closely related to the Flémalle Panels (I.18). The hypothesis proposed by Frinta to the effect that the Flémalle Panels originally formed the wing panels of the Altarpiece of the Louvain Archers is reiterated here (p. 117 ss) and is supported by the recent technological findings presented by Sander 1993. The initial reconstruction of the polyptych proposed by Thürlemann 1993b, p. 28, is in some aspects rightly criticised by Kemperdick, p. 52.

Copies: The Louvain Altarpiece must have gained early fame, as is indicated by the many faithful copies and free interpretations of it. (See the lists in Winkler, Friedländer, De Vos, p. 186s, and the study by Terner 1973). The central panel of the triptych, dated to 1443, and created for the Edelheer family in Louvain, features the group of figures taken from the work of Campin, and set, like them, in a simulated gilded shrine (Fig. 112). Though the insides of the wings are undoubtedly the work of the anonymous copyist, the grisailles on the outside probably reflect originals by Campin. (See Verougstraete-Marcq 1981 and Comblen-Sonkes 1996). The date "1488" on the Berlin copy (on a scale of 1:1) is not certain. (See Cat. Berlin 1931). The relevant literature generally takes it as given that Michael Coxcie created only one copy of the *Descent from the Cross*, to wit, the one now in the Escorial. The copy paid for by Philipp II on 18 November 1569 cannot be the same copy that Mary of Hungary presented to the Archers of Louvain in exchange for the original and which, according to Molanus, was also made by Coxcie (see Folie 1963, p. 209, and De Vos, p. 186).

Commentary: See pp. 109-130. It is surprising to find in a Descent from the Cross a figure whose traditional attributes – bald pate, short beard – identify him as Saint Peter (cf. Blum 1969, p. 52). It is possible that the apostle bearing the ointment jar of Mary Magdalene and whose body is almost completely concealed by the figure of Nicodemus is the patron saint of the donor (Schmarsow 1928, p. 75). Châtelet 1999, p. 108, sees in the head of Peter the portrait of a priest in charge of the chapel. At the same time (p. 107) he proposes, without adequate justification, that the traditional identification of Nicodemus and Joseph of Aremathaea as bearers of the body should be swapped. The iconography of the *Descent from the Cross* panel has been studied in depth by Simson 1953.

Provenance: The ownership of the painting of the *Descent from the Cross* can be reconstructed in full. Created, probably as the central panel of a winged altarpiece, for the high altar of the Church of Onze-Lieve-Vrouwe-van-Ginderbuiten (Notre-Dame-hors-les-murs) near Louvain, the place of religious assembly of the Guild of Archers. Acquired before 1548 by Mary of Hungary, Spanish stadholder in the Netherlands, in exchange for a copy painted by Michael Coxcie and an organ. Mounted in the chapel of Binche Palace. (See Calvete de Estrella 1548/1876 and Alvárez 1551). 1556 sent to Spain as a gift for Philipp II. Since 1574 in the Escorial; since 1939 in the Museo del Prado as a permanent loan from the Escorial.

Literature: M: Winkler, pp. 96-100; Friedländer, vol. 2, No. 3; Panofsky, pp. 256-258 and passim; Frinta, pp. 82-102; Davies, Rogier van der Weyden/Madrid 1; Asperen de Boer et al., W1; Kemperdick, pp. 45-52.

S: Calvete de Estrella 1548/1876, p. 73; Alvárez 1551, s. p.; Passavant 1858, p. 125 s; Justi 1886, p. 97 s; Schmarsow 1928, pp. 73-76; Cat. Berlin 1931; Maquet-Tombu 1949; Beenken 1951; °Simson 1953; Folie 1963, pp. 208-210; Sulzberger 1963; Blum 1969, pp. 49-58; Schulz 1971; Terner 1973; °Bermejo-Martínez 1980, pp. 103-108; Verougstraete-Marcq 1981; Asperen de Boer et al. 1983; Sander 1993; °Thürlemann 1993b; Belting/Kruse 1994, pp. 96-100; Comblen-Sonkes 1996, No. 187, pp. 118-156; °De Vos 1999, Cat. No. 4, pp. 10-41.

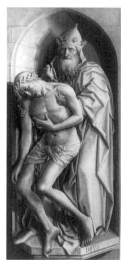

I.18 The Flémalle Panels

I.18a The Trinity of the Broken Body → Figs. 161, 110, 114-115 and det. (p. 121)

I.18b Virgin and Child (Maria lactans) → Figs. 4, 109, 248 and det. (p. 122)

I.18c/I.18c Saint Veronica displaying the Sudarium → Figs. 109, 174 and det. (p. 128)

Wood (oak); 147.5 x 57.6 cm (I.18a), 149.1 x 58.3 cm (I.18b), 148.2 x 57.7 cm (I.18c)

Frankfurt, Städelsches Kunstinstitut, Inv. Nos. 939, 939A, 939B

Inscriptions: I.18a (on the simulated socle): *SANCTA TRI[NI]TAS V[N]VS DEVS.* The first word has been erroneously amended to read *SANCTI.*

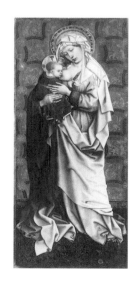

Condition: I.18a: Extensive loss of paint in the lower left quarter. The entire right underarm including hand and the left knee of the figure of Christ are later additions. The heads of Christ and God the Father are in relatively good condition. The panel has been planed and cradled.

I.18b: On the whole in good condition. Verso later painted with a portrayal of the *Mater dolorosa* in grisaille. (Fig. 115; format: 148.6 x 56.9 cm). It is probable that a transverse strip of wood was originally affixed to the back of the panel at mid-height, as regularly spaced wooden dowels can still be seen clearly.

I.18c: Heavily retouched, especially the head of Veronica. The panel has been planed and cradled.

Attribution: Described by Passavant 1858 as works by "Rogier van der Weyden the Younger" and adopted by subsequent authors as such. Tschudi regarded these three panels, which he assumed originated in a monastery at Flémalle near Liège, as masterworks by the anony-

mous artist previously known as the Mérode Master, and renamed them accordingly. Ever since, the attribution of these three panels has been linked with the debate surrounding the existence or identity of the Master of Flémalle. Dhanens 1984 attributes the panels to a Ghent artist active around 1440 who was a follower of Hubert van Eyck and assumes that the Madonna panel is from a different altarpiece. Some of the authors who identify the Master as Robert Campin (Frinta, Davies, Sander 1993) posit that Rogier van der Weyden was involved in the production of the work, though they do not agree on either the form or the extent of his collaboration. Panofsky, p. 169, points out the stylistic similarity with the Madrid *Descent from the Cross*: " ... these three panels ... are as relatively Rogerian as Roger's "Descent from the Cross" ... is relatively Flémallesque." Kemperdick also stresses the similarity.

As Kemperdick has persuasively argued, the collaboration of at least one member of the workshop has been confirmed with certainty in the case of the Saint Veronica panel. Her hands are much more clumsily painted than those of the Madonna and in the painterly execution of the garments the assistant has misconstrued the master's design. By contrast, in our opinion, the face of Saint Veronica could well be the work of Campin himself.

Dating: Circa 1430. Terminus post quem (dendrochronology according to Klein 1996): 1405/circa 1411 + min. 2 + x for I.18a, 1399/circa 1405 + min. 2 + x for I.18b, 1406/ca 1412 + min. 2 + x for I.18c. Probable terminus ante quem: 1432. As Kemperdick elaborates on Sterling 1972, the insides of the Tiefenbronn Altarpiece dated 1432 are probably based directly on the Flémalle Panels of the *Virgin and Child* and *Saint Veronica displaying the Sudarium*. The authors who accept the Master of Flémalle as an independent artist propose the following dates: Tschudi: "around mid-century"; Winkler: "before the Werl Altarpiece"; Friedländer: 1427–32; Panofsky: 1430–32; Sander 1993: 1428–32; Châtelet's early dating to around 1410–1415 does not correspond to dendrochronological analysis. Kemperdick, p. 24, dates the panels to "around the end of the 20s or a little later".

Copies: See Sander 1993, p. 107. *Maria lactans* and *Saint Veronica* were copied as drawings in the sixteenth century. The portrayal of the Madonna was particularly popular, and two half-length copies exist. (See Friedländer, No. 60a). In a devotional image frequently reiterated in tondo form around 1500 the Virgin and Child seem to have been derived from Campin's Madonna panel. (See Friedländer, No. 70a, b.)

Commentary: See pp. 117-130, where the panels are identified as wings of the Altarpiece of the Louvain Archers, as already suggested by Frinta. Châtelet, p. 287, wrongly maintains that Frinta's thesis is *matériellement indéfendable*. His sketchy reconstruction of a four-part altarpiece with two firmly linked central parts, a form not documented elsewhere, cannot be correct, if only on grounds that the outsides are wrongly aligned. Kemperdick's reconstruction of the original context as a "doubly transformable altarpiece" showing sculptures when fully opened (p. 15), is speculative. Kemperdicks assumption that the dowels that originally protruded from the verso of the Madonna panel (See *Condition*) served as a means of affixing sculptures is by no means certain.

Provenance: Towards the end of the eighteenth century the panels were purportedly housed in the Abbey of Flémalle near Liège (alternative claims are made for the Abbey of Falin near Sedan and the Cistercian Monastery of Elant near Sedan); before 1842 they were in the possession of a cleric in Liège, thereafter in the possession of Ignaz van Houtem in Aachen; purchased in 1849 by the Städelsches Kunstinstitut. (According to Sander 1993). There is no credible foundation for Châtelet's assumption that the panels originally came from the Abbey of Phalempin near Lille. As Kemperdick, p. 21 s, has shown, the panels in fact probably came from a church in Louvain. Kemperdick has persuasively demonstrated that the portrayal of the Mater Dolorosa on the verso of the panel depicting *Maria lactans* is the work of Josse van der Baren who was active in Louvain around 1600.

Literature: M: Tschudi, pp. 13-17; Winkler, pp. 35 s, 43 s; Friedländer, vol. 2, No. 60; Tolnay, No. 10; Panofsky, p. 169 et passim; Frinta, pp. 46-50; Davies, Campin/Frankfurt 2; Asperen de Boer et al., F1-3; Châtelet, Cat. 4; Kemperdick, pp. 12-28.
S: Passavant 1858; Sterling 1972, pp. 24-27; Dhanens 1984; Klein 1996; °Sander 1993.

I.19 Saint Gudule → Fig. 173

Black-brown ink (pen) on paper; 19.0 x 11.0 cm
Rotterdam, Museum Boymans-van Beuningen; Inv. No. 77

Attribution: Lees 1913 ascribes this drawing to the school of Rogier van der Weyden, Wescher 1938 attributes it to Rogier's follower Vrancke van der Stockt. Sonkes 1969 correctly excludes it from the pseudo-Vrancke van der Stockt group. Sonkes' critique of the quality of this drawing (*"Les traits de visage manquent de finesse ..."*), that leads her to describe it as a student work, is not entirely convincing, as it does not take into account the drawing's primary function as a study of drapery. An attribution to Campin is suggested above all by the technique of shading (parallel and cross hatching in the garment, marking of the floor area), which are to be found in precisely the same manner in the drawing of the *Bearing of the Body to the Sepulchre* (I.10) and in the underdrawings of some of his paintings. (See above all the underdrawings of the central panel and the right wing of the Mérode Altarpiece; cf. Asperen de Boer et al., ills. 95, 103). It is also interesting to compare the drawing with the portrayal of the same saint as we find it on the Marian Cope of the Ecclesiastical Paraments in Vienna (I.23 c; figs. 172 s). Although the saint is wearing an entirely different garment, the face is of the same type and the pose of the right hand carrying the lamp is the same.

Dating: Circa 1430. The folds of the drapery are closely related to those of the Salting Madonna (I.13) and the *Veronica* panel (I.18c).

Commentary: The proportions of the drawing lead us to believe that it served as a design for a relatively broad wing panel of an altarpiece. We may discount the possibility suggested by Kemperdinck that the panel in question had formed part of the same ensemble as the Flémalle Panels.

Provenance: Collection of M. van Parijs, Brussels; sold in Amsterdam, 11.1.1878; collection of E. Wauters, Brussels; sold at Mensing, Amsterdam, 15./16.6.1926; purchased by F. Koenigs (according to Sonkes 1969).

Literature: M: Kemperdick, p. 16s.
S: Lees 1913, pp. 61, 183; Wescher 1938, p. 4; °Sonkes 1969, Cat. D25; °Thürlemann 1993b, p. 39s.

I.20C Saint Anne, the Madonna and the Christ Child (Copy)

Wood (oak); 182.5 x 139.5 cm
Osnabrück, Diözesanmuseum (not on exhibition)

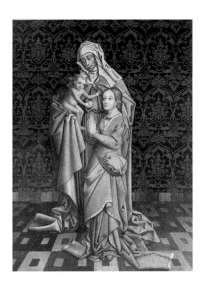

Condition: The exterior of one wing of an altarpiece has been split apart from the interior bearing a portrayal of the Holy Family, which is kept at the same location. The exterior, in particular, has been heavily overpainted.

Attribution: Copy: Koch 1910 attributes it to the Westphalian Master of 1473, so named after the Saint Anne altarpiece in the Wiesenkirche in Soest bearing this date. This attribution has since been widely accepted.

Original: The proximity of a number of individual works by this painter to the works of the Master of Flémalle has been noted frequently by art historians, especially by Heise 1918 and Stange 1954. (Though the *Madonna in Half Length* attributed by Stange 1954, p. 25, to the Master of 1473 is compositionally too weak to be a faithful copy after Campin.) The grisaille of *Saint Anne, the Madonna and the Christ Child*, as far as we are aware, has not hitherto been classified as a copy after Robert Campin. Although the overall effect of the work has been distorted by what Stange 1954 describes as "Falstaffian" overpainting, we feel that the remarkably inventive drapery, the compact, sculptural treatment of the overall form and the striking face of Saint Anne justify attributing the original on which this is based to Robert Campin.

Dating: Copy: 1484 (date on inner wing). *Original:* The lost original must have been a mature work by Campin created around 1430.

Commentary: The presence of Christ suggests that the model was not – as proposed by Stange 1967 – the outside of a right-hand panel, but of the left-hand panel of a triptych. The composition is both persuasive in its design and original in it iconography. The figure of Saint Anne, a matronly figure not unlike that of Saint Veronica in the Flémalle Panels (I.18c), is holding the Christ Child on her right arm and has placed her left hand on the shoulder of the young Virgin Mary who is standing before her. Mary, her hands folded, is gazing upwards at the Infant who is holding a fruit towards her. Exactly the same iconographic type can be found in southern German rococo sculpture, for example in the work of J. W. Jorhan (circa 1732/34) and J. A. Feuchtmayer (1750); (ill. 2, plate 14 and ill. 12 in Reinle/Schürer-von Witz-

leben 1967). The group of *Saint Anne, the Madonna and the Christ Child* in the portrayal of the Holy Family on the inside of the panel corresponds to a traditional schema in which these three figures are staggered according to the sequence of generations. Yet the artist has adapted the face of Saint Anne to that in the group based on Campin.

It may be assumed that Campin's original was not a grisaille, but a coloured group set in front of a brocade drape in the manner of the Flémalle Panels (I.18b, I.18c).

Provenance: Unknown.

Literature: S: Koch 1910, p. 816; Heise 1918, p. 36s, p. 139, n. 14; Busch 1940, p. 107; Stange 1954, pp. 22-26; Stange 1967, Cat. no. 515; Reinle/Schürer-von Witzleben 1967.

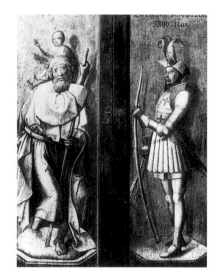

I.21C Saint Christopher (Copy)

Wood (oak); 92 x 37 cm
Messina, Museo Nazionale, Inv. No. 549

Inscriptions: On the pendant (right wing): *SANCTE SEBASTIANE / ANNO 1503.*

Attribution: The triptych on whose left wing (outside) the figure of Saint Christopher is portrayed in grisaille is associated by Ragghianti 1958 and Consoli 1980 with Jacob von Oostsanen. This attribution is called into question by Collobi Ragghianti 1990. The figure of Saint Christopher, which is stylistically quite distinct from all the other figures, especially from the Saint Sebastian opposite, has not previously been recognised as a copy after Campin.

Dating: Original: Circa 1430. The drapery style is indicative of a work dating from Campin's mature period.

Copy: The date "1503" on the outside of the right-hand wing may be regarded as authentic. It is problematic only if we ascribe the triptych to Jacob von Oostsanen, who was not admitted to the Amsterdam Guild of St Luke until 1507. Jacob von Oostsanen portrayed the figure of Saint Christopher twice in his œuvre, but in a different form. (See Friedländer vol. 12, No. 239, 247.)

Commentary: The original on which this work is based, one of the most arresting portrayals of Saint Christopher in early Netherlandish painting, was undoubtedly a grisaille work simulating a sculpture. The base corresponds to that of the *Trinity of the Broken Body* on the Flémalle Panel. It may be assumed that the niche in the original also had a similar form.

Provenance: The triptych was originally part of the collection of the Museo Civico in Messina.

Literature: S: Ragghianti 1958, p. 38; Consoli 1980, p. 21; Collobi Ragghianti 1990, No. 319.

I.22C Series of five wise men and ten sibyls (Copies) → Figs. 130-132, 137, 141-142, 144, 148

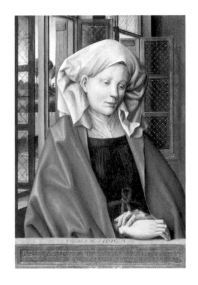

Wood (oak); 8 surviving panels, each originally measuring 44 (+1) x 30.5 (+1) cm (some now cropped at lower edge)

Münster, Landesmuseum for Kunst and Kulturgeschichte: Virgil, Milesius, The Samian Sibyl, The Cimmerian Sibyl, The Cumaean Sibyl, The Phrygian Sibyl, The Libyan Sibyl; Paris, Musée du Louvre: The Delphic Sibyl

Inscriptions: All the panels bear or originally bore on the front of the painted parapet a two-line Latin text with the name in perspectival foreshortening on the upper edge. The texts are reproduced in Cat. Münster 1996. For a detailed description of the sayings traditionally associated with the sibyls, see Vöge 1950, pp. 161-170.

Condition: Only eight of originally fifteen panels have been found to date. Three of them have been cropped to remove all or part of the parapet with the inscription.

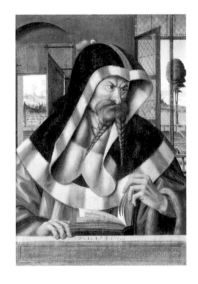

Attribution: Copies: The Paris panel was attributed by Demonts 1922 to the artist Ludger tom Ring the Elder (1496–1547) who was active in Münster, Westphalia. Geisberg 1927 adopted the same attribution for the Samian Sibyl in the Landesmuseum Münster. On the other hand, Geisberg 1930 did not regard the panels then recently acquired for the same museum (portraying the Cumaean and the Cimmerian Sibyls) as the work of the same artist and ascribed them to Ludger tom Ring the Younger. Today, Ludger the Elder is regarded as the author of all eight panels (Riewerts/Pieper 1955; Cat. Münster 1996).

Lost Originals: Demonts 1922 found the archaic traits of the Delphic Sibyl reminiscent of the Master of Flémalle, but also of Konrad Witz and most especially of Geertgen to Sint Jans. It was Geisberg 1927 who was the first to recognise – on the basis of still older woodcut and copperplate reproductions, some of which showed the same figures – that the panels painted by Ludger tom Ring the Elder were copies of early fifteenth century works. The moulding of the fireplace in the panel showing the Delphic Sibyl reminded him of works by the Master of Schöppingen and, in turn, by the Master of Flémalle. Yet in 1930 the same author put forward a rather unconvincing case for Konrad Witz as the painter of the original version. Vöge 1950 dismissed the attribution of the original series to the Master of Flémalle, considering the Sibylla Agrippa (II.7) to be an original by that very master. He proposed Strasbourg or the Netherlands as the place of origin, particularly Liège. Winkler criticised Vöge's dismissal of the possibility that the Master of Flémalle had painted the original version. Pieper 1960 thought the author was to be found "in the circle of Westphalian early realism", but admitted that there was also a possibility of a Netherlandish origin of the original series in the circle around the Master of Flémalle. By 1976 Pieper considered only the latter possibility. Clark 1978, p. 70ss, attributes the original series to Campin himself or to a painter strongly influenced by him. He also ponders the possibility that the author may have been Master Francke, or that this artist had copied a series by Campin. Rensing 1967, p. 337, noted that there is no connection between the series of pagan wise men and sibyls and the altar-piece by Master Francke mentioned directly before in a number of texts on the iconoclasm. Many aspects of the physiognomies, costumes and settings in the panels by Ludger tom Ring the Elder are typical of Campin and still extraordinarily tangible. (Note, for example, the

borders woven with gold thread, similar to those seen in the figure of one of the midwives in the *Nativity* (I.6) and in the figure of the Roman centurion in the *Thief on the Cross* (I.16).) The drapery, too – note for example the turban of the Cumana and the headdress of the Lybica – betrays the hand of Campin, even in the sixteenth century copy. The coloured decorative frame of the lozenge-glazed windows can also be found in this form in the Mérode Triptych (I.12), but not in works by the school of Campin. (On the other hand, the moulding of the fireplace, as seen in the panel of the Delphica, is to be found in the works of all Campin's students.) The most persuasive argument for ascribing the original series to Campin, however, is provided by a copy of the Tiburtine Sibyl drawn around 1460/70 by an artist in the circle around Hans Pleydenwurff (fig. 139) which precisely renders a facial type characteristic of Campin (cf. the face of the Virgin in the Louvain Altarpiece, fig. 103, det. p. 124).

Dating: The *Copies* by Ludger tom Ring the Elder are not dated. Geisberg 1937, p. 344, deduces from the form of the frame of the inscriptions, which can be traced back to Dürer's portrait engravings, a terminus post quem of 1523 for the copies. In the meantime, dendrochronological analysis of the Sibylla Delphica has shown that the wood could not have been felled before 1532 (See Cat. Münster 1996, p. 21). If we allow a few years for the wood to season, this means that the copies by Ludger tom Ring the Elder could not have been created until after the Anabaptist iconoclasm of 1534 and that it was not these works, but the lost originals themselves, that were damaged.

The *Lost Originals* are widely accepted as dating from the first half of the fifteenth century, on the basis of the costumes and furniture portrayed. Vöge 1950 dates the original series to the second third of the fifteenth century. Geisberg 1937 dates them "sometime around 1440", Pieper 1960 "about 1450". Clark 1978, p. 69, considers that they were created in the 30s. In our opinion the original series was created by Campin around 1435 and at about the same time as he produced the designs for the Burgundian Vestments. One indicator for the dating is the rather complicated headdress worn by the Delphica with its many layers of fabric. It can be found in similar form in the Tiefenbronn Altarpiece by Lukas Moser, dated 1432, and is also worn by the figure of the female donor in the *Madonna with Violets* by Stephan Lochner, created before 1443. (Reference in Cat. München 1972, p. 500, n. 12).

Further Copies: The original series must have been famous. It was reproduced in two series of prints in the early days of printing. Six coloured woodcuts of the highest quality, which formerly bore the inscriptions of the originals, from the Stiftsbibliothek St. Gallen and now in the Kupferstichkabinett Basel portray three sibyls and three pagan wise men. (Clark 1978, p. 11, assumes that there were two woodcut copies, one captioned and one uncaptioned, but this seems unlikely). The origin of the prints is unknown. Schreiber 1903, p. 11, believes they came from Alsace; according to Winkler (discussed by Pieper 1960, p. 296) they were created in the Netherlands, a theory also presented in Cat. Basel 1995. The precise date at which they were produced is also unknown. (Schreiber 1927: "not before 1465"; Geisberg 1927: "around 1465"; Geisberg 1937 and Vöge 1950: "circa 1450" (which would have been impossible, as the surviving fragment of one of the captions is typeset). The copperplate series by the Master of the Banderoles, active in the eastern Netherlands, was created before 1461. (On the dating see Lehrs 1898, p. 37s; contradicted by Schreiber 1927; affirmed by Geisberg 1930, p. 133s;

finally Clark 1978, p. 12 and n. 42). Five of the engravings from this series have survived. The Master of the Banderoles has re-used the heads of some of the sibyls and wise men, rather in the manner of a collage, for his engraving of the *Holy Family* created around 1470 (Lehrs 1921, No. 48; here fig. 149). In contrast to earlier art historians since Lehrs 1889, both series of prints were created independently; but even the copies by Ludger tom Ring the Elder in contrast to the view expressed by Riewerts/Pieper 1955, p. 15, were also made directly from the originals. Pieper 1960 shares this view. On the other hand, as Vöge 1950 proves, Jörg Syrlin the Elder based his ten sibyls and wise men, produced in 1469–1474 in the form of wooden sculptures for the choirstalls of the cathedral of Ulm, on the captioned woodcut copies.

A drawing of a sibyl (probably the Tiburtine Sibyl), not included in either of the two printed cycles, by an artist in the circle of Hans Pleydenwurff, is of particular importance. (See Rainer Schoch in Cat. Nuremberg 1983, p. 168). This drawing gives some impression of the sibyl by Campin on which Rogier van der Weyden based his figure of Mary Magdalene in the Braque triptych and which also served independently as a model for Jörg Syrlin the Elder's rendering of the Delphic Sibyl in the choirstalls of Ulm Cathedral. (Gropp 1999 erroneously interprets the drawing as a link between Rogier van der Weyden and Jörg Syrlin.)

The enlarged secondary copies, enriched by the addition of numerous supplementary attributes, which Hermann tom Ring produced in 1572/73 after the copies by his father, provide some extremely useful indications for reconstructing the scope and alignment of the original series. With the exception of one picture, this series by Hermann tom Ring, in possession of the Bayerische Staatsgemäldesammlungen (currently on loan to the Domkammer Münster), is complete. (See Geisberg 1937, pp. 345-348, with notes on dating; Riewerts/Pieper 1955, No. 63-76; Cat. München 1972, pp. 483-500. See also Clark 1978, p. 81, n. 53, with an important correction in the order of the pagan wise men). Given that the format of the stone frames in the ambulatory of Münster Cathedral, where the paintings of the sibyls by Melchior Steinhoff were finally hung, corresponded precisely to the format of these panels (78 x 54 cm), they were undoubtedly intended for the cathedral, where they probably replaced the smaller panels made by his father for the same place. This assumption is based on the premise that the chancel screens between the high choir and the ambulatory were either replaced or had their frames enlarged before 1572. (The statement by Jászai 1991, p. 98, to the effect that the chancel screens had been completed by 1542/47 and that they are *"noch heute vorhanden"* – still there today – cannot be correct, as the turn-of-the-century photograph fig. 126 shows. However, the fifteenth century dating given by Clark 1978, p. 3, on the basis of stylistic elements characteristic of the late fourteenth and early fifteenth century appears questionable.) The six sibyls painted by Melchior Steinhoff shortly before his death are dated 1602 and 1604. These works, which hung in two niches of the ambulatory until the second world war, are now kept in the *Domkammer* (cathedral treasury). (See ills. 1582–1587 in Geisberg 1937). The captions on Campin's originals are transcribed in full in a Munich manuscript from Augsburg Cathedral (Cod. lat. Monac. 3709, fols. 220-223). (See Vöge 1950, p. 161 ss, and Clark 1978, p. 270, n. 62.)

Commentary: See pp. 141-154.

Provenance: See Cat. Münster 1996, No. 7-13, and Riewerts/Pieper 1955, No. 11, p. 65 ("Delphica").

Literature: S: Lehrs 1889, p. 353; Lehrs 1898, p. 37 s; Schreiber 1903, p. 11 s; Fäh 1906, p. 12, pl. 24-29; Lehrs 1921, pp. 108-112 (Nos. 77-79), pp. 77-79 (No. 48); Demonts 1922; Schreiber 1927, p. 221 (No. 1774a-f); Geisberg 1927; Geisberg 1930; Geisberg 1937, pp. 342-350; °Vöge 1950, pp. 132-168; °Riewerts/Pieper 1955, p. 15 s, pp. 62-65 (Nos. 6-11), pp. 91-95 (Nos. 63-76); Winkler 1959, p. 62, n.16; Pieper 1960; Rensing 1967; °Cat. München 1972, pp. 483-500; Pieper 1976; °Clark 1978; Cat. Nuremberg 1983, p. 168; Jászai 1991, Nos. 59-72; Cat. Basel 1995, Nos. 12-17; °Cat Münster 1996, Nos. 4-11, 55-68; Gropp 1999, p. 161 s.

I.23 Ecclesiastical Paraments of the Order of the Golden Fleece (cartoons)
I.23a Central image of the altar dossal: Trinity of the Broken Body → Figs. 157, 162
I.23b Cope of Christ → Fig. 164 and det. (167)
I.23c Cope of Mary → Fig. 163 and det. (166, 172, 175, pp. 166-167, 170)
I.23d Cope of Saint John → Fig. 165 and det. (168, pp. 165, 168-169)

Gold, silver and silk embroidery, pearls, glass beads and velvet appliqué on linen; central image of the altar dossal: 112 x 64 cm, surplices (copes): circa 165 cm radius
Vienna, Kunsthistorisches Museum, Weltliche Schatzkammer, Inv. No.: Pl 18, 19-21

Condition: Generally good. Most damage involves the loss of individual pearls and stones.

Attribution: In his groundbreaking monographic study, Schlosser 1912 attributed the cartoons for the individual textiles that constitute the ecclesiastical paraments (two altar hangings, three surplices or copes, two dalmatics and one chasuble) to three different authors, representing three different stages of stylistic development. (Earlier attributions are discussed by Schlosser 1912, p. 11.) The earliest of these stylistic stages, according to Schlosser, is represented by the altar hangings, whose author, he claims, represents a "more progressive style than Beauneveau", though still in the international gothic style. He regards the vestments, with the exception of the chasuble, as stylistically closely related to the work of the Master of Flémalle, whom Hulin de Loo had identified shortly beforehand as Robert Campin, and his student Rogier van der Weyden. The figures in the two Epiphany scenes on the chasuble (*Baptism* and *Transfiguration*) belong to the third stylistic phase (p. 12): *"Hier war ein Künstler tätig, der etwas Derbes and Klotziges hat ... und der möglicherweise schon der Zeit and Richtung des Hugo van der Goes angehört."* (Here an artist was at work who had something rough and unrefined ... and who may be a contemporary of Hugo van der Goes.) His theories regarding the division of labour are, in our opinion, largely correct. However, a clear distinction can be made between the three surplices (copes), whose figures reflect the style of Campin, and the dalmatics, whose figural style is more rigid and monotonous. It is also striking that, wherever individual figures are overlapped by the border trims and divided in two, the artist who designed the dalmatics has copied these figures from the surplices (copes). (In contrast to the opinion voiced by Schlosser, 1912, p. 8, this fragmentation of the figures was in fact intended right from the start, as indicated by technical analyses presented by Trnek 1987

and Bauer 1989.) Schlosser's attribution of the individual parts to three stylistic stages must, however, be amended in one respect: the design for the central picture of the altar dossal featuring the *Trinity of the Broken Body* does not belong to the first stylistic stage, but is the work of Robert Campin. Troescher 1940 posits that, for the central image of the altar dossal, the Master of the Vienna Altarcloths did not follow the cartoons by Beauneveau as closely as he did in his renderings of the prophets and apostles. However, this cannot go unchallenged. There is in fact a radical stylistic difference between the central image and the figures of the apostles and prophets. Châtelet 1994 also attributes all parts of the two antependia to the same cartonnier. He maintains that the *"apparente supériorité"* of the *Holy Trinity* is due (p. 326, n. 8) to an *"interprétation directe d'une composition du Maître de Flémalle"*. In the same essay, the designer is identified, without sufficient supporting evidence, as Hue de Boulogne, who was responsible for all the decorative work in connection with the Chapters of the Order of the Golden Fleece between 1432 and 1451. We are of the opinion that there is no stylistic connection between the earlier parts of the altarcloths and the wings of the altarpiece attributed by the author to Hue de Boulogne in the church of Saint Roch in Ternant (ill. 5 and 6 in Châtelet 1994). According to Châtelet 1989, p. 297 s, the designs for the vestments of the Ecclesiastical Paraments were the work of two court painters to Charles the Bold, Pierre Coustain and Jean Hennecart, who are documented as painting a number of new standards for the Burgundian troops between 1472 and 1474. According to Châtelet, the hand of Coustain is evident in the *Transfiguration* scene on the chasuble and Hennecart was responsible for the greater part of the Marian cope. The figural style of the banners in the Burgundian treasure (illustrated in Deuchler 1963) has little in common, however, with the vestments of the Ecclesiastical Paraments. According to Pächt 1989 on the other hand, the Marian cope "is drawn in the style of the Flémalle artist, if not indeed by his own hand." Christian de Mérindol in Cockshaw/Van den Bergen-Pantens 1996, p. 236, attributes the earlier parts of the Ecclesiastical Paraments to the young Barthélemy van Eyck. Dahnens 1998, pp. 147 and 311, considers that the antependium and the copes were produced by a Ghent workshop for the chapter of the order in 1445.

Dating: Circa 1435 (after 1433, before 1442). Commentary: The year Jahr 1432 can be taken as *terminus post quem*. Two factors support this dating: the three copes (I.23 b-c) can be seen together as textile variations of the Holy Day side of the Ghent altarpiece, completed in 1432. (As proposed by Einem 1968, p. 31). In particular, the portrayal of the Deësis group on the backs of the copes would appear to echo the three central panels of the upper row of the altarpiece itself. Schlosser 1912, p. 17, has also drawn attention to a receipt of payment dated in 1432/33 among the *Recettes générales* of the Duke of Burgundy (cited in Laborde 1849, p. 277). According to this document, Philipp the Good had purchased two apparently already completed *tables d'autel très richement estoffées* with the appurtenant parament items (stola, maniples, albs and amicts) for the princely sum of 3750 livres from the embroiderer Thierry du Chastel, whom he had called from Paris to his court before 1424/25. We assume that the antependia in question were indeed the basis for the full set of the Ecclesiastical Parament in question, and that the central image of the altar dossal, whose design we ascribe to Campin, was created anew at a later date. Two reasons may have been responsible for the replacement of the central image: the dedication of the altar for which the altar hangings were purchased may have been different, and/or it may have been decided to rework the ensemble

along the lines of the Ghent Altarpiece with its iconographical programme of the *Adoration of the Trinity*. The figure of the Dead Christ in the *Trinity of the Broken Body* would thus correspond to the Lamb of God. It may be assumed that the two altar hangings had alread been created at the request of a member of the French aristocracy – most probably the Duc du Berry († 1416) – for, as Mérindol 1988 showed, Saint John and Saint Catherine, who flank the Virgin Mary in the central image of the altar dossal, were worshipped especially by the House of Valois.

A further document recently discovered by F. Francq-de Gruben (cited in Châtelet 1994, p. 322), dated 1442, apparently refers to the payment for the three completed surplices (copes): *paiment de trois chappes d'église achetées pour mondit seigneur et par luy baille audit Thierry*. According to this document the items were received by Guy Guilbaut, then Treasurer of the Order of the Golden Fleece (*confesse avoir receue pour mettre avec les aultres ornemens de la thoison d'or.*) This confirms that, contrary to earlier assumptions, the robes were indeed produced for the Order. It should also be noted that the three surplices (copes), which we regard as a single work on stylistic grounds and which we associate with Campin, are mentioned together as a group. The role played by Thierry du Chastel is not clear from the document. The conclusion drawn by Châtelet 1994, p. 322, according to which the Duke's embroiderer merely brokered the work rather than producing it in his own workshop, does not seem convincing to me. This recently discovered document establishes the year 1442 as *terminus ante quem* for Campin's designs. As embroidery is an extremely laborious process, Campin must have drawn up his designs much earlier, at some time closer to a *terminus ante quem non* of 1432.

Eisler 1967 proposes that the greater part of the figures dates from no earlier than the mid fifteenth century, but that the overall framework was created later, no earlier than the last quarter of the fifteenth century. This cannot be correct, as technical studies (see Trnek 1987 and Bauer 1989) have shown that the figures and the framework were created at the same time. Eisler's assertion that the prismatic framework of the robes does not fit stylistically in the first half of the fifteenth century, bears little weight, as there seem to be no further examples of this kind of honeycomb patterning that would permit comparison.

Copies: The figures of the saints on the two dalmatics echo, albeit in a slightly more slender and rather drier style, the figures already found on the surplices (copes). The group of figures forming the *Trinity of the Broken Body* in the central image of the altar dossal is repeated precisely in the Book of Hours of the Renssen family in a different spatial context. (Illustrated in Gorissen 1973, p. 983). Copies are also to be found in two French Books of Hours produced around 1450, now in the Walters Art Gallery. See Randall 1992, Cat. No. 123 (Walters 257, fol. 204 [fig. 85, p. 112 in Wieck 1988] with a reference to a closely related miniature in Walters 230, fol. 124). The same group of figures or a design for them was also the basis for the portrayal of the *Trinity of the Broken Body* in a triptych created by the Master of the Louvain Trinity for the Church of Saint Peter in Louvain around 1440 (III.F.1).

Commentary: See pp. 155-172.

Provenance: The embroideries are described in detail for the first time in 1477, after the death of Charles the Bold, in the inventory of the Order of the Golden Fleece. Until the end of the

eighteenth century they were normally kept in the court chapel in Brussels. They were brought to Vienna before October 1797 (Treaty of Campo Formio), entered the former Ambraser collection in 1875 and in 1889 were housed in the Kunsthistorisches Hofmuseum. Today they are kept in the Weltliche Schatzkammer there.

Literature: M: Friedländer, vol. 2, plate 99 C.

S: Laborde 1849, p. 277; °Schlosser 1912; Troescher 1940, pp. 54-62; Cat. Wien 1956, No. 143; Deuchler 1963; °Schuette/Müller-Christensen 1963, Nos. 234-268; Eisler 1967; Einem 1968; Gorissen 1973, p. 982; Smith 1979, pp. 164-170; °Trnek 1987, pp. 208-223; Mérindol 1988; Wieck 1988; Bauer 1989, pp. 17-23; Châtelet 1989; Pächt 1989, p. 33; Randall 1992; Châtelet 1994; Cockshaw/Van den Bergen-Pantens 1996; Dhanens 1998.

II. MISATTRIBUTED WORKS

The following is a list of works conventionally assigned to Robert Campin or the Master of Flémalle, but which cannot be associated either with Campin himself nor with any of his students.

II.1 The Annunciation

Fresco, circa 170 x 200 cm
Tournai, Musée d'Histoire et d'Archéologie (formerly Tournai, Saint-Brice)

In 1940 wartime damage uncovered the remains of a fresco showing the *Annunciation* in the straight eastern end of the chancel of the church of Saint Brice in Tournai. Paul Rolland (Rolland 1942 and 1946) ascribed this qualitatively very modest work indeed to the young Robert Campin on grounds of an entry dated 1407 in the records of the parish of Saint Brice. The entry in question (see doc. 3) does not actually specify that Campin painted a mural for the new chancel wall, but only mentions renovation and painting work on the figure of Mary and the Marian altar that had been moved to the new chancel. The fresco probably served, as Kemperdick surmised, as an altarpiece for the Marian altar, but the actual wording of the document of 1407 speaks against Campin's authorship. The fresco is in fact a rather weak variation of a composition that has survived in considerably more sophisticated form in an embroidered altar hanging in Lille (Châtelet Cat. 1a; ill., p. 50; Lavallée 1997, ill. 7. Cf. also the altar hanging based on the same design in the Hotel-Dieu in Beaune; ill. 6 in Lavallée 1997). The underdrawings for two angels, no longer extant, also discovered in 1940 on the wall above the *Annunciation*, though of somewhat higher quality than the *Annunciation*, are by the hand of another painter, but again not by Campin. Kemperdick dates them to the sixteenth century. The paintings traditionally ascribed to Campin do not feature the wing form found in one of the angels (ill. 10 in Rolland 1946 and ill. in Châtelet, p. 49 lower right). A surprisingly positive evaluation of the *Annunciation* scene and the busts of angels, all ascribed to Campin, is given by Leclerq-Marx 1992, p. 233 s.

Literature: M: Panofsky, p. 159; Châtelet, Cat. 1; Kemperdick, p. 156 s.
S: Rolland 1942; Rolland 1946; Leclerq-Marx 1992; Lavallée 1997.

II.2 Annunciation Group (polychromy)

White stone, polychromed
Tournai, Cathedral (formerly the church of Saint Mary Magdalene)

The Annunciation Group from the Church of Saint Mary Magdalene was linked at an early stage to Rogier van der Weyden, either as designer or as author, on grounds of some vague stylistic analogies (De la Grange/Cloquet 1887/88, Maeterlinck 1900). Châtelet, p. 189, also notes a close connection between the figure of Gabriel and the Angel of the Annunciation in

the Paris version of the *Annunciation* (III.B.11a). In 1932 Paul Rolland (Rolland 1932b) proposed the thesis, on the basis of two documents first published by him, that the sculptures were identical with group of statues created by Jean Delemer and polychromed by Robert Campin, which were donated to the Church of Saint Pierre in 1426 by Angès Piétarde, the widow of Jehan du Bos and placed on either side of the entrance to the chancel in 1428. (See Doc. 50 and De la Grange 1897, No. 627 and No. 1131 on two comparable donations in the years 1423 and 1483 for the Franciscan church and the church of Saint Mary Margaret in Tournai.) Rolland 1932b is unable to provide supporting evidence for his assumption that the statuary was transferred before 1586 from the Church of Saint Pierre to the Church of Saint Mary Magdalene. (The very fact that the group was linked to a tomb would make such a transfer unlikely.) The identification of the coats of arms which were later painted over is also uncertain. Moreover, the height of the two figures (1 m 70) does not correspond to the dimensions specified in the testament (*iiij pies*). Stylistically the Annunciation group indicates a late fifteenth century dating. The group was restored in 1858 and repainted (see appendix No. 3 in Rolland 1932b). Contrary to the assumption by Rolland, there is no indication that the faces described as *légèrement renaissantes* (Rolland 1932b, p. 338) had been subsequently reworked.

Literature: M: Panofsky, pp. 162, 254, 291 (n. 4); Châtelet, p. 189.
S: De la Grange/Cloquet 1887/88, p. 190; De la Grange 1897; Maeterlinck 1900, p. 105; Rolland 1932b.

II.3 The Crucifixion

Wood (oak); 77 x 47 cm
Berlin, Staatliche Museen, Gemäldegalerie; Inv. No. 538 A

Inscription: From the mouth of the Virgin in raised gold letters: *O fili dignare me attrahere Et crucis i[n] pedem m[anus] figere. bernhardus.* On the source of the text, see Panofsky, p. 267 (n. 3).

Condition: The sky and the upper half of the landscape have been painted over what was originally a gold ground, but whether this was done by the same artist or not remains unclear. Originally the upper part of the panel showed an aureol in the same rainbow colours as the angels.

Attribution: Passavant 1853 attributes the panel to Rogier van der Weyden the Younger, Tschudi to the Master of Flémalle. Winkler, Friedländer and Tolnay regard it as a very late work by Campin or the Master of Flémalle. Panofsky and Davies dismiss its attribution to either Campin or Rogier van der Weyden. Davies does not agree with Panofsky's association of this work with the Riggisberg Triptych (III.B.15). According to Asperen de Boer et al. the underdrawing has no connection with the Flémalle group. Châtelet on the other hand regards the panel as a work by Campin and dates it very early, to around 1432–34. Kemperdick ascribes the Crucifixion to a painter from the circle around Rogier van der Weyden,

who created the Werl Altarpiece wing showing *Saint Barbara* (III.B.4b). De Vos 1999 regards it as an early work by Rogier van der Weyden.

Dating: Around 1450. Terminus post quem (dendrochronology according to Klein 1996): 1413 / circa 1419 + min. 2 + x. Kemperdick dates the panel to the first half of the fifteenth century. For earlier proposed dating, see *Attribution*.

Commentary: The composition is rather clumsy, though painstakingly undertaken, with some remarkable coloristic effects. Many details (such as the rock on the lower left and the S-form text alignment similar to that of the central panel in Rogier's Saint John Altarpiece) indicate that this is the work of a student of Rogier van der Weyden. However, the artist followed the example of his teacher only for the three lower figures, looking instead to the work of Campin for the two standing figures and the figure of Christ himself. In our opinion, the crucifix of the Intercession fragment (III.G.3) and the design for a triptych of St Eligius (de Vos 1999, Cat. No. B19) could well be by the same painter. All three works portray the figure of Christ in near mirror symmetry.

Provenance: 1853 in the possession of Vicente Peleguer, Madrid. Auctioned in Paris, probably on 9 or 10 December 1867. Purchased 1892 by the Berlin Museum at an auction of the Anatole-Auguste Hulot collection in 1892. (According to Davies).

Literature: M: Tschudi, pp. 92-95; Winkler, p. 38s; Friedländer, vol. 2, No. 68; Tolnay, No. 15; Panofsky, pp. 174 (n. 4), 176, 267 (n. 3), 298s, 302; Frinta, p. 114, n. 3; Davies, Campin/Berlin 4; Asperen de Boer et al., W23; Châtelet, Cat. 16; Kemperdick, p. 146s.
S: Passavant 1853, p. 13; °De Vos 1999, Cat. No. 2.

II.4 The Death of the Virgin

Wood (oak); 39.4 x 35.6 cm
London, National Gallery, Inv. No. 658

Condition: The panel originally had rounded upper corners like the Berlin version (see *Further Copies*). X-radiography has shown that, like both the Berlin and Prague versions, there was a baldachin over the group of apostles. This was changed in the course of the painterly process to a background window aperture that fits in with the setting. The group of God the Father and angels was not originally envisaged, either. (Davies 1953 and Dunkerton 1983).

Attribution: This work was first ascribed by Bode 1887, then by Tschudi, to the Master of Flémalle. Winkler and Friedländer regard it as a freely interpreted copy after a composition by Hugo van der Goes (see *Further Copies*). Panofsky, Davies and Campbell 1998 see in the London version elements of both Campin and Hugo van der Goes. Campbell 1998 surmises that the London version was created in the border area between Germany and the northern Netherlands, possibly in the county of Geldern.

Dating: Circa 1500. Terminus post quem (dendrochronology according to Klein 1996): 1468/circa 1474 + min. 2 + x. Dendrochronological dating excludes the possibility of an attribution to Campin. Campbell 1988, p. 252, dates the panel to around 1515–1520 on grounds of the costumes of the figures in the window view.

[1]

Further Copies: The Staatliche Museen in Berlin and the Prague National Gallery each possess a version of this composition (Friedländer vol. 4, No. 25a, fig. [1], 25b), in which the heads of the apostles correspond broadly to those in the Bruges *Death of the Virgin* by Hugo van der Goes (Friedländer vol. 4, No. 14). The relationship between these two paintings and the London version has generally been explained in two different ways (cf. summary of the discussion in Vacková/Comblen-Sonkes 1985): Winkler and Friedländer, for example, assume that the work in London is a freely interpreted copy after a composition by Hugo van der Goes, which is more faithfully rendered in the other two versions. This view is also shared by Châtelet and Campbell 1998. Tschudi and other authors, on the other hand, assume that the London version is an original by Campin or a copy after a composition by Campin and that the heads of the original have been replaced in the Berlin version (fig. [1]) and in the Prague version by heads after the Bruges panel by Hugo. Dhanens 1998 makes no distinction between the three panels, all of which she regards as works by Ghent painters, possibly influenced by an earlier and no longer extant *Death of the Virgin* by Hugo van der Goes.

Commentary: In our opinion, the London panel, in which the figural composition of the original work is faithfully rendered, is not based on a work by Campin, but on a composition by Hubert van Eyck. The heavy drapery and grim facial traits of the apostles recall those in the Ghent *Adoration of the Lamb*. (Compare the angle of the bare feet there, which is reiterated in the second kneeling apostle from the left in the *Death of the Virgin*.) In the Berlin version (fig. [1]) and the Prague version, in the quest for the "perfect image", the faces of the apostles have been replaced by those in Hugo van der Goes' *Death of the Virgin*. (Cf. pp. 213-215, Commentary on I.14/C).

Provenance: In the collection of an unidentified "C^te R"; Sir Thomas Lawrence auction 1830; Michael Mucklow Zachary auction 1838; 1842 via Fuller and Nieuwenhuys to King William II of Holland; King William II of Holland auction 1850; 1857 via Nieuwenhuys to Edmond Beaucousin; purchased in 1860 from the collection of Edmond Beaucousin, Paris, for the National Gallery London. (According to Davies and Campbell 1998).

Literature: M: Tschudi, pp. 27-31; Winkler, p. 14s; Friedländer, vol. 2, nr. 77; Tolnay, copies No. 2; Panofsky, p. 175s; Davies, Campin/London 4; Asperen de Boer et al., F14; Châtelet, Cat. AR3.
S: Bode 1887, Davies 1953, Winkler 1964, Dunkerton 1983, Vacková/Comblen-Sonkes 1985, No. 35; °Campbell 1998, pp. 248-253; Dhanens 1998, p. 341 s.

II.5 The Slaying of Sisera by Jael → Fig. 201

Pen, grey and red watercolour on paper; 13.6 x 10.0 cm
Brunswick, Herzog Anton Ulrich-Museum, Kupferstichkabinett; Inv. No. 169

Inscriptions: On the lower edge, a later addition (possibly eighteenth century) reads: "v. Meurs".

Attribution: Winkler was the first to recognise that, because of the many striking motival analogies and overall compositional similarity, this must be a pendant to the portrayal of justice that has survived in many painted copies of *The Revenge of Tomyris* (III.E.6/C), and he attributed it accordingly to the Master of Flémalle. While most art historians (Tolnay, Panofsky, Sonkes 1969 and Châtelet) adopted this attribution and accepted its description as a copy, Friedländer considered the drawing to be closely related to Jan van Eyck and Petrus Christus. Kemperdick points out that the head of Jael can be found in one of the Three Marys at the Sepulchre in Rotterdam and that the figure of Jael fits in with the figures of the Virgins in the Ghent *Adoration of the Lamb*.
The softly modelled limbs of the figures do not favour an attribution to Campin. The specific style of the drapery and the physiognomy of Sisera permit us, we believe, to attribute the Brunswick drawing to Hubert van Eyck, who created the figures of the apostles in the Ghent Altarpiece. The drawing is remarkable for its artistic design and fine execution. The correlation between the two manifestations of blood in this image – the red cheeks of Jael and the wound of Sisera as respective signs of temptation and resultant death – is a subtly sophisticated concetto that refers to the tradition of images portraying the power of woman. It is unlikely to be the work of a copyist. The way the light flows to the ground of the tent also betrays an extraordinary creative sensitivity.

Dating: Around 1425. Winkler dates the alleged original of which he believes the drawing to be a copy to between 1400 and 1425, Sonkes 1969 to before 1430, Châtelet to between 1420 and 1425. Friedländer dates the drawing to 1425, Heusinger to 1430–1440. For further proposed dating, see Sonkes 1969.

Commentary: See pp. 191-194. The function of the drawing is unclear if we consider it as an original and as the pendant to *The Revenge of Tomyris* (III.E.6/C). It must have been intended as some kind of presentation drawing – a particularly well executed study for a specific audience or a replica, possibly altered, of a large-scale portrayal of Justice by the same artist. Dhanens 1987, p. 37, puts forward the interesting proposal that the Brunswick drawing might be one of the two studies submitted for a *taeffele* of unknown content commissioned by the magistrates of the city of Ghent from Hubert von Eyck in 1424/25.

Provenance: Unknown.

Literature: M: Winkler, pp. 23-25; Friedländer, vol. 1, plate 71D; Tolnay, copies No. 9; Panofsky, p. 175 (n. 6); Châtelet, Cat. C8; Kemperdick, pp. 112-118.
S: °Sonkes 1969, Cat. no. C2; Dhanens 1987; Heusinger 1997, p. 268s.

II.6 Portrait of a Musician

Wood (lime or maple), 32.5 x 24 cm
San Francisco, The Fine Arts Museum; Inv. No. 64.54

Attribution: Friedländer ascribes the panel to the Master of Flémalle, but sees a close relation-
ship with the portraits by Rogier van der Weyden. Panofsky is inclined to attribute it to
Campin. Frinta and Davies express doubts as to Campin's authorship. Châtelet agrees with
Winkler that the work could be German in origin.

Dating: Around 1430 (on grounds of the costume). According to Châtelet, possibly the last
quarter of the fifteenth century.

Provenance: 1895 purchased by W. Gumprecht, Berlin, in Vienna; Gumprecht auction, Berlin
1918; Chillingworth auction, Lucerne 1922; 1929 exhibited at Kleinberger's, New York; Mrs.
John E. Magnin, New York.

Literature: M: Winkler, 19s; Friedländer, vol. 2, nr. 63; Panofsky, p. 171 (n. 8); Frinta, p. 119;
Davies, Campin/New York, Magnin; Châtelet, Cat. AR4.
S: °Campbell 1973, Cat. no. XV.

II.7 Portrait of Louise of Savoy as Sibylla Agrippa → Fig. 220

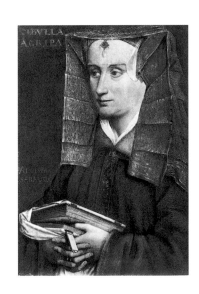

Wood (oak); 49.5 x 35.5 cm
Washington, Dumbarton Oaks Library and Collections, Inv. No. 23.1

Inscriptions: Top: *SIBYLLA / AGRIPA*; bottom (in slightly smaller letters, but identical writing):
ALOISIA / SABAUDA. The second inscription was deleted after 1900 during restoration.

Attribution: Friedländer regarded the panel as an original by Campin. Generally, however, it is
seen as a copy after a lost portrait by Campin (Tolnay, Panofsky, Troescher 1967). Campbell
1973 and Châtelet ascribe it to Jacques Daret as an original.

Dating: Around 1525. Hulin in Cat. Anvers 1930/32 and Troescher 1967 date the panel to
1427/28, on grounds of the identification of the sitter as Mary of Savoy. Campbell 1973
dates it around 1438, Châtelet 1430–40. However, it cannot possibly have been painted in the
early fifteenth century. Although the headdress and costume do correspond largely to the
fashions that prevailed in the period around 1430–40, the ornamentation and the pendant
over the brow indicate the sixteenth century.

Copies: Verona, Museo del Castelvecchio, Inv. No. 589; Wood (oak), 51 x 35 cm. See Collobi
Ragghianti 1990, Cat. no. 36 (with incorrect description of carrier). The precisely executed
copy in softer style bears the same inscription as that which originally graced the Washing-
ton panel.

Campbell 1973 has noted that the costume and pose of the figure portrayed correspond exactly to those of the female donor in a drawing by the Master of the Louvain Trinity (III.F.5).

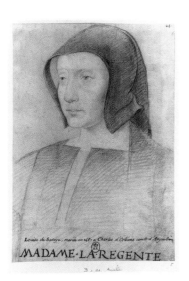

[1]

Commentary: The identification of the sitter as "Aloisia Sabauda" posed some problems for art historians who had unanimously dated this panel or the original from which it was painted to the first half of the fifteenth century, because there was no member of the princely House of Savoy who bore that name at that time. Because of this, the inscription was either dismissed as erroneous (Hulin in Cat. Anvers 1930/32 and Troescher 1967) or disqualified as a later addition (e.g. Reinach 1926, Davies and Campbell 1973). However, as the jewellery adorning the sitter's brow indicates, this panel cannot possibly date from the fifteenth century. Both the inscriptions may well be original and must therefore be taken seriously. The sitter is Louise de Savoie, mother of François I. (Identification by Reinach 1926, though not, as the author supposed, a later reference to the king's mother.) The woman, aged about 50, is portrayed in the role of the Agrippine Sibyl, possibly in reference to Agrippa von Nettesheim, who was her personal physician at the time. (For information on the role played by Agrippa at the French court, see Müller-Jahncke 1973). The facial traits of Louisa of Savoy are also recorded in a drawing in the Bibliothèque Nationale (fig. [1]) which correponds on the whole to the portrait in question. On the connection noted by Campbell 1973 between the portrait and the drawing by the Master of the Louvain Trinity (III.F.5) see Text p. 200s.

Provenance: René Boylesve, member of the Académie Française; Cernuschi auction, Paris 1900; 1923 purchased at Wildenstein by Mr. and Mrs. Robert Woods Bliss, Dumbarton Oaks; since 1940 at Harvard University, The Dumbarton Oaks Research Library and Collection.

Literature: M: Friedländer, vol. 2, no. 57; Tolnay, copies No. 12; Panofsky, p. 175; Frinta, p. 119; Davies, Campin/Washington, Dumberton Oaks; Châtelet, Cat. D6; Kemperdick, p. 119s.
S: Reinach 1926; Cat. Anvers 1930/32; Troescher 1967, p. 107; Müller-Jahncke 1973; °Campbell 1973, Cat. no. XIb; Collobi Ragghianti 1990, Cat. no. 36.

III. STUDENTS OF ROBERT CAMPIN

A. Jacques Daret

III.A.1 Fragments of a Marian Altarpiece in Arras
III.A.1a The Visitation → Fig. 250 and det. (188)
III.A.1b The Nativity → Figs. 189, 251
III.A.1c The Adoration of the Magi
III.A.d The Presentation in the Temple

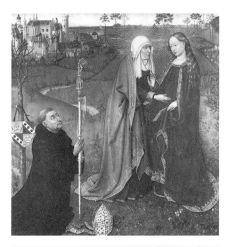

Wood (oak); each 57 x 52 cm

Berlin, Staatliche Museen, Gemäldegalerie; Inv. Nos. 542, 527 (III.A.1a, III.A.1c). Madrid, Thyssen-Bornemisza Collection; Inv. No. 1935.17 (III.A.1b). Paris, Petit Palais, Coll. Tuck (III.A.1d)

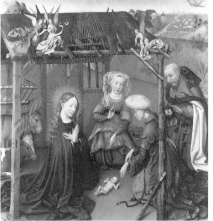

Coats of arms: On a tree behind the figure of the donor in the *Visitation* panel (III.A.1a) we can see a coat of arms, which Hulin in Cat. Bruges 1902, p. XLVI, identified as belonging to Jean du Clercq (1376–1462), Abbot of the Benedictine Abbey of Saint Vaast in Arras from 1428.

Attribution: Hulin in Cat. Bruges 1902, p. XLVI, attributed the three panels, which were known at the time, to a "good student of the Master of Flémalle". The same author had already identified the Master of Flémalle as Jacques Daret (Hulin 1901). According to Hulin, the student had probably painted the altarpiece after returning to Tournai in 1458. In 1909, on the basis of three documents already published at the time, Hulin succeeded in determining beyond doubt that the altarpiece created for Jean du Clercq was a work by Jacques Daret himself completed in 1434. Since then, this Marian Altarpiece has remained the only surviving work in the entire Flémalle group whose authorship has been ascertained unequivocally (Folie 1963, pp. 213-215). Hulin further concluded from his findings in 1909 that the Master of Flémalle could not have been a student of Daret, but vice versa: the Master of Flémalle was in fact Daret's teacher, Robert Campin. Soon afterwards, the discovery of the hitherto missing panel of *The Nativity* (Hulin 1911c) with its direct references to certain elements in the Dijon *Nativity* (I.6), underpinned the case for identifying the Master of Flémalle as Robert Campin.

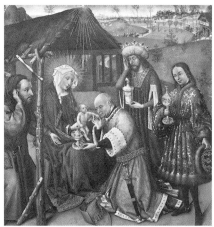

Dating: Before Hulin 1909 determined the artist, date and donor, the three known panels were dated to around 1460. (Cat. Bruges 1902, p. XLVI).

Commentary: Apart from the four large surviving panels, Daret also created two small wings showing the Annunciation, which covered the elevated part of the altarpiece, as well as an antependium and *custodia* to protect it when not in use. See Lestocquoy 1937, p. 214. (For a reconstruction of the Marian Altarpiece see Lestocquoy 1937 and Eisler 1989).

Provenance: It is not possible to trace the provenance of the four panels to 1651 when they were still in the Abbey of Saint-Vaast in Arras (see Taverne 1651 / 1936).

Literature: M: Tschudi, pp. 110-112; Friedländer, vol. 2, Nos. 78-81; Panofsky, p. 158 et passim; Frinta, p. 120s; Asperen de Boer et al., III.A.1-4; Châtelet, Cat. D8-11.
S: Taverne 1651/1936; Hulin 1901; Cat. Bruges 1902; Hulin 1909; Hulin 1911c; Lestocquoy 1937; Folie 1963; Eisler 1989.

III.A.2 Portrait of a Man → Fig. 190

Wood (oak); 37 x 30 cm
Berlin, Staatliche Museen, Gemäldegalerie; Inv. No. 537

Attribution: Tschudi, Winkler and Hulin 1939 uphold the attribution, first proposed verbally by Friedländer, to the Master of Flémalle. Tolnay and Frinta determined the work as a copy after Campin; Panofsky classifies it as a work by the school of Campin, Burroughs 1938, p. 215, having been the first to attribute it to Jacques Daret. Davies regards it as an original by Campin and dates it to before 1427. Campbell 1973 and Châtelet adopt the attribution to Daret, which we also consider convincing. Kemperdick regards the panel as a possible late work by Daret or as a painting created around 1500 after an original from the same period.

Dating: 1440/50. Hulin: after 1430 (on grounds of costume); Campbell 1973 and Châtelet: 1430–1440. According to Kemperdick the brocade pattern of the doublet probably did not become current until mid-century.

Provenance: Donated to the museum in 1836 as a gift from Baron von Werther, the Prussian ambassador in Paris.

Literature: M: Tschudi, p. 95s; Winkler, p. 10; Friedländer, vol. 2, nr. 62; Tolnay, copies No. 11; Panofsky, p. 175 (n. 9); Frinta, p. 118; Davies, Campin/Berlin 3; Châtelet, Cat. D7; Kemperdick, p. 119s.
S: Burroughs 1938; Hulin 1939; °Campbell 1973, Cat. no. X.

III.A.3 Tapestry cycle depicting scenes from the Life of Saint Peter (cartoons) → Fig. 191

Tapestry in eleven parts of varying length, between 2 m 50 and 3 m 25 high
Beauvais, Cathedral (parts 1-2, 4, 6-9), Washington, National Gallery (part 3), Paris, Musée de Cluny (part 5, fig. 191), private collections in France and U.S.A. (fragments of part 11). The designs for part 10, in Boston, Museum of Fine Arts, are by Nicolas Froment.

In an essay published in 1990 Fabienne Joubert convincingly attributed the designs for this important tapestry series to the painter Jacques Daret on the basis of detailed comparison with his paintings for the altarpiece in Arras. The series in question consists of ten of originally eleven parts forming a sequence dedicated to the *Life of Saint Peter*, and donated by Bishop Guillaume de Hellande to the Cathedral of Beauvais in 1460. It may be assumed that

Daret based the individual scenes on a series of canvases designed by Campin in 1438/39 on the same theme for the chapel of Saint Pierre in Tournai (cf. Doc. 64), just as he looked to the paintings of his teacher in devising the altarpiece in Arras.

There is a close stylistic resemblance between this series and other tapestry sequences created in Tournai around 1460, including *The History of Alexander the Great* and *The History of the Chevalier du Cygne*, both of which may well be the very same sequences of tapestries for which Pasquier Grenier, active in Tournai, received payment from Philipp the Good in 1459 and 1462. This suggests that Daret, when he returned to his home town, worked primarily as a *cartonnier*.

A detailed stylistic study of the tapestries from the workshops in the city of Tournai remains to be undertaken. A useful survey of their production can be found in Kurth 1918. For a more detailed list of works, see Joubert 1987, pp. 25-27.

Literature: S: °Kurth 1918; °Joubert 1987; Joubert 1990.

B. Rogier van der Weyden – Paintings before 1450

The following is a list, in hypothetical chronological order, of works created by Rogier van der Weyden before his pilgrimage to Rome in 1450. It is intended to outline the context of the Werl Altarpiece, dated 1438. In our view, all the works mentioned were created after Rogier had left Campin's workshop in 1432. As an apprentice to Campin, Rogier van der Weyden created the left-hand wing panel of the Mérode Triptych between 1425 and 1428 (I.12). Two male portraits traditionally ascribed to Campin (III.G.1 and III.G.2) may well be works by Rogier from the period around 1430.

III.B.1 Madonna (Fr. 7)
Vienna, Kunsthistorisches Museum
III.B.2 Saint Catherine (Fr. 7)
Vienna, Kunsthistorisches Museum
III.B.3 The Visitation (Fr. 5)
Leipzig, Museum der Bildenden Künste

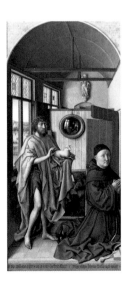

III.B.4 Two Wings of a Triptych – Werl Altarpiece
III.B.4a The Donor and John the Baptist → Fig. 257 and det. (254)
III.B.4b Saint Barbara → Fig. 258

Wood (oak); each 101 x 47 cm
Madrid, Museo del Prado; Inv. No. 1352-1353

Coats of arms: Only one, the third, of the four coats of arms in the windows of the donor wing has been identified by Davies as the conventional coat of arms of the northern Guild of Saint Luke. Tschudi believes the escutcheons have a purely decorative purpose.

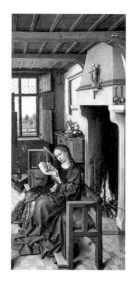

Inscription: On the front edge of the floor of the donor wing (III.B.4a) there is an inscription in three Leonine hexameters: *Ano milleno c quater x ter et octɔ · hic fecit effigiem ... de[i]ungi minister / henricus werlis magister coloniensis.* The text is not complete. We may assume that there is a gap after the word *effigiem* that has to correspond either to two long syllables or to two short syllables and one long syllable. The word *de[i]ungi* has not been firmly ascertained. Although most scholars propose that it should be read as *depingi*, Kemperdick, n. 1, p. 194, quite rightly points out that this is not possible.

Condition: According to an X-radiography published by Garrido 1996, ill. 7, the head of the donor has been overpainted. Contrary to the author's assumption, the head does not bear the same facial traits as the face that is now visible. It must therefore be assumed that the work was originally created for a different client. As no changes were made to the garment, that client must also have been a Franciscan monk, and the fact that he is shown with Saint John indicates that his own name was John. Heinrich Werl clearly had his portrait and the donor inscription added later or had a previous inscription changed. The expression *hic fecit effigiem ... de[i]ungi* ("here did [H. W.] have his ... portrait laid down") could thus be taken quite literally.

The X-radiographies of the panel depicting *Saint Barbara* (Garrido 1996, ills. 10, 11) show that, underneath the black layer of paint covering the entire verso, there is a portrayal of *Saint Anne, the Madonna and the Christ Child.* The form of the nimbus indicates that it was not painted by the same artist as the fronts of the panels. (Cf. Kemperdick, p. 135.)

Attribution: Tschudi attributed the two wing panels to the Master of Flémalle, whom he still regarded at that time as a student of Rogier van der Weyden. Even once this misconception had been realised, most scholars (Winkler, Friedländer, Tolnay, Panofsky, Châtelet) continued to uphold the attribution, which would have meant that Campin, towards the end of his life, had begun imitating the works of his student and that of Jan van Eyck. It was Jamot 1928, p. 272, who first asked whether the wing panels might actually be the work of Rogier. Frinta also questioned the attribution of the donor wing to Campin. Beenken 1951 pondered whether the landscapes of the two wings might be the work of Rogier. Davies ponders whether it is Campin who is imitating Rogier or vice versa. Both panels are attributed to Rogier by Thürlemann 1993b and by Belting/Kruse 1994. Kemperdick attributes the panels to two different artists, both of them with close connections to Rogier van der Weyden. Whether or not the head of Heinrich Werl, painted over an existing portrait, is also by Rogier, cannot been firmly ascertained. Kemperdick, p. 138, sees a close stylistic affinity between this face and some of the faces in the *Exhumation of Saint Hubert* (Friedländer vol. 2, No. 18).

Dating: Between 1434 and 1438. The year 1438 in the inscription refers to the time at which the painting was reworked. The two panels must have been created at some unknown earlier date, but certainly later than Jan von Eycks double portrait of the Arnolfini in 1434.

Commentary: See pp. 246-248 for a treatment rejecting the claim posited by Tschudi and supported by Grosshans as late as 1981 to the effect that the artist who painted the donor panel had based the hand of Saint John on the hand of Christ Resurrected in the Miraflores Altar-

piece (III.B.12). For a summary treatment of the reconstruction of the lost central panel see Kemperdick, p. 136, who proposes a portrayal of the Virgin among Virgins.

Provenance: Acquired by Charles IV of Spain (1748–1819). The panels came to the Prado from Aranjuez in 1827.

Literature: M: Tschudi, pp. 20-23, 113 s; Winkler, p. 36 s; Friedländer, vol. 2, no. 67; Tolnay, No. 16; Panofsky, pp. 173 s, 255 s, 264 et passim; Frinta, pp. 71-76, 121, n. 17; Davies, Campin/ Madrid 2; Asperen de Boer et al., F12; Châtelet, Cat. 18; Kemperdick, pp. 133-148.
S: Jamot 1928; Beenken 1951; Grosshans 1981; Thürlemann 1993 b; Belting/Kruse 1994; Garrido 1996.

III.B.5 Triptych of the Crucifixion (Fr. 11)

Vienna, Kunsthistorisches Museum

III.B.6 Three fragments of an altarpiece (Fr. 12, 36)

London, National Gallery and Lisbon, Gulbenkian Foundation

III.B.7 Portrait of a Woman (Fr. 4)

Berlin, Staatliche Museen, Gemäldegalerie

III.B.8 Madonna in Half-Length (Fr. 27)

Chicago, Art Institute

III.B.9 Saint Luke drawing the Virgin (Fr. 106c)

Boston, Museum of Fine Arts

III.B.10 Madonna in a Niche – Durán Madonna (Fr. Supp. 132)

Madrid, Prado

III.B.11 Triptych of the Annunciation (Fr. 9, 6)

Turin, Galleria Sabauda and Paris, Louvre

III.B.12 Miraflores Altarpiece (Fr. 1a)

Berlin, Staatliche Museen, Gemäldegalerie

III.B.13 Diptych of the Crucifixion (Fr. 15)

Philadelphia Museum of Art

III.B.14 Pietà (Fr. 20)

London, National Gallery

III.B.15 Triptych of the Crucifixion – Abegg Triptych (Fr. Supp. 131)

Riggisberg, Abegg-Stiftung

III.B.16 The Seven Sacraments (Fr. 16)

Antwerp, Museum voor Schone Kunsten

III.B.17 Triptych of the Nativity – Bladelin Triptych (Fr. 38)

Berlin, Staatliche Museen, Gemäldegalerie

III.B.18C Portrait of Philip the Good (Fr. 125a)

Madrid, Palacio Nacional

III.B.19 Last Judgment Altarpiece (Fr. 14)

Beaune, Hôtel-Dieu

C. Master of the Hortus conclusus (Willem van Tongeren?)

III.C.1 The Annunciation → Figs. 54, 197

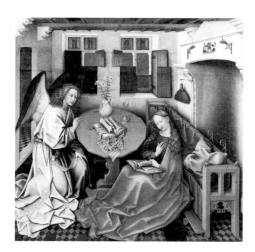

Wood (oak); 61.2 x 63.9 cm
Brussels, Musées Royaux des Beaux-Arts; Inv. No. 785

Inscriptions: The text on the hem of the Virgin's robe has been incorrectly restored in many places. It cites the beginning of the *Salve Regina* whereby the second word is reiterated. (Wrongly identified by Gottlieb 1957, n. 12). The letters in round brackets are either illegible or incorrectly restored: ... *SALVE: RE(GI)[na] REGINA MA[ter misericordiae, vita, dulcedo et spes nostr]A SALVE. [Ad te cl]AM[amus, exsules filii Hevae. Ad te suspiramu](S GEMENTES) [et] F(L)ENT[es in hac] (LAC)RIM(A)[rum valle. Eia ergo, advocata] (NOST)RA D[?] ...*

Condition: This panel was heavily restored prior to its acquisition by the Brussels museum. The face of the Virgin, in particular, has been largely reconstructed. (See Fierens-Gevaert 1923, p. 11, and Cat. Bruxelles 1996).

Attribution: The obviously close connection between this panel and the central panel of the Mérode Triptych (I.12) is interpreted in different ways by different scholars. Tschudi and Mot 1932 consider the Brussels *Annunciation* to be a further version by the Master of Flémalle, while Winkler sees it as a heavily adapted copy by a follower of the Flémalle Master and on no account as a forerunner of the Mérode *Annunciation*. According to Friedländer it is a freely interpreted copy that was probably created in the workshop of the Flémalle Master. Schmarsow 1928 describes it as a "Workshop exercise under the supervision of the Master". This evaluation is supported by the observation that the author of the Brussels *Annunciation* portrays the same pitcher that is depicted by the author of the Mérode Triptych, albeit from a different angle (Callman 1982). Hulin 1911, Burroughs 1938, Gottlieb 1957 and Châtelet ascribe the work to Jacques Daret. Frinta (cf. Frinta 1983) adopts a theory posited by Beenken 1951, according to which the Brussels *Annunciation* is based on a lost earlier version created by Campin of the composition in the central panel of the Mérode Triptych. According to Frinta the Brussels panel is a workshop product. Dijkstra 1990 and Asperen de Boer et al. deduced from a study of the underdrawing of the two Annunciation portrayals by means of infrared reflectography that the painter of the Mérode Triptych copied the Brussels *Annunciation* rather than vice versa. They tentatively ascribe the Brussels version to Campin and the Mérode Triptych to a *pasticheur* of Campin. Their reasoning, however, is not convincing. (Cf. Thürlemann 1993a, pp. 723-25). Kemperdick also regards the Mérode *Annunciation* as a second version. The convoluted argumentation he puts forward is not persuasive. Wherever the Brussels version deviates from the New York version, it is clearly weaker. The new version of the drapery in the figure of the Brussels Virgin is stiff, flat and unimaginative in comparison to that of the angel. Moreover, it lacks logic, for example beneath the right knee. The drapery of the Brussels angel can only be regarded as a tentative imitation of the drapery of the New York angel. The fact that the Brussels version was originally intended to show a lavabo niche in the place of the broom, as in the New York version, can only be explained if the New York version is given concep-

tual priority. In our opinion, the Master of the Hortus conclusus painted his version on the basis of the unusually detailed underdrawing of the Mérode *Annunciation* by Robert Campin.

Dating: 1425–1430. Terminus post quem (dendrochronology according to Vynckier in Cat. Bruxelles 1996, p. 37): 1392/circa 1398 + min. 2 + x. The dating of the work depends on how one sees the relationship to the central panel of the Mérode Triptych. (See *Attribution*).

Copies: There is an extraordinary number of copies and free variations of the Brussels *Annunciation*. As these all came from the Rhineland and Westphalia, as Winkler found, it may be assumed that the original or a copy of the original was publicly accessible in that area from an early stage. Kemperdick, p. 88, has located the many relievo copies, most of them in kaolin, at Utrecht. For a survey of the copies, see Winkler, p. 11, and Dijkstra 1990, pp. 175-77. Given that a cat features in the Utrecht clay reliefs as well as in the *Annunciation* of the Schöpping Altarpiece (See ills. 104 and 109 in Kemperdick), there must be some mutual "missing link" between these works and the Brussels Annunciation.

Commentary: See pp. 73-76, where the Brussels panel is shown as a variation on the Mérode *Annunciation*, portraying the same scene an instant later in time.

Provenance: Various private collections in Belgium; 1910 purchased by the Museum from M. Turner, London.

Literature: M: Tschudi, p. 11s; Winkler, pp. 10-12; Friedländer, vol. 2, nr. 54b; Frinta, p. 117s; Davies, Campin/New York; Asperen de Boer et al., F10; Châtelet, Cat. III.A.2; Kemperdick, pp. 77-99.
S: Hulin 1911b; Fierens-Gevaert 1923; Mot 1932; Schmarsow 1928, p. 30s; Burroughs 1938; Beenken 1951, p. 102, n. 25; Gottlieb 1957; Campbell 1974; Callman 1982; Frinta 1983; Dijkstra 1990; Thürlemann 1993a; °Cat. Bruxelles 1995, No. 1.

III.C.2 The Virgin and Child with Four Saints in the Hortus conclusus → Fig. 198

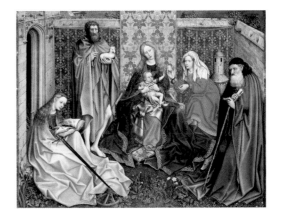

Wood (oak); 119.8 x 148.5 cm
Washington, National Gallery (Samuel H. Kress Collection); Inv. No. 1959.9.3 (1388)

Inscriptions: The frame, which is old but not original, bears the following hymn text: *O maria consolatrix. Esto nobis advocatrix Rogans regem glorie Ut nos Jungat Superis Donans nobis miseris / Post Spem frui Specie Que regina diceris · Miserere [p?]osteris · Virgo mater Gracie · Amen ·* The lettering of this text has been dated to the early sixteenth century. It is followed by a monogram which can also be found in a Boethius edition printed by Arend de Keysere in Ghent. (According to Cat. Washington 1986, n. 1, p. 39).

Condition: The painting was damaged by fire in 1956.

Attribution: With the exception of Friedländer, who regards this work as an original by Campin, this painting is generally attributed to a follower or student of Campin (according to Cat. Washington 1986, n. 18, p. 39). Sterling 1971 regards it as a work by a student of Campin, not identical with Jacques Daret, and to whom he also attributed both the *Annunciation* in the Prado (III.D.1 b) and the Brussels *Annunciation* (III.C.1). Châtelet considers Daret to be the author. Kemperdick ascribes the work to an artist by whom no other work has survived.

Dating: 1440–1450. Terminus post quem (dendrochronology according to Klein 1996): 1409/circa 1415 + min. 2 + x. Proposed datings differ widely: Sterling 1971 places the work in the early 30s of the fifteenth century, Martha Wolff dates it in Cat. Washington 1986 to between 1440 and 1460. Châtelet proposes 1425, Kemperdick suggests the mid-fifteenth century.

Provenance: Church in Bruges (according to Passavant 1833, p. 349); 1831 Imbert de Mottelettes, Bruges; 1839 Jonkheer de Potter-Soenens, Ghent; Countess de Oudemard; 1946–1949 Wildenstein and Co., New York; 1949 Samuel H. Kress, New York.

Commentary: The four saints bear the attributes of SS. John the Baptist, Anthony, Catherine and Barbara.

Literature: M: Friedländer, vol. 2, nr. Add. 152; Frinta, p. 118; Davies, Campin/Washington; Châtelet, Cat. D3; Kemperdick, p. 123 s.
S: Passavant 1833; Sterling 1971, p. 5, n. 5; Cat. Washington 1986, pp. 35-40.

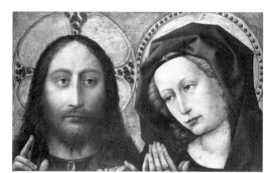

III.C.3 Christ and the Virgin Mary

Wood (oak); 28.5 x 45 cm
Philadelphia, Philadelphia Museum of Art, John G. Johnson Collection; Inv. No. 332

Condition: The panel has been planed and cradled. It may have been cropped somewhat at the top. The lower part is probably fully extant, but a piece of pinewood about 1 cm wide has been added. According to Bauman/Liedtke 1992, p. 34, the panel may also have been cropped at the bottom. A fairly large area of the face of Christ has been restored (the entire nose including the upper lip).

Attribution: Winkler, who knows the work only from photographs, agrees with the as yet unpublished attributions to the Master of Flémalle by Friedländer and Valentiner in Cat. Philadelphia 1913. It is also accepted by Tolnay, Panofsky, Davies and Châtelet as a work by Campin. On the basis of X-radiography photographs, Burroughs 1932/33 has pronounced the painterly technique entirely different to that of Campin. Frinta regards the panel as an "uninspired copy after the master". S. N. Blum in Bauman/Liedtke 1992 attributes the work to the school of Robert Campin. In Kemperdick's opinion it is by the same assistant to the Master of Flémalle who painted the *Thief on the Cross* (I.16).

Although the painterly surface is closely related to original works by Campin, the clumsy composition precludes an attribution to the master himself. (The head of the Redeemer is set too low and seems to be dominated by the head of the Virgin, which is covered by a mantle). The nimbus discs, though painted according to the same principle as those in the Flémalle Panel of *Maria lactans*, with which the work is closely related, are much more schematic. The rather harsh and wiry facial traits of the Virgin, and her seemingly swollen neck, are reminiscent of the figure of the Virgin in the Hortus conclusus (III.C.2). The style of the underdrawing does not correspond to that of the works generally attributed to Campin. (Cf. ills. 86 and 122 in Asperen de Boer et al. and ill. 54 bei Kemperdick.)

Dating: Circa 1435. Terminus post quem (dendrochronology according to Klein 1996): 1408/circa 1414 + min. 2 + x. According to Winkler the panel belongs to the earliest group of works by the Master of Flémalle; Tolnay dates it to between 1430 and 1438, Châtelet to between 1420 and 1425; Kemperdick around 1430 or later.

Copies: See *Commentary.*

Commentary: The Virgin in this work would appear to be based on the face of the *Maria lactans* in the Flémalle Panel (I.18b). (Châtelet, p. 122, describes the figures as "sisters"; Kemperdick believes that a stencil or template may have been used.) Yet a comparison reveals the weaknesses of the later work, such as the lack of proportional clarity between nose and mouth. The face of the Redeemer, too, is probably based on one of the Flémalle Panels (I.18c): it corresponds fully to the brown-toned figure of Christ on the sudarium displayed by Saint Veronica, evoking the *vera icon*. (Valentiner in Cat. Philadelphia 1913/14 believes that an icon of Christ by Jan van Eyck may have served as model). Stanton 1998 ascribes the painting in Philadelphia to Campin himself and assumes that the artist based both the Philadelphia panel and the head of Christ on the sudarium of St Veronica in the Flémalle Panel on a Byzantine icon. In our opinion, however, the painting in Philadelphia is based primarily on the Flémalle Panels and only in terms of the compositional scheme, featuring a connection between the frontal portrayal of Christ and the three-quarter profile of the Virgin against a gold ground, is it based on a Byzantine work. The same scheme can be found in an Italian diptych in the Byzantine style which was presented as a gift to Jean le Bon in 1342 and whose appearance is documented in a miniature copy after a lost fresco. (See Pächt 1961 and Sterling 1987 with ill.) Pächt interprets the Byzantine work as a combined portrayal of the *vera icon* of Christ and the Virgin. According to Sterling 1987, p. 144, the fourteenth century Italian copy was kept in Paris, and because of this it was able to create a new iconographic tradition in northern Europe. The work, which we ascribe to the Master of the Hortus conclusus, was probably the point of departure for a large number of portrayals of the figure of Christ giving His Blessing and the Intercession of Our Lady. These, however, like the Italo-Byzantine work of the French ruling house, were all painted as diptychs. One of the oldest examples, regarded by Friedländer (vol. 3, No. 61a) as a replica by Aelbrecht Bouts after a work by Dieric Bouts, bears distinctly Campinesque traits in the face of the Virgin. The folded hands of the Virgin, too, correspond precisely to the work discussed here.

Provenance: Ypres(?); (until 1792) Paignon Dijonval, Paris; (until 1821) Charles-Gilbert, vicomte Morel de Vindé; Nieuwenhuys, Brussels, Willem II, King of the Netherlands; Brothers Bourgeois, Cologne; R. Langton Douglas; John G. Jonson (after Eidelberg 1998)

Literature: M: Winkler, pp. 7, 41; Friedländer, vol. 2, no. 56; Tolnay, no. 12; Panofsky, pp. 174, 294, n. 15; Frinta, p. 117; Davies, Campin/Philadelphia; Asperen de Boer et al., F16; Châtelet, Cat. 8; Kemperdick, pp. 42-44.
S: Cat. Philadelphia 1913, No. 332; Burroughs 1932/33, p. 145 s; Gottlieb 1960; Pächt 1961; Cat. Philadelphia 1972, no. 21; Sterling 1987, vol. 1, pp. 141-144; Bauman/Liedtke 1992, pp. 34-36; Eidelberg 1998; Stanton 1998, pp. 51-87.

D. Master of the Betrothal of the Virgin

III.D.1 Fragments of a Marian Altarpiece
III.D.1a The Betrothal of the Virgin → Figs. 36, 207
Exterior: Saint James and Saint Clare
III.D.1b The Annunciation → Fig. 208
III.D.1c/C Saint Catherine (Copy) → Fig. 234

Wood (oak); 76.5 x 88.5 cm (III.D.1a) and 76.5 x 70 cm (III.D.1b)
Madrid, Museo del Prado; Inv. No. 1817a, 1915

Brown ink (pen) on paper; 35.3 x 18.5 cm (III.D.1c/C)
Amsterdam, Rijksmuseum; Inv. No. 74: 101

Coat of arms: The coat of arms in the window of the *Annunciation* panel (III.D.1a) has not been definitively identified. (Cf. Châtelet, p. 310).

Inscriptions: The hem of the Virgin's mantle in III.D.1b bears a text written in a rather odd mixture of Graeco-Roman and Hebrew letters, of which only some individual words can be deciphered, such as *JESUS CHRISTUS, AVE MA[RIA], MATER DEI.*

Condition: III.D.1a, b: As the edges of the back of the *Annunciation* panel are evenly bevelled (see Garrido 1996, ill. 18), it can only have been cropped slightly, if at all. About 1-2 cm may possibly be missing on the right hand edge (Garrido 1996, p. 67, and Kemperdick, p. 100, disagree.) The fact that this panel is the only one without a painted edge might be because it was not framed at the time of painting, having been intended as part of a sculptural ensemble (see *Commentary*).
III.D.1c/C: The drawing has been cut along the edges. The addition to the sheet on the lower quarter is original, whereas the crown has been added on a separate piece of paper at a later date.

Attribution: III.D.1a, b: Tschudi ascribes both panels, as part of a diptych in which the *Annunciation* was heavily cropped at a later date, to the Master of Flémalle. Winkler regards the

Betrothal as an original, and the *Annunciation* as the work of a student. Hulin 1911b and Tolnay put forward similar theses. Friedländer agrees with Tschudi. Panofsky considers the *Betrothal* to be the left wing of a triptych by Campin; he sees the *Annunciation* as a separate work and describes it as a "pastiche". According to Davies, in spite of the discrepancy in quality, the two panels could well be from the same altarpiece, with only the *Betrothal* being an original by Campin. Fischel 1958 regards both works, which she believes belong together, as the work of a Campin follower to whom she refers as the Master of the Betrothal of the Virgin. Frinta, p. 64, qualifies the *Betrothal* as follows, on grounds of stylistic and and painterly studies: "... rather than being a youthful work of Campin, [it] is a mature work of an eclectically oriented artist who must have been closely related to Campin and perhaps freely copied his composition." Frinta regards the *Annunciation* as a copy after Campin, making no further comment on any correlations with the *Betrothal* panel. Châtelet and Garrido 1996 regard the *Betrothal* as an original by Campin. The *Annunciation*, which both of them regard as an independent work, is attributed by Châtelet to Jacques Daret, as it is by Hulin 1911b and Gelder 1967. Garrido 1996, p. 62, in reference to Asperen de Boer et al., believes that the front and back of the *Betrothal* panel are the work of two different artists, and that the grisaille is a later addition. This theory is dismissed by Kemperdick with good reason. According to Kemperdick, the *Betrothal* is by an artist trained in the same workshop as Daret and who may also have painted the right hand panel of the Seilern Triptych. The hand of the artist who created the *Annunciation*, according to Kemperdick, cannot be found in any other surviving painting. Although they are not of the same painterly quality, the two panels are precisely harmonised with each other in terms of composition and colority and are of exactly the same height. Kemperdick, p. 102, quite rightly emphasises that they must have belonged to the same ensemble from the start. On the other hand, his proposed reconstruction of a folding polyptych is improbable. There is no reason to assume that the reverse of the *Annunciation* panel was ever painted.

III.D.1c/C: Kemperdick has convincingly described the London drawing of *Saint Catherine* as a copy after a lost grisaille from the altarpiece. The form of the base corresponds exactly to that on the surviving outer panel and even the heavily hemmed garments are echoed there. The source of light also comes from the same direction. The drawing was determined by Popham 1931/32 as a copy after a grisaille altarpiece wing panel by Campin. Sonkes 1969 adopted this thesis and considered the original model to have been either a work by Campin created before the *Saint Veronica* panel (I.18c) or the work of a student.

Dating: Circa 1440. Dating proposals for both works vary according to whether the respective author considers them to be originals by Campin, products of his workshop or the work of independent students or followers of the master. There is no need to discuss these in full here. The authors who consider the *Betrothal* to be an original by Campin generally tend to date it between the Seilern Triptych (I.3) and *The Nativity* (I.6). Fischel dates both panels to around 1445. Kemperdick proposes a date around 1435/40 in reference to various works which he probably incorrectly regards as copies.

Copies: The first two scenes in the *Life of Saint Joseph* at Hoogstraten (I.7/C) cannot, as is generally assumed, be copies after the *Betrothal* panel in Madrid. Instead, the *Life of Joseph* is a copy after a lost original by Campin. (See below). This and very probably a further original

by Campin provided the model for the painting by the Master of The Betrothal of the Virgin. A detail in the underdrawing of the *Betrothal* panel (Asperen de Boer et. al., ill. 72s; Châtelet, ill. p. 207) strengthens this assumption: the Old Testament scenes under the roof of the temple were originally intended to reach into the spandrel between the arches. This is exactly how they are portrayed in the temple painted by Jacques Daret in 1434/35 (III.A.1c), which must also be based on Campin.

It is striking that, in contrast to the Hoogstraten *Life of Joseph* (I.7/C), the figure of Joseph occupies the centre of the scene depicted in the Madrid *Betrothal*. The same figural arrangement can be found in three earlier portrayals of the scene – a panel in the Kisters Collection, a miniature in the Book of Hours of Catherine of Cleves created around 1440 and an oak sculpture in Berlin (Kemperdick fig. 132, 133 and 130). These three works, all portraying only the *Betrothal of the Virgin*, are not dependent on the Madrid version. Instead, they all point to a common model, very probably by Campin. The Madrid *Betrothal* panel seems to be a synthesis of two lost Campinesque compositions. Both versions of *The Betrothal of the Virgin*, which we ascribe to Campin, as well as the altarpiece by the Master of The Betrothal of the Virgin were famous and publicly accessible, possibly even at the same place. This assumption helps to explain how elements from these works could be freely combined in later compositions, as in *The Betrothal of the Virgin* in Antwerp Cathedral (Friedländer vol. 2, No. 84) or in the two panels by the Master of Saint Gudule (Friedländer vol. 4, No. 78, Add. 157).

As Kemperdick, p. 108, has established, there are precise correlations between the figure of Saint James on the outside of the *Betrothal* panel and a portrayal of Saint Bartholomew in the Book of Hours of Catherine of Cleves (Ms. 917, p. 218; Kemperdick, ill. 125). The figure of Saint Catherine in the drawing (III.D.1c/C) corresponds to a further miniature in the same Book of Hours (fig. 229) and the outsides of the wings of an altarpiece created by an itinerant northern European artist in Italy (fig. 236). As the grisaille figures were possibly not the original invention of the Master of The Betrothal of the Virgin, the dating of these works cannot provide a secure *terminus ante quem* for the Madrid panel.

Commentary: See pp. 50, 195 s. The two panels probably belonged to a triptych, of which they formed the left wing (III.D.1a) and an element of the fixed central part (III.D.1b). The two metre wide and immobile central part probably consisted of two panels – the Annunciation (III.D.1b) on the left and a lost panel of the same format on the right – which together flanked a sculpture or relief of the Virgin. (Examples of this type of altarpiece can be found in Budde 1986, Cat. no. 33 [Cologne Master around 1410], and Friedländer vol. 6.2, Supp. 244 [altar portrayed in a painting by the Master of the Legend of Saint Augustine].) On the lost panel of the central part and on the inside of the lost right wing there were undoubtedly two further scenes from the Life of the Virgin – probably The Nativity and The Adoration of the Magi or The Purification. The exterior of the right-hand wing showed a simulated sculpture of Saint Catherine. (Cf. III.D.1c/C).

For details of the iconography of the reliefs and stained glass portrayed in the *Betrothal* panel, see Smith 1972 and Frodl-Kraft 1981.

Given the fact that the figure of Saint Clare occupied the dominant position when the wings of the altarpiece were closed, Châtelet assumes that this retable, to which the *Betrothal* belonged, originated in a Church of the Order of Saint Clare. However, it could also have been an altarpiece in a side chapel dedicated to Saint Clare in a church dedicated to Our Lady.

Provenance: III.D.1a: Among the works sent to the Escorial by Philipp II. Mentioned in the inventory of 1584. Acquired by the Prado in 1839.

III.D.1b: Purchased by Philipp II from Jacome Trezzo; brought to the Escorial in 1577 and to the Prado in 1839.

III.D.1c/C: Thomas Weld, Lulworth Castle, Dorset; Mrs. Alfred Noyes; purchashed in 1974 from Baskett & Day, London, for the Rijksmuseum. (According to Cat. Amsterdam 1978).

Literature: M: Tschudi, pp. 23-27; Winkler, p. 12s; Friedländer, vol. 2, Nos. 51, 52; Tolnay, No. 2, copies No. 4; Panofsky, pp. 136, 160-62, 175 (n. 13) et passim; Frinta, pp. 61-64, 116s; Davies, Campin/Madrid 1; Asperen de Boer et al., F9, F13; Châtelet, Cat. 11, D5; Kemperdick, pp. 100-112.

S: Hulin 1911b; Popham 1931/32, p. 8; Winkler 1948, p. 17; Fischel 1958; Winkler 1959, p. 90; Plummer 1966, No. 145; Gelder 1967; °Sonkes 1969, C33; Smith 1972; Gorissen 1973, p. 926; °Cat. Amsterdam 1978, No. 10; Bermejo Martinez 1980, pp. 83-85; Frodl-Kraft 1981; Budde 1986; Garrido 1996, pp. 62-68.

III.D.2 Madonna Enthroned → Fig. 209

Wood (oak), 14.2 x 10.1 cm
Madrid, Thyssen-Bornemisza Collection; Inv. No. 1930.25

Condition: The panel is slightly cropped at the top. Above the central group of sculptures showing the Coronation of the Virgin the arch should be completed.

Attribution: Friedländer 1903 attributed this work to Rogier van der Weyden and this has been accepted by most authors since. Exceptions include Destrée 1930, Ward 1968, who attribute the work to Campin, and Davies, who considers it possible that the work may be by an artist other than Rogier van der Weyden or Campin.

Dating: Circa 1440. Usually dated to 1430–35 on grounds of its assessment as an early work by Rogier van der Weyden. Châtelet dates it to 1427–30 as a work by Rogier produced in Campin's workshop.

Commentary: Beenken 1940 was the first to suggest that the panel might have formed a diptych along with the portrayal of *Saint George and the Dragon* now in Washington (III.B.2). This is considered in Cat. Washington 1986, p. 249, and Eisler 1989, p. 71, as a serious possibility. It would indeed appear plausible, partly because both works came from a Prussian collection. A comparison with the Vienna Madonna by Rogier van der Weyden (III.B.1a) indicates that the similarly sized panel in the Thyssen-Bornemisza collection must have been painted by a different artist. On the other hand, the architectural details are closely related to the Betrothal of the Virgin in the Prado (III.D.1a). (Compare, for example, the simulated sculptures and architectural details in both works – such as the square apertures for affixing scaffolding under the main sill – and the way that some of the plants encroach on the beige masonry. The Virgin's crown is also very similar in both works.)

Provenance: Prussian collection; purchased by Karl Aders in Paris; auctioned by Aders in London 1835 and purchased by Samuel Rogers; auctioned by Rogers in London 1856 and purchased by Thomas Baring, First Earl of Northbrook; Francis George, Second Earl of Northbrook; 1930 Thyssen collection. (According to Eisler 1989).

Literature: M: Winkler, p. 126; Friedländer, vol. 2, no. 8; Panofsky, pp. 146s, 251s et passim; Davies, Rogier/Lugano 1; Châtelet, Cat. R1.

S: Friedländer 1903, p. 71; Destrée 1930; Beenken 1940; Birkmeyer 1962; Ward 1968; Cat. Washington 1986; Eisler 1989, Cat. no. 4.

E. Master of the Madonna before a Grassy Bench (Jan van Stoevere?)

III.E.1 Madonna of Humilty before a Grassy Bench → Fig. 200

Wood (oak); 39.2 x 27 cm

Berlin, Staatliche Museen, Gemäldegalerie; Inv. No. 1835

Attribution: Friedländer and Davies consider this to be an early work by Campin. According to Winkler and Panofsky it is (at least) from his workshop. Frinta sees it as the work of an emulator whom he identifies as an early assistant to Campin, possibly Jacques Daret. According to Asperen de Boer et al. the underdrawing, which differs considerably from the final painting, does not preclude an attribution to Campin. Châtelet ascribes the panel to Jacques Daret. Kemperdick considers that it was painted by the same artist who, in his view, designed the Seilern Triptych (I.3). However, the facial traits are entirely different from the type painted by Campin and bear close affinities with the *Madonna in an Apse* (III.E.2).

Dating: Circa 1420. Terminus post quem (dendrochronology according to Klein 1996): 1378/circa 1384 + min. 2 + x. According to Friedländer the work may have been created around 1425; Châtelet dates it to about 1420.

Commentary: The composition appears strangely out of balance. They way the two figures and the point of view are shifted to the right suggest that this was intended as the left wing of a diptych. Kemperdick considers it to be the right wing of a diptych, but this does not correspond to the perspectival portrayal of the Grassy Bench.

Provenance: Richard von Kaufmann collection, Berlin. Donated to the museum in 1917 by Mrs von Kaufmann.

Literature: M: Winkler, p. 16; Friedländer, vol. 2, nr. 50; Panofsky, pp. 128, 160, 162, 175, 252 (n. 1); Frinta, pp. 69s, 120; Davies, Campin/Berlin 1; Asperen de Boer et al., F6; Châtelet, Cat. III.A.1; Kemperdick, pp. 74-76.

III.E.2/C Madonna in an Apse (Copy) → Fig. 199

Transferred from wood to canvas; 45.1 x 34.3 cm
New York, Metropolitan Museum of Art (Rogers Fund); Inv. No. 05.39.2

Attribution: Almost all the relevant authors (Winkler, Friedländer, Tolnay, Panofsky, Frinta, Davies, Châtelet) believe that the composition is derived from a lost original by the Master of Flémalle. It was one of the most popular compositional types in netherlandish painting, particularly after 1500 and has survived in many copies and variations. Bazin 1931 attributes the original to the school of Cologne or Westphalia. The work in the Metropolitan Museum is regarded by Tolnay and Panofsky as the finest version, while Friedländer considers the panel in the Diamond collection (formerly Nuremberg, Germanisches Nationalmuseum) to be the best. Of the versions that provide a faithful rendering of the composition, the one in the Metropolitan Museum – which has been transferred to canvas – is the only one that might possibly be the original. (See *Further Copies* for information on the results of dendrochronological studies.) Ainsworth in Ainsworth/Christiansen 1998 considers it to be a copy dating from around 1480 on grounds of the painterly technique.
In our opinion the composition with the characteristic facial type and typical hands of the Virgin cannot be based on Campin. The long and slightly curved parallel lines of the folds in the drapery are also untypical of his work.

Dating: Original: circa 1420. Winkler and Friedländer believe the original was painted around the same time as The Nativity (I.6), with Friedländer dating it around 1428. According to Panofsky and Frinta the original was an early work by Campin. Beenken 1951 dates the original to 1415, Châtelet to between 1420 and 1425. According to Ainsworth 1996, p. 151, there is a version in Zagreb bearing the date 1420. This might correspond to the period in which the original was painted.

Further Copies: For a survey of the copies see Winkler, p. 8s, and Bazin 1931. Ainsworth 1996 has discussed the most important of these. On grounds of the dendrochronological data gathered by Klein none of the four versions examined by him could have been produced during Campin's own lifetime.

Provenance: Spain (Salamanca?); collection of Sir John Charles Robinson, Newton Manor, Swanage, Dorset; 1905 purchased by the Metropolitan Museum of Art.

Literature: M: Winkler, pp. 7-9, 44; Friedländer, vol. 2, Nr. 74; Tolnay, copies No. 1; Panofsky, pp. 175, 352s; Frinta, p. 115; Davies, Campin/London 3; Asperen de Boer et al., F15; Châtelet, Cat. C.4.
S: Bazin 1931; Beenken 1951, p. 21; Ainsworth 1996; Ainsworth/Christiansen 1998, p. 220.

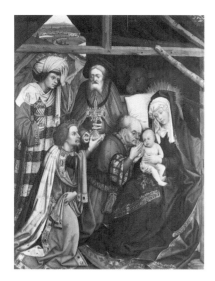

III.E.3/C Adoration of the Magi (copy) → Fig. 237

Wood (oak); 49 x 41 cm
Berlin, Staatliche Museen, Gemäldegalerie; Inv. No. 538

Inscriptions: On the mantle of the Virgin, from the outer right (incorrectly restored in parts) the text of *"Ave Maria"*: *AVE : MARIA : GRACIA : P[LENA] DOMINUS : TECVM : BE[NEDICTA TV] INMVLIERIBVS : E[T BENED]ICTVS : FRVCTVS : VENTRIS : TVI : AVE,* and at the head of the Virgin: ... *A : DOMIN ...* .

Condition: The panel is slightly cropped at the top.

Attribution: Since Hugo von Tschudi almost all scholars have attributed the lost original to the Master of Flémalle, or Robert Campin. Winkler initially ascribed it to Jacques Daret, but later amended this view in favour of Tschudi (Winkler 1960). Kerber 1938. p. 61, regarded the Berlin panel as an original by the Master of Flémalle. Tschudi sees in it a copy and attributes it to Jacob van Oostsanen (active between 1507 and 1533).

Dating: Lost original: circa 1425. According to Winkler between 1420 and 1430. The Berlin panel and the *Adoration of the Magi* in Berlin (III.A.1c) painted by Jacques Daret in 1434/35 can both be regarded as free variations on a lost composition produced by Campin possibly around 1415.
Copy: circa 1500. Terminus post quem (dendrochronology according to Klein 1996): 1487/circa 1493 + min. 2 + x. Tschudi: sixteenth century.

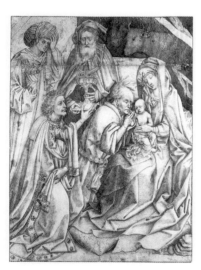

[1]

Further Copies: The Berlin Kupferstichkabinett possesses a very precise drawing which was probably copied direct from the original (Inv. No.: KdZ 2403; Sonkes C3; fig. [1]a). In a panel in the Museo di Castelvecchio in Verona, attributed to Jacob van Oostsanen or his workshop (fig. 238; Friedländer vol. 12, No. 257; Collobi Ragghianti 1990), the group of figures is very precisely copied in all its details, but set against a newly invented landscape. For a list of further copies see Friedländer and Cat. Berlin 1931.

Commentary: See pp. 191, 210-212.

Provenance: Purchased 1821 from the Solly collection.

Literature: M: Tschudi, pp. 105-107; Winkler, p. 13 s; Friedländer, vol. 2, No. 76a; Tolnay, copies No. 3; Panofsky, pp. 158, 160, 175; Davies, Campin/Berlin 6; Châtelet, Cat. C9.
S: Cat. Berlin 1931, p. 293; Kerber 1938; Winkler 1960, p. 140, n. 5; Cat. Berlin 1975, p. 79; Collobi Ragghianti 1990, No. 323.

III.E.4/C Madonna in Glory (Maria in sole) (Copy)

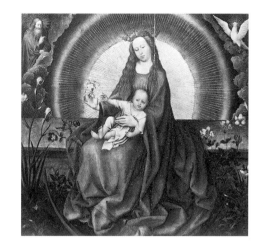

Wood (oak); 83 x 90 cm
Douai, Musée de la Chartreuse

Condition: The panel is slightly cropped at the bottom.

Attribution: According to Hulin 1902 the figure of the Virgin is copied from the Aix Madonna (III.F.4), which the author attributes to the Master of Flémalle. This is justifiably contradicted by Tombu 1930, who provides evidence of two further versions of the composition. She believes that all three are based on a lost prototype by Campin. According to Châtelet the original model which he attributes to Campin may have been a triptych.
The clumsy composition, as transmitted in the Douai version, cannot be based on Campin. At most, the figure of the Christ Child may be a copy from a work by the master. The crown of the second Wise Man in III.E.3/C is similar to the crown of the Virign.

Dating: Copy: circa 1520. Terminus post quem (dendrochronology according to Klein 1996): 1498/circa 1504 + min. 2 + x. *Lost original*: circa 1425. According to Châtelet circa 1420.

Further Copies: See Tombu 1930 and Châtelet.

Provenance: Housed in the Chapel of Our Lady in the Abbey of Saint-Bertin, Saint-Omer until the French Revolution; purchased by M. Fouquet de la Motte from a cooper in Saint-Omer; passed on by him in 1836 to Dr. Escallier in Douai, who donated the work to the museum in 1857.

Literature: M: Asperen de Boer et al., F17; Châtelet, Cat. C6.
S: Hulin 1902, XLV; Tombu 1930.

III.E.5/C Madonna with the Pear (Copy)

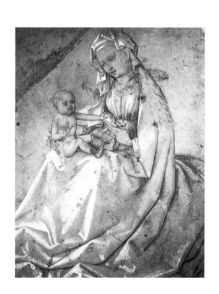

Silverpoint and pen (brown ink), heightening with white brushstrokes on brown prepared paper; 26.5 x 20.6 cm
Rotterdam, Museum Boymans van Beuningen (Koenigs collection); Inv. No. 76

Condition: Cropped on all sides.

Attribution: According to Winkler the panel painting auctioned in Vienna (see *Further Copies*) may be by a student of the Master of Flémalle in emulation of a work by his teacher, possibly the Salting Madonna (I.13). However, the panel painting is a copy of a composition that is rendered more precisely in the Rotterdam drawing which Winkler did not know of. Musper 1948 ascribes the lost original to Rogier van der Weyden, while Panofsky situates it in the circle around Campin. Sonkes 1969 believes that the original model may have been a work produced by Campin before the Salting Madonna.

In the drawing in question the Vrigin and Child have the same soft and fleshy facial traits as in the Berlin *Adoration of the Magi* (III..3 / C). The characteristically large hand and slender wrist of the Virgin can also be found there and in III.E.1.

Dating: Original: circa 1440(?). *Copy*: around 1500 or later.

Further Copies: Panel painting (35 x 26 cm), auctioned by Weniger and Strach in Vienna, ill. 9 in Winkler. The group is presented here under an arch of tracery against a dark background. The Virgin and Child also appear in a later panel painting together with the figure of the donor (auctioned by Robert Finck, Brussels, 24-17 December 1967, No. 5 with ill.).

Provenance: Frans Koenigs collection, Haarlem; 1940 D. G. van Beuningen

Literature: M: Winkler, p. 15; Panofsky, p. 252 (n. 1).
S: Musper 1948, pp. 20, 58; °Sonkes 1969, Cat. no. C6.

III.E.6/C The Revenge of Tomyris (Copy) → Fig. 202 and det. (204)

Canvas; 176 x 176 cm
Berlin, Staatliche Museen, Gemäldegalerie (not on exhibition)

Inscriptions: Numerous inscriptions, some in Kufic letters, on the robes of individual figures, on the blade of the sword and on the edge of the urn. The word *IYCTIXIa* can be deciphered on the executioner's sword-blade (according to Kemperdick, p. 189, n. 112)

Attribution: The square canvas painting with almost life-size figures was first described by Tschudi as a copy after a work by the Master of Flémalle. This attribution was subsequently adopted by most scholars (Hulin 1901, Winkler, Friedländer, Tolnay, Panofsky, Sonkes 1969, Davies and Châtelet). Two diverging views should be noted: Sobotka 1907 found that neither technique nor form offered sufficient grounds for associating the lost original with the Master of Flémalle. Dhanens 1984 assumes that the original painted for Ghent must have been created by a painter active in that city. (She suggest that the artist may have been the *presentmeester* Willem de Ritsere who died in 1447, but does not exclude the possibility that the design may have been supplied by Hubert van Eyck.) Kemperdick notes a number of analogies with works in the Flémalle group, but also considers it possible that the author was a painter in Ghent. Above all in view of the scene with Jael and Sisera (II.5), which he attributes to the same painter, he considers it possible that Hubert van Eyck was the author.

The folds of the drapery with the slightly curved parallel lines (particularly evident in the figure of the executioner) is not to be found in Campin's œuvre, but is typical of most works by the Master of the Madonna before a Grassy Bank. An attribution to this master would seem justifiable especially given the form of the left hand of Cyrus and the strikingly angled right hand of Tomyris. The crown of the beheaded victim is similar in style to that of the youngest Wise Man in the Berlin *Adoration of the Magi* (III.E.3 / C).

Dating: Circa 1425 (lost original). Friedländer considers it an early work. Kemperdick, with Hubert van Eyck in mind, believes it may have been made in 1424/25. Dhanens 1984 proposes dating the original after 1432, but bases this supposition on an incorrect interpretation of the elements in a copy dated 1610 by Pieter Pieters (fig. [1]) derived from the Ghent Altarpiece. (See *Commentary.*)

The Berlin copy dated by Hulin 1901 to the fifteenth century and by Friedländer to around 1480 was undoubtedly produced no earlier than the sixteenth century. (See Bock/Rosenberg in Cat. Berlin 1930 and Dhanens 1984, p. 40).

Further Copies: In our opinion the Berlin copy is closest to the lost original. A sketchily drawn small-scale copy (13.6 x 10 cm) on paper (fig. [2]) has survived in the Berlin Kupferstichkabinett and was probably produced directly from the original in the fifteenth century (Sonkes 1969, No. I.1). The faces, in particular, and to a lesser extent the garments, are almost entirely devoid of Campinesque traits. The sheet, which probably belonged to a sketchbook has a view of the city of Ghent on the back (fig. [3]; see Dhanens 1984, p. 40) and, contrary to the opinion voiced by Sonkes, was probably drawn by the same artist as the drawing on the front.

[1]

In comparison with the Berlin drawing, the copy created in 1610 by the Ghent painter Pieter Pieters (fig. [1]) indicates a number of distinct changes (modernised drapery, addition of a second female figure on the upper right, the bust of Tomyris amended to emulate the Virgin from the Deësis in the Ghent Altarpiece). The fact that Pieters created his copy for the Hall of Justice "van het Vrije" in Bruges indicates the the original or a copy of the original still graced a courtroom in Ghent in accordance with the original intention of the composition. Whereas Dhanens 1984 regards the Bruges painting (fig. [1]) as a more faithful rendering of the original than the Berlin copy, we assume that Pieter Pieters did not paint his copy after the original, but after the Berlin canvas which may well have replaced the original in the sixteenth century. The quillon of the sword has an independent form in the drawn copy (fig. [2]) which differs from the form shared by the Berlin painting and the Bruges version by Pieter Pieters. The painting, hung in the courtroom in Bruges, was soon famous in its own right and also served as a model for a replica now in the Gemäldegalerie der Akademie der bildenden Künste in Vienna (Friedländer, No. 75b) and for a compositional adaptation as *Judith and Holofernes* now in Greenville, U.S.A. (Friedländer, No. 75c). Kemperdick's view that Pieter Pieters copied the Vienna painting cannot be correct. The proposal by Sulzberger 1966 that the Vienna version should be attributed to Ambrosius Benson, active between 1519 and 1550, is undoubtedly wrong. Trnek 1997 ascribes it to an artist in the circle around Michiel I. Coxcie (1499–1592) and dates it more correctly to around 1600. Dhanens 1984, p. 31, n. 1, mentions further copies in private collections. The painting auctioned at Christie's in New York on 3 June 1987 (see Dhanens 1987, p. 34, n. 5) is a partial copy after the copy by Pieter Pieters in Bruges.

Commentary: See pp. 191-194. Hugo von Tschudi saw the painted copy in Berlin "in size and heathen subject matter" as a work with an affinity to the netherlandisch "town hall paintings" of a later period. He incorrectly interpreted the reliefs of the capital as scenes from the Old Testament (The Expulsion from the Garden of Eden and the Cluster of Grapes). Hulin 1901 established that the text of the *Speculum humanae salvationis* was the actual source for

recto

[2] verso

this particular portrayal and at the same time noted that this composition deviates clearly from all the miniatures known to him accompanying the typological text. Given the fact that this classical theme is so rarely portrayed in painting, he concludes that the entries in three seventeenth century inventories of paintings of the chapterhouse of Saint Bavo in Ghent (*Tomyris met het hooft van Cyrus*, etc.) refer to the original, a panel painting from the fifteenth century. Recent research by Carl van de Velde 1967 and Elisabeth Dhanens 1984 has provided considerable evidence in support of the fact that the original was created for a courtroom in Ghent.

An incorrect interpretation of the copy created by Pieter Pieters in 1610 (fig. [1]) has led Elisabeth Dhanens to an erroneous attribution and dating of the lost original. There can be no doubt that Pieters in his later version remodelled the bust of Tomyris to emulate the Virgin in the Deësis group of the Ghent Altarpiece by giving the pagan queen the facial traits of Hubert van Eyck's Madonna and ornamenting her dress and sleeves with same trimmings as the robe of the Virgin. As regards the figure of Tomyris, there is no reason whatsoever for the transparent veil appended to her turban to be extended over her shoulders and fastened with heavy ornamental rosettes, nor for the robe to be adorned with the same tasselled cords that tie the garment of the Virgin in van Eyck's altarpiece.

Dhanens 1984 points out that the seventeenth century inventories cited by Hulin 1901 already refer to a collection of works from different sources and that the chapterhouse of Saint Bavo, i.e. the courtroom of the ecclesiastical court of Ghent, need not necessarily have been the originally intended location of the Tomyris panel. The author assumes that the original was in fact part of a larger series of images of justice in one of the two courtrooms of the Ghent city hall mentioned in glowing terms by two sixteenth century authors with no mention of the artists' names or the themes portrayed. According to Kemperdick on the other hand, the chapterhouse was the original location because the building was used as the seat of the magistrates in the fifteenth century.

The original *Revenge of Tomyris* was probably part of a diptych, and its pendant may well have been a typologically appropriate scene from the *Speculum humanae salvationis*, such as Jael and Sisera or Judith and Holofernes. Either of these themes would lend themselves as images of Justice. Lutz/Pedrizet 1907/1909 and Châtelet reconstructed the original ensemble as a triptych. According to Kemperdick the original ensemble featured all four scenes of the *Speculum*, including Our Lady's Victory over the Devil. It is questionable that the drawing of the servant of Judith, first published by Kemperdick (ill. 138) had any connection with the courtroom paintings.

Winkler and Dhanens 1984 assume, probably correctly, that the pendant to the Tomyris scene has survived in a drawing of *Jael and Sisera* (II.5) now in Brunswick, which both authors attribute to the painter of the *Tomyris* panel. This drawing is of unusually high quality – we regard it as a possible original by Hubert van Eyck – and although the composition has a different scale between the figures and the picture format, the similarities between the two compositions listed by Winkler suggest a close relationship between the two works.

Provenance: Described in 1636 in the Alcázar of Madrid, possibly in the Pardo palace as early as 1564. Donated to the museum in 1893 by Sir J. Charles Robinson (according to Kemperdick and Franke).

319

Literature: M: Tschudi, pp. 103-105; Winkler, pp. 22s, 45; Friedländer, vol. 2, No. 75 a-c; Tolnay, copies No. 8; Panofsky, p. 175 (n. 5); Davies, Campin/Berlin 5; Châtelet, Cat. C7; Kemperdick, pp. 112-118.

S: °Hulin 1901; Sobotka 1907; Lutz/Pedrizet 1907/1909, p. 294; Cat. Berlin 1930, No. 1975; Cat. Berlin 1931, No. 537B; Braun 1954; Sulzberger 1966; van de Velde 1967, pp. 198, 200s; °Sonkes 1969, No. I.1; Mairinger/Hutter 1981; °Dhanens 1984, pp. 31-52; Trnek 1997, p. 58; Franke 1997, pp. 29-32.

F. Master of the Louvain Trinity

III.F.1 Trinity of the Broken Body with Angels → Figs. 111, 211

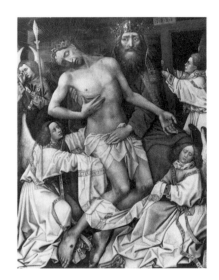

Wood (oak); 127.7 x 93 cm
Louvain, Stedelijk museum Vander Kelen-Mertens, Inv. No. 8

Inscriptions: In golden letters on the seam of the left sleeve of the figure of God: *DE P[RO]FUNDIS · CLAM ...*; and on the hem of the robe: *MARIA : GRACIA : PLENA : D[O]MINUS : TEC ...*

Condition: Only the feet of the dove of the Holy Spirit remain. The face of Christ and the face of the angel bearing a lance are largely reconstructed.

Attribution: Tschudi regards the work as an original by the Master of Flémalle. Friedländer, Tolnay, Frinta and Davies consider it to be a copy after Campin. Panofsky ascribes it to Campin's workshop. Infrared studies have shown distinct differences between the underdrawing and the painterly execution, indicating that this is not a copy in the narrower sense. The argumentation presented by Taubert 1959 to the effect that the panel and the version by Colijn de Coter are both based on a lost work by Robert Campin is unconvincing. Asperen de Boer et al. ascribe the underdrawing to Rogier van der Weyden and the painterly execution to his workshop. (A similar thesis was posited by Steppe 1975.) According to Kemperdick the panel may be by a master who underwent his training around mid-century in the workshop of the municipal painter of Brussels. Châtelet sees it as a work by Jacques Daret. However, the shaded areas of the underdrawing frequently feature the slightly curved and intertwined vertical strokes so typical of many drawings in the Pseudo-Vrancke van der Stockt group. (See Asperen de Boer et al., ill. 272). The same abbreviature for eyes and nose can also be found in the underdrawing and in the group of drawings. (See Asperen de Boer et al., ill. 272).

[1]

Dating: Circa 1435. Terminus post quem (dendrochronology according to Klein 1996): 1378/circa 1384 + min. 2 + x. Steppe assumes that the panel was produced between 1435 and 1445. Châtelet proposes 1425–30, which would contradict the original destination as an altarpiece. Kemperdick regards it as a freely interpreted copy after an original which he dates to some time before 1450.

Copies: In spite of its modest artistic quality, the painting, originally the central panel of a triptych, is one of the most frequently copied works of early Netherlandish painting. Adhémar 1962 lists 28 such copies. The most important works for a reconstruction of the original appearance are the fragments, now in the Louvre, of a triptych by Colijn de Coter (fig. [1]; see Adhémar 1962) and a drawing published by Steppe 1975, ill. 4, showing the kneeling donor on the left hand panel wearing the ceremonial robes of the Louvain Guild of Cross-bowmen. The figures of the Virgin Mary and Saint John were probably set above him, with Mary Magdalene on the right hand panel together with another mourning woman. There is nothing to support Kemperdick's assumption that there was a further no longer extant variation of this composition in a broader format.

Commentary: See p. 197 s. According to Steppe the triptych was intended for the altar of the Chapel of the Holy Trinity in the ambulatory of the Church of Saint Peter in Louvain. It probably served as a burial chapel for the patrician family van Baussele. The chapel was built in the years 1435–1445. (According to Asperen de Boer et al., p. 223, it was completed in 1434). The donor may have been the city clerk of records Gerard van Baussele († 1473).
Scholars unanimously agree that there is a connection with the other portrayals of the Trinity of the broken body in the Flémalle group. In our opinion, the *Trinity* is a variation on the design for the central image of the altar dossal of the Order of the Golden Fleece (I.23a), created by Robert Campin after 1433. (God bears the same crown of lilies; even the position of the dove's feet is identical.)

Provenance: Louvain Church of Saint Peter, Chapel of the Trinity in the ambulatory; replaced before 1669 by a new altarpiece by Gaspar der Crayer; documented in 1824 as part of the art collection in the Louvain Town Hall.

Literature: M: Tschudi, pp. 99-101; Friedländer, vol. 2, No. 71a; Tolnay, copies No. 6; Panofsky, p. 175; Frinta, p. 115 s; Davies, Campin/Louvain; Asperen de Boer et al., W9; Châtelet, Cat. Da; Kemperdick, pp. 128-131.
S: Bauch 1944; Taubert 1959; Adhémar 1962; Sonkes 1971/72; Smeyers 1975; °Steppe 1975; Dijkstra 1990; Dierick 1991.

III.F.2 The Holy Family → Fig. 219

Tempera on canvas; 208 x 180 cm
Le Puy-en-Velay, Cathedral (Trésor)

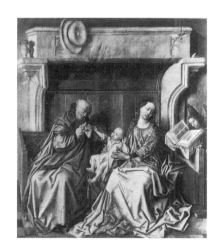

Attribution: Bloch 1963 regards this work as a copy after an original by Campin dating from around 1440, whereas Eisler 1963 sees it as a pastiche in the style of Campin from the period after 1525. According to Dupont it is by a student in Campin's workshop, who worked with Rogier van der Weyden. Likewise Sterling, who assumes that the design was by Campin himself. For Davies it is a copy after a composition by Campin or an original by one of his followers. Dhanens 1984 regards the work as a piece commissioned from a

Ghent artist by Saint Colette, founder of the Convent of Poor Clares in Le Puy, who died in Ghent in 1447. Reynaud 1989 ascribes the work to the young Barthélemy van Eyck. For Coo 1991 it is by Campin himself. Châtelet considers the painting to be a work by Colijn de Coter.

In our view, the attribution to the Master of the Louvain Trinity may be taken as certain. For the draperies of the Virgin the painter has reiterated an earlier design for a *Madonna with Reading Infant*, whose watermark can be dated to 1431. (See Sonkes 1973, Cat. no. 2; first indication of the connection between the drawing and the painting in Thürlemann 1993b). The face of the angel with the book corresponds to that of the angels in the *Trinity* (III.F.1).

Dating: Circa 1435. Bloch dates the painting to around 1500, Eisler after 1525, Dupont to the second half of the fifteenth centurys. Sterling posits 1431/32. According to Reynaud 1989 the altarpiece, which she dates to around 1435, was part of the original fittings of the Convent of Poor Clares founded in 1432. De Coo, who sees a connection with Campin's alleged pilgrimage to St. Gilles, dates the commission for the painting to 1430. Châtelet dates the work to 1490 on grounds of its attribution to de Coter.

Copy: A late sixteenth century copy is to be found in Clermont-Ferrand, Mission diocésaine (ill. in Dupont 1966).

Commentary: On the origins of the figure of the child from Campin's œuvre, see Vos 1971. The pattern on the faience vase on the mantlepiece can also be found on similar vessels in a number of works by painters of the school of Campin, albeit portrayed from different angles. (See III.E.6, III.B.11, III.D.1b).

Provenance: from the Convent of Poor Clares in Le Puy; since 1964 in the Cathedral of Le Puy.

Literature: M: Friedländer, vol. 2, nr. Add. 153; Davies, Campin/Le Puy; Châtelet, Cat. AR.7. S: Bloch 1963; Eisler 1963; Dupont 1966; Vos 1971; Sterling 1971, p. 5, n. 24; Sonkes 1973, Cat. no. 2; Dhanens 1984, p. 95 s; Reynaud 1989, p. 22 s; Coo 1991, pp. 87-90; Thürlemann 1993b, p. 41 s.

III.F.3 Diptych → Fig. 210
III.F.3a Trinity of the Broken Body
III.F.3b Virgin and Child

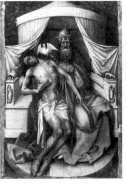

Wood (oak), each 34.3 x 24 cm (panel), each 28.5 x 18.5 cm (painting)
St. Petersburg, Hermitage; Inv. No. 447, 448

Condition: The original frames which were an integral part of the pictures themselves, were later planed off and painted with a red ornamental pattern.

Attribution: Following Tschudi, the diptych was ascribed to the Master of Flémalle or Robert Campin by Winkler, Friedländer, Tolnay, Loewinson-Lessing/Nicouline 1965 and Châtelet.

Panofsky considers the *Trinity* (III.F.3a) to be possibly no more than an excellent replica. For Frinta, who sees more or less faithful repetitions after early compositions by Campin, the diptych is painted in the same style as the Madonna of Aix. Kemperdick proposes a different authorship even though he too sees affinities with this work.

Although the format of the diptych is not the same as that of the Louvain Trinity its attribution to the same painter may be regarded as certain. Compare, in particular, the face of God, who has a very similar expression of sorrow in both works; the strangely tentacle-like black wisps at the end of his beard are also identical.

Dating: Circa 1440. Similar datings are proposed by Winkler (not much later than 1440) and Friedländer (around 1438). Tolnay dates the work to between 1430–38; Panofsky dates the diptych or the corresponding originals by Campin to around 1427/28. Frinta also regards the two works as copies after early works by Campin. Loewinson-Lessing/Nicouline 1965 date them to 1433–35, Châtelet to 1420–25. Kemperdick believes they were created in the second half of the fifteenth century.

The diptych was produced around the same time as the Madonna of Aix (III.F.4) and the design for the Holy Family Altarpiece (III.F.5), with which it shares a number of similarities. Note, in particular, the Madonna type common to all three works and the similarity of Gods crown in the St. Petersburg Trinity to the tiara of Saint Peter in the Aix painting.

Copies: Both compositions have survived in a number of variations (see Loewinson-Lessing/Nicouline 1965, pp. 14-17), of which none has been definitively identified as an actual copy. Both groups of figures are apparently based on Campin.

Commentary: See p. 198. The *Trinity* group (III.F.3a) is, in our opinion, yer another variation – in addition to the Louvain Trinity (III.F.1) – based on Campin's design for the central image of the altar dossal in the Ecclesiastical Paraments of the Order of the Golden Fleece (I.23a). In some respects, it digresses further from Campin's original (as for example in the position of Christ's left foot), whereas in other aspects it is closer to the original (such as the position of the left arm of Christ).

Provenance: Donated to the museum in 1845 as the bequest of Dimitri Tatistcheff.

Literature: M: Tschudi, pp. 96-99; Winkler, pp. 17s, 45; Friedländer, vol. 2, Nos. 64, 65; Tolnay, Nos. 6, 7; Panofsky, pp. 124s, 172s et passim; Frinta, pp. 65-67; Davies, Campin/Leningrad; Châtelet, Cat. 9; Kemperdick, pp. 126-128.
S: °Loewinson-Lessing/Nicouline 1965.

III.F.4 Madonna in a Glory (with Saint Peter, Saint Augustine and Donor) → Fig. 215

Wood (oak); 48 x 21.6 cm (including the original frame)
Aix-en-Provence, Musée Granet; Inv. No. 300

Coat of arms: The coat of arms on the offset of the original frame (*d'azur à la bande componée de gueule et d'or*) has not yet been identified.

Condition: The face of the donor has been largely reconstructed.

Attribution: The attribution of this panel to the Master of Flémalle by Witting 1900 was initially accepted by all scholars – Winkler, Friedländer, Tolnay, Panofsky and Davies – though its proximity to the style of Rogier was occasionally emphasised. Frinta was the first to exclude this panel from the œuvre of Campin and regard it as the eclectic work of a follower, possibly the same artist who painted the donor wing of the Mérode Triptych (I.12). Coo 1990 and Kemperdick also reject Campin's authorship. Coo 1990 surmises that Campin provided Rogier with a design for execution by the student. Châtelet ascribes the panel to Campin. Winkler and Frinta quite rightly emphasise the stylistic affinity with the St. Petersburg diptych (III.F.3) and Winkler points out its stylistic similarity to the Paris drawing for a family altar (III.F.5).

Dating: Circa 1440. Winkler dates the panel to before 1438, Panofsky to before the Flémalle Panels. According to Troescher 1967 Campin painted this work during his alleged pilgrimage to Saint-Gilles in 1429/30. Châtelet and Kemperdick date it around 1435.

Commentary: See p. 198s. Two proposals have been made so far regarding the identity of the donor who commissioned this work. Hulin 1902 suggested it was Abbot Pierre l'Escuyer from the Abbey of Eaucourt in Artois. According to Hulin he was the only Augustine abbot with this first name on Franco-Flemish territory during the first half of the fifteenth century. Châtelet regards the panel as a work commissioned around 1435 by Pierre Assalbit in memory of Cardinal Pierre Ameil who died in Rome in 1401. He bases his theory on a late (probably eighteenth century) note on the reverse of the panel stating that it belonged to Cardinal Pierre Ameil, who took holy orders "in this monastery": *tableau du R.P. Amelius évêque pr[ofès] de ce couvent confesseur et sacristain des papes Urbin [Grég]oire et Boniface évêque de Senogallicus après archevêque de Tarente patriarche d'Alexandrie et administrateur de la ville ... l'an ... et mourut lan ...* This note can, at the very most, be taken as evidence that the panel came from the Augustinian priory at Limoux and that the eighteenth century monks there associated the ancient work with a clergyman who had once been connected with their community.
The panel has the character of a private votive image. The coat of arms on the offset, not identical with the coat of arms of Pierre Ameil, must have been the signet of the unknown Augustine prior who, as the presence of Saint Peter suggests, probably bore the name of Pierre.

Provenance: Probably from the Augustinian priory at Limoux (Aude), dissolved after the French Revolution. Donated to the museum in 1863 by Jean-Baptiste-Marie de Bourguignon de Fabregoules.

Literature: M: Winkler, pp. 2-5, 34s; Friedländer, vol. 2, nr. 66 Tolnay, No. 8; Panofsky, pp. 169s, 172; Frinta, p. 68s; Davies, Campin/Aix; Châtelet, Cat. 17; Kemperdick, pp. 122-126.
S: Witting 1900; Hulin 1902, p. XLV; Troescher 1967, p. 108s; Coo 1990, p. 42.

III.F.5 Madonna with Donor Family and Two Saints → Fig. 221

Brown ink (pen and wash) over black charcoal on white paper; 17.8 x 23.5 cm
Paris, Musée du Louvre, Cabinet des dessins; Inv. No. 20.669

Attribution: Hulin 1902 initially regarded this drawing as an original by the Master of Flémalle, later (according to Sonkes 1969) as a copy after one of his paintings. This later assessment is also shared by Winkler and Friedländer. Winkler quite rightly sees a close relationship to the Madonna in Aix (III.F.4) and the Madonna in the St. Petersburg diptych (III.F.3b). According to Schmarsow 1928 it is an original that has later been reworked with pen and wash. Winkler 1965 added this drawing to the list of drawings attributed by Wescher 1932 to Vrancke van der Stockt. This attribution is rejected by Sonkes 1969 and Sonkes 1973, even though Winkler 1965 established the use of precisely the same abbreviatures for eyes and nose as in the other drawings. Frinta finds that the facial traits of the Virgin are the same as in the works by Jacques Daret. For Davies this drawing is either a design by Campin or a copy after one of his works. For Sterling 1971, p. 8, and Sonkes 1969 it is a copy.

Dating: Circa 1440. Winkler and Panofsky, who regarded the drawing as a copy, dated the original to around 1438, the period in which the Werl Panels were painted. Winkler dates it to around the time of the *Madonna in a Glory* (III.F.4) and the St. Petersburg diptych (III.F.3), but considers it slightly later on grounds of the more freely drawn pose of the Virgin. Sterling 1971 proposes that the original was created some time between 1425 and 1435, on grounds of costume, while Sonkes 1969 dates the original around 1433/34. This author dates the drawing itself to the sixteenth century.

Copy: A work at the Ecole des Beaux-Arts in Paris (Sonkes 1969, Cat. no. 8) is a later copy after the drawing in the Louvre.

Commentary: See p. 200. The drawing is listed here by way of example of the twenty surviving drafts by the Master of the Louvain Trinity. The remaining sheets, albeit with different attributions and datings, are described in detail by Sonkes 1973. The compositional similarity with early fifteenth century tombstones in Tournai has been pointed out on several occasions, as by Ring 1923 and Rolland 1931. Tombu 1930 noted that the pose of the Infant Christ corresponds to that of the Douai Virgin (III.E.4/C). The patron saint of the donor, thought by Winkler to represent Saint Roger, was correctly identified by Schmarsow 1928, p. 66, as Saint James the Greater. (Cf. also Sterling 1971). The female saint is Saint Catherine.
This sheet with its unusual technique was probably intended, as Schmarsow 1928, p. 65, surmised, to "arouse a satisfactory and appealing impression of the finished painting in the eyes of the potential donor couple".

Provenance: As 1.10.

Literature: M: Winkler, pp. 5 s, 33, 34, 35, 37 s, 40; Friedländer, vol. 2, nr. 72a; Panofsky, p. 173, n.; Frinta, p. 121; Davies, Campin/Paris; Châtelet, Cat. 15.

S: Hulin 1902, p. XXXVIs; Ring 1923, p. 283 s; Schmarsow 1928, p. 65 s; Tombu 1930, p. 122; Rolland 1931, p. 303; Wescher 1938 (not mentioned); Winkler 1965, p. 155; Cat. Paris 1968, No. 11; °Sonkes 1969, Cat. no. C7, C8; Sterling 1971; Sonkes 1973.

III.F.6 Diptych
III.F.6a Portrait of a Franciscan Monk
III.F6b Virgin and Child

Wood (oak); 22.7 x 15.3 cm: III.F.6a; 22.5 x 15.4 cm: III.F.6b (with frame); 18.7 x 11.7 cm: III.F-6a; 18.7 x 11.6 cm: III.F.6b (painted surface)
London, National Gallery; Inv. No. 6377, 6514

Attribution: Davies 1966 ascribes the portrait to Robert Campin and compares it with the male donor in the Mérode Triptych (I.12). This attribution is indirectly called into question by Smith/Wyld 1988 in that the authors consider the newly discovered Madonna panel to be of considerably higher quality than the portrait. According to Campbell 1996, p. 130, both works were produced in Campin's workshop. The author regards the Virgin and Child as the work of Jacques Daret and the portrait as that of another, unknown, student of Campin. Campbell 1973 drew a link between the portrait and the author of the Mérode Triptych, which he distinguishes from Campin. Châtelet labels both works a "pastiche" on grounds of what he regards as inconsistencies, insinuating that they are forgeries. Kemperdick also stresses alleged inconsistencies in the composition. In his view there is a material connection, rather than a stylistic one, between the two panels, which he does not regard as belonging to the Flémallesque œuvre in a narrower sense.

In our view, both panels are by the same artist, the Master of the Louvain Trinity, and were intended as a pair. If the *Virgin and Child* appears to be of higher quality, then this may be because the artist was able to base it on a composition by his teacher Campin. Although the Virgin has a facial type that differs from that of the works produced around 1430 (III.F.3b, III.F.4, III.F.5), the drapery style is the same. The fire in both the London and St. Petersburg portrayals of the Madonna (III.F.3b) must have been painted by the same artist.

Dating: 1445/1450. Terminus post quem (dendrochronology according to Klein 1996): 1331/circa 1337 + min. 2 + x for both panels, both of which are cut from the same tree trunk.

Davies 1966 does not comment on the date of the portrait. Campbell 1973 dates the male portrait to around 1430.

Commentary: In our view the two works belong together as a diptych. The arguments presented by Smyth/Wild 1988 against this possibility are not necessarily watertight. The fact that there are no hinges might merely indicate that the two small panels were kept together, perhaps in a leather case, for instance. The difference in size and the fact that the portrait occupies the heraldically dominant position can be explained by the fact that the *Virgin and Child* is not iconic and is intended as a scene contemplated inwardly by the donor. The two portrayals are related both in the use of colour and in the treatment of space. The monk

with the scroll in his hand – probably an indication of a prayer uttered by him – is looking to the right, towards the *Virgin and Child*. The fact that the orthogonals in the Marian scene, as in the comparable work in St. Petersburg (III.F.3b), run towards a vanishing point to the left beyond the actual picture plane strongly indicates that this painting possessed a pendant.

Provenance: III.F.3a: A.L. Nicholson collection; 1965 Bonham sale; 1966 purchased for the museum from Messrs Agnew, London. III.F.3b: Melanie von Risenfels (1898–1984), Schloss Seisenegg; 1987 purchased from Edward Speelman Limited. (According to Campbell 1998)

Literature: M: Friedländer, vol. 2, Add. 148; Davies, Campin/London 5; Châtelet, Cat. AR5, AR6; Kemperdick, p. 131 s.
S: Davies 1966; Campbell 1973, Cat. no. VIII; Smith/Wild 1988; Urbach 1995; Campbell 1996, °Campbell 1998, pp. 80-82, 83-91.

G. Various students and emulators

This last section lists works that bear a close stylistic affinity with originals by Campin. They may have been painted by other students of Campin or by artists skilled in emulating his style. The first two works mentioned here, III.G.1 and III.G.2, may well be early portraits (around 1430) by Rogier van der Weyden. III.G.4 and III.G.5/C would also appear to belong together. Apart from those whose names we actually know, Robert Campin also had a number of other students, and it should therefore come as no surprise to find his style reflected frequently, albeit with the different personal slant of other artists.

III.G.1 Portrait of a Man

Wood (oak); 31.8 x 23 cm
New York, Metropolitan Museum of Art (Bequest of Mary Stillman Harkness); Inv.-No. 50.145.35

Condition: The portrait is in poor condition. It appears to have been cropped slightly on all sides. The background is overpainted.

Attribution: Hulin 1926 posits it as an early work by Rogier van der Weyden. Destrée 1930, Winkler 1942 and Panofsky, p. 292, accept this attribution. Tolnay ascribes it to Campin. Frinta, p. 78, sees a stylistic affinity between the portrait and the fragment showing Saint Joseph in the Gulbenkian Foundation (III.B.6). Campbell 1973, who points out its affinity with the *Portrait of a Man* in London (III.G.2), ponders an attribution to Campin.
In our opinion the elegantly elongated fingers favour an attribution to Rogier. The treatment of the neck area is very similar here to the Portrait of a Man in London (III.G.2). Ainsworth in Ainsworth/Christiansen 1998 also emphasises the affinity to Rogier van der Weyden.

Dating: Circa 1430. Terminus post quem (dendrochronology according to Klein 1996): 1421/circa 1427 + min. 2 + x. Hulin 1926 and Panofsky regard the portrait as one of the earliest surviving works by Rogier van der Weyden. According to Campbell 1973 the portrait was probably painted before 1450, and if the attribution to Campin is correct, it was painted around the same time as the *Portrait* of a Man in London (III.G.2). Ainsworth in Ainsworth/Christiansen 1998 dates it to around 1430/35.

Copy: Brescia, Pinacoteca Tosio-Martinengo. On copper; 33.5 x 24.5. Apparently old. It shows the portrait in its uncropped state. (ill. 6 in Campbell 1996).

Commentary: Hulin 1926 assumes that this was originally the right wing of a diptych with the Virgin and Child. Panofsky and Campbell 1973 surmise, less persuasively, that the panel may be a fragment of a larger composition. Campbell 1996 and Ainsworth in Ainsworth/Christiansen 1998 adopt Hulin's view.

Provenance: Collection of the Earls of Darnley; auctioned in London in 1925; Colnaghi London; 1927/28 Knoedler New York; Harkness Collection, New York; 1950 donated to the museum.

Literature: M: Tolnay, No. 11; Panofsky, p. 292.
S: Hulin 1926; Destrée 1930, p. 180; Winkler 1942; Campbell 1973, Cat. no. IV; Campbell 1996, p. 127; °Ainsworth/Christiansen 1998, p. 146.

III.G.2 Portrait of a Man → Fig. 60

Wood (oak); 40.6 x 28.1 cm
London, National Gallery; Inv. No. 653.1

Condition: This portrait is not as well preserved as the Portrait of a Woman (I.9), with which it forms a diptych of a married couple. The paint is unusually strongly craquelé in the area of the red chaperon.

Attribution: On previous attributions see I.9. As Frinta has outlined most persuasively on the basis of style and painterly technique, the *Portrait of a Man* cannot have been painted by the same artist as the *Portrait of a Woman* (I.9) with which it forms a diptych. However, as the two portraits are painted on exactly the same support material, it must be assumed that Campin had one of his students undertake the *Portrait of a Man* for the diptych. A comparison with the New York *Portrait of a Man* (III.G.1) suggests that the student in question may well have been Rogier van der Weyden. The neck area, in particular, is very similar in both these portraits.

Dating: Circa 1430 like the corresponding Portrait of a Woman. See I.9.

Commentary: See p. 80.

Provenance: See I.9.

Literature: M: Tschudi, pp. 31-34; Winkler, p. 10; Friedländer, vol. 2, No. 55; Tolnay, No. 13; Panofsky, p. 172; Frinta, p. 57s; Davies, Campin/London 1; Châtelet, Cat. 14; Kemperdick, pp. 119-122.

S: Passavant 1858, p. 128s; Bode 1887, p. 218s; Hulin 1939; Davies 1953, No. 33; Campbell 1973, Cat. no. III, pp. 370-372; Campbell 1974, p. 642s; Campbell 1996, pp. 123-127; Campbell 1998, pp. 72-79.

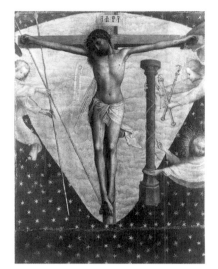

III.G.3 The Intercession (Fragment)

Wood (oak); 37.7 x 26.6 cm
Brussels, Musées Royaux des Beaux-Arts; Inv. No. 4058

Inscriptions: On the banderole beside the upper torso of Christ: *consummatum est.*

Condition: This panel is a fragment of a composition. The full version has survived in the form of two copies which, though stylistically very closely related to one other, each feature different donor figures. (See *Copies*). The composition has been sawn apart and two pieces reaffixed, in a different position from that of the originally intended composition, and overpainted accordingly (Cat. Bruxelles 1996, ill. 20). Yet even the original itself was a painterly palimpsest. The original state featured the crucifix, while the second altered state featured the angels with the *arma Christi* and the overpainting of the background with a starry sky and bands of clouds. The theory posited in Cat. Bruxelles 1996 to the effect that the panel was created in a single working process that also included the angels cannot be correct, as the X-radiography photograph (ill. 22) shows that the two angels to the right of the crucifix are superimposed over the remains of a long banderole on two pieces of wood.

Attribution: According to Frinta, the figure of Christ crucified, which the author erroneously regards as overpainting, can be associated with Campin's workshop. Châtelet considers the Brussels fragment to be the remains of a copy, possibly produced in Campin's workshop, after an original by Campin himself. (For earlier attributions see Cat. Bruxelles 1996, p. 58s). Frinta's remark that the crucifix shows how Campin's type of Christ crucified may have looked is supported by a comparison with the partial copy produced by Gerard David after a *Crucifixion* by Campin (I.14/C). Yet this does not mean that the crucifix with the extremely slender limbs in the Brussels fragment is an original by Campin. Stylistically, it is closer to the work of Rogier van der Weyden. In our opinion it could be an early work by the author of the Berlin *Crucifixion* (II.3), presumably a co-worker of Rogier van der Weyden.

Dating: Around 1440 (original composition with the crucifix) and 1451(?) (overpainting with angels). Terminus post quem (dendrochronology according to Vynckier in Cat. Bruxelles 1996, p. 55): 1401/circa 1407 + min. 2 + x. Châtelet dates what he regards as the lost original to around 1415–1420. The dating "A.M. 1451" on the drawing that is a partial copy (see *Copies*) may have been adopted from the reworked original of which the Brussels fragment is a part.

[1]

Copies: Bruges, Church of Saint Saviour (held in the Groeninge-Museum): wood, 68 x 69 cm (fig. [1]), and Madrid, Museo Lazaro Galdiano; Inv. No. 3034: wood, 69 x 56 cm. Both panels are probably works by a painter active in Bruges in the second half of the fifteenth century. A third version dating from the early sixteenth century, featuring only the cross and the figure of the Virgin Mary (interpreted by Reis-Santos as Mary Magdalen) in a landscape that has at the very least been modernised (Fig. [2]), was formerly in the collection of Dr. Ricardo de Espirito Santo Silva in Lisbon. This work may reflect the original, Rogieresque composition prior to overpainting. Sonkes 1969 lists a drawing that is a partial copy of the head of the Virgin Mary dated *"A.M. 1451"*.

Provenance: Borghese Collection, 1891 collection auctioned in Paris; Edouard Aynard Collection, Paris; 1913 acquired by the museum at the auction of the collection in Paris.

Literature: M: Frinta, pp. 113-15; Châtelet, Cat. C3.
S: Reis-Santos 1962, pp. 57-60; Sonkes 1969, Cat. no. C19; °Cat. Bruxelles 1996, No. 2.

[2]

III.G.4 The "Scupstoel" Drawing (Men Shoveling Chairs)

Pen (brown ink) over black charcoal on paper; 29.8 x 42.5 cm
New York, Metropolitan Museum of Art (Robert Lehman Collection); Inv. No. 1975.1.848

Inscription: verso in fifteenth century script: *tpatroen van den scupst[oe]l / ende van spapenkeld onder*

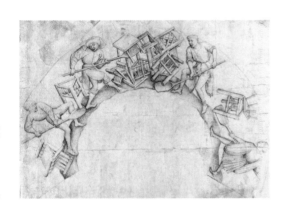

Attribution: The drawing, whose connection with Brussels has been ascertained (see *Commentary*), is generally ascribed to an assistant in the workshop of Rogier van der Weyden. This artist is frequently identified – correctly, we believe – with the Master of the Exhumation of Saint Hubertus (Friedländer vol. 2, Nos. 18, 19). In our view, the same master created a further unusual drawing in a similar large format: the Procession in the British Museum (Sonkes 1969, Cat. no. I.41). The close relationship between these two drawings is also stressed by Haverkamp-Begemann in Cat. New York 1999. The smaller figures in Rogier's Seven Sacraments altarpiece in Antwerp (III.B.16) are also probably by the Master of the Exhumation of Saint Hubertus. De Vos 1999 recently described the drawing as a possible original by Rogier van der Weyden.

Scholars previously failed to notice that the "Scupstoel" drawing, in terms of technique and costumes, is closely related to the design created by Campin around 1415 for two scenes from the life of Saint Julian of Brioude (I.4). (Compare for example the first figure on the right in the "Scupstoel" drawing with the central figure in Campin's design.) Moreover, the costume of the second figure from the right also occurs in an earlier drawing of the Flagellation of Christ created around 1420 by the Master of the Louvain Trinity (Fig. 216). It may be assumed that the picturesque figure is an invention by Campin. We think it likely that the Master of the Exhumation of Saint Hubertus, a leading assistant to Rogier van der Weyden in the period around 1440–50 (cf. Campbell 1993, pp. 16-20), was also about the same age as Rogier and a former fellow student under Campin.

Dating: Circa 1445. Sonkes 1969 dates the drawing to around 1445–50.

Commentary: This drawing, discovered only in 1948, is a design in the form of a programme for a still extant capital in the east wing of the Brussels Town Hall. The themes make punning references to the names of the houses demolished to make way for the new building erected in 1444–1450, including a house known as "de Scupstoel". For details, see Haverkamp-Begemann in Cat. New York 1999, p. 108s.

Provenance: Robert Lehman Collection.

Literature: S: °Sonkes 1969, Cat. no. I.43; Campbell 1993; de Vos 199, Cat. No. B15; °Cat. New York 1999, Cat. No. 23.

III.G.5/C The Mass of Saint Gregory

Wood (oak); 85 x 73 cm
Brussels, Musées Royaux des Beaux-Arts; Inv. No. 6298

Attribution: Since Tschudi the version formerly held in New York (Fig. [1]; see *Further Copies*) has been regarded by almost all scholars (Hulin 1902, Winkler, Friedländer, Tolnay, Panofsky, Frinta and Châtelet) as a copy after a lost original by Campin. One exception is Davies, who does not believe that the composition should be associated with Campin at all. Valentiner 1945 regards the New York version as an original by Rogier van der Weyden; for Musper 1952 on the other hand, the Brussels version is the original. He does not give an attribution. According to Kemperdick the composition has less to do with the Flémallesque œuvre than with the circle around Rogier.

In our view the drapery and figures, and especially the treatment of space, do not correspond stylistically to the works known with certainty to be by Campin. Instead, it is a copy after a work by the Master of the Exhumation of Saint Hubertus from the period around 1440, when the panels in London and Los Angeles were also created (Friedländer vol. 2, Nos. 18, 19). A comparison of the deacon on the right with the deacon in the same position in the London painting renders any further justification of this thesis more or less unnecessary. (Fischel 1958 was the first to link it with the panel of the Exhumation of Saint Hubertus. Kemperdick ascribes the lost original of the Mass of Saint Gregory to the author of the Dream of Pope Sergius who is not, in his opinion, the Master of the Exhumation of Saint Hubertus.)

Dating: Original: circa 1440. *Copy:* circa 1510. Terminus post quem (dendrochronology according to Vynckier in Cat. Bruxelles 1996, p. 65): 1484/circa 1490 + min. 2 + x. Friedländer dates the lost original to 1430, while Frinta places it in the period of the Seilern triptych.

Further Copies: A further copy of equal quality dated to 1514 (83.5 x 71 cm), from the Nationalmuseum in Nuremberg, formerly in the Weber Collection in Hamburg and Nicholas M. Acquavella Galleries, New York; Fig. [1], is now in the Marston Collection, USA. A portrayal

[1]

of *The Mass of Saint Gregory* on an outer wing of the altarpiece dated to 1473 in the parish church of St. Maria zur Wiese in Soest is a freely interpreted copy of the composition (ill. in Cat. Münster 1952, Nr. 234).

Commentary: Given the laterally shifted point of view, the original may have been the left wing of a diptych. Inventories of the collection of Margarethe of Austria dated 1516 and 1524 mention a diptych ascribed to Rogier van der Weyden whose pendant featured a Crucifixion with the Virgin embracing the cross. In contrast to the views expressed by Davies and Châtelet this may well have referred to the lost original. (See Firmenich-Richartz 1898/99).

Provenance: Moreira Collection, Lisbon(?); 1932 purchased by the Brussels museum from R. Poupé

Literature: M: Tschudi, p. 107 s; Winkler, p. 19; Friedländer, vol. 2, No. 73a, Add. 150; Tolnay, copies No. 5; Panofsky, p. 175 (n. 4); Frinta, p. 117; Davies, Campin/Brussels 2; Châtelet, Cat. C13; Kemperdick, p. 144 s.
S: Firmenich-Richartz 1898/99, p. 11; Hulin 1902, Cat. no. 156; Valentiner 1945; Musper 1952; Cat. Münster 1952; Cat. Detroit 1960; Cat. Bruxelles 1996, No. 3.

III.G.6 The Crucifixion

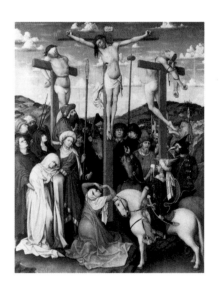

Wood (mahogany?); 119 x 92 cm
Poznan, Muzeum Narodowe; Inv. No. M0126

Inscriptions: An inscription (according to Is. 53) on the old but not necessarily original frame is cited by Châtelet.

Attribution: Bialostocki/Walicki 1955 ascribe the panel to an artist of the Netherlandish school. Regarded by Boon 1957 as a Spanish copy after the Master of Flémalle. Rostworowski 1960 also considers the work to be Spanish. Châtelet regards the work as a copy after a lost original by Campin, which originally had a gold ground.

Dating: Second half of the fifteenth century(?). According to Châtelet this is a copy after an original dating from around 1410–15.

Commentary: In this teeming Crucifixion scene there are motifs based largely on the van Eyck *Crucifixion* in New York (Friedländer vol. 1, plate 36), reinterpreted in a style more closely related to Campin. The artist seems to have had some difficulty in combining the individual motifs to a persuasive whole. The dappled horse in the lower right, for example, is much too small in comparison with the standing figures. It cannot be a copy after a composition by Campin.

Provenance: Purchased around 1850 by Athanasius Raczynski in Madrid.

Literature: *M*: Châtelet C2.

S: Bialostocki/Walicki 1955, Cat. no. 34; Boon 1957, p. 177; Rostworowski 1960, p. 367 s.

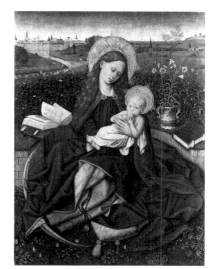

III.G.7 Madonna of Humility before a Grassy Bench

Wood (oak); 46.8 x 36 cm
J. Paul Getty Museum, Los Angeles

Attribution: Tolnay is the first to ascribe this painting to Robert Campin and he regards it as a masterpiece from his later period; According to Friedländer it is by a follower of the Master of Flémalle. Panofsky regards it as a copy after Campin. For Davies this work is far removed from Campin, at least in technique. Châtelet shares this view. Gottlieb 1957 ascribes the work to Jacques Daret.

Although the artist who created this highly accomplished work cannot have been a student of Campin, he bases his figures on a composition by Campin or one of the latter's students. The manner in which the Virgin carries the swaddled Infant on her long-fingered hands is reminiscent of the *Madonna in an Apse* (III.E.2/C).

Dating: Circa 1450(?)

Provenance: G. Müller Collection, Brussels; Baroness Gendebien Collection, Brussels

Literature: *M*: Friedländer, vol. 2, No. Add. 151; Tolnay, No. 17; Panofsky, p. 175 (n. 1); Davies, Campin/Brussels, Gendebien; Châtelet, Cat. AR2.
S: Gottlieb 1957, p. 59, n. 16.

III.G.8/C Adoration of the Magi (Copy)

Pen (brown ink) on paper; 20.3 x 19.2 cm
Frankfurt, Städelsches Kunstinstitut, Graphische Sammlung; Inv. No. 738

Attribution: For Crowe and Cavalcaselle 1875 this drawing is executed in the style of Rogier van der Weyden. Rothes 1925 ascribes it to Jacques Daret. The drawing, which portrays the figures precisely in painstaking hatching, while leaving the spatial surroundings and objects sketchy, has all the signs of a copy. Winkler 1960 believes it is based on a lost panel painting by Robert Campin that is documented in further copies and variations. Sonkes 1969 and Sander in Cat. Frankfurt 1996, assume that the composition projected in the drawing is based on the *Adoration of the Magi* in Rogier van der Weyden's Columba Altarpiece, though this seems uncertain to us. The stance of the third King – removing his crown as he offers his gift – fits in smoothly with the scene, in contrast to the work by Rogier. The work reiterated in the drawing need not necessarily be an archaisising pasticcio (as suggested by Sonkes and Sander). Nor can the original be attributed to Campin himself. The facial types – for example that of Joseph – are not to be found in his œuvre. The original may be by a student of

Campin. It is possibly a much later variation on the theme of *The Adoration of the Magi* by the Master of the Madonna before a Grassy Bench, on which the Berlin panel (III.E.3 / C) is based. The faces of the Virgin and the third King are very similar in both compositions. Châtelet, rather surprisingly, considers the drawing to belong to the van Eyck group of works.

Dating: Original: circa 1440. *Copy*: According to Winkler 1960 it may date from the fifteenth century. In keeping with the purported link with Rogier van der Weyden's Columba Altarpiece, Sonkes 1969 dates the lost original to as late as 1470. According to Sonkes the drawing is to be dated around the same period. Châtelet apparently regards the drawing as original and dates it to 1420.

Further Copies: Winkler 1960, p. 136, lists six further works based on the lost composition. Yet only one panel painting created after 1510 (formerly Cologne, Wallraf-Richartz-Museum; ill. 147 in Winkler 1960) can be regarded as a copy in the narrower sense, at least as far as the figures are concerned.

Commentary: The composition recorded in the drawing possesses a narrative structure that represents a further development of the version of this same biblical scene in the Berlin painting (III.E.3 / C). The oldest King, having offered his gift and kissed the Infant, has withdrawn in adoration and the second King takes his place.

Provenance: Unknown.

Literature: M: Châtelet, Cat. AR1.
S: Crowe / Cavalcaselle 1875, p. 452; Rothes 1925, p. 9; °Winkler 1960; °Sonkes 1969, cat. D13; Cat. Frankfurt 1996, No. 33.

Documents on the life and work of Robert Campin

On the following pages, documents referring explicitly to Robert Campin and mentioning his name are presented chronologically. Unless otherwise stated, they were originally held in the *Archives communales* of the city of Tournai and burned in May 1940 during the bombardment by German troops. In the case of documents which have been lost and which are not cited verbatim in secondary literature, the content of the document in question is outlined.

Following in the footsteps of Alexandre Pinchart (Pinchart 1867), A. de la Grange and Louis Cloquet also transcribed and analysed a number of biographically and art historically relevant documents in their *Etudes sur l'art à Tournai et sur les anciens artistes de cette ville* (De la Grange/Cloquet 1887/88). Further important information can also be found in Soil de Moriamé 1908, Houtart 1914, Destrée 1930, Renders 1931 and Rolland 1932a, 1932b. Later studies by Feder 1966, Wymans 1969 and Schabacker 1980, 1982 had to rely on previously published transcriptions of the original documents.

Doc. 1 (1405/1406)

Robert Campin purchases two columns and one angel belonging to the Altar of Our Lady from the parish of Saint-Brice.

Vendut à Robert Campin pointre deux vieses coullolles (colonnes?) et deux angles qui servoient à l'autel devant Nostre-Dame, deux couronnes de Franche quy vallent à monnoie de ches comptes, x lb. ix s. viij d.

(Comptes de l'église Saint-Brice pour l'année 1405–1406 – Soil de Moriamé 1908, p. 127)

[The "coullolles" are undoubtedly two bronze or gilded wooden columns that served as supports for the altar drapes and which were normally crowned by figures of angels. See Steinmetz 1995, in which a number of altars with such columns are illustrated.]

Doc. 2 (1406)

Robert Campin, living in la Lormerie, receives payment from the estate of the late Jeanne Esquierqueline, widow of the leading sculptor Jacques de Braibant, for a panel painting and a cross he had created for her while she was still alive.

A maistre Robert Campin, pointre, demorant en le Lormerie, pour un tabliel et une croix que il avoit fait et livré du vivant de ladite défuncte, 45 s.

(C. d'exéc. test. de Jehanne Esquierqueline, veuve de Jacques de Braibant, 1406 – De la Grange/Cloquet 1888, p. 221)

[For further information on Jacques de Braibant, see De la Grange/Cloquet 1887, pp. 94-96.]

Doc. 3 (1406/1407)

Master Robert receives payment from the parish of Saint-Brice for restoration and painting around the statue of the Virgin and the apertaining altar and for further restoration of the gilding not envisaged in the contract.

Pour avoir reparet et point par mestre Robiert le pointre entour Nostre-Dame et l'autel comme il s'appert, et parmy le caritet de ii los de vin de ix gros, qui en fut payet, présents aucuns de messeigneurs de le paroche et dont il debvoit avoir x lb. et pour l'amendement de le dorure qu'il a fait qui ne fut point deviset au marquiet, xl sous pour tout ce xij lb. v. s. v d.

(Comptes de l'église Saint-Brice pour l'année 1406–1407 – Soil de Moriamé 1908, p. 134)

[Neither this Document nor Doc. 7 from the treasury books of parish offices actually mentions the painter's surname. However, given that Campin had purchased part of the same altar the previous year (cf. Doc. 1), he is undoubtedly the person who carried out the work in question. The repairs had probably been necessary as a result of moving the Altar of Our Lady in the course of extending the choir of the church of Saint-Brice. (See Rolland 1946). Paul Rolland's theory that it was Campin who painted the fragment of a mural showing the Annunciation and two angels which was uncovered in the area of the choir in June 1940 following the bombardment of Tournai is mere speculation and is not borne out in any way by the document itself. (Cf. Cat. II.1). The expressions "reparet et point" undoubtedly belong

together and it is to be assumed that the words "entour Nostre-Dame" refer to the shrine in which the statue of the Virgin was kept.]

Doc. 4 (6 February 1408)

Campin purchases a house in la Lormerie, now rue des Chapeliers, in the immediate vicinity of the Cathedral of Tournai.

/ Le 6 février 1408 il acquit pour 60 livres tournois, outre les charges, une maison sise en la Lormerie (actuellement rue des Chapeliers) devant la grande boucherie et touchant par derrière aux dépendances de la cathédrale. /

(Chirographes de la Cité, 1408 – Houtart 1914, p. 89)

[Campin had already lived in the same street. Cf. Doc. 2]

Doc. 5 (1408)

The city of Tournai pays Campin for a banner painted in oils with the municipal coat of arms for the tower of the city hall or halle des consaux.

A maistre Robiert Campin, pointre, pour son salaire et desserte de avoir point à olle ladite banière [de la tour des halles], et y fait de fines couleurs les armes de le ville, 35 s.

(C. d'ouv. de 1408 – De la Grange / Cloquet 1888, p. 221)

Doc. 6 (1408/1409)

Campin polychromes a statue of Saint Maurus by the sculptor Wille Hasard for the church of Saint-Brice and paints the wings of the appurtenant shrine.

A Robiert le pointre pour y celly imaige [de saint Mort] repoindre avecq les feuilles de son tabernacle pour tout ce faire, lv s.

(Comptes de l'église Saint-Brice pour l'année 1408 / 1409 – Soil de Moriamé 1908, p. 143)

[It is interesting to note that here, as in Doc. 10, 16, 19, 28, Campin is referred to without the title of "maistre". In all other municipal documents and in the register of the guild (Doc. 38 and 57) he is invariably referred to as "maistre Robert Campin". For an analysis of the possible significance and meanings of this title, see Wymans 1969, p. 386 ss.]

Doc. 7 (1409/1410)

Campin polychromes and gilds the statue of the church's patron saint by sculptor Jean Tuscap and its shrine made by Jean Daret for the church of Saint-Brice.

A maistre Robiert le pointre a qui fut marchandé par lesd gliseurs et par l'accord de nosseigneurs de la loy de poindre et dorer lad. ymage et tabernacle de S. Brixse en le somme de lviij couronnes d'or qui valent... lvj lb. xviij s. x d.

(Comptes de l'église Saint-Brice pour l'année 1409 / 1410 – Soil de Moriamé 1908, p. 147)

[For information on the sculptor Jean Tuscap see De la Grange / Cloquet 1887, pp. 55, 97, and 185-187. The document was not fully quoted by Soil de Moriamé as is evident in the following remark by Houtart 1914, p. 89: "Les comptes de Saint-Brice (...) le montrent encore occupé dans cette église en 1409–1410. Il fut chargé d'y peindre et dorer la statue du patron de la paroisse et le dais qui la couvrait. C'était un travail d'atelier dans lequel le maître n'intervint que pour diriger, comme le montre le texte suivant: 'aux valets dudit maistre Robert, pour le vin et courtoisie faite à eux afin que ledit ouvrage fut avancé ...'."

The document shows that Campin headed a workshop by 1409/10 at the latest. The fact that his apprentices were offered bonus payments as motivation to work faster has been correctly interpreted by Houtart as suggesting that the master delegated such work as polychroming to the employees and apprentices in his workshop. The same probably also applies to the many decorative works commissioned by the municipality, mentioned in the following documents. The phrase "à Robert Campin ... pour avoir point" generally means that Campin was paid for work carried out by the members of his workshop. Only one document (see Doc. 15) actually specifies this in the wording "poir avoir point et fait poindre".]

Doc. 8 (29 December 1410)

Robert Campin obtains citizens' rights in the city of Tournai.

Maistre Robert Campin, pointre, a accaté et juré se bourghesie pour quatre livres tournois, le lundi XXIX^e jour de décembre l'an 1410.

(Reg. de le Loy – Pinchart 1867, p. 489, n. 2, De la Grange / Cloquet 1888, p. 221)

[The fact that Campin is documented as obtaining citizen's rights in Tournai has, since Houtart 1914, p. 88, been widely taken to mean that the artist was not actually born in Tournai. Houtart presumes that Campin originally came from Valenciennes, where his surname, not documented in Tournai, is relatively common. These assumptions regarding Campin's origins have been called into question by Schabacker 1980, p. 8s. The author points out that citizen's rights were not hereditary in Tournai and that they even had to be acquired by the sons of those who already possessed them. In other words, the document does not permit us to assume that Campin was born elsewhere. Moreover, Schabacker 1980, p. 9, n. 25, refers to a document from Tournai, in which the surname "Campaen" is recorded as early as the 14th century.

On the other hand, because Campin was a craftsman, and therefore by definition "de petit état et condition", it is rather unusual that he should have been granted citizen's rights at all. According to Houtart 1914, p. 89, this privilege was available only to craftsmen in the service of the city. The works commissioned by the municipal authorities, especially after 1410, would indicate that Campin was at least *de facto* a muncipal painter for the city of Tournai.]

Doc. 9 (1410, 1412)

Campin paints the banners of the company of crossbowmen and their coat of arms.

/On le voit (...) en 1410 et 1412 peindre les écussons des bannières que la compagnie des arbalétriers emportait en campagne./

(Houtart 1907, p. 9)

Doc. 10 (1411)

Campin polychromes and gilds the shrine of the statue of Saint Gislenus for the church of Saint-Brice.
A lui (Robert le pointre) pour son salaire labeure et deserte d'avoir au terme de ces présens comptes doré et point le tabernacle saint Gillain en ladite église iij couronnes de france et demie qui valent au tournois, lxxix s. vij d.
(Comptes de l'église Saint-Brice pour l'année 1410/1411 – Soil de Moriamé 1908, p. 149)

Doc. 11 (1413)

Campin supplies ground red earth pigment with which to paint the walls of the halle de grandmont.
A maistre Robert Campin, pointre, pour rouge terre par lui livrée toute moulue, de lequelle on a point de rouge les parois de ladite halle de Grantmont, 12 s. 6 d.
(C. d'ouv. de 1413 – De la Grange/Cloquet 1888, p. 221)

Doc. 12 (1414)

The city of Tournai pays Campin for painting the oriel (bretèque) *of the* halle des consaux.
A maistre Robert Campin, pointre, pour son salaire et desserte de avoir point, doré et ordonné ladite bretesque d'ouvrage de pointure par la manière que elle est, et livré l'or et aultres couleurs qui furent en ce employées, ainsi et par la manière qu'il en fu marchandé à lui par le six esleux ou nom de la communaulté d'icelle ville et que le cédulle de le devise dudit marchié porte, 48 lib.
(C. d'ouv. de 1414 – De la Grange/Cloquet 1888, p. 221)

[The *bretèque communale* was undoubtedly demolished when a structure with a huge double stairway was erected in front of the facade some time around 1607. See De la Grange/Cloquet 1887, p. 52.]

Doc. 13 (1414)

Campin is remunerated for his painting of the oriel of the halle des consaux, *above and beyond the scope of the work specified in the contract.*
Audit maistre Robert Campin, pointre, pour son salaire et desserte de avoir fait et ordonné à ladite bretesque pluiseurs ouvrages de pointure oultre et par dessus ce qu'il avoit marchandé de faire, 4 lb.
(C. d'ouv. de 1414 – De la Grange/Cloquet 1888, p. 221)

Doc. 14 (1414, 1415)

Campin paints standards, pennants and shields in two consecutive years for the crossbowmen of the city departing on campaigns.
/... en 1414, lorsque les arbalétriers tournaisiens partirent en campagne, il fut chargé de peindre leurs étendards, pennons et pavois; de même en 1415./
(Houtart 1914, p. 89)

[Cf. Doc. 9 and Doc. 15.]

Doc. 15 (1415)

Campin is commissioned by the city to paint various banners and standards, including those intended for the beffroi.

/ En 1415, il lui fut payé par le magistrat de cette ville une somme de 6 livres tournois "pour avoir point et fait poindre et ordonner deux estandars à servir à l'effroy [*sic*, pour beffroi], l'un des armes du roy, nostre sire, et l'autre des armes de la ville, et pour avoir réparé deux autres banières armoyés des armes de ladicte ville à mettre sur le belfroy" et une autre somme de 65 sous "pour trois penons de ménestriers et un grant penon de trompette faite sur bougran: avecq iiij autres telz penons fais de soie à servir à l'onneur [*sic*]." /
(Volume des comptes des arbalétriers, etc., de 1410 à 1446 – Pinchart 1867, p. 489 s)

Doc. 16 (1417)

Campin pays tax on six and a half barrels of wine he has purchased.

/ Recette des xx s. tourn. pour chaque tonneau de vin vendu en gros à Tournay /
tant pour les marchands taverniers d'icelle (ville) comme autres ...
De Martin Campin, marchant forain, pour
vi tonn. xix st – vi lb. iiii s. ii d.
De Robert Campin, pointre, pour VI tonn. demy,
i m. vi st – vi lb. xv s. ix d. /
(Comptes généraux de Tournai, 1 juil. – 30 sept. 1417; Archives générales du Royaume, Chambres des Comptes, n° 39932, f° 6 r° – Rolland 1932a, p. 36, n. 1)

[The two consecutive entries in this document indicate that Robert Campin joined forces with another person of the same surname, probably a nephew who was a merchant on the markets of Tournai, in order to purchase a large quantity of wine. For information on Martin Campin, born in Valenciennes, and a possible further relative of the artist, one Jan Campin, see Châtelet, pp. 358-361.]

Doc. 17 (1418)

Jacques Daret, about 15 years old, eldest son of the widowed sculptor Jean Daret, belongs to Campin's workshop and lives in his house.

/ L'atelier de Campin florissait alors (...); on y mit Jacquelotte, et c'est là que nous le rencontrons pour la première fois, en avril 1418, logé, nourri et "ouvrant de son métier". /
(Houtart 1907, p. 29)

[Houtart 1914, p. 95 s, assumes that Jacques Daret, who was born some time between 1400 and 1403 was apprenticed to Campin in the year 1416. As no support was paid for the apprentice between 1418 and 1426 he assumes that Jacques Daret was already well advanced in the craft of painting by 1418. Houtart also draws attention to documents that indicate Campin's close relationship with the Daret family. He often worked with Jacques Daret's father, the sculptor Jean Daret, arranged an apprenticeship as sculptor for his youngest son, and attended the funeral of his daughter Catherine along with the next of kin.]

Doc. 18 (1418)

Campin designs heraldic lilies to be embroidered by Pierre Scampié on the banners of the crossbowmen dispatched by the city to serve under the French king.

/Dans un compte de 1418, Robert Campin est mentionné comme ayant taillé ou plutôt découpé des fleurs de lis qui furent brodées par Pierre Scampié sur les bannières des arbalétriers fournis par la ville pour le service du roi de France./

(Volume des comptes des arbalétriers, etc., de 1410 à 1446 – Pinchart 1867, p. 490)

Doc. 19 (1419)

From the estate of the wealthy and respected Ghent painter Gheraart van Stoevere an outstanding debt is paid to Robert Campin. It is owed to him for the maintenance of the dead man's son Jan, who had been apprenticed to Campin.

Item Robt Canfin, Hannekins meester te Dornike, van resten van houdenessen, 1_ ghulden nobel.

(Municipal archives of the city of Ghent, Staten 1419–1420, fol. 13 v – van der Haeghen 1913, p. 127)

[This important document proves that Robert Campin must already have enjoyed a reputation as one of the most oustanding painters in the Netherlands as early as 1415, when he accepted Jan van Stoevere as an apprentice in his workshop. This is the only plausible explanation for the fact that the most renowned painter of the city of Ghent – Gheraart van Stoevere was head of the guild of painters there in 1412 – should have apprenticed his own son to Campin. For information on Jan van Stoevere see pp. 11, 191]

Doc. 20 (4 March 1420)

Campin receives payment for the gilded lilies above the rood screen of the church of Saint-Brice, next to the cross, and for refurbishing the polychroming of the figures in the crucifixion group. These were taken down from the triumphal arch by Campin together with other craftsmen and assistants on 4 March.

A mestre Robiert Campin pointre pour avoir dorret et ordonnet d'or les fleurs de lis qui sont debous de le grande croix en hault deseure le lichenier de lentrée dou cuer, au deseure du marchiet a lui fait par Laurench Lesenne quy le sourplux donna et asmonna au reparer lad. croix le cruchefit et les deux imaghenes d'empres, ce luy fu payet par traitiet a luy fet pour son amendement de l'avoir fait dor en viers que des coulleurs qui devisées luy estoient par led. Laurench, iiij lb. x s.

Pour troes los de vin bus a le maison Daniel Berenghier le lundy IIIIe jour de march par Henry Haubiers, Coppars le charpentier, maistre Loys Corin, Jehan Daret, maistre Robert Campin et plusieurs autres qui furent aidans mettre jus le crucefit et les II imaghenes que pour poindre et reparer. fu payet parmy les biens? qui dispenssés y furent, xvj s. vj d.

(Comptes de l'église Saint-Brice pour l'année 1419/1420 – Soil de Moriamé 1908, p. 158)

Doc. 21 (15 November 1420)

Campin sells his house in la Lormerie and moves to the rue Puits-l'eau in the parish of Saint-Pierre.
/ En 1420, Robert Campin vendit sa maison de la Lormerie et s'établit dans la paroisse de Saint-Pierre, quartier bourgeois et commerçant, central et animé, petit monde où il fallut compter avec lui. /
(Chirographe du 15 novembre 1420 – Houtart 1907, p. 13)

/ Vers 1420, il avait quitté la Lormerie pour s'installer rue du Puits-l'eau... /
(Houtart 1914, p. 91)

Doc. 22 (1420)

Campin becomes church warden of the parish of Saint-Pierre.
/ Etabli en 1420 dans la paroisse Saint-Pierre, il devient égliseur de cette paroisse (...). /
(Rolland 1932a, p. 34)

Doc. 23 (1420)

Campin becomes procureur *of the convent of Sœurs Noires.*
/ ... il était en outre procureur des "damoiselles de la haultevie" (Sœurs Noires). /
(Chirographes des 27 avril, 2 mai, 1er août 1420, 5 janvier 1426, 26 janvier 1427 – Houtart 1907, p. 13)

Doc. 24 (1422)

At the age of 47 Robert Campin acquires life annuities from the city of Tournai for himself and his wife Elisabeth van Stockem, who is about 54 years old.
A maistre Robert Campin, aux vies de lui qui estoit de xlvij ans d'eage, et de demisielle Ysabiel de Stoquain, se femme, de liiij ans d'eage ou environ ...
(Cart. de rentes créées en 1422 – De la Grange / Cloquet 1888, p. 220)

[According to this document, Campin was born at the end of 1375. Houtart 1914, p. 88, however, points out – without citing them verbatim – that there are documents dated 1427 and 1428 suggesting he was born in 1378 or 1379. Elisabeth Goffaert, later the wife of Campin's student Rogier van der Weyden, may well have been a niece of Campin's wife. Her mother, who was married to the cobbler Jan Goffaert of Brussels, was called Catherine van Stockem. (See Renders / Lyna 1933, p. 136s.) As Rogier's wife has the same baptismal name, Elisabeth, as Campin's own wife, Feder 1966, p. 420, concludes that the latter may well have been her godmother. Houtart 1914, p. 89, deduces from the fact that Campin was married to a woman some seven years his senior that she was previously widowed.]

Doc. 25 (30 April 1422)

The painter Rogier Bonnevacq sells a house to Campin.

Rogier Bonnevacq, pointre, a vendu, werpy et clamé quite à tousjours hiretablement à maistre Robert Campin, aussi pointre, une maison et hiretage, ...

(Acte scabinal du 30 avril 1422 – Renders 1931, p. 168)

[The house purchased by Campin was situated in the rue des Corriers. This is probably the street now known as rue du Corbeau, parallel to the rue Puits-l'eau, where Campin was living at the time. Châtelet 1993, p. 17, assumes that Campin intended to improve his living quarters and workplace by purchasing this nearby house. Cf. Doc. 63.]

Doc. 26 (1422)

Robert Campin and the priest Victor de Mesnil sign documents envisaging the establishment of a chaplain's sinecure for the altar of Saint Luke in the church of Saint-Pierre in Tournai.

De parochia sancti Petri Tornacensis: de capellania ad altare beate Luce: Quatuor littere scilicet III cirographi et I littera regis, de institutione et dotatione capellanie ad altare beate Luce per Robertum Campin pictorem et dominum Victorem de Mesnil presbiterum.

(Original document extant: Grand Répertoire des Archives de la Cathédrale de 1422; Tournai, Archives de la Cathédrale – Dumoulin/Pycke 1993, p. 281)

[The original documents mentioned in the surviving register were probably destroyed by 1566. They were no longer known to authors publishing before 1940. The altar of Saint Luke in question is the altar of the guild of painters. It was transferred from the cathedral around this time to the parish church of Saint-Pierre, which was demolished in the 19th century. (Cf. Ninane 1977, p. 411). A Guild of Saint Luke with a religious purpose already existed in Tournai prior to 1364. Initially, painters were incorporated within the occupational group of goldsmiths. In 1404, however, they joined forces with the sculptors. After 1424, when the old guild organisation was reinstated according to 36 occupational groups or "bannieres" following the craftsmen's uprising of 1423, painters were once again subordinated to the goldsmiths. (See De la Grange/Cloquet 1887, p. 66, and Schabacker 1982). It may be assumed that Campin did not sign the contracts in his own name – as Châtelet, p. 348, supposes – but in his capacity as head of the Guild of Saint Luke, which still retained its purely religious status prior to 1423. As Campin was also a church warden of the parish of Saint-Pierre (cf. Doc. 22), it is probable that he was one of the driving forces behind the transfer of the altar. Dumoulin/Pycke 1993, p. 281, point out that a 16th century document mentions a house "a l'enseigne de Saint-Luc en la rue de la Cordonnerie" belonging to the chapel of Saint Luke.]

Doc. 27 (1422/1423)

Campin produces and repairs various objects for the parish of Saint-Brice to be carried on religious processions.

A mestre Robert Campin pour avoir tendut et point lad. toille [à tendre sur le cassich sur quoy les blazons du Roy nostre sire sont assis] et pour avoir coussut les blazons et remis a point, xix s. x d.

A luy pour avoir point de viermel et doret le civière sur quoy on porte le Saint-Sacrement, xj s. viij d.

A luy pour une couronne de Dieu, deux mondes, les croix et les fanons nouviaux repoint et plusieurs autres coses a porter a pourcession par lesdits enfans, viij s ij d.

(Comptes de l'église Saint-Brice pour l'année 1422–23 – Soil de Moriamé 1908, p. 165)

Doc. 28 (1423/1424)

Campin gilds and polychromes two processional crucifixes made by the sculptor Jean Daret for the parish of Saint-Brice.

A Robiert Campin pour avoir dorét et estoffé lesdites croix [a porter a pourcession et en vissitation] payé, iiij s. ij d.

(Comptes de l'église Saint-Brice pour l'année 1423–24 – Soil de Moriamé 1908, p. 166)

Doc. 29 (1424)

Campin paints the wooden carvings of the two angels bearing the arms and crest of the French king by Henry de Cologne on the facade of the halle des doyens.

A maistre Robert Campin, pointre, pour avoir point et doré les angles, le hachement et armes du Roy, nostre sire, mis et ordonné de nouvel à le devanture de le halle, 18 lb.

(C. d'ouv. de 1424 – De la Grange/Cloquet 1888, p. 221 s)

[For information on the *Halle des Doyens des Métiers* see De la Grange/Cloquet 1887, p. 56.]

Doc. 30 (19 February 1425)

Representatives of the parish of Saint-Pierre appoint Campin to the council of eswardeurs, *the lowest of the three organs of municipal government.*

/Il fut élu eswardeur, lors du renouvellement du magistrat, le 19 février 1425 (n. st.)./

(Registre de la loi de 1414 à 1425 – Pinchart 1867, p. 492)

[According to Schabacker 1980, p. 5 s, in contrast to Houtart 1914, p. 90, this appointment does not necessarily mean that Campin had previously held the office of a *sous-doyen de la bannière des orfèvres*. In any case, there is no basis for the assumption – still made by Châtelet 1990 – that Campin played any role in the craftmen's uprising of June 1423. Schabacker 1980 points out that Campin, as a citizen of Tournai, enjoyed precisely those political privileges that the rebelling craftsmen and proletarians sought to gain. Further official positions held by Campin in the years 1420, 1426 and 1427 are mentioned by Houtart 1914, p. 90: "égliseur" of the parish of Saint-Pierre (see Doc. 22), "capitaine de son quartier", "procureur du couvent de la Haute-Vie" (see Doc. 23), "un des VI commis aux comptes de la ville". For information on the political organisms of the city of Tournai see Houtart 1908; on the "conseil des eswardeurs" in particular see p. 22-28. Campin held the office of "eswardeur" a second time. See Doc. 37.]

Doc. 31 (1425)

Campin paints and gilds the tablet with figures on which oaths are sworn for the court hearings held before the "doyens"

A maistre Robert Campin, pointre, pour avoir fait et doré le tavelet et ymaiges sur lequel on fait serment pardevant les doyens, 50 s.

(C. d'ouv. de 1425 – De la Grange/Cloquet 1888, p. 222)

Doc. 32 (1425)

Campin polychromes and gilds the sculptures that grace the halle des doyens.

/... peindre et dorer (...) les statues ornant la Halle des doyens 12 lb. t./

(Comptes d'entremise – Houtart 1907, p. 11)

[The reference here is to the three new statues mounted on the facade facing the *beffroi*: a Madonna flanked by the city's patron saints Eleutherius and Piatus. See De la Grange/Cloquet 1887, p. 56. Cf. Doc. 41.]

Doc. 33 (1426)

Campin paints an azure blue escutcheon with three golden lilies for the porte de Marvis *and mounts the crown above it in ultramarine and gold.*

A maistre Robert Campin, pointre, pour avoir point, ordonné et doré ung escu d'asur à trois fleurs de lis d'or et le couronne estant audeseure d'icelluy, estoffé et ordonné d'or et d'azur, lequel escu est mis à le porte de Marvis, 55 s.

(C. d'ouv. de 1426 – De la Grange/Cloquet 1888, p. 222)

Doc. 34 (1426)

Campin produces a tablet of oath for the magistrates of Saint-Brice and adds a crucifixion scene to the gospel book incorporated in it.

A maistre Robert Campin, pointre, pour ung tavelet ou qu'il avoit et a entailliet un ymage et ung cruchefy parmy l'évangille qui est encassée en icelluy, lequel tavelet a esté délivré à messieurs les eschevins de S. Brixe pour sur ycellui faire jurer, 56 s. 8 d.

(C. d'ouv. de 1426 – De la Grange/Cloquet 1888, p. 222)

[The text of this document, possibly incomplete, is not easy to decipher. It would appear that the "crucifix" mentioned was an illumination added to the gospel book by Campin. Cf. Doc. 55.]

Doc. 35 (1426)

Campin is one of the executors of the estate of Piérart de le Vigne, painter, who died in 1426.

/Ses exécuteurs testamentaires furent Robert Campin, Jehan de Weulle et Nicaise Barat, tous peintres./

(De la Grange/Cloquet 1887, p. 232)

[For information on Piérart de le Vigne see De la Grange/Cloquet 1887, pp. 56, 61 and 232.]

Doc. 36 (1426)

Following the dissolution of the confrérie des damoiseaux, *a patrician society of longstanding tradition, the municipal authorities commission Campin, together with other craftsmen, to produce a new ensemble of processional items for the September procession, to be carried by the magistrates of the three councils* (membres de la Loi): *a gilded shrine, banners and other insignia.*

A maistre Robert Campin et aultres cy après nommés, pour le fachon et estoffes livrées et mises aux fiertres et confanons des bourgeois de ledite ville, renouvelés, et ledite fiertre viestie à ledite fieste de le proucession de Tournay, les parties et pour les causes qui s'ensuivent. C'est assavoir: à Haynne Carpentier, dit du Bos, pour x onches de soye de pluiseurs tires, mises et employés ès nouviaux confanons, et vj ausnes et vij quartiers de samit, dont on fist les fanons, 37 s. 6 d. de gr.; – item, à Guy le Corneteur, pour xviij ausnes de toille dont on fist les parquiaux des ymages ès dis confanons, et ledite toille avoir cousue, 5 s. 3 d. de gr.; – item, à Grigor le fustailleur, pour iiij bastons et les pumiaux desdits confanons, 32 gr.; – item, à Jakem Catau, pour lesdis confanons avoir fais, cousus, appomiés et assemblés, 16 s. 7 d. de gr.; – item, à Gillart du Mollin, fèvre, pour les fiérures par lui faites et livrées auxdits bastons, 9 gr.; – item, à luy et audit Catau, qu'il fu donné par courtoisie à leurs ouvriers, 9 gr.; – item, à Regnaut Hacquet, pour xxxvj ventres de menu vair dont les sambues de ladite fiertre furent fourées, 7 s. 5 d. de gr.; – item, pour une paire de linchieux pour enveloper les confanons, et au casurier de Nostre-Dame et ouvriers de la taille de le fiertre et de le pointure, 4 s. 8 d. de gr.; – item, pour les vins de le carité soustenus par Jehan du Bos et ledit maistre Robert Campin, 12 s. de gr; – item, pour le salaire de le paine et travail dudit maistre Robert, d'avoir ladite fiertre taillié, faite, livrée, dorée, et poindre et estoffer les parquiaux et ymages desdits confanons, avoir fais fourmes, estoffés et dorés, et aussi les fleurs de lis d'or avecq tous les bastons et pumiaux d'iceux, estoffé et doré les xix pignons des angèles, des ménestriers et trompettes, à deux lés, et bien lxxij escuchons estoffés, par taux et ordonnance faicte pour ce faire audit maistre Robert, 8 lb. de gr.; – item, pour l'acat de ledite monnoye de Flandres contre blans du Roy, 31 s.; – lesquelles parties montent en somme, le monnoye de Flandres avaluée à sols et deniers tournois, 87 lb. 17 s. 1 d.

(C. gén. de 1426 – De la Grange/Cloquet 1888, p. 222 s)

[For information on the dissolution of the *confrérie des damoiseaux* see Houtart 1908, p. 351 s. The wording of the document indicates that Campin, together with Jean du Bos, was in charge of the overall work. (For information on Jean du Bos, who held the position of a *changeur aux offices*, see Rolland 1932 b, p. 50 ss.) Campin seems to have been the author of all the designs, including those for the textiles (coverings for the processional shrine, and flags) and for the newly sculpted shrine. The document unequivocally states that Campin was not acting as a sculptor, but had delegated the task of woodcarving to specialist craftsmen – *ouvriers de la taille de la fiertre* – working under his supervision. See De la Grange/Cloquet 1887, p. 123.]

Doc. 37 (1427)

Campin is appointed eswardeur *for the second time.*

/ (...) en 1427, membre du collège des eswardeurs (...)/

(Houtart 1914, p. 90)

[Cf. Doc. 30. In this function Campin was also appointed to the important position of one of the city's six auditors, *commis aux comptes de la ville.*]

Doc. 38 (1427)

Robert Campin is listed together with three other painters, also designated by the title of maistre, *at the head of a register of eighteen painters and stained glass artists working in Tournai prior to 1424 who achieved the status of free masters on the reorganisation of the Guild of Saint Luke in 1427.*

Ce sont les noms des personnes paintres et voiriers lesquelz estoient ouvrans des mestiers des paintres et voiriers [*later addition*: et mirliers] au paravant le previllege ottroyé ausdits maistres desdis mestiers en ceste ville et cité de Tournay.

Et premiers

Maistre Houdain, paintre.

Maistre Henri le Quien, paintre.

Maistre Robert Canpin, paintre.

Jehan van Hetuse, voirier.

Evrart Rondemain, voirier.

Lottart le Fevre, paintre.

Collart Dutrecht, paintre.

Morian Tabuet, paintre.

Martin de Gand, voirier.

Andrieu le Roux, paintre.

Jehan de le Fosse, paintre.

Pierart Vicart, paintre.

Haquinet de Quien, filz Henry, paintre.

Jehan Bruselerre, paintre.

Jaquemin de Mons, paintre.

Bauduin de Lictevelle, paintre.

Maistre Mathis.

Arnoulet.

(Registre de Saint-Luc pour les années 1424–1480 – Renders 1931, p. 133 s)

[The register of the guild of painters, destroyed in 1940, was actually a copy drawn up around 1482 in which some of the listings of the original guild register had been rearranged. (Cf. Houtart 1907, p. 21, n. 2, and Renders 1931, p. 130.) The relevant literature generally states that the guild of painters of Tournai was reorganised in 1424. However, the date 1424 is found only on the document, issued by Charles VII, at the beginning of the guild register, granting the privilege for the reinstatement of the 36 *bannières*, under which the craftsmen of Tournai had been grouped sixty years before. With one exception (start of the apprenticeship of Jean de Blandain on 30 April 1426; see Doc. 48) none of the entries

bears a date earlier than 1427. The list of names printed here, with which the register compiled in 1482 begins, is probably ordered according to the rank and age of the craftsmen. It may be assumed that the first three names at least, bearing the title *maistre*, headed their own workshops in Tournai in the year 1427. Campin, about 50 years old at the time, would have been the youngest of them. Nevertheless, Campin appears to have enjoyed a special status among the three "masters". He is the one who, presumably in his role as municipal painter to the city of Tournai, regularly received small and major contracts from the city. (See De la Grange/Cloquet 1888.) The remaining fifteen – ten painters, three stained glass artists, two of unspecified occupation, were probably for the most part trained craftsmen employed by one of the three masters at the head of the list as *varlets* or *compagnons*. (Only two of the ten painters are mentioned in other documents in Tournai under this occupational group: Haquinet [Jean] le Quien and Jacquemin de Mo[i]ns; see Renders 1931, p. 161). The copy of the guild register lists, with dates after 15 May 1427, the apprentice painters and apprentice stained glass artists who had been appointed free masters on the basis of a minimum 4-year apprenticeship in accordance with the new regulations. For the first five years (until 10 May 1432) nineteen are mentioned, albeit without specifying their respective teacher. Only three of them were later to have their own workshop in Tournai with their own apprenticeships: the stained glass artist Tierry Blanquart (from 1429), the painters Nicaise Barat (from 1429) and Gillart le Rike (from 1433). In 1433 Campin's student Jacques Daret joined their ranks. The register compiled around 1482 does not indicate how many students and *compagnons* Campin employed in his workshop in 1427 apart from these four, three of whom became free masters themselves in 1427 (see Doc. 58). According to Houtart 1907, p. 21, in contrast to other occupations, painters were not subject to any restrictions regarding the number of apprentices they could have. One Jean Villain, who had been designated a master in 1428 (see Renders 1931, p. 134), may well have been a former student of Campin, as posited by Campbell 1974, p. 638. Campbell's assumption is based on the fact that Jacques Daret gave Jean Villain a wedding present in 1425. (See Houtart 1907, p. 30.)]

Doc. 39 (1427)

Campin is paid by the city for a processional shrine.

A maistre Robert Campin, pointre, pour le fachon et estoffes de le fierte de le ville portée le jour de la procession autour d'icelle, laquelle il a faite et livrée, taillée, pointe et dorée … vijxx.

(Du Mortier 1862, p. 223)

[In this case, too, it may be assumed that Campin designed and polychromed the shrine, but did not actually sculpt it himself. Cf. Doc. 36.]

Doc. 40 (1427)

Campin paints three escutcheons bearing the coats of arms of the king and the city on the porte de Saint-Martin; *at the same time he adorns the gable of the defences with coats of arms.*

A maistre Robert Campin, pointre, pour avoir fait et ordonné sur le crépon de le garitte faite

à le porte S. Martin trois escuz armoyés des armes du Roy et de la ville, et d'avoir point et armoyé desdites armes les pignons au dessus de ladite garitte, 55 s.

(C. d'ouv. de 1427 – De la Grange/Cloquet 1888, p. 223)

Doc. 41 (1427)

Campin repaints the sculptures on the facade of the halle des doyens.

A maistre Robert Campin, pointre, pour avoir repoint, réparé et mis à point les ymages et personnages qui sont à le devanture de le halle de messieurs les doyens, 4 lb.

(C. d'ouv. de 1427 – De la Grange/Cloquet 1888, p. 223)

[Cf. Doc. 32. This time the reference is to the figures on the facade facing the *halle des consaux*: a Madonna and statues of the king and queen, previously repaired by Jacquemart du Bos. See De la Grange/Cloquet 1887, p. 56.]

Doc. 42 (1427)

Campin paints and gilds the false cupola of the chapel of the halle des consaux.

A maistre Robert Campin, pour avoir point et dorét le faulse coupple de le cappelle de le halle, 24 lb.

(C. d'ouv. de 1427 – De la Grange/Cloquet 1888, p. 223)

Doc. 43 (26 January 1428)

Campin is once again documented as a churchwarden of the parish of Saint-Pierre.

/L'un [des actes de l'échevinage] le qualifie de marguillier de l'église de Saint-Pierre (gliseurs de l'église perroschial Saint-Pierre): il porte la date du 26 janvier 1427 (1428, n. st.)./

(Actes de l'échevinage du 26 janvier 1427 – Pinchart 1867, p. 492)

[Cf. Doc. 22.]

Doc. 44 (1428)

Campin paints and gilds the two flag-shaped filials of the porte de Morel *and a brass Lamb of God for the chapel of the* halle des consaux.

A Robert Hanon, pour son sallaire et déserte d'avoir fait et ordonné deux pignons en fourme de banière mis sur le garitte de Morel-porte, et ung augnus Dey tout de laiton mis au-dessus de le cappelle de le halle de la ville: lx s.

A maistre Robert Campin, pointre, pour avoir armoyé, point et doré lesdis pignons, augnus Dey, et ordonné deux escus, l'un des armes du roy et l'autre de la ville, par accord à luy fait: ls.

(Compte des ouvrages du 20 février 1427 [v. st.] au 15 mai 1428 – Pinchart 1867, p. 491)

Doc. 45 (4 April 1428)

The councillors accept Robert Campin's design for the robes of the membres de la loi *with their embroidered insignia.*

Du patron des cottes de ceux de la Loi, que maistre Robert Campin a fait: accord sur les patrons et brodures que chaque collège aura.

(Délibérations des Consaux, 4 avril 1428 – Houtart 1914, p. 91)

[The magistrates referred to as *ceux de la Loi* are the two *prévôts*, the eighteen *jurés*, and the seven *échevins* respectively of Tournai and Saint-Brice. The members of the three councils wore robes of different colours for the September procession. (See Houtart 1908, p. 26 and 352.)]

Doc. 46 (1428)

Campin gilds and paints in oils the figures of the city's patron saints Piatus and Eleutherius, the king, queen, dauphin and other personnages for the entrance to the halle des jurés, *a room inside the* halle des consaux.

A maistre Robert Campin, pointre, pour avoir point et dorét de couleur à olle, à l'entrée de le halle des jurés, les personnages et ymages de Saint-Piat, Saint-Lehirre, du Roy, de la Roynne et de monseigneur le Dauphin et aultres personnages, comme il appert par lad or comptrolleurs ite œuvre, 10 lb.

(C. d'ouv. de 1428 – De la Grange / Cloquet 1888, p. 223)

[From the fact that "maistre Rogier" is to receive the commission in 1436 to copy this decoration with a view to later reconstruction, Châtelet 1999, p. 15 and 20, deduces that it was Rogier van der Weyden who executed the wallpainting in 1428 on behalf of his teacher Robert Campin. This assumption is understandably questioned by De Vos 1999, p. 396 (App. B27, n.2).]

Doc. 47 (1428)

Campin gilds and paints four banners and two escutcheons with the coats of arms of the kind and the city for the porte de Sainte-Catherine; *as well as an angel with two escutcheons for the* halle des doyens.

A maistre Robert Campin, pointre, pour avoir armoyé, point et doré quatre banières de piet et demy de long, et y ordonné deux escus, l'un des armes du roy et l'autre de la ville, mises sur la porte Saincte-Catherine, et avecq ce point et doret ung angle tenant deux escuchons, lesdictes armes servant sur le halle de messeigneurs les doyens; par accord à luy fait: c s.

(Compte des ouvrages du 15 mai au 14 août 1428 – Pinchart 1867, p. 491)

Doc. 48 (1428)

Campin paints a dozen pewter jugs for the city's Wine of Honour and ornaments them with coats of arms.

A maistre Robert Campin, dessus nommé, pour son sallaire, paine et déserte d'avoir point et armoyé xij quennes d'estain, [...].

(Compte des ouvrages du 15 mai au 14 août 1428 – Pinchart 1867, p. 491)

Doc. 49 (1428)

Campin receives payment for an iron vessel and the four escutcheons painted on it by him bearing the coats of arms of the king, the queen, the dauphin and the city, intended for the chapel of the halle des consaux.

A maistre Robert Campin, pointre, pour une boiste de fier et y fait quattre escuchons des armes du Roy, de la Roynne, du Dauphin et de la ville, mise et servant en le cappelle de le halle, 10 s.

(C. d'ouv. de 1428 – De la Grange/Cloquet 1888, p. 223)

Doc. 50 (21 September 1428)

Campin polychromes an Annunciation group by sculptor Jean Delemer for the church of Saint-Pierre and the two appurtenant baldachins.

A maistre Robiert Campin, paintre, pour sa deserte d'avoir paint de pluiseurs couleurs les dites ymages et capitieux, comme il s'apert pour ce par marchié à lui fait dix escus d'or telz que dis sont au dit pris, vallent XIII lb., VIII s.

(Compte d'exécution testamentaire d'Agnès Piétarde, veuve de Jean du Bus – Rolland 1932b, p. 339)

[There is no firm basis for the theory posited by Paul Rolland (1932b), according to which the two sculptures currently housed in the Cathedral of Tournai but originally from the church of Sainte-Marie-Madeleine, are those created by Jean Delemer for Saint-Pierre. The group mentioned in the document has undoutedly been lost (cf. Cat. II.2).]

Doc. 51 (1428)

Campin invests a large sum of money in life annuities of the city of Tournai.

/En 1428, il plaça cent écus sur la ville de Tournai./

(Houtart 1914, p. 94)

[Houtart substantiates the claim that Campin came into considerable wealth around this time by pointing out further documents: "Quelques documents recueillis dans les actes de l'échevinage de 1420 à 1430 le montrent propriétaire de maisons et de rentes." Pinchart 1867, p. 492, n. 2, lists a number of magistrates' records documenting the puchase and sale of mortgages by Campin on the following dates: 26 January and 24 December 1428, 11 March, 29 April and 9 July 1429, 26 January 5 and 23 April 1431.]

Doc. 52 (21 March 1429)

Campin is sentenced to a fine and ordered to undertake a pilgrimage to Saint-Gilles in Provence for obstructing the course of justice by concealing the truth under oath during a court hearing before prévots and jurés This sentence also involves a loss of political rights and a ban on holding office.

Maistre Robert Campin, pointre, [fut condamné] à deux fois x lb., [et d'aller en pèlerinage à] Saint-Gilles, pour oultraiges d'avoir celé vérité, lui sur ce requis par nous prévostz et juréz pour le bien de justice, par son serment que pour ce l'en avions fait jurer, comme en tel cas est accoustumé; et avec ce est privé à tousjours d'estre en loy, ne avoir office en ladicte ville. Fait le lundi xxjᵉ jour de mars l'an mil iiijᶜ xxviij.

(Reg. de la Loy – Pinchart 1867, p. 492, De la Grange/Cloquet 1888, p. 221; corrected according to Wymans 1969, p. 381)

[This sentence was long regarded as an act of vengeance aimed at Campin by the oligarchy for having allegedly been one of the main agitators in the craftmen's uprising of 1423. Schabacker 1980, p. 7, was the first to cast doubt on this interpretation by pointing out that Campin, a member of the middle classes with full citizen's rights, would have had no personal interest in joining forces with the majority of the craftsmen. The reasons for Campin's conviction was probably not perjury as such, but simply a refusal to make any statement. It is probable that Campin did not want to make any statements detrimental to his fellow painter Henri le Quien, who was sentenced on the same day. (The sentence passed on le Quien is printed in Pinchart 1882, p. 582s, together with a clearly political explanation.) Moreover, the fact that no grounds for prosecution are mentioned in respect of Campin would indicate that Campin was not in fact the main person accused.

As Pinchart 1882, p. 584, already noted, Campin very probably did not undertake the pilgrimage, but had it commuted to a fine, as was common practice among wealthier circles. Wymans 1969 has also pointed out in an undeservedly little-known essay that Campin's sentence is dated according to the old calendar and would actually correspond to 12 March 1429 by today's calendar. As Campin received payment before 13 August of the same year for work carried out, he would have had to undertake his pilgrimage to St.-Gilles and back with the space of just five months.]

Doc. 53 (1429)

Campin refurbishes two escutcheons with varnish and paint for the city authorities.

A maistre Robert Campin, pointre, pour avoir revernit et repoint de vermeillon deux escus, etc.

(Compte des ouvrages du 14 mai au 13 août 1429 – Pinchart 1867, p. 491)

Doc. 54 (1430)

Campin receives payment for the city's shrine to be carried in the September procession. The contract also covers further related items such as the insignia of the herolds.

A maistre Robert Campin, pointre, pour le fachon, taille et dorure de le fiertre de la ville faicte et portée à le procession en cest an mil iiijᶜ et xxx, ensemble les ensengnes des ménestriés, soignes et aultres semblables, pour tout et par marchié fait à lui, 60 lb.

(C. gén. de 1430 – De la Grange/Cloquet 1888, p. 223)

[The *fiertre de la ville* is not the same as the *fiertre* for which Campin was paid four years previously (see Doc. 36). Once again, Campin acts as "general contractor" for the entire work.]

Doc. 55 (1430/1431)

Campin paints a crucifixion scene for a newly transcribed missal for the Church of Sainte-Marguerite.

... a maistre Robert Campin, pour avoir fait et point oudit messel ung crucefit, 22 s. 4 d.

(Original document extant: Comptes de la paroisse Sainte-Marguerite du 24 juin 1430 au 24 juin 1431; Tournai, Archives de la Cathédrale, f° 12v –14r – Dumoulin/Pycke 1993, p. 301)

[This recently discovered document is evidence of the fact that Campin also illuminated manuscripts. See also Doc. 34.]

Doc. 56 (30 July/25 October 1432)

Campin is sentenced to one year's banishment for maintaining an adulterous relationship with Laurence Polette. At the intervention of Margaret of Burgundy, the sentence is quashed three months later on payment of a substantial sum of money.

Maistre Robert Campin, pointre, à ung an pour l'orde et dissolue vie que lui, qui est marié, a maintenue par loing temps en la cité avecq Leurence Polette. Fait le pénultième jour dudit mois de jullet l'an xxxij. Et le xxv^e jour d'octobre ensuivant, ledit ban d'ung an fut quité audit maistre Robert à le requeste de Madame de Haynau, qui sur ce en avoit escript, et parmy païant comptant l solz tournois.

(Reg. de la Loy – Pinchart 1867, p. 495, De la Grange/Cloquet 1888, p. 221)

[Earlier scholars saw this sentence as a further act of revenge by the oligarchy against their former political rival Campin. Schabacker 1980, p. 12, however, has quite rightly pointed out that the document gives no indication as to who actually filed the charge of adultery against him and that it could quite possibly have been Campin's wife Elisabeth van Stockem.

However, there is certainly a connection between Campin's sentence and the fact that two of his students, Rogier van der Weyden and Willemet, were designated free masters within a few days, with a third student, Jacques Daret, following shortly afterwards (see Doc. 57). The only possible conclusion to be drawn from this is that Campin disbanded his workshop at the time due to the threat of banishment. The reason for this could be, as surmised by Schabacker 1980, p. 12, that Campin did not wish to leave the workshop under the direction of his wife during his absence. According to prevailing legislation, she would probably have had authority to represent him.

For a long time, scholars disagreed as to the identity of "Madame de Haynau" who intervened on Campin's behalf. She may have been either Margaret of Burgundy or her daughter Jacqueline. The decisive argument for identifying this petitioner with the mother, Margaret of Burgundy, widow of William IV, has been presented by Houtart 1914, p. 92, n. 2. Houtart has shown that the messenger who submitted the petition on her behalf, named in the documents as Colart Galeriau (see Doc. 58), was in the service of Margaret of Burgundy, who was living in seclusion at the Chateau du Quesnoy near Valenciennes at the time. Wymans 1969,

p. 386 and n. 40, who does not give any consideration to Houtart's thesis, has stated his case strongly in favour of Jacqueline being the petitioner.

Both Houtart 1907, p. 8, and Rolland 1932a, p. 35 s, surmised that Margaret of Burgundy may have had an interest in pardoning the painter because he was involved in a certain major work for the court of Hennegau. However, it is also possible that Duchess Margaret intervened in response to a request from a third person who was a friend of Campin.

It is not known with any certainty whether Campin opened another workshop after the sentence had been commuted. Two facts would seem to suggest that he did not. Firstly, Jacques Daret and Rogier van der Weyden established their own workshops shortly afterwards and, secondly, the guild register (see Renders/Lyna 1933, p. 137 ss) does not mention any students of Campin for the period after 1432. On the other hand, the fact that very few contracts of work for Campin are actually documented in the archives of Tournai after 1432 need not necessarily be taken as evidence that his workshop had been closed down. A reduction in the number of local contracts may also have been the result of the city's economic recession following the craftsmen's uprising of 1423, as pointed out by Schabacker 1980, p. 11.]

Doc. 57 (1 August/2 August/18 October 1432)

According to the register of the guild of painters, three students of Campin whose official 4-year apprenticeship in accordance with the new regulations had begun in 1426 and 1427 were all designated free masters within a brief space of time: Rogelet/Rogier de le Pasture (Rogier van der Weyden) on 1 August 1432, a certain Willemet on 2 August and Jacques Daret on 18 October, the name day of Saint Luke. At an evening banquet on the same date, Daret was appointed prévost of the guild. There is no entry recording the completion of the apprenticeship of a fourth student of Campin, Jean de Blandain.

[f° 81 n° 3.] Et prumiers.

Rogelet de le Pasture, natif de Tournay, commencha son apresure le cinquiesme jour de mars l'an mil CCCC. vingt six [1427 n. s.] et fut son maistre, maistre Robert Campin, paintre. Lequel Rogelet a parfait son apresure deuement avec son dit maistre.

[f° 17ᵛ n° 1.] Maistre Rogier de le Pasture, natif de Tournay, fut receu à le francise du mestier des paintres le premier jour d'aoust l'an dessusdit [1432].

[f° 81ᵛ.] Haquin de Blandain, commencha son apresure le nuit de may [le 30 avril] l'an mil CCCC. vingt six, et fut son maistre, maistre Robert Canpin, paintre. Lequel Haquin a parfait son apresure bien et deuement.

[f° 81ᵛ.] Jaquelotte Daret, natif de Tournay, commencha son apresure le douzième [deuxième?] jour d'avril l'an mil CCCC. vingt sept avec le dit maistre Robert; et a parfait son apresure bien et deuement.

[f° 17ᵛ n° 3.] Maistre Jaques Daret, natif de Tournay, fut receu à le francise du mestier des paintres le jour Saint Luc oudit an [le 18 octobre 1432], et fut fait ledit Jaques prevost de Saint Luc icelui jour au disner.

[f⁰ 81ᵛ.] Willemet commencha son apresure le treizieme jour de may oudit an [1427], avec ledit maistre Robert Canpin; et a ledit Willemet parfait son apresure bien et deuement.

[f⁰ 17ᵛ n⁰ 2.] Willemet fut receu à le francise du mestier des paintres le second jour d'aoust dessusdit [1432].

(Registre de Saint-Luc pour les années 1424–1480 – Renders 1931, p. 136s)

[Houtart 1907, p. 21, n. 2, regarded the fact that Rogier van der Weyden heads the list of apprentices designated free masters according to the new regulations of the guild as evidence that the order of names was changed when the register was transcribed around 1482. According to the old-style calendar, 5 March, the date on which Rogier became a free master, follows 1 May (or 30 April), the date on which the second artist, Haquin de Blandain, is named. According to Houtart, this change was made so that the list could be headed by a famous name. The date on which the name of Jacques Daret is entered in the list of apprentices is also problematic. 12 April does not exist in the old-style calendar. According to Houtart this is due to an error by the scrivener, and he proposes reading it as "deuxième", or 2 April 1428 (new style).]

Doc. 58 (25 October 1432)

The messenger of the duchesse de Haynau, *Colart Galeriau, who submitted her petition with regard to the banishment of Robert Campin, receives a small remuneration from the city.*

A Colart Galeriau, messager de Madame la duchesse de Henau, qui, ledit jour [25 oct. 1432] apporta la lettre de ladite dame touchant le bannissement de mestre Robert Campin, pour ce un durdrech de XXII s. IIII d.

(Compte d'entremises 1432 – Houtart 1907, p. 8, n. 1; Rolland 1932a, p. 35)

[Cf. Doc. 56.]

Doc. 59 (1433/1434)

Campin receives payment for gilding [the wrought iron finial of an ornamental fountain?] and two pennants with the coat of arms of the king, the dauphin and the city.

A maistre Robert Campin, pointre, pour son sallaire et déserte d'avoir point de fin or la fertissure quy avoit servy au puch-l'auwe, et aussy point des armes du roy, du dauphin et de la ville deux banierettes, etc.: lx s.

(Compte des ouvrages du 21 novembre 1433 au 20 février suivant – Pinchart 1867, p. 491, De la Grange/Cloquet 1888, p. 223)

Doc. 60 (1434)

When the parish board of Saint-Nicolas decides to commission the sculptor Jean de Sandres with a new altarpiece for the high altar, Campin accompanies him together with the parish elders on a tour of various churches in the city.

... Item fu paié et soutenu a la maison Ernoul de la Cuvelerie tavernier quant les dis gliseurs alerent voir le table de saint Jacques de saint Nicaise et de saint Pierre avec Jehan de Sandres,

maistre Robert Campin et aultres pour marchands ascelui de Sandres de faire une table de saint Nicolay en le dicte église du Bruisle ...

(Comptes de l'église Saint-Nicolas – De la Grange/Cloquet 1888, p. 124)

[For information on Jean de Sandres see De la Grange/Cloquet 1887, p. 169, where it is reported that the sculptor was to receive for his work "la somme élevée de 120 livres de gros 10 sols". The document suggests some artistic collaboration between Campin and Jean de Sandres on the altarpiece in question and it may be assumed that he polychromed the figures created by the sculptor (cf. Doc. 61), and was possibly also responsible for the painted wings on the shrine. It is also probable that the three churches visited by the parish elders and the artists, Saint-Jacques, Saint-Nicaise and Saint-Pierre, already had altarpieces – referred to in the document as *tables* – that were the work of the sculptor and the painter. For a definition of the term *table* see De la Grange/Cloquet 1887, p. 170.]

Doc. 61 (1434)

Campin paints and gilds the baldachin(?) of the statue of the church's patron saint Nicolas.
A maistre Robert Campin pointre pour son sallaire davoir point et dore le pignon Saint-Nicolay par marchet fait à lui, lxxvii s. vii d.
(Comptes de l'église Saint-Nicolas 1434 – De la Grange/Cloquet 1888, p. 124)

Doc. 62 (1435)

Campin receives payment from the executors of the estate of one Jehan Hughelin for a panel painting completed on 15 March 1433 during the late patron's lifetime.
A Maistre Robert Campin, pointre, pour un tavelet par lui fait et point à le requestre dudit feu du vivant d'icelluy et dont il lui devoit encores son sallaire au jour de son trespas, payé une couronne d'or, vault pareillement xx s. viii d.

Doc. 63 (1436)

One maistre Rogier, le pointre *produces a copy on paper, commissioned by the city, of part of the wall decoration created by Campin in 1428 for the* halle des consaux. *Because part of the work had to be destroyed in the course of building a new wall, the copy was needed in order to reconstruct the work afterwards. The section in question showed the kings of France and Aragon on horseback.*
A maistre Rogier, le pointre, pour son sallaire et desserte d'avoir, en ung foellet de papyer, point deux personnages à cheval, l'un du Roy de France et l'autre du Roy d'Arragon, en la fourme et manière que ilz estoyent poins en le paroit qui faisoit reffens de le Halle des jurez et de le salle de ladicte Halle où on a fait, au lieu de ladite paroit, ung pignon de bricque dont dessus est faict mention, adfin d'avoir le pattron desdits personnages pour iceulx poindre chy apriès se on volloit audit pignon de bricque, comme il estoit paravant, pour ce par marchié à luy fait vi s. vi d.
(Compte des ouvrages de 1436 – De la Grange/Cloquet 1888, pp. 126 and 270; with discrepancies in transcription.)

[Cf. Doc. 46 of 1428, recording the settlement of Campin's fee for this work which was to remain intact for only eight years. Sosson 1981, p. 40, incorrectly assumes that the drawing in question was a "projet de fresque". De la Grange/Cloquet 1887, p. 125 s, identified the copyist named as "maistre Rogier" as one Rogier Wanebac, designated a free master on 15 May 1427 according to the guild register, Rogier van der Weyden having been appointed municipal painter of Brussels by 22 May 1436 at the latest. (For information on Rogier Wanebac in relationship to Campin see Doc. 25.) Kemperdick, p. 200, n. 40, also favours this identification. However, as there is no record of Rogier Wanebac bearing the honorary title *maistre* and given that Rogier van der Weyden continued to maintain close personal and professional contact with Tournai even after he moved to Brussels (see Feder 1966, p. 427), it is more likely that the copyist in question was in fact Campin's student Rogier van der Weyden.]

Doc. 64 (1438)

Campin is commissioned to design a sequence of canvases showing the life and passion of Saint Peter and to present these to several masters with a view to negotiating the most reasonable fee for their completion. The contract is finally awarded to Henri de Beaumetiel. Campin's design was based on a description of the life of Saint Peter by a monk of the city's Franciscan order.

... Item, je donne à le chappelle S. Pierre en le rue S. Martin, pour une fois, la somme de dix livres de gros, lesquelles dix livres de gros seront mises et employées à faire poindre en ladite capelle la vie et passion du benoit et glorieux S. Pierre.

(Testament de Regnault de Viesrain du 16 août 1438 – De la Grange 1897, p. 226, No. 797)

Item comme ledit feu testateur euist par sondit testament laissié et donné a le cappielle S. Pierre scituée en le rue S. Martin en Tournai la somme de dix livres de gros pour une fois, lesquelles dix livres de gros fuissent mises et employées à faire poindre en ladite cappelle le vie et passion du benoist glorieux S. Pierre, assavoir est que lesdis exécuteurs ont d'icelle somme payé les parties qui s'ensuivent c'est assavoir:

A maître Robert Campin pointre pour son salaire d'avoir premièrement foit le patron de ladicte vie et passion dudit monseigneur S. Pierre pour monstrer icelluy à plusieurs maistres pour en marchander et trouver le meilleur marcheit que faire se pora, et en avoir eu son advis et conseil sur ce viii l. de gros valent lvi s. iiii d.

Item à Henry de Beaumetiel pour avoir marchandé à lui par le moyen dudit maistre Robert de poindre en draps de toille ladite vie et passion, bien et deument selon ledit patron comme il appartient vii l. de gros vallent xlix lb. viii s. ii d.

A Mahieu Fournier pour lvi aunes de fine toille achetée pour y poindre ladite passion au pris de trois gros l'aune sont iiii lb. xix s. v d.

Item à luy pour autres xii aunes de toille pareille à lui achetée pour y poindre les deux pryans c'est assavoir ledit Regnault de Viesrain et sa femme audit pris sont xxi s. ii d. t.

Item et pour ce que les draps de lad. vie et passion ne ont peu estre ne avoir esté poins ne parfais endedans l'année de ceste présente exécution, pour les mettre et assir en lad. cappelle dudit S. Pierre, qui ne sera le Noel prochain, lesdis exécuteurs pour les lambourdes qu'il convenra avoir pour les y assir cxii s. xi d.

... Donné à un des freres mineurs de laditte ville pour avoir baillié par escript la vie et mem-
oire de le passion dudit monseigneur S. Pierre sur laquelle ledit maistre Robert Campin fit
son patron ...

(Fonds des comptes d'exécution testamentaire 1439 – Soil de Moriamé 1891, p. 371 s)

[Campin's role in this contract, though correctly viewed by Destrée 1914, p. 330s, is erro-
neously interpreted by Wymans 1969, p. 386. The manner in which the work was delegated
clearly indicates that Campin was regarded as the more important of the two painters and
that he had been chosen specially for the design on grounds of his outstanding creative imag-
ination and his talent for narrative imagery. The considerably higher fee paid to Beaumetiel
merely reflects the greater number of working hours involved in his contribution as well as
the cost of materials provided by the artist. The fact that Campin was provided with a Life of
Saint Peter – presumably in French – may also be seen as an indication that he designed the
scenes anew and did not work from older paintings. The history paintings, including the por-
traits of the patron Regnault de Viesrain and his wife, have been destroyed. However, indi-
vidual fragments of tapestries showing scenes from the Life of Saint Peter have survived in
Paris and Beauvais. The designs for these tapestries have been attributed, on good grounds,
to Jacques Daret and Nicolas Froment (cf. Cat. III.A.3). It may be assumed that Daret, at
least, took his inspiration from the work of his former teacher and that the surviving tapes-
tries relate to the lost cycle by Campin in much the same way as Daret's Nativity in Arras
(Cat. III.A.16) relates to Campin's earlier portrayal of the same scene in Dijon (Cat. I.6).]

Doc. 65 (1441)

*Campin paints with gold, ultramarin and oils the new coats of arms of the king and the city of Tour-
nai for the porte de Saint-Martin.*

A maistre Robert Campin, pointre, pour avoir point de fin or mat, d'asur et de coulleur à olle
les armes du Roy à ung léz et les armes de la ville à l'aultre léz à ladite naeve banière de la
porte Saint-Martin, 10 s.

(C. d'ouv. de 1441 – De la Grange/Cloquet 1888, p. 223)

Doc. 66 (26 April 1444, correct date: 1445)

Robert Campin's death is documented as 26 April 1444.

Par le trespas maistre Robert Campin est rescheu à le ville xx couronnes qu'il avoit de rente
à se vie sur icelle, ... lequel trespassa le xxvj[e] jour d'avril d'an xliiij.

(C. gén. de 1444 – De la Grange/Cloquet 1888, p. 221)

[As Campin was mentioned as being alive on 23 April 1445 (see Doc. 67) the year of his death
normally cited in earlier literature probably ought to be corrected by a year.]

Doc. 67 (23 April 1445)

*Martin Campin in Valenciennes, a nephew of the painter, mentions in a contract with his future
son-in-law that he has a relative by the name of Robert Campin living in Tournai.*

/ Martin Campin s'engage à racheter, de son vivant, une rente viagère de vingt couronnes vendue à "Robert Campin sen cousin pour lors demorant à Tournay". /
(Valenciennes, Archives municipales, Werps, liasse 37 – Châtelet, p. 361)

Doc. 68 (s. d.)

Campin had no children in his marriage with Elisabeth van Stockem. This is evident from a testament in which the couple specify each other as their respective heirs should either of them die.

/ ... son épouse (...) dont il n'avait pas d'enfant. [Note:] Puisque les conjoints se "ravestirent", c'est-à-dire se firent donation mutuelle de tous leurs biens après décès. /
(Rolland 1932a, p. 34 and n. 4, with reference to an unpublished document discovered by A. Hoquet See also Rolland 1932b, p. 54, n. 5.)

Bibliography

Adhémar 1962
: Hélène Adhémar, Le Musée National du Louvre, vol. l. (= Les Primitifs Flamands I: Corpus de la peinture des anciens Pays-Bas méridionaux au quinzième siècle 5), Brussels 1962

Ainsworth 1996
: Maryan W. Ainsworth, »The *Virgin and Child in an Apse*: Reconsidering a Campin Workshop Design«, in: Foister/Nash 1996, pp. 147-158

Ainsworth/Christiansen 1998
: Maryan W. Ainsworth – Keith Christiansen (eds.), From van Eyck to Bruegel: Early Netherlandish Painting in The Metropolitan Museum of Art, New York 1998

Alvárez 1551
: Vicente Alvárez, Relacion del camino y buen viaje que hizo el Principe de Espana D. Phelipe nuestro senor, ano del nascimiento de nuestro Salvador, y Redemptor Jesu Christo de 1543 años [...], s.l. 1551

Arasse 1976
: Daniel Arasse, »A propos de l'article de Meyer Schapiro Muscipola Diaboli: le ›réseau figuratif‹ du retable de Mérode«, in: D. Arasse – G. Brunel (eds.), Symboles de la Renaissance, Paris 1976, pp. 47-51

Arasse 1993
: Daniel Arasse, Le détail: pour une histoire rapprochée de la peinture, Paris 1992

Arquié-Bruley 1987
: Françoise Arquié-Bruley et al., La collection Saint-Morys au Cabinet des Dessins du Musée du Louvre, 2 vols., Paris 1987

Asperen de Boer 1979
: J. R. J. van Asperen de Boer, »A Scientific Re-examination of the Ghent Altarpiece«, Oud Holland 93 (1979), pp. 141-214

Asperen de Boer et al.
: J. R. J. van Asperen de Boer – J. Dijkstra – R. van Schoute (with the collaboration of C.M.A Dalderup and J. P. Filedt Kok), Underdrawing in paintings of the group Roger van der Weyden/Master of Flémalle, Nederlands Kunsthistorisch Jaarboek (40) 1990, Zwolle 1992

Avril et al. 1989
: François Avril – Louisa Dunlop – Brunsdon Yapp, Les Petites Heures du Duc de Berry: Kommentar zu Ms. lat. 18014 der Bibliothèque Nationale Paris, Luzern 1989

Bätschmann 1979
: Oskar Bätschmann, »Poussins Narziss und Echo im Louvre: die Konstruktion von Thematik und Darstellung aus den Quellen«, Zeitschrift für Kunstgeschichte 42 (1979), pp. 31-47

Baldass 1952
: Ludwig von Baldass, Jan van Eyck, London 1952

Bauch 1944
: Kurt Bauch, »Ein Werk Robert Campins?«, Pantheon 32 (1944), pp. 30-40

Bauer 1989
: Rotraud Bauer, »The Burgundian Vestments«, in: The Conservation of Tapestries and Embroideries: Proceedings of Meetings at the Institut Royal du Patrimoine Artistique, Brussels 21-24 september 1987, Los Angeles 1989, pp. 17-23

Bauman/Liedtke 1992
: Guy C. Bauman – Walter A. Liedtke (ed.), Flemish Paintings in America: A Survey of Early Netherlandish and Flemish Paintings in the Public Collections of North America, Antwerp 1992

Baxandall 1974
: Michael Baxandall, Painting and Experience in Fifteenth Century Italy: A Primer in the Social History of Pictorial Style, Oxford 21974

Bazin 1931
: Germain Bazin, »L'esprit d'imitation dans l'art flamand«, Amour de l'Art 12 (1931), pp. 495-500

Beaujean 2001
: Dieter Beaujean, Bilder in Bildern: Studien zur niederländischen Malerei des 17. Jahrhunderts, Weimar 2001

Bedaux 1986
: Jean Baptiste Bedaux, »The Reality of Symbols: The Question of Disguised Symbolism in Jan van Eyck's *Arnolfini Portrait*, Simiolus 16 (1986), pp. 5-28

Beenken 1940
: Hermann Beenken, »Rogier van der Weyden und Jan van Eyck«, Pantheon 30 (1940), pp. 129-137

Beenken 1951
: Hermann Beenken, Rogier van der Weyden, Munich 1951

Belting/Eichberger 1983
: Hans Belting – Dagmar Eichberger, Jan van Eyck als Erzähler: Frühe Tafelbilder im Umkreis der New Yorker Doppeltafel, Worms 1983

Belting/Kruse 1994
: Hans Belting – Christiane Kruse, Die Erfindung des Gemäldes: Das erste Jahrhundert der niederländischen Malerei, Munich 1994

Berchtold 1992
: Jacques Berchtold, Des rats et des ratières: anamorphoses d'un champ métaphorique de Saint Augustin à Jean Racine, Geneva 1992

Berenson 1901
: Bernard Berenson, The Study and Criticism of Italian Art, London 1901

Berg 1966
: Gösta Berg, »Medieval Mouse Traps«, Studia Ethnographica Upsoliensia 26 (1966), pp. 1-13

Bergen-Pantens 1967
: Christian van den Bergen-Pantens, »Une Annonciation de l'école du Maître de Flémalle offerte par Jean IV de Sainte-Aldegonde«, Bulletin historique trimestriel de la Société académique des antiquaires de la Morinie 20 (1967), pp. 559-563

Bermejo Martinez 1980
: Elisa Bermejo Martinez, La pintura de los primitivos flamencos en España, 2 vols., Madrid 1980

Bialostocki/Walicki 1955
: Jan Bialostocki – Michal Walicki, Malarstwo europejskie w sbiorach polskich, s.l. [Warsaw] 1955

Birkmeyer 1962
: Karl M. Birkmeyer, »Notes on the Two Earliest Paintings by Rogier van der Weyden«, The Art Bulletin 44 (1962), pp. 329-331

Bloch 1963

Vitale Bloch, »An Unknown Composition by the Master of Flémalle«, The Burlington Magazine 105 (1963), p. 72

Blum 1969

Shirley Neilsen Blum, Early Netherlandish Triptychs: a Study in Patronage, Berkeley / Los Angeles 1969

Blum 1970

Shirley Neilsen Blum, Rez. Frinta, The Genius of Robert Campin, Art Bulletin 52 (1970), pp. 434-37

Boccaccio 1531/1976

Giovanni Boccaccio, Généalogie, Paris 1531; repr. New York / London 1976

Bode 1887

Wilhelm von Bode, »La Renaissance au musée de Berlin (I)«, Gazette des Beaux-Arts 29 (1887), pp. 204-220

Bode 1912/17

»Zwei Cassone-Tafeln aus dem Besitz des Piero de' Medici in der Sammlung Eduard Simon zu Berlin«, Mitteilungen des Kunsthistorischen Institutes in Florenz 2 (1912/17), pp. 149-151

Bodenehr 1720

Gabriel Bodenehr, Force d'Europe oder Die Merck-würdigst- und Fürnehmste (...) Staette, Vestungen, Seehaefen, Paesse, Camps de Bataille in Europa (...), Augsburg s.d. [1720]

Boon 1957

Karel G. Boon, Rez. Panofsky, Early Netherlandish Painting, Oud Holland 72 (1957), pp. 169-190

Botvinick 1992

Matthew Botvinick, »The painting as pilgrimage: traces of a subtext in the work of Campin and his contemporaries«, Art History 15 (1992), pp. 1-18

Bozière 1864

A.-F.-J. Bozière, Tournai ancien et moderne: description historique et pittoresque de cette ville, de ses monuments, de ses institutions, depuis son origine jusqu'à nos jours, Tournai 1864

Braun 1954

Edmund W. Braun, Stichwort »Cyrus«, in: O. Schmitt (ed.), Reallexikon zur deutschen Kunstgeschichte, vol. 3, Stuttgart 1954, cols. 899-911

Brinkmann 1996

Bodo Brinkmann, »Master of Catherine of Cleves«, in: Jane Turner (ed.), The Dictionary of Art, London 1996, vol. 20, pp. 642-45

Budde 1986

Rainer Budde, Köln und seine Maler 1300-1500, Cologne 1986

Burroughs 1932/33

Alan Burroughs, »Campin and Van der Weyden again«, Metropolitan Museum Studies 4 (1932/33), pp. 131-150

Burroughs 1938

Alan Burroughs, Art Criticism from a Laboratory, Boston 1938, Reprint Westport 1971

Busch 1940

Harald Busch, »Der Meister von 1473«, Zeitschrift des Deutschen Vereins für Kunstwissenschaft 7 (1940), pp. 104-122

Buyle/Bergmans 1994

Marjan Buyle – Anna Bergmans, Middeleeuwse muur-schilderingen in Vlaanderen, Brussels 1994

Calkins 1979

Robert G. Calkins, »Distribution of Labor: The Illu-minators of the Hours of Catherine of Cleves and their Workshop«, Transactions of the American Philo-sophical Society 69 (1979, part V), pp. 3-83

Callman 1982

Ellen Callman, »Campin's maiolica pitcher«, The Art Bulletin 64 (1982), pp. 629-631

Calvete de Estrella 1548/1876

Juan Cristoval Calvete de Estrella, Le très-heureux voyage fait par très-haut et très-puissant Don Philippe [...], traduit de l'espagnol par Jules Petit, 5 vol., Bruxel-les 1873-1884; vol. 3 (= Publications de la Société des Bibliophiles de Belgique vol. 11), Brussels 1876

Campbell 1973

Ian Lorne Campbell, Portrait-Painting in the Nether-lands: Campin and his Circle, unpublished diss. London, Courtauld Institute s.d. [1973]

Campbell 1974

Lorne Campbell, »Robert Campin, the Master of Flémalle and the Master of Mérode«, The Burlington Magazine 116 (1974), pp. 634-646

Campbell 1990

Lorne Campbell, Renaissance Portraits: European Portrait-Painting in the 14th, 15th and 16th Centuries, New Haven / London 1990

Campbell 1993

Lorne Campbell, »Rogier van der Weyden and his Workshop«, Proceedings of the British Academy 84 (1993), pp. 1-24

Campbell et al. 1994

Lorne Campbell – David Bomford – Ashok Roy – Raymond White, »The Virgin and Child before a Firescreen: History, Examination and Treatment«, National Gallery Technical Bulletin 15 (1994), pp. 20-35

Campbell 1996

Lorne Campbell, »Campin's Portraits«, in: Foister / Nash 1996, pp. 123-135

Campbell 1998

Lorne Campbell, The Fifteenth Century Netherlan-dish Schools (National Gallery Catalogues), London 1998

Carrier 1986/87

David Carrier, »Naturalism and Allegory in Flemish Painting«, Journal of Aesthetics and Art Criticism 45 (1986/87), pp. 237-249

Cat. Amsterdam 1973

Jaap Leeuwenberg, Beeldhowkunst in het Rijks-museum, Amsterdam 1973

Cat. Anvers 1930/32

Trésor de l'art flamand du moyen âge au XVIIIe siècle: mémorial de l'exposition d'art flamand ancien à Anvers 1930, Brussels 1932

Cat. Antwerpen 1985

Paul Vandenbroeck, Koninklijk museum voor schone kunsten Antwerpen: Catalogus schilderkunst 14e-15e eeuw, Antwerp 1985

Cat. Augsburg 1978

Staatsgalerie Augsburg, Städtische Kunstsammlungen Bd. 1: Altdeutsche Gemälde, Catalogue, Munich 1978

Cat. Basel 1995

Die Einblattholzschnitte des 15. Jahrhunderts aus dem Kupferstichkabinett Basel, Basel 1995

Cat. Berlin 1930

Elfried Bock – Jakob Rosenberg, Die Niederländischen Meister: Beschreibendes Verzeichnis sämtlicher Zeichnungen (Staatliche Museen zu Berlin: Die Zeichnungen alter Meister im Kupferstichkabinett), vol. 1, Berlin 1930

Cat. Berlin 1931

Beschreibendes Verzeichnis der Gemälde im Kaiser-Friedrich-Museum und Deutschen Museum, Berlin ⁹1931

Cat. Berlin 1975

Gemäldegalerie Staatliche Museen Preußischer Kulturbesitz Berlin: Katalog der ausgestellten Gemälde des 13-18. Jahrhunderts, Berlin-Dahlem 1975

Cat. Boston 1994

Laurence B. Kanter, Italian Paintings in the Museum of Fine Arts Boston, vol. 1: 13th-15th century, Boston 1994

Cat. Bruges 1902

Georges Hulin de Loo, Catalogue critique: exposition de tableaux flamands des XIVe, XVe et XVIe siècles, Bruges 1902, Gand 1902

Cat. Bruxelles 1863 / 1889

Édouard Fétis, Musées royaux de peinture et de sculpture de Belgique: catalogue descriptif et historique des tableaux anciens, Brussels 1863, ⁶1889

Cat. Bruxelles 1900

Alphonse-Jules Wauters, Le Musée de Bruxelles – Tableaux anciens: Notice, guide et catalogue, Brussels 1900

Cat. Bruxelles 1964

L'Œuvre de Roger de le Pasture-van der Weyden: 1399-1400/1464, Brussels 1964

Cat. Bruxelles 1979

Rogier van der Weyden – Rogier de le Pasture, peintre officiel de la Ville de Bruxelles, Portraitiste de la Cour de Bourgogne, Bruxelles, Musée communal Maison du Roi, Brussels 1979

Cat. Bruxelles 1985

Splendeurs d'Espagne et les villes belges 1500-1700, 2 vols., Bruxelles, Palais des Beaux-Arts, 25 septembre – 22 décembre 1985, Brussels 1985

Cat. Bruxelles 1996

Cyriel Stroo – Pascale Syfer-d'Olne, Catalogue Royal Museums of Fine Arts of Belgium, The Flemish Primitives, vol I: The Master of Flémalle and Rogier van der Weyden Groups, Brussels 1996

Cat. Cambridge 1960

Horst Gerson (ed.), Fitzwilliam Museum Cambridge: Catalogue of Paintings, vol. 1, Cambridge 1960

Cat. Cambridge 1967

J. W. Goodison – G. H. Robertson, Fitzwilliam Museum Cambridge: Catalogue of Paintings, vol. II: Italian Schools, Cambridge 1967

Cat. Cleveland 1974

The Cleveland Museum of Art: European Paintings Before 1500: Catalogue of Paintings: Part One, Cleveland 1974

Cat. Detroit 1960

Flanders in the Fifteenth Century: Art and Civilisation, Detroit Institute of Arts, Detroit 1960

Cat. Frankfurt 1996

Die Entdeckung der Kunst: Niederländische Kunst des 15. und 16. Jahrhunderts, Städelsches Kunstinstitut und Städtische Galerie Frankfurt am Main, Mainz 1996

Cat. Köln 2001

Genie ohne Namen: Der Meister des Bartholomäus-Altars. Wallraf-Richartz-Museum, Köln, 20. 5.-19. 8. 2001, Cologne 2001

Cat. Leuven 1975

Dirk Bouts en zijn tijd: tentoonstelling, Leuven, Sint-Pieterskerk, 12 sept.-3 von. 1975, Leuven 1975

Cat. Liège 1968

Jean Lejeune, Catalogue de l'Exposition Liège et Bourgogne. Musée de l'Art wallon, Liège, octobre-novembre 1968, Liège 1968

Cat. Liverpool 1963 / 66

Walker Art Gallery: Foreign Schools Catalogue, 2 vols., Liverpool 1963 / 66

Cat. Liverpool 1977

Walker Art Gallery, Liverpool: Foreign Catalogue, 2 vols., Liverpool 1977

Cat. London 1955

Flemish Paintings and Drawings at 56 Princes Gate, London SW7, London 1955

Cat. London 1971

Corrigenda and Addenda to the Catalogue of Paintings and Drawings at 56 Princes Gate, London SW7, London 1971

Cat. München 1935

Die Anfänge der Münchener Tafelmalerei, Munich 1935

Cat. München 1972

Gisela Goldberg – Gisela Schefler (eds.), Bayerische Staatsgemäldesammlungen Alte Pinakothek München: Altdeutsche Gemälde – Köln und Norwestdeutschland, 2 vols., Munich 1972

Cat. Münster 1937

Der Maler Derick Baegert und sein Kreis; Münster, Landesmuseum der Provinz Westfalen, Münster 1937

Cat. Münster 1952

Westfälische Meister der Spätgotik 1440-1490; Münster, Landesmuseum, 20 Juni-30. September 1952, Münster 1952

Cat. Münster 1986

Paul Pieper (ed.), Westfälisches Landesmuseum [...]: Die deutschen, niederländischen und italienischen Tafelbilder bis um 1530, Münster 1986

Cat. Münster 1996

Angelika Lorenz (ed.), Die Maler tom Ring, Kat. Westfälisches Landesmuseum Münster, 2 vols., Münster 1996

Cat. New York 1995

Marian W. Ainsworth (ed.), Petrus Christus, Renaissance Master of Bruges, Metropolitan Museum of Art, New York, New York 1995

Cat. New York 1999

Egbert Haverkamp-Begemann et al., The Robert Lehman Collection, vol. VII: Fifteenth- to Eighteenth-Century European Drawings: Central Europe, The

Netherlands, France, England, Metropolitan Museum of Art, New York, New York 1999

Cat. Nürnberg 1983

Rainer Kahsnitz (ed.), Nürnberg 1300-1550: Kunst der Gotik und Renaissance, Germanisches National-museum, Nuremberg/Munich 1983

Cat. Paris 1968

Frits Lugt, Musée du Louvre: Inventaire général des dessins des écoles du nord: maîtres des anciens Pays-Bas nés avant 1550, Paris 1968

Cat. Paris 1981

Les Fastes du Gothique: le siècle de Charles V, Paris 1981

Cat. Philadelphia 1913

Wilhelm Reinhold Valentiner, Catalogue of a Collection of Paintings and some Art Objects, vol. 2: Flemish and Dutch Painting, Philadelphia 1913

Cat. Philadelphia 1972

John G. Johnson Collection: Catalogue of Flemish and Dutch Paintings, rev. ed. of catalogue by W. R. Valentiner 1913-1914, Philadelphia 1972

Cat. Washington 1986

John Oliver Hand – Martha Wolff, Early Netherlandish Painting: The Collections of the National Gallery of Art Washington, Systematic Catalogue, Washington 1986

Cat. Wien 1956

Hermann Fillitz, Kunsthistorisches Museum: Katalog der weltlichen und der geistlichen Schatzkammer, Vienna 1956

Cat. Wien 1962

Europäische Kunst um 1400, Kunsthistorisches Museum Wien, Vienna 1962

Cavallo 1993

Adolfo Salvatore Cavallo, Medieval Tapestries in the Metropolitan Museum of Art, New York 1993

Ceulaer 1988

Roeland de Ceulaer, De Sint-Catharinakerk te Hoog-straten, Gent 1988

Chastel 1984

Musca depicta, Milan 1984

Châtelet

Albert Châtelet, Robert Campin – Le Maître de Flémalle: La fascination du quotidien, Anvers 1996

Châtelet 1974

Albert Châtelet, »Deux points controversés de la vie de Roger«, Rogier van der Weyden en zijn Tijd (Inter-nationaal Colloquium, 11-12 juni 1964), Koninklijke Academie voor Wetenschappen, Letteren en Schone Kunsten van België, Klasse der Schone Kunsten 1974, pp. 37-41

Châtelet 1989

Albert Châtelet, »Roger van der Weyden et le lobby polinois«, Revue de l'Art 84 (1989), pp. 9-21

Châtelet 1990

Albert Châtelet, »Révolution et art et révolution dans l'art: l'exemple du XVe siècle«, in: L'art et les révolu-tions: conférences, plénières, XXVIIe congrès inter-national d'histoire de l'art: Strasbourg, 1-7 septembre 1989, Strasbourg 1990, pp. 147-166

Châtelet 1993

Albert Châtelet, »L'atelier de Robert Campin«, in:

J. Dumoulin – J. Pycke, Les Grands Siècles de Tournai (12e-15e siècles), Tournai/Louvain-La-Neuve 1993, pp. 13-37

Châtelet 1994

Albert Châtelet, »Un brodeur et un peintre à la cour de Bourgogne: Thierry du Chastel et Hue de Bou-logne«, Aachener Kunstblätter 60 (1994) (= Festschrift für Hermann Fillitz), pp. 319-26

Châtelet 1999

Albert Châtelet, Rogier van der Weyden: problèmes de la vie et de l'œuvre, Strasbourg 1999

Clark 1978

Gregory T. Clark, An early fifteenth-century series of sibyls and pagan wise men in Münster cathedral from the circle of Robert Campin, unpublished Thesis for the Master of Arts, Queens College of the City Uni-versity of New York, 1978 [copy at the Westfälisches Landesmuseum, Münster]

Clercq 1979

C. de Clercq, »Contribution à l'iconographie des Sybilles II«, in: Jaarboek Koninklijk Museum voor Schone Kunsten Antwerp 1979, pp. 7-65

Clercq 1980

C. de Clercq, »Contribution à l'iconographie des Sybilles I«, in: Jaarboek Koninklijk Museum voor Schone Kunsten Antwerp 1980, pp. 7-35

Cockshaw/Van den Bergen-Pantens 1996

Pierre Cockshaw – Christiane Van den Bergen-Pantens (ed.), L'ordre de la Toison d'or, de Philippe le Bon à Philippe le Beau (1430-1505): idéal ou reflet d'une société?, Turnhout 1996

Cohen 1956

Gustave Cohen, Etudes d'histoire du théâtre en France au moyen-âge et à la renaissance, Paris 1956

Colalucci 1990

Francesco Colalucci, »»Muscipula diaboli‹? Una pseudo-trappola per topi nell'›Adorazione‹ di Lorenzo Lotto a Washington«, Artibus et historiae 21 (1990), pp. 71-88

Collart 1651

Jean Collart, Annotations au Journal de la Paix d'Arras, Paris 1651

Collobi Ragghianti 1990

Licia Collobi Ragghianti, Dipinti Fiamminghi in Italia (1420-1570): Catalogo (= Musei d'Italia, Meraviglie d'Italia 24), Bologna 1990

Comblen-Sonkes 1986

Micheline Comblen-Sonkes, Le Musée des Beaux-Arts de Dijon (= Les Primitifs flamands I: Corpus de la peinture des Anciens Pays-Bas méridionaux au quinzi-ème siècle 14), Brussels 1986

Comblen-Sonkes 1996

Micheline Comblen-Sonkes, The Collegiate Church of Saint Peter Louvain (= Corpus of Fifteenth-Century Painting in the Southern Netherlands and the Principality of Liège 18), Brussels 1996

Consoli 1980

Giuseppe Consoli, Messina: Museo Regionale, Bologna 1980

Conway 1921

William Martin Conway, The Van Eycks and their Followers, London 1921

Coo 1981

Jozef de Coo, »A Medieval look at the Merode Annunciation«, Zeitschrift für Kunstgeschichte 44 (1981), pp. 114-132

Coo 1990

Jozef de Coo, »Robert Campin: vernachlässigte Aspekte zu seinem Werk«, Pantheon 48 (1990), pp. 36-53

Coo 1991

Jozef de Coo, »Robert Campin: weitere vernachlässigte Aspekte«, Wiener Jahrbuch für Kunstgeschichte 44 (1991), pp. 79-105

Coremans 1953

Paul Coremans, L'Agneau mystique au laboratoire, Anvers 1953

Cousin 1619

Jean Cousin, Histoire de Tournay, Douai 1619

Crick-Kuntziger 1930

M. Crick-Kuntziger, »Les plus anciennes tapisseries occidentales conservées en Belgique«, Cahiers de Belgique 1930, pp. 177-184

Crowe/Cavalcaselle 1875

Joseph Archer Crowe – Giovanni Battista Cavalcaselle, Geschichte der altniederländischen Malerei, deutsche Original-Ausgabe bearbeitet von Anton Springer, Leipzig 1875

Davies

Martin Davies, Rogier Van der Weyden: an essay with a critical catalogue of paintings assigned to him and to Robert Campin, London 1972

Davies 1937

Martin Davies, »National Gallery Notes III: Netherlandish Primitives: Rogier van der Weyden and Robert Campin«, Burlington Magazine 71 (1937), pp. 140-45

Davies 1953

Martin Davies, The National Gallery, London, 2 vols. (= Les Primitifs Flamands I: Corpus de la peinture des anciens Pays-Bas méridionaux au quinzième siècle 3), Antwerp 1953/54

Davies 1966

Martin Davies, »A Portrait by Campin«, The Burlington Magazine 108 (1966), p. 622

Degenhardt/Schmidt 1984

Jacopo Bellini: The Louvre Album of Drawings, New York 1984

De la Grange/Cloquet 1887/88

A. de la Grange – Louis Cloquet, Etudes sur l'art à Tournai et sur les anciens artistes de cette ville, Tournai 1887/88 (= Mémoires de la Société historique et littéraire de Tournai 20, 21)

De la Grange 1897

A. de la Grange, »Choix de testaments tournaisiens antérieurs au XVIe siècle«, Annales de la Société historique et archéologique de Tournai, n.s. 2 (1897), pp. 5-365

Dehaisnes 1881

C. Dehaisnes, Inventaire sommaire des archives départementales antérieures à 1790, Nord, Archives civiles – Série B, vol. 4, Lille 1881

Demonts 1922

Louis Demonts, »La ›Sibylle delphique‹ de Ludger tom Ring le Vieux au Musée du Louvre«, Gazette des Beaux-Arts 64 (1922), pp. 69-76

Destrée 1919

Jules Destrée, »A propos de l'influence de Roger van der Weyden (Roger de la Pasture) sur la sculpture brabançonne«, Annales de la Société d'archéologie de Brussels 28 (1919), pp. 1-11

Destrée 1926

Joseph Destrée, »Altered in the Nineteenth Century? A Problem at the National Gallery, London«, The Connoisseur 74 (1926), pp. 209s

Destrée 1930

Jules Destrée, Le Maître de Flémalle (= Les grands maîtres), Brussels/Paris 1930

Deuchler 1963

Florens Deuchler, Die Burgunderbeute, Bern 1963

De Vos 1999

Dirk de Vos, Rogier van der Weyden: das Gesamtwerk, München 1999 [orig.: Rogier van der Weyden: het volledige Œuvre, Antwerp 1999]

Dhanens 1980

Elisabeth Dhanens, Hubert und Jan van Eyck, Königstein im Taunus 1980

Dhanens 1984

Elisabeth Dhanens, »Tussen de van Eyck's en Hugo van der Goes«, Medelingen van de Koniklijke Academie voor Wetenschappen, Letteren en Schone Kunsten van België: Klasse der Schone Kunsten 45, no 1 (1984), pp. 1-98

Dhanens 1987

Elisabeth Dhanens, »ACTUM GANDAVI: Zeven bijdragen in verband met de Oude Kunst te Gent«, Mededelingen van de Koninklijke Academie voor Wetenschappen, Letteren en Schone Kunsten van België: Klasse der Schone Kunsten 48, no 2 (1987), pp. 1-137

Dhanens 1998

Elisabeth Dhanens, Hugo van der Goes [éd. française], Antwerp 1998

Dhanens/Dijkstra 1999

Elisabeth Dhanens – Jellie Dijkstra, Rogier de le Pasture – van der Weyden: introduction à l'œuvre – relecture des sources, Tournai 1999

Didier 1981

Robert Didier, »Le milieu bruxellois et le problème Flémalle – de le Pasture – van der Weyden«, in: D. Hollanders-Favart – R. van Schoute (ed.). Le dessin sous-jacent dans la peinture, colloque 3, 1979, Louvain-la-Neuve 1981, pp. 9-26

Dierick 1991

Alfons Lieven Dierick, »La lecture des textes«, in: Verougstraete-Marcq-van Schoute 1991, pp. 181-184

Dijkstra 1990

Jellie Dijkstra, Origineel en kopie: een onderzoeg naar de navolging van der Meester van Flémalle en Rogier van der Weyden, Diss. Universität Amsterdam, Amsterdam 1990

Dülberg 1990

Angelica Dülberg, Privatporträts: Geschichte und Ikonologie einer Gattung im 15. und 16. Jahrhundert, Berlin 1990

Du Mortier 1862

B. du Mortier, »Recherches sur les principaux monu-

ments de Tournai«, Bulletin de la Société historique et littéraire de Tournai 8 (1862), pp. 137-379

Dumoulin/Pycke 1982

Jean Dumoulin – Jacques Pycke, »La tapisserie de Saint-Piat et de Saint-Éleuthère à la cathédrale de Tournai (1402): son utilisation et son histoire«, Revue des archéologues et historiens d'art de Louvain 15 (1982), pp. 184-200

Dumoulin/Pycke 1993

Jean Dumoulin – Jacques Pycke, »Comptes de la paroisse Sainte-Marguerite de Tournai au XVe siècle: documents inédits relatifs à Roger de le Pasture, Robert Campin et d'autres artisans tournaisiens«, in: J. Dumoulin – J. Pycke, Les grands siècles de Tournai (12e-15e siècles), Tournai 1993, pp. 279-320

Dunkerton 1983

Jill Dunkerton, »›The Death of the Virgin‹: A Technical Approach to an Art-Historical Problem«, National Gallery Technical Bulletin 7 (1983), pp. 21-29

Du Péage 1908

P. Denis du Péage, »Recueil de généalogies lilloises III«, Mémoires de la Société d'études de la province de Cambrai 14 (1908), pp. 899-918

Dupont 1966

Jacques Dupont, »La Sainte Famille des Clarisses du Puy«, Monuments historiques de la France 12 (1966), pp. 150-157

Duverger 1955

Jozef Duverger, »Brugse Schilders ten tijde van Jan van Eyck«, Bulletin des Musées Royaux des Beaux-Arts de Belgique, 4 (1955) (= Miscellanea Erwin Panofsky), pp. 83-120

Eidelberg 1998

Martin Eidelberg, »On the Provenance of Robert Campin's ›Christ and the Virgin‹«, Oud Holland 112 (1998), pp. 247-250

Einem 1968

Herbert von Einem, »Bemerkungen zur Sinneinheit des Genter Altars«, in: Miscellanea Jozef Duverger: bijdragen tot de kunstgeschiedenis der Nederlanden, vol. 1, Gent 1968, pp. 24-36

Eisler 1963

Colin Eisler, »A Flemish ›Holy Family‹« [Letter], The Burlington Magazine 105 (1963), p. 371

Eisler 1967

Colin Eisler, »Two Early Franco-Flemish Embroideries: suggestions for their settings«, The Burlington Magazine 109 (1967), pp. 571-581

Eisler 1989

Colin Eisler, The Thyssen-Boirnemisza Collection: Early Netherlandish painting, London 1989

Euw 1965

Anton von Euw, »Der Kalvarienberg im Schnütgen-Museum«, Wallraf-Richartz-Jahrbuch 27 (1965), pp. 87-128

Even 1895

Edward van Even, Louvain dans le passé et dans le présent, Louvain 1895

Fahy 1989

Everett Fahy, »The Argonaut Master«, Gazette des Beaux-Arts 114 (1989), pp. 285-299

Fäh 1906

Adolf Fäh, Frühdrucke aus der Stiftsbibliothek in St.Gallen (= Einblattdrucke des 15. Jahrhunderts, vol.3), Strasbourg 1906

Feder 1966

Theodore H. Feder, »A Re-examination through Documents of the First Fifty Years of Roger van der Weyden's Life«, The Art Bulletin 48 (1966), pp. 416-431

Fierens-Gevaert 1923

Hippolyte Fierens-Gevaert, »L'art belge ancien et moderne«, Gazette des Beaux-Arts 7 (1923), pp. 317-342

Firmenich-Richartz 1898/99

Eduard Firmenich-Richartz, »Roger van der Weyden, der Meister von Flémalle: ein Beitrag zur Geschichte der vlämischen Malerschule«, Zeitschrift für bildende Kunst, N.F. 10 (1898/99), pp. 1-12, 129-144

Fischel 1958

Lilli Fischel, »Die ›Vermählung Mariä‹ des Prado zu Madrid«, Bulletin des Musées Royaux des Beaux-Arts de Belgique 7 (1958), pp. 3-17

Fisher 1996

Celia Fisher, »Floral Motifs and the Problem of a Campin Workshop«, in: Foister/Nash 1996, pp. 117-122

Foister/Nash 1996

Susan Foister – Susie Nash (ed.), Robert Campin: New Directions in Scholarship, Turnhout 1996

Folie 1963

Jacqueline Folie, »Les œuvres authentifiées des primitifs flamands«, Bulletin des l'Institut royal du patrimoine artistique 6 (1963), pp. 183-256

Franke 1997

Birgit Franke, »›Huisvrouw‹, Ratgeberin und Regentin: zur niederländischen Herrscherinnenikonographie des 15. und beginnenden 16. Jahrhunderts«, Jahrbuch der Berliner Museen N.F. 39 (1997), pp. 23-38

Fredricksen 1981

Burton B. Fredricksen, »A Flemish Deposition of ca. 1500 and Its Relation to Rogier's Lost Composition«, The J. Paul Getty Museum Journal 9 (1981), pp. 133-156

Freeman 1957

Margaret B. Freeman, »The Iconography of the Merode Altarpiece«, Bulletin of the Metropolitan Museum of Art 16.4 (1957), pp. 130-139

Friedländer

Max J. Friedländer, Early Netherlandish Painting, 14 vol., Brussels/Leyden 1967-1976

Friedländer 1902

Max J. Friedländer, »Ein Bildnis des Meisters von Flémalle«, Jahrbuch der königlichen preussischen Kunstsammlungen 23 (1902), pp. 17-19

Friedländer 1903

Max J. Friedländer, Meisterwerke der niederländischen Malerei des XV. und XVI. Jahrhunderts auf der Ausstellung zu Brügge 1902, Munich 1903

Friedländer 1924

Max J. Friedländer, Die altniederländische Malerei, vol. 2: Rogier van der Weyden und der Meister von Flémalle, Berlin 1924

Friedländer 1950

Max J. Friedländer, »Von den drei grossen Altniederländern aus dem Berliner Museum«, Weltkunst vol. 20, no. 23 (1. Dez. 1950), pp. 3-4

Frinta

Mojmír S. Frinta, The Genius of Robert Campin, The Hague 1966

Frinta 1983

Mojmír S. Frinta, »Some Observations on the Campinesque Annunciation in Brussels«, in: D. Hollanders-Favart – R. van Schoute (ed.), Le dessin sous-jacent dans la peinture, Colloque 4, 1981, Louvain-la-Neuve 1983, pp. 87-97

Frodl-Kraft 1977/78

Eva Frodl-Kraft, »Die Farbsprache der gotischen Malerei«, Wiener Jahrbuch für Kunstgeschichte 30/31(1977/78), pp. 89-178

Frodl-Kraft 1981

Eva Frodl-Kraft, »Der Tempel von Jerusalem in der ›Vermählung Mariae‹ des Meisters von Flémalle: archäologische Realien und ideale Bildwirklichkeit«, in: Sumner McK. Crosby et al. (ed.), Etudes d'art médiéval offertes à Louis Grodecki, Paris 1981, pp. 293-316

Gandelman 1991

Claude Gandelman, Reading Pictures – Viewing Texts, Bloomington, Indiana 1991

Garrido 1996

Carmen Garrido, »The Campin Group Paintings in the Prado Museum«, in: Foister/Nash 1996, pp. 55-70

Gavelle 1904

Emile Gavelle, Le Maître de Flémalle et quatre portraits lillois, Lille 1904

Geisberg 1927

Max Geisberg, »Die Sibyllen im Dome zu Münster«, Westfalen 13 (1927), pp. 64-80

Geisberg 1930

Max Geisberg, »Die Sibyllen im Landesmuseum«, Westfalen 15 (1930), pp. 130-136

Geisberg 1937

Max Geisberg, Bau- und Kunstdenkmäler von Westfalen: Die Stadt Münster, vol. 5: Der Dom, Münster 1937

Gelder 1967

J. G. van Gelder, »An early Work by Robert Campin«, Oud Holland 82 (1967), pp. 1-17

Geldhof 1975

J. Geldhof, Pelgrims, dulle lieden en vondelingen te Brugge, 1275-1975: zeven eeuwen geschiedenis van het Sint-Juliaansgasthuis en van de Psychiatrische kliniek O.-L.-Vrouw te Brugge-Sint-Michiels, Brugge 1975

Génicot 1960

Luc. F. Génicot, »A propos de Huy dans la Nativité du Maître de Flémalle à Dijon«, Bulletin de la Commission royale des Monuments et de Sites (Bruxelles) 11 (1960), pp. 175-185

Gerdts 1954

William H. Gerdts, »The Sword of Sorrow«, The Art Quarterly 17 (1954), pp. 212-229

Gorissen 1973

Friedrich Gorissen, Das Stundenbuch der Katharina von Kleve: Analyse und Kommentar, Berlin 1973

Gottlieb 1957

Carla Gottlieb, »The Brussels Version of the Mérode ›Annunciation‹«, The Art Bulletin 39 (1957), pp. 53-59

Gottlieb 1960

Carla Gottlieb, »The Mystical Window in Paintings of the Salvator Mundi«, Gazette des Beaux-Arts 56 (1960), pp. 313-332

Gottlieb 1970

Carla Gottlieb, »Respiciens per Fenestras: the Symbolism of the Mérode Altarpiece«, Oud-Holland 85 (1970), pp. 65-84

Grange 1969

T. P. Grange, Rez. M. J. Friedländer, Early Netherlandish Painting, M. S. Frinta, The Genius of Robert Campin, The Burlington Magazine 111 (1969), p. 460

Grodecki 1965

Louis Grodecki (ed.), Plans en reliefs de villes belges levés par des ingénieurs militaires français – XVIIe-XIXe siècle, Brussels 1965

Grohn 1957

Hans-Werner Grohn, »Zwei Cassoni mit Darstellungen aus der Erzählung von Amor und Psyche«, Forschungen und Berichte 1 (1957), pp. 90-100

Gropp 1999

David Gropp, Das Ulmer Chorgestühl und Jörg Syrlin der Ältere: Untersuchungen zu Architektur und Bildwerk, Berlin 1999

Grosshans 1981

Rainald Grosshans, »Rogier van der Weyden: der Marienaltar aus der Kartause Miraflores«, Jahrbuch der Berliner Museen 23 (1981), pp. 47-112

Guesnon 1910

A. Guesnon, »Le hautelisseur Pierre Feré d'Arras, auteur de la tapisserie de Tournai (1402)«, Revue du Nord 1 (1910), pp. 201-215

Hahn 1986

Cynthia Hahn, »›Joseph Will Perfect, Mary Enlighten and Jesus Save Thee‹: The Holy Family as Marriage Model in the Mérode Tritych«, The Art Bulletin 68 (1986), pp. 54-66

Haussherr 1968

Reiner Haussherr, »Templum Salomonis und Ecclesia Christi: zu einem Bildvergleich der Bible moralisée«, Zeitschrift für Kunstgeschichte 31 (1968), pp. 101-121

Heckscher 1968

William S. Heckscher, »The Annunciation of the Mérode Altarpiece«, in: Miscellanea Jozef Duverger, Bijdragen tot de Kunstgeschiedenes der Nederlanden, vol. I, Gent 1968, pp. 37-65

Heins 1907

A. Heins, »La vue de Gand qui paraît avoir été interprétée sur les volets de l'Annonciation du Maître de Flémalle ou de Mérode«, Bulletin de la Société d'histoire et d'archéologie de Gand 15 (1907), pp. 201-24

Heise 1918

Carl Georg Heise, Norddeutsche Malerei: Studien zu ihrer Entwicklungsgeschichte im 15. Jahrhundert von Köln bis Hamburg, Leipzig 1918

Held 1955

Julius S. Held, Rez. Panofsky, Early Netherlandish Painting, The Art Bulletin 37 (1955), pp. 205-234

Henne/Wauters 1845

Alexandre Henne – Alphonse Wauters, Histoire de la Ville de Bruxelles, Brussels 1845

Herman 1980

Pierre Herman, »L'église Saint-Julien à Ath«, Etudes et documents du cercle royal d'histoire et d'archéologie d'Ath et de la région 2 (1980), pp. 9-13

Herrlinger 1951/53

Robert Herrlinger, »Zur Frage der ersten anatomisch richtigen Darstellung des menschlichen Körpers in der Malerei«, Centaurus 2 (1951/53), pp. 284-286

Heusinger 1997

Christian von Heusinger, Herzog Anton Ulrich-Museum Braunschweig, Sammlungskataloge, vol. III: Die Handzeichnungssammlung, Geschichte und Bestand [Katalog zu Tafelband I: Von der Gotik bis zum Manierismus, Braunschweig 1992], Braunschweig 1997

Hind 1935

A. M. Hind, An Introduction to a History of Woodcut, London 1935

Hocquet 1925

Adolphe Hocquet, »Le Maître de Flémalle: quelques documents«, Annales de l'Académie royale d'Archéologie de Belgique 73 (1925), pp. 5-17

Houben 1949

W. Houben, »Raphael and Rogier van der Weyden«, The Burlington Magazine 91 (1949), pp. 312, 315

Houtart 1907

Maurice Houtart, Jacques Daret, Tournai s.d. [1907]

Houtart 1908

Maurice Houtart, Les Tournaisiens et le roi de Bourges = Annales de la Société historique et archéologique de Tournai, n.s. 12 (1908)

Houtart 1914

Maurice Houtart, »Quel est l'état de nos connaissances relativement à Robert Campin, Jacques Daret, et Roger van der Weyden?«, in: Annales de la Fédération archéologique et historique de Belgique, XXIIIe Congrès, Gand 1913, (Liège) 1914, vol. 3, pp. 88-108

Huizinga 1969

Johan Huizinga, Herbst des Mittelalters: Studien über Lebens- und Geistesformen des 14. und 15. Jahrhunderts in Frankreich und in den Niederlanden, Stuttgart 1969

Hulin 1901

Georges Hulin de Loo, »Le tableau de ›Tomyris et Cyrus‹ au musée de Berlin et dans l'ancien palais épiscopal de Gand«, Bulletin van de Geschied- en Oudheidkundige Kring van Gent 9 (1901), pp. 222-234

Hulin 1902

Georges Hulin de Loo, Catalogue critique de l'exposition de tableaux flamands, Bruges, 1902, Gand 1902

Hulin 1909

Georges Hulin de Loo, »An Authentic Work by Jacques Daret, Painted in 1434«, The Burlington Magazine 15 (1909), pp. 202-208

Hulin 1911

Georges Hulin de Loo, »Sur la date de quelques œuvres du Maître de Flémalle«, Bulletin de l'Académie royale d'archéologie de Belgique (1911), pp. 109-112

Hulin 1926

Georges Hulin de Loo, ›Robert Campin or Rogier van der Weyden? Some Portraits Painted between 1432 and 1444«, The Burlington Magazine 49 (1926), pp. 268-74

Hulst 1959

Roger-Adolf d'Hulst, Tapisseries flamandes, Brussels 1959

Hütt 1989

Michael Hütt, »›...Das dich Gott wöll behüten vor vnraine durch sein güte‹: zur Funktion eines Details auf spätmittelalterlichen Bildern«, Marburger Jahrbuch für Kunstwissenschaft 22 (1989), pp. 159-168

Huvelle 1983/1984

Jean Huvelle, »Iconographie des saints Piat et Éleuthére«, Mémoires de la Société royale d'histoire et d'archéologie de Tournai 4 (1983-1984), pp. 489-567

Installé 1992

Henri Installé, »Le triptyque Merode: évocation mnémonique d'une famille de marchands colonais, réfugiée à Malines«, Handelingen van de Koninklijke Kring voor Oudheidkunde, Letteren en Kunst van Mechelen 1992, pp. 55-154

Jacobus a Voragine 1890

Jacobi a Voragine Legenda Aurea vulgo historia lombardica dicta, ed. Th. Graesse, Breslau 31890

Jakoby 1987

Barbara Jakoby, Der Einfluß niederländischer Tafelmalerei des 15. Jahrhunderts auf die Kunst der benachbarten Rheinlande am Beispiel der Verkündigungsdarstellung in Köln, am Niederrhein und in Westfalen (1440-1490), Diss. Köln, Cologne 1987

Jamot 1928

Paul Jamot, »Roger van der Weyden et le prétendu Maître de Flémalle«, Gazette des Beaux-Arts, 5e pér., 18 (1928), pp. 259-282

Jászai 1986

Géza Jászai, »Im Hinblick des Malers: Notizen zu Derick Baegerts Altarbild ›Der Evangelist Lukas malt die Muttergottes‹«, Das Kunstwerk des Monats, Westfälisches Landesmuseum, Münster 1986 (June)

Jászai 1991

Géza Jászai, Die Domkammer der Kathedralkirche Sankt Paulus in Münster, Kommentare zu ihrer Bildwelt, Münster 1991

Jooss 1999

Birgit Jooss, Lebende Bilder: Körperliche Nachahmung von Kunstwerken in der Goethezeit, Berlin 1999

Joris 1976

André Joris (avec la collaboration de Christiane De Craecker-Dussart), Le Visage de Huy, Brussels 1976

Joubert 1987

Fabienne Joubert, La tapisserie médiévale au musée de Cluny, Paris 1987

Joubert 1990

Fabienne Joubert, »Jacques Daret et Nicolas Froment cartonniers de tapisseries«, Revue de l'art 88 (1990.2), pp. 39-47

Joubert 1993

Fabienne Joubert, »A propos de la tapisserie tournaisienne au 15e siècle: la question des modèles«, in: Dumoulin/Pycke 1993, pp. 41-58

Justi 1886

Carl Justi, »Altflandrische Bilder in Spanien und

Portugal«, Zeitschrift für Bildende Kunst 21 (1886),
pp. 93-98

Kemperdick

Stephan Kemperdick, Der Meister von Flémalle:
Die Werkstatt Robert Campins und Rogier van der
Weydens, Turnhout 1997

Kemperdick 1994

Stephan Kemperdick, »Zum Werk des Johannes Borne-
mann: Überlegungen zu Chronologie und Vorbil-
dern«, Niederdeutsche Beiträge zur Kunstgeschichte
33 (1994), pp. 57-86

Kemperdick 1995

Stephan Kemperdick, »The Impact of Flemish Art
on Northern German Painting around 1440«, in:
Smeyers/Cardon 1995, pp. 605-618

Kerber 1931/32

Ottmar Kerber, »Robert Campin und Rogier van der
Weyden«, Kritische Berichte zur kunstgeschichtlichen
Literatur 1931/32, pp. 234-50

Kerber 1938

Ottmar Kerber, »Frühe Werke des Meisters von
Flémalle im Berliner Museum«, Jahrbuch der Preußi-
schen Kunstsammlungen 59 (1938), pp. 59-66

Kermer 1967

Wolfgang Kermer, Studien zum Diptychon in der
sakralen Malerei von den Anfängen bis zur Mitte des
sechzehnten Jahrhunderts, Diss. Tübingen 1967

Kern 1971

Peter Kern, Trinität, Maria, Inkarnation: Studien zur
Thematik der deutschen Dichtung des späten Mittel-
alters (= Philologische Studien und Quellen 55),
Berlin 1971

Kieser 1968

Emile Kieser, »Die Geburt Christi des Meisters von
Flémalle in Dijon«, in: Amici Amico: Festschrift für
Werner Gross zu seinem 65. Geburtstag, Munich
1968, pp. 155-178

Kirchhoff 1976

Margret Kirchhoff, Die Marientafeln der Obersten
Stadtkirche in Iserlohn, Iserlohn 1976

Klein 1933

Dorothee Klein, St. Lukas als Maler der Maria: Ikono-
graphie der Lukas-Madonna, Berlin 1933

Klein 1995

Peter Klein, »Dendrochronological Findings of the
Van Eyck-Christus-Bouts Group«, in: Maryan W. Ains-
worth (ed.), Petrus Christus in Renaissance Bruges:
an interdisciplinary approach, New York 1995, pp. 149-
165

Klein 1996

Peter Klein, »Dendrochronological Findings in Panels
of the Campin Group«, in: Foister/Nash 1996,
pp. 77-86

Koch 1910

Ferdinand Koch, »Die Kunst der westfälischen Graf-
schaft Mark«, in: Beiheft zu A. Meisters Festschrift:
Die Grafschaft Mark, Dortmund 1910, pp. 791-822

Koch 1975

Guntram Koch, Die mythologischen Sarkophage,
6. Teil: Meleager (= F. Matz – B. Andreae (eds.),
Die antiken Sarkophagreliefs, Bd. 12, 6. Teil), Berlin
1975

Kraut 1986

Gisela Kraut, Lukas malt die Madonna: Zeugnisse
zum künstlerischen Selbstverständnis in der Malerei,
Worms 1986

Kühnel 1989

Harry Kühnel, »Die Fliege – Symbol des Teufels und
der Sündhaftigkeit«, in: Aspekte der Germanistik:
Festschrift für Hans-Friedrich Rosenfeld zum 90.
Geburtstag (= Göppinger Arbeiten zur Germanistik,
Bd. 521), Göppingen 1989, pp. 285-305

Künstler 1974

Gustav Künstler, »Vom Entstehen des Einzelbildnisses
und seiner frühen Entwicklung in der flämischen
Malerei«, Wiener Jahrbuch für Kunstgeschichte 27
(1974), pp. 20-64

Kurth 1918

Betty Kurth, »Die Blütezeit der Bildwirkerkunst zu
Tournai und der burgundische Hof«, Jahrbuch der
kunsthistorischen Sammlungen des allerhöchsten
Kaiserhauses (Wien) 34 (1918), pp. 53-110

Laborde 1849-52

Léon de Laborde, Les ducs de Bourgogne, Paris 1849-52

Lactance 1986

Lactance, Institutions divines, livre I, ed. Pierre Monat
(= Sources chrétiennes vol. 326), Paris 1986

Lane 1975

Barbara G. Lane, »»Depositio et Elevatio: the Symbo-
lism of the Seilern Triptych«, The Art Bulletin 57
(1975), pp. 21-30

Lane 1984

Barbara G. Lane, The Altar and the Altarpiece:
Sacramental Themes in Early Netherlandish Painting,
New York 1984

Lavallée 1997

Marie-Hélène Lavallée, »Les collections du moyen-
âge au Musée des Beaux-Arts de Lille«, La revue du
Louvre et des musées de France 47 (1997), pp. 85-92

Leclercq-Marx 1992

Jacqueline Leclercq-Marx, »Tournai – Deux fresques
médiévales oubliées: L'Entrée du Christ à Jérusalem
(XIVe siècle) et un fragment d'Annonciation de Robert
Campin«, Revue belge d'histoire de l'art 61 (1992),
pp. 230-234

Lees 1913

F. Lees, The Art of the Great Masters as exemplified
by Drawings in the Collection of Emile Wauters,
membre de l'Académie Royale de Belgique, London
1913

Lehrs 1889

Max Lehrs, »Der deutsche und niederländische Kupfer-
stich des fünfzehnten Jahrhunderts in den kleineren
Sammlungen«, Repertorium für Kunstwissenschaft 12
(1889), pp. 19-13, 250-276, 339-357

Lehrs 1898

Max Lehrs, »Der deutsche und niederländische Kupfer-
stich des fünfzehnten Jahrhunderts in den kleineren
Sammlungen«, Repertorium für Kunstwissenschaft
19 (1898), pp. 28-53, 309-343

Lehrs 1921

Max Lehrs, Geschichte und kritischer Katalog des
deutschen, niederländischen und französischen
Kupferstichs im XV. Jahrhundert, vol. 4, Vienna 1921

Lespinasse 1934

J. Abbé Lespinasse, »Le culte de saint Julien de Brioude«, Almanach de Brioude 1934

Lestocquoy 1937

Jean Lestocquoy, »Le rôle des artistes tournaisiens à Arras au XVe siècle: Jacques Daret et Michel de Gand«, Revue belge d'archéologie et d'histoire de l'art 7 (1937), pp. 211-227

Lestocquoy 1978

Jean Lestocquoy, Deux siècles de l'histoire de la tapisserie (1300-1500): Paris, Arras, Lille, Tournai, Bruxelles, Arras 1978 (= Mémoires de la Commission départementale des Monuments Historiques du Pas-de-Calais, vol. 19)

Leuridan 1903

Théodore Leuridan, Epigraphie du Nord, Mémoires de la Société d'Etudes de la Province de Cambrai, vol. 8, No. 1, juin 1903

Löhneysen 1956

Hans Wolfgang von Löhneysen, Die ältere niederländische Malerei: Künstler und Kritiker, Eisenach/Kassel, 1956

Loewinson-Lessing/Nicouline 1965

Vladimir Loewinson-Lessing – Nicolas Nicouline, Le Musée de l'Ermitage, Leningrad (= Les Primitifs flamands, I. Corpus de la peinture des anciens Pays-Bas méridionaux du quinzième siècle, vol. 8, Brussels 1965

Lorentz 1994

Philippe Lorentz, »De Sienne à Strasbourg: postérité d'une composition d'Ambrogio Lorenzetti, la ›Nativité de la Vierge de l'hôpital Santa Maria della Scala à Sienne‹«, in: P. Rosenberg et al. (ed.), Hommage à Michel Laclotte: études sur la peinture du Moyen Age et de la Renaissance, Milan/Paris 1994, pp. 118-131

Ludolphus de Saxonia 1878

Ludolphus de Saxonia, Vita Jesu Christi, ed. by L. M. Rigollot, 4 vol., Paris/Brussels 1878

Lutz/Pedrizet 1907/1909

Jules Lutz – Paul Pedrizet, Speculum humanae salvationis: kritische Ausgabe [der] Übersetzung von Jean Mielot (1448), 2 vol. (Text, Tafeln), Leipzig 1907, 1909

Lyna 1955

Frédéric Lyna, »Les van Eyck et les ›Heures de Turin et de Milan‹«, Bulletin des musées royaux des beaux-arts 1955.1-3 (= Miscellanea Erwin Panofsky), pp. 7-15

Maeterlinck 1900

Louis Maeterlinck, »Roger van der Weyden et les »ymaigiers« de Tournai« = Académie royale des sciences, des lettres, et des beaux-arts de Belgique: Mémoires, couronnés et autres mémoires (1900); mémoire no. 7

Maginnis 1988

H. B. J. Maginnis, »The Lost Façade Frescoes from Siena's Ospedale di S. Maria della Scala«, Zeitschrift für Kunstgeschichte 51 (1988), pp. 180-194

Mairinger/Hutter 1981

F. Mairinger – H. Hutter, »Copies by Flémalle-van der Weyden followers at the Akademie der bildenden Künste in Vienna«, in: H. Verougstraete-Marcq – R. van Schoute (ed.), Le dessin sous-jacent dans la peinture, colloque III, septembre 1979, Louvain-la-Neuve 1981, pp. 131-136

Mann 1992

Heinz Herbert Mann, Augenglas und Perspektiv: Studien zur Ikonographie zweier Bildmotive, Berlin 1992

Maquet-Tombu 1951

Jeanne Maquet-Tombu, »L'intimisme de Roger, ›Maître de Flémalle‹«,in: Annales de la Fédération archéologique et historique de Belgique, 33e congrès, Tournai 1949, vol.2, Brussels 1951, pp. 635-646

Marijnissen 1985

Roger H. Marijnissen, Paintings genuin, fraud, fake: modern methods of examining paintings, Brussels 1985

Marlier 1957

Georges Marlier, Ambrosius Benson et la peinture à Bruges au temps de Charles-Quint, Damme 1957

Marrow 1979

James H. Marrow, Passion Iconography in Northern European Art of the Late Middle Ages and Early Renaissance, Kortrijk 1979

Martens 1992

Pieter Jan Martens, Artistic Patronage in Bruges Institutions ca. 1400-1482, Ann Arbor 1992

Martens 1996

Maximiliaan P. J. Martens, Rez. Sander 1993, Simiolus 24 (1996), pp. 77-81

Mazurczakowa 1985

Ursula M. Mazurczakowa, »Próba analizy czasu przedstawionego wobrazie [An Essay on the Analysis of Time Presented in the Painting]«, Rocznik Historii Sztuki 15 (1985), pp. 5-54

McCann 1978

Anna Marguerite McCann, Roman Sarcophagi in The Metropolitan Museum of Art, New York 1978

Meiss 1936

Millard Meiss, »The Madonny of Humility«, The Art Bulletin 18 (1936), pp. 434-464

Meiss 1945

Millard Meiss, »Light as Form and Symbol in some Fifteenth-Century Paintings«, The Art Bulletin 27 (1945), pp. 175-181

Meiss 1974

Millard Meiss, French Painting in the Time of Jean de Berry: The Limbourgs and their Contemporaries, 2 vols., New York 1974

Meissner 1992

Günter Meissner (ed.), Allgemeines Künstlerlexikon, vol. 3, Munich/Leipzig 1992

Merback 1999

Mitchell B. Merback, The Thief, the Cross and the Wheel: Pain and the Spectacle of Punishment in Medieval and Renaissance Europe, London 1999

Mérindol 1988

Christian de Mérindol, »Nouvelles observations sur le symbolisme royal à la fin du Moyen Age: le couple de saint Jean-Baptiste et de sainte Catherine au portail de l'église de la Chartreuse de Champmol«, Bulletin de la société nationale des Antiquaires de France 1988, pp. 288-301

Michel 1931
Édouard Michel, »La solution du problème van der Weyden«, Revue de l'art ancien et moderne, 60 (1931), pp. 121-127

Michel 1934
Édouard Michel, »Le Maître de Francfort«, Gazette des Beaux-Arts, 6e pér., tome 12, 76 (1934), pp. 236-244

Minott 1969
Charles Ilsley Minott, »The Theme of the Mérode Altarpiece«, The Art Bulletin 51 (1969), pp. 267-271

Minott 1985
Charles Ilsley Minott, »Notes on the Iconography of Robert Campin's ›Nativity‹ in Dijon«, in: William W. Clark et al. (ed.), Tribute to Lotte Brand Philip: Art Historian and Detective, New York 1985

Monroe 1992
William S. Monroe, »The Guennol Triptych and the Twelfth-Century Revival of Jurisprudence«, in: Elizabeth C. Parker (ed.), The Cloisters: Studies in Honor of the Fiftieth Anniversary, New York 1992, pp. 167-177

Mot 1932
Paul de Mot, »École des anciens pays-bas: Maître de Flémalle ou son atelier (1er moitié du XVe siècle): L'Annonciation«, Société des amis des musées royaux de l'État à Bruxelles 25 (années d'activité 1907-1932), Brussels/Paris 1932, pp. 38-41

Müller-Jahncke 1973
Wolf Dieter Müller-Jahncke, Magie als Wissenschaft im frühen 16. Jahrhundert: Die Beziehungen zwischen Magie, Medizin und Pharmacie im Werk des Agrippa von Nettesheim (1486-1535), Diss. Marburg, Marburg an der Lahn 1973

Musper 1948
Heinrich Theodor Musper, Untersuchungen zu Rogier van der Weyden und Jan van Eyck, Stuttgart 1948

Musper 1952
Heinrich Theodor Musper, »Die Brüsseler Gregormesse, ein Original«, Bulletin des Musées royaux des beaux-arts de Belgique 1 (1952), pp. 89-94

Nagelmackers 1967
A. Nagelmackers, »A propos des bateaux de la ›Nativité du Maître de Flémalle‹ à Dijon: L'histoire d'un petit bateau ou l'erreur historique évitée«, Bulletin de la Société royale Le Vieux-Liège, vol. 7, No. 159, pp. 220-25

Nickel 1965/66
Helmut Nickel, »The Man beside the Gate«, Metropolitan Museum of Art Bulletin (New York) 24 (1965/66), pp. 237-244

Nilgen 1967
Ursula Nilgen, »The Epiphany and the Eucharist: On the Interpretation of Eucharistic Motifs in Mediaeval Epiphany Scenes«, The Art Bulletin 49 (1967), pp. 311-316

Ninane 1964
Lucie Ninane, »Le mystère Flémalle-Roger«, in: L'œuvre de Roger de le Pasture-van der Weyden, Brussels 1964

Ninane 1977
Lucie Ninane, »Robert Campin et Roger de le Pasture«, in: R. Lejeune – J. Stiennon (ed.), La Wallonie:

le pays et les hommes: lettres – art – culture, vol. 1: Des origines à la fin du XVe siècle, Brussels 1977, pp. 409-413, 425-427

Nützmann 1997
Hannelore Nützmann, »Verschlüsselt in Details: Hochzeitsbilder für Lorenzo de' Medici«, Jahrbuch Preußischer Kulturbesitz 34 (1997), pp. 223-235

Nützmann 2000
Hannelore Nützmann, Alltag und Feste: Florentinische Cassone- und Spallieramalerei aus der Zeit Botticellis, Berlin 2000

Oppenheim 1907/1911
Benoît Oppenheim, Originalbildwerke aus meiner Sammlung, Berlin 1907, 1911 [Nachtrag]

Pächt 1956
Otto Pächt, »Panofsky's ›Early Netherlandish Painting‹ [I, II]«, The Burlington Magazine 98 (1956), pp. 110-116, 267-279

Pächt 1961
Otto Pächt, »The ›Avignon Diptych‹ and Its Eastern Ancestry«, in: Millard Meiss (ed.), De artibus opuscula XL: Essays in Honor of Erwin Panofsky, New York 1961, vol. 1 pp. 402-421, vol. 2 pp. 130-135

Pächt 1977
Otto Pächt, »Künstlerische Originalität und ikonographische Erneuerung«, in: O. Pächt, Methodisches zur kunsthistorischen Praxis, Munich 1977, pp. 153-164

Pächt 1978
Otto Pächt, »»La Terre de Flandres«« , Pantheon 36 (1978), pp. 3-16

Pächt 1989
Otto Pächt, Van Eyck: Die Begründer der altniederländischen Malerei, Munich 1989

Panofsky
Erwin Panofsky, Early Netherlandish Painting: Its Origins and Character, Cambridge, Mass. 1953

Passavant 1833
Johann David Passavant, Kunstreise durch England und Belgien, Frankfurt a. M. 1833

Passavant 1843
Johann David Passavant, »Beiträge zur Kenntniß der altniederländischen Malerschulen bis zur Mitte des sechzehnten Jahrhunderts«, Kunstblatt 24 (1843), pp. 225-263

Passavant 1853
Johann David Passavant, Die christliche Kunst in Spanien, Leipzig 1853

Passavant 1858
Johann David Passavant, »Die Maler Roger van der Weyden und einige Notizen über Goswin und Peter van der Weyden«, Zeitschrift für christliche Archäologie und Kunst 2 (1858), pp. 1-20, 120-130, 178-180

Petri 1956
Franz Petri, »Vom Verhältnis Westfalens zu den östlichen Niederlanden«, Westfalen 34 (1956), pp. 161-168

Petrus Comestor 1855
Petrus Comestor, Historia scholastica, in: J.-P. Migne (ed.), Patrologia latina, vol. 198, Paris 1855

Piccard 1980
Gerhard Piccard, Die Wasserzeichenkartei Piccard im Hauptstaatsarchiv Stuttgart: Wasserzeichen Fabel-

tiere: Greif – Drache – Einhorn, Findbuch X,
Stuttgart 1980

Pieper 1937

Paul Pieper, »Der Lukasaltar des Derick Baegert«,
Westfalen 22 (1937), pp. 233-235

Pieper 1960

Paul Pieper, »Die Propheten- und Sibyllenfolge von
circa 1450: Oberrhein oder Westfalen?«, Kunstchronik
13 (1960), p. 295

Pieper 1966a

Paul Pieper, »Das Stundenbuch der Katharina van
Lochorst und der Meister von Katharina von Kleve«,
Westfalen: Hefte für Geschichte, Kunst und Volks-
kunde 44 (1966), pp. 97-157

Pieper 1966b

Paul Pieper, »Eine Tafel von Robert Campin«,
Pantheon 24 (1966), pp. 279-282

Pieper 1976

Paul Pieper, Stichwort »Ring d.ä., Ludger tom«, in:
Kindlers Malerei Lexikon

Pigler 1964

André Pigler, »La mouche peinte: un talisman«,
Bulletin du Musée hongrois des Beaux-Arts 24 (1964),
pp. 47-64

Pilz 1970

Wolfgang Pilz, Das Triptychon als Kompositions- und
Erzählform in der deutschen Tafelmalerei von den
Anfängen bis zur Dürerzeit, Munich 1970

Pinchart 1867

Alexandre Pinchart, »Roger de le Pasture dit van der
Weyden«, Bulletin des Commissions royales d'art et
d'archéologie 6 (1867), pp. 408-494

Pinchart 1882

Alexandre Pinchart, »Quelques artistes et quelques
artisans de Tournai des XIVe, XVe et XVIe siècles«,
Bulletin de l'Académie Royale des Sciences, des Lettres
et des Beaux-Arts de Belgique 51, 3e série t. 4 (1882),
pp. 559-615

Pitts 1986

Frances Pitts, »Iconographic Mode in Campin's
London Madonna«, Konsthistorisk Tidskrift 55 (1986),
pp. 87-100

Plummer 1966

John Plummer, Die Miniaturen aus dem Stundenbuch
der Katharina von Kleve, Berlin 1966

Polleross 1988

Friedrich B. Polleross, Das sakrale Identifikations-
porträt: ein höfischer Bildtypus vom 13. bis zum
20. Jahrhundert, Worms 1988

Pope-Hennessy 1966

The Portrait in the Renaissance, Princeton 1966

Popham 1931/32

A. E. Popham, »Robert Campin (The Master of
Flémalle) (Copy after): St. Catherine – Coll. of Mrs.
Alfred Noyes«, Old Master Drawings 6 (1931/32),
p. 8

Quarré-Reybourbon 1900

Louis Quarré-Reybourbon, »Trois recueils de portraits
aux crayons ou à la plume représentant des souverains
et des personnages de la France et des Pays-Bas«,
Bulletin de la Commission historique du département
du Nord 23 (1900), pp. 1-127

Ragghianti 1958

Carlo L. Ragghianti, »Arte olandese dei secoli di
mezzo«, Sele-Arte vol. 7, no. 38 (1958), pp. 61-63

Randall 1992

Lilian M. C. Randall, Medieval and Renaissance
Manuscripts in the Walters Art Gallery, vol. II: France,
1420-1540, Baltimore/London 1992

Reinle/Schürer von Witzleben 1967

Adolf Reinle – Elisabeth Schürer von Witzleben,
»Anna-Selbdritt«, in: K. Algermissen et al. (ed.),
Lexikon der Marienkunde, vol. 1, Regensburg 1967,
col. 248-252

Reis-Santos 1962

Luís Reis-Santos, Masterpieces of Flemish Painting
of the Fifteenth and Sixteenth Centuries in Portugal,
Lisbon 1962

Renders 1931

Émile Renders, La solution du problème van der
Weyden – Flémalle – Campin [avec la collaboration de
Jos. de Smet et Louis Beyaert-Carlier] 2 vols., Bruges
1931

Renders/Lyna 1931

Émile Renders – Frédéric Lyna, »Le Maître de
Flémalle, Robert Campin et la prétendue école de
Tournai«, Gazette des Beaux-Arts, 6e pér., 6 (1931),
pp. 289-297

Renesse 1892-1903

Théodore de Renesse, Dictionnaire des figures héral-
diques, 7 vol., Brussels 1892-1903

Rensing 1967

Theodor Rensing, »Über die Herkunft des Meisters
Francke«, Wallraf-Richartz-Jahrbuch 29 (1967),
pp. 31-60

Reuterswärd 1998

Patrik Reuterswärd, »New Light on Robert Campin«
(Rez. Albert Châtelet, Robert Campin – Le Maître de
Flémalle), Konsthistorisk Tidskrift 67 (1998), pp. 43-54

Reynaud 1989

Nicole Reynaud, »Barthélemy d'Eyck avant 1450«,
Revue de l'Art 84 (1989), pp. 22-43

Reynaud 1999

Nicole Reynaud, »Les Heures du chancelier Guillaume
Jouvenel des Ursins et la peinture parisienne autour
de 1440«, Revue de l'Art 126 (1999), pp. 23-35

Reynaud 2000

Nicole Reynaud, »Le retable de la ›Trinité aux cha-
noines‹ de Notre-Dame de Paris (suite)«, Revue de
l'Art 128 (2000), pp. 30-32

Reynolds 1996

Catherine Reynolds, »Reality and Image: Interpreting
Three Paintings of the ›Virgin and Child in an Interior‹
Associated with Campin«, in: Foister/Nash 1996,
pp. 183-195

Rietstap 1884

J. B. Rietstap, Armorial général, Gouda 1884

Riewerts/Pieper 1955

Theodor Riewerts – Paul Pieper, Die Maler tom Ring:
Ludger d. Ae., Hermann, Ludger d. J., Munich 1955

Ring 1913

Grete Ring, Beiträge zur Geschichte Niederländischer
Bildnismalereien im 15. und 16. Jahrhundert (= Bei-
träge zur Kunstgeschichte N.F. 40), Leipzig 1913

Ring 1923

Grete Ring, »Beiträge zur Plastik von Tournai im 15. Jahrhundert«, in: Paul Clemen (ed.), Belgische Kunstdenkmäler, vol. 1, Munich 1923, pp. 269-291

Robb 1936

David M. Robb, »The Iconography of the Annunciation in the Fourteenth and Fifteenth Centuries«, The Art Bulletin 18 (1936), pp. 480-526

Robinet 1977

René Robinet, »L'église Sainte-Marie-Madeleine de Lille«, Bulletin de la commission historique du département du Nord 41 (1977), pp. 51-66, 10 fig.

Roethel 1954

Hans Konrad Roethel, »Die Ausstellung flämischer Malerei in London«, Kunstchronik 7 (1954), p. 89

Rohlmann 1994

Michael Rohlmann, Auftragskunst und Sammlerbild: altniederländische Tafelmalerei im Florenz des Quattrocento, Alfter 1994

Rolland 1931

Paul Rolland, »La double école de Tournai: peinture et sculpture«, in: Mélanges Hulin de Loo, Brussels/Paris 1931, pp. 296-305

Rolland 1932a

Paul Rolland, Les primitifs tournaisiens: peintres et sculpteurs, Brussels/Paris 1932

Rolland 1932b

Paul Rolland, »Une sculpture encore existante polychromée par Robert Campin«, Revue belge d'archéologie et d'histoire de l'art 2 (1932), pp. 335-345

Rolland 1942

Paul Rolland, »Peintures murales en l'église Saint-Brice de Tournai (L'Annonciation de Robert Campin)«, Recueil des travaux du Centre de recherches archéologiques [Anvers] 3 (1942), pp. 5-18

Rolland 1946

Paul Rolland, »Découvertes de peintures murales à Tournai: L'Annonciation de Robert Campin à Saint-Brice [II]«, Phoebus [Basel] 1 (1946), pp. 161-164

Roosen-Runge 1972

Heinz Roosen-Runge, Die Rolin-Madonna des Jan van Eyck: Form und Inhalt, Wiesbaden 1972

Rostworowski 1960

Marek Rostworowski, »Netherlandish Paintings in Polish Collections«, The Burlington Magazine 105 (1960), pp. 366-368

Rothes 1925

Walter Rothes, Die altniederländische Kunst in Farbe und Graphik, Munich 1925

Rotsaert 1975

Jan Rotsaert, »Het hoogaltaar in de Sint-Jakobskerk te Brugge«, Brugs Ommeland 15 (1975), pp. 125-135

Rousseau 1957

Theodore Rousseau Jr., »The Mérode Altarpiece«, The Metropolitan Museum of Art Bulletin 16.4 (1957), pp. 117-29

Saint Jérôme 1977

Saint Jérôme, Commentaire sur S. Matthieu, vol. I, Paris 1977

Sander 1993

Jochen Sander, Niederländische Gemälde im Städel 1400-1500, Mainz 1993

Savels 1904

C. A. Savels, Der Dom zu Münster in Westfalen: Geschichte und Beschreibung des Baues und seiner bildnerischen Ausstattung, Münster i.W. 1904

Saxl 1922

Fritz Saxl, »Rinascimento dell'Antichità: Studien zu den Arbeiten A. Warburgs«, Repertorium für Kunstwissenschaft 43 (1922), pp. 220-272

Schabacker 1980

Peter H. Schabacker, »Notes on the Biography of Robert Campin«, Medelingen van de Koninklijke Academie voor Wetenschappen, Letteren en Schone Kunsten van België, Klasse der Schone Kunsten (Bruxelles) 41.2 (1980), pp. 1-14

Schabacker 1982

Peter H. Schabacker, »Observations on the Tournai Painter's Guild, with Special Reference to Rogier van der Weyden and Jacques Daret«, Medelingen von de Koniklijke Academie voor Wetenschappen, Letteren en Schone Kunsten van België, Klasse der Schone Kunsten (Bruxelles) 43.1 (1982), pp. 9s-28

Schapiro 1945

Meyer Schapiro, »»Muscipula Diaboli«: The Symbolism of the Mérode Altarpiece«, The Art Bulletin 27 (1945), pp. 182-187 [reprinted in: M. S., Late Antique, Early Christian and Medieval Art, New York 1979, pp. 1-11]

Schiller 1968

Gertrud Schiller, Ikonographie der christlichen Kunst, Bd. 2, Gütersloh 1968

Schlosser 1912

Julius von Schlosser, Der Burgundische Paramentenschatz des Ordens vom Goldenen Vliesse, Vienna 1912

Schmarsow 1928

August Schmarsow, »Robert van der Kampine und Roger van der Weyden: Kompositionsgesetze des Mittelalters in der nordeuropäischen Renaissance«, Abhandlungen der philologisch-historischen Klasse der sächsischen Akademie der Wissenschaften 39.2, Leipzig 1928

Schöne 1938

Wolfgang Schöne, Dieric Bouts und seine Schule, Berlin/Leipzig 1938

Schreiber 1903

Wilhelm Ludwig Schreiber, Oracula Sibyllina, Strasbourg 1903

Schreiber 1927

Wilhelm Ludwig Schreiber, Handbuch der Holz- und Metallschnitte des XV. Jahrhunderts, vol. 3, Leipzig 1927

Schreiner 1990

U. Schreiner, »Marienverehrung, Lesekultur, Schriftlichkeit: bildungs- und frömmigkeitsgeschichtliche Studien zur Auslegung und Darstellung von ›Mariä Verkündigung‹«, Frühmittelalterliche Studien 24 (1990), pp. 314-368

Schubring 1912

Paul Schubring, »Zwei Cassone-Tafeln mit Apuleius' Märchen von Amor und Psyche«, Zeitschrift für bildende Kunst 27 (1912), pp. 315-20

Schuette/Müller-Christensen 1963

Marie Schuette – Sigrid Müller-Christensen, Das Stickereiwerk, Tübingen 1963

Schuler 1992

Carol M. Schuler, »The Seven Sorrows of the Virgin: popular culture and cultic imagery in pre-Reformation Europe«, Simiolus 21 (1992), pp. 5-28

Schulz 1971

Anne Markham Schulz, »The Columba Altarpiece and Roger van der Weyden's stylistic development«, Münchner Jahrbuch der bildenden Kunst 3. Folge 22 (1971), pp. 63-116

Seeck 1899/1900

Otto Seeck, »Ein neues Zeugnis über die Brüder Van Eyck«, Kunstchronik, N.F. 11 (1899/1900), col. 65-72, 81-87

Seitz 1908

Joseph Seitz, Die Verehrung des hl. Joseph in ihrer geschichtlichen Entwicklung bis zum Konzil von Trient dargestellt, Freiburg i.Br. 1908

Sigüenza 1602/1909

José de Sigüenza, Historia de la Orden de San Jerónimo [1602], vol. 2, Madrid 1909

Simson 1953

Otto G. von Simson, »Compassio and Co-redemptio in Roger van der Weyden's Descent from the Cross«, The Art Bulletin 35 (1953), pp. 9-16

Smeyers 1975

Maurits Smeyers, »De kapel van de H. Drievuldigheid in de Sint-Pieterskerk te Leuven en het geslacht van Baussele«, Bijlage 1 in: Cat. Leuven 1975

Smith 1972

Graham Smith, »The Betrothal of the Virgin by the Master of Flémalle«, Pantheon 30 (1972), pp. 115-132

Smith 1979

Jeffrey Chipps Smith, The Artistic Patronage of Philip the Good, Duke of Burgundy (1419-1467), Diss. Columbia University 1979

Smith/Wyld 1988

Alistair Smith – Martin Wyld, »Robert Campin's ›Virgin and Child in an interior‹«, The Burlington Magazine 130 (1988), pp. 570-572

Snyder 1985

James Snyder, Northern Renaissance Art: Painting, Sculpture, the Graphic Arts from 1350-1575, New York 1985

Sobotka 1907

George Sobotka, »The Revenge of Tomyris: a Composition after the Master of Flémalle«, The Burlington Magazine 11 (1907), pp. 389-390

Söding 1995

Ulrich Söding, Rez. Jochen Sander, Niederländische Gemälde im Städel 1400-1500, Kunstchronik 48 (1995), pp. 116-121

Soil de Moriamé 1883

anon. [Eugène Justine Soil de Moriamé], Tapisseries du quinzième siècle conservées à la cathédrale de Tournay [...], Tournay/Lille 1883

Soil de Moriamé 1891

Eugène Justine Soil de Moriamé, Les tapisseries de Tournai: les tapissiers et les hautelisseurs de cette ville: recherches et documents (= Mémoires de la Société historique et littéraire de Tournai, vol. 22), Tournai 1891

Soil de Moriamé 1908

Eugène Justine Soil de Moriamé, »L'église Saint-Brice à Tournai«, Annales de la Société historique et archéologique de Tournai n. s. 13 (1908), pp. 73-638

Sonkes 1969

Micheline Sonkes, Dessins du XVe siècle: Groupe van der Weyden (Les Primitifs flamands III, vol. 5), Brussels 1969

Sonkes 1971/72

Micheline Sonkes, »Le dessin sous-jacent chez Roger Van der Weyden et le problème de la personnalité du maître de Flémalle«, Bulletin de l'Institut Royal du Patrimoine Artistique (Bruxelles) 13 (1971/72), pp. 161-206

Sonkes 1973

Micheline Sonkes, »Les dessins du Maître de la Rédemption du Prado, le présumé Vrancke van der Stockt«, Revue des archéologues et historiens d'art de Louvain 6 (1973), pp. 98-125

Sosson 1981

Jean-Pierre Sosson, »Les années de formation de Rogier van der Weyden (1399/1400-1435): relecture des documents«, Le problème Maître de Flémalle – van der Weyden, Louvain-la-Neuve 1981, pp. 37-42

Spaemann 1925

Hans Spaemann, »Ein Altarbild der Gebrüder Dünwege in der Kirche zu Stolzenhain«, Heimatkalender für den Kreis Schweinitz 6 (1925), pp. 23 s

Sprung 1937

Annemarie Sprung, Derick Bagert aus Wesel, seine Werkstatt und seine Nachfolge: Ein Beitrag zur Geschichte des niederrheinisch-klevischen Kunstschaffens des ausgehenden Mittelalters, Cologne 1937

Stange 1954

Alfred Stange, Deutsche Malerei der Gotik, Bd. 6: Nordwestdeutschland in der Zeit von 1450-1515, Munich/Berlin 1954

Stange 1966

Alfred Stange, »Vier südflandrische Marientafeln: Ein Beitrag zur Genese der niederländischen Malerei«, Alte und moderne Kunst 11 (1966), pp. 2-19

Stange 1967

Alfred Stange, Kritisches Verzeichnis der deutschen Tafelbilder vor Dürer, vol. 1 (Köln, Niederrhein, Westfalen, Hamburg, Lübeck und Niedersachsen), Munich 1967

Stanton 1998

Thomas Stanton, Forging the Missing Links: Robert Campin and Byzantine Icons, Thesis Case Western Reserve University 1998 [UMI 98-33920]

Stechow 1964

Wolfgang Stechow, »Joseph of Arimathea or Nicodemus?«, in: Wolfgang Lotz – Lise Lotte Möller (eds.), Studien zur toskanischen Kunst: Festschrift für Ludwig Heinrich Heydenreich zum 23. März 1963, Munich 1964, pp. 289-302

Steinmetz 1995

Anja Sibylle Steinmetz, Das Altarretabel in der altniederländischen Malerei: Untersuchung zur Darstellung eines sakralen Requisits vom frühen 15. bis zum späten 16. Jahrhundert, Weimar 1995

Steppe 1975

Jan Karel Steppe, »Het paneel van de Triniteit in het Leuvense Stadsmuseum: nieuwe gegevens over een enigmatisch schilderij«, in: Cat. Leuven 1975, pp. 447-495

Steppe 1985

Jan Karel Steppe, »Mécénat espagnol et art flamand au XVIe siècle«, in: Cat. Brussels 1985, vol. 1, pp. 247-282

Sterling 1969/1971

Charles Sterling, »Etudes savoyardes I: au temps du duc Amédée«, L'Œil 178 (octobre 1969), pp. 2-13 et supplément: 195/96 (mars-avril 1971), pp. 14-19, 36

Sterling 1971

Charles Sterling, »Observations on Petrus Christus«, The Art Bulletin 53 (1971), pp. 1-26

Sterling 1972

Charles Sterling, »Observations on Moser's Tiefenbronn Altarpiece«, Pantheon 30 (1972), pp. 19-32

Sterling 1987

Charles Sterling, La peinture médiévale à Paris 1300-1500, 2 vols., Paris 1987

Stucky-Schürer 1972

Monica Stucky-Schürer, Die Passionsteppiche von San Marco in Venedig: ihr Verhältnis zur Bildwirkerei in Paris und Arras im 14. und 15. Jahrhundert, Bern 1972

Suckale 1995

Robert Suckale, Rogier van der Weyden – Die Johannestafel: Das Bild als stumme Predigt, Frankfurt am Main 1995

Suhr 1957

William Suhr, »The Restoration of the Mérode Altarpiece«, The Metropolitan Museum of Art Bulletin 16.4 (1957), pp. 140-44

Sulzberger 1950/51

Suzanne Sulzberger, »Relations artistiques italo-flamandes: autour d'une œuvre perdue de Roger van der Weyden«, Bulletin de l'Institut historique belge de Rome 26 (1950/51), pp. 251-261

Sulzberger 1961

Suzanne Sulzberger, La Réhabilitation des Primitifs Flamands: 1802-1867, Brussels 1961

Sulzberger 1963

Suzanne Sulzberger, »La descente de croix de Rogier van der Weyden«, Oud Holland 78 (1963), p. 150s

Sulzberger 1966

Suzanne Sulzberger, »Ajoutes au catalogue de Ambrosius Benson?«, Oud-Holland 81 (1966), pp. 187-189

Taubert 1959

Johannes Taubert, »La Trinité du Musée de Louvain: une nouvelle méthode de critique des copies«, Bulletin de l'Institut royal du patrimoine artistique 2 (1959), pp. 20-33

Taverne 1651/1936

Antoine de la Taverne, Journal de la Paix d'Arras faite en l'Abbaye Royale de Sainct Vaast, entre le Roy Charles VII et Philippe le Bon, Duc de Bourgogne, Prince Souverain des Pays-Bas [1435], ed. par Jean Collard, Paris 1651, ed. André Bossuat, Arras 1936

Terner 1973

Rudolf Terner, Die Kreuzabnahme Roger van der Weydens: Untersuchungen zu Ikonographie und Nachleben, Diss. Münster 1973

Thomas/Nazet 1995

Françoise Thomas – Jacques Nazet, Tournai: une ville, un fleuve, Bruxelles 1995

Thürlemann 1989

Felix Thürlemann, Mantegnas Mailänder Beweinung: Die Konstitution des Betrachters durch das Bild, Konstanz 1989

Thürlemann 1990

Felix Thürlemann, »Der Blick hinaus auf die Welt: zum Raumkonzept des Mérode-Triptychons von Robert Campin«, in: Peter Fröhlicher et al. (ed.), Espaces du texte: recueil d'hommages pour Jacques Geninasca, Lausanne 1990, pp. 383-396

Thürlemann 1992

Felix Thürlemann, »Das Lukas-Triptychon in Stolzenhain: ein verlorenes Hauptwerk von Robert Campin in einer Kopie aus der Werkstatt Derick Baegerts«, Zeitschrift für Kunstgeschichte 61 (1992), pp. 524-564

Thürlemann 1993a

Felix Thürlemann, Rez. van Asperen de Boer et al., Underdrawing in Paintings of the Rogier van der Weyden and Master of Flémalle Groups, Zwolle 1992. Kunstchronik 46 (1993), pp. 718-731

Thürlemann 1993b

Felix Thürlemann, »Die Madrider Kreuzabnahme und die Pariser Grabtragung: das malerische und das zeichnerische Hauptwerk Robert Campins«, Pantheon 51 (1993), pp. 18-45

Thürlemann 1997a

Felix Thürlemann, Robert Campin – Das Mérode-Triptychon: Ein Hochzeitsbild für Peter Engelbrecht und Gretchen Schrinmechers aus Köln, Frankfurt am Main 1997

Thürlemann 1997b

Felix Thürlemann, »Abschied von der Ikone: Das Bildkonzept Robert Campins und seine Rezeption in Malerei und Kunstgeschichte«, in: Gerhart Schröder (ed.), Anamorphosen der Rhetorik, Munich 1997, pp. 249-266

Thürlemann 1997c

Felix Thürlemann, »Robert Campin um 1400 als Malergeselle in Tournai: ein kennerschaftlicher Versuch zu den Tapisserien der heiligen Piatus und Eleutherius«, Pantheon 55 (1997), pp. 24-31

Tolnai 1932

Karl von Tolnai, »Zur Herkunft des Stiles der van Eyck«, Münchner Jahrbuch der bildenden Kunst, N.F. 9 (1932), pp. 320-338

Tolnay 1939

Charles de Tolnay, Le Maître de Flémalle et les Frères van Eyck, [Éditions de la Connaissance] Brussels 1939

Tolnay 1959

Charles de Tolnay, »L'Autel Mérode du Maître de Flémalle«, Gazette des Beaux-Arts 53 (1959), pp. 65-78

Tombu 1930

Jeanne Tombu, Colyn de Coter, peintre bruxellois, Brussels 1937

Trnek 1987

Helmut Trnek, Kunsthistorisches Museum Wien:

weltliche und geistliche Schatzkammer: Bildführer, Vienna 1987

Trnek 1997

Renate Trnek, Die Gemäldegalerie der Akademie der bildenden Künste in Wien: die Sammlung im Überblick, Vienna 1997

Troescher 1940

Georg Troescher, Die burgundische Plastik des ausgehenden Mittelalters und ihre Wirkung auf die europäische Kunst, vol. 1, Frankfurt a. M. 1940

Troescher 1967

Georg Troescher, »Die Pilgerfahrt des Robert Campin: altniederländische und südwestdeutsche Maler in Südostfrankreich«, Jahrbuch der Berliner Museen 9 (1967), pp. 100-134

Tschudi

Hugo von Tschudi, »Der Meister von Flémalle«, Jahrbuch der königlich-preußischen Kunstsammlungen 19 (1898), pp. 8-34, 89-116

Underwood 1966

Paul A. Underwood, The Kariye Djami, 4 vol.; vol. 1: Historical Introduction and Description of the Mosaics and Frescoes, vol. 2: Plates 1-334; the Mosaics (= Bollington Series 70), New York/London 1966

Urbach 1995

Susan Urbach, »On the Iconography of Campin's Virgin and Child in an Interior: The Child Jesus Comforting his Mother after the Circumcision«, in: Smeyers/Cardon 1995, pp. 557-568

Vacková/Comblen-Sonkes 1985

Jarmila Vacková – Micheline Comblen-Sonkes, Collections de Tchécoslovaquie (= Répertoire des peintures flamandes du quinzième siècle, vol. 4), Brussels 1985

Valentiner 1945

William Reinhold Valentiner, »Rogier van der Weyden, ›The Mass of St. Gregory‹«, Art Quarterly 8 (1945), pp. 240-243

Van Camp 1951

Gaston Van Camp, »Le Paysage de la Nativité du Maître de Flémalle à Dijon«, Revue belge d'archéologie et d'histoire de l'art 20 (1951), pp. 295-300

Vandenbroeck 1863

H. Vandenbroeck, Extraits des anciens registres aux délibérations des consaux de la ville de Tournai 1422-1430 (= Mémoires de la Société historique et littéraire de Tournai 8), Tournai 1863

Vanden Haute 1913

C. Vanden Haute, La Corporation des peintres de Bruges, Bruges/Kortrijk 1913

van der Haeghen 1913

Victor van der Haeghen, »Un élève de Robert Campin à Gand«, Bulletin de la Société d'histoire et d'archéologie de Gand 21 (1913), pp. 126-130

van der Haeghen 1919

Victor van der Haeghen, »Autour des frères Van Eyck, cartulaire«, Handelingen der Maatchappij van geschied- en oudheidkunde te Gent (= Annales de la Société d'histoire et d'archéologie de Gand) 15 (1919), pp. 3-67

van de Velde 1967

Carl van de Velde, »Enkele gegevens over gentse schilderijen«, Gentse bijdragen tot de kunstgeschiedenis en de oudheidkunde 20 (1967), pp. 193-235

van Even 1895

Edward van Even, L' Ancienne École de Peinture de Louvain, Brussels/Louvain 1870

van Miegroet 1989

Hans J. van Miegroet, Gerard David, Antwerpen 1989

van Ysendyck 1888/9

J.-J. van Ysendyck, Documents classés de l'Art dans les Pays-Bas du Xe au XVIIIe siècles, s.l. [Antwerp] 1888/9

Veit 1936

Ludwig Andreas Veit, Volksfrommes Brauchtum und Kirche im deutschen Mittelalter: ein Durchblick, Freiburg im Breisgau 1936

Verhaegen 1962

Nicole Verhaegen, »The Arenberg ›Lamentation‹ in the Detroit Institute of Arts«, The Art Quarterly 25 (1962), pp. 295-312

Verlant 1924

Ernest Verlant, La peinture ancienne à l'exposition de l'Art belge à Paris en 1923, Brussels/Paris 1924

Verlet 1977

Pierre Verlet et al., La tapisserie: histoire et technique du XIVe au XXe siècle, Lausanne 1977

Veronée-Verhaegen 1966

Nicole Veronée-Verhaegen, »Iconographie [Triptyque de Watervliet«, Bulletin de l'Institut Royal du patrimoine artistique, Bruxelles 9 (1966), pp. 40-53

Verougstraete-Marcq 1981

Hélène Verougstraete-Marcq (en collaboration avec R. van Schoute et D. Hollanders-Favart), »Le Triptyque Edelheer: examen au laboratoire et rapports avec la Descente de croix de van der Weyden du Prado à Madrid«, in: Le dessin sous-jacent dans la peinture. Colloque III, 6-8 sept. 1979, Louvain-la-Neuve 1981, pp. 119-129

Verougstraete-Marcq/Schoute 1989

Hélene Verougstraete-Marcq – Roger van Schoute, Cadres et supports dans la peinture flamande aux 15e et 16e siècles. Heure-le-Romain 1989

Villers/Bruce-Gardner 1996

Caroline Villers – Robert Bruce-Gardner, »The ›Entombment‹ Triptych in the Courtauld Institute Galleries, in: Foister/Nash 1996, pp. 27-36

Vines 1978

Vera Vines, »Jacques Daret: some Questions of Iconography«, Australian Journal of Art (Florence) 1 (1978), pp. 41-57

Vöge 1950

Wilhelm Vöge, Jörg Syrlin der Ältere und seine Bildwerke, vol. 2: Stoffkreis und Gestaltung, Berlin 1950

Voisin 1863

J. Voisin, »Notice sur les anciennes tapisseries de la cathédrale de Tournai«, Bulletin de la Société historique et archéologique de Tourani 9 (1863), pp. 213-45

Voll 1923

Karl Voll, Die altniederländische Malerei von Jan van Eyck bis Memling: ein entwicklungsgeschichtlicher Versuch, Leipzig 1923

Vos 1971

Dirk de Vos, »De Madonna-en-Kindtypologie bij

Rogier van der Weyden: en enkele minder gekende
Flemalleske voorlopers«, Jahrbuch der Berliner
Museen 13 (1971), pp. 60-161

Ward 1968
John L. Ward, »A New Attribution for the »Madonna
Enthroned« in the Thyssen Bornemisza Collection«,
The Art Bulletin 50 (1968), pp. 354-356

Warichez 1934
Joseph Warichez, La Cathédrale de Tournai et son
chapitre, Wetteren 1934

Warichez 1935
Joseph Warichez, La Cathédrale de Tournai, 2 vols.,
Brussels 1935

Weale 1903
W. H. James Weale, »The early Painters of the
Netherlands as illustrated by the Bruges Exhibition
of 1902, II«, The Burlington Magazine 1 (1903),
pp. 202-17

Weale 1908
W. H. James Weale, Hubert and John van Eyck: Their
Life and Work, London 1908

Weinberger 1945
Martin Weinberger, »A Sixteenth-Century Restorer«,
The Art Bulletin 27 (1945), pp. 266-269

Wescher 1938
Paul Wescher, »The Drawings of Vrancke van der
Stoct (The Master of the Cambrai Altar)«, Old Master
Drawings 13 (1938/39), no. 49, June 1938, pp. 1-5

Wieck 1988
Roger S. Wieck, Time Sanctified: The Book of Hours
in Medieval Art and Life, New York/London 1988

Winkler
Friedrich Winkler, Der Meister von Flémalle und
Rogier van der Weyden: Studien zu ihren Werken und
zur Kunst ihrer Zeit mit mehreren Katalogen zu
Rogier, Straßburg 1913 (= Zur Kunstgeschichte des
Auslandes, Heft 103)

Winkler 1913/14
Friedrich Winkler, »Some Early Netherland Drawings,
III. A Triptych after van der Weyden«, The Burlington
Magazine 24 (1913/14), pp. 224-231

Winkler 1941
Friedrich Winkler, »Flémalle-Meister-Dämmerung?«,
Pantheon 28 (1941), pp. 145-153

Winkler 1942
Friedrich Winkler, »Weyden, Rogier van der«, in:
Thieme-Becker, vol. 35, Leipzig 1942, pp. 468-76

Winkler 1948
Friedrich Winkler, »Ein deutsch-niederländischer Altar
in Oberitalien«, Zeitschrift für Kunstwissenschaft 2
(1948), pp. 15-18

Winkler 1950
Friedrich Winkler, »Meister von Flémalle«, in:
H. Thieme – F. Becker, Allgemeines Lexikon der
bildenden Künstler von der Antike bis zur Gegen-
wart, vol. 37, Leipzig 1950

Winkler 1957
Friedrich Winkler, »Das Bildnis des Robert de
Masmines(?) vom Meister von Flémalle«, Berliner
Museen: Berichte aus den ehemaligen Preussischen
Kunstsammlungen, n.s. 7 (1957), pp. 37-41

Winkler 1958
Friedrich Winkler, »Vorbilder primitiver Holzschnitte«,
Zeitschrift für Kunstwissenschaft 12 (1958), pp. 37-45

Winkler 1959
Friedrich Winkler, »Jos Ammann von Ravensburg«,
Jahrbuch der Berliner Museen 1 (1959), pp. 51-118

Winkler 1960
Friedrich Winkler, »Die Anbetung der Könige mit
dem Baldachin von Robert Campin«, in: Heinz Laden-
dorf – Horst Vey (eds.), Mouseion: Studien aus Kunst
und Geschichte für Otto H. Förster, Cologne 1960,
pp. 138-140

Winkler 1964
Friedrich Winkler, Das Werk des Hugo van der Goes,
Berlin 1964

Winkler 1965
Friedrich Winkler, »The Drawings of Vrancke van der
Stockt«, Master Drawings 3 (1965), pp. 155-158

Wit 1937
Kees de Wit, »Das Horarium der Katharina van Kleve
als Quelle für die Geschichte der südniederländischen
Tafelmalerei«, Jahrbuch der preußischen Kunstsamm-
lungen 58 (1937), pp. 114-123

Witting 1900
Felix Witting, »Ein Werk des Meisters von Flémalle
in der Galerie zu Aix«, Zeitschrift für bildende Kunst
N.F. 11 (1900), p. 90s

Wymans 1969
Gabriel Wymans, »Sur un prétendu pèlerinage expia-
toire de Robert Campin en Provence (1428-1430)«,
in: Annales de la Fédération archéologique et histo-
rique de Belgique, XLe Congrès, Liège 1968, Liège
1969, vol. I, pp. 381-392

Zülch 1938
Walter Karl Zülch, Der historische Grünewald: Mathis
Gothardt-Neithardt, Munich 1938

Synopsis of Critical Catalogues

Max J. Friedländer, *Early Netherlandish Painting, vol. II: Rogier van der Weyden and the Master of Flémalle*, Leyden/Brussels 1967

Martin Davies, *Rogier van der Weyden: an essay with a critical catalogue of paintings assigned to him and to Robert Campin*, London 1972

Friedländer	Thürlemann	Davies	Thürlemann
3	I.17	Rogier/Lugano 1	III.D.2
8	III.D.2	Rogier/Madrid 1	I.17
50	III.E.1	Campin/Aix	III.F.4
51	III.D.1a	Campin/Berlin 1	III.C.1
52	III.D.1b	Campin/Berlin 2	I.5/C
53	I.6	Campin/Berlin 3	III.A.2
54	I.12	Campin/Berlin 4	II.3
54b	III.C.1	Campin/Berlin 5	III.E.6/C
55	I.9, III.G.2	Campin/Berlin 6	III.E.3/C
56	III.C.3	Campin/Brussels 1	I.8/C
57	II.7	Campin/Brussels 2	III.G.5/C
58	I.13	Campin/Brussels, Gendebien	III.G.7
59	I.16	Campin/Cleveland	I.2
60	I.18a-c	Campin/Dijon	I.6
61	I.5/C	Campin/Frankfurt 1	I.16
62	III.A.2	Campin/Frankfurt 2	I.18
63	II.6	Campin/Leningrad	III.F.3
64	III.F.3b	Campin/Le Puy	III.F.2
65	III.F.3a	Campin/London 1	I.9, III.G.2
66	III.F.4	Campin/London 2	I.13
67	III.B.4	Campin/London 3	III.E.2/C
68	II.3	Campin/London 4	II.4
69	I.8/C	Campin/London 5	III.F.6
70	–	Campin/London, Seilern	I.3
71a	III.F.1	Campin/Louvain	III.F.1
72a	III.F.5	Campin/Lugano	I.14/C
73a	III.G.5/C	Campin/Madrid 1	III.D.1 (I.7/C)
74	III.E.2/C	Campin/Madrid 2	III.B.4
75a	III.E.6/C	Campin/New York	I.12 (III.C.1)
76a	III.E.3/C	Campin/New York, Magnin	II.6
77	II.4	Campin/Paris	III.F.5
78	III.A.1a	Campin/Philadelphia	III.C.3
79	III.A.1b	Campin/Various Collections	
80	III.A.1d	Campin/Washington	III.C.2
81	III.A.1c	Campin/Washington,	
82	I.7/C	Dumbarton Oaks	II.7
94a	I.10		
Add. 147	I.3		
Add. 148	III.F.6a		
Add. 149	I.2		
Add. 151	III.G.7		
Add. 152	III.C.2		
Add. 153	III.F.2		
Plate 99C	I.23a		
Vol. I, plate 71D	II.5		

Albert Châtelet, *Robert Campin – Le Maître de Flémalle:*
la fascination du quotidien, Antwerp 1996

Châtelet	Thürlemann
Œuvres de Robert Campin	
1	II.1
2	I.2
3	I.3
4	I.18
5	I.16
6	I.12
7	I.13
8	III.C.3
9	III.F.3
10	I.6
11	III.D.1 (I.7C)
12	I.5/C
13	III.G.2
14	I.9
15	III.F.5
16	II.3
17	III.F.4
18	III.B.4

Copies d'après Robert Campin et œuvres d'atelier	
C1	–
C2	III.G.6
C3	III.G.3
C4	III.E.2/C
C5	–
C6	III.E.4/C
C7	III.E.6/C
C8	–
C9	III.E.3/C
C10	–
C11	I.8a/C
C12	I.8b/C
C13	III.G.5/C
C14	–
C15	–
C16b,c	I.15/C

Œuvres de Jacques Daret jusqu'à 1535	
D1	III.E.1
D2	III.C.1
D3	III.C.2
D4	III.F.1
D5	III.D.1
D6	II.7
D7	III.A.2
D8	III.A.1a
D9	III.A.1b
D10	III.A.1c
D11	III.A.1d

Œuvres de Rogier van der Weyden dans l'atelier de Robert Campin	
R1	III.D.2
R2	–
R3	III.B.3
R4	III.B.11

Attributions à Robert Campin rejetées	
AR1	III.G8/C
AR2	III.G.7
AR3	II.4
AR4	II.6
AR5	III.F.6a
AR6	III.F.6b
AR7	III.F.2

New attributions
The following works are not included in the catalogues
mentioned:

I.1
I.4
I.11/C
I.19
I.20/C
I.21/C
I.22/C
I.23
II.2
III.A.3
III.D.1c/C
III.E.5/C
III.G.1
III.G.4

Index

Photographic Credits

The illustrations in this publication were kindly provided by the museums and lenders or taken from the archives of the author or the publisher, with the following exceptions:

A.C.L., Brussels: pp. 20-25, 26 right, 27, 53 top, 54 bottom, 56, 57 bottom, 73, 79, 90 upper left, 102, 104 bottom, 107 lower left, 116 bottom, 119, 129 centre, 131 top, 140 lower left, 152 upper right, 152 bottom, 153 upper right and left, 153 bottom, 157, 173, 174, 175 top, 185, 187, 202 top, 253, 261, 262, 263, 293 top, 298 top, 303, 316 bottom, 318 bottom, 330 top and centre, 332 top, 334 top

Acquavella Galleries, New York: p. 332 bottom

AFSMO, Modena: p. 208 bottom

Archivi Alinari: pp. 88 top, 178 bottom

Artothek, photo: Ursula Edelmann: pp. 16, 120 bottom, 133-136, 171 lower left, 239, 276 centre, 282 centre and bottom

J.R.J. van Asperen de Boer: p. 236 left

Bildarchiv Foto Marburg: pp. 69, 152 upper left and centre, 205 bottom, 293 bottom

© Bildarchiv Preußischer Kulturbesitz, Berlin, photo: Jörg P. Anders: pp. 75 top, 153 top centre, 179 bottom, 191, 213, 247 top, 249 lower left, 258 top, 294, 296, 300 top, 300 centre, 301 top, 314 top, 315, 316 top, 318 top, 319

© Bildarchiv Preußischer Kulturbesitz, Berlin, photo: G. Schultz: p. 246 right

Byzantine Visual Resources, Dumbarton Oaks: p. 57 top

© The Cleveland Museum of Art, 2002: pp. 17, 255

CNMHS, Paris: p. 11

Deutsches Archäologisches Institut, Rome: p. 88 bottom

© Ursula Edelmann, Frankfurt a.M: pp. 121, 122, 128, 129 upper left, 130 bottom, 132, 238 top, 276 bottom, 334 bottom

Fitzwilliam Museum, Cambridge (UK): p. 139 bottom

Foto Strenger, Osnabrück: p. 284

Tom Haartsen, Ouderkerk a/d Amstel: pp. 171 upper right, 200 right, 283

F. Jay, 1999: pp. 41-47, 259

Bernd-Peter Keiser: pp. 96 top, 147 centre left, 150 centre, 192 bottom, 268, 297

S. Kemperdick/J. Sander: p. 236 right

Kunstfoto Speltdoorn, Brussels: p. 75 bottom

Laboratorio Fotografico Chomon, Turin: p. 186 left and right

Michael Lindner: p. 101

David A. Loggie, New York: pp. 206, 207 left

Photograph © 1996 The Metropolitan Museum of Art, New York: pp. 58-62, 63, 64 left, 65, 74, 89 lower left, 269, 314 bottom, 328, 331, cover

© Museo Nacional del Prado, Madrid: pp. 55 bottom, 113 bottom, 114-115, 116 top, 120 bottom, 123-127, 176 left, 196 top, 197 upper left, 197 upper right, 279, 302, 303, 309, 310

© National Gallery of Art, Washington: pp. 189, 307 top

© 2002, Board of Trustees, National Gallery of Art, Washington, photo: Richard Carafelli: pp. 189, 307 top

Österreichische Nationalbibliothek, Vienna: p. 54 top

Photographie Bulloz, Paris: p. 183 bottom

Phototheque des Musées de la Ville de Paris: p. 300 bottom

Phototheque des Musées de la Ville de Paris, photo: Pierrain: p. 35

Enrico Polidori, Genoa: p. 208 top

Rijksbureau voor Kunsthistorische Documentatie, Den Haag, photo: J.R.J. Asperen de Boer: pp. 85 upper left, 246 left

Rijksmuseum Amsterdam: pp. 104 top, 118, 209 top, 311

Rijksmuseum Het Catharijneconvent, Utrecht: p. 106 top

RMN, Paris: pp. 51, 84, 85 upper right, 89 right, 186 centre, 198 upper left, 200 top, 257, 266, 301 bottom, 321 bottom, 322, 324, 325

RMN – Michèle Bellot: pp. 51, 84

RMN – René-Gabriel Ojeda: p. 145 lower right

Gordon H. Roberton, A.C. Cooper Ltd., London: pp. 28-32, 255

© Städtisches Museum Vander Kelen-Mertens, Louvain: p. 197 bottom

Statens Konstmuseer, Stockholm: p. 94 bottom

Bernard Terlay: p. 198

Umberto Tomba, Verona: p. 211

© Elke Walford, Hamburg: p. 70 top

Westfälisches Amt für Denkmalpflege, Münster: pp. 203 bottom, 275

Westfälisches Landesmuseum für Kunst und Kulturgeschichte, photo: Sabine Ahlbrand-Dornseif: pp. 204, 207 right

Westfälisches Landesmuseum für Kunst und Kulturgeschichte, photo: Rudolf Wakonigg: pp. 103, 105, 145 lower left, 145 bottom centre, 147 bottom, 148 lower left, 148 lower right, 149 bottom, 150 bottom, 274 bottom, 286, 287, 288

Zentralbibliothek Zürich: p. 10

© Prestel Verlag Munich · Berlin · London · New York, 2002

Cover illustration: detail from the central panel of the
Mérode Triptych by Robert Campin (see p. 59)
Frontispiece: Robert Campin, *Portrait of a Woman*,
(detail, see p. 81)

Photographic Credits page: p. 385

The Library of Congress Cataloguing-in-Publication data
is available
Die Deutsche Bibliothek lists this publication in the
Deutsche Nationalbibliografie; detailed bibliographic data
is available in the Internet at http://dnb.ddb.de

Prestel Verlag
Königinstrasse 9
80539 Munich
Tel. +49 (89) 38 17 09-0
Fax +49 (89) 38 17 09-35

4 Bloomsbury Place
London WC1A 2QA
Tel. +44 (020) 73 23-5004
Fax +44 (020) 7636-8004

175 Fifth Avenue, Suite 402
New York, NY 10010
Tel. +1 (212) 995-2720
Fax +1 (212) 995-2733

www.prestel.com

Prestel books are available worldwide. Please contact your
nearest bookseller or one of the Prestel offices listed above
for details concerning your local distributor.

Translated from the German by Ishbel Flett, Edinburgh
Editorial direction: Christopher Wynne

Design and layout: Saskia Helena Kruse, Munich
Typeset using Dante and Form fonts
Lithography: Trevicolor srl, Treviso/Italy
Printing and Binding: GRASPO, Zlín/Czech Republic

Printed in the Czech Republic on acid-free paper
ISBN 3-7913-2778-X